The Collected Writings

of

Zelda Fitzgerald

The Collected Writings

of

Zelda Fitzgerald

Edited by
Matthew J. Bruccoli

With an Introduction by
Mary Gordon

The University of Alabama Press

Tuscaloosa

Originally published as *Zelda Fitzgerald: The Collected Writings* by Scribner, an imprint of
Simon & Schuster, Inc. First paperback edition published in 1992 by Collier Books, an imprint of
Macmillan Publishing Company.

The University of Alabama Press
Tuscaloosa, Alabama 35487-0380
Manufactured in the United States of America

This is a work of fiction. Names, characters, places, and incidents are either a product of the
author's imagination or are used fictitiously. Any resemblance to actual events or persons living
or dead is entirely coincidental.

Library of Congress Cataloging-in-Publication Data

Fitzgerald, Zelda, 1900–1948.
[Works. 1997]
The collected writings of Zelda Fitzgerald / edited by Matthew J. Bruccoli : with an
introduction by Mary Gordon.
p. cm.
Originally published: The collected writings. New York : Scribner, c1991.
ISBN 0-8173-0884-9 (alk. paper)
I. Bruccoli, Matthew Joseph, 1931– II. Fitzgerald, Zelda, 1900–1948.
Works. 1991. III. Title.
PS3511.I9234 1997
813'.52—dc21 97-2017

2 3 4 5 6 7 8 9 • 07 06 05 04 03 02 01 00

To the memory
of Frances Fitzgerald Lanahan Smith
(1921–1986)

In dedicating this collection of our grandmother's writings to the memory of our mother, we are certain that she would have been very pleased to see Zelda Fitzgerald's work published in a volume of her own. In this area that was so close to her heart we think it best to let our mother speak for herself. Therefore, we submit to the reader the following excerpts from an introduction she wrote for an exhibition catalogue of Grandmother's paintings in the Montgomery Museum of Fine Arts in 1974.

<div align="right">

ELEANOR LANAHAN
SAMUEL J. LANAHAN, JR.
CECILIA LANAHAN ROSS

</div>

I was surprised, when Women's Lib finally became part of our national consciousness, to find that my mother was considered by many to be one of the more flamboyant symbols of The Movement. To a new generation, the generation of her grandchildren, she was the classic "put down" wife, whose efforts to express her artistic nature were thwarted by a typically male chauvinist husband (except that authors are the worst kind, since they spend so much time around the house). Finally, in a sort of ultimate rebellion, she withdrew altogether from the arena; it's a script that reads well, and will probably remain a part of the "Scott and Zelda" mythology forever, but is not, in my opinion, accurate.

It is my impression that my father greatly appreciated and encouraged his wife's unusual talents and ebullient imagination. Not

only did he arrange for the first showing of her paintings in New York in 1934, he sat through long hours of rehearsals of her one play, *Scandalabra,* staged by a Little Theater group in Baltimore; he spent many hours editing the short stories she sold to *College Humor* and to *Scribner's Magazine;* and though I was too young to remember clearly, I feel quite sure that he was even in favor of her ballet lessons (he paid for them, after all) until dancing became a twenty-four-hour preoccupation which was destroying her physical and mental health. He did raise a terrible row when she published her novel, *Save Me the Waltz,* while he was still working on his own *Tender Is the Night,* a novel drawing on the same Paris and Riviera experiences. But this sort of competition is traditionally the bane of literary romances: only last year, the well-publicized love affair between a witty Washington blonde and a popular "Southern Writer" broke up when he published *his* novel about the very same events she had described in her nonfiction best-seller.

What I propose, rather, is that my mother was surprisingly emancipated for a woman born in the Cradle of the Confederacy at a time when the Civil War was still a vivid memory. One of her older sisters, Rosalind Smith, was the first girl "of good family" ever to get a job in Montgomery (other than teaching, of course), and she remembers that the day she started working at the bank, lines of young men formed outside just to stare through the window at the daredevil daughter of Judge A. D. Sayre. Both the Judge and my grandmother apparently took the position that their girls could do no wrong, for they fended off all criticism of their iconoclastic ways. Whether wise or not, this attitude undoubtedly played an important part in the willingness to attempt anything which characterized their baby, Zelda.

For in defining genius as one percent inspiration and ninety-nine percent perspiration, Edison surely meant in one direction, not in three. It was my mother's misfortune to be born with the ability to write, to dance, *and* to paint, and then never to have acquired the discipline to make her talent work for, rather than against, her. Growing up in Montgomery, she was apparently an accomplished amateur dancer; her name appears time and again in the *Advertiser* of World War I years as a featured soloist at various pageants and entertainments. After she was married she painted; then she studied at a Russian ballet school in Paris, getting just professional enough to be offered a job with the Naples Opera before her total collapse; on the advice of the doctors that she never dance again, she turned to writing, then back, finally, to

painting. As one who cannot draw a whisker on a cat, I marvel at the one percent of genius coming through on canvas despite her almost casual attitude, as if creating a work of art was no more challenging than, say, planting a row of zinnias. . . .

Her love of flowers, of color, of tradition are surely as Southern as the jasmine she often wrote of. As well as the passionate enjoyment of life which she kept until the end, a sort of triumph in defeat as poignant as the tombstones in the Confederate Cemetery at Oakwood, her favorite place to be when she felt quite alone.

<div align="right">SCOTTIE FITZGERALD SMITH</div>

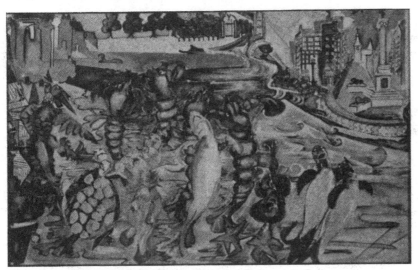

The Lobster Quadrille by Zelda Fitzgerald (Arlyn F. Bruccoli Collection)

CONTENTS

◇

PREFACE

◇

Zelda Sayre Fitzgerald's writings can be read now as autobiography, as social history, as literary history, as an evocation of something imprecisely labeled "the romantic view of life"—and they can be read as the expression of a complex sensibility. Proper assessment of this writer as more than a cult figure and as more than an appendage of the F. Scott Fitzgerald saga requires that her work be available. Her publication career spanned a dozen years, from 1922 to 1934. *Save Me the Waltz* (1932), her only novel, was republished in 1967, and ten short stories were collected in *Bits of Paradise*[1]; but except for the two essays in *The Crack-Up*,[2] her nonfiction has remained interred in old magazines.

Apart from a high school poem, "Over the Top with Pershing," written in collaboration with her mother, there is no evidence that Zelda Sayre had literary ambitions before her marriage at the age of twenty. Her writing during the Thirties was a quest for identity apart from her status as "wife of," as well as evidence of the rivalry that had developed in the Fitzgerald marriage. Marriage to a celebrated writer made it easier for her to have her work published; but it impeded her development as a professional writer—one who successfully competes in the marketplace.

She possessed a characteristic wit, the ability to make surprising connections between ideas, and an idiosyncratic style. Thus from *Save Me the Waltz*: "A shooting star, ectoplasmic arrow, sped through the nebular hypothesis like a wanton hummingbird. From Venus to Mars to Neptune it trailed the ghost of comprehension, illuminating far horizons over the pale battlefields of reality." Had Zelda Sayre been compelled to serve a rigorous literary apprenticeship, she could have succeeded on her own. However, she started serious work late and under terrible strains; most of the work in this volume was written after her 1930 breakdown. "Auction—Model 1934" was her last publication, but she continued to write.

She began a second novel, "Caesar's Things," probably after Fitzger-

ald's death and worked on it intermittently for the rest of her life. It
survives at the Princeton University Library in a fragmented typescript
with pieces of perhaps seven chapters. The autobiographical novel cov-
ers much the same ground as *Save Me the Waltz*. Janno, the daughter of
a Southern judge, falls in love with Jacob during World War I. He
becomes a successful painter in New York. They go to Paris, where he
drinks too much and has an affair. They move to the Riviera, and she
falls in love with a French aviator named Jacques. "Caesar's Things"
combines hallucinations or fantasy with narrative; there is also a strain
of religiosity. As a work in progress it is incoherent.

The attributions of Zelda Fitzgerald's publications are muddied be-
cause editors put F. Scott Fitzgerald's byline on her work—either as
collaborator or as sole author. His name sold magazines. The situation
is further complicated by the circumstance that he polished or edited her
writing, so that the stories collected here represent various degrees of
F. Scott Fitzgerald's participation, short of collaboration.

Zelda Fitzgerald seems to have been wryly amused by the byline
juggling, except for the series of "girl" stories that she wrote for *College
Humor* in 1928–1930. Since these stories were intended to earn money
to pay for her ballet lessons—an attempt to establish her own career
to replace her "wife of" status—she was resentful that they were un-
sellable without her husband's name. "A Millionaire's Girl," the fifth
story in the series, caused particular bitterness because Harold Ober,
Fitzgerald's agent, sold it to *The Saturday Evening Post* as an
F. Scott Fitzgerald story without consulting her. The *Post* had the largest
circulation of any American magazine and was the publication with
which F. Scott Fitzgerald's work was identified; although *College Humor*
was not as frivolous as its name suggests, it did not claim literary atten-
tion or substantial readership. The *Post* paid $4,000 for "A Millionaire's
Girl" when *College Humor* was paying $500 for the joint-byline "girl"
stories.

The byline manipulation has inevitably led to speculation about the
possibility of Zelda Fitzgerald's unacknowledged participation in F.
Scott Fitzgerald's work. There is no evidence to encourage such guess-
work. The problem pieces are accounted for: he kept a record of "Zel-
da's Earnings" in his bio-bibliographical *Ledger* and identified her work.[3]
Moreover, his extant manuscripts bear no trace of her hand.

This volume provides only a partial view of Zelda Sayre Fitzgerald's
expressive efforts in the artforms that engaged her. Her paintings—most
of which are lost and possibly destroyed—required a large share of her
working energy; and her intense commitment to ballet cannot be repli-

cated. These writings provide evidence of an individualized literary capacity. She wrote like no one else. It is regrettable that the conditions under which she worked prevented her from mastering her craft.

A key word in Zelda Sayre Fitzgerald's vocabulary is "promissory." Her fiction, in particular, evokes not just the possibilities of life—but expectations. Promises kept and promises unfulfilled.

M.J.B.

1. *Bits of Paradise: 21 Uncollected Stories by F. Scott Fitzgerald and Zelda Fitzgerald,* ed. Scottie Fitzgerald Smith and Matthew J. Bruccoli. New York: Scribners, 1974.

2. F. Scott Fitzgerald, *The Crack-Up,* ed. Edmund Wilson. New York: New Directions, 1945.

3. *F. Scott Fitzgerald's Ledger: A Facsimile.* Washington, D.C.: Bruccoli Clark/Microcard Books, 1972.

INTRODUCTION

◊

When David asked her about dancing ... her expression had been full of "You-see-what-I-means," and "Can't you understands," and David was annoyed and called her a mystic.

"Nothing exists, that can't be expressed," he said, angrily.

◊

"I hope you realize that the biggest difference in the world is between the amateur and the professional in the arts."

—*Save Me the Waltz*

Whenever we read the work of women writers, we are tempted to go to the biography for illumination; when we read Zelda Fitzgerald, we feel the temptation as a duty. The details of her life are as well known to literary types as Marilyn Monroe's are to movie fans, and the appeal of the two is similar. Doomed and beautiful, suggestive of a particularly highly lit American gorgeousness, the tragic deaths of both women satisfy some deep need—for what?—retribution, justice, as if gifts given too lavishly require a lavish, public payment of the debt.

Zelda Sayre Fitzgerald was born on July 24, 1900. She was the same age as the century, although when her husband made a fictional character of her, he made her one year younger. Hers was an old Southern family; her father, a judge, was one of the pillars of Montgomery, Alabama; her family had owned slaves and been proud supporters of the Confederacy. Her parents were middle-aged when she was born; she was the youngest, by seven years, of her five siblings. Her mother was vague and indulgent; her father, admirable and aloof. She grew up, rather wild and untended, and became Montgomery's premiere belle. In July of 1918, she met F. Scott Fitzgerald, an officer stationed in Mont-

gomery, and in April of 1920, they were married. They quickly became the emblematic couple of their age, the Jazz Age, which Scott named. They spent wildly and drank heavily; they were careless and outrageous and brilliant in their self-display. In 1921, they had a daughter, who was named after her father. They moved to Europe: Paris, the Riviera—and they moved back to America. They knew everyone: Hemingway, and Gertrude Stein and Archibald MacLeish and the Murphys, Gerald and Sara, who made well known the Spanish proverb: "Living well is the best revenge." (No one has ever asked on what or whom.)

Scott's drinking turned from a good show to a bad scene; there were flirtations; Zelda, at the too late age of twenty-seven, tried to become a ballerina of the first rank. She began to have breakdowns in 1930; this was attributed to the strain of her futile commitment to the dance. Scott's fortunes and popularity declined; she was in and out of mental hospitals, in and out of lucidity, in and out of crushing misery. At times, her beautiful body became covered with painful eczema. Scott went to Hollywood to try and make money; he became involved with the columnist Sheilah Graham, although he remained loyal to Zelda and continued to support her and to write her with the complicated devotion that marked all their relations. He died in 1940, in Graham's apartment, reading about the Princeton football team. Zelda became increasingly incoherent; her zealotries turned religious. She again committed herself to Highland Hospital in Asheville, North Carolina. She died in 1948 in a fire caused by bad wiring, her body identified by her slipper caught beneath it.

If this is not, in the words of Ford Madox Ford, the saddest story you have ever heard, it is certainly one of them. As a story it is irresistible: the promise, the symbolic status of the characters, the wasteful, foolish fall. Would we be interested in the story if the male lead weren't acknowledged to be one of the greatest writers of the century? If the material of the life hadn't been shaped into work that we agree is of the highest order, would we give the life more attention than the latest installment of *People* magazine? This question brings in its wake another and, perhaps, more vexing one. We know about the male lead—he was a writer, we agree, a great one. But who was she?

Was she a writer? The text that follows would seem to make the question absurd. She wrote a novel, a play, stories, articles: she must have been a writer. The residual difficulty we have in according her this status reveals the loaded, the exalted nature of the word writer in our imaginations and our dreams. It is, in one way, easy to be a writer; any literate person can write. It's not like painting, or playing a musical

instrument; the skill required has been learned before the desire for questionable self-expression set in. It is, perhaps, most analogous to dance: all children dance, but who is a dancer? Is it because of our fear of our inability to distinguish between good and bad writing or between the serious and the fooling around that we want our categories to be so neat, and ringed by so implacable and dark a line? "The biggest difference in the world is between the amateur and the professional in the arts," says David Knight to his wife, Alabama, in *Save Me the Waltz*, and we nod our heads in complicitous agreement. But is he right? Do we really want to say that the biggest difference in the world, even in the world of the arts, is between the professional—he or she who is paid for it, he or she who defines himself or herself by work—and he or she who is not paid, and who may not name him- or herself as a practitioner. Do we really want to say that this is a more important distinction than that between the talented or the nontalented artist, the artist who executes his or her vision fully and the one who does not? Rather, what placing the stress on amateur versus professionalism does is to indicate our attachment to the notion of art as commodity, that which can be traded, bought, and owned.

Scott Fitzgerald felt that Zelda's using the same material (their lives) in *Save Me the Waltz* that he was planning to in *Tender Is the Night* was a personal betrayal. He felt, as well, that it was a threat to both the artistic execution and the public reception of his work. Why such a vehement display of insecurity? And why does the issue, nearly fifty years later, still seem a lively one?

The case of Zelda and Scott Fitzgerald, their symbiotic relationship as creator and object of creation, may be unique in the history of literature—at least in the history of literary married couples. It is indicative, I think, of our attitudes not only about literature but about marriage as well. Our conventions dictate that the woman take on the man's name; this would suggest that we consider a subsuming of the female identity in the male a seemly one. We are only now beginning to play with the idea that marriage should be a partnership of equals. But when this tentative perception collides with the superstition that good art is finite, our fears, our desire to nervously accuse and exclude, come to the surface. Why is it that we are tempted to ally ourselves with Scott Fitzgerald and to deny Zelda Fitzgerald the valorized place of writer? Why do we feel that if he's the real thing, she can't be? Why is it so difficult for us to examine her work as text that does and can exist independently of her husband's? Why can't we rejoice at the differences of their use of the same biographical stuff, rather than feeling we have

to call one superior to the other? Why do we feel as if we can belong to only one of two armed camps, the camp that sees her as a formless, scattershot nothing who made a great writer's last days miserable with her pretensions and demands, or the camp that is sure she wrote his best work, and blames him for her disintegration. Was it because she was beautiful, female, mad; and he was handsome and a drunk who died a failure? How can we clear away all these occlusions and read their work as work? In his case, the problem is smaller; his reputation was firmly in place before the facts of her biography became public lore. But in her case, real labor is required to read her without prejudice of one sort or another, to read her not as a symbol of something but as the creator of works of art.

Although they shared much of the same material, the approaches and use of it are dramatically different. They both rely heavily on the sensual apprehension of detail—but there the similarity ends. Scott Fitzgerald is a pretty even blend of classicist and romantic: his characters experience extreme emotions and situations, but they are described in sentences and stories and novels that are formally rhythmic and carefully shaped. Zelda Fitzgerald's best prose is brilliantly uneven; her flights are high and wild, and the form draws its strength from the enigmatic appeal of the fragment. Scott Fitzgerald's work is undeniably written; Zelda Fitzgerald's gives the impression of the spoken word—its associative brilliance calls to mind Edmund Wilson's comments on her conversation. "She talked with so spontaneous a color and wit—almost exactly in the way she wrote—that I very soon ceased to be troubled by the fact that the conversation was in the nature of free association of ideas and one could never follow up anything. I have rarely known a woman who expressed herself so delightfully and so freshly; she had no ready-made phrases on the one hand and made no straining for effect on the other."[1] Her descriptions are full of movement: often inanimate objects take on an overvivid and dangerous life. Flowers and food can turn disorienting or menacing in the blink of an eye. "She bought ... a bowl of nasturtiums like beaten brass, anemones pieced out of wash material and malignant parrot tulips scratching the air with their jagged barbs, and the voluptuous scrambled convolutions of Parma violets ... lemon-yellow carnations perfumed with the taste of hard candy ... threatening sprays of gladioli, and the soft even purr of black tulips ... flowers like salads and flowers like fruits ... and flowers with the brilliant

1. Edmund Wilson, "A Weekend in Ellersie," in *The Shores of Light,* Boston, 1985, p. 379.

carnivorous qualities of Van Gogh."[2] Love and fear and horror mix themselves as well; she describes her beloved ballet teacher's brown eyes as "like the purple bronze footpaths through an autumn beech wood where the mold is drenched with mist, and clear fresh lakes spurt up about your feet from the loam."[3] When Alabama realizes she is in love with David, her first response is a fantasy trip through his brain:

> She crawled into the friendly cave of his ear. The area inside was gray and ghostly classic as she stared about the deep trenches of the cerebellum. There was not a growth nor a flowery substance to break those smooth convolutions, just the puffy rise of sleek gray matter. "I've got to see the front lines," Alabama said to herself. The lumpy mound rose wet above her head and she set out following the creases. Before long she was lost. Like a mystic maze the folds and ridges rose in desolation; there was nothing to indicate one way from another. She stumbled on and finally reached the medulla oblongata. Vast tortuous indentations led her round and round. Hysterically, she began to run. David, distracted by a tickling sensation at the head of his spine, lifted his lips from hers.[4]

Over and over again, Zelda Fitzgerald takes up the method of the surrealists, confusing and conjoining realms, types, categories to make up a rich atmosphere. Her use of *and*s and commas to create a strung together, litany effect accentuates the pileup of dissimilar elements, and the reader is taken on an exhilarating ride that brings together glamour, terror, wit, and the seductive fog of the unconscious set loose. It is interesting to compare Zelda's description of a schoolroom with the famous eyes of Dr. T. J. Eckleburg that begin chapter 2 of *The Great Gatsby*. Hers reads: "Flushed with the heat of palpitant cheeks, the school room swung from the big square windows and anchored itself to a dismal lithograph of the signing of the Declaration of Independence."[5] The description takes a perfectly ordinary room and makes of it an unmoored, comic strangeness. In comparison, Scott's description of something that is, in itself, quite strange is remarkably low-voiced and bounded:

> But above the gray land and the spasms of bleak dust which drift endlessly over it, you perceive, after a moment, the eyes of Doctor T. J. Eckleburg. The eyes of Doctor T. J. Eckleburg are blue and gigantic—

2. Zelda Fitzgerald, *The Collected Writings*, New York, 1991, p. 130.
3. *Ibid.*, p. 139.
4. *Ibid.*, p. 40.
5. *Ibid.*, p. 15.

their retinas are one yard high. They look out of no face, but, instead, from a pair of enormous yellow spectacles which pass over a non-existent nose. Evidently some wild wag of an oculist set them there to fatten his practice in the borough of Queens, and then sank down himself into external blindness, or forgot them and moved away. But his eyes, dimmed a little by many paintless days under sun and rain, brood on over the solemn dumping ground.[6]

Scott's language and syntax is smooth, formal, almost biblical; the offense of the sign is aesthetic and perhaps moral, but it is an offense, rather than a menace. What would Zelda have done with Doctor Eckleburg's eyes? What crimes would they have seen, what punishments suggested? Scott Fitzgerald is a creator of myths; his characters are brought to their sad ends through forces that are foreseeable, and if unavoidable, at least explicable. The world, for Zelda, is too disorderly to be the stuff of myth; it is the material of dream, random, unfinished, with connections that can only be guessed at or left out.

It is possible to see the Twenties as both the stuff of myth or frenzied dream leading to nightmare, but Zelda's deliberate cutting of integuments, her willingness to follow the associative trend are more distinctly modern in their quality than the shaped orderliness of her husband's fictions. It is their mining of the unconscious, the irrational, that marks the great, revolutionary modernist works: Joyce's *Ulysses* and *Finnegans Wake,* and the more radical creations of Gertrude Stein, for example. Zelda Fitzgerald knew Gertrude Stein, and, unlike her husband, had no use for her; Zelda considered Stein's conversation "sententious gibberish."[7] She had little use for other women, and it's hardly likely that she'd make an exeption in favor of one so serious, overweight, and ill-dressed as Gertrude Stein. But it's a shame, because Zelda might have got some understanding from Stein; it's amusing to speculate on the putting together of such strikingly different heads.

The first draft of *Save Me the Waltz* took only two months to write; it was completed at Johns Hopkins Hospital. Its structure is loose; it is joined together more by its preoccupations than by any balanced ideas of rhythm or pace. Its primary shaping element is the body of the father: lively and upright in the beginning, dead at the end. " 'Those girls,' people said, 'think they can do anything and get away with it.' That was because of the sense of security they felt in their father. He was a

6. F. Scott Fitzgerald, *The Great Gatsby,* New York, 1925, pp. 27–28.
7. James R. Mellow, *Invented Lives,* Boston, 1984, p. 259.

living fortress. . . ."[8] Later, the narrator says that the young girl "wants
to be told what she is like, being too young to know that she is like
nothing at all and will fill out her skeleton with what she gives off, as
a general might reconstruct a battle following the advances and reces-
sion of his forces with bright-colored pins. She does not know that what
effort she makes will become herself. It was much later that the child,
Alabama, came to realize that the bones of her father could indicate only
her limitations."[9] At the end of the novel, she looks at her father on his
deathbed: "His wrists were no bigger than a bird's."[10]

Alabama, the marvelously named heroine, obviously stands for Zelda,
as David Knight, Alabama's painter-husband, stands for Scott. The
novel traces the Knights' life from Alabama's girlhood to her father's
death. It is episodic, and the connections between episodes are not
stressed. All of Zelda Fitzgerald's strengths as a writer come to play in
Save Me the Waltz, as well as the important themes she touched on in
everything she wrote. It is a kind of jazz *Bildungsroman,* with the potent
jerky mistiness of early film. It avoids the *Bildungsroman*'s usual inward-
ness and speculation; for Alabama, life is a matter of appearances, or
perceptions; this is a sensual, rather than a psychological novel. Yet it
does concern itself, like the ordinary *Bildungsroman,* with the young per-
son's creation of a self.

But this self is a female self, and a female self coming to maturity in
the age of the flapper. For any girl, the process of self-definition is
complicated by the world's habit of defining her by how she looks; it is
difficult for her to define herself in terms of who she is, rather than
whom she is seen to be. For a belle in the year 1918, the problem of
the constructed, observed, rather than authentic, self is particularly
acute. In speaking of the "flapper," that is to say, the young girl of her
era, Zelda Fitzgerald is clear how much has to do with self-presentation,
and self-dramatization. The ideal flapper, she tells us in her essays "Eu-
logy on the Flapper" and "What Became of the Flappers?," is someone
who is seen by and in a crowd, but is intimate with no one, "fully airing
the desire . . . for dramatizing herself. . . . The best flapper is reticent
emotionally and courageous morally. You always know what she thinks
but she does all her feeling alone . . . an artist in her particular field, the
art of being—being young, being lovely, being an object."[11] She is an

8. Zelda Fitzgerald, *The Collected Writings,* p. 9.
9. *Ibid.,* p. 11.
10. *Ibid.,* p. 184.
11. *Ibid.,* p. 398.

artist; the form is the public dramatization, the material is herself. She has no models upon which to base this enterprise, and no community should she fail. The future holds nothing for her but the end of the art form. Yet, Zelda tells us, the successful flapper becomes the successfully bored young married woman: having sown her oats, she can settle down.

But Alabama doesn't settle down. She marries her glamorous David, and has, rather perfunctorily, and absentmindedly, her perfect child Bonnie. She goes to Europe; she goes to the beach; she goes to parties. But this is not enough for her. She wants to express herself in terms larger than herself: she devotes herself to the ideal of Diaghilev's Russian Ballet.

Alabama is devoted to the ideal of dance—an ideal expressed by her Russian teacher—and devotedness is not a quality the flapper possesses. She wants to serve something greater than herself (as the idea of her father is greater than herself) and to lose herself in the process. Her goals are ascetic and almost religious. "It seemed to Alabama that, reaching her goal, she would drive the devils that had driven her—that in proving herself, she would achieve that peace which she imagined went only in surety of one's self—that she would be able, through the medium of the dance, to command her emotions, to summon love or pity or happiness at will, having provided a channel through which they might flow."[12] One of her colleagues at the studio says to her, "Oh, but you will be a dancer . . . but I do not see *why,* since you already have a husband." Alabama replies: "Can't you understand that I am not trying to get anything—at least I don't think I am—but to get rid of some of myself." It is as if, in the process of creating a self, she must literally express self—the excessive part of the self that was created by vanity and greed. Only forgetfulness of the self can create the true self—physical, emotional, and spiritual. "The complete control of her body freed her from all fetid consciousness of it."[13]

The parameters of her journey are the bones of her father's skeleton; there is no flesh to nourish or to knit the bones. Flesh belongs to the mother, and, like everything female, for Alabama, it is inferior. The aloof, father-judge is replaced by the implacable ideal of pure art; the female, growing in the middle, can only be starved into madness. Alabama's quest for herself is very much of its time; the flapper, who bound

12. *Ibid.,* p. 118.
13. *Ibid.,* p. 127.

her breasts so she might look like a boy, had to deny her femaleness in order to be freed from what she saw as its constraints.

Here is how Zelda Fitzgerald describes the female world that the flapper must rebel against in order not to be suffocated: "Women ... go through life with a death-bed air either snatching the last moment or with martyr-resignation," she says, and describes the kind of girl who preceded the flapper as "the kind of girl who ... quoted the Rubaiyat at you and told you how misunderstood she was; or the kind who straightened your tie as evidence that in her lay the spirit of the eternal mother; or the kind who spent long summer evenings telling you that it wasn't the *number* of cigarettes you smoked that she minded but just the *principle,* to show off her nobility of character."[14]

Clearly, no communication between a girl of spirit and such dull girls as she describes is possible: she can only talk to men. Even the audience whom she assumes is a male audience (your tie is being straightened). "We were happy and we hated women," she says in a letter to Scott, recalling their golden years. But the man who should be her partner in the journey away from suffocation is too unfixed to help her; he is not, like the father, the pole star to her comet. David is even more desperate than Alabama; while she dances, he drinks. And their child is nowhere for them; she is there to be slapped when she calls her mother a liar, to be shipped to her mother in Naples for a disastrous birthday party and back to her father to be his pseudo-paramour. No future lies ahead for them. "He and she appeared to her like people in a winter of adversity picking very old garments left over from a time of wealth."[15] They return home for the death of the father, and after that, there is nothing, only another dreadful party with food, drink, and people who can only make things worse. "On the cocktail tray, mountains of things represented something else: canapés like goldfish, and caviar in balls, butter bearing faces and frosted glasses sweating with the burden of reflecting such a lot of things to stimulate the appetite to satiety before eating."[16]

The Jazz Age was not the Depression and depression doesn't mark *Save Me the Waltz.* For all the failure and slippage that we witness, we also enjoy the sights Alabama sees and her ability to give us the tenor of the times.

> They were having the bead line at the Ritz that year. Everybody was there. People met people they knew in hotel lobbies smelling of orchids

14. *Ibid.,* p. 398.
15. *Ibid.,* p. 123.
16. *Ibid.,* pp. 194–95.

and plush and detective stories, and asked each other where they'd been since the last time. Charlie Chaplin wore a yellow polo coat. People were tired of the proletariat—everyone was famous. All the other people who weren't well known had been killed in the war; there wasn't much interest in private lives.[17]

Those last words give us an important clue to a motivating force behind everything Zelda Fitzgerald wrote. "There wasn't much interest in private lives." She isn't interested in writing about emotions; she is interested in description, and, surprisingly, in generalization and in abstract thought. Her work is studded with aphorisms like the work of an eighteenth-century neoclassicist; like Zelda Fitzgerald, they didn't much go in for "private lives," they believed in life that could be watched, like a theatrical scene. In the story "The Girl with Talent," the narrator says, "To my mind people never change until they actually look different, so I didn't find her greatly modified." Zelda Fitzgerald has little interest in the workings of the heart; the body, particularly the eye, and the brain that can put all that the eye sees into some sort of satisfying order: these are the aspects of the human that she finds worthwhile.

There is a link between the aphorism and the flirtatious throw-away line that a certain kind of heady smart girl might excel in, and Zelda Fitzgerald's work sometimes negotiates the unsure borders between the two. This is one reason she is so unsettling; we're not sure if she's being intelligent or clever (merely clever, we would say). In her articles and shorter fiction, her aphoristic talent seems to fall into the latter category. "By the time a man has blundered confusedly into the age of responsibilities he has realized that the qualities he sought in people he found most satisfactorily understandable in himself,"[18] she says in "Who Can Fall in Love After Thirty?" "When women cease wanting to please, there usually comes a withering of the spirit,"[19] she tells us in her defense of female adornment in "Paint and Powder." Her earlier stories, which have a kind of unfinished charm and liveliness of description (the young woman in "Our Own Movie Queen" is said to have "a warm moist look about her, as if she had materialized out of hot milk vapor"[20]) often seem like inferior versions of Scott's "Bernice Bobs Her Hair." There is very little character development in them, and the shortness of the form doesn't allow for the atmospheric buildup that is so effective

17. *Ibid.,* p. 48.
18. *Ibid.,* p. 412.
19. *Ibid.,* p. 416.
20. *Ibid.,* p. 274.

in *Save Me the Waltz*. The story that comes nearest realization is "A Couple of Nuts," in which two carefree American jazz singers come, through their own greed and lack of judgment, to a tragic end.

In places where she is more relaxed—her novel, her journal-like reminiscences and her letters—the aphorisms lose their too-quick brightness and show a genuine intellectual power. Alabama muses in her father's house: "The inevitable happened to people, and they found themselves prepared. The child forgives its parents when it perceives tha accidents of birth."[21] Receiving David after he has been unfaithful to her, Alabama notes, "Men . . . never seem to become the things they do, like women, but belong to their own philosophic interpretations of their actions."[22] In "Show Mr. and Mrs. F. to Number——," Zelda Fitzgerald uses the memories of all the hotel rooms she and Scott have stayed in as a kind of index of their past. Most of the rooms have something wrong with them; there is a decidedly melancholy cast to the tone of the memories, culminating, perhaps, in the remark, "It is sadder to find the past again and find it inadequate to the present than it is to have it elude you and remain forever a harmonious conception of memory."[23]

Most touchingly, perhaps, and surprisingly, Zelda's late letters to Scott reveal her gift for abstract thought. "Nobody has ever been able to experience what they have thoroughly understood—or understand what they have experienced until they have achieved a detachment that renders them incapable of repeating the experience," she writes to her husband, during one of her many incarcerations.[24] Her letters are full of a stoic humility; she is sorry for her life and for the trouble she's caused her husband, but she's never abject or groveling. Her accusations of him seem just and measured; they never take on the tone of self-justification and defensive anger that we find in his. She loved and admired him to the end, and she had a generous understanding of his gifts. In her tribute to him, written after his death, she says, "The prophet destined to elucidate and catalogue these pregnant and precarious circumstances was F. Scott Fitzgerald. The times exacted a dramatization compelling enough to save its protagonists from sleep-walking over the proscenium in the general doesn't-matter suasion of the let-down."[25]

21. *Ibid.*, pp. 190–91.
22. *Ibid.*, p. 110.
23. *Ibid.*, p. 427.
24. *Ibid.*, pp. 465–66.
25. *Ibid.*, p. 440.

In reading her last letters to Scott, I was brought up short when I encountered an analysis she made of the aesthetic theories of Aristotle.

> You talk of the function of art. I wonder if anybody has ever got nearer the truth than Aristotle: he said that all emotions and all experience were common property—that the transposition of these into form was individual and art. But, God, it's so involved by whether you aim at direct or indirect appeals and whether the emotional or the cerebral is the most compelling approach, and whether the shape of the edifice or the purpose for which it is designated is paramount that my conceptions are in a sad state of flux. At any rate, it seems to me the artist's business is to take a willing mind and guide it to hope or despair contributing *not* his interpretations but a glimpse of his honestly earned scars of battle and his rewards. I am still adamant against the interpretive school. Nobody but educators can show people how to think—but to open some new facet of the stark emotions or to preserve some old one in the grace of a phrase seem nearer the artistic end. You know how a heart will rise or fall to the lilt of an a-laden troche or the sonorous dell of an o—and where you will use these business secrets certainly depends on the author's special evaluations. That was what I was trying to accomplish with the book I began: I wanted to say "This is a love story—maybe not your love story—maybe not even mine, but this is what happened to one isolated person in love. There is no judgment."—I don't know—abstract emotion is difficult of transcription, and one has to find so many devices to carry a point that the point is too often lost in transit—[26]

Once again, I had to ask myself, Who is this woman? As if she had no right to Aristotle. She wasn't a professional. Who was she to talk, with such developed consciousness, about technique? I was comfortable thinking of her as the *femme-enfant* celebrated by the surrealists: the woman-child who picks up what she knows through her lovely, hypersensitive skin. Too easily I accepted her self-evaluation: "I am that little fish who swims about under a shark and, I believe, lives indelicately on its offal. . . . Life moves over me in a vast black shadow and I swallow whatever it drops with relish. . . ."[27] It was all right for her to apprehend, to describe, to aphorize; but to theorize? That was not for her. For whom, then? Her husband? Her father? Some woman who hadn't been self-dramatizing, reckless, admired for her looks, a careless mother, mad?

26. *Ibid.,* pp. 475–76.
27. *Ibid.,* p. 465.

A proper reading of the work of Zelda Fitzgerald challenges our easy dualities: the belief that a woman who wants fun and excitement can't have a mind; the notion that the formal, finished, and pared down is aesthetically superior to the associative and the fragmentary, that an art that believes that it can, through its facility, express "everything" is more desirable than one which leaves gaps for what cannot be expressed. Perhaps now, in the wake of a literary movement that tries to come to terms with the artist's struggle with what cannot be said—or cannot be said in terms of what we used to be comfortable calling "realism"—a more open reading can occur. One that is willing to step back and forth over borders, to make a place for the "You see what I means," and the "Can't you understands."

MARY GORDON

SAVE ME THE WALTZ

◇

Save Me the Waltz was written during January and February 1932 in Montgomery, Alabama, and at the Phipps Clinic of Johns Hopkins Hospital; it was sent to Maxwell Perkins at Scribners in March 1932.[1] The version that Perkins first saw had not been read by F. Scott Fitzgerald, for Zelda Fitzgerald was anxious to succeed without her husband's help or interference. The original manuscript and typescripts have not survived; but the first draft was a more personal document—that is, more transparently about the Fitzgeralds' marriage—and, indeed, David Knight was originally named Amory Blaine after the hero of Fitzgerald's novel *This Side of Paradise,* who was an autobiographical character. When Fitzgerald did read the novel, he was angered on two counts: he felt it exposed too much of his private life; and he thought it drew upon material he had written for *Tender Is the Night,* which was then in progress.

The story of the publication of *Save Me the Waltz* can be traced through F. Scott Fitzgerald's correspondence. On March 16—some four days after Zelda Fitzgerald sent the novel to Perkins—Fitzgerald instructed him not to decide anything until it was revised.[2] Although he wanted his wife to have a success and praised the novel to Perkins, Fitzgerald was concerned that the original version would injure both of them—but especially him:

> Turning up in a novel signed by my wife as a somewhat anemic portrait painter with a few ideas lifted from Clive Bell, Léger, etc. puts me in an absurd + Zelda in a ridiculous position. The mixture of fact + fiction is calculated to ruin us both, or what is left of us, and I can't let it stand. Using the name of a character I invented to put intimate facts in the hands of the friends and enemies we have accumulated *en route*—my God, my

1. Zelda Fitzgerald to Maxwell Perkins, c. March 12, 1932. Charles Scribner's Sons Archives, Princeton University Library.
2. Charles Scribner's Sons Archives, Princeton University Library.

books made her a legend and her single intention in this somewhat thin portrait is to make me a non-entity.[3]

He urged his wife to revise and no doubt helped her, but the extent of his labor is by no means clear in the absence of the working papers. It seems likely, though, that the assumption that he actually rewrote *Save Me the Waltz* is false. The available documents indicate that his work was advisory. On March 25 he wired Perkins that the novel would require only minor revisions and that it was a fine novel; but three days later he informed Perkins that the whole middle section needed to be rewritten.[4] By May 2 he was able to report: "Zelda's novel is now good, improved in every way. It is new. She has largely eliminated the speak-easy-nights-and-our-trip-to-Paris atmosphere."[5] The letter warns Perkins about exciting her with too-generous praise.

On or about May 14, Fitzgerald sent the revised novel, stating:

> It is a good novel now, perhaps a very good novel—I am too close to it to tell. . . . (at first she refused to revise—then she revised completely, added on her own suggestion + has changed what was a rather flashy and self-justifying "true confessions" that wasn't worthy of her into an honest piece of work. She can do more with the galley but I cant ask her to do more now.)—but now praise will do her good within reason.[6]

Fitzgerald's estimate of *Save Me the Waltz* was later revised downward. On February 8, 1936, he wrote to his agent, Harold Ober: "Please don't have anybody read Zelda's book because it is a bad book!"[7]

The printer's copy for *Save Me the Waltz* and five sets of galley proofs are in the Fitzgerald Papers at the Princeton University Library. The typescript is clean copy, prepared by a typist, with only a few authorial corrections and printer's or editor's queries. The proof consists of two sets of very heavily revised—not just corrected—galleys, two duplicate sets, and one set of paged final galleys. In revising the galleys, Zelda Fitzgerald completely rewrote the opening of Chapter 2, the account of

3. Quoted in Andrew Turnbull, *Scott Fitzgerald* (New York: Scribners, 1962), p. 207. This letter was presumably written to Zelda Fitzgerald's psychiatrist.

4. Charles Scribner's Sons Archives, Princeton University Library.

5. Fitzgerald to Perkins. *Dear Scott/Dear Max,* ed. John Kuehl and Jackson R. Bryer (New York: Scribners, 1971), p. 173.

6. Fitzgerald to Perkins. *Dear Scott/Dear Max,* p. 176. This letter warns Perkins not to discuss the novel with Ernest Hemingway, who had *Death in the Afternoon* coming out that season and who would therefore regard *Save Me the Waltz* as competition.

7. *The Letters of F. Scott Fitzgerald,* ed. Andrew Turnbull (New York: Scribners, 1963), p. 402.

the visit by Alabama's parents to the Knights; twenty-five pages of typed copy were substituted for the original thirty-three. At the same time ten pages of typescript revisions for part three of Chapter 2 were prepared. The revised galleys are drastically worked over, but almost all the marks are in Zelda Fitzgerald's hand. F. Scott Fitzgerald did not systematically work on the surviving proofs: only eight of the words written on them are clearly in his hand.

Perhaps the wholesale revisions discouraged the proofreaders, or perhaps the author resisted editorial help—but whatever the reasons, *Save Me the Waltz* was one of the most sloppily edited novels produced by a distinguished American publisher. Apart from troublesome authorial eccentricities of style and usage, there are hundreds of errors that almost certainly affected reader response.[8]

The size of the initial printing has not been determined, but it was probably a Depression run of no more than three thousand copies. Only one printing was required. In 1953, Grey Walls Press published a new edition in England; but *Save Me the Waltz* was not republished in America until the Southern Illinois University Press edition of 1967. This corrected text—which was reprinted in America and England—is used here. No attempt has been made to improve the author's style or to make more than the really necessary corrections. Baffling sentences have not been solved, and puzzling words have been left wherever they make any sense. Much of the unusual quality of *Save Me the Waltz* comes from its idiosyncratic prose; no good purpose would be served by tampering with it.

8. At least two reviews specifically complained about the proofreading—*New York Times Book Review* (October 16) and *Bookman* (November). These and three other reviews all commented on the unusual word usage—*Boston Transcript* (November 30), *Saturday Review of Literature* (October 22), and *Forum* (December).

SAVE ME THE WALTZ

◇

We saw of old blue skies and summer seas
* When Thebes in the storm and rain*
Reeled, like to die.
O, if thou can'st again,
* Blue sky—blue sky!*

<div align="right">OEDIPUS, King of Thebes</div>

1

◇

◦ I ◦

"Those girls," people said, "think they can do anything and get away with it."

That was because of the sense of security they felt in their father. He was a living fortress. Most people hew the battlements of life from compromise, erecting their impregnable keeps from judicious submissions, fabricating their philosophical drawbridges from emotional retractions and scalding marauders in the boiling oil of sour grapes. Judge Beggs entrenched himself in his integrity when he was still a young man; his towers and chapels were builded of intellectual conceptions. So far as any of his intimates knew he left no sloping path near his castle open either to the friendly goatherd or the menacing baron. That inapproachability was the flaw in his brilliance which kept him from having become, perhaps, a figure in national politics. The fact that the state looked indulgently upon his superiority absolved his children from the early social efforts necessary in life to construct strongholds for themselves. One lord of the living cycle of generations to lift their experiences above calamity and disease is enough for a survival of his progeny.

One strong man may bear for many, selecting for his breed such expedient subscriptions to natural philosophy as to lend his family the semblance of a purpose. By the time the Beggs children had learned to meet the changing exigencies of their times, the devil was already upon their necks. Crippled, they clung long to the feudal donjons of their fathers, hoarding their spiritual inheritances—which might have been more had they prepared a fitting repository.

One of Millie Beggs' school friends said that she had never seen a more troublesome brood in her life than those children when they were little. If they cried for something, it was supplied by Millie within her

powers or the doctor was called to subjugate the inexorabilities of a world which made, surely, but poor provision for such exceptional babies. Inadequately equipped by his own father, Austin Beggs worked night and day in his cerebral laboratory to better provide for those who were his. Millie, perforce and unreluctantly, took her children out of bed at three o'clock in the morning and shook their rattles and quietly sang to them to keep the origins of the Napoleonic Code from being howled out of her husband's head. He used to say, without humor, "I will build me some ramparts surrounded by wild beasts and barbed wire on the top of a crag and escape this hoodlum."

Austin loved Millie's children with that detached tenderness and introspection peculiar to important men when confronting some relic of their youth, some memory of the days before they elected to be the instruments of their experience and not its result. You will feel what is meant in hearing the kindness of Beethoven's "Springtime" Sonata. Austin might have borne a closer relation to his family had he not lost his only boy in infancy. The Judge turned savagely to worry fleeing from his disappointment. The financial worry being the only one which men and women can equally share, this was the trouble he took to Millie. Flinging the bill for the boy's funeral into her lap, he cried heartbreakingly, "How in God's name do you expect me to pay for that?"

Millie, who had never had a very strong sense of reality, was unable to reconcile that cruelty of the man with what she knew was a just and noble character. She was never again able to form a judgment of people, shifting her actualities to conform to their inconsistencies till by a fixation of loyalty she achieved in her life a saintlike harmony.

"If my children are bad," she answered her friend, "I have never seen it."

The sum of her excursions into the irreconcilabilities of the human temperament taught her also a trick of transference that tided her over the birth of the last child. When Austin, roused to a fury by the stagnations of civilization, scattered his disillusions and waning hope for mankind together with his money difficulties about her patient head, she switched her instinctive resentment to the fever in Joan or Dixie's twisted ankle, moving through the sorrows of life with the beatific mournfulness of a Greek chorus. Confronted with the realism of poverty, she steeped her personality in a stoic and unalterable optimism and made herself impervious to the special sorrows pursuing her to the end.

Incubated in the mystic pungence of Negro mammies, the family hatched into girls. From the personification of an extra penny, a streetcar

ride to whitewashed picnic grounds, a pocketful of peppermints, the Judge became, with their matured perceptions, a retributory organ, an inexorable fate, the force of law, order, and established discipline. Youth and age: a hydraulic funicular, and age, having less of the waters of conviction in its carriage, insistent on equalizing the ballast of youth. The girls, then, grew into the attributes of femininity, seeking respite in their mother from the exposition of their young-lady years as they would have haunted a shady protective grove to escape a blinding glare.

The swing creaks on Austin's porch, a luminous beetle swings ferociously over the clematis, insects swarm to the golden holocaust of the hall light. Shadows brush the Southern night like heavy, impregnated mops soaking its oblivion back to the black heat whence it evolved. Melancholic moonvines trail dark, absorbent pads over the string trellises.

"Tell me about myself when I was little," the youngest girl insists. She presses against her mother in an effort to realize some proper relationship.

"You were a good baby."

The girl had been filled with no interpretation of herself, having been born so late in the life of her parents that humanity had already disassociated itself from their intimate consciousness and childhood become more of a concept than the child. She wants to be told what she is like, being too young to know that she is like nothing at all and will fill out her skeleton with what she gives off, as a general might reconstruct a battle following the advances and recessions of his forces with bright-colored pins. She does not know that what effort she makes will become herself. It was much later that the child, Alabama, came to realize that the bones of her father could indicate only her limitations.

"And did I cry at night and raise hell so you and Daddy wished I was dead?"

"What an idea! All my children were sweet children."

"And Grandma's, too?"

"I suppose so."

"Then why did she run Uncle Cal away when he came home from the Civil War?"

"Your grandmother was a queer old lady."

"Cal, too?"

"Yes. When Cal came home, Grandma sent word to Florence Feather that if she was waiting for her to die to marry Cal, she wanted the Feathers to know that the Beggs were a long-lived race."

"Was she so rich?"

"No. It wasn't money. Florence said nobody but the devil could live with Cal's mother."

"So Cal didn't marry, after all?"

"No—grandmothers always have their way."

The mother laughs—the laugh of a profiteer recounting incidents of business prowess, apologetic of its grasping security, the laugh of the family triumphant, worsting another triumphant family in the eternal business of superimposition.

"If I'd been Uncle Cal I wouldn't have stood it," the child proclaims rebelliously. "I'd have done what I wanted to do with Miss Feather."

The deep balance of the father's voice subjugates the darkness to the final diminuendo of the Beggs' bedtime.

"Why do you want to rehash all that?" he says judiciously.

Closing the shutters, he boxes the special qualities of his house: an affinity with light, curtain frills penetrated by sunshine till the pleats wave like shaggy garden borders about the flowered chintz. Dusk leaves no shadows or distortions in his rooms but transfers them to vaguer, grayer worlds, intact. Winter and spring, the house is like some lovely shining place painted on a mirror. When the chairs fall to pieces and the carpets grow full of holes, it does not matter in the brightness of that presentation. The house is a vacuum for the culture of Austin Beggs' integrity. Like a shining sword it sleeps at night in the sheath of his tired nobility.

The tin roof pops with the heat; the air inside is like a breath from a long unopened trunk. There is no light in the transom above the door at the head of the upstairs hall.

"Where is Dixie?" the father asks.

"She's out with some friends."

Sensing the mother's evasiveness, the little girl draws watchfully close, with an important sense of participation in family affairs.

"Things happen to us," she thinks. "What an interesting thing to be a family."

"Millie," her father says, "if Dixie is out traipsing the town with Randolph McIntosh again, she can leave my house for good."

Her father's head shakes with anger; outraged decency loosens the eyeglasses from his nose. The mother walks quietly over the warm matting of her room, and the little girl lies in the dark, swelling virtuously submissive to the way of the clan. Her father goes down in his cambric nightshirt to wait.

From the orchard across the way the smell of ripe pears floats over

the child's bed. A band rehearses waltzes in the distance. White things gleam in the dark—white flowers and paving stones. The moon on the windowpanes careens to the garden and ripples the succulent exhalations of the earth like a silver paddle. The world is younger than it is, and she to herself appears so old and wise, grasping her problems and wrestling with them as affairs peculiar to herself and not as racial heritages. There is a brightness and bloom over things; she inspects life proudly, as if she walked in a garden forced by herself to grow in the least hospitable of soils. She is already contemptuous of ordered planting, believing in the possibility of a wizard cultivator to bring forth sweet-smelling blossoms from the hardest of rocks, and night-blooming vines from barren wastes, to plant the breath of twilight and to shop with marigolds. She wants life to be easy and full of pleasant reminiscences.

Thinking, she thinks romantically on her sister's beau. Randolph's hair is like nacre cornucopias pouring forth those globes of light that make his face. She thinks that she is like that inside, thinking in this nocturnal confusion of her emotions with her response to beauty. She thinks of Dixie with excited identity as being some adult part of herself divorced from her by transfiguring years, like a very sunburned arm which might not appear familiar if you had been unconscious of its alterations. To herself, she appropriates her sister's love affair. Her alertness makes her drowsy. She has achieved a suspension of herself with the strain of her attenuated dreams. She falls asleep. The moon cradles her tanned face benevolently. She grows older sleeping. Someday she will awake to observe the plants of Alpine gardens to be largely fungus things, needing little sustenance, and the white discs that perfume midnight hardly flowers at all but embryonic growths; and, older, walk in bitterness the geometrical paths of philosophical Le Nôtres rather than those nebulous byways of the pears and marigolds of her childhood.

Alabama never could place what woke her mornings as she lay staring about, conscious of the absence of expression smothering her face like a wet bath mat. She mobilized herself. Live eyes of a soft wild animal in a trap peered out in skeptic invitation from the taut net of her features; lemon-yellow hair melted down her back. She dressed herself for school with liberal gestures, bending forward to watch the movements of her body. The schoolbell on the still exudings of the South fell flat as the sound of a buoy on the vast mufflings of the sea. She tiptoed into Dixie's room and plastered her face with her sister's rouge.

When people said, "Alabama, you've got rouge on your face," she simply said, "I've been scrubbing my face with the nailbrush."

Dixie was a very satisfactory person to her young sister; her room was full of possessions; silk things lay about. A statuette of the Three Monkeys on the mantel held matches for smoking. *The Dark Flower, The House of Pomegranates, The Light that Failed, Cyrano de Bergerac,* and an illustrated edition of *The Rubáiyát* stretched between two plaster "Thinkers." Alabama knew the *Decameron* was hid in the top bureau drawer— she had read the rough passages. Over the books, a Gibson girl with a hatpin poked at a man through a magnifying glass; a pair of teddy bears luxuriated over a small white rocker. Dixie possessed a pink picture hat and an amethyst bar pin and a pair of electric curling irons. Dixie was twenty-five. Alabama would be fourteen at two o'clock in the morning on the fourteenth of July. The other Beggs sister, Joan, was twenty-three. Joan was away; she was so orderly that she made little difference in the house, anyway.

Alabama slid down the banisters expectantly. Sometimes she dreamed that she fell down the well of the staircase and was saved at the bottom by landing astride the broad railing—sliding, she rehearsed the emotions of her dream.

Already Dixie sat at table, withdrawn from the world in furtive defiance. Her chin was red and red welts stood out on her forehead from crying. Her face rose and fell in first one place and then another beneath the skin, like water boiling in a pot.

"I didn't ask to be born," she said.

"Remember, Austin, she is a grown woman."

"The man is a worthless cuss and an unmitigated loafer. He is not even divorced."

"I make my own living and I'll do as I please."

"Millie, that man is not to enter my house again."

Alabama sat very still, anticipating some spectacular protest against her father's interruption of the course of romance. Nothing transpired but the child's stillness.

The sun on the silvery fern fronds, and the silver water pitcher, and Judge Beggs' steps on the blue and white pavings as he left for his office measured out so much of time, so much of space—nothing more. She heard the trolley stop under the catalpa trees at the corner and the Judge was gone. The light flicked the ferns with a less organized rhythm without his presence; his home hung pendant on his will.

Alabama watched the trumpet vine trailing the back fence like chip coral necklaces wreathing a stick. The morning shade under the chinaberry tree held the same quality as the light—brittle and arrogant.

"Mamma, I don't want to go to school any more," she said, reflectively.

"Why not?"

"I seem to know everything."

Her mother stared at her in faintly hostile surprise; the child, thinking better of her intended expositions, reverted to her sister to save her face.

"What do you think Daddy will do to Dixie?"

"Oh, pshaw! Don't worry your pretty head about things like that till you have to, if that's what's bothering you."

"If I was Dixie, I wouldn't let him stop me. I like 'Dolph."

"It is not easy to get everything we want in this world. Run on, now—you will be late to school."

Flushed with the heat of palpitant cheeks, the schoolroom swung from the big square windows and anchored itself to a dismal lithograph of the signing of the Declaration of Independence. Slow days of June added themselves in a lump of sunlight on the far blackboard. White particles from the worn erasers sprayed the air. Hair and winter serge and the crust in the inkwells stifled the soft early summer burrowing white tunnels under the trees in the street and poulticing the windows with sweet sickly heat. Humming Negroid intonations circulated plaintively through the lull.

"H'ye ho' tomatoes, nice ripe tomatoes. Greens, colla'd greens."

The boys wore long black winter stockings, green in the sun.

Alabama wrote "Randolph McIntosh" under "A debate in the Athenian Assembly." Drawing a ring around "All the men were at once put to death and the women and children sold into slavery," she painted the lips of Alcibiades and drew him a fashionable bob, closing her *Myer's Ancient History* on the transformation. Her mind rambled on irrelevantly. How did Dixie make herself so fluffy, so ready always for anything? Alabama thought that she herself would never have every single thing about her just right at once—would never be able to attain a state of abstract preparedness. Dixie appeared to her sister to be the perfect instrument for life.

Dixie was the society editor of the town paper. There was telephoning from the time she came home from the office in the evening till supper. Dixie's voice droned on, cooing and affected, listening to its own vibrations.

"I can't tell you now——" Then a long slow gurgle like the water running out of a bathtub.

"Oh, I'll tell you when I see you. No, I can't tell you now."

Judge Beggs lay on his stern iron bed sorting the sheafs of the yellowing afternoons. Calfskin volumes of the *Annals of British Law* and *Annotated Cases* lay over his body like leaves. The telephone jarred his concentration.

The Judge knew when it was Randolph. After half an hour, he'd stormed into the hall, his voice quaking with restraint.

"Well, if you can't talk, why do you carry on this conversation?"

Judge Beggs brusquely grabbed the receiver. His voice proceeded with the cruel concision of a taxidermist's hands at work.

"I will thank you never to attempt to see or to telephone to my daughter again."

Dixie shut herself in her room and wouldn't come out or eat for two days. Alabama reveled in her part of the commotion.

"I want Alabama to dance at the Beauty Ball with me," Randolph had said over the wire.

Her children's tears infallibly evoked their mother.

"Why do you bother your father? You could make your arrangements outside," she said placatingly. The wide and lawless generosity of their mother was nourished from many years of living faced with the irrefutable logic of the Judge's fine mind. An existence where feminine tolerance plays no role being insupportable to her motherly temperament, Millie Beggs, by the time she was forty-five, had become an emotional anarchist. It was her way of proving to herself her individual necessity of survival. Her inconsistencies seemed to assert her dominance over the scheme had she so desired. Austin couldn't have died or got sick with three children and no money and an election next fall and his insurance and his living according to law; but Millie, by being a less closely knit thread in the pattern, felt that she could have.

Alabama mailed the letter that Dixie wrote on her mother's suggestion and they met Randolph at the "Tip-Top" Café.

Alabama, swimming through her teens in a whirlpool of vigorous decision, innately distrusted the "meaning" communicated between her sister and Randolph.

Randolph was a reporter for Dixie's paper. His mother kept his little girl in a paintless house downstate near the canebrakes. The curves of his face and the shape of his eyes had never been mastered by Randolph's expression, as if his corporeal existence was the most amazing experience he had ever achieved. He conducted night dancing classes for which Dixie got most of his pupils—his neckties, too, for that matter, and whatever about him that needed to be rightly chosen.

"Honey, you must put your knife on your plate when you're not

using it," Dixie said, pouring his personality into the mold of her society.

You'd never have known he had heard her, though he seemed to be always listening for something—perhaps some elfin serenade he expected, or some fantastic supernatural hint about his social position in the solar system.

"And I want a stuffed tomato and potatoes au gratin and corn on the cob and muffins and chocolate ice cream," Alabama interrupted impatiently.

"My God!—So we're going to do the *Ballet of the Hours,* Alabama, and I will wear harlequin tights and you will have a tarlatan skirt and a three-cornered hat. Can you make up a dance in three weeks?"

"Sure. I know some steps from last year's carnival. It will go like this, see?" Alabama walked her fingers one over the other inextricably. Keeping one finger firmly pressed on the table to mark the place she unwound her hands and began again. "——And the next part is this way——And it ends with a br—rr—rr—oop!" she explained.

Dubiously Randolph and Dixie watched the child.

"It's very nice," commented Dixie hesitantly, swayed by her sister's enthusiasm.

"You can make the costumes," Alabama finished, glowing with the glamour of proprietorship. Marauder of vagrant enthusiasm, she piled the loot on whatever was at hand, her sisters and their sweethearts, performances and panoplies. Everything assumed the qualities of improvisation with the constant change in the girl.

Every afternoon Alabama and Randolph rehearsed in the old auditorium till the place grew dim with dusk and the trees outside seemed bright and wet and Véronèse as if it had been raining. It was from there that the first Alabama regiment had left for the Civil War. The narrow balcony sagged on spindle iron pillars and there were holes in the floor. The sloping stairs led down through the city markets: Plymouth Rocks in cages, fish, and icy sawdust from the butcher shop, garlands of Negro shoes and a doorway full of army overcoats. Flushed with excitement, the child lived for the moment in a world of fictitious professional reserves.

"Alabama has inherited her mother's wonderful coloring," commented the authorities, watching the gyrating figure.

"I scrubbed my cheeks with a nailbrush," she yelled back from the stage. That was Alabama's answer about her complexion; it was not always accurate or adequate, but that was what she said about her skin.

"The child has talent," they said, "it should be cultivated."

"I made it up myself," she answered, not in complete honesty.

When the curtains fell at last on the tableau at the end of the ballet she heard the applause from the stage as a mighty roar of traffic. Two bands played for the ball; the Governor led the grand march. After the dance she stood in the dark passage that led to the dressing room.

"I forgot once," she whispered expectantly. The still fever of the show went on outside.

"You were perfect," Randolph laughed.

The girl hung there on his words like a vestment waiting to be put on. Indulgently, Randolph caught the long arms and swept her lips with his as a sailor might search the horizons of the sea for other masts. She wore this outward sign that she was growing up like a decoration for valor—it stayed on her face for days, and recurred whenever she was excited.

"You're almost grown, aren't you?" he asked.

Alabama did not concede herself the right to examine those arbitrary points of view, meeting places of the facets of herself envisaged as a woman, conjured up behind his shoulders by the kiss. To project herself therein would have been to violate her confessional of herself. She was afraid; she thought her heart was a person walking. It was. It was everybody walking at once. The show was over.

"Alabama, why won't you go out on the floor?"

"I've never danced. I'm scared."

"I'll give you a dollar if you'll dance with a young man who's waiting."

"All right, but s'pose I fall down or trip him up?"

Randolph introduced her. They got along quite nicely, except when the man went sideways.

"You are so cute," her partner said. "I thought you must be from some other place."

She told him he could come to see her sometime, and a dozen others, and promised to go to the country club with a redhead man who slid over the dance floor as if he were skimming milk. Alabama had never imagined what it would be like to have a date before.

She was sorry when the makeup came off of her face with washing next day. There was only Dixie's rouge pot to help her masquerading through the engagements she had made.

Sloshing his coffee with the folded *Journal,* the Judge read the account of the Beauty Ball in the morning's paper. "The gifted Miss Dixie Beggs, oldest daughter of Judge and Mrs. Austin Beggs of this city," the paper said, "contributed much to the success of the occasion, acting

as impresario to her talented sister, Miss Alabama Beggs, assisted by Mr. Randolph McIntosh. The dance was one of startling beauty and the execution was excellent."

"If Dixie thinks that she can introduce the manners of a prostitute into my family, she is no daughter of mine. Identified in print with a moral scapegoat! My children have got to respect my name. It is all they will have in the world," the Judge exploded.

It was the most Alabama had ever heard her father say about what he exacted of them. Isolated by his unique mind from the hope of any communication with his peers, the Judge lived apart, seeking only a vague and gentle amusement from his associates, asking only a fair respect for his reserve.

So Randolph came in the afternoon to say good-bye.

The swing creaked, the Dorothy Perkins browned in the dust and sun. Alabama sat on the steps watering the lawn with a hot rubber hose. The nozzle leaked lugubriously over her dress. She was sad about Randolph; she had hoped some occasion would present itself for kissing him again. Anyway, she told herself, she would try to remember that other time for years.

Her sister's eyes followed the man's hands as if she expected the path of his fingers to lead her to the ends of the earth.

"Maybe you'll come back when you've got your divorce," Alabama heard Dixie say in a truncated voice. The shape of Randolph's eyes was heavy with finality against the roses. His distinct voice carried clear and detached to Alabama.

"Dixie," he said, "you taught me how to use my knife and fork and how to dance and choose my suits, and I wouldn't come back to your father's house if I'd left my Jesus. Nothing is good enough for him."

Sure enough, he never did. Alabama had learned from the past that something unpleasant was bound to happen whenever the Saviour made his appearance in the dialogue. The savor of her first kiss was gone with the hope of its repetition.

The bright polish on Dixie's nails turned yellow and deposits of neglect shone through the red. She gave up her job on the paper and went to work at the bank. Alabama inherited the pink hat and somebody stepped on the bar pin. When Joan got home the room was so untidy that she moved her clothes in with Alabama. Dixie hoarded her money; the only things she bought in a year were the central figures from the "Primavera" and a German lithograph of "September Morn."

Dixie covered her transom with a block of pasteboard to prevent her father's knowing that she was sitting up after midnight. Girls came and

went. When Laura spent the night the family was afraid of catching tuberculosis; Paula, gold and effulgent, had a father who had stood a murder trial; Marshall was beautiful and malicious with many enemies and a bad reputation; when Jessie came all the way from New York to visit she sent her stockings to the dry cleaner. There was something immoral about that to Austin Beggs.

"I don't see why," he said, "my daughter has to choose her companions from the scum of the earth."

"Depending on which way you look at it," protested Millie. "The scum might be a valuable deposit."

Dixie's friends read aloud to each other. Alabama sat in the little white rocker and listened, imitating their elegance and cataloguing the polite, bibelotic laughs which they collected from one another.

"She won't understand," they reiterated, staring at the girl with liquidated Anglo-Saxon eyes.

"Understand what?" said Alabama.

The winter choked itself in a ruching of girls. Dixie cried whenever a man talked her into giving him a date. In the spring, word came about Randolph's death.

"I hate being alive," she screamed in hysterics. "I hate it, I hate it, I hate it! I could have married him and this wouldn't have happened."

"Millie, will you call the doctor?"

"Nothing serious, just nervous strain, Judge Beggs. Nothing to worry about," the doctor said.

"I cannot put up with this emotional nonsense any longer," Austin said.

When Dixie was better she went to New York to work. She cried when she kissed them all good-bye and went off with a bunch of kiss-me-at-the-gate in her hand. She shared a room with Jessie on Madison Avenue, and looked up everybody from home who had drifted up there. Jessie got her a job with the same insurance company as herself.

"I want to go to New York, Mamma," said Alabama as they read Dixie's letters.

"What on earth for?"

"To be my own boss."

Millie laughed. "Well, never mind," she said. "Being boss isn't a question of places. Why can't you be boss at home?"

Within three months Dixie married up there—a man from Alabama, downstate. They came home on a trip and she cried a lot as if she was sorry for all the rest of the family who had to go on living at home. She changed the furniture about in the old house and bought a buffet

for the dining room. She bought Alabama a Kodak and they took pictures together on the steps of the State Capitol, and under the pecan trees and holding hands on the front steps. She said she wanted Millie to make her a patchwork quilt and to have a rose garden planted around the old house, and for Alabama not to paint her face so much, that she was too young, that in New York the girls didn't.

"But I am not in New York," said Alabama. "When I go there, I will, anyway."

Then Dixie and her husband went away again, out of the Southern doldrums. The day her sister left, Alabama sat on the back porch watching her mother slice the tomatoes for lunch.

"I slice the onions an hour beforehand," Millie said, "and then I take them out so just the right flavor stays in the salad."

"Yes'm. Can I have those ends?"

"Don't you want a whole one?"

"No'm. I love the greenish part."

Her mother attended her work like a chatelaine ministering to a needy peasant. There was some fine, aristocratic, personal relationship between herself and the tomatoes, dependent on Miss Millie to turn them into a salad. The lids of her mother's blue eyes rose in weary circumflex as her sweet hands moved in charity through the necessities of her circumstance. Her daughter was gone. Still there was something of Dixie in Alabama—the tempestuousness. She searched the child's face for family resemblances. And Joan would be coming home.

"Mamma, did you love Dixie very much?"

"Of course. I still do."

"But she was troublesome."

"No. She was always in love."

"Did you love her better than me, for instance?"

"I love you all the same."

"I will be troublesome, too, if I can't do as I please."

"Well, Alabama, all people *are*, about one thing or another. We must not let it influence us."

"Yes'm."

Pomegranates in the leathery lacing of their foliage ripened outside the lattice to an exotic décor. The bronze balls of a mournful crape myrtle at the end of the lot split into lavender tarlatan gurgles. Japanese plums splashed heavy sacks of summer on the roof of the chicken yard.

"Cluck, *cluck*, cluck, *cluck!*"

"That old hen must be laying again."

"Maybe she's caught a June bug."

"The figs aren't ripe yet."

A mother called her children from a house across the way. Pigeons cooed in the oak next door. The rhythmic flap of a pounding beefsteak began in a neighbor's kitchen.

"Mamma, I don't see why Dixie had to go all the way to New York to marry a man from so near home."

"He's a very nice man."

"But I wouldn't have married him if I was Dixie. I would have married a New Yorker."

"Why?" said Millie curiously.

"Oh, I don't know."

"More conquering," Millie mocked.

"Yes'm, that's it."

A distant trolley ground to a stop on the rusty rails.

"Isn't that the streetcar stopping? I'll bet it's your father."

◦ II ◦

"And I tell you I will *not* wear it if you fix it that way," Alabama screeched, pounding her fist on the sewing machine.

"But, dear, it's the very thing."

"If it has to be blue serge, it *doesn't* have to be long as well."

"When you're going out with boys, you can't go back to short dresses."

"I'm not going out with boys in the daytime—ever," she said. "I am going to play in the day and go out at night."

Alabama tilted the mirror and inspected the long gored skirt. She began to cry with impotent rage.

"I won't have it! I really won't—how can I run or anything?"

"It's lovely, isn't it, Joan?"

"If she were my child, I'd slap her jaw," said Joan succinctly.

"You would, would you! Well, I'd slap your own jaw."

"When I was your age I was glad to get anything. My dresses were all made out of Dixie's old ones. You're a vixen to be so spoiled," pursued her sister.

"Joan! Alabama just wants her dress fixed differently."

"Mamma's little angel! It's exactly like she said she wanted it."

"How could I tell it would look like that?"

"I know what I would do if you were mine," Joan threatened.

Alabama stood in the special Saturday sun and straightened the sailor collar. She ran her fingers tentatively inside the breast pocket, staring pessimistically at her reflection.

"The feet look as if they were somebody else's," she said. "But maybe it'll be all right."

"I've never heard so much fuss made about a dress," said Joan. "If I were Mamma I'd make you buy them ready-made."

"There's none in the stores that I like. Besides, you have lace on all your things."

"I pay for it myself."

Austin's door slammed.

"Alabama, will you stop that dispute? I am trying to take a nap."

"Children, your father!" said Millie in dismay.

"Yes, sir, it's Joan," shrieked Alabama.

"My Lord! She always has to blame somebody else. If it isn't me, it's Mamma or whoever's near—never herself."

Alabama thought resentfully of the injustice of a life which had created Joan before herself. Not only that, but had given her sister an unattainable hue of beauty, dark as a black opal. Nothing Alabama ever did could turn her eyes gold and brown or hollow out those dark mysterious sockets from her cheekbones. When you saw Joan directly under a light, she seemed like a ghost of her finest points awaiting inhabitation. Transparent blue halos shone around the edge of her teeth; her hair was smooth to a colorless reflection.

People said Joey was a sweet girl—compared to the others. Being over twenty, Joan had attained her right to the family spotlight. When she heard them planning vaguely for Joan, Alabama hung on her parents' rare delvings into what she felt was the substance of herself. Hearing little bits of things about the family characteristics that she too must have in her, was like finding she had all five toes when up to the present she had been able to count only four. It was nice to have indications about yourself to go on.

"Millie," Austin asked anxiously one night, "is Joey going to marry that Acton boy?"

"I don't know, dear."

"Well, I don't think she ought to have gone galavanting about the country visiting his parents if she doesn't mean business, and she is seeing too much of the Harlan man if she does."

"I visited Acton's people from my father's house. Why did you let her go?"

"I didn't know about Harlan. There are obligations——"

"Mamma, do you remember your father well?" interrupted Alabama.

"Certainly. He was thrown from a race cart when he was eighty-three years old, in Kentucky." That her mother's father had a graphic life of his own to dramatize was promising to Alabama. There was a show to join. Time would take care of that, and she would have a place, inevitably—somewhere to enact the story of her life.

"What about this Harlan?" pursued Austin.

"O, pshaw!" Millie said noncommittally.

"I don't know. Joey seems very fond of him. He can't make a living. Acton is well established. I will not have my daughter become a public charge."

Harlan called every night and sang with Joan the songs she brought with her from Kentucky: "The Time, The Place and The Girl," "The Girl from the Saskatchewan," "The Chocolate Soldier," songs with two-tone lithograph covers of men smoking pipes and princes on a balustrade and worlds of clouds about the moon. He had a serious voice like an organ. He stayed too much to supper. His legs were so long that the rest of him seemed merely a decorative appendage.

Alabama invented dances to show off for Harlan, tapping about the outside edges of the carpet.

"Doesn't he ever go home?" Austin fretted to Millie on each succeeding visit. "I don't know what Acton would think. Joan must not be irresponsible."

Harlan knew how to ingratiate himself personally; it was his status that was unsatisfactory. Marrying him would have meant, for Joan, starting over where the Judge and Millie had started, and Austin didn't have racehorses to pull her background for her like Millie's father had had.

"Hello, Alabama, what a pretty bib you've got on." Alabama blushed. She strove to sustain the pleasurable emotion. It was the first time she could remember blushing; another proof of something or other, or that all the old responses were her proper heritage—embarrassment and pride and responsibility for them.

"It's an apron. I've got on a new dress and I was helping fix supper." She exposed the new blue serge for Harlan's admiration.

He drew the lanky child across his knee.

Alabama, unwilling to relinquish the discussion of herself, went on hurriedly, "But I have a beautiful dress to wear to the dance, more beautiful than Joan's even."

"You are too young to go to a dance. You look such a baby, I'd be

ashamed to kiss you." Alabama was disappointed at sensing Harlan's paternal air.

Harlan pulled the pale hair away from her face. There were many geometrical formations and shining knolls and an element of odalisque retrocession about its stillness. Her bones were stern like her father's, an integrity of muscle structure bound her still to extreme youth.

Austin came in for his paper.

"Alabama, you are too big to sprawl on young men's laps."

"But he's not *my* beau, Daddy!"

"Good evening, Judge."

The Judge spat contemplatively into the hearth, disciplining his disapproval.

"It makes no difference, you are too old."

"Will I always be too old?"

Harlan rose to his feet spilling her to the floor. Joan stood in the door.

"Miss Joey Beggs," he said, "the prettiest girl in town!"

Joan giggled the way people do when, entrenched in an enviable position, they are forced to deprecate their superiority to spare others —as if she had always known she was the prettiest.

Alabama watched them enviously as Harlan held Joey's coat and took her off possessively. Speculatively she watched her sister change into a more fluctuating, more ingratiating person, as she confided herself to the man. She wished it were herself. There would be her father at the supper table. It was nearly the same; the necessity of being something that you really weren't was the same. Her father didn't know what she really was like, she thought.

Supper was fun; there was toast with a taste of charcoal and sometimes chicken, warm, like a breath of the air from beneath a quilt, and Millie and the Judge talking ceremoniously of their household and their children. Family life became a ritual passed through the sieve of Austin's strong conviction.

"I want some more strawberry jam."

"It'll make you sick."

"Millie, in my opinion, a respectable girl does not engage herself to one man and permit herself to be interested in another."

"There's no harm in it. Joan's a good girl. She is not engaged to Acton."

Her mother knew that Joan was engaged to Acton because one summer night when it poured with rain and the vines swished and dripped like ladies folding silken skirts about them, and the drains growled and

choked like mournful doves and the gutters ran with foamy mud, Millie had sent Alabama with an umbrella and Alabama had found the two of them clinging together like moist stamps in a pocketbook. Acton said to Millie afterwards that they were going to be married. But Harlan sent roses on Sundays. Lord knows where he got the money to buy so many flowers. He couldn't ask Joan to marry him, he was so poor.

When the town gardens began to bloom so prettily, Harlan and Joan took Alabama with them on their walks. Alabama, and the big japonicas with leaves like rusting tin, viburnum and verbena and Japanese magnolia petals lying about the lawns like scraps from party dresses, absorbed the quiet communion between them. The presence of the child held them to trivialities. By her person, they held at bay the issue.

"I want one of those bushes when I have a house," Joan pointed out.

"Joey! I can't afford it! I'll grow a beard instead," expostulated Harlan.

"I love little trees, arborvitae and juniper, and I'm going to have a long walk winding between like featherstitching and a terrace of Clotilde Soupert at the end." Alabama decided that it didn't much matter whether her sister was thinking of Acton or Harlan—certainly the garden was to be very nice, for either or neither or both, she amended confusedly.

"O, Lord! Why can't I make money?" protested Harlan.

Yellow flags like anatomical sketches and pools of lotus flowers, the brown and white batik of snowball bushes, the sudden emotional gush of burning brush and the dead cream of Joey's eggshell face under her leghorn hat made up that spring. Alabama understood vaguely why Harlan rattled the keys in his pockets where there was no money and walked the streets like a dizzy man traversing a log. Other people had money; he had only enough for roses. If he did without the roses he would have nothing for ages and ages while he saved until Joan was gone or different or lost forever.

When the weather was hot they hired a buggy and drove through the dust to daisy fields like nursery rhymes where dreamy cows saddled with shade nibbled the summer off the white slopes. Alabama stood up behind and brought back the flowers. What she said in this foreign world of restraint and emotion seemed to her especially significant, as a person will imagine himself wittier than usual in an unfamiliar tongue. Joan complained to Millie that Alabama talked too much for her age.

Creaking and swaying like a sail in a swelling gale, the love story breasted July. At last the letter from Acton came. Alabama saw it on the Judge's mantelpiece.

"And being able to support your daughter in comfort and, I believe, in happiness, I ask your sanction to our marriage."

Alabama asked to keep it. "To make a family document," she said.

"No," said the Judge. He and Millie never kept things.

Alabama's expectations for her sister envisaged everything except that love might roll on using the bodies of its dead to fill up the craters in the path to its line of action. It took her a long time to learn to think of life unromantically as a long, continuous exposition of isolated events, to think of one emotional experience as preparation to another.

When Joey said "Yes" Alabama felt cheated out of a drama to which she had bought her ticket with her interest. "No show today; the leading lady has cold feet," she thought.

She couldn't tell whether Joan was crying or not. Alabama sat polishing white slippers in the upstairs hall. She could see her sister lying on the bed, as if she had laid herself down there and gone off and forgotten to come back, but she didn't seem to be making a noise.

"Why don't you want to marry Acton?" she heard the Judge say kindly.

"Oh—I haven't got any trunk, and it means leaving home, and my clothes are all worn out," answered Joan evasively.

"I'll get you a trunk, Joey, and he is well able to give you clothes and a good home and all you will be needing in life."

The Judge was gentle with Joan. She was less like him than the others; her shyness had made her appear more composed, more disposed to bear with her lot than Alabama or Dixie.

The heat pressed down about the earth inflating the shadows, expanding the door and window ledges till the summer split in a terrific clap of thunder. You could see the trees by the lightning flashes gyrating maniacally and waving their arms about like furies. Alabama knew Joan was afraid of a storm. She crept into her sister's bed and slipped her brown arm over Joan like a strong bolt over a sagging door. Alabama supposed that Joan had to do the right thing and have the right things; she could see how that might be necessary if a person was like Joan. Everything about Joan had a definite order. Alabama was like that herself sometimes on a Sunday afternoon when there was nobody in the house besides herself and the classic stillness.

She wanted to reassure her sister. She wanted to say, "And, Joey, if you ever want to know about the japonicas and the daisy fields it will be all right that you have forgotten because I will be able to tell you about how it felt to be feeling that way that you cannot quite

remember—that will be for the time when something happens years from now that reminds you of now."

"Get out of my bed," said Joan abruptly.

Alabama wandered sadly about, in and out through the pale acetylene flashes.

"Mamma, Joey's scared."

"Well, do you want to lie here by me, dear?"

"*I'm* not scared; I just can't sleep. But I'll lie there, please, if I may."

The Judge often sat reading Fielding. He closed his book over his thumb to mark the end of the evening.

"What are they doing at the Catholic Church?" the Judge said. "Is Harlan a Catholic?"

"No, I believe not."

"I'm glad she's going to marry Acton," he said inscrutably.

Alabama's father was a wise man. Alone his preference in women had created Millie and the girls. He knew everything, she said to herself. Well, maybe he did—if knowing is paring your perceptions to fit into the visible portion of life's mosaic, he did. If knowledge is having an attitude toward the things we have never experienced and preserving an agnosticism toward those we have, he did.

"I'm not glad," Alabama said decisively. "Harlan's hair goes up like a Spanish king. I'd rather Joey married *him.*"

"People can't live off the hair of Spanish kings," her father answered.

Acton telegraphed that he would arrive at the end of the week and how happy he was.

Harlan and Joan rocked in the swing, jerking and creaking the chain and scraping their feet over the worn gray paint and snipping the trailers off the morning glories.

"This porch is always the coolest, sweetest place," said Harlan.

"That's the honeysuckle and star jasmine you smell," said Joan.

"No," said Millie, "it's the cut hay across the way, and my aromatic geraniums."

"Oh, Miss Millie, I hate to leave."

"You'll be back."

"No, not any more."

"I'm very sorry, Harlan——" Millie kissed him on the cheek. "You're just a baby," she said, "to care. There'll be others."

"Mamma, that smell is the pear trees," Joan said softly.

"It's my perfume," said Alabama impatiently, "and it cost six dollars an ounce."

* * *

From Mobile, Harlan sent Joan a bucket of crabs for Acton's supper. They crawled about the kitchen and scurried under the stove and Millie dropped their live green backs into a pot of boiling water one by one.

Everybody ate them except Joan.

"They're too clumsy," she said.

"They must have arrived in the animal kingdom just about where we have in mechanical development. They don't work any better than tanks," said the Judge.

"They eat dead men," said Joan.

"Joey, is that necessary at table?"

"They do, though," Millie corroborated distastefully.

"I believe I could make one," said Alabama, "if I had the material."

"Well, Mr. Acton, did you have a nice trip?"

Joan's trousseau filled the house—blue taffeta dresses and a black and white check, and a shell-pink satin, a waist of turquoise blue and black suede shoes.

Brown and yellow silk and lace and black and white and a self-important suit and sachet pads of rose filled the new trunk.

"I don't want it that way," she sobbed. "My bust is too big."

"It's very becoming and will be so useful in a city."

"You must come to visit me," Joan said to her friends. "I want you all to come to see me when you come to Kentucky. Someday we'll move to New York."

Joan held excitedly to some intangible protestation against her life's purpose like a puppy worrying a shoestring. She was irritable and exacting of Acton, as if she had expected him to furnish her store of gladness with the wedding ring.

They put them on the train at midnight. Joan didn't cry, but she seemed ashamed that she might. Walking back across the railroad tracks, Alabama felt the strength and finality in Austin more than ever. Joan was produced and nourished and disposed of; her father, in parting with his daughter, seemed to have grown the span of Joan's life older; there was only Alabama's future now standing between him and his complete possession of his past. She was the only unresolved element that remained of his youth.

Alabama thought of Joan. Being in love, she concluded, is simply a presentation of our pasts to another individual, mostly packages so unwieldy that we can no longer manage the loosened strings alone. Looking for love is like asking for a new point of departure, she thought,

another chance in life. Precociously for her age, she made an addendum: that one person never seeks to share the future with another, so greedy are secret human expectations. Alabama thought a few fine and many skeptical thoughts, but they did not essentially affect her conduct. She was at seventeen a philosophical gourmand of possibilities, having sucked on the bones of frustration thrown off from her family's repasts without repletion. But there was much of her father in her that spoke for itself and judged.

From him, she wondered why that brisk important sense of being a contributory factor in static moments could not last. Everything else seemed to. With him, she enjoyed the concision and completion of her sister's transference from one family to another.

It was lonesome at home without Joan. She could almost have been reconstructed by the scraps she'd left behind.

"I always work when I'm sad," her mother said.

"I don't see how you learned to sew so well."

"By sewing for you children."

"Anyway, won't you please let me have this dress without sleeves at all, and the roses up here on my shoulder?"

"All right, if you want. My hands are so rough nowadays, they stick in the silk and I don't sew so well as I did."

"It's perfectly beautiful, though. It's better on me than it ever was on Joan."

Alabama pulled out the full, flowing silk to see how it would blow in a breeze, how it would have looked in a museum on the "Venus de Milo."

"If I could just stay this way till I got to the dance," she thought, "it would be pretty enough. But I will all come to pieces long before then."

"Alabama, what *are* you thinking about?"

"About fun."

"That's a good subject matter."

"And about how wonderful she is," teased Austin. Privy to the small vanities of his family, these things so absent in himself amused him in his children. "She's always looking in the glass at herself."

"Daddy! I am not!" She knew, though, that she looked more frequently than her satisfaction in her appearance justified in the hope of finding something more than she expected.

Her eyes trailed in embarrassment over the vacant lot next door that lay like a primrose dump through the windows. The vermilion hibiscus curved five brazen shields against the sun; the altheas drooped in faded

purple canopies against the barn, the South phrased itself in engraved invitation—to a party without an address.

"Millie, you oughtn't to let her get so sunburned if she's going to wear that kind of clothes."

"She's only a child yet, Austin."

Joan's old pink was finished for the dance. Miss Millie hooked up the back. It was too hot to stay inside. One side of her hair was flattened by the sweat on her neck before she had finished the other. Millie brought her a cold lemonade. The powder dried in rings around her nose. They went down to the porch. Alabama seated herself in the swing. It had become almost a musical instrument to her; by jiggling the chains she could make it play a lively tune or somnolently protest the passage of a boring date. She'd been ready so long that she wouldn't be any more by the time they got here. Why didn't they come for her, or telephone? Why didn't something happen? Ten o'clock sounded on a neighbor's clock.

"If they don't come on, it'll be too late to go," she said carelessly, pretending she didn't care whether she missed the dance or not.

Spasmodic unobtrusive cries broke the stillness of the summer night. From far off down the street the cry of a paperboy floated nearer on the heat.

"Wuxtry! Wuxtry! Yad—y—add—vo—tize."

The cries swelled from one direction to another, rose and fell like answering chants in a cathedral.

"What's happened, boy?"

"I don't know, Ma'am."

"Here, boy! Gimme a paper!"

"Isn't it awful, Daddy! What does it mean?"

"It may mean a war for us."

"But they were warned not to sail on the *Lusitania,*" Millie said.

Austin threw back his head impatiently.

"They can't do that," he said, "they can't warn neutral nations."

The automobile loaded with boys drew up at the curb. A long, shrill whistle sounded from the dark; none of the boys got out of the car.

"You will not leave this house until they come inside for you," the Judge said severely.

He seemed very fine and serious under the hall light—as serious as the war they might have. Alabama was ashamed for her friends as she compared them with her father. One of the boys got out and opened the door; she and her father could call it a compromise.

"War! There's going to be a war!" she thought.

Excitement stretched her heart and lifted her feet so high that she floated over the steps to the waiting automobile.

"There's gonna be a war," she said.

"Then the dance ought to be good tonight," her escort answered.

All night long Alabama thought about the war. Things would disintegrate to new excitements. With adolescent Nietzscheanism, she already planned to escape on the world's reversals from the sense of suffocation that seemed to her to be eclipsing her family, her sisters, and mother. She, she told herself, would move brightly along high places and stop to trespass and admire, and if the fine was a heavy one—well, there was no good in saving up beforehand to pay it. Full of these presumptuous resolves, she promised herself that if, in the future, her soul should come starving and crying for bread it should eat the stone she might have to offer without complaint or remorse. Relentlessly she convinced herself that the only thing of any significance was to take what she wanted when she could. She did her best.

<div align="center">◦ III ◦</div>

"She's the wildest one of the Beggs, but she's a thoroughbred," people said.

Alabama knew everything they said about her—there were so many boys who wanted to "protect" her that she couldn't escape knowing. She leaned back in the swing visualizing herself in her present position.

"Thoroughbred!" she thought, "meaning that I never let them down on the dramatic possibilities of a scene—I give a damned good show."

"He's just like a very majestic dog," she thought of the tall officer beside her, "a hound, a noble hound! I wonder if his ears would meet over his nose." The man vanished in metaphor.

His face was long, culminating in a point of lugubrious sentimentality at the self-conscious end of his nose. He pulled himself intermittently to pieces, showered himself in fragments above her head. He was obviously at an emotional tension.

"Little lady, do you think you could live on five thousand a year?" he asked benevolently. "To start with," he added, on second thought.

"I could, but I don't want to."

"Then why did you kiss me?"

"I had never kissed a man with a mustache before."

"That's hardly a reason——"

"No. But it's as good a reason as many people have to offer for going into convents."

"There's no use in my staying any longer, then," he said sadly.

"I s'pose not. It's half past eleven."

"Alabama, you're positively indecent. You know what an awful reputation you've got and I offer to marry you anyway and——"

"And you're angry because I won't make you an honest man."

The man hid dubiously beneath the impersonality of his uniform.

"You'll be sorry," he said unpleasantly.

"I hope so," Alabama answered. "I like paying for things I do—it makes me feel square with the world."

"You're a wild Comanche. Why do you try to pretend you're so bad and hard?"

"Maybe so—anyway, the day that I'm sorry I'll write it in the corner of the wedding invitations."

"I'll send you a picture, so you won't forget me."

"All right—if you want to."

Alabama slipped on the night latch and turned off the light. She waited in the absolute darkness until her eyes could distinguish the mass of the staircase. "Maybe I ought to have married him, I'll soon be eighteen," she tabulated, "and he could have taken good care of me. You've got to have some sort of background." She reached the head of the stairs.

"Alabama," her mother's voice called softly, almost indistinguishable from the currents of the darkness, "your father wants to see you in the morning. You'll have to get up to breakfast."

Judge Austin Beggs sat over the silver things about the table, finely controlled, coordinated, poised in his cerebral life like a wonderful athlete in the motionless moments between the launchings of his resources.

Addressing Alabama, he overpowered his child.

"I tell you that I will not have my daughter's name bandied about the street corners."

"Austin! She's hardly out of school," Millie protested.

"All the more reason. What do you know of these officers?"

"P—l—e—a—s—e——"

"Joe Ingham told me his daughter was brought home scandalously intoxicated and she admitted that you had given her the liquor."

"She didn't have to drink it—it was a freshman leadout and I filled my nursing bottle with gin."

"And you forced it on the Ingham girl?"

"I did not! When she saw people laughing, she tried to edge in on

the joke, having none of her own to amuse them with," Alabama re-
torted arrogantly.

"You will have to find a way of conducting yourself more circum-
spectly."

"Yes, sir. Oh, Daddy! I'm so tired of just sitting on the porch and
having dates and watching things rot."

"It seems to me you have plenty to do without corrupting others."

"Nothing to do but drink and make love," she commented privately.

She had a strong sense of her own insignificance; of her life's slipping
by while June bugs covered the moist fruit in the fig trees with the
motionless activity of clustering flies upon an open sore. The bareness
of the dry Bermuda grass about the pecan trees crawled imperceptibly
with tawny caterpillars. The matlike vines dried in the autumn heat and
hung like empty locust shells from the burned thickets about the pillars
of the house. The sun sagged yellow over the grass plots and bruised
itself on the clotted cotton fields. The fertile countryside that grew
things in other seasons spread flat from the roads and lay prone in
ribbed fans of broken discouragement. Birds sang dissonantly. Not a
mule in the fields nor a human being on the sandy roads could have
borne the heat between the concave clay banks and the mediant cypress
swamps that divided the camp from the town—privates died of sun-
stroke.

The evening sun buttoned the pink folds of the sky and followed a
busload of officers into town, young lieutenants, old lieutenants, free
from camp for the evening to seek what explanation of the world war
this little Alabama town had to offer. Alabama knew them all with vary-
ing degrees of sentimentality.

"Is your wife in town, Captain Farreleigh?" asked a voice in the
joggling vehicle. "You seem very high tonight."

"She's here—but I'm on my way to see my girl. That's why I'm
happy," the captain said shortly, whistling to himself.

"Oh." The especially young lieutenant didn't know what to say to
the captain. It would be about like offering congratulations for a still-
born child he supposed to say to the man, "Isn't that splendid" or "How
nice!" He might say, "Well, Captain, that'll be very scandalous indeed!"
—if he wanted to be court-martialed.

"Well, good luck, I'm going to see mine tomorrow," he said finally,
and further to show that he bore no moral prejudice, he added "good
luck."

"Are you still panhandling in Beggs Street?" asked Farreleigh
abruptly.

"Yes," the lieutenant laughed uncertainly.

The car deposited them in the breathless square, the center of the town. In the vast space enclosed by the low buildings the vehicle seemed as minuscular as a coach in the palace yard of an old print. The arrival of the bus made no impression on the city's primal sleep. The old rattletrap disgorged its cargo of clicking masculinity and vibrant official restraint into the lap of this invertebrate world.

Captain Farreleigh crossed to the taxi stand.

"Number five Beggs Street," he said with loud insistence, making sure his words reached the lieutenant, "as fast as you can make it."

As the car swung off, Farreleigh listened contentedly to the officer's forced laugh stabbing the night behind him.

"Hello, Alabama!"

"Ho, there, Felix!"

"My name is not Felix."

"It suits you, though. What is your name?"

"Captain Franklin McPherson Farreleigh."

"The war's on my mind, I couldn't remember."

"I've written a poem about you."

Alabama took the paper he gave her and held it to the light falling through the slats of the shutters like a staff of music.

"It's about West Point," she said disappointed.

"That's the same thing," said Farreleigh. "I feel the same way about you."

"Then the United States Military Academy appreciates the fact that you like its gray eyes. Did you leave the last verse in the taxi or were you keeping the car in case I should shoot?"

"It's waiting because I thought we could ride. We ought not to go to the club," he said seriously.

"Felix!" reproved Alabama, "you know I don't mind people's jabbering about us. Nobody will notice that we are together—it takes so many soldiers to make a good war."

She felt sorry for Felix; she was touched that he did not want to compromise her. In a wave of friendship and tenderness. "You mustn't mind," she said.

"This time it's my wife—she's here," Farreleigh said crisply, "and she might be there."

He offered no apology.

Alabama hesitated.

"Well, come on, let's ride," she said, at last. "We can dance another Saturday."

He was a tavern sort of man buckled into his uniform, strapped with the swagger of beef-eating England, buffeted by his incorruptible, insensitive, roistering gallantry. He sang "The Ladies" over and over again as they rode along the horizons of youth and a moonlit war. A southern moon is a sodden moon, and sultry. When it swamps the fields and the rustling sandy roads and the sticky honeysuckle hedges in its sweet stagnation, your fight to hold on to reality is like a protestation against a first waft of ether. He closed his arms about the dry slender body. She smelled of Cherokee roses and harbors at twilight.

"I'm going to get myself transferred," said Felix impatiently.

"Why?"

"To avoid falling out of aeroplanes and cluttering up roadsides like your other beaux."

"*Who* fell out of an aeroplane?"

"Your friend with the Dachshund face and the mustache, on his way to Atlanta. The mechanic was killed and they've got the lieutenant up for court-martial."

"Fear," said Alabama as she felt her muscles tighten with a sense of disaster, "is nerves—maybe all emotions are. Anyway, we must hold on to ourselves and not care.

"Oh—how did it happen?" she inquired casually.

Felix shook his head.

"Well, Alabama, I *hope* it was an accident."

"There isn't any use worrying about the dog-one," Alabama extricated herself. "Those people, Felix, who spread their sensibilities for the passage of events live like emotional prostitutes; they pay with a lack of responsibility on the part of others—no Walter Raleighing of the inevitable for me," she justified.

"You didn't have the right to lead him on, you know."

"Well, it's over now."

"Over in a hospital ward," commented Felix, "for the poor mechanic."

Her high cheekbones carved the moonlight like a scythe in a ripe wheat field. It was hard for a man in the army to censure Alabama.

"And the blond lieutenant who rode with me to town?" Farreleigh went on.

"I'm afraid I can't explain him away," she said.

Captain Farreleigh went through the convulsive movements of a drowning man. He grabbed his nose and sank to the floor of the car.

"Heartless," he said. "Well, I suppose I shall survive."

"Honor, Duty, Country, and West Point," Alabama answered dreamily. She laughed. They both laughed. It was very sad.

"Number five Beggs Street," Captain Farreleigh directed the taximan, "immediately. The house is on fire."

The war brought men to the town like swarms of benevolent locusts eating away the blight of unmarried women that had overrun the South since its economic decline. There was the little major who stormed about like a Japanese warrior flashing his gold teeth, and an Irish captain with eyes like the Blarney stone and hair like burning peat, and aviation officers, white around their eyes from where their goggles had been with swollen noses from the wind and sun; and men who were better dressed in their uniforms than ever before in their lives communicating their consequent sense of a special occasion; men who smelled of Fitch's hair tonic from the camp barber and men from Princeton and Yale who smelled of Russian Leather and seemed very used to being alive, and trademark snobs naming things and men who waltzed in spurs and resented the cut-in system. Girls swung from one to another of the many men in the intimate flush of a modern Virginia reel.

Through the summer Alabama collected soldiers' insignia. By autumn she had a glove box full. No other girl had more and even then she'd lost some. So many dances and rides and so many golden bars and silver bars and bombs and castles and flags and even a serpent to represent them all in her cushioned box. Every night she wore a new one.

Alabama quarreled with Judge Beggs about her collection of bric-a-brac and Millie laughed and told her daughter to keep all those pins; that they were pretty.

It turned as cold as it ever gets in that country. That is to say, the holiness of creation misted the lonesome green things outside; the moon glowed and sputtered nebulous as pearls in the making; the night picked itself a white rose. In spite of the haze and the clouds in the air, Alabama waited for her date outside, pendulously tilting the old swing from the past to the future, from dreams to surmises and back again.

A blond lieutenant with one missing insignia mounted the Beggs' steps. He had not bought himself a substitute because he liked imagining the one he had lost in the battle of Alabama to be irreplaceable. There seemed to be some heavenly support beneath his shoulder blades that lifted his feet from the ground in ecstatic suspension, as if he secretly enjoyed the ability to fly but was walking as a compromise to convention. Green gold under the moon, his hair lay in Cellinian frescoes and fashionable porticoes over his dented brow. Two hollows over his eyes

like the ends of mysterious bolts of fantasy held those expanses of elec-
tric blue to the inspiration of his face. The pressure of masculine beauty
equilibrated for twenty-two years had made his movements conscious
and economized as the steps of a savage transporting a heavy load of
rocks on his head. He was thinking to himself that he would never be
able to say to a taxi driver "Number five Beggs Street" again without
making the ride with the ghost of Captain Farreleigh.

"You're ready already! Why outdoors?" he called. It was chilly in the
mist to be swinging outside.

"Daddy has the blight and I have retired from the field of action."

"What particular iniquity have you committed?"

"Oh, he seems to feel for one thing, that the army has a right to its
epaulettes."

"Isn't it nice that parental authority's going to pieces with everything
else?"

"Perfect—I love conventional situations."

They stood on the frosted porch in the sea of mist quite far away
from each other, yet Alabama could have sworn she was touching him,
so magnetic were their two pairs of eyes.

"And——?"

"Songs about summer love. I hate this cold weather."

"And——?"

"Blond men on their way to the country club."

The clubhouse sprouted inquisitively under the oaks like a squat
clump of bulbs piercing the leaves in spring. The car drew up the gravel
drive, poking its nose in a round bed of cannas. The ground around the
place was as worn and used as the plot before a children's playhouse.
The sagging wire about the tennis court, the peeling drab-green paint
of the summerhouse on the first tee, the trickling hydrant, the veranda
thick in dust all flavored of the pleasant atmosphere of a natural growth.
It is too bad that a bottle of corn liquor exploded in one of the lockers
just after the war and burned the place to the ground. So much of the
theoretical youth—not just transitory early years, but of the projections
and escapes of inadequate people in dramatic times—had wedged itself
beneath the low-hung rafters, that the fire destroying this shrine of war-
time nostalgias may have been a case of combustion from emotional
saturation. No officer could have visited it three times without falling in
love, engaging himself to marry and to populate the countryside with
little country clubs exactly like it.

Alabama and the lieutenant lingered beside the door.

"I'm going to lay a tablet to the scene of our first meeting," he said.
Taking out his knife he carved in the doorpost:
"David," the legend read, "David, David, Knight, Knight, Knight, and Miss Alabama Nobody."

"Egotist," she protested.

"I love this place," he said. "Let's sit outside awhile."

"Why? The dance only lasts until twelve."

"Can't you trust me for three minutes or so?"

"I do trust you. That's why I want to go inside." She was a little angry about the names. David had told her about how famous he was going to be many times before.

Dancing with David, he smelled like new goods. Being close to him with her face in the space between his ear and his stiff army collar was like being initiated into the subterranean reserves of a fine fabric store exuding the delicacy of cambrics and linen and luxury bound in bales. She was jealous of his pale aloofness. When she saw him leave the dance floor with other girls, the resentment she felt was not against any blending of his personality with theirs, but against his leading others than herself into those cooler detached regions which he inhabited alone.

He took her home and they sat together before the grate fire in a still suspension of externals. The flames glittered in his teeth and lit his face with transcendental qualities. His features danced before her eyes with the steady elusiveness of a celluloid target on a shooting-gallery spray. She searched her relations with her father for advice about being clever; there, she found nothing relative to human charm. Being in love, none of her personal aphorisms were of the slightest help.

Alabama had grown tall and thin in the last few years; her head was blonder for its extra distance from the earth. Her legs stretched long and thin as prehistoric drawings before her; her hands felt poignant and heavy as if David's eyes lay a weight over her wrists. She knew her face glowed in the firelight like a confectioner's brewing, an advertisement of a pretty girl drinking a strawberry sundae in June. She wondered if David knew how conceited she was.

"And so you love blond men?"

"Yes." Alabama had a way of talking under pressure as if the words she said were some unexpected encumbrance she found in her mouth and must rid herself of before she could communicate.

He verified himself in the mirror—pale hair like eighteenth-century moonlight and eyes like grottoes, the blue grotto, the green grotto,

stalactites and malachites hanging about the dark pupil—as if he had taken an inventory of himself before leaving and was pleased to find himself complete.

The back of his head was firm and mossy and the curve of his cheek a sunny spreading meadow. His hands across her shoulders fit like the warm hollows in a pillow.

"Say 'dear,' " he said.

"No."

"You love me. Why won't you?"

"I never say anything to anybody. Don't talk."

"Why won't you talk to me?"

"It spoils things. Tell me you love me."

"Oh—I love you. Do you love me?"

So much she loved the man, so close and closer she felt herself that he became distorted in her vision, like pressing her nose upon a mirror and gazing into her own eyes. She felt the lines of his neck and his chipped profile like segments of the wind blowing about her consciousness. She felt the essence of herself pulled finer and smaller like those streams of spun glass that pull and stretch till there remains but a glimmering illusion. Neither falling nor breaking, the stream spins finer. She felt herself very small and ecstatic. Alabama was in love.

She crawled into the friendly cave of his ear. The area inside was gray and ghostly classic as she stared about the deep trenches of the cerebellum. There was not a growth nor a flowery substance to break those smooth convolutions, just the puffy rise of sleek gray matter. "I've got to see the front lines," Alabama said to herself. The lumpy mounds rose wet above her head and she set out following the creases. Before long she was lost. Like a mystic maze, the folds and ridges rose in desolation; there was nothing to indicate one way from another. She stumbled on and finally reached the medulla oblongata. Vast tortuous indentations led her round and round. Hysterically, she began to run. David, distracted by a tickling sensation at the head of his spine, lifted his lips from hers.

"I'll see your father," he said, "about when we can be married."

Judge Beggs rocked himself back and forth from his toes to his heels, sifting values.

"Um—m—m—well, I suppose so, if you think you can take care of her."

"I'm sure of it, sir. There's a little money in the family—and my earning capacity. It will be enough."

David thought doubtfully to himself that there wasn't much money

—perhaps a hundred and fifty thousand between his mother and his grandmother, and he wanted to live in New York and be an artist. Perhaps his family wouldn't help. Well, anyway, they were engaged. He had to have Alabama, anyway, and money—well once he had dreamed of a troop of Confederate soldiers who wrapped their bleeding feet in Rebel banknotes to keep them off the snow. David, in his dream, had been there when they found that they did not feel sorry about using up the worthless money after they had lost the war.

Spring came and shattered its opalescent orioles in wreaths of daffodils. Kiss-me-at-the-gate clung to its angular branches and the old yards were covered with a child's version of flowers: snowdrops and *Primula veris,* pussywillow and calendula. David and Alabama kicked over the oak leaves from the stumpy roots in the woods and picked white violets. They went on Sundays to the vaudeville and sat in the back of the theater so they could hold hands unobserved. They learned to sing "My Sweetie" and "Baby" and sat in a box at *Hitchy-Koo* and gazed at each other soberly through the chorus of "How Can You Tell?" The spring rains soaked the heavens till the clouds slid open and summer flooded the South with sweat and heat waves. Alabama dressed in pink and pale linen and she and David sat together under the paddles of ceiling fans whipping the summer to consequence. Outside the wide doors of the country club they pressed their bodies against the cosmos, the gibberish of jazz, the black heat from the greens in the hollow like people making an imprint for a cast of humanity. They swam in the moonlight that varnished the land like a honey-coating and David swore and cursed the collars of his uniforms and rode all night to the rifle range rather than give up his hours after supper with Alabama. They broke the beat of the universe to measures of their own conception and mesmerized themselves with its precious thumping.

The air turned opaque over the singed grass slopes, and the sand in the bunkers flew up dry as gunpowder under a niblick. Tangles of goldenrod shredded the sun; the splendid summer lay ground into powder over the hard clay roads. Moving day came and the first day of school spiced the mornings—and one summer ended with another fall.

When David left for the port of embarkation, he wrote Alabama letters about New York. Maybe, after all, she would go to New York and marry.

"City of glittering hypotheses," wrote David ecstatically, "chaff from a fairy mill, suspended in penetrating blue! Humanity clings to the streets like flies upon a treacle stream. The tops of the buildings shine like crowns of gold-leaf kings in conference—and oh, my dear, you are my

princess and I'd like to keep you shut forever in an ivory tower for my private delectation."

The third time he wrote that about the princess, Alabama asked him not to mention the tower again.

She thought of David Knight at night and went to the vaudeville with the dog-faced aviation officer till the war was over. It ended one night with the flash of a message across the vaudeville curtain. There had been a war, but now there were two more acts of the show.

David was sent back to Alabama for demobilization. He told Alabama about the girl in the Hotel Astor the night he had been so drunk.

"Oh, God!" she said to herself. "Well, I can't help it." She thought of the dead mechanic, of Felix, of the faithful dog-lieutenant. She hadn't been too good herself.

She said to David that it didn't matter: that she believed that one person should only be faithful to another when they felt it. She said it was probably her fault for not making him care more.

As soon as David could make the arrangements, he sent for her. The Judge gave her the trip north for a wedding present; she quarreled with her mother about her wedding clothes.

"I don't want it that way. I want it to drop off the shoulders."

"Alabama, it's as near as I can get it. How can it stay up with nothing to hold it?"

"Aw, Mamma, you can fix it."

Millie laughed, a pleased sad laugh, and indulgent.

"My children think I can accomplish the impossible," she said, complacently.

Alabama left her mother a note in her bureau drawer the day she went away:

My dearest Mamma:
 I have not been as you would have wanted me but I love you with all my heart and I will think of you every day. I hate leaving you alone with all your children gone. Don't forget me.

 Alabama

The Judge put her on the train.

"Good-bye, daughter."

He seemed very handsome and abstract to Alabama. She was afraid to cry; her father was so proud. Joan had been afraid, too, to cry.

"Good-bye, Daddy."

"Good-bye, Baby."

The train pulled Alabama out of the shadow-drenched land of her youth.

The Judge and Millie sat on the familiar porch alone. Millie picked nervously at a palmetto fan; the Judge spat occasionally through the vines.

"Don't you think we'd better get a smaller house?"

"Millie, I've lived here eighteen years and I'm not going to change my habits of life at my age."

"There are no screens in this house and the pipes freeze every winter. It's so far from your office, Austin."

"It suits me, and I'm going to stay."

The old empty swing creaked faintly in the breeze that springs up from the gulf every night. Children's voices floated past from the street corner where they played some vindictive trick on time under the arc light. The Judge and Millie silently rocked the paintless porch chairs. Uncrossing his feet from the banisters, Austin rose to close the shutters for the night. It was his house at last.

"Well," he said, "this night next year you'll probably be a widow."

"Pshaw!" said Millie. "You've been saying that for thirty years."

The sweet pastels of Millie's face faded in distress. The lines between her nose and mouth drooped like the cords of a flag at half-mast.

"Your mother was just the same," she said, reproachfully, "always saying she was going to die and she lived to be ninety-two."

"Well, she did die, didn't she, at last?" the Judge chuckled.

He turned out the lights in his pleasant house and they went upstairs, two old people alone. The moon waddled about the tin roof and bounced awkwardly over Millie's windowsill. The Judge lay reading Hegel for half an hour or so and fell asleep. His deeply balanced snoring through the long night reassured Millie that this was not the end of life although Alabama's room was dark and Joan was gone and the board for Dixie's transom was long thrown away with the trash and her only boy lay in the cemetery in a little grave beside the common grave of Ethelinda and Mason Cuthbert Beggs. Millie didn't think anything much about personal things. She just lived from day to day; and Austin didn't think anything at all about them because he lived from one century to another.

It was awful, though, for the family to lose Alabama, because she was the last to go and that meant their lives would be different with her away. . . .

Alabama lay thinking in room number twenty-one-o-nine of the Biltmore Hotel that her life would be different with her parents so far away.

David David Knight Knight Knight, for instance, couldn't possibly make her put out her light till she got good and ready. No power on earth could make her do anything, she thought frightened, any more, except herself.

David was thinking that he didn't mind the light, that Alabama was his bride and that he had just bought her that detective story with the last actual cash they had in the world, though she didn't know it. It was a good detective story about money and Monte Carlo and love. Alabama looked very lovely herself as she lay there reading, he thought.

2

◇

◦ I ◦

It was the biggest bed that both of them together could imagine. It was broader than it was long, and included all the exaggerated qualities of their combined disrespect for tradition in beds. There were shining black knobs and white enamel swoops like cradle rockers, and specially made covers trailing in disarray off one side onto the floor. David rolled over on his side; Alabama slid downhill into the warm spot over the mass of the Sunday paper.

"Can't you make a little more room?"

"Jesus Chr—Oh Jesus," groaned David.

"What's the matter?"

"It says in the paper we're famous," he blinked owlishly.

Alabama straightened up.

"How nice—let's see——"

David impatiently rustled the Brooklyn real estate and Wall Street quotations.

"Nice!" he said—he was almost crying—"nice! But it says we're in a sanitarium for wickedness. What'll our parents think when they see that, I'd like to know?"

Alabama ran her fingers through her permanent wave.

"Well," she began tentatively. "They've thought we ought to be there for months."

"——But we haven't been."

"We aren't now." Turning in alarm she flung her arms about David. "Are we?"

"I don't know—are we?"

They laughed.

"Look in the paper and see."

"Aren't we silly?" they said.

"Awfully silly. Isn't it fun—well, I'm glad we're famous anyway."

45

With three running steps along the bed Alabama bounced to the floor. Outside the window gray roads pulled the Connecticut horizons from before and behind to a momentous crossing. A stone minuteman kept the peace of the indolent fields. A driveway crawled from under the feathery chestnuts. Ironweed wilted in the heat; a film of purple asters matted over their stalks. Tar melted in the sun along the loping roads. The house had been there forever, chuckling to itself in the goldenrod stubble.

New England summer is an Episcopal service. The land basks virtuously in a green and homespun stretch; summer hurls its thesis and bursts against our dignity explosively as the back of a Japanese kimono.

Dancing happily about, she put on her clothes, feeling very graceful and thinking of ways to spend money.

"What else does it say?"

"It says we're wonderful."

"So you see——" she began.

"No, I don't see, but I suppose everything will be all right."

"Neither do I—David, it must be your frescoes."

"Naturally, it couldn't be us, megalomaniac."

Playing about the room in the Lalique ten o'clock sun, they were like two uncombed Sealyhams.

"Oh," wailed Alabama from the depths of the closet. "David, just look at that suitcase, and it's the one you gave me for Easter."

Exhibiting the gray pigskin she exposed the broad watery yellow ring disfiguring the satin lining. Alabama stared at her husband lugubriously.

"A lady in our position can't go to town with a thing like that," she said.

"You've got to see the doctor—what happened to it?"

"I lent it to Joan the day she came to bawl me out to carry the baby's diapers in."

David laughed conservatively.

"Was she very unpleasant?"

"She said we ought to save our money."

"Why didn't you tell her we'd spent it?"

"I did. She seemed to feel that that was wrong so I told her we were going to get some more almost immediately."

"What'd she say to that?" asked David confidently.

"She was suspicious; she said we were against the rules."

"Families always think the idea is for nothing to happen to people."

"We won't call her up again—I'll see you at five, David, in the Plaza lobby—I'm gonna miss my train."

"All right. Good-bye, darling."

David held her seriously in his arms. "If anybody tries to steal you on the train tell them you belong to me."

"If you'll promise me you won't get run over——"

"Good—by—e!"

"Don't we adore each other?"

Vincent Youmans wrote the music for those twilights just after the war. They were wonderful. They hung above the city like an indigo wash, forming themselves from asphalt dust and sooty shadows under the cornices and limp gusts of air exhaled from closing windows. They lay above the streets like a white fog off a swamp. Through the gloom, the whole world went to tea. Girls in short amorphous capes and long flowing skirts and hats like straw bathtubs waited for taxis in front of the Plaza Grill; girls in long satin coats and colored shoes and hats like straw manhole covers tapped the tune of a cataract on the dance floors of the Lorraine and the St. Regis. Under the somber ironic parrots of the Biltmore a halo of golden bobs disintegrated into black lace and shoulder bouquets between the pale hours of tea and dinner that sealed the princely windows; the clank of lank contemporaneous silhouettes drowned the clatter of teacups at the Ritz.

People waiting for other people twisted the tips of the palms into brown mustache ends and ripped short slits about their lower leaves. It was just a lot of youngness: Lillian Lorraine would be drunk as the cosmos on top of the New Amsterdam by midnight, and football teams breaking training would scare the waiters with drunkenness in the fall. The world was full of parents taking care of people. Debutantes said to each other, "Isn't that the Knights?" and "I met him at a prom. My dear, please introduce me."

"What's the use? They're c—r—a—z—y about each other," smelted into the fashionable monotone of New York.

"Of course it's the Knights," said a lot of girls. "Have you seen his pictures?"

"I'd rather look at him any day," answered other girls.

Serious people took them seriously; David made speeches about visual rhythm and the effect of nebular physics on the relation of the primary colors. Outside the windows, fervently impassive to its own significance, the city huddled in a gold-crowned conference. The top of New York twinkled like a golden canopy behind a throne. David and Alabama faced each other incompetently—you couldn't argue about having a baby.

"So what did the doctor say?" he insisted.

"I told you—he said 'Hello!' "

"Don't be an ass—what else did he say?—We've got to know what he said."

"So then we'll have the baby," announced Alabama, proprietarily.

David fumbled about his pockets. "I'm sorry—I must have left them at home." He was thinking that then they'd be three.

"What?"

"The bromides."

"I said 'Baby.' "

"Oh."

"We should ask somebody."

"Who'll we ask?"

Almost everybody had theories: that the Longacre Pharmacies carried the best gin in town; that anchovies sobered you up; that you could tell wood alcohol by the smell. Everybody knew where to find the blank verse in Cabell and how to get seats for the Yale game, that Mr. Fish inhabited the aquarium, and that there were others besides the sergeant ensconced in the Central Park Police Station—but nobody knew how to have a baby.

"I think you'd better ask your mother," said David.

"Oh, David—don't! She'd think I wouldn't know how."

"Well," he said tentatively, "I could ask my dealer—he knows where the subways go."

The city fluctuated in muffled roars like the dim applause rising to an actor on the stage of a vast theater. *Two Little Girls in Blue* and *Sally* from the New Amsterdam pumped in their eardrums and unwieldy quickened rhythms invited them to be Negroes and saxophone players, to come back to Maryland and Louisiana, addressed them as mammies and millionaires. The shopgirls were looking like Marilyn Miller. College boys said Marilyn Miller where they had said Rosie Quinn. Moving-picture actresses were famous. Paul Whiteman played the significance of amusement on his violin. They were having the breadline at the Ritz that year. Everybody was there. People met people they knew in hotel lobbies smelling of orchids and plush and detective stories, and asked each other where they'd been since last time. Charlie Chaplin wore a yellow polo coat. People were tired of the proletariat—everybody was famous. All the other people who weren't well known had been killed in the war; there wasn't much interest in private lives.

"There they are, the Knights, dancing together," they said, "isn't it nice? There they go."

"Listen, Alabama, you're not keeping time," David was saying.

"David, for God's sake will you try to keep off of my feet?"

"I never could waltz anyway."

There were a hundred thousand things to be blue about exposed in all the choruses.

"I'll have to do lots of work," said David. "Won't it seem queer to be the center of the world for somebody else?"

"Very. I'm glad my parents are coming before I begin to get sick."

"How do you know you'll get sick?"

"I should."

"That's no reason."

"No."

"Let's go someplace else."

Paul Whiteman played "Two Little Girls in Blue" at the Palais Royal; it was a big expensive number. Girls with piquant profiles were mistaken for Gloria Swanson. New York was more full of reflections than of itself—the only concrete things in town were the abstractions. Everybody wanted to pay the cabaret checks.

"We're having some people," everybody said to everybody else, "and we want you to join us," and they said, "We'll telephone."

All over New York people telephoned. They telephoned from one hotel to another to people on other parties that they couldn't get there —that they were engaged. It was always teatime or late at night.

David and Alabama invited their friends to throw oranges into the drum at the Plantation and themselves into the fountain at Union Square. Up they went, humming the New Testament and Our Country's Constitution, riding the tide like triumphant islanders on a surfboard. Nobody knew the words to "The Star-Spangled Banner."

In the city, old women with faces as soft and ill lit as the side streets of Central Europe offered their pansies; hats floated off the Fifth Avenue bus; the clouds sent out a prospectus over Central Park. The streets of New York smelled acrid and sweet like drippings from the mechanics of a metallic night-blooming garden. The intermittent odors, the people and the excitement, suctioned spasmodically up the side streets from the thoroughfares, rose in gusts on the beat of their personal tempo.

Possessing a rapacious, engulfing ego their particular genius swallowed their world in its swift undertow and washed its cadavers out to sea. New York is a good place to be on the upgrade.

The clerk in the Manhattan thought they weren't married but he gave them the room anyway.

"What's the matter?" David said from the twin bed under the cathedral print. "Can't you make it?"

"Sure. What time is the train?"

"Now. I've got just two dollars to meet your family," said David searching his clothes.

"I wanted to buy them some flowers."

"Alabama," said David sententiously, "that's impractical. You've become nothing but an aesthetic theory—a chemistry formula for the decorative."

"There's nothing we can do with two dollars anyway," she protested in a logical tone.

"I s'pose not——"

Attenuated odors from the hotel florist tapped the shell of the velvet vacuum like silver hammers.

"Of course, if we have to pay the taxi——"

"Daddy'll have some money."

Puffs of white smoke aspired against the station skylight. Lights like unripe citrus fruits hung in the gray day from the steel rafters. Swarms and swarms of people passed each other coming up the stairway. The train clicked up with the noise of many keys turning in many rusty locks.

"If I'd only known it would be like that at Atlantic City," they said —or, "Could you believe it, we're half hour late?"—or, "The town hasn't changed much without us," they said, rustling their packages and realizing their hats were all wrong for wear in the city.

"There's Mamma!" cried Alabama.

"Well, how do ye do——"

"Isn't it a great city, Judge?"

"I haven't been here since 1882. There's been considerable change since then," said the Judge.

"Did you have a nice trip?"

"Where is your sister, Alabama?"

"She couldn't come down."

"She couldn't come down," corroborated David lamely.

"You see," went on Alabama at her mother's look of surprise, "the last time Joan came she borrowed my best suitcase to carry away wet diapers and since then we've—well, we haven't seen her so much."

"Why shouldn't she?" the Judge demanded sternly.

"It was my best suitcase," explained Alabama patiently.

"But the poor little baby," sighed Miss Millie. "I suppose we can telephone them."

"You will feel differently about things like that after you have children of your own," said the Judge.

Alabama wondered suspiciously if her figure showed.

"But I can see how she felt about the suitcase," continued Millie magnanimously. "Even as a baby, Alabama was particular like that about her own things—never wanted to share them, even then."

The taxi steamed up the vaporous chute of the station runway.

Alabama didn't know how to go about asking the Judge to pay the taxi—she hadn't been absolutely sure of how to go about anything since her marriage had precluded the Judge's resented direction. She didn't know what to say when girls postured in front of David hoping to have him sketch them on his shirtfront, or what to do when David raved and ranted and swore that it ruined his talent to have his buttons torn off in the laundry.

"If you children will get these suitcases into the train, I'll pay the taxi," said the Judge.

The green hills of Connecticut preached a sedative sermon after the rocking of the gritty train. The gaunt, disciplined smells of New England lawn, the scent of invisible truck gardens bound the air in tight bouquets. Apologetic trees swept the porch, insects creaked in the baking meadows widowed of their crops. There didn't seem room in the cultivated landscape for the unexpected. If you wanted to hang anybody, reflected Alabama, you'd have to do it in your own backyard. Butterflies opened and shut along the roads like the flash of white in a camera lens. "You couldn't be a butterfly," they said. They were silly butterflies, flying about that way and arguing with people about their potentialities.

"We meant to get the grass cut," began Alabama—"but——"

"It's much better this way," finished David. "It's more picturesque."

"Well, I like the weeds," the Judge said amiably.

"They make it smell so sweet in the country," Miss Millie added. "But aren't you lonely out here at night?"

"Oh, David's friends from college come out occasionally and sometimes we go into town."

Alabama didn't add how often they went in to New York to waste the extra afternoons sloshing orange juice through bachelor sanctuaries, droning the words to summer behind insoluble locks. They went there ahead, awaiting the passage of that progressive celebration that a few years later followed the boom about New York like the Salvation Army follows Christmas, to absolve themselves in the waters of each other's unrest.

"Mister," Tanka greeted them from the steps, "and Missy."

Tanka was the Japanese butler. They couldn't have afforded him without borrowing from David's dealer. He cost money; that was be-

cause he constructed botanical gardens out of cucumbers and floral displays with the butter and made up the money for his flute lessons from the grocery bills. They had tried to do without him till Alabama cut her hand on a can of baked beans and David sprained his painting wrist on the lawn mower.

The Oriental swept the floor in an inclusive rotation of his body, indicating himself as the axis of the earth. Bursting suddenly into a roar of disquieting laughter, he turned to Alabama.

"Missy, kin see you jessy minute—jessy minute, this way, please."

"He's going to ask for change," thought Alabama, uneasily following him to the side porch.

"Look!" said Tanka. With a gesture of negation, he indicated the hammock swung between the columns of the house where two young men lay uproariously asleep with a bottle of gin by their sides.

"Well," she said hesitantly, "you'd better tell Mister—but not in front of the family, Tanka."

"Velly careful," nodded the Jap, making a shushing sound and barring his lips with his fingers.

"Listen, Mamma, I think you'd better come upstairs and rest before dinner," suggested Alabama. "You must be tired after your trip."

From the sense that she had nothing whatever to do with herself which radiated from the girl as she descended from her parents' room, David knew that something was wrong.

"What's the matter?"

"Matter! There are drunks in the hammock. If Daddy sees *that* there'll be hell to pay!"

"Send them away."

"They can't move."

"My God! Tanka'll just have to see that they stay outside until after dinner."

"Do you think the Judge would understand?"

"I'm afraid so——"

Alabama stared about disconsolately.

"Well—I suppose there comes a moment when people must choose between their contemporaries and their families."

"Are they in very bad shape?"

"Pretty hopeless. If we send for the ambulance, it would just make a scene," she said tentatively.

The moiré sheen of the afternoon polished the sterility of the rooms' colonial picturesqueness and scratched itself on the yellow flowers that

trailed the mantel like featherstitching. It was a priestly light curving in the dips and hollows of a melancholic waltz.

"I don't see what we can do about it," they agreed.

Alabama and David stood there anxiously in the quiet till the clang of a spoon on a tin waiter summoned them to dinner.

"I'm glad to see," said Austin over the beets like roses, "that you have succeeded in taming Alabama a little. She seems to have become a very good housekeeper since her marriage." The Judge was impressed with the beets.

David thought of his buttons upstairs. They were all off.

"Yes," he said vaguely.

"David has been working very well out here," Alabama broke in nervously.

She was about to paint a picture of their domestic perfections when a loud groan from the hammock warned her. Staggering through the dining room door with a visionary air, the young man eyed the gathering. On the whole he was all there; just a little awry—his shirttail was out.

"Good evening," he said formally.

"I think your friend had better have some dinner," suggested the baffled Austin.

The friend exploded in foolish laughter.

Miss Millie confusedly inspected Tanka's flowery architecture. Of course, she *wanted* Alabama to have friends. She had always brought up her children with that in mind, but circumstances were, at times, dubious.

A second disheveled phantom groped through the door; the silence was broken only by squeaky grunts of suppressed hysteria.

"He does that way because he's been operated on," said David hastily. The Judge bristled.

"They took out his larynx," David added in alarm. His eyes wildly sought the protoplasmic face. Luckily, the fellows seemed to be listening to what he was saying.

"One's mute," Alabama explained with inspiration.

"Well, I'm glad of that," answered the Judge enigmatically. His tone was not without hostility. He seemed chiefly relieved that any further conversation was precluded.

"I can't speak a word," burst from the ghost unexpectedly. "I'm mute."

"Well," thought Alabama, "this is the end. *Now* what can we say?"

Miss Millie was saying that salt air spoiled the table silver. The Judge faced his daughter implacable and reproving. The necessity for saying anything was dispelled by a weird and self-explanatory carmagnole about the table. It was not exactly a dance; it was an interpretive protest against the vertebrate state punctuated by glorious ecstatic paeans of rhythmic backslappings and loud invitations to the Knights to join the party. The Judge and Miss Millie were generously included in the invitation.

"It's like a frieze, a Greek frieze," commented Miss Millie distractedly.

"It's not very edifying," supplemented the Judge.

Exhausted, the two men wobbled unsteadily to the floor.

"If David could lend us twenty dollars," gasped the mass, "we were just going on to the roadhouse. Of course, if he can't we'll stay a little longer, maybe."

"Oh," said David, spellbound.

"Mamma," said Alabama, "can't you let us have twenty dollars till we can get to the bank tomorrow?"

"Certainly, my dear—upstairs in my bureau drawer. It's a pity your friends have to leave; they seem to be having such a good time," she continued vaguely.

The house settled. The cool chirp of the crickets like the crunching of fresh lettuce purged the living room of dissonance. Frogs wheezed in the meadow where the goldenrod would bloom. The family group yielded itself to the straining of the night lullaby through the boughs of the oak.

"Escaped," sighed Alabama as they snuggled together in the exotic bed.

"Yes," said David, "it's all right."

There were people in automobiles all along the Boston Post Road thinking everything was going to be all right while they got drunk and ran into fireplugs and trucks and old stone walls. Policemen were too busy thinking everything was going to be all right to arrest them.

It was three o'clock in the morning when the Knights were awakened by a stentorian whispering on the lawn.

An hour passed after David dressed and went down. The noise rose in increasingly uproarious muffles.

"Well, then, I'll take a drink with you if you'll try to make a little less noise," Alabama heard David say as she meticulously put on her clothes. Something was sure to happen; it was better to be looking your best when the authorities arrived. They must be in the kitchen. She stuck her head truculently through the swinging door.

"Now, Alabama," David greeted her, "I would advise you to keep your nose out of this." In a husky melodramatic aside he continued confidentially, "This is the most expedient way I could think of——"

Alabama stared, infuriated over the carnage of the kitchen.

"Oh, shut up!" she yelled.

"Now listen, Alabama," began David.

"It was you who said all the time that we should be so respectable and now look at you!" she accused.

"He's all right. David's perfectly all right," the prostrate men muttered feebly.

"And what if my father comes down now? What'll _he_ have to say about this being all right?" Alabama indicated the wreckage. "What are all those old cans?" she demanded contemptuously.

"Tomato juice. It sobers you up. I've just been giving some to the guests," explained David. "First I give them tomato juice and then I give them gin."

Alabama snatched at the bottle in David's hand. "Give me that bottle." As he fended her off, she slid against the door. To save the noise of a crash in the hall, she precipitated her body heavily into the jamb. The swinging door caught her full in the face. Her nose bled jubilantly as a newly discovered oil well down the front of her dress.

"I'll see if there's a beefsteak in the icebox," proffered David. "Stick it under the sink, Alabama. How long can you hold your breath?"

By the time the kitchen was in some kind of order, the Connecticut dawn drenched the countryside like a firehose. The two men staggered off to sleep at the inn. Alabama and David surveyed her black eyes disconsolately.

"They'll think I did it," he said.

"Of course—it won't make any difference what I say."

"When they see us together you'd think they'd believe."

"People always believe the best story."

The Judge and Miss Millie were down early to breakfast. They waited amidst the soggy mountains of damp bloated cigarette butts while Tanka burnt the bacon in his expectation of trouble. There was hardly a place to sit without sticking to dried rings of gin and orange juice.

Alabama's head felt as if somebody had been making popcorn in her cranium. She tried to conceal her bruised eyes with heavy coatings of face powder. Her face felt peeled under the mask.

"Good morning," she said brightly.

The Judge blinked ferociously.

"Alabama," he said, "about that telephone call to Joan—your mother

and I felt that we'd better make it today. She will be needing help with the baby."

"Yes, sir."

Alabama had known this would be their attitude, but she couldn't prevent a cataclysmic chute of her insides. She had known that no individual can force other people forever to sustain their own versions of that individual's character—that sooner or later they will stumble across the person's own conception of themselves.

"Well!" she said defiantly to herself, "families have no right to hold you accountable for what they inculcate before you attain the age of protestation!"

"And since," the Judge continued, "you and your sister do not seem to be on the best of terms, we thought we would join her alone tomorrow morning."

Alabama sat silently inspecting the debris of the night.

"I suppose Joan will stuff them with moralities and tales about how hard it is to get along," she said to herself bitterly, "and neatly polish us off in contrast to herself. We're sure to come out of this picture black demons, any way you look at it."

"Understand," the Judge was saying, "that I am not passing a moral judgment on your personal conduct. You are a grown woman and that is your own affair."

"I understand," she said. "You just disapprove, so you're not going to stand it. If I don't accept your way of thinking, you'll leave me to myself. Well, I suppose I have no right to ask you to stay."

"People who do not subscribe," answered the Judge, "have no rights."

The train that carried the Judge and Miss Millie to the city was lumbered with milk cans and the pleasant paraphernalia of summer in transit. Their attitude was one of reluctant disavowal as they said goodbye. They were going south in a few days. They couldn't come back to the country again. David would be away seeing to his frescoes, and they thought Alabama would be better off at home during his absence. They were glad of David's success and popularity.

"Don't be so desolate," said David. "We'll see them again."

"But it will never be the same," wailed Alabama. "Our rôle will always be discounting the character they think we are from now on."

"Hasn't it always been?"

"Yes—but David, it's very difficult to be two simple people at once, one who wants to have a law to itself and the other who wants to keep all the nice old things and be loved and safe and protected."

"So," he said, "I believe many people have found out before. I suppose all we can really share with people is a taste for the same kinds of weather."

Vincent Youmans wrote a new tune. The old tunes floated through the hospital windows from the hurdy-gurdies while the baby was being born and the new tunes went the luxurious rounds of lobbies and grills, palm gardens and roofs.

Miss Millie sent Alabama a box of baby things and a list of what must be done for bathing infants to pin on the bathroom door. When her mother got the telegram about Bonnie's birth, she wired Alabama, "My blue-eyed baby has grown up. We are so proud." It came through Western Union "glue-eyed." Her mother's letters asked her simply to behave; they implied that Alabama and David were wanton to a certain extent. As Alabama read them over she could hear the slow springs creaking in on the rusty croaking of the frogs in the cypress swamps at home.

The New York rivers dangled lights along the banks like lanterns on a wire; the Long Island marshes stretched the twilight to a blue Campagna. Glimmering buildings hazed the sky in a luminous patchwork quilt. Bits of philosophy, odds and ends of acumen, the ragged ends of vision suicided in the sentimental dusk. The marshes lay black and flat and red and full of crime about their borders. Yes, Vincent Youmans wrote the music. Through the labyrinthine sentimentalities of jazz, they shook their heads from side to side and nodded across town at each other, streamlined bodies riding the prow of the country like metal figures on a fast-moving radiator cap.

Alabama and David were proud of themselves and the baby, consciously affecting a vague bouffant casualness about the fifty thousand dollars they spent on two years' worth of polish for life's baroque façade. In reality, there is no materialist like the artist, asking back from life the double and the wastage and the cost on what he puts out in emotional usury.

People were banking in gods those years.

"Good morning," the bank clerks said in the marble foyers, "did you want to draw on your Pallas Athene?" and "Shall I credit the Diana to your wife's account?"

It costs more to ride on the tops of taxis than on the inside; Joseph Urban skies are expensive when they're real. Sunshine comes high to darn the thoroughfares with silver needles—a thread of glamour, a Rolls-Royce thread, a thread of O. Henry. Tired moons ask higher wages. Lustily splashing their dreams in the dark pool of gratification,

their fifty thousand dollars bought a cardboard baby nurse for Bonnie, a secondhand Marmon, a Picasso etching, a white satin dress to house a beaded parrot, a yellow chiffon dress to snare a field of ragged robins, a dress as green as fresh wet paint, two white knickerbocker suits exactly alike, a broker's suit, an English suit like the burnt fields of August, and two first-class tickets for Europe.

In the packing case a collection of plush teddy bears, David's army overcoat, their wedding silver, and four bulging scrapbooks full of all the things people envied them for were ready to be left behind.

"Good-bye," they had said on steel station stairways. "Someday you must try our home brew," or "The same band will play at Baden-Baden for the summer, perhaps we'll see you there," they said, or "Don't forget what I told you and you'll find the key in the same old place."

"Oh," groaned David from the depths of the bed's sagacious enamel billows, "I'm glad we're leaving."

Alabama inspected herself in the hand mirror.

"One more party," she answered, "and I'd have to see Viollet-le-Duc about my face."

David inspected her minutely.

"What's the matter with your face?"

"Nothing, only I've been picking at it so much I can't go to the tea."

"Well," said David blankly, "we've got to go to the tea—it's because of your face that they're having it."

"If there'd been anything else to do, I wouldn't have done the damage."

"Anyway, you're coming, Alabama. How would it look for people to say, 'And how is your charming wife, Mr. Knight?' 'My wife, oh, she's at home picking at her face.' How do you think I'd feel about that?"

"I could say it was the gin or the climate or something."

Alabama stared woefully at her reflection. The Knights hadn't changed much externally—the girl still looked all day long as if she'd just got up; the man's face was still as full of unexpected lilts and jolts as riding the amusements on the Million-Dollar Pier.

"I want to go," said David, "look at this weather! I can't possibly paint."

The rain spun and twisted the light of their third wedding anniversary to thin prismatic streams; alto rain, soprano rain, rain for Englishmen and farmers, rubber rain, metal rain, crystal rain. The distant philippics of spring thunder hurtled the fields in thick convolutions like heavy smoke.

"There'll be people," she demurred.

"There'll always be people," agreed David. "Don't you want to say good-bye to your beaux?" he teased.

"David! I'm much too much on their side to be very romantic to men. They've always just floated through my life in taxis full of cold smoke and metaphysics."

"We won't discuss it," said David peremptorily.

"Discuss what?" Alabama asked idly.

"The somewhat violent compromises of certain American women with convention."

"Horrors! Please let's not. Do you mean to say that you're jealous of me?" she asked incredulously.

"Of course. Aren't you?"

"Terribly. But I thought we weren't supposed to be."

"Then we're even."

They looked at each other compassionately. It was funny, compassion under their untidy heads.

The muddy afternoon sky disgorged a white moon for teatime. It lay wedged in a split in the clouds like the wheel of a gun carriage in a rutted, deserted field of battle, slender, and tender and new after the storm. The brownstone apartment was swarming with people; the odor of cinnamon toast embalmed the entry.

"The master," the valet pronounced as they rang, "left word, sir, to the guests that he was escaping, that they were to make themselves at home."

"He did!" commented David. "People are always running all over the place to escape each other, having been sure to make a date for cocktails in the first bar outside the limits of convenience."

"Why did he leave so suddenly?" asked Alabama disappointed.

The valet considered gravely, Alabama and David were old clients.

"The master," he decided to trust them, "has taken one hundred and thirty hand-woven handkerchiefs, the *Encyclopaedia Britannica,* two dozen tubes of Frances Fox ointment and sailed. Don't you find, sir, the luggage a bit extraordinary?"

"He might have said good-bye," pursued Alabama petulantly. "Since he knew we were going and he wouldn't see us for ages."

"Oh, but he did leave word, Madam. 'Good-bye,' he said."

Everybody said that they wished they could get away themselves. They all said they would be perfectly happy if they didn't have to live the way they lived. Philosophers and expelled college boys, movie directors and prophets predicting the end said people were restless because the war was over.

The tea party told them that nobody stayed on the Riviera in summer—that the baby would take cholera if they carried her into the heat. Their friends expected they'd be bitten to death by French mosquitoes and find nothing to eat but goat. They told them they'd find no sewage on the Mediterranean in summer and remembered the impossibility of ice in the highballs; there was some suggestion of packing a trunk with canned goods.

The moon slid mercurially along the bright mathematical lines of the ultra-modern furniture. Alabama sat in a twilit corner, reassuring herself of the things that made up her life. She had forgotten to give the Castoria to a neighbor. And Tanka could just as well have had the half-bottle of gin. If the nurse was letting Bonnie sleep at this hour at the hotel, she wouldn't sleep on the boat—first-class passengers, midnight sailing, C deck, 35 and 37; she could have telephoned her mother to say good-bye but it would only have frightened her from so far away. It was too bad about her mother.

Her eyes strayed over the rose-beige living room full of people. Alabama said to herself they were happy—she had inherited that from her mother. "We are very happy," she said to herself, as her mother would have said, "but we don't seem to care very much whether we are or not. I suppose we expected something more dramatic."

The spring moonlight chipped the pavement like an ice pick; its shy luminosity iced the corners of the buildings with glittering crescents.

It would be fun on the boat; there'd be a ball and the orchestra would play that thing that goes "um—ah—um"—you know—the one Vincent Youmans wrote with the chorus explaining why we were blue.

The air was sticky and stuffy in the ship's bar. Alabama and David sat in their evening clothes, sleek as two borzois on the high stools. The steward read the ship's news.

"There's Lady Sylvia Priestly-Parsnips. Shall I ask her to have a drink?"

Alabama stared dubiously about. There was nobody else in the bar. "All right—but they say she sleeps with her husband."

"But not in the bar. How do you do, Madam?"

Lady Sylvia flapped across the room like an opaque protoplasm propelling itself over a sandbank.

"I have been chasing you two over the entire boat," she said. "We have word that the ship is about to sink, so they are giving the ball tonight. I want you for my dinner party."

"You do not owe us a party, Lady Parsnips, and we are not the sort

of people who pay steerage rates and ride in the honeymoon suite. So
what is it?"

"I am quite altruistic," she expostulated. "I've got to have *somebody*
for the party, though I hear you two are quite mad about each other.
Here's my husband."

Her husband thought of himself as an intellectual; his real talent was
piano playing.

"I've been wanting to meet you. Sylvia here—that's my wife—tells
me you are an old-fashioned couple."

"A Typhoid Mary of time-worn ideals," supplied Alabama, "but I
consider it only fair to tell you we are not paying any wine checks."

"Oh, we didn't expect you to. None of my friends pay for us any
more—I can't trust them at all since the war."

"It seems there's going to be a storm," said David.

Lady Sylvia belched. "The trouble with emergencies is," she said,
"that I always put on my finest underwear and then nothing happens."

"I find the easiest way to provoke the unexpected is by deciding to
sleep in pore cream." Alabama crossed her legs to above the tabletop
in a triangular checkmark.

"My place in the sun of incalculability could be had with five Octagon
soap wrappers," said David emphatically.

"There are my friends," interrupted Lady Sylvia. "These Englishmen
were sent to New York to save them from decadence and the American
gentleman is seeking refinements in England."

"So we pool our resources and think we'll be able to live out the
trip." They were a handsome quartet intent on portraying the romantic
ends they anticipated.

"And Mrs. Gayle's joining us, aren't you, dear?"

Mrs. Gayle blinked her round eyes with conviction.

"I'd just love to, but parties nauseate my husband, Lady Sylvia. He
really can't stand them."

"That's all right, my dear, so do they me," said Lady Sylvia.

"No more than the rest of us."

"But more actively," her ladyship insisted. "I've given parties in one
room after another of my house till finally I had to leave because of the
broken fixtures, there being no place left to read."

"Why didn't you have them mended?"

"I needed the money for more parties. Of course, I didn't want to
read—that was my husband. I spoil him so."

"Boxing with the guests broke Sylvia's lights," added milord, "and she
was very unpleasant about it, bringing me to America and back this way."

"You loved the rusticity once you became accustomed to it," said his wife decisively.

The dinner was one of those ship's meals with everything tasting of salty mops.

"We must all have an air of living up to something," Lady Sylvia directed, "to please the waiters."

"But I do," sang Mrs. Gayle. "I really have to. There's been so much suspicion of us about, that I've been afraid to have children for fear they'd be born with almond-shaped eyeballs or blue fingernails."

"It's one's friends," said Lady Sylvia's husband. "They rope you into dull dinners, cut you on the Riviera, devour you in Biarritz, and spread devastating rumors about your upper bicuspids over the whole of Europe."

"When I marry a woman she will have to avoid social criticism by dispensing with all natural functions," said the American.

"You must be sure you dislike her to escape her condemnation," David said.

"It's approval you need to avoid," said Alabama emphatically.

"Yes," commented Lady Sylvia, "tolerance has reached such a point that there's no such thing as privacy in relations any more."

"By privacy," said her husband, "Sylvia means something disreputable."

"Oh, it's all the same, my dear."

"Yes, I suppose it actually is."

"One is so sure to be outside the law these days."

"There's such a crowd behind the barn," Lady Sylvia sighed, "one can't find a place to show off one's defense mechanism."

"I suppose marriage is the only concept we can never fully work out of our system," said David.

"But there are reports about that you two have made a success of your marriage."

"We are going to present it to the Louvre," Alabama corroborated. "It's been accepted already by the French government."

"I thought for a long time that Lady Sylvia and I were the only ones who'd stuck together—of course, it's more difficult when you're not in the arts."

"Most people feel nowadays that marriage and life do not go together," said the American gentleman.

"But nothing does go with life," echoed the Englishman.

"If you feel," interrupted Lady Parsnips, "that we are now well

enough established in the eyes of our public, we might have some more champagne."

"Oh, yes, it's better to be well started on our dissolution before the storm begins."

"I've never seen a storm at sea. I suppose it will be a fiasco after all they've led us to expect."

"The theory is not to drown, I believe."

"But, my dear, my husband says you're safer on a boat than anywhere at all if you're at sea when there's a storm."

"Oh, much better off."

"Decidedly."

It began very suddenly. A billiard table crashed a pillar in the salon. The sound of splintering subdued the ship like a presage of death. A quiet, desperate organization pervaded the boat. Stewards sped through the corridors, hastily lashing the trunks to the washbasins. By midnight the ropes were broken and fixtures loosened from the walls. Water flooded the ventilators and sogged the passage and word went round that the ship had lost her radio.

The stewards and stewardesses stood in formation at the foot of the stairway. The strained faces and roving, self-conscious eyes of people whose routed confidence would lead you to believe that they are contemptuous of the forces which dissipate their superficial disciplinary strength to a more direct egotism, surprised Alabama. She'd never thought of training as being superimposed on temperaments, but as temperaments being fit to carry the burden of selfless routines.

"Everybody can share the worst things," she thought as she dashed along the soggy corridors to her cabin, "but there's almost nobody at the top. I s'pose that's why my father was always so alone." A heave threw her across from one berth to another. Her back felt as if it must be broken. "Oh, God, can't it stop rocking for a minute, before it goes down?"

Bonnie peered at her mother dubiously. "Don't be 'fraid," said the child.

Alabama was scared half to death.

"I'm not frightened, dear," she said. "Bonnie, if you move from the berth you will be killed, so lie there and hold on to the sides while I look for Daddy."

Rocking and whipping with the ship, she clung to the rails. The faces of the personnel stared at her blankly as she passed, as if she had lost her mind.

"Why don't they signal for the lifeboats?" Alabama shrieked hysterically in the calm face of the radio officer.

"Go back to your cabin," he said. "No boat could be launched in a sea like this."

She found David in the bar with Lord Priestly-Parsnips. The tables were massed one on top of the other; heavy chairs were bolted to the floor and bound with ropes. They were drinking champagne, sloshing it over the place like tilted slop pails.

"It's the worst I've seen since I came back from Algiers. Then I literally walked on my cabin walls," milord was saying placidly, "and then, too, the transport during the war was pretty bad. I thought we should certainly lose her for ages."

Alabama crawled across the bar, lunging from one post to another. "David, you've got to come down to the cabin."

"But, dearest," he protested—he was fairly sober, more so than the Englishman, anyway—"what on earth can *I* do?"

"I thought we'd better all go down together——"

"Rot!"

Launching herself along the room, she heard the Britisher's voice trailing after her, "Isn't it funny how danger makes people passionate? During the war——"

Frightened, she felt very second rate. The cabin seemed to grow smaller and smaller as if the reiterant shocks were mashing in the sides. After a while she grew accustomed to the suffocation and the intestinal ripping. Bonnie slept quietly by her side.

There was nothing but water outside the porthole, no sky at all. The motion made her whole body itch. She thought all night that they would be dead by morning.

By morning Alabama was too sick and nervous to bear the stateroom any longer. David helped her along the rail to the bar. Lord Parsnips slept in a corner. A low conversation issued from the backs of two deep leather chairs. She ordered a baked potato and listened, wishing something would prevent the two men from talking. "I'm very antisocial," she tabulated. David said all women were. "I guess so," she thought resignedly.

One of the voices resounded with the conviction of learning. It had the tone with which doctors of mediocre intelligence expound the medical theories of more brilliant colleagues to their patients. The other spoke with the querulous ponderousness of a voice which is dominant only in the subconscious.

"It's the first time I ever started thinking about things like that—

about the people in Africa and all over the world. It made me think that men don't know as much as they think they do."

"What do you mean?"

"Well, hundreds of years ago those fellows knew nearly as much about saving life as we do. Nature certainly looks after itself. You can't kill anything that's going to live."

"Yes, you can't exterminate anything that's got a will to live. You can't kill 'em!"

The voice grew alarmingly accusative. The other voice changed the subject defensively.

"Did you go to many shows in New York?"

"Three or four, and of all the trivial indecent things! You never get a thing to take away with you. There's nothing to it," the second voice welled in accusation.

"They've got to give the public what it wants."

"I was talking to a newspaperman the other day and he said just that, and I told him just look at *The Cincinnati Enquirer*. They never carry a word of all this scandal and stuff, and it's one of the biggest papers in the country."

"It's not the public—they have to take what they get."

"Of course, I just go myself to see what's doing."

"I don't go much myself—not more than three or four times a month."

Alabama staggered to her feet. "I can't stand it!" she said. The bar smelled of olive brine and dead ashes. "Tell the man I want the potato outdoors."

Clinging to the rail, she reached the back sun parlor. A gigantic swish and suction burst over the deck. She heard the chairs go overboard. The waves closed like marble tombstones over her vision and opened again and no water showed. The boat floated precariously in the sky.

"Everything in America is like its storms," drawled the Englishman, "or would you say we were in Europe?"

"Englishmen are never frightened," she remarked.

"Don't worry about Bonnie, Alabama," said David. "She's, after all, a child. She doesn't feel things very much, yet."

"Then it would be more horrible if anything should happen to her!"

"No. If I had to choose between the saving of you two theoretically, I'd take the proven material."

"I wouldn't. I'd save her first. She may be some wonderful person."

"Maybe, but none of us are, and we know *we're* not absolutely terrible."

"Seriously, David, do you think we'll get through?"

"The purser says it's a Florida tidal wave with a ninety-mile wind—seventy's a hurricane. The ship's listing thirty-seven degrees. It won't go over till we hit forty. They think the wind may drop. Anyway, we can't do anything about it."

"No. What do you think about?"

"Nothing. I'm ashamed to confess, I've been having too many *fines*. It's made me sort of sick."

"I don't think, either. The elements are splendid—I don't really care if we sink. I've grown very savage."

"Yes, when we find we have to dispense with so much of ourselves to function, we do—to save the rest."

"Anyway, there's nobody in this boat or in any other gathering I have examined at first hand that it would matter a damn if they were lost."

"You mean geniuses?"

"No. Links in that intangible thread of evolution which we call first science, then civilization—instruments of purpose."

"As denominators to sense the past?"

"More to imagine the future."

"Like your father?"

"In a way. He's done his job."

"So have the others."

"But they don't know it. Consciousness is the goal, I feel."

"Then the direction of education should be to teach us to dramatize ourselves, to realize to the fullest extent the human equipment?"

"That's what I think."

"Well, it's hooey!"

After three days the salon opened its doors again. Bonnie clamored to see the ship's movie.

"Do you think she ought to? I believe it's full of sex appeal," Alabama said.

"Most certainly," replied Lady Sylvia. "If I had a daughter, I'd send her to every performance so she should learn something useful for when she grew up. After all, it's the parents who pay."

"I don't know what I think about things."

"Nor I—but sex appeal is in a class by itself, my dear."

"Which would you rather have, Bonnie, sex appeal or a walk in the sun on the deck?"

Bonnie was two, priestess of obscure wisdoms and reverenced of her

parents as if she were two hundred. The Knight household having exhausted the baby interest during the long months of weaning, her standing was that of a voting member.

"Bonnie walks *afterwards*," the child responded promptly.

The air felt already very un-American. The sky was less energetic. The luxuriance of Europe had blown up with the storm.

Clamp—clamp—clamp—clamp, their feet fell on the resounding deck. She and Bonnie stopped against the rail.

"A ship must be very pretty passing in the night," said Alabama.

"See the dipper?" pointed Bonnie.

"I see Time and Space wedded in painted static. I have seen it in a little glass case in a planetarium, the way it was years ago."

"Did it change?"

"No, people just saw it differently. It was something different from what they were thinking all along."

The air was salty, such beautiful air, from the ship's rail.

"It's the quantity makes it so beautiful," thought Alabama. "Immensity is the most beautiful of all things."

A shooting star, ectoplasmic arrow, sped through the nebular hypothesis like a wanton hummingbird. From Venus to Mars to Neptune it trailed the ghost of comprehension, illuminating far horizons over the pale battlefields of reality.

"It's pretty," said Bonnie.

"This will be in a case for your grandchildren's grandchildren's grandchildren."

"Child'en's child'en in a case," commented Bonnie profoundly.

"No, dear, the stars! Perhaps they will use the same case—externals seem to be all that survive."

Clamp—clamp! Clamp—clamp! round the deck they went. The night air felt so good.

"You must go to bed, my baby."

"There won't be any stars when I wake up."

"There will be others."

David and Alabama climbed together to the prow of the boat. Phosphorescent, their faces gleamed in the moonlight. They sat on a coil of rope and looked back on the netted silhouette.

"Your picture of a boat was wrong; those funnels are ladies doing a very courteous minuet," she commented.

"Maybe. The moon makes things different. I don't like it."

"Why not?"

"It spoils the darkness."

"Oh, but it's so unhallowed!" Alabama rose to her feet. Contracting her neck, she pulled herself high on her toes.

"David, I'll fly for you, if you'll love me!"

"Fly, then."

"I can't fly, but love me anyway."

"Poor wingless child!"

"Is it so hard to love me?"

"Do you think you are easy, my illusive possession?"

"I did so want to be paid, somehow, for my soul."

"Collect from the moon—you'll find the address under Brooklyn and Queens."

"David! I love you even when you are attractive."

"Which isn't very often."

"Yes, often and most impersonal."

Alabama lay in his arms feeling him older than herself. She did not move. The boat's engine chugged out a deep lullaby.

"It's been a long time since we've had a passage like this."

"Ages. Let's have one every night."

"I've composed a poem for you."

"Go on."

Why am I this way, why am I that?
Why do myself and I constantly spat?
Which is the reasonable, logical me?
Which is the one who must will it to be?

David laughed. "Am I expected to answer that?"

"No."

"We've reached the age of caution when everything, even our most personal reactions, must pass the test of our intellects."

"It's very fatiguing."

"Bernard Shaw says all people over forty are scoundrels."

"And if we do not achieve that desirable state by then?"

"Arrested development."

"We're spoiling our evening."

"Let's go in."

"Let's stay—maybe the magic will come back."

"It will. Another time."

On the way down they passed Lady Sylvia rapturously kissing a shadow behind a lifeboat.

"Was that her husband? It must have been true—that about their being in love."

"A sailor—sometimes I'd like to go to a Marseilles dance hall," said Alabama vaguely.

"What for?"

"I don't know—like eating rump steak, I suppose."

"I would be furious."

"You would be kissing Lady Sylvia behind the lifeboat."

"Never."

The orchestra blared out the flower duet from *Madame Butterfly* in the ship's salon.

> *There's David for Mignonette*
> *And somebody else for the violette,*

hummed Alabama.

"Are you artistic?" asked the Englishman.

"No."

"But you were singing."

"Because I am happy to find that I am a very self-sufficient person."

"Oh, but are you? How narcissistic!"

"Very. I am very pleased with the way I walk and talk and do almost everything. Shall I show you how nicely I can?"

"Please."

"Then treat me to a drink."

"Come along to the bar."

Alabama swung off in imitation of some walk she had once admired. "But I warn you," she said, "I am only really myself when I'm somebody else whom I have endowed with these wonderful qualities from my imagination."

"But I shan't mind that," said the Englishman, feeling vaguely that he should be expectant. Anything incomprehensible has a sexual significance to many people under thirty-five.

"And I warn you that I am a monogamist at heart if not in theory," said Alabama, sensing his difficulty.

"Why?"

"A theory that the only emotion which cannot be repeated is the thrill of variety."

"Are you wisecracking?"

"Of course. None of my theories work."

"You're as good as a book."

"I am a book. Pure fiction."

"Then who invented you?"

"The teller of the First National Bank, to pay for some mistakes he made in mathematics. You see, they would have fired him if he hadn't got the money *some* way," she invented.

"Poor man."

"If it hadn't been for him I should have had to go on being myself forever. And then I shouldn't have had all these powers to please you."

"You would have pleased me anyway."

"What makes you think so?"

"You are a solid person at heart," he said seriously.

Afraid of having compromised himself, he added hastily, "I thought your husband promised to join us."

"My husband is up enjoying the stars behind the third lifeboat on the left-hand side."

"You're kidding! You couldn't know; how could you?"

"Occult gifts."

"You are an outrageous faker."

"Obviously. And I'm very fed up with myself. Let's talk about you."

"I meant to make money in America."

"Everybody intends to."

"I had letters."

"You can put them in your book when you write it."

"I am not a writer."

"All people who have liked America write books. You will get neurosis when you have recovered from your trip, then you will have something that had so much better be left unsaid that you will try to get it published."

"I should like to write about my travels. I liked New York."

"Yes, New York is like a Bible illustration, isn't it?"

"Do you read the Bible?"

"The Book of Genesis. I love the part about God's being so pleased with everything. I like to think that God is happy."

"I don't see how he could be."

"I don't either, but I suppose *somebody* has to feel every possible way about everything that happens. Nobody else claiming that particular attribute, we have accredited it to God—at least, Genesis has."

The coast of Europe defied the Atlantic expanse; the tender slid into the friendliness of Cherbourg amidst the green and faraway bells and the clump of wooden shoes over the cobbles.

New York lay behind them. The forces that produced them lay be-

hind them. That Alabama and David would never sense the beat of any other pulse half so exactly, since we can only recognize in other environments what we have grown familiar with in our own, played no part in their expectations.

"I could cry!" said David, "I want to get the band to play on the deck. It's the most thrilling goddamned thing in the world—all the experiences of man lie there to choose from!"

"Selection," said Alabama, "is the privilege for which we suffer in life."

"It's so magnificent! It's glorious! We can have wine with our lunch!"

"Oh, Continent!" she apostrophized, "send me a dream!"

"You have one now," said David.

"But where? It will only be the place where we were younger in the end."

"That's all any place is."

"Crab!"

"Soapbox orator! I could bowl a bomb through the Bois de Boulogne!"

Passing Lady Sylvia at the douane, she called to them from a heap of fine underwear, a blue hot-water bag, a complicated electrical appliance, and twenty-four pairs of American shoes.

"You will come out with me tonight? I will show you the beautiful city of Paris to portray in your pictures."

"No," said David.

"Bonnie," counselled Alabama, "if you walk into the trucks, they'll almost certainly mash your feet, which would be neither 'chic' nor 'élégante'—France, I am told, is full of such fine distinctions."

The train bore them down through the pink carnival of Normandy, past the delicate tracery of Paris and the high terraces of Lyons, the belfries of Dijon and the white romance of Avignon into the scent of lemon, the rustle of black foilage, clouds of moths whipping the heliotrope dusk—into Provence, where people do not need to see unless they are looking for the nightingale.

◦ II ◦

The deep Greek of the Mediterranean licked its chops over the edges of our febrile civilization. Keeps crumbled on the gray hillsides and sowed the dust of their battlements beneath the olives and the cactus. Ancient moats slept bound in tangled honeysuckle; fragile poppies bled the

causeways; vineyards caught on the jagged rocks like bits of worn carpet. The baritone of tired medieval bells proclaimed disinterestedly a holiday from time. Lavender bloomed silently over the rocks. It was hard to see in the vibrancy of the sun.

"Isn't it wonderful?" said David. "It's so utterly blue, except when you examine it. Then it's gray and mauve and if you look closely, it's harsh and nearly black. Of course, on close inspection, it's literally an amethyst with opal qualities. What *is* it, Alabama?"

"I can't see for the view. Wait a minute." Alabama pressed her nose against the mossy cracks of the castle wall. "It's really Chanel, Five," she said positively, "and it feels like the back of your neck."

"Not Chanel!" David protested. "I think it's more robe de style. Get over there, I want to take your picture."

"Bonnie, too?"

"Yes. I guess we'll have to let her in."

"Look at Daddy, privileged infant."

The child wooed its mother with wide incredulous eyes.

"Alabama, can't you tilt her a little bit? Her cheeks are wider than her forehead and if you could lean her a little bit forward, she wouldn't look so much like the entrance to the Acropolis."

"Boo, Bonnie," Alabama essayed.

They both toppled over in a clump of heliotrope.

"My God! I've scratched its face. You haven't got any Mercurochrome with you, have you?"

She inspected the sooty whirlpools that formed the baby's knuckles.

"It doesn't seem to be serious, but we ought to go home and disinfect, I suppose."

"Baby home," Bonnie pronounced ponderously, pushing the words between her teeth like a cook straining a puree.

"Home, home, home," she chanted tolerantly, bobbing down the hill on David's arm.

"There it is, my dear. 'The Grand Hotel of Petronius and the Golden Isles.' See?"

"I think, David, that maybe we should have gone to the Palace and the Universe. They have more palms in their garden."

"And pass up a name like ours? Your lack of a historical sense is the biggest flaw in your intelligence, Alabama."

"I don't see why I should have to have a chronological mind to appreciate these white-powdered roads. We remind me of a troupe of troubadours, your carrying the baby like that."

"Exactly. Please don't pull Daddy's ear. Have you ever seen such heat?"

"And the flies! I don't know how people stand it."

"Maybe we'd better move further up the coast."

"These cobbles make you feel as if you had a peg leg. I'm going to get some sandals."

They followed the pavings of the French Republic past the bamboo curtains of Hyères, past strings of felt slippers and booths of women's underwear, past gutters flush with the lush wastage of the south, past the antics of exotic dummies inspiring brown Provençal faces to dream of the freedom of the Foreign Legion, past scurvy-eaten beggars and bloated clots of bougainvillea, dust and palms, a row of horse cabs, the toothpaste display of the village coiffeur exuding the smell of Chypre, and past the caserne which drew the town together like a family portrait will a vast disordered living room.

"There."

David deposited Bonnie in the damp cool of the hotel lobby on a pile of last year's *Illustrated London News*.

"Where's Nanny?"

Alabama poked her head into the bilious plush of the lace parlor.

"Madame Tussaud's is deserted. I s'pose she's out gathering material for her British comparison table so when she gets back to Paris she can say, 'Yes, but the clouds in Hyères were a touch more battleship gray when I was there with the David Knights.'"

"She'll give Bonnie a sense of tradition. I like her."

"So do I."

"Where's Nanny?" Bonnie rolled her eyes in alarm.

"Darling! She'll be back. She's out collecting you some nice opinions."

Bonnie looked incredulous.

"Buttons," she said, pointing to her dress. "I want some orange jluice."

"Oh, all right—but you'll find opinions will be much more useful when you grow up."

David rang the bell.

"Can we have a glass of orange juice?"

"Ah, Monsieur, we are completely desolated. There aren't any oranges in summer. It's the heat; we had thought of closing the hotel since one can have no oranges because of the weather. Wait a minute, I'll see."

The proprietor looked like a Rembrandt physician. He rang the bell. A valet de chambre, who also looked like a Rembrandt physician, responded.

"Are there any oranges?" the proprietor asked.

"Not even one," the man responded with gloomy emphasis.

"You see, Monsieur," the proprietor announced in a tone of relief, "there is not even one orange."

He rubbed his hands contentedly—the presence of oranges in his hotel would certainly have caused him much trouble.

"Orange jluice, orange jluice," bawled the baby.

"Where in the hell is that woman?" shrieked David.

"Mademoiselle?" the proprietor asked. "But she is in the garden, under an olive that is over one hundred years old. What a splendid tree! I must show you."

He followed them out of the door.

"Such a pretty little boy," he said. "He will speak French. I have spoke very good English before."

Bonnie's femininity was the most insistent thing about her.

"I'm sure you have," said David.

Nanny had constructed a boudoir out of the springy iron chairs. Sewing was scattered about, a book, several pairs of glasses, Bonnie's toys. A spirit lamp burned on the table. The garden was completely inhabited. On the whole, it might have been an English nursery.

"I looked on the menu, Madam, and there was goat again, so I just stopped in at the butcher's. I'm making Bonnie a little stew. This is the filthiest place, if you'll pardon me, Madam. I don't believe we shall be able to stand it."

"We think it *is* too hot," Alabama said apologetically. "Mr. Knight's going to look for a villa further up the coast if we don't find a house this afternoon."

"I'm sure we could be better pleased. I have spent some time in Cannes with the Horterer-Collins, and we found it very comfortable. Of course, in summer, *they* go to Deauville."

Alabama felt, somehow, that they, perhaps, should have gone to Deauville—some obligation on their parts to Nanny.

"I might try Cannes," David said, impressed.

The deserted dining room buzzed with the turbulent glare of midday in the tropics. A decrepit English couple teetered over the rubbery cheese and soggy fruit. The old woman leaned across and distantly rubbed one finger over Bonnie's flushed cheeks.

"So like my little granddaughter," she said patronizingly.

Nanny bristled. "Madam, you will please not to stroke the baby."

"I wasn't stroking the baby. I was only touching her."

"This heat has upset her stomach," concluded Nanny, peremptorily.

"No dinner. I won't have my dinner," Bonnie broke the long silence of the English encounter.

"I don't want mine either. It smells of starch. Let's get the real estate man now, David."

Alabama and David stumbled through the seething sun to the main square. An enchantment of lethargy overwhelmed the enclosure. The cabbies slept under whatever shade they could find, the shops were closed, no shadows broke the tenacious, vindictive glare. They found a sprawling carriage and managed to wake the driver by jumping on the step.

"Two o'clock," the man said irritably. "I am closed till two o'clock!"

"Well, go to this address anyway," David insisted. "We'll wait."

The cabby shrugged his shoulders reluctantly.

"To wait is ten francs an hour," he argued disgruntled.

"All right. We are American millionaires."

"Let's sit on the robe," said Alabama, "the cab looks full of fleas."

They folded the brown army-issue blanket under their soaking thighs.

"*Tiens!* There is the Monsieur!" The cabby pointed indolently at a handsome meridional with a patch over one eye who was engrossed in removing the handle from his shop door directly across the way.

"We want to see a villa, the 'Blue Lotus,' which I understand is for rent," David began politely.

"Impossible. For nothing in the world is it barely possible. I have not had my lunch."

"Of course, Monsieur will allow me to pay for his free time——"

"That is different," the agent beamed expansively. "Monsieur understands that since the war things are different and one must eat."

"Of course."

The rickety cab rolled along past fields of artichoke blue as spots of the hour's intensity, through long stretches of vegetation shimmering in the heat like submarine growths. A parasol pine rose here and there in the flat landscape, the road wound hot and blinding ahead to the sea. The water, chipped by the sun, spread like a floor of luminous shavings in a workshop of light.

"There she is!" the man cackled proudly.

The "Blue Lotus" parched in a treeless expanse of red clay. They opened the door and stepped into the coolness of the shuttered hall.

"This is the master's bedroom."

On the huge bed lay a pair of batik pajamas and a chartreuse pleated nightgown.

"The casualness of life in this country amazes me," Alabama said. "They obviously just spent the night and went off."

"I wish we could live like that, without premeditation."

"Let's see the plumbing."

"But, Madame, the plumbing is a perfection. You see?"

A massive carved door swung open on a Copenhagen toilet bowl with blue chrysanthemums climbing over the edge in a wild Chinese delirium. The walls were tiled with many-colored fishing scenes of Normandy. Alabama tentatively tested the brass rod designed to operate these pictorial fantasies.

"It doesn't work," she said.

The man raised his eyebrows Buddhistically.

"But! It must be because we have had no rain! Sometimes when it doesn't rain, there is no water."

"What do you do if it doesn't rain again all summer?" David asked, fascinated.

"But then, Monsieur, it is sure to rain," the agent smiled cheerfully.

"And in the meantime?"

"Monsieur is unnatural."

"Well, we've got to have something more civilized than this."

"We ought to go to Cannes," Alabama said.

"I'll take the first train when we get back."

David telephoned her from St-Raphaël.

"Just the place," he said, "for sixty dollars a month—garden, waterworks, kitchen stove, wonderful composition from the cupola—metal roofing of an aviation field, I understand—I'll be over for you tomorrow morning. We can move right in."

The day enveloped them in an armor of sunshine. They hired a limousine stuffy with reminiscences of state occasions. Paper nasturtiums fading in the cubism of a cut glass triangle obscured the view along the coast.

"Drive, drive, why can't I drive?" Bonnie screamed.

"Because the golf sticks have to go there, and, David, you can get your easel back here."

"Um—um—um," the baby droned, content with the motion. "Nice, nice, nice."

The summer ate its way into their hearts and crooned along the shaggy road. Tabulating the past, Alabama could find no real upheavals in spite of the fact that its tempo created the illusion that she lived in

madcap abandon. Feeling so wonderful, she wondered why they had ever left home.

Three o'clock in July, and Nanny gently thinking of England from hilltops and rented motorcars and under all unusual circumstances, white roads and pines—life quietly humming a lullaby. Anyway, it was fun being alive.

"Les Rossignols" was back from the sea. The smell of tobacco flowers permeated the faded blue satin of the Louis XV parlor; a wooden cuckoo protested the gloom of the oak dining room; pine needles carpeted the blue and white tiles of the balcony; petunias fawned on the balustrade. The gravel drive wound round the trunk of a giant palm sprouting geraniums in its crevices and lost itself in the perspective of a red-rose arbor. The cream calcimined walls of the villa with its painted windows stretched and yawned in the golden shower of late sun.

"There's a summerhouse," said David proprietorily, "built of bamboo. It looks as if Gauguin had put his hand to landscape gardening."

"It's heavenly. Do you suppose there really is a *rossignol?*"

"Undoubtedly—every night on toast for supper."

"Comme ça, Monsieur, comme ça," Bonnie sang exultantly.

"Look! She can speak French already."

"It's a marvelous, marvelous place, this France. Isn't it, Nanny?"

"I've lived here for twenty years, Mr. Knight, and I've never got to understand these people. Of course, I haven't had much opportunity to learn French, being always with the better class of family."

"Quite," said David emphatically. Whatever Nanny said sounded like an elaborate recipe for making fudge.

"The ones in the kitchen," said Alabama, "are a present from the house agent, I suppose."

"They are—three magnificent sisters. Perhaps the Three Fates, who knows?"

Bonnie's babbling rose to an exultant yell through the dense foliage.

"Swim! Now swim!" she cried.

"She's thrown her doll in the goldfish pool," observed Nanny excitedly. "Bad Bonnie! To treat little Goldilocks that way."

"Her name's Comme Ça," Bonnie expostulated. "Did you see her swimming?"

The doll was just visible at the bottom of the sleek green water.

"Oh, we are going to be so happy away from all the things that almost got us but couldn't quite because we were too smart for them!" David grabbed his wife about the waist and shoved her through the wide windows onto the tile floors of their new home. Alabama inspected

the painted ceiling. Pastel cupids frolicked amidst the morning glories and roses in garlands swelled like goiters or some malignant disease.

"Do you think it will be as nice at it seems?" she said skeptically.

"We are now in Paradise—as nearly as we'll ever get—there's the pictorial evidence of the fact," he said, following her eyes.

"You know, I can never think of a *rossignol* without thinking of the *Decameron.* Dixie used to hide it in her top drawer. It's funny how associations envelop our lives."

"Isn't it? People can't really jump from one thing to another, I don't suppose—there's always something carried over."

"I hope it's not our restlessness, this time."

"We'll have to have a car to get to the beach."

"Sure. But tomorrow we'll go in a taxi."

Tomorrow was already bright and hot. The sound of a Provençal gardener carrying on his passive resistance to effort woke them. The rake trailed lazily over the gravel; the maid put their breakfast on the balcony.

"Order us a cab, will you, daughter of this flowery republic?"

David was jubilant. It was unnecessary to be anything so dynamic before breakfast, commented Alabama privately with matinal cynicism.

"And so, Alabama, we have never known in our times the touch of so strong and sure a genius as we have before us in the last canvases of one David Knight! He begins work after a swim every day, and he continues until another swim at four o'clock refreshes his self-satisfaction."

"And I luxuriate in this voluptuous air and grow fat on bananas and Chablis while David Knight grows clever."

"Sure. A woman's place is with the wine," David approved emphatically. "There is art to be undone in the world."

"But you're not going to work all the time, are you?"

"I hope so."

"It's a man's world," Alabama sighed, measuring herself on a sunbeam. "This air has the most lascivious feel——"

The machinery of the Knights' existence, tended by the three women in the kitchen, moved without protest through the balmy world while the summer puffed itself slowly to pompous exposition. Flowers bloomed sticky and sweet under the salon; the stars at night caught in the net of the pine tops. The garden trees said, "Whip—poor—will," the warm black shadows said, "Whoo—oo." From the windows of "Les Rossignols" the Roman arena at Fréjus swam in the light from the moon bulging low over the land like a full wineskin.

David worked on his frescoes; Alabama was much alone.

"What'll we *do,* David," she asked, "with ourselves?"

David said she couldn't always be a child and have things provided for her to do.

A broken-down carryall transported them every day to the beach. The maid referred to the thing as *la voiture* and announced its arrival in the mornings with much ceremony during their brioche and honey. There was always a family argument about how soon it was safe to swim after a meal.

The sun played lazily behind the Byzantine silhouette of the town. Bathhouses and a dancing pavilion bleached in the white breeze. The beach stretched for miles along the blue. Nanny habitually established a British Protectorate over a generous portion of the sands.

"It's bauxite makes the hills so red," Nanny said. "And, Madam, Bonnie will need another bathing costume."

"We can get it at the Galeries des Objectives Perdues," Alabama suggested.

"Or the Occasion des Perspectives Oubliés," said David.

"Sure. Or off a passing porpoise, or out of that man's beard."

Alabama indicated a lean burned figure in duck trousers with shiny ribs like an ivory Christ and faunlike eyes beckoning an obscene fantasy.

"Good morning," the figure said formidably. "I have often seen you here."

His voice was deep and metallic and swelled with the confidence of a gentleman.

"I am the proprietor of my little place. We have eating and there is dancing in the evenings. I am glad to welcome you to St-Raphaël. There are not many people in the summer, as you see, but we make ourselves very happy. My establishment would be honored if you would accept an American cocktail after your bath."

David was surprised. He hadn't expected a welcoming committee. It was as if they had passed a club election.

"With pleasure," he said hastily. "Do we just come inside?"

"Yes, inside. Then I am Monsieur Jean to my friends! But you must surely meet the people, so charming people." He smiled contemplatively and vanished in splinters on the sparkle of the morning.

"There aren't any people," Alabama said, staring about.

"Maybe he keeps them in bottles inside. He certainly looks enough like a genie to be capable of it. We'll soon know."

Nanny's voice, ferocious in its disapproval of gin and genies, called Bonnie from over the sands.

"I said no! I said no! I said no!" The child raced to the water's edge. "I'll get her, nurse."

The David Knights precipitated themselves into the blue dye after the child.

"You ought to come out a sailor, somehow," Alabama suggested.

"But I'm being Agamemnon," protested David.

"I'm a little teeny fish," Bonnie contributed. "A lovely fish, I am!"

"All right. You can play if you want to. Oh, my! Isn't it wonderful to feel that nothing could disturb us now and life can go on as it should?"

"Perfectly, radiantly, gorgeously wonderful! But I want to be Agamemnon."

"Please be a fish with me," Bonnie inveigled. "Fishes are nicer."

"Very well. I'll be an Agamemnon fish. I can only swim with my legs, see?"

"But how can you be two things at once?"

"Because, my daughter, I am so outrageously clever that I believe I could be a whole world to myself if I didn't like living in Daddy's better."

"The salt water's pickled your brain, Alabama."

"Ha! Then I shall have to be a pickled Agamemnon fish, and that's much harder. It has to be done without the legs as well," Alabama gloated.

"Much easier, I should think, after a cocktail. Let's go in."

The room was cool and dark after the glare of the beach. A pleasantly masculine smell of dried salt water lurked in the draperies. The rising waves of heat outside gave the bar a sense of motion as if the stillness of the interior were a temporary resting place for very active breezes.

"Combs, yes we have no combs today," Alabama sang, inspecting herself in the mildewed mirror behind the bar. She felt so fresh and slick and salty! She decided the part was better on the other side of her head. In the dim obliteration of the ancient mirror she caught the outline of a broad back in the stiff white uniform of the French Aviation. Gesticulating Latin gallantries, indicating first her, then David, the glass blurred the pantomime. The head of the gold of a Christmas coin nodded urgently, broad bronze hands clutched the air in the vain hope that its tropical richness held appropriate English words to convey so Latin a meaning. The convex shoulders were slim and strong and rigid and slightly hunched in the man's effort to communicate. He produced a

small red comb from his pocket and nodded pleasantly to Alabama. As
her eyes met those of the officer, Alabama experienced the emotion of
a burglar unexpectedly presented with the combination of a difficult safe
by the master of the house. She felt as if she had been caught red-
handed in some outrageous act.

"Permettez?" said the man.

She stared.

"Permettez," he insisted. "That means, in English, 'permettez' you
see?"

The officer lapsed into voluble incomprehensible French.

"No understand," said Alabama.

"Oui understand," he repeated superiorly. "Permettez?" He bowed
and kissed her hand. A smile of tragic seriousness lit the golden face,
an apologetic smile—his face had the charm of an adolescent forced to
enact unexpectedly in public some situation long rehearsed in private.
Their gestures were exaggerated as if they were performing a role for
two other people in the distance, dim spectres of themselves.

"I am not a *germe,*" he said astonishingly.

"Oui can see—I mean, it's obvious," she said.

"Regardez!" The man ran the comb effectively through his hair to
demonstrate its functions.

"I'd love using it," Alabama looked dubiously at David.

"This, Madame," boomed Monsieur Jean, "is the Lieutenant Jacques
Chevre-Feuille of the French Aviation. He is quite harmless and these
are his friends, the Lieutenant Paulette et Madame, Lieutenant Bellan-
deau, Lieutenant Montague, who is a Corse, as you will see—and those
over there are René and Bobbie of St-Raphaël, who are very nice boys."

The grilled red lamps, the Algerian rugs precluding the daylight, the
smell of brine and incense gave Jean's Plage the sense of a secret place
—an opium den or a pirate's cave. Scimitars lined the walls; bright brass
trays set on African drumheads glowed in the dark corners; small tables
encrusted with mother-of-pearl accumulated the artificial twilight like
coatings of dust.

Jacques moved his sparse body with the tempestuous spontaneity of
a leader. Back of his flamboyant brilliance stretched his cohort; the fat
and greasy Bellandeau who shared Jacques' apartment and had matured
in the brawls of Montenegro; the Corse, a gloomy romantic, intent on
his own desperation, who flew his plane so low along the beach in the
hope of killing himself that the bathers could have touched the wings;
the tall, immaculate Paulette followed continually by the eyes of a wife
out of Marie Laurencin. René and Bobbie protruded insistently from

their white beach clothes and talked in undertones of Arthur Rimbaud. Bobbie pulled his eyebrows and his feet were flat and silent butler's feet. He was older and had been in the war and his eyes were as gray and desolate as the churned spaces about Verdun—during that summer, René painted their rainwashed shine in all the lights of that varied sea. René was the artistic son of a Provençal *avocat*. His eyes were brown and consumed by the cold fire of a Tintoretto boy. The wife of an Alsatian chocolate manufacturer furtively brooded over the cheap phonograph and pandered loudly to her daughter Raphaël, burned black to the bone of her unforgotten, southern, sentimental origin. The white tight curls of two half-Americans in the early twenties, torn between Latin curiosity and Anglo-Saxon caution, hovered through the gloom like a cherub detail from a dark corner of a Renaissance frieze.

David's pictorial sense rose in wild stimulation on the barbaric juxtapositions of the Mediterranean morning.

"So now I will buy the drinks, but they will have to be a Porto because I have no money, you see." Despite Jacques' grandiloquent attempts at English he made known his desires with whatever dramatic possibilities he found at hand for expansive gesture.

"Do you think he actually *is* a god?" Alabama whispered to David. "He looks like you—except that he is full of the sun, whereas you are a moon person."

The lieutenant stood by her side experimentally handling things that she had touched, making tentative emotional connections between their persons like an electrician installing a complicated fuse. He gesticulated volubly to David and pretended a vast impassivity to Alabama's presence, to hide the quickness of his interest.

"And so I will come to your home in my aeroplane," he said generously, "and I will be here each afternoon to swim."

"Then you must drink with us this afternoon," said David, amused, "because now we've got to get back to lunch and there isn't time for another."

The rickety taxi poured them through the splendid funnels of Provençal shade and scrambled them over the parched stretches between the vineyards. It was as if the sun had absorbed the coloring of the countryside to brew its sunset mixtures, boiling and bubbling the tones blindingly in the skies while the land lay white and devitalized awaiting the lavish mixture that would be spread to cool through the vines and stones in the late afternoon.

"Look, Madam, at the baby's arms. We shall want a sunshade certainly."

"Oh, Nanny, do let her tan! I love these beautiful brown people. They seem so free of secrets."

"But not too much, Madam. They say it spoils the skin for afterwards, you know. We must always think of the future, Madam."

"Well, I personally," said David, "am going to grill myself to a high mulatto. Alabama, do you think it would be effeminate if I shaved my legs? They'd burn quicker."

"Can I have a boat?" Bonnie's eyes roved the horizon.

"The *Aquitania,* if you like, when I've finished my next picture."

"It's too *démodé,*" Alabama joined in, "I want a nice beautiful Italian liner with gallons of the Bay of Naples in the hold."

"Reversion to type," David said, "you've gone Southern again—but if I catch you making eyes at that young Dionysus, I'll wring his neck, I warn you."

"No danger. I can't even speak intelligibly to him."

A lone fly beat its brains against the light over the unsteady lunch table; it was a convertible billiard table. The holes in the felt top stuck up in bumps through the cloth. The Graves Monopole Sec was green and tepid and unappetizing colored by blue wineglasses. There were pigeons cooked with olives for lunch. They smelled of a barnyard in the heat.

"Maybe it would be nicer to eat in the garden," suggested David.

"We should be devoured by insects," said Nanny.

"It does seem silly to be uncomfortable in this lovely country," agreed Alabama. "Things were so nice when we first came."

"Well, they get worse and more expensive all the time. Did you ever find out how much a kilo is?"

"It's two pounds, I believe."

"Then," stormed David, "we can't have eaten fourteen kilos of butter in a week."

"Maybe it's *half a pound,*" said Alabama apologetically. "I hope you're not going to spoil things over a kilo——"

"You have to be very careful, Madam, in dealing with the French."

"I don't see why," expostulated David, "when you complain of having nothing to do, you can't run this house satisfactorily."

"What do you expect me to do? Every time I try to talk to the cook she scuttles down the cellar stairs and adds a hundred francs to the bill."

"Well—if there's pigeon again tomorrow I'm not coming to lunch," David threatened. "Something has got to be done."

"Madam," said Nanny, "have you seen the new bicycles the help have bought since we arrived here?"

"Miss Meadow," David interrupted abruptly, "would you mind helping Mrs. Knight with the accounts?"

Alabama wished David wouldn't drag Nanny in. She wanted to think about how brown her legs were going to be and how the wine would have tasted if it had been cold.

"It's the Socialists, Mr. Knight. They're ruining the country. We shall have another war if they aren't careful. Mr. Horterer-Collins used to say——"

Nanny's clear voice went on and on. It was impossible to miss a word of the clear enunciation.

"That's sentimental tommyrot," David retorted irritably. "The Socialists are powerful because the country is in a mess already. Cause and effect."

"I beg your pardon, sir, the Socialists caused the war, really, and now——" The crisp syllables expounded Nanny's unlimited political opinions.

In the cool of the bedroom where they were supposed to be resting, Alabama protested.

"We can't have that every day," she said. "Do you think she's gonna talk like that through every meal?"

"We can have them eat upstairs at night. I suppose she's lonely. She's been just sitting by herself on the beach every morning."

"But it's awful, David!"

"I know—but *you* needn't complain. Suppose you had to be thinking of composition while it was going on. She'll find somebody to unload herself on. Then it will be better. We mustn't let externals ruin our summer."

Alabama wandered in idleness from one room to another of the house; usually only the distant noise of a functioning ménage interrupted the solitude. This last noise was the worst of all—a fright. The villa must be falling to pieces.

She rushed to the balcony; David's head appeared in the window.

The beating, drumming whirr of an aeroplane sounded above the villa. The plane was so low that they could see the gold of Jacques' hair shining through the brown net about his head. The plane swooped malevolently as a bird of prey and soared off in a tense curve, high into the blue. Banking swiftly back, the wings glittering in the sun, it dropped in a breathless spiral, almost touching the tile roof. As the plane straightened itself, they saw Jacques wave with one hand and drop a small package in the garden.

"That damn fool will kill himself! It gives me heart failure," protested David.

"He must be terribly brave," said Alabama dreamily.

"*Vain*, you mean," he expostulated.

"Voilà! Madame, Voilà! Voilà! Voilà!"

The excited maid presented the brown dispatch box to Alabama. There was no thought in the French fastnesses of her mind that it might have been for the masculine element of the family that a machine would fly so dangerously low to leave a message.

Alabama opened the box. On a leaf of squared notebook paper was written diagonally in blue pencil "Toutes mes amitiés du haut de mon avion. Jacques Chevre-Feuille."

"What do you suppose it means?" Alabama asked.

"Just greetings," David said. "Why don't you get a French dictionary?"

Alabama stopped that afternoon at the librairie on the way to the beach. From rows of yellow-paper volumes she chose a dictionary and *Le Bal du Comte d'Orgel* in French to teach herself the language.

Beginning at four by prearrangement, the breeze blew a blue path through sea-drenched shadows at Jean's. A three-piece version of a jazz band protested the swoop of the rising tide with the melancholia of American popular music. A triumphant rendering of "Yes, We Have No Bananas" brought several couples to their feet. Bellandeau danced in mock coquetry with the lugubrious Corsican; Paulette and Madame hurtled wildly through the intricacies of what they believed to be an American fox-trot.

"Their feet look like a tightrope walker's gymnastics," commented David.

"It looks fun. I'm going to learn to do it."

"You'll have to give up cigarettes and coffee."

"I suppose. Will you teach me to do that, Monsieur Jacques?"

"I am a bad dancer. I have only danced with men in Marseilles. It is not for real men, dancing well."

Alabama didn't understand his French. It didn't make any difference. The man's valvating golden eyes drew her back and forth, back and forth obliviously through the great Republic's lack of bananas.

"You like France?"

"I love France."

"You cannot love France," he said pretentiously. "To love France you must love a Frenchman."

Jacques' English was more adequate about love than about anything else. He pronounced the word "lahve" and emphasized it roundly as if he were afraid of its escaping him.

"I have bought a dictionary," he said. "I will learn English."

Alabama laughed.

"I'm learning French," she said, "so I can love France more articulately."

"You must see Arles. My mother was an Arlésienne," he confided. "The Arlésienne women are very beautiful."

The sad romanticism in his voice reduced the world to ineffable inconsequence. Together they skimmed the boom of the blue sea and gazed out over the tip of the blue horizon.

"I'm sure," she murmured—what about, she had forgotten.

"And your mother?" he asked.

"My mother is old. She is very gentle. She spoiled me and gave me everything I wanted. Crying for things I couldn't have grew to be quite characteristic of me."

"Tell me about when you were a little girl," he said tenderly.

The music stopped. He drew her body against him till she felt the blades of his bones carving her own. He was bronze and smelled of the sand and sun; she felt him naked underneath the starched linen. She didn't think of David. She hoped he hadn't seen; she didn't care. She felt as if she would like to be kissing Jacques Chevre-Feuille on the top of the Arc de Triomphe. Kissing the white-linen stranger was like embracing a lost religious rite.

Nights after dinner David and Alabama drove into St-Raphaël. They bought a little Renault. Only the façade of the town was illuminated like a shallow stage set to cover a change of scene. The moon excavated fragile caverns under the massive plane trees back from the water. The village band played *Faust* and merry-go-round waltzes in a round pavilion by the sea. An itinerant street fair pitched its panoplies and the young Americans and the young officers swung into the southern heavens on the cable swings of *chevaux de bois*.

"A breeding place for whooping cough, that square, Madam," Nanny admonished.

She and Bonnie waited in the car to avoid the germs or took slow walks in the swept place before the station. Bonnie became intractable and howled so lustily for the nightlife of the fair that finally they had to leave the nurse and child at home in the evenings.

Every night they met Jacques and his friends at the Café de la Flotte. The young men were uproarious and drank many beers and Portos and

even champagne when David was paying, addressing the waiters bois-terously as "Amiraux." René drove his yellow Citroën up the steps of the Hotel Continental. The fliers were Royalists. Some were painters and some tried to write when they weren't flying their aeroplanes and all were amateurs of garrison life. For flying at night they got extra pay. The red and green lights of Jacques and Paulette swept over the seafront in aerial fête very often. Jacques hated David to pay for his drinks and Paulette needed the money—he and Madame had a baby in Algiers with his parents.

The Riviera is a seductive place. The blare of the beaten blue and those white palaces shimmering under the heat accentuates things. That was before the days when High Potentates of the Train Bleu, First Muck-a-mucks of the Biarritz-Backs and Dictators-in-Chief to interior decorators employed its blue horizons for binding their artistic enter-prises. A small horde of people wasted their time being happy and wasted their happiness being time beside the baked palms and vines brittlely clawing the clay banks.

Alabama read Henry James in the long afternoons. She read Robert Hugh Benson and Edith Wharton and Dickens while David worked. The Riviera afternoons are long and still and full of a consciousness of night long before evening falls. Boatloads of bright backs and the rhythmic chugging of motor launches tow the summer over the water.

"What can I do with myself?" she thought restlessly. She tried to make a dress; it was a failure.

Desultorily, she asserted herself on Nanny. "I think Bonnie is getting too much starch in her food," she said authoritatively.

"*I* do not think so, Madam," Nanny answered curtly. "No child of mine in twenty years has ever got too much starch."

Nanny took the matter of the starch to David.

"Can't you at least not interfere, Alabama?" he said. "Peace is abso-lutely essential to my work at present."

When she was a child and the days slipped lazily past in the same indolent fashion, she had not thought of life as furnishing up the slow uneventful sequence, but of the Judge as meting it out that way, cur-tailing the excitement she considered was her due. She began to blame David for the monotony.

"Well, why don't you give a party?" he suggested.

"Who'll we ask?"

"I don't know—the real estate lady and the Alsatian."

"They're horrible——"

"They're all right if you think of them as Matisse."

The women were too bourgeoise to accept. The rest of the party met in the Knights' garden and drank Cinzano. Madame Paulette plucked the lilt of "Pas Sur la Bouche" from the tinny teakwood piano. The French talked volubly and incomprehensively to David and Alabama about the works of Fernand Léger and René Crevel. They bent from the waist as they spoke and were strained and formal in acknowledgment of the oddity of their presence there—all but Jacques. He dramatized his unhappy attraction to David's wife.

"Aren't you afraid when you do stunts?" Alabama asked.

"I am afraid whenever I go in my aeroplane. That is why I like it," he answered defiantly.

If the sisters of the kitchen were wanting on weekdays they rose like July fireworks to special occasions. Venomous lobsters writhed in traps of celery, salads fresh as an Easter card sprouted in mayonnaise fields. The table was insistently wreathed in smilax; there was even ice, Alabama confirmed, on the cement floor of the basement.

Madame Paulette and Alabama were the only women. Paulette held himself aloof and watchful of his wife. He seemed to feel that dining with Americans was as risqué a thing to do as attending the Quatre-Arts ball.

"Ah, oui," smiled Madame, "mais oui, certainement oui, et puis o—u—i." It was like the chorus of a Mistinguett song.

"But in Monte-Negro—you know Monte-Negro, of course?" said the Corse—"*all* the men wear corsets."

Somebody poked Bellandeau about the ribs.

Jacques kept his eyes fastened disconsolately on Alabama.

"In the French Navy," he declaimed, "the Commandant is glad, proud to sink with his ship.—*I* am an officer of the French Marine!"

The party soared on the babble of French phrases senseless to Alabama; her mind drifted inconsequently.

"Do let me offer you a taste of the Doge's dress," she said, dipping into the currant jelly, "or a nice spoonful of Rembrandt?"

They sat in the breeze on the balcony and talked of America and *Indo-Chine* and France and listened to the screech and moan of night birds out of the darkness. The unjubilant moon was tarnished with much summer use in the salt air and the shadows black and communicative. A cat clambered over the balcony. It was very hot.

René and Bobbie went for ammonia to keep off the mosquitoes; Bellandeau went to sleep; Paulette went home with his wife, careful of his French proprieties. The ice melted on the pantry floor; they cooked eggs

in the blackened iron pans of the kitchen. Alabama and David and Jacques drove in the copper dawn to Agay against the face of the cool golden morning into the patterns of the creamy sun on the pines and the white odors of closing flowers of the night.

"Those are the caves of Neathandral man," David said, pointing to the purple hollows in the hills.

"No," said Jacques, "it was at Grenoble that they found the remains."

Jacques drove the Renault. He drove it like an aeroplane, with much speed and grinding and protesting tensions scattering echoes of the dawn like swarms of migrating birds.

"If this car were my own I'd drive into the ocean," he said. They sped down the dim obliteration of Provence to the beach, following the languorously stretching road where it crinkled the hills like rumpled bedclothes.

It was going to cost five hundred francs at least to get the car repaired, thought David, as he deposited Jacques and Alabama at the pavilion to swim.

David went home to work till the light changed—he insisted he couldn't paint anything but exteriors in the noon light of the Midi. He walked to the beach to join Alabama for a quick plunge before lunch. He found her and Jacques sitting in the sand like a couple of—well a couple of something, he said to himself distastefully. They were as wet and smooth as two cats who had been licking themselves. David was hot from the walk. The sun in the perspiration of his neck stung like a nettled collar.

"Will you go in with me again?" He felt he had to say something.

"Oh, David—it's awfully chilly this morning. There's going to be a wind." Alabama employed an expletive tone as if she were brooking a child's unwelcome interruption.

David swam self-consciously alone, looking back at the two figures glittering in the sun side by side.

"They are the two most presumptuous people I have ever seen," he said to himself angrily.

The water was already cold from the wind. The slanting rays of the sun cut the Mediterranean to many silver slithers and served it up on the deserted beach. As David left them to dress he saw Jacques lean over and whisper to Alabama through the first gusts of a mistral. He could not hear what they were saying.

"You'll come?" Jacques whispered.

"Yes—I don't know. Yes," she said.

When David came out of the cabin the blowing sand stung his eyes. Tears were pouring over Alabama's cheeks, strained till the deep tan glowed yellow on her cheekbones. She tried to blame it on the wind.

"You're sick, Alabama, insane. If you see that man any more, I'll leave you here and go back to America alone."

"You can't do that."

"You'll see if I can't!" he said threateningly.

She lay in the sand in the smarting wind, miserable.

"I'm going—he can take you home in his aeroplane." David strode off. She heard the Renault leave. The water shone like a metal reflector under the cold white clouds.

Jacques came; he brought a Porto.

"I have been to get you a taxi," he said. "If you like, I will not come here again."

"If I do not come to your apartment day after tomorrow when he goes to Nice, you must not come again."

"Yes——" He waited to serve her. "What will you say to your husband?"

"I'll have to tell him."

"It would be unwise," said Jacques in alarm. "We must hang on to our benefits——"

The afternoon was harsh and blue. The wind swept cold clots of dust about the house. You could hardly hear yourself speaking out of doors.

"We don't need to go to the beach after lunch, Nanny. It's too cold to swim."

"But, Madam, Bonnie gets so restless with this wind. I think we should go, Madam, if you don't mind. We needn't bathe—it makes a change, you know. Mr. Knight was willing to take us."

There was nobody at all on the *plage*. The crystalline air parched her lips. Alabama lay sunning herself, but the wind blew the sun away before it warmed her body. It was unfriendly.

René and Bobbie strolled out of the bar.

"Hello," said David shortly.

They sat down as if they shared some secret that might concern the Knight family.

"Have you noticed the flag?" said René.

Alabama turned in the direction of the aviation field.

The flag blew rigidly out at half-mast over the metallic cubistic roofs, brilliant in the thin light.

"Somebody is killed," René went on. "A soldier say it is Jacques—flying in this mistral."

Alabama's world grew very silent as if it had stopped, as if an awful collision of astral bodies were imminent.

She rose vaguely. "I've got to go," she said quietly. She felt cold and sick at her stomach. David followed her to the car.

He slammed the Renault angrily into gear. It wouldn't go any faster.

"Can we go in?" he said to the sentry.

"*Non, Monsieur.*"

"There has been an accident—Could you tell me who it is?"

"It is against the rules."

In the glare of a white sandy stretch before the walls, an avenue of oleanders bent behind the man in the mistral.

"We are interested to know if it was the Lieutenant Chevre-Feuille."

The man scrutinized Alabama's miserable face.

"That, Monsieur—I will see," he said at last.

They waited interminably in the malevolent gusts of the wind.

The sentry returned. Courageous and proprietary, Jacques swung along behind him to the car, part of the sun and part of the French Aviation and part of the blue and the white collar of the beach, part of Provence and the brown people living by the rigid discipline of necessity, part of the pressure of life itself.

"*Bonjour,*" he said. He took her hand firmly as if he were dressing a wound.

Alabama was crying to herself.

"We had to know," said David tensely as he started the car—"but my wife's tears are for me."

Suddenly David lost his temper.

"God damn it!" he shouted. "Will you fight this out?"

Jacques spoke steadily into Alabama's face.

"I cannot fight," he said gently. "I am much stronger than he."

His hands gripping the side of the Renault were like iron mitts.

Alabama tried to see him. The tears in her eyes smeared his image. His golden face and the white linen standing off from him exhaling the gold glow of his body ran together in a golden blur.

"You couldn't either," she cried out savagely. "You couldn't either beat him!"

Weeping, she flung herself on David's shoulder.

The Renault shot furiously off into the wind. David drew the car short with a crash before Jean's picket fence. Alabama reached for the emergency brake.

"Idiot!" David pushed her angrily away. "Keep your hands off those brakes!"

"I'm sorry I didn't let him beat you to a pulp," she yelled infuriated.

"I could have killed him if I had wanted," said David contemptuously.

"Was it anything serious, Madam?"

"Just somebody killed, that's all. I don't see how they stand their lives!"

David went straight to the room at "Les Rossignols" that he had arranged as a studio. The soft Latin voices of two children gathering figs from the tree at the end of the garden drifted up on the air in a low hum lulled louder and softer by the rise and fall of the twilit wind.

After a long time, Alabama heard him shout out the window: "Will you get the hell out of that tree! Damn this whole race of Wops!"

They hardly spoke to each other at dinner.

"These winds are useful, though," Nanny was saying. "They blow the mosquitoes inland and the atmosphere is so much clearer when they fall, don't you find, Madam? But my, how they used to upset Mr. Hor-terer-Collins! He was like a raging lion from the moment the mistral commenced. You don't feel it *very* much, do you, Madam?"

Hardened to a quiet determination to settle the row, David insisted on driving downtown after dinner.

René and Bobbie were alone at the café drinking verveine. The chairs were piled on the tables out of the mistral. David ordered champagne.

"Champagne is not good when there is the wind," René advised—but he drank it.

"Have you seen Chevre-Feuille?"

"Yes, he tells me he goes to *Indo-Chine.*"

Alabama was afraid from his tone that David was going to fight if he found Jacques.

"When is he leaving?"

"A week—ten days. When he can get transferred."

The lush promenade under the trees so rich and full of life and summer seemed swept of all its content. Jacques had passed over that much of their lives like a vacuum cleaner. There was nothing but a cheap café and the leaves in the gutter, a dog prowling about, and a Negro named Sans-Bas with a sabre cut over one cheek who tried to sell them a paper. That was all there was left of July and August.

David didn't say what he wanted with Jacques.

"Perhaps he is inside," René suggested.

David crossed the street.

"Listen, René," Alabama said quickly, "you *must* see Jacques and tell him I cannot come—just that. You will do this for me?"

Compassion lit his dreamy, passionate face. René took her hand and kissed it.

"I am very sorry for you. Jacques is a good boy."

"You are a good boy, too, René."

Jacques was not on the beach next morning.

"Well, Madame," Monsieur Jean greeted them. "You have had a nice summer?"

"It's been lovely," Nanny answered, "but I think Madam and Monsieur will soon have had enough of it here."

"Well, the season will soon be over," Monsieur Jean commented philosophically.

There were pigeons for lunch and the rubbery cheese. The maid fluttered about with the account book; Nanny talked too much.

"It has been very pleasant, I must say, here this summer," she commented.

"I hate it. If you can have our things packed by tomorrow we're going to Paris," said David fiercely.

"But there's a law in France that you must give the servants ten days' notice, Mr. Knight. It's an absolute law," expostulated Nanny.

"I'll give them money. For two francs, you could buy the President, the lousy Kikes!"

Nanny laughed, flustered by David's violence. "They are certainly very pecuniary."

"I'll pack tonight. I'm going walking," Alabama said.

"You won't go into town without me, Alabama?"

Their resistance met and clung with the taut suspense of two people seeking mutual support in a fast dance turn.

"No, I promise you, David. I'll take Nanny with me."

She roamed through the pine forests and over the high roads back of the villa. The other villas were boarded up for the summer. The plane trees covered the driveways with leaves. The jade porcelain gods in front of the heathen cemetery seemed very indoor gods and out of place on the bauxite terrace. The roads were smooth and new up there to make walking easier for the British in winter. They followed a sandy path between the vineyards. It was just a wagon track. The sun bled to death in a red and purple hemorrhage—dark arterial blood dyeing the grape leaves. The clouds were black and twisted horizontally and the land spread biblical in the prophetic light.

"No Frenchman ever kisses his wife on the mouth," said Nanny confidentially. "He has too much respect for her."

They walked so far that Alabama carried Bonnie astride her back to rest the short legs.

"Git up, horsey, Mummy, why won't you run?" the baby whined.

"Sh—sh—sh. I'm an old tired horse with hoof-and-mouth disease, darling."

A peasant in the hot fields gestured lasciviously and beckoned to the women. Nanny was frightened.

"Can you imagine that, Madam, and we with a little child? I shall certainly speak to Mr. Knight. The world is not safe since the war."

At sundown the tom-toms beat in the Senegalese camp—rites they performed for the dead in their monster-guarded burial ground.

A lone shepherd, brown and handsome, herded a thick drove of sheep along the stubbly tracks leading to the villa. They swept around Alabama and the nurse and child, whirling up the dust with their pattering feet.

"J'ai peur," she called to the man.

"Oui," he said gently, "vous avez peur! Gi—o." He clucked the sheep on down the road.

They couldn't get away from St-Raphaël until the end of the week. Alabama stayed at the villa and walked with Bonnie and Nanny.

Madame Paulette telephoned. Would Alabama come to see her in the afternoon? David said she could go to say good-bye.

Madame Paulette gave her a picture from Jacques and a long letter.

"I am very sorry for you," Madame said. "We had not thought that it was so serious an affair—we had thought it was just an affair."

Alabama could not read the letter. It was in French. She tore it in a hundred little pieces and scattered it over the black water of the harbor beneath the masts of many fishing boats from Shanghai and Madrid, Colombia and Portugal. Though it broke her heart, she tore the picture, too. It was the most beautiful thing she'd ever owned in her life, that photograph. What was the use of keeping it? Jacques Chevre-Feuille had gone to China. There wasn't a way to hold on to the summer, no French phrase to preserve its rising broken harmonies, no hopes to be salvaged from a cheap French photograph. Whatever it was that she wanted from Jacques, Jacques took it with him to squander on the Chinese. You took what you wanted from life, if you could get it, and you did without the rest.

The sand on the beach was as white as in June, the Mediterranean as blue as ever from the windows of the train that extracted the Knights from the land of lemon trees and sun. They were on their way to Paris. They hadn't much faith in travel nor a great belief in a change of scene

as a panacea for spiritual ills; they were simply glad to be going. And
Bonnie was glad. Children are always glad of something new, not re-
alizing that there is everything in anything if the thing is complete in
itself. Summer and love and beauty are much the same in Cannes or
Connecticut. David was older than Alabama; he hadn't really felt glad
since his first success.

<div align="center">

◦ III ◦

</div>

Nobody knew whose party it was. It had been going on for weeks.
When you felt you couldn't survive another night, you went home and
slept and when you got back, a new set of people had consecrated
themselves to keeping it alive. It must have started with the first boat-
loads of unrest that emptied themselves into France in 1927. Alabama
and David joined in May, after a terrible winter in a Paris flat that
smelled of a church chancery because it was impossible to ventilate.
That apartment, where they had fastened themselves up from the winter
rain, was a perfect breeding place for the germs of bitterness they
brought with them from the Riviera. From out their windows the gray
roofs before shaved the gray roofs behind like lightly grazing fencing
foils. The gray sky came down between the chimneys in inverted ethe-
real Gothic dividing the horizon into spires and points which hung over
their unrest like the tubes of a vast incubator. The etching of the bal-
conies of the Champs-Elysées and the rain on the pavements about the
Arc de Triomphe was all they could see from their red and gilt salon.
David had a studio on the Left Bank in that quarter of the city beyond
the Pont de l'Alma, where rococo apartment buildings and long avenues
of trees give on colorless openings with no perspective.
 There he lost himself in the retrospect of autumn disembodied from
its months, from heat and cold and holidays, and produced his lullabies
of recapitulation that drew vast crowds of the advance guard to the
Salon des Indépendants. The frescoes were finished: this was a new, more
personal, David on exhibit. You heard his name in bank lobbies and in
the Ritz Bar, which was proof that people were saying it in other places.
The steely concision of his work was making itself felt even in the lines
of interior decoration. *Des Arts Décoratifs* carried a dining room after one
of his interiors painted because of a gray anemone; the *Ballet Russe*
accepted a décor—phantasmagoria of the light on the *plage* at St-Ra-
phaël to represent the beginning of the world in a ballet called *Evolution*.
 The rising vogue of the David Knights brought Dickie Axton flying

symbolically across their horizons, scribbling over the walls of their prosperity a message from Babylon which they did not bother to read, being at that time engrossed in the odor of twilit lilacs along the Boulevard St-Germain and the veiling of the Place de la Concorde in the expensive mysticism of the Blue Hour.

The telephone rang and rang and rustled their dreams to pale Valhallas, Ermenonville, and the celestial twilight passages of padded hotels. As they slept in their lyric bed dreaming the will of the world to be probate, the bell rained on their consciousness like the roll of distant hoops; David grabbed the receiver.

"Hello. Yes, this is both the Knights."

Dickie's voice slid down the telephone wire from high-handed confidence to a low wheedle.

"I hope you're coming to my dinner." The voice descended by its teeth like an acrobat from the top of a circus tent. The limits of Dickie's activities stopped only at the borders of moral, social, and romantic independence, so you can well imagine that her scope was not a small one. Dickie had at her beck and call a catalogue of humanity, an emotional casting agency. Her existence was not surprising in this age of Mussolinis and sermons from the mount by every passing Alpinist. For the sum of three hundred dollars she scraped the centuries' historic deposits from under the nails of Italian noblemen and passed it off as caviar to Kansas débutantes; for a few hundreds more she opened the doors of Bloomsbury and Parnassus, the gates of Chantilly, or the pages of Debrett's to America's postwar prosperity. Her intangible commerce served up the slithered frontiers of Europe in a *céleri-rave*—Spaniards, Cubans, South Americans, even an occasional black floating through the social mayonnaise like bits of truffle. The Knights had risen to so exalted a point in the hierarchy of the "known" that they had become material for Dickie.

"You needn't be so high-hat," Alabama protested to David's lack of enthusiasm. "All the people will be white—or were once."

"We'll come, then," said David into the receiver.

Alabama twisted her body experimentally. The patrician sun of late afternoon spread itself aloofly over the bed where she and David untidily collected themselves.

"It's very flattering," she said, propelling herself to the bathroom, "to be sought after, but more provident, I suppose, to seek."

David lay listening to the violent flow of the water and the quake of the glasses in their stands.

"Another jag!" he yelled. "I find I can get along very well without my basic principles, but I cannot sacrifice my weaknesses—one being an insatiability about jags."

"What did you say about the Prince of Wales being sick?" called Alabama.

"I don't see why you can't listen when I'm talking to you," David answered crossly.

"I hate people who begin to talk the minute you pick up a toothbrush," she snapped.

"I said the sheets of this bed are actually scorching my feet."

"But there isn't any potash in the liquor over here," said Alabama incredulously. "It must be a neurosis—have you a new symptom?" she demanded jealously.

"I haven't slept in so long I would be having hallucinations if I could distinguish them from reality."

"Poor David—what will we do?"

"I don't know. Seriously, Alabama"—David lit a cigarette contemplatively—"my work's getting stale. I need new emotional stimulus."

Alabama looked at him coldly.

"I see." She realized that she had sacrificed forever her right to be hurt on the glory of a Provençal summer. "You might follow the progress of Mr. Berry Wall through the columns of the *Paris Herald,*" she suggested.

"Or choke myself on a chiaroscuro."

"If you *are* serious, David, I believe it has always been understood between us that we would not interfere with each other."

"Sometimes," commented David irrelevantly, "your face looks like a soul lost in the mist on a Scotch moor."

"Of course, no allowance has been made in our calculations for jealousy," she pursued.

"Listen, Alabama," interrupted David, "I feel terrible; do you think we can make the grade?"

"I want to show off my new dress," she said decisively.

"And I've got an old suit I'd like to wear out. You know we shouldn't go. We should think of our obligations to humanity." Obligations were to Alabama a plan and a trap laid by civilization to ensnare and cripple her happiness and hobble the feet of time.

"Are you moralizing?"

"No. I want to see what her parties are like. The last of Dickie's soirées netted no profits to charity though hundreds were turned away

at the gates. The Duchess of Dacne cost Dickie three months in America by well-placed hints."

"They're like all the others. You just sit down and wait for the inevitable, which is the only thing that never happens."

The post-war extravagance which had sent David and Alabama and some sixty thousand other Americans wandering over the face of Europe in a game of hare without hounds achieved its apex. The sword of Damocles, forged from the high hope of getting something for nothing and the demoralizing expectation of getting nothing for something, was almost hung by the third of May.

There were Americans at night, and day Americans, and we all had Americans in the bank to buy things with. The marble lobbies were full of them.

Lespiaut couldn't make enough flowers for the trade. They made nasturtiums of leather and rubber and wax gardenias and ragged robins out of threads and wires. They manufactured hardy perennials to grow on the meagre soil of shoulder straps and bouquets with long stems for piercing the loamy shadows under the belt. Modistes pieced hats together from the toy-boat sails in the Tuileries; audacious dressmakers sold the summer in bunches. The ladies went to the foundries and had themselves some hair cast and had themselves half-soled with the deep chrome fantasies of Helena Rubenstein and Dorothy Gray. They read off the descriptive adjectives on the menu-cards to the waiters and said, "Wouldn't you like" and "Wouldn't you really" to each other till they drove the men out to lose themselves in the comparative quiet of the Paris streets which hummed like the tuning of an invisible orchestra. Americans from other years bought themselves dressy house with collars and cuffs in Neuilly and Passy, stuffed themselves in the cracks of the rue du Bac like the Dutch boy saving the dikes. Irresponsible Americans suspended themselves on costly eccentricities like Saturday's servants on a broken Ferris wheel and made so many readjustments that a constant addenda went on about them like the clang of a Potin cash register. Esoteric *pelletiers* robbed a secret clientele in the rue des Petits-Champs; people spent fortunes in taxis in search of the remote.

"I'm sorry I can't stay, I just dropped in to say 'hello,' " they said to each other and refused the table d'hôte. They ordered Veronese pastry on lawns like lace curtains at Versailles and chicken and hazelnuts at Fontainebleau where the woods wore powdered wigs. Discs of umbrellas poured over suburban terraces with the smooth round ebullience of a Chopin waltz. They sat in the distance under the lugubrious dripping elms, elms like maps of Europe, elms frayed at the end like bits of

chartreuse wool, elms heavy and bunchy as sour grapes. They ordered the weather with a continental appetite, and listened to the centaur complain about the price of hoofs. There were bourgeois blossoms on the bill of fare and tall architectural blossoms on the horse chestnut and crystallized rosebuds to go with the Porto. The Americans gave indications of themselves but always only the beginning like some eternal exposition, a clef before a bar of music to be played on the minors of the imagination. They thought all French schoolboys were orphans because of the black dresses they wore, and those of them who didn't know the meaning of the word "insensible" thought the French thought that they were crazy. All of them drank. Americans with red ribbons in their buttonholes read papers called the *Eclaireur* and drank on the sidewalks, Americans with tips on the races drank down a flight of stairs, Americans with a million dollars and a standing engagement with the hotel masseuses drank in suites at the Meurice and the Crillon. Other Americans drank in Montmartre, *pour le soif* and *contre la chaleur* and *pour la digestion* and *pour se guérir*. They were glad the French thought they were crazy.

Over fifty thousand francs' worth of flowers had wilted to success on the altars of Notre-Dame-des-Victoires during the year.

"Maybe something will happen," said David.

Alabama wished nothing ever would again but it was her turn to agree—they had evolved a tacit arrangement about waiting on each other's emotions, almost mathematical like the trick combination of a safe, which worked by the mutual assumption that it would.

"I mean," he pursued, "if somebody would come along to remind us about how we felt about things when we felt the way they remind us of, maybe it would refresh us."

"I see what you mean. Life has begun to appear as tortuous as the sentimental writhings of a rhythmic dance."

"Exactly. I want to make some protestations since I'm largely too busy to work very well."

"Mama said 'Yes' and Papa said 'Yes' " to the gramophone owners of France. "Ariel" passed from the title of a book to three wires on the housetop. What did it matter? It had already gone from a god to a myth to Shakespeare—nobody seemed to mind. People still recognized the word: "Ariel!" it was. David and Alabama hardly noticed the change.

In a Marne taxicab they clipped all the corners of Paris precipitous enough to claim their attention and descended at the door of the Hôtel George-V. An atmosphere of convivial menace hung over the bar. Delirious imitations of Picabia, the black lines and blobs of a commercial

attempt at insanity squeezed the shiplike enclosure till it communicated the sense of being corseted in a small space. The bartender inspected the party patronizingly. Miss Axton was an old customer, always bringing somebody new; Miss Dickie Axton, he knew. She'd been drinking in his bar the night she shot her lover in the Gare de l'Est. Alabama and David were the only ones he'd never seen before.

"And has Mademoiselle Axton completely recovered from so stupid a contretemps?"

Miss Axton affirmed in a magnetic, incisive voice that she had, and that she wanted a gin highball damn quick. Miss Axton's hair grew on her head like the absentminded pencil strokes a person makes while telephoning. Her long legs struck forcefully forward as if she pressed her toes watchfully on the accelerator of the universe. People said she had slept with a Negro. The bartender didn't believe it. He didn't see where Miss Axton would have found the time between white gentlemen—pugilists, too, sometimes.

Miss Douglas, now, was a different proposition. She was English. You couldn't tell whom she had slept with. She had even stayed out of the papers. Of course she had money, which makes sleeping considerably more discreet.

"We will drink the same as usual, Mademoiselle?" He smiled ingratiatingly.

Miss Douglas opened her translucent eyes; she was so much the essence of black chic that she was nothing but a dark aroma. Pale and transparent, she anchored herself to the earth solely by the tenets of her dreamy self-control.

"No, my friend, this time it's Scotch and soda. I'm getting too much of a stomach for sherry flips."

"There's a scheme," said Miss Axton, "you put six encyclopædias on your stomach and recite the multiplication table. After a few weeks your stomach is so flat that it comes out at the back, and you begin life again hind part before."

"Of course," contributed Miss Douglas, punching herself where a shade of flesh rose above her girdle like fresh rolls from a pan, "the only sure thing is"—leaning across she sputtered something in Miss Axton's ear. The two women roared.

"Excuse me," finished Dickie hilariously, "and in England they take it in a highball."

"I never exercise," pronounced Mr. Hastings with unenthusiastic embarrassment. "Ever since I got my ulcers I've eaten nothing but spinach so I manage to avoid looking well that way."

"A glum sectarian dish," concluded Dickie sepulchrally.

"I have it with eggs and then with croutons and sometimes with——"

"Now, dear," interrupted Dickie, "you mustn't excite yourself." Blandly explaining, she elaborated. "I have to mother Mr. Hastings; he's just come out of an asylum, and when he gets nervous he can't dress or shave himself without playing his phonograph. The neighbors have him locked up whenever it happens, so I have to keep him quiet."

"It must be very inconvenient," muttered David.

"Frightfully so—travelling all the way to Switzerland with all those discs, and ordering spinach in thirty-seven different languages."

"I'm sure Mr. Knight could tell us some way of staying young," suggested Miss Douglas. "He looks about five years old."

"He's an authority," said Dickie, "a positive authority."

"What about?" inquired Hastings skeptically.

"Authorities are all about women this year," said Dickie.

"Do you care for Russians, Mr. Knight?"

"Oh, very much. We love them," said Alabama. She had a sense that she hadn't said anything for hours and that something was expected of her.

"We don't," said David. "We don't know anything about music."

"Jimmie," Dickie seized the conversation rapaciously, "was going to be a celebrated composer, but he had to take a drink every sixteen measures of counterpoint to keep the impetus of the thing from falling and his bladder gave out."

"I couldn't sacrifice myself for success the way some people do," protested Hastings querulously implying that David had sold himself, somehow, to something.

"Naturally. Everybody knows you anyway—as the man without any bladder."

Alabama felt excluded by her lack of accomplishment. Comparing herself with Miss Axton's elegance, she hated the reticent solidity, the savage sparse competence of her body—her arms reminded her of a Siberian branch railroad. Compared with Miss Douglas' elimination, her Patou dress felt too big along the seams. Miss Douglas made her feel that there was a cold cream deposit at the neckline. Slipping her fingers into the tray of salted nuts, she addressed the barman dismally, "I should think people in your profession would drink themselves to death."

"Non, Madame. I did use to like a good sidecar but that was before I became so well-known."

The party poured out into the Paris night like dice shaken from a

cylinder. The pink flare from the streetlights tinted the canopy scallop-
ing of the trees to liquid bronze: those lights are one of the reasons why
the hearts of Americans bump spasmodically at the mention of France;
they are identical with the circus flares of our youth.

The taxi careened down the boulevard along the Seine. Careening
and swerving, they passed the brittle mass of Notre-Dame, the bridges
cradling the river, the pungence of the baking parks, the Norman towers
of the Department of State, the pungence of the baking parks, the
bridges cradling the river, the brittle mass of Notre-Dame, sliding back
and forth like a repeated newsreel.

The Ile St-Louis is boxed by many musty courtyards. The entryways
are paved with the black and white diamonds of the Sinister Kings and
grilles dissect the windows. East Indians and Georgians serve the deep
apartments opening on the river.

It was late when they arrived at Dickie's.

"So, as a painter," Dickie said as she opened the door, "I wanted
your husband to meet Gabrielle Gibbs. You must, sometime; if you're
knowing people."

"Gabrielle Gibbs," echoed Alabama, "of course, I've heard of her."

"Gabrielle's a half-wit," continued Dickie calmly, "but she's very at-
tractive if you don't feel like talking."

"She has the most beautiful body," contributed Hastings, "like white
marble."

The apartment was deserted; a plate of scrambled eggs hardened on
the centre table; a coral evening cape decorated a chair.

"Qu'est-ce tu fais ici?" said Miss Gibbs feebly from the bathroom
floor as Alabama and Dickie penetrated the sanctuary.

"I can't speak French," Alabama answered.

The girl's long blonde hair streamed in chiselled segments about her
face, a platinum wisp floated in the bowl of the toilet. The face was as
innocent as if she had just been delivered from the taxidermist's.

"Quelle dommage," she said laconically. Twenty diamond bracelets
clinked against the toilet seat.

"Oh, dear," said Dickie philosophically, "Gabrielle can't speak En-
glish when she's drunk. Liquor makes her highbrow."

Alabama appraised the girl; she seemed to have bought herself in sets.

"Christ," the inebriate remarked to herself morosely, "etait né en
quatre cent Anno Domini. C'etait vraiment *très* dommage." She gathered
herself together with the careless precision of a scene-shifter, staring
skeptically into Alabama's face from eyes as impenetrable as the back-
ground of an allegorical painting.

"I've got to get sober." The face quickened to momentary startled animation.

"You certainly do," Dickie ordered. "There's a man outside such as you have never met before especially lured here by the prospect of meeting you."

"Anything can be arranged in the toilet," Alabama thought to herself. "It's the woman's equivalent for the downtown club since the war." She'd say that at table, she thought.

"If you'll leave me I'll just take a bath," Miss Gibbs proposed majestically.

Dickie swept Alabama out into the room like a maid gathering dust off the parlor floor.

"We think," Hastings was saying in a tone of finality, "that there's no use working over human relations."

He turned accusingly to Alabama. "Just who is this hypothetical we?"

Alabama had no explanation to offer. She was wondering if this was the time to use the remark about the toilet when Miss Gibbs appeared in the doorway.

"Angels," cried the girl, peering about the room.

She was as dainty and rounded as a porcelain figure; she sat up and begged; she played dead dog, burlesquing her own ostentation attentively as if each gesture were a configuration in some comic dance she composed as she went along and meant to perfect late. It was obvious that she was a dancer—clothes never become part of their sleek bodies. A person could have stripped Miss Gibbs by pulling a central string.

"Miss Gibbs!" said David quickly. "Do you remember the man who wrote you all those mash notes back in 1920?"

The fluttering eyes ruminated over the scene uncritically. "So," she said, "it is you whom I am to meet. But I've heard you were in love with your wife."

David laughed. "Slander. Do you disapprove?"

Miss Gibbs withdrew behind the fumes of Elizabeth Arden and the ripples of a pruned international giggle. "It seems rather cannibalistic in these days." The tone changed to one of exaggerated seriousness; her personality was alive like a restless pile of pink chiffon in a breeze.

"I dance at eleven, and we must dine if you ever had that intention. Paris!" she sighed—"I've been in a taxi since last week at half-past four."

From the long trestle table a hundred silver knives and forks signalled the existence of as many million dollars in curt cubistic semaphore. The grotesquerie of fashionable tousled heads and the women's scarlet

mouths opening and gobbling the candlelight like ventriloquists' dummies brought the quality of a banquet of a mad, mediæval monarch to the dinner. American voices whipped themselves to a frenzy with occasional lashings of a foreign tongue.

David hung over Gabrielle. "You know," Alabama heard the girl say, "I think the soup needs a little more eau de cologne."

She was going to have to overhear Miss Gibbs' line all during dinner, which fact considerably hampered her own.

"Well," she began bravely—"the toilet for women——"

"It's an outrage—a conspiracy to cheat us," said the voice of Miss Gibbs. "I wish they'd use more aphrodisiac."

"Gabrielle," yelled Dickie, "you've no idea how expensive such things are since the war."

The table achieved a shuttlecock balance which gave the illusion of looking out on the world from a fast-flying train window. Immense trays of ornamental foods passed under their skeptical distraught eyes.

"The food," said Hastings crabbily, "is like something Dickie found in a geologist's excavation."

Alabama decided to count on his being cross at the right point; he was always a little bit cross. She had almost thought of something to say when David's voice floated up like driftwood on a tidal wave.

"A man told me," he was saying to Gabrielle, "that you have the most beautiful blue veins all over your body."

"I was thinking, Mr. Hastings," said Alabama tenaciously, "that I would like somebody to lock me up in a spiritual chastity belt."

Having been brought up in England, Hastings was intent on his food.

"Blue ice cream!" he snorted contemptuously. "Probably frozen New England blood extracted from the world by the pressure of modern civilization on inherited concepts and acquired traditions."

Alabama went back to her original premise that Hastings was hopelessly calculating.

"I wish," said Dickie unpleasantly, "that people would not flagellate themselves with the food when they're dining with me."

"I have no historical sense! I am an unbeliever!" shouted Hastings. "I don't know what you're talking about!"

"When Father was in Africa," interrupted Miss Douglas, "they climbed inside the elephant and ate the entrails with their hands—at least, the Pygmies did; Father took pictures."

"And," said David's voice excitedly, "he said that your breasts were like marble dessert—a sort of blancmange, I presume."

"It would be quite an experience," yawned Miss Axton idly, "to seek stimulation in the church and asceticism in sex."

The party lost body with the end of dinner—the people, intent on themselves in the big living room, moved about like officials under masks in an operating room. A visceral femininity suffused the umber glow.

Night lights through the windows glittered miniature and precise as carvings of stars in a sapphire bottle. Quiet sound from the street rose above the party's quiescence. David passed from one group to another, weaving the room into a lacy pattern, draping its substance over Gabrielle's shoulders.

Alabama couldn't keep her eyes off them. Gabrielle was the center of something; there was about her that suspension of direction which could only exist in a centre. She lifted her eyes and blinked at David like a complacent white Persian cat.

"I imagine you wear something startling and boyish underneath your clothes," David's voice droned on, "BVD's or something."

Resentment flared in Alabama. He'd stolen the idea from her. She'd worn silk BVD's herself all last summer.

"Your husband's too handsome," said Miss Axton, "to be so well known. It's an unfair advantage."

Alabama felt sick at her stomach—controllably, but too sick to answer—champagne is a filthy drink.

David opened and closed his personality over Miss Gibbs like the tentacles of a carnivorous maritime plant. Dickie and Miss Douglas leaning against the mantel suggested the weird arctic loneliness of totem poles. Hastings played the piano too loud. The noise isolated them all from each other.

The doorbell rang and rang.

"It must be the taxis come to take us to the ballet," Dickie sighed with relief.

"Stravinsky is conducting," supplied Hastings. "He's a plagiarist," he added lugubriously.

"Dickie," said Miss Gibbs peremptorily, "could you just leave me the key? Mr. Knight will see me to the Acacias—that is, if you don't mind." She beamed on Alabama.

"Mind? Why should I?" Alabama answered disagreeably. She wouldn't have minded if Gabrielle had been unattractive.

"I don't know. I'm in love with your husband. I thought I'd try to make him if you didn't mind—of course, I'd try anyway—he's such an

angel." She giggled. It was a sympathetic giggle covering any unexpected failure in its advance apology.

Hastings helped Alabama with her coat. She was angry about Gabrielle—Gabrielle made her feel clumsy. The party burrowed into their wraps.

The lamps swung and swayed soft as the ribbons of a Maypole along the river; the spring sniggered quietly to itself on the street corners.

"But what a 'lahvely' night!" Hastings proffered facetiously.

"Weather is for children."

Somebody mentioned the moon.

"Moons?" said Alabama contemptuously. "They're two for five at the five-and-ten, full or crescent."

"But this is an especially nice one, Madam. It has an especially fashionable way of looking at things!"

In her deepest moods of discontent, Alabama, on looking back, found the overlying tempo of that period as broken and strident as trying to hum a bit of *La Chatte*. Afterwards, the only thing she could place emotionally was her sense of their all being minor characters and her dismay at David's reiterance that many women were flowers—flowers and desserts, love and excitement, and passion and fame! Since St-Raphaël she had had no uncontested pivot from which to swing her equivocal universe. She shifted her abstractions like a mechanical engineer might surveying the growing necessities of a construction.

The party was late at the Châtelet. Dickie hustled them up the converging marble stairs as if she directed a processional to Moloch.

The décor swarmed in Saturnian rings. Spare, immaculate legs and a consciousness of rib, the vibrant suspension of lean bodies precipitated on the jolt of reiterant rhythmic shock, the violins' hysteria, evolved themselves to a tortured abstraction of sex. Alabama's excitement rose with the appeal to the poignancy of a human body subject to its physical will to the point of evangelism. Her hands were wet and shaking with its tremolo. Her heart beat like the fluttering wings of an angry bird.

The theatre settled in a slow nocturne of plush culture. The last strain of the orchestra seemed to lift her off the earth in inverse exhilaration —like David's laugh, it was, when he was happy.

Down the stairs many girls looked back at important men with silver-fox hair from the marble balustrade and influential men looked from side to side jingling things in their pockets—private lives and keys.

"There is the princess," said Dickie. "Shall we take her along? She used to be very famous."

A woman with a shaved head and the big ears of a gargoyle paraded a Mexican hairless through the lobby.

"Madame used to be in the ballet until her husband exhausted her knees so she couldn't dance," went on Dickie, introducing the lady.

"It is many years since my knees have grown quite ossified," the woman said plaintively.

"How did you manage?" said Alabama breathlessly. "How did you get in the ballet? And get to be important?"

The woman regarded her with velvety bootblack's eyes, begging the world not to forget her, that she herself might exist oblivious.

"But I was born in the ballet." Alabama accepted the remark as if it were an explanation of life.

There were many dissensions about where to go. As a compliment to the Princess the party chose a Russian *boîte*. The voice of a fallen aristocracy tethered its wails to the flexible notes of tzigane guitars; the low clang of bottles against champagne buckets jangled the tone of the dungeon of pleasure like the lashing of spectral chains. Cold-storage necks and throats like vipers' fangs pierced the ectoplasmic light; eddying hair whirled about the shallows of the night.

"Please, Madame," Alabama persisted intently, "would you give me a letter to whoever trains the ballet? I would do anything in the world to learn to do that."

The shaved head scanned Alabama enigmatically.

"Whatever for?" she said. "It is a hard life. One suffers. Your husband could surely arrange——"

"But why should anyone want to do *that?*" Hastings interrupted. "I'll give you the address of a Black Bottom teacher—of course, he's colored, but nobody cares any more."

"I do," said Miss Douglas. "The last time I went out with Negroes I had to borrow from the headwaiter to pay the check. Since then I've drawn the color line at the Chinese."

"Do you think, Madame, that I am too old?" Alabama persisted.

"Yes," said the Princess briefly.

"They live on cocaine anyway," said Miss Douglas.

"And pray to Russian devils," added Hastings.

"But some of them do lead actual lives, I believe," said Dickie.

"Sex is such a poor substitute," sighed Miss Douglas.

"For what?"

"For sex, idiot."

"I think," said Dickie surprisingly, "that it would be the very thing

for Alabama. I've always heard she was a little peculiar—I don't mean actually batty—but a little difficult. An art would explain. I really think you ought, you know," she said decisively. "It would be almost as exotic as being married to a painter."

"What do you mean 'exotic'?"

"Running around caring about things—of course, I hardly know you, but I do think dancing would be an asset if you're going to care *anyhow*. If the party got dull you could do a few whirlygigs." Dickie illustrated her words by gouging a hole in the tablecloth with her fork, "like that!" she finished enthusiastically. "I can see you now!"

Alabama visualized herself suavely swaying to the end of a violin bow, spinning on its silver bobbin, the certain disillusions of the past into uncertain expectancies of the future. She pictured herself as an amorphous cloud in a dressing room mirror which would be framed with cards and papers, telegrams and pictures. She followed herself along a stone corridor full of electric switches and signs about smoking, past a water cooler and a pile of Lily Cups and a man in a tilted chair to a gray door with a stencilled star.

Dickie was a born promoter. "I'm sure you can do it—you certainly have the body!"

Alabama went secretly over her body. It was rigid, like a lighthouse. "It might do," she mumbled, the words rising through her elation like a swimmer coming up from a deep dive.

"Might?" echoed Dickie with conviction. "You could sell it to Cartier's for a gold mesh sweatshirt!"

"Who can give me a letter to the necessary people?"

"I will, my dear—I have all the unobtainable entrées in Paris. But it's only fair to warn you that the gold streets of heaven are hard on the feet. You'd better take along a pair of crepe soles when you're planning the trip."

"Yes," Alabama agreed unhesitantly. "Brown, I suppose, because of the gutters—I've always heard stardust shows up on the white."

"It's a tomfool arrangement," said Hastings abruptly. "Her husband says she can't even carry a tune!"

Something must have happened to make the man so grouchy—or maybe it was that nothing had. They were all grouchy, nearly as much so as herself. It must be nerves and having nothing to do but write home for money. There wasn't even a decent Turkish bath in Paris.

"What have you been doing with—*your*self?" she said.

"Using up my war medals for pistol practice targets," he answered acidly.

Hastings was as sleek and brown as pulled molasses candy. He was an intangible reprobate, discouraging people and living like a moral pirate. Many generations of beautiful mothers had endowed him with an inexhaustible petulance. He wasn't half as good company as David.

"I see," said Alabama. "The arena is closed today, since the matador had to stay home and write his memoirs. The three thousand people can go to the movies instead."

Hastings was annoyed at the tartness in her tone.

"Don't blame me," he said, "about Gabrielle's borrowing David." Seeing the earnestness in her face he continued helpfully, "I don't suppose you'd want me to make love to you?"

"Oh, no, it's quite all right—I like martyrdom."

The small room smothered in smoke. A powerful drum beleaguered the drowsy dawn; bouncers from other cabarets drifted in for their morning supper.

Alabama sat quietly humming, "Horses, Horses, Horses," in a voice like the whistle of boats putting out to sea in a fog.

"This is my party," she insisted as the check appeared. "I've been giving it for years."

"Why didn't you invite your husband?" said Hastings maliciously.

"Damn it," said Alabama hotly. "I did—so long ago that he forgot to come."

"You need somebody to take care of you," he said seriously. "You're a man's woman and need to be bossed. No, I mean it," he insisted when Alabama began to laugh.

Nourishing his roots on the disingenuous expectations of ladies whose exploits permitted them a remembrance of the fairy tales, Alabama concluded that he was nevertheless not a prince.

"I was just going to begin doing it myself," she chuckled. "I made a date with the Princess and Dickie to arrange for a future. In the meantime, it is exceedingly difficult to direct a life which has no direction."

"You've a child, haven't you?" he suggested.

"Yes," she said, "there's the baby—life goes on."

"This party," said Dickie, "has been going on forever. They're saving the signatures on the earliest checks for the war museum."

"What we need is new blood in the party."

"What we all need," said Alabama impatiently, "is a good——"

The dawn swung over the Place Vendôme with the slow silver grace of a moored dirigible. Alabama and Hastings spilled into the Knights' gray apartment on the morning like a shower of last night's confetti shaken from the folds of a cloak.

"I thought David would be at home," she said, searching the bedroom.

"I didn't," Hastings mocked. "For I, thy God, am a Jewish God, Baptist God, Catholic God——"

She had wanted to cry for a long time, she realized suddenly. In the weary stuffiness of the salon she collapsed. Sobbing and shaking, she did not lift her face when David finally stumbled into the dry, hot room. She lay sprawled like a damp wrung towel over the windowsill, like the transparent shed carcass of a brilliant insect.

"I suppose you're awfully angry," he said.

Alabama didn't speak.

"I've been out all night," explained David cheerfully, "on a party."

She wished she could help David to seem more legitimate. She wished she could do something to keep everything from being so undignified. Life seemed so uselessly extravagant.

"Oh, David," she sobbed. "I'm much too proud to care—pride keeps me from feeling half the things I ought to feel."

"Care about what? Haven't you had a good time?" mumbled David placatively.

"Perhaps Alabama's angry about my not getting sentimental about her," said Hastings, hastily extricating himself. "Anyway I'll just run along if you don't mind. It must be quite late."

The morning sun shone brightly through the windows.

For a long time she lay sobbing. David took her on his shoulder. Under his arms smelled warm and clean like the smoke of a quiet fire burning in a peasant's mountain cottage.

"There's no use explaining," he said.

"Not the slightest."

She tried to see him through the early dusk.

"Darling!" she said, "I wish I could live in your pocket."

"Darling," answered David sleepily, "there'd be a hole you'd forgotten to darn and you'd slip through and be brought home by the village barber. At least, that's been my experience with carrying girls about in my pockets."

Alabama thought she'd better put a pillow under David's head to keep him from snoring. She thought he looked like a little boy who had just been washed and brushed by a nurse a few minutes before. Men, she thought, never seem to become the things they do, like women, but belong to their own philosophic interpretations of their actions.

"I don't care," she repeated convincingly to herself: as neat an incision into the tissue of life as the most dexterous surgeon could hope to

produce over a poisoned appendix. Filing away her impressions like a person making a will, she bequeathed each passing sensation to that momentary accumulation of her self, the present, that filled and emptied with the overflow.

It's too late in the morning for peccadilloes; the sun bathes itself with the night's cadavers in the typhus-laden waters of the Seine; the market carts have long since rumbled back to Fontainebleau and St-Cloud; the early operations are done in the hospitals; the inhabitants of the Ile de la Cité have had their bowl of café au lait and the night chauffeurs *un verre*. The Paris cooks have brought down the refuse and brought up the coal, and many people with tuberculosis wait in the damp bowels of the earth for the Metro. Children play in the grassplots about the Tour Eiffel and the white floating veils of English nannies and the blue veils of the French nounous flap out the news that all is well along the Champs-Elysées. Fashionable women powder their noses in their Porto glasses under the trees of the Pavillon Dauphine, just now opening its doors to the creak of Russian leather riding boots. The Knights' *femme de chambre* has orders to wake her masters in time for lunch in the Bois de Boulogne.

When Alabama tried to get up she felt nervous, she felt monstrous, she felt bilious.

"I can't stand this any longer," she screamed at the dozing David. "I don't want to sleep with the men or imitate the women, and I can't stand it!"

"Look out, Alabama, I've got a headache," David protested.

"I won't look out! I won't go to lunch! I'm going to sleep till time to go to the studio."

Her eyes glowed with the precarious light of a fanatic determination. There were white triangles under her jawbone and blue rings around her neck. Her skin smelled of dry dirty powder from the night before.

"Well, you can't sleep sitting up," he said.

"I can do exactly as I please," she said; "anything! I can sleep when I'm awake if I want to!"

David's delight in simplicity was something very complex that a simple person would never have understood. It kept him out of many arguments.

"All right," he said, "I'll help you."

The macabre who lived through the war have a story they love to tell about the soldiers of the Foreign Legion giving a ball in the expanses around Verdun and dancing with the corpses. Alabama's continued brewing of the poisoned filter for a semiconscious banquet table, her

insistence on the magic and glamour of life when she was already feeling its pulse like the throbbing of an amputated leg, had something of the same sinister quality.

Women sometimes seem to share a quiet, unalterable dogma of persecution that endows even the most sophisticated of them with the inarticulate poignancy of the peasant. Compared to Alabama's, David's material wisdom was so profound that it gleamed strong and harmonious through the confusion of these times.

"Poor girl," he said, "I understand. It must be awful just waiting around eternally."

"Aw, shut up!" she answered ungratefully. She lay silent for a long time. "David," she said sharply.

"Yes."

"I am going to be as famous a dancer as there are blue veins over the white marble of Miss Gibbs."

"Yes, dear," agreed David noncommittally.

3

◇

◦ I ◦

The High parabolas of Schumann fell through the narrow brick court and splashed against the red walls in jangling crescendo. Alabama traversed the dingy passage behind the stage of the Olympia Music Hall. In the gray gloom the name of Raquel Meller faded across a door marked with a scaling gold star; the paraphernalia of a troupe of tumblers obstructed the stairway. She mounted seven flights of stairs worn soft and splintery with the insecure passage of many generations of dancers and opened the studio door. The hydrangea blue of the walls and the scrubbed floor hung from the skylight like the basket of a balloon suspended in the ether. Effort and aspiration, excitement, discipline, and an overwhelming seriousness flooded the vast barn of a room. A muscular girl stood in the centre of this atmosphere winding the ends of space about the rigidity of her extended thigh. Round and round she went, and, dropping the thrill of the exciting spiral to the low, precise organization of a lullaby, brought herself to an orgastic pause. She walked awkwardly across to Alabama.

"I have a lesson with Madame at three," Alabama addressed the girl in French. "It was arranged by a friend."

"She is coming soon," the dancer said with an air of mockery. "You will get ready, perhaps?"

Alabama couldn't decide whether the girl was ridiculing the world in general or Alabama in particular, or, perhaps, herself.

"You have danced a long while?" asked the dancer.

"No. This is my first lesson."

"Well, we all begin sometime," said the girl tolerantly.

She twirled blindingly three or four times to end the conversation.

"This way," she said, indicating her lack of interest in a novice. She showed Alabama into the vestibule.

Along the walls of the dressing room hung the long legs and rigid feet of flesh and black tights molded in sweat to the visual image of the decisive tempos of Prokofiev and Sauguet, of Poulenc and Falla. The bright, explosive carnation of a ballet skirt projected under the edges of a face towel. In a corner the white blouse and pleated skirt of Madame hung behind a faded gray curtain. The room reeked of hard work.

A Polish girl with hair like a copper-wire dishcloth and a purple, gnomish face bent over a straw chest sorting torn sheets of music and arranging a pile of discarded tunics. Odd toe shoes swung from the light. Turning the pages of a ragged Beethoven album, the Pole unearthed a faded photograph.

"I think it is her mother," she said to the dancer.

The dancer inspected the picture proprietorily; she was the ballerina.

"I think, *ma chère* Stella, that it is Madame herself when she was young. I shall keep it!" She laughed lawlessly and authoritatively—she was the centre of the studio.

"No, Arienne Jeanneret. It is I who will keep it."

"May I see the picture?" asked Alabama.

"It is certainly Madame herself."

Arienne handed the picture to Alabama with a shrug of dismissal. Her motions had no continuity; she was utterly immobile between the spasmodic electric vibrations that propelled her body from one cataclysmic position to another.

The eyes of the picture were round and sad and Russian, a dreamy consciousness of its own white dramatic beauty gave the face weight and purpose as if the features were held together by spiritual will. The forehead was bound by a broad metallic strip after the fashion of a Roman charioteer. The hands posed in experimental organization on the shoulders.

"Is she not beautiful?" asked Stella.

"She's not un-American," Alabama answered.

The woman reminded her obscurely of Joan; there was the same transparence about her sister that shone through the face in the picture like the blinding glow of a Russian winter. It was perhaps a kindred intensity of heat that had worn Joan to that thin external radiance.

The girl turned quickly, listening to the tired footsteps of someone hesitantly traversing the studio.

"Where have you found that old picture?" Madame's voice, broken with sensitivity, would have you believe that it was apologetic. Madame

smiled. She was not humorless, but no manifestation of her emotions intruded on the white possessed mysticism of her face.

"In the Beethoven."

"Before," Madame said succinctly, "I turned out the lights in my apartment and played Beethoven. My sitting room in Petrograd was yellow and always full of flowers. I said then to myself, 'I am too happy. This cannot last.'" She waved her hand resignedly and raised her eyes challengingly to Alabama.

"So my friend tells me you want to dance? Why? You have friends and money already." The black eyes moved in frank childish inspection over Alabama's body, loose and angular as those silver triangles in an orchestra—over her broad shoulder blades and the imperceptible concavity of her long legs, fused together and controlled by the resilient strength of her thick neck. Alabama's body was like a quill.

"I have been to the Russian ballet," Alabama tried to explain herself, "and it seemed to me—Oh, I don't know! As if it held all the things I've always tried to find in everything else."

"What have you seen?"

"*La Chatte,* Madame, I *must* do that someday!" Alabama replied impulsively.

A faint flicker of intrigued interest moved the black eyes recessionally. Then the personality withdrew from the face. Looking into her eyes was like walking through a long stone tunnel with a gray light shining at the other end, sloshing blindly through dank dripping earth over a moist curving bottom.

"You are too old. It is a beautiful ballet. Why have you come to me so late?"

"I didn't know before. I was too busy living."

"And now you have done all your living?"

"Enough to be fed up," laughed Alabama.

The woman moved quietly about amongst the appurtenances of the dance.

"We will see," she said. "Make yourself ready."

Alabama hastily dressed herself. Stella showed her about tying her toe shoes back of her anklebones so the knot of the ribbon lay hid in a hollow.

"About *La Chatte*——" said the Russian.

"Yes?"

"You cannot do that. You must not build your hopes so high."

The sign above the woman's head said, "Do Not Touch the Looking

Glass" in French, English, Italian, and Russian. Madame stood with her back to the huge mirror and gazed at the far corners of the room. There was no music as they began.

"You will have the piano when you have learned to control your muscles," she explained. "The only way, now that it is so late, is to think constantly of placing your feet. You must always stand with them *so.*" Madame spread her split satin shoes horizontally. "And you must stretch *so* fifty times in the evenings."

She pulled and twisted the long legs along the bar. Alabama's face grew red with effort. The woman was literally stripping the muscles of her thighs. She could have cried out with pain. Looking at Madame's smoky eyes and the red gash of her mouth, Alabama thought she saw malice in the face. She thought Madame was a cruel woman. She thought Madame was hateful and malicious.

"You must not rest," Madame said. "Continue."

Alabama tore at her aching limbs. The Russian left her alone to work at the fiendish exercise. Reappearing, she sprayed herself unconcernedly before the glass with an atomizer.

"Fatiguée?" she called over her shoulder nonchalantly.

"Yes," said Alabama.

"But you must not stop."

After a while the Russian approached the bar.

"When I was a little girl in Russia," she said impassively, "I did four hundred of those every night."

Rage rose in Alabama like the gurgling of gasoline in a visible tank. She hoped the contemptuous woman knew how much she hated her. "I will do four hundred."

"Luckily, the Americans are athletic. They have more natural talent than the Russians," Madame remarked. "But they are spoiled with ease and money and plenty of husbands. That is enough for today. You have some eau de cologne?"

Alabama rubbed herself with the cloudy liquid from Madame's atomizer. She dressed amongst the confused startled eyes and naked bodies of a class which drifted in. The girls spoke hilariously in Russian. Madame invited her to wait and see the work.

A man sat sketching on a broken iron chair; two heavy bearded personages of the theatre pointed to first one, then another of the girls; a boy in black tights with his head in a bandanna package and the face of a mythical pirate pulverized the air with ankle beats.

Mysteriously the ballet grouped itself. Silently it unfolded its mute clamor in the seductive insolence of back jetés, insouciant pas de chats,

the abandon of many pirouettes, launched its fury in the spring and
stretch of the Russian schstay,* and lulled itself to rest in a sweep of
cradling chassés. Nobody spoke. The room was as still as a cyclone
center.

"You like it?" said Madame implacably.

Alabama felt her face flush with a hot gush of embarrassment. She
was very tired from her lesson. Her body ached and trembled. This first
glimpse of the dance as an art opened up a world. "Sacrilege!" she felt
like crying out to the posturing abandon of the past as she thought
ignominiously of *The Ballet of the Hours* that she had danced ten years
before. She remembered unexpectedly the exaltation of swinging side-
ways down the pavements as a child and clapping her heels in the air.
This was close to that old forgotten feeling that she couldn't stay on
the earth another minute.

"I *love* it. What is it?"

The woman turned away. "It is a ballet of mine about an amateur
who wanted to join a circus," she said. Alabama wondered how she'd
thought those nebulous amber eyes were soft; they seemed to be infer-
nally laughing at her. Madame went on: "You will work again at three
tomorrow."

Alabama rubbed her legs with Elizabeth Arden muscle oil night after
night. There were blue bruises inside above the knee where the muscles
were torn. Her throat was so dry that at first she thought she had fever
and took her temperature and was disappointed to find that she had
none. In her bathing suit she tried to stretch on the high back of a Louis
Quatorze sofa. She was always stiff, and she clutched the gilt flowers in
pain. She fastened her feet through the bars of the iron bed and slept
with her toes glued outwards for weeks. Her lessons were agony.

At the end of a month, Alabama could hold herself erect in ballet
position, her weight controlled over the balls of her feet, holding the
curve of her spine drawn tight together like the reins of a racehorse and
mashing down her shoulders till they felt as if they were pressed flat
against her hips. The time moved by in spasmodic jumps like a school
clock. David was glad of her absorption at the studio. It made them less
inclined to use up their leisure on parties. Alabama's leisure was a
creaky muscle-sore affair and better spent at home. David could work
more freely when she was occupied and making fewer demands on his
time.

*This word spelled *stchay* or *schstay* in the first edition of the novel has been regular-
ized to *schstay* here. It has not been verified as a ballet term, and its meaning is unknown.

At night she sat in the window too tired to move, consumed by a longing to succeed as a dancer. It seemed to Alabama that, reaching her goal, she would drive the devils that had driven her—that, in proving herself, she would achieve that peace which she imagined went only in surety of one's self—that she would be able, through the medium of the dance, to command her emotions, to summon love or pity or happiness at will, having provided a channel through which they might flow. She drove herself mercilessly, and the summer dragged on.

The heat of July beat on the studio skylight and Madame sprayed the air with disinfectant. The starch in Alabama's organdy skirts stuck to her hands and sweat rolled into her eyes till she couldn't see. Choking dust rose off the floor, the intense glare threw a black gauze before her eyes. It was humiliating that Madame should have to touch her pupil's ankles when they were so hot. The human body was very insistent. Alabama passionately hated her inability to discipline her own. Learning how to manage it was like playing a desperate game with herself. She said to herself, "My body and I," and took herself for an awful beating: that was how it was done. Some of the dancers worked with a bath towel pinned around their necks. It was so hot under the burning roof that they needed something to absorb the sweat. Sometimes the mirror swam in red heat waves if Alabama's lesson came at the hours when the direct sun fell on the glass overhead. Alabama was sick of moving her feet in the endless battements without music. She wondered why she came to her lessons at all: David had asked her to swim at Corne-Biche in the afternoon. She felt obscurely angry with Madame that she had not gone off in the cool with her husband. Though she did not believe that the careless happy passages of their first married life could be repeated—or relished if they were, drained as they had been of the experiences they held—still, the highest points of concrete enjoyment that Alabama visualized when she thought of happiness, lay in the memories they held.

"Will you pay attention?" Madame said. "This is for you." Madame moved across the floor mapping the plan of a simple adagio.

"I can't do it," said Alabama. She began negligently, following the path of the Russian. Suddenly she stopped. "Oh, but it is beautiful!" she said rapturously.

The ballet mistress did not turn around. "There are many beautiful things in the dance," she said laconically, "but you cannot do them—yet."

After her lesson, Alabama folded her soaking clothes into her valise. Arienne wrung out her tights in pools of sweat on the floor. Alabama

held the ends while she squeezed and twisted. It cost a lot of sweat to learn to dance.

"I am going away for a month," Madame said one Saturday. "You can continue here with Mlle Jeanneret. I hope that when I come back you will be able to have the music."

"Then I can't have my lesson on Monday?" She had given so much of her time to the studio that it was like being precipitated into a void to think of life without it.

"With Mademoiselle."

Alabama felt great hot tears rolling inexplicably down her face as she watched the tired figure of their teacher disappear in the dusty fog. She ought to be glad of the respite; she had expected to be glad.

"You must not cry," the girl said to her kindly. "Madame must go away for her heart to Royat." She smiled gently at Alabama. "We will get Stella to play for your lessons at once," she said with the air of a conspirator.

Through the heat of August they worked. The leaves dried and decayed in the basin of St-Sulpice; the Champs-Elysées simmered in gasoline fumes. There was nobody in Paris; everybody said so. The fountains in the Tuileries threw off a hot vaporous mist; *midinettes* shed their sleeves. Alabama went twice a day to the studio. Bonnie was in Brittany visiting friends of Nanny. David drank with the crowds of people in the Ritz Bar celebrating the emptiness of the city together.

"Why will you never come out with me?" he said.

"Because I can't work next day if I do."

"Are you under the illusion that you'll ever be any good at that stuff?"

"I suppose not; but there's only one way to try."

"We have no life at home any more."

"You're never there anyway—I've got to have something to do with myself."

"Another female whine—I have to do my work."

"I'll do anything you want."

"Will you come with me this afternoon?"

They went to Le Bourget and hired an aeroplane. David drank so much brandy before they left that by the time they were over the Porte St-Denis he was trying to get the pilot to take them to Marseilles. When they got back to Paris he urged Alabama to get out with him at the Café Lilas. "We'll find somebody and have dinner," he said.

"David, I can't honestly. I get so sick when I drink. I'll have to have morphine if I do, like last time."

"Where are you going?"

"I'm going to the studio."

"Yet you can't stay with me! What's the use of having a wife? If a woman's only to sleep with there are plenty available for that——"

"What's the use of having a husband or anything else? You suddenly find you have them all the same, and there you are."

The taxi whirred through the rue Cambon. Unhappily she climbed the steps. Arienne was waiting.

"What a sad face!" she said.

"Life is a sad business, isn't it, my poor Alabama?" said Stella.

When the preliminary routines at the bar were over, Alabama and Arienne moved to the centre of the floor.

"Bien, Stella."

The sad coquetries of a Chopin mazurka fell flat on the parched air. Alabama watched Arienne searching for the mental processes of Madame. She seemed very squat and sordid. She was the *première danseuse* of the Paris Opéra, nearly at the top. Alabama began sobbing inaudibly.

"Lives aren't as hard as professions," she gasped.

"Well," Arienne cackled, exasperated, "this is not a pension de jeunes filles! Will you do the step your own way if you do not like the way I do?" She stood with her hands on her hips, powerful and uninspired, implying that Alabama's knowledge of the step's existence imposed on her the obligation to perform it. Somebody had to master the thing; it was there in the air. Arienne had put it there, let Arienne do it.

"It is for you, you know, that we work," said Arienne harshly.

"My foot hurts," said Alabama petulantly. "The nail has come off."

"Then you must grow a harder one. Will you begin? *Dva*, Stella!"

Miles and miles of pas de bourrée, her toes picking the floor like the beaks of many feeding hens, and after ten thousand miles you got to advance without shaking your breasts. Arienne smelled of wet wool. Over and over she tried. Her ankles turned; her comprehension moved faster than her feet and threw her out of balance. She invented a trick: you must pull with your spirit against the forward motions of the body, and that gave you the tenebrous dignity and economy of effort known as style.

"But you are a *bête*, an *impossible!*" screeched Arienne. "You wish to understand it before you can do it."

Alabama finally taught herself what it felt like to move the upper part of her body along as if it were a bust on wheels. Her pas de bourrée progressed like a flying bird. She could hardly keep from holding her breath when she did it.

When David asked about her dancing she adopted a superior manner. She felt he couldn't have understood if she had tried to explain about the pas de bourrée. Once she did try. Her exposition had been full of "You-see-what-I-means" and "Can't-you-understands," and David was annoyed and called her a mystic.

"Nothing exists that can't be expressed," he said angrily.

"You are just dense. For me, it's quite clear."

David wondered if Alabama had ever really understood any of his pictures. Wasn't any art the expression of the inexpressible? And isn't the inexpressible always the same, though variable—like the X in physics? It may represent anything at all, but at the same time, it's always actually X.

Madame came back during the September drouth.

"You have made much progress," she said, "but you must get rid of your American vulgarities. You surely sleep too much. Four hours is enough."

"Are you better for your treatments?"

"They put me in a cabinet," she laughed. "I could only stay with somebody holding my hand. Rest is not *commode* for tired people. It is not good for artists."

"It has been a cabinet here this summer," said Alabama savagely.

"And you still want to dance *La Chatte,* poor?"

Alabama laughed. "You will tell me," she said, "when I do well enough to buy myself a tutu?"

Madame shrugged her shoulders, "Why not now?" she said.

"I'd like to be a fine dancer first."

"You must work."

"I work four hours a day."

"It is too much."

"Then how can I be a dancer?"

"I do not know how anybody can be anything," said the Russian.

"I will burn candles to St. Joseph."

"Perhaps that will help; a Russian saint would be better."

During the last days of the hot weather David and Alabama moved to the Left Bank. Their apartment, tapestried in splitting yellow brocade, looked out over the dome of St-Sulpice. Old women hatched in the shadows about the corners of the cathedral; the bells tolled incessantly for funerals. The pigeons that fed in the square ruffled themselves on their window ledge. Alabama sat in the night breezes, holding her face to the succulent heavens, brooding. Her exhaustion slowed up her pulses to the tempo of her childhood. She thought of the time when she

was little and had been near her father—by his aloof distance he had presented himself as an infallible source of wisdom, a bed of sureness. She could trust her father. She half hated the unrest of David, hating that of herself that she found in him. Their mutual experiences had formed them mutually into an unhappy compromise. That was the trouble: they hadn't thought they would have to make any adjustments as their comprehensions broadened their horizons, so they accepted those necessary reluctantly, as compromise instead of as change. They had thought they were perfect and opened their hearts to inflation but not alteration.

The air grew damp with autumn maze. They dined here and there amongst the jeweled women glittering like bright scaled fish in an aquarium. They went for walks and taxi rides. A growing feeling of alarm in Alabama for their relationship had tightened itself to a set determination to get on with her work. Pulling the skeleton of herself over a loom of attitude and arabesque, she tried to weave the strength of her father and the young beauty of her first love with David, the happy oblivion of her teens and her warm protected childhood into a magic cloak. She was much alone.

David was a gregarious person; he went out a great deal. Their life moved along with a hypnotic pound and nothing seemed to matter short of murder. She presumed they wouldn't kill anybody—that would bring the authorities; all the rest was bunk, like Jacques and Gabrielle had been. She didn't care—she honestly didn't care a damn about the loneliness. Years later, she was surprised to remember that a person could have been so tired as she was then.

Bonnie had a French governess who poisoned their meals with *"N'est-ce pas, Monsieur?"* and *"Du moins, j'aurais pensée."* She chewed with her mouth open and the crumbs of sardines about the gold fillings of her teeth nauseated Alabama. She ate staring out on the bare autumnal court. She would have got another governess, but something was sure to happen with things at such a tension and she thought she'd wait.

Bonnie was growing fast and full of anecdotes of Josette and Claudine and the girls at her school. She subscribed to a child's publication, outgrew the guignol, and began to forget her English. A certain reserve manifested itself in her dealings with her parents. She was very superior with her old English-speaking Nanny, who took her out on the days of Mademoiselle's *sortie:* exciting days when the apartment reeked of Coty's L'Origan and Bonnie incurred eruptions on her face from the scones at Rumpelmayer's. Alabama could never make Nanny admit that Bonnie had eaten them; Nanny insisted the spots were in the blood and that it

was better for them to come out, hinting at a sort of exorcising of hereditary evil spirits.

David bought Alabama a dog. They named him Adage. The *femme de chambre* addressed him as "Monsieur" and cried when he was spanked so nobody could ever house-train the beast. They kept him in the guest room with the photographic likenesses of the apartment owner's immediate family peering through the fumes of his *saleté*.

Alabama felt very sorry for David. He and she appeared to her like people in a winter of adversity picking over old garments left from a time of wealth. They repeated themselves to each other; she dragged out old expressions that she knew he must be tired of; he bore her little show with a patent mechanical appreciation. She felt sorry for herself. She had always been so proud of being a good stage manager.

November filtered the morning light to a golden powder that hung over Paris stabilizing time till the days stayed at morning all day long. She worked in the gray gloom of the studio and felt very professional in the discomfort of the unheated place. The girls dressed by an oil stove that Alabama bought for Madame; the dressing room reeked of glue from the toe shoes warming over the thin blaze, of stale eau de cologne, and of poverty. When Madame was late, the dancers warmed themselves by doing a hundred relevés to the chanted verses of Verlaine. The windows could never be opened because of the Russians, and Nancy and May, who had worked with Pavlova, said the smell made them sick. May lived at the Y.W.C.A. and wanted Alabama to come to tea. One day, as they were going down the steps together, she said to Alabama that she could not dance any more, that she was quite sick.

"Madame's ears are so filthy, my dear," she said, "it makes me quite sick."

Madame had made May dance behind the others. Alabama laughed at the girl's disingenuousness.

There was Marguerite, who came in white, and Fania in her dirty rubber undergarments, and Anise and Anna who lived with millionaires and dressed in velvet tunics, and Céza in gray and scarlet—they said she was a Jew—and somebody else in blue organdie, and thin girls in apricot draperies like folds of skin, and three Tanyas like all the other Russian Tanyas, and girls in the starkness of white who looked like boys in swimming, and girls in black who looked like women, a superstitious girl in mauve, and one dressed by her mother who wore cerise to blind them all in that pulsating gyroscope, and the thin pathetic femininity of Marte, who danced at the Opéra Comique and swept off belligerently after classes with her husband.

Arienne Jeanneret dominated the vestibule. She dressed with her face to the wall and had many preparations for rubbing herself and bought fifty pairs of toe slippers at a time, which she gave to Stella when she'd worn them a week. She kept the girls quiet when Madame was giving a lesson. The vulgarity of her hips repelled Alabama but they were good friends. It was with Arienne that she sat in the café under the Olympia after their lessons and drank the daily Cap Corse with seltzer. Arienne took her backstage at the Opéra where the dancer was well respected, and Arienne came to lunch with Alabama. David hated her guts because she tried to give him moral lectures about his opinions and his drinking, but she was not bourgeoise: she was gamine, full of strident jokes about firemen and soldiers, and Montmartre songs about priests and peasants and cuckolds. She was almost an elf, but her stockings were always wrinkled and she talked in sermons.

She took Alabama to see Pavlova's last performance. Two men like Beerbohm cartoons asked to see them home. Arienne refused.

"Who are they?" asked Alabama.

"I do not know—subscribers to the Opéra."

"Then why do you talk to them if you've never met them?"

"One does not meet the patrons of the first three rows of the National Opéra; the seats are reserved for men," said Arienne. She herself lived with her brother near the Bois. Sometimes she cried in the dressing room.

"Zambelli still dancing *Coppélia!*" she'd say. "You don't know how difficult life is, Alabama, you with your husband and your baby." When she cried the black came off her eyelashes and dried in lumps like a wet watercolor. There was a spiritual open space between her gray eyes that seemed as pure as an open daisy field.

"Oh, *Arienne!*" said Madame enthusiastically. "There's a dancer! When she cries it is not for nothing." Alabama's face grew colorless with fatigue and her eyes sank in her head like the fumes of autumnal fires.

Arienne helped her to master the entrechats.

"You must not rest when you come down after the spring," she said, "but you must depart again immediately, so that the impetus of the first leap carries you through the others like the bouncing of a ball."

"*Da,*" said Madame, "*da! da!*—But it is not enough." It was never enough to please Madame.

She and David slept late on Sundays, dining at Foyot's or someplace near their home.

"We promised your mother to come home for Christmas," he said over many tables.

"Yes, but I don't see how we can go. It's so expensive, and you haven't finished your Paris pictures."

"I'm glad you are not too disappointed because I had decided to wait until spring."

"There's Bonnie's school, too. It would be a shame to switch just now."

"We'll go for Easter, then."

"Yes."

Alabama did not want to leave Paris where they were so unhappy. Her family grew very remote with the distention of her soul in schstay and pirouette.

Stella brought a Christmas cake to the studio, and two chickens for Madame that she had received from her uncle in Normandy. Her uncle wrote her that he could send no more money: the franc was down to forty. Stella made her living copying sheet music, which ruined her eyes and left her starving. She lived in a garret and got sinus trouble from the drafts, but she would not give up wasting her days at the studio.

"What can a Pole do in Paris?" she said to Alabama. What can anybody do in Paris? When it comes to fundamentals, nationalities do not count for much.

Madame got Stella a job turning pages for musicians at concerts, and Alabama paid her ten francs a pair for darning her toe shoes on the ends to keep them from slipping.

Madame kissed them all on both cheeks for Christmas, and they ate Stella's cake. It was as much of a Christmas as she would have at their apartment, thought Alabama without emotion—that was because she hadn't put any interest into their Christmas at home.

Arienne sent Bonnie an expensive kitchen outfit as a present. Alabama was touched when she thought how her friend probably needed the money it cost. Nobody had any money.

"I shall have to give up my lessons," said Arienne. "The pigs at the Opéra pay us a thousand francs a month. I cannot live on it."

Alabama invited Madame to dinner and to see a ballet. Madame was very white and fragile in a pale-green evening dress. Her eyes were fixed on the stage. A pupil of hers was dancing *Le Lac des Cygnes*. Alabama wondered what passed behind those yellow Confucian eyes as she watched the white sifting stream of the ballet.

"It is much too small nowadays," the woman said. "When I danced, things were of a different scale."

Alabama looked incredulous. "Twenty-four fouettés, she did," she said. "What more can anybody do?" It had physically hurt her to see the ethereal steely body of the dancer snapping and whipping itself in the mad convolutions of those turns.

"I do not know what they can do. I only know that I did something else," said the artist, "that was better."

She did not go backstage after the performance to congratulate the girl. She and Alabama and David went to a Russian cabaret. At the table next to theirs sat Hernandara trying to fill a pyramid of champagne glasses by pouring into the top one only. David joined him; the two men sang and shadowboxed on the dance floor. Alabama was ashamed and afraid that Madame would be offended.

But Madame had been a princess in Russia with all the other Russians.

"They are like puppies playing," she said. "Leave them. It is pretty."

"Work is the only pretty thing," said Alabama, "—at least, I have forgotten the rest."

"It is good to amuse oneself when one can afford it," Madame spoke reminiscently. "In Spain, after a ballet, I drank red wine. In Russia it was always champagne."

Through the blue lights of the place and the red lamps in iron grilles, the white skin of Madame glowed like the arctic sun on an ice palace. She did not drink much but ordered caviar and smoked many cigarettes. Her dress was cheap; that saddened Alabama—she had been such a great dancer in her time. After the war she had wanted to quit, but she had no money and kept her son at the Sorbonne. Her husband fed himself on dreams of the Corps des Pages and quenched his thirst with reminiscences till there was nothing left of him but a bitter aristocratic phantom. The Russians! suckled on a gallant generosity and weaned on the bread of revolution, they haunt Paris! Everything haunts Paris. Paris is haunted.

Nanny came to Bonnie's Christmas tree, and some friends of David's. Alabama thought dispassionately of Christmas in America. They did not sell little frosted houses to hang on Christmas trees in Alabama. In Paris the florists' were filled with Christmas lilacs, and it rained. Alabama took flowers to the studio.

Madame was enraptured.

"When I was a girl, I was a miser for flowers," she said. "I loved the

flowers of the fields and gathered them in bouquets and *boutonnières* for the guests who came to my father's house." These little details from the past of so great a dancer seemed glamorous and poignant to Alabama.

By springtime, she was gladly, savagely proud of the strength of her Negroid hips, convex as boats in a wood carving. The complete control of her body freed her from all fetid consciousness of it.

The girls carried away their dirty clothes to wash them. There was heat incubating again in the rue des Capucines and another set of acrobats at the Olympia. The thin sunshine laid pale commemoration tablets on the studio floor, and Alabama was promoted to Beethoven. She and Arienne kidded along the windy streets and roughhoused in the studio, and Alabama drugged herself with work. Her life outside was like trying to remember in the morning a dream from the night before.

◦ II ◦

"Fifty-one, fifty-two, fifty-three—but I tell you, Monsieur, you must give me the message. I occupy the position of the advisor of Madame —fifty-four, fifty-five——"

Hastings surveyed the panting body coldly. Stella lapsed into a technically seductive attitude. She had often seen Madame behave just so. She stared into his face as if she were in possession of some vital secret, and awaited his application for an introduction to the mystery. Her petits battements had been well done. She was quite *réchauffé* for so early in the afternoon.

"It was Mrs. David Knight that I wanted to see," said Hastings.

"Our Alabama! She will surely be here before long. She is a dear, Alabama," cooed Stella.

"There was nobody at home at the apartment, so they told me to come here." Hastings' eyes roved about incredulously as if there must be some mistake.

"Oh, she!" said Stella. "She is always here. You have only to wait. If Monsieur will excuse me——?"

Fifty-seven, fifty-eight, fifty-nine. At three hundred and eighty Hastings rose to leave. Stella sweated and blew like a porpoise making believe she hated the difficulties of the self-imposed bar work. She made believe she was a beautiful galley slave whom Hastings might possibly be wanting to purchase.

"Just tell her I came, will you?" he said.

"Of course, and that you went away. I am sorry that what I can do is not more interesting for Monsieur. There is a class at five if Monsieur would care to——"

"Yes, tell her I went away." He stared about him distastefully. "I don't suppose she'd be free for a party, anyway."

Stella had been so much in the studio that she had absorbed an air of complete confidence in her work like all the pupils of Madame. If people who watched were not fascinated, it must be some lack in themselves of aesthetic appreciation.

Madame allowed Stella to work without paying; many dancers did the same who had no money. When there was money they paid—that was the Russian system.

The crash of a suitcase bumping up the stairs announced the arrival of a student.

"A friend has called," she said importantly. It was inconceivable to the isolated Stella that a visit could be without consequence. Alabama, too, was forgetting the old casual modulations of life. Against the violent twist and thump of tour jeté nothing stood out but the harshest, most dissonant incident.

"What did they want?"

"How should I know?"

A vague unreasoning dread filled Alabama—she must keep the studio apart from her life—otherwise one would soon become as unsatisfactory as the other, lost in an aimless, impenetrable drift.

"Stella," she said, "if they should come again—if anyone should come here for me, you will always say you don't know anything about me—that I am not here."

"But why? It is for the appreciation of your friends that you will dance."

"No, no!" Alabama protested. "I cannot do two things at once—I wouldn't go down the Avenue de l'Opéra leaping over the traffic cop with pas de chat, and I don't want my friends rehearsing bridge games in the corner while I dance."

Stella was glad to share in any personal reactions to life, that side of her own being an empty affair boxed by attics and berated by landladies.

"Very well! Why should life interfere with us artists?" she agreed pompously.

"Last time he was here my husband smoked a cigarette in the studio," continued Alabama in an attempt to justify the clandestine protestations.

"Oh," Stella was scandalized. "I see. If I had been here, I would have told him about the awfulness of smells when one is working."

Stella dressed herself in the worn-out ballet skirts of other dancers and pink gauze shirts from the Galeries Lafayette. She pinned the shirt down over the yoke of the skirt with big safety pins to form a basque. She lived at the studio during the day, clipping the stems of the flowers the pupils brought Madame to keep them fresh, polishing the great mirror, repairing the music with strips of adhesive, and playing for lessons when the pianist was absent. She thought of herself as councillor to Madame. Madame thought of her as a nuisance.

Stella was very conscientious about earning her lessons. If anyone else tried to do the smallest thing for Madame, it precipitated a scene of sulks and weeping. Her dreamy Polish eyes were faded to the yellowish green of scum on a stagnant pool by the glaze of starvation and intensity. The girls bought her croissants and café au lait at midday and called her *"ma chère."* Alabama and Arienne gave her money on one pretext or another. Madame gave her old clothes and cakes. In return, she told them each separately that Madame had said they were making more progress than the others and juggled the working hours in Madame's little book so that her eight-hour day sometimes held nine or ten one-hour periods. Stella lived in an air of general intrigue.

Madame was severe with the girl. "You know you can never dance. Why do you not get work to do?" she scolded. "You will be old, I will be old—then what will become of you?"

"I have a concert next week. I will have twenty francs for turning pages. Oh, Madame, please let me stay!"

No sooner had Stella the twenty francs than she approached Alabama. "If you would give me the rest," she pleaded persuasively, "we could buy a medicine cabinet for the studio. Only last week someone turned an ankle—we should have means to disinfect our blisters." Stella talked incessantly about the cabinet until Alabama went with her one morning to get it. They waited in the golden sunshine crystallizing the gilt front of Au Printemps for the store to open. The thing cost a hundred francs and was to be a surprise for Madame.

"You may give it to her, Stella," said Alabama, "but I am going to pay. You cannot afford such an extravagance."

"No," mourned Stella, "I have no husband to pay for me! *Hélas!*"

"I give up other things," Alabama replied crossly. She couldn't feel resentment against the misshapen, melancholy Pole.

Madame was displeased.

"It is ridiculous," she said. "There is not room for so bulky an affair in the dressing room." When she saw Stella's frantic eyes, gluey with disappointment, she added, "But it will be very convenient. Leave it. Only you must not spend your money on me."

She delegated to Alabama the job of seeing that Stella bought her no more presents.

Madame argued over the dried raisins and licorice bonbons that Stella brought to leave on her table and about the Russian bread she brought in little packages; bread with cheese cooked inside and bread with sugar pellets, caraway bread and glutinous black tragedian breads, breads hot from the oven smelling of innocence, and moldy epicurean breads from Yiddish bakeries. Anything Stella had money to buy, she bought for Madame.

Instead of curbing Stella, Alabama absorbed the aimless extravagance of the girl. She couldn't wear new shoes; her feet were too sore. It seemed a crime owning new dresses to smell them up with eau de cologne and leave them hanging all day long against the studio walls. She thought she could work better when she felt poor. She had abandoned so many of the occasions of exercising personal choice that she spent the hundred-franc notes in her purse on flowers, endowing them with all the qualities of the things she might have bought under other circumstances, the thrill of a new hat, the assurance of a new dress.

Yellow roses she bought with her money like Empire satin brocade, and white lilacs and pink tulips like molded confectioner's frosting, and deep-red roses like a Villon poem, black and velvety as an insect wing, cold blue hydrangeas clean as a newly calcimined wall, the crystalline drops of lily of the valley, a bowl of nasturtiums like beaten brass, anemones pieced out of wash material, and malignant parrot tulips scratching the air with their jagged barbs, and the voluptuous scrambled convolutions of Parma violets. She bought lemon-yellow carnations perfumed with the taste of hard candy, and garden roses purple as raspberry puddings, and every kind of white flower the florist knew how to grow. She gave Madame gardenias like white kid gloves and forget-me-nots from the Madeleine stalls, threatening sprays of gladioli, and the soft, even purr of black tulips. She bought flowers like salads and flowers like fruits, jonquils and narcissus, poppies and ragged robins, and flowers with the brilliant carnivorous qualities of Van Gogh. She chose from windows filled with metal balls and cactus gardens of the florists near the rue de la Paix, and from the florists uptown who sold mostly plants and purple iris, and from florists on the Left Bank whose shops were lumbered up with the wire frames of designs, and from outdoor

markets where the peasants dyed their roses to a bright apricot, and stuck wires through the heads of the dyed peonies.

Spending money had played a big part in Alabama's life before she had lost, in her work, the necessity for material possessions.

Nobody was rich at the studio but Nordika. She came to her lessons in a Rolls-Royce, sharing her hours with Alacia, who had the same essence as a Bryn Mawr graduate, she was so practical. It was Alacia who took His Highness away from Nordika, but Nordika hung on to the money and they made a go of it together some way. Nordika was the pretty one like a blonde ejaculation, and Alacia was the one who had moved Milord to pity. Nordika was tremulous with a glassy excitement that she tried to repress—they said in the ballet that Nordika's excitement ruined all of her costumes. Nordika couldn't go around vibrating in a void so her friend managed to anchor her feet enough to the ground to keep the car. Both of them threatened to leave Madame's studio because Stella hid a half-eaten can of shrimp behind their mirror, where it slowly soured. Stella said to the girls that the smell was dirty clothes. When they found what it really was, they were merciless to poor Stella. Stella liked having the chic Nordika and her friend in the class because they were almost the same as an audience.

"*Polissonne!*" they said to Stella. "It is bad enough to eat shrimp at home without bringing it here like a stink bomb."

Stella had so little room at home that she had to keep her trunk jammed out the attic window half in the open. A can of shrimp would have asphyxiated her in the small place.

"Don't mind," said Alabama. "I will take you to Prunier's for shrimp."

Madame said Alabama was a fool to take Stella to Prunier's for shrimp. Madame could remember the days when she and her husband had eaten caviar together in the butchery fumes of the rue Duphot. Forever, to Madame, a presage of disaster lay in the conjured image of the oyster bar—revolutions would almost certainly follow excursions to Prunier's, and poverty and hard times. Madame was superstitious; she never borrowed pins and had never danced in purple, and she somehow thought of trouble in connection with the fish she had loved so well when she could afford it. Madame was very afraid of any luxury.

The saffron in the bouillabaisse made Alabama sweat under the eyes and turned the Barsac tasteless. During the lunch Stella fidgeted across the table and folded something into her napkin. The girl was not as impressed as Alabama would have liked with Prunier's.

"Barsac is a monkish wine," suggested Alabama absently.

Secretively Stella extracted whatever it was she dredged from the bottomless soup. She was too engrossed to answer. She was as absorbed as a person searching for a dead body.

"What on earth are you doing, *ma chère?*" It irritated Alabama that Stella was not more enthusiastic. She resolved never to take another poor person to a rich man's place; it was a waste of money.

"Sh—sh—sh! *Ma chère* Alabama, it is pearls I have found—big ones, as many as three! If the waiters know they will claim them for the establishment, so I make a cache in my napkin."

"Really," asked Alabama, "show me!"

"When we are in the street. I assure you it is so. We will grow rich, and you will have a ballet and I will dance in it."

The girls finished their lunch breathlessly. Stella was too excited to make her usual senseless protestations about paying the check.

In the pale filtrations of the street they opened the napkin carefully.

"We will buy Madame a present," she crowed.

Alabama inspected the globular yellow deposits.

"They're only lobster eyes," she pronounced decisively.

"How should I know? I have never eaten lobsters before," said Stella phlegmatically.

Imagine living your life with your only hope of finding pearls and fortunes and the unexpected stewed in the heart of a bouillabaisse! It was like being a child and keeping your eyes forever glued to the ground looking for a lost penny—only children do not have to buy bread and raisins and medicine cabinets with the pennies they find on the pavement!

Alabama's lessons began the day at the studio.

In the cold barracks the maid scrubbed and coughed. The woman rubbed her fingers unfeelingly through the flame of the oil stove, pinching the wick.

"The poor woman!" said Stella. "She has a husband who beats her at night—she has showed me the places—her husband has no jawbone since the war. We should give her something, perhaps?"

"Don't *tell* me about it, Stella! We can't be sorry for everybody."

It was too late—Alabama had already noticed the caked black blood under the woman's fingernails where they were split by the stiff brush in her freezing pail of eau de Javelle. She gave her ten francs and hated the woman for making her sorry. It was bad enough working in the cold asthmatic dust without knowing about the maid.

Stella broke the thorns from the rose stems and gathered the shattered

petals off the floor. She and Alabama shivered and worked quickly to get warm.

"Show me again how Madame has shown you in your private lessons," urged Stella.

Alabama went over and over for her the breathless contraction and muscular abandon necessary to attain elevation. You did the same thing for years, and after three years you might lift yourself an inch higher—of course, there was always the chance that you wouldn't.

"And you must, after the effort of launching your body is accomplished, let it fall in midair—this way." She heaved her body with a stupendous inflation off the floor and came to rest limply, like a deflated balloon.

"Oh, but you will be a dancer!" the girl sighed gratefully, "but I do not see *why,* since you have already a husband."

"Can't you understand that I am not trying to get anything—at least, I don't think I am—but to get rid of some of myself?"

"Then why?"

"To sit this way, expectant of my lesson, and feel that if I had not come the hour that I own would have stood vacant and waiting for me."

"Is your husband not angry that you are so much away?"

"Yes. He is so angry that I must be away even more to avoid rows about it."

"He does not like the dance?"

"Nobody does, only dancers and sadists."

"Incorrigible! Teach me again about the jeté."

"You cannot do it—you are too fat."

"Teach me and I shall be able to play it on the piano for your lessons."

When anything went wrong with the adagio, in silent and controlled rage, Alabama blamed the girl.

"You hear something far away," said Madame, suggesting.

Alabama could not manage to convey hearing with the lines of her body. She was humiliated to listen with her hips.

"I hear only Stella's discords," she whispered fiercely. "She does not keep time."

Madame withdrew herself when her pupils quarreled.

"A dancer's supposed to lead the music," she said succinctly. "There is no melody in ballet."

One afternoon David came with some old friends.

Alabama was angry with Stella when she saw him there.

"My lessons are not a circus. Why did you let them come in?"

"It was your *husband!* I cannot stand in front of the door like a dragon."

"Failli, cabriole, cabriole, failli, soubresaut, failli, coupé, ballonné, ballonné, ballonné, pas de basque, deux tours."

"Isn't that 'Tales from the Vienna Woods'?" asked the tall chic Dickie, smoothing herself over.

"I don't see why Alabama didn't take from Ned Weyburn," said the elegant Miss Douglas with her hair like a porphyry tomb.

The yellow sun of the afternoon poured a warm vanilla sauce in the window. "Failli, cabriole," Alabama bit her tongue.

Running to the window to spit the quick blood, she was overwhelmingly conscious of the woman beside her. The blood trickled down her chin.

"What is it, *chérie?*"

"Nothing."

Miss Douglas said indignantly, "I think it's ridiculous to work like that. She can't be getting any fun out of it, foaming at the mouth that way!"

Dickie said, "It's abominable! She'll never be able to get up in a drawing room and do *that!* What's the good of it?"

Alabama had never felt so close to a purpose as she did at that moment. "Cabriole, failli"—"Why" was something the Russian understood and Alabama almost understood. She felt she would know when she could listen with her arms and see with her feet. It was incomprehensible that her friends should feel only the necessity to hear with their ears. That was "Why." Fierce loyalty to her work swelled in Alabama. Why did she need to explain?

"We'll meet you at the corner in the bistro," said David's note.

"You will join your friends?" Madame asked disinterestedly as Alabama read.

"No," answered Alabama abruptly.

The Russian sighed. "Why not?"

"Life is too sad, and I will be too dirty after my lesson."

"What will you do at home alone?"

"Sixty fouettés."

"Do not forget the pas de bourrée."

"Why can I not have the same steps as Arienne," stormed Alabama, "or at least as Nordika? Stella says that I dance nearly as well."

So Madame led her through the intricacies of the waltz from *Pavillon*

d'Armide, and Alabama knew that she did the thing like a child jumping rope.

"You see," said Madame, "not yet! It is difficult to dance for Diaghilev."

Diaghilev called his rehearsals at eight in the morning. His dancers left the theater around one at night. From the requisite work with their *maître de ballet* they came direct to the studio. Diaghilev insisted that they live at so much nervous tension that movement, which meant dancing to them, became a necessity, like a drug. They worked incessantly.

One day there was a wedding in his troupe. Alabama was surprised to see the girls in street clothes, in furs and shadow lace as they congregated at the studio. They appeared older; there was a distinction about them that came from the consciousness of their beautiful bodies even in their cheap clothes. If they weighed more than fifty kilos, Diaghilev protested in his high screeching voice, "You must get thin. I cannot send my dancers to a gymnasium to fit them for adagio." He never thought of the women as dancers, except the stars. An allegiance to his genius as strong as a cult determined all their opinions. The quality that set them off from other dancers was his insistence on their obliteration of self to the integral purpose of his ballet. There was no *petite marmite* in his productions, nor in the people that he produced out of ragged Russian waifs, some of them. They lived for the dance and their master.

"What are you doing with your face?" Madame would say scathingly. "It is not a cinema we are making. You will please to keep it as expressionless as you can."

"Race, dva, tree, race, dva, tree——"

"Show me, Alabama," Stella cried in despair.

"How can I show you? I can't do it myself," she answered irritably. She was angry when Stella placed her in the same class with herself. She said to herself that she would give Stella no more money to teach her her place. But the girl came to her tearfully smelling of butter and the mechanics of life, offering an apple she had bought for Alabama or a sack of mint tips, and Alabama gave her ten francs anyway, to pay for the apple.

"If you were not here," Stella said, "how could I live? My uncle can send me no more money."

"How can you live when I have gone to America?"

"Other people will come—perhaps from America." Stella smiled improvidently. Though she talked a great deal about the difficulties of the future, it was impossible for her to think further ahead than a day.

Maleena came to give Stella money. She wanted to open a studio of her own, and she offered Stella the job as her pianist if she could get enough pupils away from the classes of Madame. It was Maleena's mother who wanted to do the dishonest thing—she had herself been a dancer but not a big one.

The mother was as bloated as the delicatessen sausages that kept her alive, and half blinded by the vicissitudes of life. In her pudgy, greasy hands she held a lorgnette and peered at her daughter. "See," she said to Stella. "Pavlova cannot do sauts sur les pointes like that! There is no dancer like my Maleena. You will get your friends to come to our studio?"

Maleena was chicken-breasted; she performed the dance like a person administering lashes with a scourge.

"Maleena is like a flower," the old lady said. When Maleena perspired she smelled of onions. Maleena pretended that she loved Madame. She was an old pupil—her mother thought Madame should have got her a job with the Russian ballet.

In watering the floor before class the watering can slipped in Stella's hands and drenched the parquet over Maleena's place in line. She did not dare complain, imagining that Madame would suspect her hostility.

"Failli, cabriole, cabriole, failli——"

Maleena slipped in the puddle and split her kneecap.

"I knew our chest would be useful," said Stella. "You will help me with the bandage, Alabama."

"——Race, Dva, Tree!"

"The roses are dead," Stella reminded Alabama reproachfully. She begged for the old organdy skirts which would not meet across her back and gapped scandalously over her dingy tights. Alabama had them made with four ruffles on a broad band that bound her hips—five francs it cost to get them ironed in a French laundry. There was a red and white check for weather like Normandy, a chartreuse for decadent days, pink for her lessons at midday, and sky blue for late afternoon. In the mornings she liked white skirts best to match the colorless reflection on the skylight.

For the waist she bought cotton bicycle shirts and faded them in the sun to pastel shades, burnt orange to wear over the pink, green for the pale chartreuse. It was a game to Alabama discovering new combinations. The habitual flamboyance expressed in her street dress flowered in this less restricted medium. She wore a chosen color for every mood.

David complained that her room smelled of eau de cologne. There

SAVE ME THE WALTZ

was always a pile of dirty clothes from the studio dumped in the corner. The voluminous ruffles of the skirts wouldn't fit in the closets or drawers. She wore herself to a frazzle, and didn't notice about the room.

Bonnie came in one day to say good morning. Alabama was late; it was half past seven; the damp of the night air had taken the stiffening out of her skirt. She turned crossly to Bonnie. "You haven't brushed your teeth this morning," she said irritably.

"Oh, but I have!" said the little girl defiantly, angry at her mother's suspicion. "You told me to always before I did anything in the mornings."

"I told you to, so you just thought you wouldn't today. I can see the brioche still on the front ones," Alabama pursued.

"I did so brush them."

"Don't lie to me, Bonnie," said her mother angrily.

"It's you who's a lie!" flared Bonnie recklessly.

"Don't you dare say that to me!" Alabama grabbed the small arms and slapped the child soundly over the thighs. The short explosive sound warned her that she had used more force than she had intended. She and her daughter stared at each other's red reproachful faces.

"I'm sorry," said Alabama pathetically. "I didn't mean to hurt you."

"Then why did you slap me?" protested the child, full of resentment.

"I meant to make it just hard enough to show you that you have to pay for being wrong." She did not believe what she said, but she had to offer some explanation.

Alabama hastily left the apartment. On her way past Bonnie's door down the corridor she paused.

"Mademoiselle?"

"Oui, Madame?"

"Did Bonnie brush her teeth this morning?"

"Naturally! Madame has left orders that that is to be tended to first thing on rising, though I personally think it spoils the enamel——"

"Damn it," said Alabama viciously to herself, "there were nevertheless crumbs. What can I say to make up to Bonnie for the sense of injustice she must have?"

Nanny brought Bonnie to the studio one afternoon when Mademoiselle was out. The dancers spoiled her dreadfully; Stella gave her candy and sweets, and Bonnie choked and sputtered, rubbing her hands through the melted chocolate that plastered her mouth, Alabama had been so severe about her not making a noise that the child tried not to cough. Stella led the little red-faced, gasping girl into the vestibule, patting her over the back.

"You will dance also," she said, "when you are bigger?"

"No," said Bonnie emphatically, "it is too 'sérieuse' to be the way Mummy is. She was nicer before."

"Madam," said Nanny, "I was really astonished at how well you do, really. You do nearly as well as the others. I wonder if I should like it —it must be very good for you."

"Lord," Alabama said infuriated.

"We must all have something to do, and Madam never plays bridge," persisted Nanny.

"We get something to do and as soon as we've got it, it gets us." Alabama wanted to say "Shut up!"

"Isn't that always the way?"

When David suggested coming again to the studio Alabama protested.

"Why not?" he said. "I should think you would want me to see you practice."

"You wouldn't understand," she answered egotistically. "You will just see that I am given only the things I can't do and discourage me."

The dancers worked always beyond their strength.

"Why 'déboulé'?" Madame expostulated. "You do that already— passably."

"You're so thin," said David patronizingly. "There's no use killing yourself. I hope that you realize that the biggest difference in the world is between the amateur and the professional in the arts."

"You might mean yourself and me——" she said thoughtfully.

He exhibited her to his friends as if she were one of his pictures.

"Feel her muscle," he said. Her body was almost their only point of contact.

The *saillants* of her sparse frame glowed with the gathering despair of fatigue that lit her interiorly.

David's success was his own—he had earned his right to be critical —Alabama felt that she had nothing to give to the world and no way to dispose of what she took away.

The hope of entering Diaghilev's ballet loomed before her like a protecting cathedral.

"You're not the first person who's ever tried to dance," David said. "You don't need to be so sanctimonious about it."

Alabama was despondent, nourishing her vanity on the questionable fare of Stella's liberal flattery.

Stella was the butt of the studio. The girls, angry and jealous of each other, took out their spite and ill temper on the clumsy, massive Pole.

She made such an effort to please that she was always in the way of
everybody—she flattered them all.

"I can't find my new tights—four hundred francs they cost," flared
Arienne. "I have not got four hundred francs to throw from the window!
There have never been thieves before in the studio." She glared at the
dancers and fixed on Stella.

Madame was called to quell the rising insults. Stella had put the tights
in Nordika's chest. Nordika said angrily that she would have to have
her tunics dry-cleaned; it was unnecessary, her saying that; Arienne was
immaculate.

It was Stella who placed Kira behind Arienne that she might better
learn by imitating the fine technician. Kira was a beautiful girl with long
brown hair and high voluptuous curves. She was a protégée—nobody
knew of whom, but she was unable to move without supervision.

"Kira!" shrieked Arienne, "will spoil my dancing! She sleeps at the
bar and sleeps on the floor. You would think this is a rest cure!"

Kira's voice was cracked. "Arienne," she wheedled, "you will help
me with my batterie?"

"You have no batterie," stormed Arienne, "outside of a batterie de
cuisine, perhaps, and I would have Stella know that I form my own
protégées."

When Stella had to tell Kira to move farther down the bar, Kira cried
and went to Madame.

"What has Stella to do with where I stand?"

"Nothing," answered Madame, "but since she lives here, you must
not notice her more than the walls."

Madame never said much. She seemed to expect the girls to quarrel.
Sometimes she discussed the qualities of yellow or cerise or Mendels-
sohn. Inevitably the sense of her words was lost for Alabama, drifting
off into that dark mournful harvest of the tides of the Sea of Marmara,
the Russian language.

Madame's brown eyes were like the purple bronze footpaths through
an autumn beechwood where the mold is drenched with mist, and clear
fresh lakes spurt up about your feet from the loam. The classes swayed
to the movements of her arms like an anchored buoy to the tides. Saying
almost nothing in that ghoulish Eastern tongue, the girls were all mu-
sicians and understood that Madame was exhausted with their self-as-
sertion when the pianist began the pathetic lullaby from the entr'acte of
Cleopatra; that the lesson was going to be interesting and hard when she
played Brahms. Madame seemed to have no life outside her work, to
exist only when she was composing.

"Where does Madame live, Stella?" asked Alabama curiously.

"But, ma chère, the studio is her home," said Stella, "for us anyway."

Alabama's lesson was interrupted one day by men with measuring rods. They came and paced the floor and made laborious estimates and calculations. They came again at the end of the week.

"What is it?" said the girls.

"We will have to move, chéries," Madame answered sadly. "They are making a moving-picture studio of my place here."

At her last lesson, Alabama searched behind the dismantled segments of the mirror for lost pirouettes, for the ends of a thousand arabesques.

There was nothing but thick dust, and the traces of hairpins rusted to the wall where the huge frame had hung.

"I thought I might find something," she explained shyly, when she saw Madame looking at her curiously.

"And you see there is nothing!" said the Russian, opening her hands. "But in my new studio you may have a tutu," she added. "You asked me to tell you. Perhaps in its folds, who knows what you may find."

The fine woman was sad to leave those faded walls so impregnated with her work.

Alabama had sweated to soften the worn floor, worked with the fever of bronchitis to appease the drafts in winter, candles were burning at St-Sulpice. She hated to leave, too.

She and Stella and Arienne helped Madame to move her piles of old abandoned skirts, worn toe shoes, and discarded trunks. As she and Arienne and Stella sorted and arranged these things redolent of the struggle for plastic beauty, Alabama watched the Russian.

"Well?" said Madame. "Yes, it is very sad," she said implacably.

◦ III ◦

The high corners of the new studio in the Russian Conservatory carved the light to a diamond's facets.

Alabama stood alone with her body in impersonal regions, alone with herself and her tangible thoughts, like a widow surrounded by many objects belonging to the past. Her long legs broke the white tutu like a statuette riding the moon.

"Khorosho," the ballet mistress said, a guttural word carrying the sound of hail and thunder over the Steppes. The Russian face was white and prismatic as a dim sun on a block of crystal. There were blue veins

in her forehead like a person with heart trouble, but she was not sick except from much abstraction. She lived a hard life. She brought her lunch to the studio in a little valise: cheese and an apple, and a Thermos full of cold tea. She sat on the steps of the dais and stared into space through the sombre measures of the adagio.

Alabama approached the visionary figure, advancing behind her shoulder blades, bearing her body tightly possessed, like a lance in steady hands. A smile strained over her features painfully—pleasure in the dance is a hard-earned lesson. Her neck and chest were hot and red; the back of her shoulders strong and thick, lying over her thin arms like a massive yoke. She peered gently at the white lady.

"What do you find in the air that way?"

There was an aura of vast tenderness and of abnegation about the Russian.

"Forms, child, shapes of things."

"It is beautiful?"

"Yes."

"I will dance it."

"Well, pay attention to the design. You do well the steps, but you never follow the configuration: without that, you cannot speak."

"You will see if I can do it."

"Go, then! Chérie, it is my first role."

Alabama yielded herself to the slow dignity of the selfless ritual, to the voluptuous flagellation of the Russian minors. Slowly she moved to the protestations of the adagio from *Le Lac des Cygnes*.

"Wait a minute."

Her eyes caught the white transparent face in the glass. The two smiles met and splintered.

"But I will do it if I break my leg," she said, beginning again.

The Russian gathered her shawl about her shoulders. From a deep mysticism she said tentatively and without conviction, "It is not worth that trouble—then you could not dance."

"No," said Alabama, "it's not worth the trouble."

"Then, little one," sighed the aging ballerina, "you will do it—just right."

"We will try."

The new studio was different. Madame had less space to spare; she gave fewer lessons for nothing. There was no room in the dressing room to practice changement de pieds. The tunics were cleaner since there was no place to leave them to dry. There were many English girls

in the classes who still believed in the possibility of both living and dancing, filling the vestibule with gossip of boat rides on the Seine and soirées in the Montparnasse.

It was awful in the afternoon classes. A black fog from the station hung over the studio skylight, and there were too many men. A Negro classicist from the Folies-Bergère appeared at the bar. He had a gorgeous body but the girls laughed. They laughed at Alexandre with his intellectual face and glasses—he used to own a box at the ballet in Moscow when he had been in the army. They laughed at Boris, who stopped in the café next door for ten drops of valerian before his lessons; they laughed at Schiller because he was old and his face was puffy from years of makeup like a bartender's or a clown's. They laughed at Danton because he could toe-dance, though he tried to restrain how superb he was to look at. They laughed at everybody except Lorenz—nobody could have laughed at Lorenz. He had the face of an eighteenth-century faun; his muscles billowed with proud perfection. To watch his brown body ladling out the measures of a Chopin mazurka was to feel yourself anointed with whatever meaning you may have found in life. He was shy and gentle, though the finest dancer in the world, and sometimes sat with the girls after classes, drinking coffee from a glass and munching Russian rolls soggy with poppy seeds. He understood the elegant cerebral abandon of Mozart, and had perceived the madnesses against which the consciousness of the race sets up an early vaccine for those intended to deal in reality. The *voluptés* of Beethoven were easy for Lorenz, and he did not have to count the churning revolutions of modern musicians. He said he could not dance to Schumann, and he couldn't, being always ahead or behind the beat whipping the romantic cadences beyond recognition. He was perfection to Alabama.

Arienne bought her way free from laughter with gnomish venom and an impeccable technique.

"What a wind!" somebody would cry.

"It is Arienne turning," was the answer. Her favorite musician was Liszt. She played on her body as if it were a xylophone, and had made herself indispensable to Madame. When Madame called out ten or so consecutive steps only Arienne could put them together. Her rigid insteps and the points of her toe shoes sliced the air like a sculptor's scalpel, but her arms were stubby and could not reach the infinite, frustrated by the weight of great strength and the broken lines of too much muscle. She loved telling how when she had been operated on the doctors came to look anatomically at the muscles in her back.

"But you have made much progress," the girls said to Alabama, crowding before her to the front of the class.

"You will leave a place for Alabama," corrected Madame.

She did four hundred battements every night.

Arienne and Alabama split the cost of the taxi each day as far as the Place de la Concorde. Arienne insisted that Alabama come to lunch at her apartment.

"I go so much with you," she said. "I do not like to be indebted."

It was a desire to discover what they were mutually jealous of in each other that drew them together. In both of them there was an undercurrent of disrespect for discipline which allied them in a hoydenish comradeship.

"You must see my dogs," said Arienne. "There is one who is a poet and the other who is very well trained."

There were ferns, silvery in the sun, on little tables and many autographed photographs.

"I have no photograph of Madame."

"Perhaps she will give us one."

"We can buy one from the photographer who made the proofs the last year she danced in the ballet," suggested Arienne illicitly.

Madame was both pleased and angry when they carried the photographs to the studio.

"I will give you better ones," she said.

She gave Alabama a picture of herself in *Carnaval* in a wide polka-dotted dress which her fingers held like a butterfly wing. Madame's hands constantly surprised Alabama: they were not long and thin; they were stubby. Arienne never got her picture, and she begrudged Alabama the photograph and grew more jealous than ever.

Madame gave a housewarming at the studio. They drank many bottles of sweet champagne that the Russians provided, and ate the sticky Russian cakes. Alabama contributed two magnums of Pol Roger Brut, but the Prince, Madame's husband, had been educated in Paris, and he took them home to drink for himself.

Alabama was nauseated from the gummy pastry—the Prince was delegated to ride with her in the taxi.

"I smell lily of the valley everywhere," she said. Her head swam with the heat and the wine. She held onto the straps of the car to keep herself from throwing up.

"You are working too hard," said the Prince.

His face was gaunt in the passing flares from the streetlamps. People

said he kept a mistress on the money he had from Madame. The pianist kept her husband; he was sick—almost everybody kept somebody else. Alabama could barely remember when that would have offended her— it was just the exigencies of life.

David said he would help her to be a fine dancer, but he did not believe that she could become one. He had made many friends in Paris. When he came from his studio he nearly always brought somebody home. They dined out amongst the prints of Montagné's, the leather and stained glass of Foyot's, the plush and bouquets of the restaurants around the Place de l'Opéra. If she tried to induce David to go home early, he grew angry.

"What right have you to complain? You have cut yourself off from all your friends with this damn ballet."

With his friends they drank Chartreuse along the boulevards under the rose-quartz lamps, and the trees, wielded by the night over the streets like the feathery fans of acquiescent courtesans.

Alabama's work grew more and more difficult. In the mazes of the masterful fouetté her legs felt like dangling hams; in the swift elevation of the entrechat cinq she thought her breasts hung like old English dugs. It did not show in the mirror. She was nothing but sinew. To succeed had become an obsession. She worked till she felt like a gored horse in the bullring, dragging its entrails.

At home, the household fell into a mass of dissatisfaction without an authority to harmonize its elements. Before she left the apartment in the morning Alabama left a list of things for lunch which the cook never bothered to prepare—the woman kept the butter in the coal bin and stewed a rabbit every day for Adage and gave the family what she pleased to eat. There wasn't any use getting another; the apartment was no good anyway. The life at home was simply an existence of individuals in proximity; it had no basis of common interest.

Bonnie thought of her parents as something pleasant and incalculable as Santa Claus that had no real bearing on her life outside the imprecations of Mademoiselle.

Mademoiselle took Bonnie for promenades in the Luxembourg Gardens, where the child seemed very French in her short white gloves bowling her hoop between the beds of metallic zinnias and geraniums. She was growing fast; Alabama wanted her to start training for the ballet—Madame had promised to give her a debut when she found time. Bonnie said she didn't want to dance, an incomprehensible aversion to Alabama. Bonnie reported that Mademoiselle walked with a chauffeur in the Tuileries. Mademoiselle said it was beneath her dignity to contest

the supposition. The cook said the hairs in the soup were from the black mustachios of Marguerite, the maid. Adage ate up in a silk canapé. David said the apartment was a pest house: the people upstairs played "Punchinello" at nine in the morning on their gramophone and cut short his sleep. Alabama spent more and more time at the studio.

Madame at last took Bonnie as a pupil. It was thrilling to her mother to see her little legs and arms seriously follow the sweeping movements of the dancer. The new Mademoiselle had worked for an English duke; she complained that the atmosphere of the studio was not fit for the little girl. That was because she couldn't speak Russian. She thought the girls were Fiends Infernal jabbering in the cacophony of a strange tongue and posturing immodestly before the mirror. The new Mademoiselle was a lady neurasthenic. Madame said Bonnie did not seem to have talent, but it was too soon to tell.

One morning Alabama came early to her lesson. Paris is a pen-and-ink drawing before nine o'clock. To avoid the thick traffic of the Boulevard des Batignolles, Alabama tried the Metro. It smelled of fried potatoes, and she slipped in the spit on the dank stairs. She was afraid of getting her feet crushed in the crowd. Stella waited for her in tears in the vestibule.

"You must take my part," she said. "Arienne does nothing but abuse me; I mend her shoes and piece her music and Madame has offered me to gain money by playing for her lessons and she refuses."

Arienne was bent over her straw chest in the dark, packing.

"I shall never dance again," she said. "Madame has time for children, time for amateurs, time for everybody, but Arienne Jeanneret must work at hours when she cannot get a decent pianist to play."

"I do my best. You have only to tell me," Stella sobbed.

"I am telling you. You are a nice girl, but you play the piano like a cochon!"

"If you would only explain what you want," pled Stella. It was horrible to see the dwarfish face red and swollen with fright and tears.

"I explain at this instant. I am an artist, not a teacher of piano. So Arienne goes that Madame may continue her kindergarten." She, too, was crying angrily.

"If anybody goes, Arienne," said Alabama, "it will be me. Then you may have your hour again."

Arienne turned to her, sobbing.

"I have explained to Madame that I cannot work at night after my rehearsals. My lessons cost money; I cannot afford them. I must make progress when I am here. I pay the same as you," sobbed Arienne.

She turned defiantly to Alabama.

"I live by my work," she said contemptuously.

"Children have to begin," said Alabama. "It was you who said one must begin sometime—the first time I ever saw you."

"Certainly. Then let them begin like the others, with the less great."

"I will share my time with Bonnie," Alabama said at last. "You must stay."

"You are very good." Arienne laughed suddenly. "Madame is a weak woman—always for something new," she said. "I will stay, however, for the present."

She kissed Alabama impulsively on her nose.

Bonnie protested her lessons. She had three hours a week of Madame's time. Madame was fascinated by the child. The woman's personal emotions had to be wedged in between the spacings of her work since it was incessant. She brought Bonnie fruit and chocolate *langue-de-chat,* and took great pains with the placing of her feet. Bonnie became her outlet for affection; the emotions of the dance were of a sterner stuff than sentimental attachments. The little girl ran continually through the apartment in leaps and pas de bourrée.

"My God," said David. "One in the family is enough. I can't stand this."

David and Alabama passed each other in the musty corridors hastily and ate distantly facing each other with the air of enemies awaiting some gesture of hostility.

"If you don't stop that humming, Alabama, I'll lose my mind," he complained.

She supposed it *was* annoying the way the music of the day kept running through her head. There was nothing else there. Madame told her that she was not a musician. Alabama thought visually, architecturally, of music—sometimes it transformed her to a faun in twilit spaces unpenetrated by any living soul save herself; sometimes to a lone statue to forgotten gods washed by the waves on a desolate coast—a statue of Prometheus.

The studio was redolent of rising fortunes. Arienne passed the Opéra examinations first of her group. She permeated the place with her success. She brought a small group of French into the class, very Degas and coquettish in their long ballet skirts and waistless backs. They covered themselves with perfume, and said the smell of the Russians made them sick. The Russians complained to Madame that they could not breathe with the smell of French musk in their noses. Madame sprinkled the floor with lemon oil and water to placate them all.

"I am to dance before the President of France," cried Arienne jubilantly one day. "At last, Alabama, they have begun to appreciate La Jeanneret!"

Alabama could not suppress a surge of jealousy. She was glad for Arienne; Arienne worked hard and had nothing in her life but the dance. Nevertheless, she wished it could have been herself.

"So I must give up my little cakes and Cap Corse and live like a saint for three weeks. Before I begin my schedule I want to give a party, but Madame will not come. She goes out to dine with you—she will not go out with Arienne. I ask her why—she says, 'But it is different—you have no money.' I will have money someday."

She looked at Alabama as if she expected her to protest the statement. Alabama had no convictions whatsoever on the subject.

A week before Arienne danced, the Opéra called a rehearsal that fell at the time of her lesson with Madame.

"So I will work in the hour of Alabama," she suggested.

"If she can change with you," said Madame, "for a week."

Alabama couldn't work at six in the afternoon. It meant that David dined alone and that she couldn't get home until eight. She was all day at the studio as it was.

"Then we cannot do that," said Madame.

Arienne was tempestuous. She lived at a terrible nervous pitch, dividing her resistance between the opera and the studio.

"And this time I go for good! I will find someone who will make me a great dancer," she threatened.

Madame only smiled.

Alabama would not oblige Arienne; the two girls worked in a state of amicable hatred.

Professional friendship would not bear close inspection—best everybody for herself, and interpret things to conform to personal desires—Alabama thought like that.

Arienne was intractable. Outside the province of her own genre, she refused to execute the work of the class. With the tears streaming down her face, she sat on the steps of the dais and stared into the mirror. Dancers are sensitive, almost primitive people: she demoralized the studio.

The classes filled with dancers other than Madame's usual pupils. The Rubenstein ballets were rehearsing and dancers were being paid enough to afford lessons with Madame again. Girls who had been to South America drifted back to town from the disbanded Pavlova troupe—the steps could not always be the tests of strength and technique to suit

Arienne. It was the steps that molded the body and offered it bit by bit to the reclaiming tenors of Schumann and Glinka that Arienne hated most—she could only lose herself in the embroiling rumbles of Liszt and the melodrama of Leoncavallo.

"I will go from this place," she said to Alabama, "next week." Arienne's mouth was hard and set. "Madame is a fool. She will sacrifice my career for nothing. But there are others!"

"Arienne, it is not like that that one becomes one of the great," said Madame. "You must rest."

"There is nothing I can do here any more; I had better go away," Arienne said.

The girls ate nothing but pretzels before the morning class—the studio was so far away from their homes they couldn't get breakfast in time; they were all irritable. The winter sun came in bilious squares through the fog, and the gray buildings about the Place de la République took on the air of a cold caserne.

Madame called upon Alabama to execute the most difficult steps alone before the others with Arienne. Arienne was a finished ballerina. Alabama was conscious of how much she must fall short of the fine concision that marked the French girl's work. When they danced together the combinations were mostly steps for Arienne rather than the lyrical things that Alabama did best, yet always Arienne cried out that the steps were not for her. She protested to the others that Alabama was an interloper.

Alabama bought Madame flowers which wilted and shriveled in the steam of the overheated studio. The place being more comfortable, more spectators came to the classes. A critic of the Imperial Ballet came to witness one of Alabama's lessons. Impressive, reeking of past formalities, he left at the end on a flood of Russian.

"What did he say?" asked Alabama when they were alone. "I have done badly—he will think you are a bad teacher." She felt miserable at Madame's lack of enthusiasm: the man was the first critic of Europe.

Madame gazed at her dreamily. "Monsieur knows what kind of a teacher I am," was all she said.

In a few days the note came:

> On the advice of Monsieur——I am writing to offer you a solo debut in the opera *Faust* with the San Carlos Opera of Naples. It is a small role, but there will be others later. In Naples there are pensions where one can live very comfortably for thirty lire a week.

Alabama knew that David and Bonnie and Mademoiselle couldn't live in a pension that cost thirty lire a week. David couldn't live in Naples at all—he had called it a postcard city. There wouldn't be a French school for Bonnie in Naples. There wouldn't be anything but coral necklaces and fevers and dirty apartments and the ballet.

"I must not get excited," she said to herself. "I must work."

"You will go?" said Madame expectantly.

"No. I will stay, and you will help me to dance *La Chatte.*"

Madame was noncommittal. Looking into the woman's fathomless eyes was like walking over a stretch of blistering pebbles through a tree-less, shadeless August as Alabama searched them for some indication.

"It is hard to arrange a debut," she said. "One should not refuse."

David seemed to feel that there was something accidental about the note.

"You can't do that," he said. "We've got to go home this spring. Our parents are old, and we promised last year."

"I am old, too."

"We have some obligations," he insisted.

Alabama no longer cared. David was a better person at heart than she to care about hurting people, she thought.

"I don't want to go to America," she said.

Arienne and Alabama teased each other mercilessly. They worked harder and more consistently than the others. When they were too tired to put on their clothes after classes, they sat on the floor of the vestibule laughing hysterically and slapping each other with towels drenched in eau de cologne or Madame's lemon water.

"And I think——" Alabama would say.

"Tiens!" shrieked Arienne. "Mon enfant begins to think. Ah! Ma fille, it is a mistake—all the thinking you do. Why do you not go home and mend your husband's socks?"

"Méchante," Alabama answered. "I will teach you to criticize your elders!" The wet towel fell with a smack across Arienne's rigid buttocks.

"Give me more room. I cannot dress so near to this polissonne," retorted Arienne. She turned to Alabama seriously and looked at her questioningly. "But it is true—I have no more place here since you have filled the dressing room with your fancy tutus. There is nowhere to hang my poor woolens."

"Here is a new tutu for you! I make you a present!"

"I do not wear green. It brings bad luck in France." Arienne was offended.

"If I had a husband to pay I, too, could buy them for myself," she pursued disagreeably.

"What business of yours is it who pays? Or is that all the patrons of your first three rows can talk to you about?"

Arienne shoved Alabama into the group of naked girls. Somebody pushed her hurriedly back into Arienne's gyrating body. The eau de cologne spilled over the floor and gagged them. A swat of the towel end landed over Alabama's eyes. Groping about she collided with Arienne's hot, slippery body.

"Now!" shrieked Arienne. "See what you have done! I shall go at once to a magistrate and have it constaté!" She wept and hurled Apache invective at the top of her lungs. "It is not today that it shows but tomorrow. I will have a cancer! You have hit me in the breast from a bad spirit! I will have it constaté, so when the cancer develops you will pay me much money, even if you are at the ends of the earth! You will pay!" The whole studio listened. The lesson Madame was giving outside could not continue, the noise was so loud. The Russians took sides with the French or the Americans.

"Sale race!" they shrieked indiscriminately.

"One can never have confidence in the Americans!"

"One must never trust the French!"

"They are too nervous, the Americans and the French."

They smiled long, superior Russian smiles as if they had long ago forgotten why they were smiling: as if the smile were a hallmark of their superiority to circumstance. The noise was deafening yet somehow surreptitious. Madame protested—she was angry with the two girls.

Alabama dressed as fast as she could. Out in the fresh air her knees trembled as she waited for a taxi. She wondered if she was going to take cold from her soaking hair under her hat.

Her upper lip felt cold and peppery with drying sweat. She had put on a stocking that wasn't her own. What was it all about, she said to herself—fighting like two kitchen maids and just barely getting along on the ends of their physical resources, all of them?

"My God!" she thought. "How sordid! How utterly, unmitigatedly sordid!"

She wanted to be in some cool and lyrical place asleep on a cool bed of ferns.

She did not go to the afternoon class. The apartment was deserted. She could hear Adage clawing at his door to get out. The rooms hummed with emptiness. In Bonnie's room she found a red carnation such as they give away in restaurants fading in a marmalade pot.

"Why don't I get *her* some flowers?" she asked herself.

A botched attempt at a doll's tutu lay on the child's bed; the shoes by the door were scuffed at the toes. Alabama picked up an open drawing book from the table. Inside Bonnie had designed a clumsy militant figure with mops of yellow hair. Underneath ran the legend, "My mother is the most beautiful lady in the world." On the page opposite, two figures held hands gingerly; behind them trailed Bonnie's conception of a dog. "This is when my Mother and Father go out walking," the writing said. "C'est très chic, mes parents ensemble!"

"Oh, God!" thought Alabama. She had almost forgotten about Bonnie's mind going on and on, growing. Bonnie was proud of her parents the same way Alabama had been of her own as a child, imagining into them whatever perfections she wanted to believe in. Bonnie must be awfully hungry for something pretty and stylized in her life, for some sense of a scheme to fit into. Other children's parents were something to them besides the distant "chic," Alabama reproached herself bitterly.

All afternoon she slept. Out of her subconscious came the feeling of a beaten child, and her bones ached in her sleep and her throat parched like blistering flesh. When she woke up she felt as if she had been crying for hours.

She could see the stars shining very personally into her bedroom. She could have lain in bed for hours listening to the sounds from the streets.

Alabama went only to her private lessons to avoid Arienne. As she worked she could hear the girl's cackling laugh in the vestibule raking over the arriving class for support. The girls looked at her curiously. Madame said she must not mind Arienne.

Dressing herself hurriedly, Alabama peeped between the dusty curtains at the dancers. The imperfections of Stella, the manoeuvres of Arienne, the currying of favor, the wrangling over the front line appeared to her in the moated sun falling through the glass roof like the groveling, churning movement of insects watched through the sides of a glass jar.

"Larvae!" said the unhappy Alabama contemptuously.

She wished she had been born in the ballet, or that she could bring herself to quit altogether.

When she thought of giving up her work she grew sick and middle-aged. The miles and miles of pas de bourrée must have dug a path inevitably to somewhere.

Diaghilev died. The stuff of the great movement of the Ballet Russe lay rotting in a French law court—he had never been able to make money.

Some of his dancers performed around the swimming pool at the Lido to please the drunk Americans in summer; some of them worked in music-hall ballets; the English went back to England. The transparent celluloid décor of *La Chatte* that had stabbed its audience with silver swords from the spotlights of Paris and Monte Carlo, London and Berlin lay marked "No Smoking" in a damp, ratty warehouse by the Seine, locked in a stone tunnel where a gray light from the river sloshed over the dark, dripping earth and over the moist, curving bottom.

"What's the use?" said Alabama.

"You can't give up all that time and work and money for nothing," said David. "We'll try to arrange something in America."

That was nice of David. But she knew she'd never dance in America.

The intermittent sun disappeared from the skylight over her last lesson.

"You will not forget your adagio?" said Madame. "You will send me pupils when you go to America?"

"Madame," Alabama answered suddenly, "do you think I could still go to Naples? Will you see the man immediately and tell him that I will leave at once?"

Looking into the woman's eyes was like watching those blocks of black and white pyramids where there are sometimes six and sometimes seven squares. Looking into her eyes was to experience an optical illusion.

"So!" she said. "I am sure the place is still open. You will leave tomorrow? There is no time to waste."

"Yes," said Alabama, "I will go."

4

◇

◦ I ◦

Dahlias stuck out of green tins at the station flower stalls like the paper fans that come with popcorn packages; the oranges were piled like Minié balls along the newsstands; the windows of the *buffet de la gare* sported three American grapefruit like the balls of a gastronomic pawnshop. Saturated air hung between the train windows and Paris like a heavy blanket.

David and Alabama filled the second-class *wagon-lit* with brassy cigarette smoke. He rang for an extra pillow.

"If you need anything I'll always be there," he said.

Alabama cried and swallowed a spoonful of yellow sedative.

"You'll get awfully sick of telling people how I'm getting along——"

"I'm going to Switzerland as soon as we can close the apartment—I'll send Bonnie to you when you're ready to have her."

A demi-Perrier sizzled in the car window. David choked on the dank must.

"It's silly to travel second class. Won't you let me have them change you to first?" he said.

"I'd rather feel I could afford it from the beginning."

The weight of their individual reactions separated them like a barrage. Unconscious relief buckled their parting with sad constraint—innumerable involuntary associations smothered their good-byes in platonic despair.

"I'll send you some money. I'd better be getting off."

"Good-bye—Oh, David!" she called as the train shoved away. "Be sure to have Mademoiselle get Bonnie's underwear from Old England——"

"I'll tell her—good-bye, dear!"

Alabama stuck her head inside the dim incandescence of the train lit

like a spiritualist's séance. Her face flattened to a stone carving in the mirror. Her suit wasn't right for second class; Yvonne Davidson had made it out of the reflections of an Armistice parade—the lines of the horizon-blue helmet and the sweep of the cape were too generous for the constraint of the scratchy lace-covered benches. Alabama went over her plans sympathetically to herself as a mother might soothe an unhappy child. She couldn't see the *maîtresse de ballet* till the day after she got there. It was nice of Mademoiselle to give her a bunch of maguey; she was sorry she had forgotten it on the mantelpiece at home. She had some dirty clothes in the laundry, too—Mademoiselle could pack them with the linen when they moved. She supposed David would leave the linen at the American Express. It wouldn't be hard packing, they had so little junk: a broken tea set, relic of a pilgrimage to Valence from St-Raphaël, a few photographs—she was sorry she hadn't brought the one of David taken on the porch in Connecticut—some books, and David's crated paintings.

The glow from the electric signs blared over Paris in the distance like the glare of a pottery kiln. Her hands sweated under the coarse red blanket. The carriage smelled like the inside of a small boy's pocket. Her thoughts insistently composed gibberish in French to the click of the car wheels.

> *La belle main gauche l'éther compact,*
> *S'étendre dans l'air qui fait le beau*
> *Trouve la haut le rhythm intact*
> *Battre des ailes d'un triste oiseau.*

Alabama got up to look for a pencil.

"Le bruit constant de mille moineaux," she added. She wondered if she'd lost the letter—no, it was in her Cutex box.

She must have gone to sleep—it was hard to tell in a train. Tramping in the corridors awoke her. This must be the border. She rang the bell. Nobody came for ages. A man in the green uniform of a circus animal trainer appeared at last.

"Water?" said Alabama ingratiatingly.

The man stared blankly about the wagon. There was no response in the smooth enigma of his fascinated countenance.

"Acqua, de l'eau, w*ataire,*" Alabama persisted.

"Fräulein rings," commented the man.

"Listen," said Alabama. She raised her arms in the motions of the

Australian crawl and finished with a tentative compromise between exaggerated swallows and a gargle. She faced the guard anticipatorily.

"No, no, No!" he cried out in alarm and vanished from the compartment.

Alabama got out her Italian phrase book and rang again.

"Do´—veh pos´—so com—prar´—eh ben—zee´—no," the book said. The man laughed hilariously. She must have lost the place.

"Nothing," Alabama told him reluctantly and went back to her composing. The man had driven the rhythm out of her head. She was probably in Switzerland by now. She couldn't remember whether or not it was Byron who had crossed the Alps with the curtains of his carriage down. She tried to see out of the window—some milk cans glistened in the dark. What she should have done about Bonnie's underwear was to have had it made by a seamstress. Mademoiselle would see to it. She got up and stretched, holding on to the sliding door.

The man informed her disparagingly that she couldn't open the doors in the second class and she couldn't have breakfast served in a *couchette*.

The country from the windows of the diner next day was flat like the land from which the sea has receded with sparse feather-duster trees tickling the bright sky. Little clouds foamed over the placidity aimlessly as froth from a beer pail; castles tumbled over the round hills like crowns awry; nobody sang "O Sole Mio."

There was honey for breakfast and bread like a stone mallet. She was afraid to change in Rome without David. The Rome station was full of palms; the fountains scrubbed the baths of Caracalla with sprays of sunshine opposite the terminus. In the open friendliness of the Italian air, her spirits rose.

"Ballonné, deux tours," she said to herself. The new train was filthy. There were no carpets on the floor and it smelled of the Fascisti, of guns. The signs pronounced a litany; Asti Spumante, Lagrima Christi, Spumoni, Tortoni. She didn't know what it was she had lost—the letter was still in the Cutex. Alabama took possession of herself as a small boy walking in a garden might close his hand over a firefly.

"Cinque minuti mangiare," said the attendant.

"All right," she said, counting on her fingers, "una, due, tre—It's all right," she assured him.

The train swerved this way and that, trying to avoid the disorder of Naples. The cabbies had forgotten to move their cabs off the car rails, sleepy men forgot which way they were going in the middle of the streets, children spread their mouths and soft hurt eyes and forgot the

emotion of crying. White dust blew about the city; delicatessens sold sharp smells, cubes and triangles and wicker globes of odor. Naples shrunk in the lamplight from its public squares, suppressed by a great pretense of discipline, quelled by its blackened stone façade.

"Venti lire!" expostulated the cabby.

"The letter," said Alabama haughtily, "said I could *live* on thirty lire a week in Naples."

"Venti, venti, venti," caroled the Italian without turning around.

"It's going to be difficult not being able to communicate," thought Alabama.

She gave the man the address the *maîtresse* had sent her. Flourishing his whip grandiloquently, the cabby urged the horse's hoofs pendulously through the munificence of the night. As she gave the man his money his brown eyes swung on hers like cups set on a tree to catch a precious sap. She thought he would never quit looking.

"Signorina will like Naples," he said surprisingly. " 'The city's voice is soft like solitude's.' "

The cab clumped away through the red and green lights set about the brim of the bay like stones in the filigree of a Renaissance poison cup. The syrupy drippings of the fly-specked south seeped up on the breeze that blew the vast aquamarine translucence into emotional extinction.

The light from the pension entry shone in globular drops in Alabama's fingernails. Her movements gathered up in consequential stirrings of the air as she passed inside leaving no traces on the stillness behind her.

"Well, I've got to live here," said Alabama, "so that's all there is to that."

The landlady said the room had a balcony—it did, but there wasn't any floor to the balcony; the iron rails joined the peeling pink wash of the outside walls. However, there was a lavabo with gigantic spouts sticking out over the bowl and splashing the square of oilcloth underneath. The breakwater curved its arm about the ball of blue night from her window; the smell of pitch rose from the harbor.

Alabama's thirty lire bought a white iron bed that had obviously once been green; a maple wardrobe with a beveled mirror opaling the Italian sun, and a rocker made of a strip of Brussels carpet. Cabbage three times a day, a glass of Amalfi wine, gnocchi on Sundays, and the chorus of "Donna" by the loafers beneath the balcony at night were included in the price. It was a huge room with no shape, being all bays and

SAVE ME THE WALTZ

corners till it gave her a sense of inhabiting a whole apartment. There is a suggestion of gilt about everything in Naples, and though Alabama could not find a trace of it in her room, she felt somehow as if the ceilings were encrusted with gold leaf. Footfalls rose from the pavements below in sumptuous warm reminiscence. Nights fell out of the classics; the merest suggestion of people floated off into view, fantastic excrescences of happy existence; cacti speared the summer; the backs of fish glinted in the open boats below like mica splinters.

Madame Sirgeva conducted her classes on the stage of the opera house. She complained incessantly about the price of the lights; the piano sounded very ineffectual in the Victorian chasms. The darkness from the wings and the dimness between the three globes she kept burning overhead divided the stage into small intimate compartments. Madame paraded her ghost through the sway of tarlatan, the creak of toe shoes, the subdued panting of the girls.

"No noise, less noise," she reiterated. She was as pale and dyed and shriveled and warped by poverty as a skin that has been soaked under acid. The black dye in her hair, coarse as the stuffing of a pillow, was yellow along the part; she taught her girls in puffed-sleeved blouses and pleated skirts which she wore on the street afterward beneath her coat.

Swirling round and round like an exercise in penmanship, Alabama threaded the line through the spots of light.

"But you are like Madame!" said Madame Sirgeva. "We were at the Imperial School together in Russia. It was I who taught her her entrechats, though she never did them properly. Mes enfants! There are four counts to a quatre-temps, please, p—l—e—a—s—e!"

Alabama clamorously dropped her person bit by bit into the ballet like pieces dropped through a mechanical piano.

The girls were unlike the Russians. Their necks were dirty and they came to the theatre with paper bags filled with thick sandwiches. They ate garlic; they were fatter than the Russians and their legs were shorter; they danced with bent knees and their Italian-silk tights crinkled over their dimples.

"God and the Devil!" shrieked Sirgeva. "It is Moira who is never in step, and the ballet goes on in three weeks."

"Oh, Maestra!" remonstrated Moira. "Molto bella!"

"Oh," gasped Madame, turning to Alabama. "You see? I provide them with steel shoes to hold up their lazy feet and the moment I turn my back they dance flatfoot—and I am paid only sixteen hundred lire for all that! Thank heavens, I have *one* from a Russian school!" The

mistress went on like a churning piston rod. She sat in the humid closed opera house with a seal cape about her shoulders, faded and dyed like her hair, coughing into her handkerchief.

"Mother Maria," sighed the girls. "Sanctified Mary!" They drew together in frightened groups in the gloom. They were suspicious of Alabama because of her clothes. Over the backs of the canvas chairs in the dingy dressing room she flung her things: two hundred dollars' worth of black tulle "Adieu Sagesse," moss roses floating through a nebula like seeds in a strawberry ice, costly nebula—one hundred, two hundred dollars; some yellow clownish fringe, a chartreuse hooded cloak, white shoes, blue shoes, buckles for Bobby Shafto, silver buckles, steel buckles, hats and red sandals, shoes with the signs of the zodiac, a velvet cape soft as the roof of an old château, a cap of pheasant's feathers—she hadn't realized in Paris that she had had so many clothes. She would have to wear them out now that she was living on six hundred lire a month. She was glad of all those clothes that David had bought her. After the class, she dressed amidst the fine things with the purposeful air of a father inspecting a child's toy.

"Holy Mother," whispered the girls shyly, fingering her lingerie. Alabama was cross when they did that; she didn't want them smearing sausage over her chiffon step-ins.

She wrote to David twice a week—their apartment appeared to her far away, and dull. Rehearsals were coming—any life compared with that seemed dreary. Bonnie answered on little paper with French nursery rhymes on the heading.

Dearest Mummy—
 I was the hostess while Daddy put on his cuff buttons for a lady and gentleman. My life is working quite well. Mademoiselle and the chambermaid said they never saw a box of paints so pretty as the one you sent. I jumped of joy with the paintbox and made some pictures of *des gens à la mer, nous qui jouons au croquet et une vase avec des fleurs dedans d'après nature.* When we are Sunday in Paris I go to Catechism to learn of the horrible sufferings of Jesus Christ.

 Your loving daughter,
 Bonnie Knight

Alabama took the yellow sedative at night to forget Bonnie's letters. She made friends with a dark Russian girl blowing through the ballet like a sirocco. Together they went to the Galleria. In the blank stone enclosure where footsteps spattered like steady rain, they sat over their

beers. The girl refused to believe that Alabama was married; she lived in constant hopes of meeting the man who provided her friend with so much money, and of stealing him away. Crowds of men passing arm in arm eyed them callously and disdainfully—they wouldn't pick up women who went to the Galleria at night alone, they seemed to say. Alabama showed her friend Bonnie's picture.

"You are happy," said the girl. "One is happier when one doesn't marry." Her eyes were a deep brown that glowed red and clear like violin rosin when she was exhilarated by a little alcohol. On especial occasions she wore a pair of black net teddies with lavender bows that she had bought when she worked in the chorus of the Ballet Russe before Diaghilev died.

Rehearsing in the big empty theater, the troupe went over and over the *Faust* ballet. The orchestra leader conducted Alabama's three-minute solo like lightning. Madame Sirgeva did not dare to speak to the Maestro. At last with tears in her eyes, she stopped the performance.

"You are killing my girls," she wept. "It is inhuman!"

The man threw his stick across the piano; the hair stood up on his head like grass sprouting on a clay scalp.

"Sapristi!" he screamed. "The music is written so!"

He dashed distractedly out of the opera house and they finished without music. The following afternoon the Maestro was more determined, the music went faster than ever. He had looked up a copy of the original score; he had never made an error. The arms of the violins rose above the stage bent and black as grasshopper legs; the Maestro snapped his backbone like a rubber slingshot, flinging the fast chords up over the footlights with an impossible rapidity.

Alabama was unused to a slanting stage. To habituate herself she worked alone at lunchtime after the morning class, turning, turning. The slant threw her turns out of balance. She worked so hard that she felt like an old woman by a fireside in a far Nordic country as she sat on the floor dressing afterwards. The telescoping vacation blue and brighter blue of the Bay of Naples was blinding to stumble through on her way home. Alabama's feet were bleeding as she fell into bed.

When at last her first performance was over she sat on the base of a statue of the Venus de Milo, outside the studded doors of the opera greenrooms; Pallas Athene stared at her across the musty hall. Her eyes throbbed with the beat of her pulse, her hair clung like Plasticine about her head; "Bravo" and "Benissimo" for the ballet rang about her ears like persistent gnats. "Well, it's done," she said.

She didn't dare look at the girls in the dressing room; she tried to

hold on to the magic for a long time. She knew her eyes would see the sagging breasts like dried August gourds, and wound themselves on the pneumatic buttocks like lurid fruits in the pictures of Georgia O'Keeffe.

David had telegraphed a basket of calla lilies. "From your two sweethearts" the card should have read, but it had come through the Neapolitan florist "sweat-hearts." She didn't laugh. She hadn't written to David in three weeks. She plastered her face with cold cream and sucked on the half lemon she had brought in her valise. Her Russian friend embraced her. The ballet girls seemed to be waiting about for something more to happen; no men waited in the shadows of the opera door. The girls were mostly ugly, and some of them were old. Their faces were vacuous and so stretched with fatigue that they would have fallen apart save for the cordlike muscles developed by years of hard breathing. Their necks were pinched and twisted like dirty knots of mending thread when they were thin, and when they were fat the flesh hung over their bones like bulging pastry over the sides of paper containers. Their hair was black with no nuances to please the tired senses.

"Jesu!" they cried in admiration, "the lilies! How much can they have cost? They are fit for a cathedral!"

Madame Sirgeva kissed Alabama gratefully.

"You have done well! When we give the ballet programme for the year, you will have the stellar rôle—these girls are too ugly. I can do nothing with them. There was no interest in ballet before—now we shall see! Do not worry. I will write to Madame! Your flowers are beautiful, piccola ballerina," she finished softly.

Alabama sat in her window listening to the night chorus of "Donna."

"Well," she sighed distractedly, "there should be something to do after a success."

She put her wardrobe in order and thought of her friends in Paris. Sunday friends with satin-coated wives toasting impeccable accents in the sun of foreign *plages;* tumultuous friends drowning the Chopin in modern jazz in vintage wines; cultured friends hanging over David like a group of relations over a first-born. They would have taken her out somewhere. Calla lilies, in Paris, would not have been tied with a white tulle bow.

She sent David the clippings from the paper. They were agreed that the ballet was a success, and that the new addition to Madame Sirgeva's corps was a competent dancer. She had promise and should be given a bigger rôle, the papers said. Italians like blondes; they said Alabama was as ethereal as a Fra Angelico angel because she was thinner than the others.

Madame Sirgeva was proud of those notices. It seemed more important to Alabama that she should have discovered a new make of toe shoe from Milan; the shoes were soft as air. Alabama ordered a hundred pairs—David sent her the money. He was living in Switzerland with Bonnie. She hoped he had bought Bonnie woolen bloomers—up to the age of ten girls need to have their stomachs protected. At Christmas he wrote her that he had bought Bonnie a blue ski suit, and sent her Kodak snaps of the snow and of the two of them falling down the hills together.

Asthmatic Christmas bells tolled over Naples; flat metallic sheets of sound like rustled sheafs of roofing. The steps about the public places were filled with jonquils and roses dyed orange, dripping red water. Alabama went to see the wax Nativities at Benediction. There were calla lilies everywhere and tapers and worn, bland faces smiling convulsively over the season. From the reflection of the candle flicker on the gilt, from the chants that rose and fell like the beating of the tides on amorphous shores before the birth of man, from the spattering tread of the women with heads bound in lace veils, Alabama absorbed a sense of elation as if she marched to the righteous tune of spiritual organization. The surplices of the priests in Naples were of white satin, lush with passion flowers and pomegranates. During the services Alabama thought of Bourbon princes and hemophilia, papal counts, and maraschino cherries. The gleam of gold damask on the altar was as warm and rich as what it represented. Her thoughts prowled about her introspection like leopards in a cage at the zoo. Her body was so full of static from the constant whip of her work that she could get no clear communication with herself. She said to herself that human beings have no right to fail. She did not feel what failure was. She thought of Bonnie's tree. Mademoiselle could get it together as well as she.

Unexpectedly she laughed, tapping her spirit experimentally like a piano being tuned.

"There's a lot in religion," she said to her Russian friend, "but it has too much meaning."

The Russian told Alabama about a priest she had known who became so aroused by the tales he had heard in the confessional that he got drunk on the Holy Sacrament. He drank so much during the week that there wasn't any communion to give to the penitents on Sunday, who had also been drinking during the week and needed a pick-me-up. His church became known as a lousy dump that borrowed its blood of Christ from the synagogue, the girl said, and lost many customers, amongst them herself.

"I," the girl rambled on, "used to be very religious. Once in Russia when I found my carriage was being drawn by a white horse I got out and walked three miles through the snow to the theatre and I got pneumonia. Since, I have cared less for God—between the priests and white horses."

The Opera gave *Faust* three times during the winter, and Alabama's tea-rose tarlatan that had risen at first like a frozen fountain wore streaked and crushed. She loved the lessons the morning after a performance—the letdown and still floral calm like the quiet of an orchard in bloom that followed the excitement, and her face's being pale, and the traces of makeup washed out of the corner of her eyes with perspiration.

"Stations of the Cross!" moaned the girls, "but my legs ache, and I am sleepy! My mother beat me last night because I was late; my father refuses me Bel Paese—I cannot work on goat cheese!"

"Ah," the fat mothers deflated themselves, "bellissima, my daughter—she should be ballerina, but the Americans grab everything. But Mussolini will show them, Holy Sacrament!"

For the end of Lent the Opera demanded a whole programme of ballet; Alabama at last was to dance ballerina of *Le Lac des Cygnes*.

As the ballet went into rehearsal, David wrote asking if she would like Bonnie for two weeks. Alabama got permission to miss a morning class to meet her child at the station. A swishing army officer helped Bonnie and Mademoiselle out of the train into the Neapolitan jargon of sound and color.

"Mummy," the child cried excitedly. "Mummy!" She clung about Alabama's knees adoringly; a soft wind swept her bangs back in little gusts. Her round face was as flushed and translucent as the polish on the day of her arrival. The bones had begun to come up in her nose; her hands were forming. She was going to have those wide-ended fingers of a Spanish primitive like David. She was very like her father.

"She has given an excellent example to the travelers," said Mademoiselle straightening her hair.

Bonnie clung to her mother, bristling with resentment of Mademoiselle's proprietary air. She was seven, had just begun to sense her position in the world, and was full of the critical childish reserves that accompany the first formations of social judgment.

"Is your car outside?" she bubbled.

"I haven't any car, dear. There's a flea-bitten horse cab that's much nicer to take us to my pension."

A determination not to manifest her disappointment showed in Bonnie's face.

"Daddy has a car," she said critically.

"Well, here we travel in chariots." Alabama deposited her on the crinkled linen covers of the voiture.

"You and Daddy are very 'chic,'" Bonnie went on speculatively. "You should have a car—"

"Mademoiselle, did you tell her that?"

"Certainly, Madame. I should like to be in Mademoiselle Bonnie's place," said Mademoiselle emphatically.

"I suppose I shall be very rich," said Bonnie.

"My God, no! You must get things like that out of your head. You will have to work to get what you want—that's why I wanted you to dance. I was sorry to hear you had given it up."

"I did not like dancing, except the presents. At the end Madame gave me a little silver evening bag. Inside there was a glass and a comb and real powder—that part I liked. Would you like to see it?"

From a small valise she produced an incomplete pack of cards, several frayed paper dolls, an empty matchbox, a small bottle, two souvenir fans, and a notebook.

"I used to make you keep your things in better order," commented Alabama, staring at the untidy mess.

Bonnie laughed. "I do more as I please now," she said. "Here is the bag."

Handling the little silver envelope, an unexpected lump rose to Alabama's throat. A faint scent of eau de cologne brought back the glitter on the crystal beads of Madame; the music hammering the afternoon to a beaten-silver platter, David and Bonnie waiting at dinner, swirled in her head like snowflakes settling in a glass paperweight.

"It's very pretty," she said.

"Why do you cry? I will let you carry it sometime."

"It's the smell makes my eyes water. What have you got in your suitcase that smells so?"

"But, Madame," expostulated Mademoiselle, "it is the very same mixture they make for the Prince of Wales. One takes one part lemon, one part eau de cologne, one part Coty's jasmine, and——"

Alabama laughed. "——And you shake it up, and pour off two parts ether and half a dead cat!"

Bonnie's eyes widened disdainfully.

"You can take it in trains for when your hands are soiled," she protested, "or for if you have the 'vertige.'"

"I see—or in case the engine runs out of oil. Here's where we get out."

The cab shook itself to an indeterminate stop before the pink boardinghouse. Bonnie's eyes wandered incredulously over the flaking wash and the hollow entry. The doorway smelled of damp and urine; stone steps cradled the centuries in their worn centers.

"Madame has not make a mistake?" protested Mademoiselle querulously.

"No," Alabama said cheerfully. "You and Bonnie have a room to yourselves. Don't you *love* Naples?"

"I hate Italy," pronounced Bonnie. "I like it better in France."

"How do you know? You've just got here."

"The Italians are very dirty, isn't it?" Mademoiselle reluctantly parted with an unclassifiable facial expression.

"Ah," said the landlady, smothering Bonnie in a vast convex embrace. "Mother of God, it is a beautiful child!" Her breasts hung over the stunned little girl like sandbags.

"Dieu!" Mademoiselle sighed. "These Italians are a religious people!"

The Easter table was decorated with lugubrious crosses made of dried palmetto leaves. There was gnocchi and vino da Capri for dinner, and a purple card with cupids pasted in the centre of gold radiations resembling medals of state. In the afternoon they walked along the pulverized white roads and up the steep alleys gashed with bright rags hung out to dry in the glare. Bonnie waited in her mother's room while Alabama prepared for rehearsal. The child amused herself by sketching in the rocker.

"I cannot make a good likeness," she announced, "so I have changed to caricature. It is Daddy when he was a young man."

"Your father's only thirty-two," said Alabama.

"Well, that's quite old, wouldn't you say?"

"Not so old as seven, my dear."

"Oh, of course—if you count backwards," agreed Bonnie.

"And if you begin in the middle, we are a very young family all round."

"I should like to begin when I am twenty, and have six children."

"How many husbands?"

"Oh, no husbands. They shall, perhaps, be away at the time," said Bonnie vaguely. "I have seen them so in the movies."

"What was that remarkable film?"

"It was about dancing, so Daddy took me. There was a lady in the Russian Ballet. She had no children but a man and they both cried a lot."

"It must have been interesting."

"Yes. It was Gabrielle Gibbs. Do you like her, Mummy?"

"I've never seen her except in life, so I couldn't say."

"She is my favorite actress. She is a very pretty lady."

"I must see the picture."

"We could go if we were in Paris. I could carry my silver sac de soirée."

Every day during rehearsals, Bonnie sat in the cold theatre with Mademoiselle, lost under the dim trimmings like rose and gold cigar bands, terrified by the seriousness and the emptiness and Madame Sirgeva. Alabama went over and over the adagio.

"Blue devils," gasped the *maîtresse*. "Nobody has done that with two turns! Ma chére Alabama—you will see with the orchestra that it cannot be!"

On their way home they passed a man ponderously swallowing frogs. The frogs' legs were tied to a string, and he pulled them up again out of his stomach, as many as four at a time. Bonnie gloated with disgusted delight. It made her quite sick to see; she was fascinated.

The pasty food at the boardinghouse gave Bonnie a rash.

"It is ringworm from the filth," said Mademoiselle. "If we stay, Madame, it may turn to erysipelas," she threatened. "Besides, Madame, our bath is dirty!"

"It is quite like broth, mutton broth," corroborated Bonnie distastefully, "only without the peas!"

"I had wanted to give Bonnie a party," said Alabama.

"Could Madame suggest where I might get a thermometer?" Mademoiselle interjected hastily.

Nadjya, the Russian, unearthed a little boy for Bonnie's party. Madame Sirgeva incalculably furnished a nephew. Though all of Naples was covered with buckets of anemones and night-blooming stock, pale violets like enameled breastpins, strawflowers and bachelor's buttons, and the covetous enveloping bloom of azaleas, the landlady insisted upon decorating the children's table with poisonous pink-and-yellow paper flowers. She produced two children for the party, one with a sore under its nose, and one who had had to have its head recently shaved. The children arrived in corduroy pants worn over the seat like a convict's head. The table was loaded with rock cakes and honey and warm pink lemonade.

The Russian boy brought a monkey which hopped about the table tasting from all the jams and throwing the spoons about recklessly.

Alabama watched them under the scraggly palms from the low sill of her room; the French governess tore ineffectually about on the outskirts of their activities.

"Tiens, Bonnie! Et toi, ah, mon pauvre chou-chou!" she shrieked without pause.

It was a witch's incantation. What magic philter was the woman brewing to be drunk by the passing years? Alabama's senses floated off on dreams. A sharp scream from Bonnie startled her back to reality.

"Ah, quelle sale bête!"

"Well, come here, dear, we'll put iodine on it," Alabama called from the casement.

"So Serge takes the monkey," Bonnie stammered, "and he th—r—o—ws him at me, and he is horrible, and I hate the children of Naples!"

Alabama held the child on her knee. Her body felt very little and helpless to her mother.

"Monkeys have to have *something* to eat," Alabama teased.

"You are lucky he has not bitten your nose," Serge commented unsolicitously. The two Italians were only concerned about the animal, rubbing him affectionately and soothing him with dreamy Italian prayer like a love song.

"Che—che—che," chittered the parakeet.

"Come," said Alabama, "I will tell you a story."

The young eyes hung suspended on her words like drops of rain under a fence rail; their little faces followed hers like pale pads of clouds beneath the moon.

"I would never have come," declaimed Serge, "if I had known there wasn't going to be Chianti!"

"Nor I, Hail Mary!" echoed the Italians.

"Don't you want to hear about the Greek temples, all bright reds and blues?" Alabama insisted.

"Si, Signora."

"Well—they are white now because the ages have worn away their original, dazzling——"

"Mummy, may I have the compote?"

"Do you want to hear about the temples or not?" said Alabama crossly. The table came to a dead expectant silence.

"That's all I know about them," she concluded, feebly.

"Then may I please now have the compote?" Bonnie dripped the purple stain down the knife pleats of her best dress.

"Doesn't Madame feel that we have had enough for one afternoon?" said Mademoiselle in dismay.

"I feel sick, a little," confessed Bonnie. She was ghastly pale.

The doctor said he thought it was the climate. Alabama forgot to get the emetic he prescribed at the drugstore and Bonnie lay in bed for a week, living on limewater and mutton broth while her mother rehearsed the waltz. Alabama was distracted; Madame Sirgeva had been right— she couldn't do two turns with the orchestra unless it slowed up. The Maestro was adamant.

"Mother of women," the girls breathed from the dark corners. "She will break her back so!"

Somehow she got Bonnie well enough to board the train. She bought them a spirit lamp for the voyage.

"But what will we do with it, Madame?" asked Mademoiselle suspiciously.

"The British always have a spirit lamp," explained Alabama, "so when the baby gets croup they can take care of it. We never have anything, so we get to know the inside of many hospitals. The babies all come out the same, only later in life some prefer spirit lamps and some prefer hospitals."

"Bonnie has not got croup, Madame," Mademoiselle reproved huffily. "Her illness is the result solely of our visit." She wanted the train to start to extricate herself and Bonnie from Neapolitan confusions. Alabama wanted also to be extricated.

"We should have taken the train-de-luxe," said Bonnie. "I am in rather a hurry to get to Paris."

"This is the train-de-luxe, snob!"

Bonnie gazed at her mother in impassive skepticism.

"There are many things in the world you don't know, Mummy."

"It's just barely possible."

"Ah," fluttered Mademoiselle approvingly, "Au 'voir, Madame, au 'voir! And good luck!"

"Good-bye, Mummy. Do not dance too hard!" called Bonnie perfunctorily as the train moved off.

The poplar trees before the station jingled their tops like pockets full of silver money; the train whistled mournfully as it rounded a bend.

"For five lire," said Alabama to the dog-eared cabdriver, "you must take me to the Opera House."

She sat alone that night without Bonnie. She hadn't realized how much fuller life was with Bonnie there. She was sorry she hadn't sat more with her child when she was sick in bed. Maybe she could have missed rehearsals. She had wanted her child to see her dance the ballet. In one more week of rehearsal she would have her debut as a ballerina!

Alabama threw the broken fan and the pack of picture postcards that Bonnie had left behind in the wastebasket. They seemed hardly worth sending after her to Paris. She sat down to mend her Milanese tights. The Italian toe shoes were good but Italian tights were too heavy—they cut your thighs on the arabesque croisé.

◦ II ◦

"D'you have a good time?"

David met Bonnie under the pink explosive apple trees where Lake Geneva spread a net below the undulating acrobacies of the mountains. Opposite the Vevey Station a bridge of pencil strokes clipped pleasantly over the river; the mountains braced themselves out of the water on the Dorothy Perkins stems and thongs of purple clematis. Nature had padded every crack and crevice with floral stuffing; narcissus banded the mountains in a milky way, the houses tethered themselves to the earth with browsing cows and pots of geraniums. Ladies in lace with parasols, ladies in linen with white shoes, ladies in tangerine smiles patronized the elements in the station square. Lake Geneva, pounded for so many summers by the cruel brightness, lay shaking its fist at the high heavens, swearing up at God from the security of the Swiss Republic.

"Lovely," replied Bonnie succinctly.

"How was Mummy?" pursued David.

Dressed in a catalogue of summer, even Bonnie noticed that his clothes were a little amazing, suggesting a studied sartorial selection. He was dressed in pearly gray and he looked as if he had stepped down inside his angora sweater and flannel pants with such precision that he had hardly deranged their independent decorative purpose. If he hadn't been so handsome he could never have achieved so speculative and tentative an effect. Bonnie was proud of her father.

"Mummy was dancing," said Bonnie.

Deep shadows sprawled about the streets of Vevey like lazy summer drunkards; clouds full of moisture floated like lily pads in the luminous puddle of the sky.

They mounted the hotel bus.

"The rooms, Prince," said the sad, suave hotel man, "will be eight dollars a day because of the fête."

The valet carried their luggage to a white-and-gold encrusted suite.

"Oh, what a beautiful sitting room!" ejaculated Bonnie. "There is even a telephone. Such 'élégance'!"

She spun about, switching on the lurid floor lamps.

"And I have a room to myself, and a bath of my own," she hummed. "It was nice of you, Daddy, to give Mademoiselle 'vacances'!"

"How would the royal visitor like her bath?" said David.

"Well—cleaner, please, than in Naples."

"Was your bath dirty in Naples?"

"Mummy said 'no'——" said Bonnie hesitantly, "but Mademoiselle said 'yes.' Everybody gives me much contrary advice," she confided.

"Alabama should have seen to your bath," said David.

He heard the thin treble voice singing to itself in the tub, "Savez-vous planter les choux——" There was no sound of splashing.

"Are you washing your knees?"

"I haven't got to them yet—'à la manière de chez-nous, à la manière de chez-nous'——"

"Bonnie, you *must* hurry up."

"Can I stay up till ten o'clock tonight?—'on les plante avec le nez'——"

Bonnie tore giggling through the rooms.

The sun winked in the gold braid, the curtains blew softly in the ghostly breeze, the lamps glowed like abandoned campfires under their pink shades in the daylight. The flowers in the room were pretty. There must be a clock. Round and round the child's brain raced contentedly. The tops of the trees outside were shiny blue.

"Didn't Mummy *say* anything?" said David.

"Oh, yes," said Bonnie, "she gave me a party."

"That was nice; tell me about it."

"Well," said Bonnie, "there was a monkey, and I was sick, and Mademoiselle cried about the preserves on my dress."

"I see—well, what did Mummy say?"

"Mummy said if it weren't for the orchestra she could do two turns."

"It must have been very interesting," said David.

"Oh, yes," Bonnie compromised, "it was very interesting. Daddy——"

"Yes, dear?"

"I love you, Daddy."

David laughed in little sharp jerks like a person making tatting.

"Well, you'd better."

"I think so, too. Do you think I could sleep in your bed tonight?"

"Of course not!"

"It would be very comfortable."

"Your own is just the same."

The child's tone changed to sudden practicality. "It's safer near you. No wonder Mummy liked sleeping in your bed."

"How silly!"

"When I am married all my family will sleep together in a large bed. Then I shall be quite easy about them, and they will not be afraid of the dark," went on the child. "You liked being near your parents until you had Mummy, didn't you?"

"We had our parents—then we had you. The present generation is always the one without the comfort of people to lean on."

"Why?"

"Because solace, Bonnie, is an affair of retrospect and expectation. If you don't hurry up, our friends will be here before you are dressed."

"Are there children coming?"

"Yes, I am taking the family of one of my friends for you to meet. We are going to Montreux to see the dancing. But," said David, "the sky is clouding over. It looks like rain."

"Daddy, I hope not!"

"So do I. Something always spoils a party, monkeys or rain. There are our friends now."

Behind their governess three blond children traversed the hotel court through the thin sun pinking suggestively the trunks of the firs.

"Bonjour," said Bonnie, extending her hand limply in a juvenile interpretation of a grande dame. Inconsistently she pounced on the little girl. "Oh, but you are dressed as Alice in Wonderland!" she shrieked.

The child was several years older than Bonnie.

"Grüss Gott," she answered demurely, "you too have on a pretty dress."

"Et bonjour, Mademoiselle!" The two little boys were younger. They clambered over Bonnie with the stiff military formality of the Swiss schoolboy.

The children were very decorative under the vista of cropped plane trees. The green hills stretched away like a canvas sea to faint recesses of legend. Pleasantly loitering mountain vegetation dangled over the hotel front in swaying clots of blue and mauve. The childish voices droned through the mountain clarity conversing intimately in the sense of seclusion conveyed by the overhanging Alps.

"What is this 'it' I saw in the papers?" said the eight-year-old voice.

"Don't be silly, it's only sex appeal," answered the voice of ten.

"Only beautiful ladies can have it in the movies," said Bonnie.

"But sometimes, don't men have it too?" said the little boy disappointed.

"Father says everybody does," called the older girl.

"Well, Mother said only a few. What did your parents say, Bonnie?"

"They didn't say anything, since I had not read it in the papers."

"When you are older," said Genevra, "you will—if it is still there."

"I saw my father in a shower bath," offered the smallest boy expectantly.

"That's nothing," sniffed Bonnie.

"Why is it nothing?" the voice insisted.

"Why is it something?" said Bonnie.

"I have swimmed with him naked."

"Children—children!" reproved David.

Black shadows fell on the water, echoes of nothing poured down the hills and steamed over the lake. It began to rain; a Swiss downpour soaked the earth. The flat bulbous vines about the hotel windows bled torrents over the ledges; the heads of the dahlias bent with the storm.

"How can they have the fête in the rain?" the children cried in dismay.

"Perhaps the ballet will wear their 'caoutchouc' as we have done," said Bonnie.

"I'd rather they had trained seals anyway," said the little boy optimistically.

The rain was a slow sparkling leak from a lachrymose sun. The wooden platforms about the estrade were damp and soaked with dye from the wet serpentine and sticky masses of confetti. Fresh wet light through the red and orange mushrooms of shiny umbrellas glowed like a lamp store display; a fashionable audience glistened in bright cellophane slickers.

"What if it rains down his horn?" said Bonnie, as the orchestra appeared beneath the rain-washed set of chinchilla-like mountains.

"But it might be pretty," protested the boy. "Sometimes in my bath when I sink beneath the water I make the most beautiful noises by blowing."

"It is ravishing," pronounced Genevra, "when my brother blows."

The damp air flattened the music like a sponge; girls brushed the rain from their hats; the rolling back of the tarred canvas exposed the slick and dangerous boards.

"It is *Prometheus* they're going to give," said David, reading the programme. "I will tell you the story afterwards."

From a whirr of revolving leaps Lorenz collected his brown magnificence, clenching his fists in the air and chinning the mystery of the mountain sky. His bare rain-polished body tortured itself to inextricable postures, straightened, and dropped to the floor with the suspended float of falling paper.

"Look, Bonnie," David called, "there's an old friend of yours!"

Arienne, subduing a technical maze of insolent turns and arrogant twists, represented a pink cupid. Damp and unconvincing, she tenaciously gripped the superhuman exigencies of her role. The workman underneath the artist ground out her difficult interpretation.

David felt an overwhelming unexpected surge of pity for the girl going through all that while the spectators thought of how wet they were getting and how uncomfortable they were. The dancers, too, were thinking of the rain, and shivered a little through the bursting crescendo of the finale.

"I liked best the ones in black who fought themselves," said Bonnie.

"Yes," said the boy, "when they were bumping each other it was far best."

"We'd better stay in Montreux for dinner—it's too wet to drive back," suggested David.

About the hotel lobby sat many groups with an air of professional waiting; the smell of coffee and French pastry permeated the half gloom; raincoats trickled in the vestibule.

"Bonjour!" yelled Bonnie suddenly, "you have danced very well, better than in Paris even!"

Sleek and well-dressed Arienne traversed the room. She turned like a mannequin, exhibiting herself. A slight embarrassment covered the gray honest meadow between her eyes.

"I am sorry I am so *dégouttante,*" she said pretentiously, shaking her coat, "in this old thing from Patou! But you have grown so big!" She fondled Bonnie affectedly. "And how is your mother?"

"She too is dancing," said Bonnie.

"I know."

Arienne freed herself as quickly as she could. She had given her drama of success—Patou was the chosen couturiere of the stars of the ballet; only the finest sack-cloth was sewed by Patou. Arienne had said Patou. "Patou," she said, emphatically.

"I must go to my room, our étoile is waiting for me there. Au 'voir, cher David! Au 'voir, ma petite Bonnie!"

The children were very dainty about the table, and somehow not an anachronism in this night place that had had music before the war. The wine barred the table with topaz shafts, the beer protested the cold restraint of silver mugs, the children giggled ebulliently beneath parental discipline like boiling water shaking the lid of a saucepan.

"I want the hors d'oeuvre," said Bonnie.

"Why, daughter! It's too indigestible for night."

"But I want it, too!" wailed the boy.

"The old will order for the young," announced David, "and I will tell you about Prometheus so you will not notice that you are not getting what you want. Prometheus was tied to an immense rock and——"

"May I have the apricot jam?" interrupted Genevra.

"Do you want to hear about Prometheus, or not?" said Bonnie's father impatiently.

"Yes, sir. Oh, yes, of course."

"Then," resumed David, "he writhed there for years and years and——"

"That is in my 'Mythologie,'" said Bonnie proudly.

"And then what?" said the little boy, "after he was writhing."

"Then what? Well——" David glowed with the exhilaration of being attractive, laying out the facets of his personality for the children like stacks of expensive shirts for admiring valets. "Do you remember exactly what *did* happen?" he said lamely to Bonnie.

"No. I've forgot since a long time."

"If that is all, may I please have the compote?" Genevra politely insisted.

Riding home through the flickering night, the country passed in visions of twinkling villages and cottage gardens obstructing their passage with high sunflower stalks. The children, wrapped in the bright armor of Bonnie's father's car, dozed against the felt cushions. Safe in the glittering car they rode: the car-at-your-disposal, the mystery-car, the Rajah's-car, the death-car, the first-prize, puffing the power of money out on the summer air like a seigneur distributing largesse. Where the night sky reflected the lake they rode like a rising bubble through the bowl of the mercurial, welded globe. They drove through the black impenetrable shadows clouding the road like fumes from an alchemist's laboratory and sped across the gleam of the open mountaintop.

"I would not like to be an artist," said the little boy sleepily. "Unless I could be a trained seal, I wouldn't," he qualified.

"I would," said Bonnie. "They will be having supper when we are already asleep."

"But," protested Genevra reasonably, "we have had our supper."

"Yes," Bonnie agreed, "but supper is always nice to be having."

"It's not when you're full," said Genevra.

"Well, when you're full you wouldn't care whether it was nice or not," said Bonnie.

"Why do you always argue so?" Genevra settled in cold withdrawal against the window.

"Because you interrupted when I was thinking what would be nice."

"We'll go straight to your hotel," suggested David. "You children seem to be tired."

"Father says conflict develops the character," said the older boy.

"I think it spoils the evening," said David.

"Mummy said it ruins the disposition," contributed Genevra.

Moving about the hotel rooms alone with David, Bonnie approached her father.

"I suppose I should have been much nicer?"

"Yes. Sometime you will realize that people are more important than digestion, even."

"They should have made me *feel* nice then, don't you think? They were the company."

"Children are always company," said David. "People are like almanacs, Bonnie—you never can find the information you're looking for, but the casual reading is well worth the trouble."

"These rooms are very nice," reflected Bonnie. "What is that thing in the bathroom where the water squirts out like a hose?"

"I have told you a thousand times not to touch those things! It's a sort of a fire extinguisher."

"Do they always think there's going to be a fire in the bathroom?"

"Very seldom."

"Of course," said Bonnie, "it would be too bad for the people, but it would be fun to see the excitement."

"Are you ready for bed? I want you to write to your mother."

"Yes, Daddy."

Bonnie sat in the still parlor with its deep majestic windows facing the sepia square, composing.

Dearest Mummy:

As you will see, we are back in Switzerland——The room was very big and quiet.

——It is very interesting to see the Swiss! The hotelman called Daddy a Prince!

The curtains waved just softly in the breeze, then lay still.

——*Figurez-vous, Maman,* that would make me a Princess. Imagine them thinking anything so silly——

There were enough lamps for a room to have, even a big chic room
such as this.

——Mademoiselle Arienne had a Patou dress. She was glad about your
success——

They had even thought of putting flowers to make the room so much
prettier at her father's hotel.

——If I were a Princess, I should always have my own way. I would
bring you to Switzerland——

The cushions were hard but very pretty with their gold tassels hang-
ing down the chair legs.

——I was glad when you were home——

The shadows seemed to move. Only babies were frightened of shad-
ows or of moving things at night.

——I have not many experiences to relate. I am making myself as spoiled
as I can——

There couldn't be anything hiding in the shadows. They just appeared
to move that way. Was that the door opening?

"Oh—oh—oh," shrieked Bonnie in terror.

"Sh—sh—sh," David reassured the child, holding out the promise of
warmth and comfort to his daughter.

"Did I frighten you?"

"No—It was the shadows. I am sometimes silly when I am all by
myself."

"I understand," he soothed. "Grown people are too, very often."

The lights of the hotel fell somnolently over the park opposite; an air
of waiting hung over the streets like a flag lying about its staff without
a breeze.

"Daddy, I want to sleep with my lights on."

"What an idea! There's nothing to be afraid of—you've got me and
Mummy."

"Mummy is in Naples," said Bonnie, "and if I fall asleep you will surely be going out!"

"All right then, but it's absurd!"

Some hours later when David tiptoed in, he found Bonnie's room dark. Her eyes were much too tightly closed to be unconscious; she had arranged a small crack in the door to the living room to compromise.

"What's keeping you awake?" he said.

"I was thinking," murmured Bonnie. "It is better here than with Mummy's success in Italy."

"But I have success," said David, "only I got it before you were born so it just appears the natural order to you!"

Insects reverberated in the trees beside the silent room.

"Was it so awful in Naples?" he pursued.

"Well," hesitated Bonnie, "I don't know how it was for Mummy, of course——"

"Didn't she say anything at all about me?"

"She said—let me see—I don't know what Mummy said, Daddy, only she said her piece of advice that she had to give me was not to be a backseat driver about life."

"Did you understand?"

"Oh, no," sighed Bonnie gratefully and complacently.

The summer quavered down from Lausanne to Geneva, trimming the lake like the delicate border of a porcelain plate; the fields yellowed in the heat; the mountains across from their windows yielded up no more details even on the brightest of days.

Bonnie played in sibylline detachment watching the Juras wedge their inky shadows between the rushes at the water's edge. White birds flying in inverted circumflex accented the colorless suggestion of a bounded infinite.

"Has the little one slept well?" asked the people recovering from long illnesses who painted the view in the garden.

"Yes," answered Bonnie politely, "but you must not disturb me—I am the watcher who tells when the enemy is coming."

"Then can I be King of the Castle?" called David from the window, "and cut off your head if you make a mistake?"

"You," said Bonnie, "are a prisoner, and I have pulled out your tongue so you cannot complain—but I am good to you anyway," she relented, "so you needn't feel unhappy, Daddy—unless you want to! Of course, it would be *better* to be unhappy, perhaps!"

"All right," said David, "I'm one of the unhappiest of people! The laundry has faded my pink shirt, and I've just been invited to a wedding."

"I don't allow you to go out visiting," said Bonnie severely.

"Well, then, I'm only half as unhappy as I was."

"I won't let you play any more if you act that way. You're supposed to be sad and homesick for your wife."

"Look! I dissolve in tears!" David draped himself like a puppet over the wet bathing suits drying on the window ledge.

The bellboy bringing up the telegram seemed rather surprised to find Monsieur le Prince Américain in such an unusual position. David tore open the envelope.

"Father stricken," he read. "Recovery doubtful. Come at once. Try to save Alabama from shock. Devotedly. Millie Beggs."

David stared trancelike at the white butterflies fluttering under a tree with crooked branches elbowing the ground impassively. He watched his emotions sliding past the present like a letter dropped down a glass chute; the telegram cut into their lives as decisively as the falling blade of a guillotine. Grabbing a pencil he started to write out a telegram to Alabama, decided to telephone, and remembered that the Opera was closed in the afternoon. He sent the wire to the pension.

"What's the matter, Daddy, aren't you playing any more?"

"No, dear; you'd better come in, Bonnie. I've had some bad news."

"What's happened?"

"Your grandpa's dying, so we'll have to go to America. I'll send for Mademoiselle to stay with you. Mummy will probably come straight to Paris to meet me—unless I sail from Italy."

"I wouldn't," advised Bonnie. "I'd surely go from France."

They waited distractedly for word from Naples.

The answer from Alabama fell like a shooting star, a cold mass of lead from the heavens. From voluble hysterical Italian, David finally deciphered the message.

"Madame is ill in the hospital since two days. You must come here to save her. There is none to look after her though she refuse us your address, still hoping to be well alone. It is serious. We have no one to count on but you and Jesus."

"Bonnie," groaned David, "where in the hell have I put Mademoiselle's address?"

"I don't know, Daddy."

"Then you'll have to pack for yourself—and be quick."

"Oh, Daddy," wept Bonnie, "I just came from Naples. I don't want to go!"

"Your mother needs us," was all David said. They caught the midnight express.

It was a little like the Inquisition at the Italian hospital—they had to wait outside with Alabama's landlady and Madame Sirgeva till it opened its doors at two o'clock.

"So much promise," moaned Madame, "she would perhaps have been a big dancer in time—"

"And Holy Angels, so young!" murmured the Italian.

"Only of course there wasn't any time," added Sirgeva sorrowfully. "She was too old."

"And always alone, so help me God, Signor," sighed the Italian reverentially.

The streets ran about the tiny grass plots like geometrical calculations—some learned doctor's half-effaced explanatory diagrams on a slate. A charwoman opened the doors.

David did not mind the smell of the ether. Two doctors talked together in an anteroom about golf scores. It was the uniforms that made it like the Inquisition, and the smell of green soap.

David felt very sorry for Bonnie.

David didn't believe the English interne had made a hole in one.

The doctors told him about the infection from the glue in the box of the toe shoe—it had seeped into a blister. They used the word "incision" many times over as if they were saying a Hail Mary.

"A question of time," they repeated, one after the other.

"If she had only disinfected," said Sirgeva. "I will keep Bonnie while you go in."

In the desperate finality of the room, David stared at the ceiling.

"There's nothing the matter with my foot," screamed Alabama. "It's my stomach. It's killing me!"

Why did the doctor inhabit another world from hers? Why couldn't he hear what she was saying, and not stand talking about ice packs?

"We will see," the doctor said, staring out of the window impassively.

"I've got to have some water! *Please* give me some water!"

The nurse went on methodically straightening the dressings on the wheel table.

"Non c'è acqua," she whispered.

She didn't need to be so confidential about it.

The walls of the hospital opened and shut. Alabama's room smelled

like hell. Her foot lay off the bed in a yellow fluid that turned white after a while. She had a terrible backache. It was as if she had been beaten with heavy beams.

"I've got to have some orange juice," she thought she said. No, it was Bonnie who had said that. David will bring me some chocolate ice cream and I will throw it up; it smells like a soda fountain, thrown-up, she thought. There were glass tubes in her ankle like stems, like the headdress of a Chinese empress—it was a permanent wave they were giving her foot, she thought.

The walls of the room slid quietly past, dropping one over the other like the leaves of a heavy album. They were all shades of gray and rose and mauve. There was no sound when they fell.

Two doctors came and talked together. What did Salonika have to do with her back?

"I've got to have a pillow," she said feebly. "Something broke my neck!"

The doctors stood impersonally at the end of the bed. The windows opened like blinding white caverns, entrances to white funnels that fitted over the bed like tents. It was too easy to breathe inside that tented radiance—she couldn't feel her body, the air was so light.

"This afternoon, then, at three," said one of the men, and left. The other went on talking to himself.

"I can't operate," she thought he said, "because I've got to stand here and count the white butterflies today."

"And so the girl was raped by a calla lily," he said, "—or, no, I believe it was the spray of a shower bath that did the trick!" he said triumphantly.

He laughed fiendishly. How could he laugh so much of *Pulcinella?* And he as thin as a matchstick and tall as the Eiffel Tower! The nurse laughed with another nurse.

"It isn't *Pulcinella,*" Alabama thought she said to the nurse. "It's *Apollon-Musagète.*"

"You wouldn't know. How could I possibly expect you to understand that?" she screamed contemptuously.

Meaningfully the nurses laughed together and left her room. The walls began again. She decided to lie there and frustrate the walls if they thought they could press her between their pages like a bud from a wedding bouquet. For weeks Alabama lay there. The smell of the stuff in the bowl took the skin off her throat, and she spit red mucus.

Those agonizing weeks David cried as he walked along the streets,

and he cried at night, and life seemed senseless and over. Then he grew desperate, and murder and violence played in his heart till he wore himself out.

Twice a day he came to the hospital and listened to the doctors telling about blood poison.

Finally they let him see her. He buried his head in the bedclothes and ran his arms underneath her broken body and cried like a baby. Her legs were up in sliding pulleys like a dentist's paraphernalia. The weights ached and strained her neck and back like a mediaeval rack.

Sobbing and sobbing, David held her close. He felt of a different world to Alabama; his tempo was different from the sterile, attenuated rhythms of the hospital. He felt lush and callous, somehow, like a hot laborer. She felt she hardly knew him.

He kept his eyes glued persistently to her face. He hardly dared look at the bottom of the bed.

"Dear, it's nothing," he said with affected blandness. "You will be well in no time." Somehow she was not reassured. He seemed to be avoiding some issue. Her mother's letters did not mention her foot and Bonnie was not brought to the hospital.

"I must be very thin," she thought. The bedpan cut her spine, and her hands looked like bird claws. They clung to the air like claws to a perch, hooking the firmament as her right to a footrest. Her hands were long and frail and blue over the knuckles like an unfeathered bird.

Sometimes her foot hurt her so terribly that she closed her eyes and floated off on the waves of the afternoon. Invariably she went to the same delirious place. There was a lake there so clear that she could not tell the bottom from the top; a pointed island lay heavy on the waters like an abandoned thunderbolt. Phallic poplars and bursts of pink geranium and a forest of white-trunked trees whose foliage flowed out of the sky covered the land. Nebulous weeds swung on the current: purple stems with fat animal leaves, long tentacular stems with no leaves at all, swishing balls of iodine and the curious chemical growths of stagnant waters. Crows cawed from one deep mist to another. The word "sick" effaced itself against the poisonous air and jittered lamely about between the tips of the island and halted on the white road that ran straight through the middle. "Sick" turned and twisted about the narrow ribbon of the highway like a roasting pig on a spit, and woke Alabama gouging at her eyeballs with the prongs of its letters.

Sometimes she shut her eyes and her mother brought her a cool lemonade, but this happened only when she was not in pain.

David came when anything new occurred, like a parent supervising a child who is learning to walk.

"And so—you must know sometime, Alabama," he said at last. The bottom fell out of her stomach. She could feel the things dropping through.

"I've known for ages," she said in sickly calm.

"Poor darling—you've still got your foot. It's not *that*," he said compassionately. "But you will never be able to dance again. Are you going to mind terribly?"

"Will I have crutches?" she asked.

"No—nothing at all. The tendons are cut and they had to scrape through an artery, but you will be able to walk with a slight limp. Try not to mind."

"Oh, my body," she said. "And all that work for nothing!"

"Poor, my dear one—but it has brought us together again. We have each other, dear."

"Yes—what's left," she sobbed.

She lay there, thinking that she had always meant to take what she wanted from life. Well—she hadn't wanted this. This was a stone that would need a good deal of salt and pepper.

Her mother hadn't wanted her boy to die, either, she supposed, and there must have been times when her father hadn't wanted any of them dragging about his thighs and drawing his soul off in lager.

Her father! She hoped they would get home while he was still alive. Without her father the world would be without its last resource.

"But," she remembered with a sudden sobering shock, "it will be me who is the last resource when my father is dead."

◦ III ◦

The David Knights stepped out of the old brick station. The Southern town slept soundless on the wide palette of the cotton fields. Alabama's ears were muffled by the intense stillness as if she had entered a vacuum. Negroes, lethargic and immobile, draped themselves on the depot steps like effigies to some exhausted god of creation. The wide square, masked in velvet shadows, drowned in the lull of the South, spread like soft blotting paper under man and his heritage.

"So we will find us a beautiful house and live here?" asked Bonnie.

"*Que c'est drôle!*" ejaculated Mademoiselle. "So many Negroes! Do they have missionaries to teach them?"

"Teach them what?" asked Alabama.

"Why—religion."

"Their religion is very satisfactory, they sing a lot."

"It is well. They are very sympathetic."

"Will they bother me?" asked Bonnie.

"Of course not. You're safer here than you've ever been in your life. This is where your mother was little."

"I went to a Negro baptism in that river at five o'clock on a Fourth of July morning. They were dressed in white robes and the red sun slanted down over the muddy water's edge, and I felt very rapturous and wanted to join their church."

"I would like to see that."

"Maybe."

Joan was waiting in the little brown Ford.

Alabama felt like a little girl again to see her sister after so many years. The old town where her father had worked away so much of his life spread before her protectively. It was good to be a stranger in a land when you felt aggressive and acquisitive, but when you began to weave your horizons into some kind of shelter it was good to know that hands you loved had helped in their spinning—made you feel as if the threads would hold together better.

"I'm awfully glad you got here," Joan said sadly.

"Is grandpa very sick?" said Bonnie.

"Yes, dear. I've always thought Bonnie was such a sweet child."

"How are your children, Joan?" Joan wasn't much changed. She was conventional, more like their mother.

"Just fine. I couldn't bring them. All this is very depressing for children."

"Yes. We'd better leave Bonnie at the hotel. She can come out in the morning."

"Let her just come to say 'Hello.' Mamma adores her so." She turned to David. "She's always liked Alabama better than the rest of us."

"Junk! Because I'm the youngest."

The car sped up the familiar streets. The soft inconsequential night, the smell of the gently perspiring land, the crickets in the grass, the heavy trees conspiring together over the hot pavements, lulled the blank fear in Alabama's heart to a sense of impotence.

"Can't we do *anything?*" she said.

"We've done everything. There's no cure for old age."

"How is Mamma?"

"As brave as she always is—but I am glad you could come."

The car stopped before the quiet house. How many nights had she coasted up to that walk just that way to keep from waking her father with the grind of the brakes after dances? The sweet smell of sleeping gardens lay in the air. A breeze from the gulf tolled the pecan trees mournfully back and forth. Nothing had changed. The friendly windows shone in the just benediction of her father's spirit, the door spread open to the just decency of his will. Thirty years he had lived in his house, and watched the scattered jonquils bloom and seen the morning glories wrinkle in the morning sun and snipped the blight from his roses and admired Miss Millie's ferns.

"Ain't they pretty?" he'd say. Measured, marked only by the absence of an accent, his balanced diction swayed to the aristocracy of his spirit.

He had caught a crimson moth once in the moonvines and pinned it over his mantel on a calendar. "It's a very good place for it," he had said, stretching the fragile wings over a railroad map of the South. The Judge had a sense of humor.

Infallible man! How his children had gloated when something went wrong—the unsuccessful operation on a chicken's craw with the Judge's pocketknife and a needle from Millie's sewing basket, an overturned glass of iced tea on the Sunday dinner table, a spot of turkey dressing on the clean Thanksgiving cloth—these things had rendered the cerebral machinery of the honest man more tangible.

The quick fear of unclassified emotion seized Alabama, an overwhelming sense of loss. She and David climbed the steps. How high those cement slabs that held the ferns had seemed when she was a child jumping from one to the other—and there was the place where she had sat while somebody told her about Santa Claus, and hated the informer and hated her own parents that the myth should be untrue and yet exist, crying out, "I will believe—"; and there the dry Bermuda grass between the hot bricks had tickled her bare thighs, and there was the limb of the tree her father had forbade her to swing on. It seemed incredible that the thin branch could ever have supported her body. "You must not abuse things," her father had corrected.

"It won't hurt the tree."

"In my judgment it will. If you want to have things, you have got to take care of them."

He who had had so few things! An engraving of his father and a miniature of Millie, three buckeyes from a Tennessee vacation, a pair of gold cuff buttons, an insurance policy, and some summer socks was what Alabama remembered of his top bureau drawer.

"Hello, darling," her mother kissed her tremulously, "and my darling!

Let me kiss you on the top of your head." Bonnie clung to her grandmother.

"Can we see Grandpa, Grandma?"

"It will make you sad, dear."

The old lady's face was white and reticent. She moved slowly back and forth in the old swing, rocking with gentle condolence their spiritual losses.

"Oh—o—o—o—, Millie," the Judge's voice called feebly.

The tired doctor came to the porch.

"Cousin Millie, I thought if the children want to see their father, he is conscious now." He turned kindly to Alabama. "I'm glad you got here," he said.

Trembling, she followed his lean, protective back into the room. Her father! Her father! How weak and pale he was. She could have cried out at her inability to frustrate this useless, inevitable waste.

She sat quietly on the bed. Her beautiful father!

"Hello, baby." His gaze wandered over her face. "Are you going to stay here awhile?"

"Yes, it's a good place."

"I've always thought so."

The tired eyes traveled to the door. Bonnie waited, frightened, in the hall.

"I want to see the baby." A sweet tolerant smile lit the Judge's face. Bonnie approached the bed timidly.

"Hello, there, baby. You're a little bird," the man smiled. "And you're as pretty as two little birds."

"When will you be well again, Grandpa?"

"Pretty soon. I'm very tired. I'll see you tomorrow." He waved her aside.

Alone with her father, Alabama's heart sank. He was so thin and little now that he was sick, to have got through so much of life. He had had a hard time providing for them all. The noble completeness of the life withering on the bed before her moved her to promise herself many promises.

"Oh, my father, there are so many things I want to ask you."

"Baby," the old man patted her hand. His wrists were no bigger than a bird's. How had he fed them all?

"I never thought you'd known till now."

She smoothed the gray hair, even Confederate gray.

"I've got to go to sleep, baby."

"Sleep," she said, "sleep."

She sat there a long time. She hated the way the nurse moved about the room as if her father were a child. Her father knew everything. Her heart was sobbing, and sobbing.

The old man opened his eyes proudly, as was his wont.

"Did you say you wanted to ask me something?"

"I thought you could tell me if our bodies are given to us as counterirritants to the soul. I thought you'd know why when our bodies ought to bring surcease from our tortured minds, they fail and collapse; and why, when we are tormented in our bodies, does our soul desert us as a refuge?"

The old man lay silent.

"Why do we spend years using up our bodies to nurture our minds with experience and find our minds turning then to our exhausted bodies for solace? Why, Daddy?"

"Ask me something easy," the old man answered, very weak and far away.

"The Judge must sleep," said the nurse.

"I'll go."

Alabama stood in the hall. There was the light her father turned out when he went up to bed; there was the peg with his hat hanging there.

When man is no longer custodian of his vanities and convictions, he's nothing at all, she thought. Nothing! There's nothing lying on that bed—but it is my father and I loved him. Without his desire, I should never have lived, she thought. Perhaps we are all just agents in a very experimental stage of organic free will. It cannot be that myself is the purpose of my father's life—but it can be that what I can appreciate of his fine spirit is the purpose of my own.

She went to her mother.

"Judge Beggs said yesterday," said Millie to the shadows, "that he would like to go for a ride in the little car to see the people on their front porches. He tried all summer to learn to drive, but he was too old. 'Millie,' he said, 'tell that hoary-headed angel to dress me. I want to go out.' He called the nurse his hoary-headed angel. He always had a dry sense of humor. He loved his little car."

Like the good mother she was, she went on and on—as if she could teach Austin to live again by rehearsing all those things. Like a mother speaking of a very young child, she told Alabama about the sick Judge, her father.

"He said he wanted to order some new shirts from Philadelphia. He said he would like some breakfast bacon."

"He gave Mamma a check for the undertaker for a thousand dollars," added Joan.

"Yes," Miss Millie laughed as if at a child's capricious prank. "Then he said, 'But I want it back if I don't die.'"

"Oh, my poor mother," thought Alabama, "and all the time he's going to die. Mamma knows, but she can't say to herself, 'He's going to die.' Neither can I."

Millie had nursed him so long, sick and well. When he was a young man in the law office and the other clerks no older than himself addressed him already as "Mr. Beggs," when he was middle-aged and consumed with poverty and care, when he was old and had more time to be kindly.

"My poor mother," said Alabama. "You have given your life for my father."

"My father said we could be married," answered her mother, "when he found that your father's uncle was thirty-two years in the United States Senate and his father's brother was a Confederate general. He came to my father's law office to ask him for my hand. *My* father was eighteen years in the Senate and the Confederate Congress."

She saw her mother as she was, part of a masculine tradition. Millie did not seem to notice about her own life, that there would be nothing left when her husband died. He was the father of her children, who were girls, and who had left her for the families of other men.

"My father was a proud man," Millie said, proudly. "When I was a little girl I loved him dearly. There were twenty of us and only two girls."

"Where are your brothers?" said David curiously.

"Dead and gone long ago."

"They were half-brothers," said Joan.

"It was my own brother who came here in the spring. He went away and said he'd write, but he never did."

"Mamma's brother was a darling," Joan said. "He owned a drugstore in Chicago."

"Your father was very kind to him and took him driving in the car."

"Why didn't you write to him, Mamma?"

"I did not think to get his address. When I came to live with your father's family I had so much to do I couldn't keep track of my own."

Bonnie was asleep on the hard porch bench. When Alabama had slept that way as a little girl, her father had carried her upstairs to bed in his arms. David lifted the sleeping child.

"We ought to go," he said.

"Daddy," Bonnie whispered, snuggling under his coat lapels. "My Daddy."

"You will come again tomorrow?"

"Early in the morning," Alabama answered. Her mother's white hair was done in a crown around her head like a Florentine saint. She held her mother in her arms. Oh, she remembered how it felt to be close to her mother!

Every day Alabama went to the old house, so clean inside and bright. She brought her father little special things to eat, and flowers. He loved yellow flowers.

"We used to gather yellow violets in the woods when we were young," her mother said.

The doctors came and shook their heads, and so many friends came that nobody ever had more friends to bring them cakes and flowers, and old servants came to ask about the Judge, and the milkman left an extra pint of milk out of his own pocket to show that he was sorry, and the Judge's fellow judges came with sad and noble faces like the heads on postage stamps and cameos. The Judge lay in his bed, fretting about money.

"We can't afford this sickness," he said over and over. "I've got to get up. It's costing money."

His children talked it over. They would share the expenses. The Judge would not have allowed them to accept his salary from the State if he had known he was not going to get well. All of them were able to help.

Alabama and David rented a house to be near her parents. It was bigger than her father's house, in a garden with roses and a privet hedge, and iris planted to devour the spring, and many bushes and shrubs under the windows.

Alabama tried to persuade her mother to take a ride. It was months since she had left the house.

"I can't go," Millie said. "Your father might want me while I'm away." She waited constantly for some last illuminating words from the Judge, feeling that he must have something to tell her before he left her alone at the last.

"We'll just stay half an hour," Millie finally agreed.

Alabama drove her mother past the Capitol, where her father had spent so many years of his life. The clerks sent them roses from the rosebed under his office window. Alabama wondered if his books were covered with dust. Perhaps he would have prepared some last communication there, in one of his drawers.

"How did you happen to marry Daddy?"

"He wanted to marry me. I had many beaux."

The old lady looked at her daughter as if she expected a protest. She was more beautiful than her children. There was much integrity in her face. Surely she had had many beaux.

"There was one who wanted to give me a monkey. He told my mother monkeys all had tuberculosis. My grandmother looked at him and said, 'But you look very healthy to me.' She was French, and a very beautiful woman. A young man sent me a baby pig from his plantation, and another sent me a coyote from New Mexico, and one of them drank, and another married Cousin Lil."

"Where are they all?"

"Dead and gone years ago. I wouldn't know them if I saw them. Ain't the trees pretty?"

They passed the house where her mother and father had met—"at a New Year's ball," her mother told her. "He was the handsomest man there, and I was visiting your Cousin Mary."

Cousin Mary was old and her red eyes cried continually under her spectacles. There wasn't much left of her, yet she had given a ball on New Year's.

Alabama had never pictured her father dancing.

When she saw him in the casket at the end, his face was so young and fine and humorous, the first thing Alabama thought of was that New Year's ball so many years ago.

"Death is the only real elegance," she said to herself. She had been afraid to look, afraid of what discoveries she might make in the spent and lifeless face. There was nothing to be afraid of, only plastic beauty and immobility.

There was nothing amongst the papers in his bare skeleton office, and nothing in the box with his insurance premiums except a tiny moldy purse containing three nickels wrapped in an ancient newspaper.

"It must be the first money he ever earned."

"His mother gave it to him for laying out the front yard," they said.

There was nothing amongst his clothes or hid behind his books. "He must have forgot," Alabama said, "to leave the message."

The State sent a wreath to the funeral and the Court sent a wreath. Alabama was very proud of her father.

Poor Miss Millie! She had a mourning veil pinned over her black straw hat from last year. She had bought that hat to go to the mountains with the Judge.

Joan cried about the black. "I can't afford it," she said.

So they didn't wear black.

They didn't have music. The Judge had never liked songs save the tuneless "Old Grimes" that he sang to his children. They read "Lead Kindly Light" at the funeral.

The Judge lay sleeping on the hillside under the hickory-nut trees and the oak. From his grave the dome of the Capitol blotted out the setting sun. The flowers wilted, and the children planted jasmine vines and hyacinths. It was peaceful in the old cemetery. Wildflowers grew there, and rosebushes so old that the flowers had lost their color with the years. Crape myrtle and Lebanon cedars shed their barbs over the slabs; rusty Confederate crosses sank into the clematis vines and the burned grass. Tangles of narcissus and white flowers strayed the washed banks and ivy climbed in the crumbling walls. The Judge's grave said:

<div align="center">

AUSTIN BEGGS

APRIL, EIGHTEEN FIFTY-SEVEN

NOVEMBER, NINETEEN THIRTY-ONE

</div>

But what had her father said? Alabama, alone on the hillside, fixed her eyes on the horizon in an effort to hear again that abstract measured voice. She couldn't remember that he had ever said anything. The last thing he said was:

"This thing is costing money," and when his mind was wandering, "Well, son, I could never make money either." And he had said Bonnie was as pretty as two little birds, but what had he said to her when she was a little girl? She couldn't remember. There was nothing in the mackerel sky but cold spring rain.

Once he had said, "If you want to choose, you must be a goddess." That was when she had wanted her own way about things. It wasn't easy to be a goddess away from Olympus.

Alabama ran from the first drops of the bitter drizzle.

"We are certainly accountable," she said, "for all the things manifest in others that we secretly share. My father has bequeathed me many doubts."

Panting, she threw the car into gear and slid off down the already slippery red clay road. She was lonely at night for her father.

"Everybody gives you belief for the asking," she said to David, "and so few people give you anything more to believe in than your own belief—just not letting you down, that's all. It's so hard to find a person who accepts responsibilities beyond what you ask."

"So easy to be loved—so hard to love," David answered.

Dixie came after a month had passed.

"I've plenty of room now for whoever wants to stay with me," said Millie sadly.

The girls were much with their mother, trying to distract her.

"Alabama, please take the red geranium for your house," insisted her mother. "It doesn't matter here any more."

Joan took the old writing desk and crated it and shipped it away.

"But you must be careful not to let them fix the corner where the Yankee shell fell through my father's roof—that would spoil it."

Dixie asked for the silver punch bowl, and expressed it to her home in New York.

"Be careful not to dent it," said Millie. "It is made by hand from silver dollars that the slaves saved to give to your grandfather after they were freed—you children may choose what you like."

Alabama wanted the portraits, Dixie took the old bed where she and her mother and Dixie's son had been born.

Miss Millie sought her consolation in the past.

"My father's house was square with crossing halls," she'd say. "There were lilacs about the double parlor windows, and an apple orchard far down by the river. When my father died, I carried you children down to the orchard to keep you away from the sadness. My mother was always very gentle, but she was never the same, after."

"I'd like that old daguerreotype, Mamma," said Alabama. "Who is it?"

"My mother and my little sister. She died in a Federal prison during the war. My father was considered a traitor. Kentucky did not secede. They wanted to hang him for not upholding the Union."

Millie at last agreed to move to a smaller house. Austin would never have stood for the little house. The girls persuaded her. They ranged their memories on the old mantel like a collection of bric-a-brac, and closed the shutters of Austin's house on the light and all of himself left there. It was better so for Millie—that memories should be sharp when one has nothing else to live for.

They all had bigger houses than Austin's and much bigger than the one he left to Millie, yet they came there to Millie feeding on what she remembered of their father and on her spirit, like converts imbibing a cult.

The Judge had said, "When you're old and sick, you will wish you had saved your money."

They had, someday, to accept the tightening up of the world—to begin someplace to draw in their horizons.

Alabama lay awake thinking at night: the inevitable happened to peo-

ple, and they found themselves prepared. The child forgives its parents
when it perceives the accident of birth.

"We will have to begin all over again," she said to David, "with a
new chain of associations, with new expectations to be paid from the
sum of our experience like coupons clipped from a bond."

"Middle-aged moralizing!"

"Yes, but we *are* middle-aged, aren't we?"

"My God! I hadn't thought of it! Do you suppose my pictures are?"

"They're just as good."

"I've got to get to work, Alabama. Why have we practically wasted
the best years of our lives?"

"So that there will be no time left on our hands at the end."

"You are an incurable sophist."

"Everybody is—only some people are in their private lives, and some
people are in their philosophy."

"Well?"

"Well, the object of the game is to fit things together so that when
Bonnie is as old as we and investigates our lives, she will find a beautiful
harmonious mosaic of two gods of the hearthstone. Looking on this
vision, she will feel herself less cheated that at some period of her life
she has been forced to sacrifice her lust for plunder to protect what she
imagines to be the treasure that we have handed on to her. It will lead
her to believe that her restlessness will pass."

Bonnie's voice drifted up from the drive on the evangelistic afternoon.

"And so good-bye, Mrs. Johnson. My mother and father will be very
pleased and glad that you have been so kind and delightful about the
nice time."

She mounted the stairs contentedly. Alabama heard her purring in the
hall.

"You must have had a wonderful time——"

"I hated her stupid old party!"

"Then what was the oration about?"

"You said," Bonnie stared at her parent contemptuously, "that I was
not polite the last time when I didn't like the lady. So I hope you are
glad now with how I was this time."

"Oh, quite!"

People can't learn about their relations! As soon as they're understood
they're over. "Consciousness," Alabama murmured to herself, "is an
ultimate betrayal, I suppose." She had asked Bonnie simply to spare the
lady's feelings.

The child played often at her grandmother's house. They played at keeping house. Bonnie was the head of the family; her grandma made an agreeable little girl to have.

"Children were not brought up so strictly when mine were young," she said. She felt very sorry for Bonnie, that the child should have to learn so much of life before it began for her. Alabama and David insisted on that.

"When your mother was young, she charged so much candy at the corner store that I had an awful time hiding it from her father."

"Then I will be as Mummy was," said Bonnie.

"As much as you can get by with," chuckled her grandmother. "Things have changed. When I was a child it was the maid and the coachman who argued about whether or not I could carry a demijohn into the church with me on Sundays. Discipline used to be a matter of form and not a personal responsibility."

Bonnie stared intently at her grandmother.

"Grandma, tell me some more about when you were little."

"Well, I was very happy in Kentucky."

"But go on."

"I can't remember. I was much the same as you."

"I shall be different. Mummy says I shall be an actress if I want, and go to school in Europe."

"I went to school in Philadelphia. That was considered a long way then."

"And I shall be a great lady and wear fine clothes."

"My mother's silks were imported from New Orleans."

"You don't remember anything else?"

"I remember my father. He brought me toys from Louisville, and thought that girls should marry young."

"Yes, Grandma."

"I didn't want to. I was having too good a time."

"Didn't you have a good time when you were married?"

"Oh, yes, dear, but different."

"I suppose it can't be always the same."

"No."

The old lady laughed. She was very proud of her grandchildren. They were smart, good children. It was very pretty to see her with Bonnie, both of them pretending great wisdom about things, both of them eternally pretending.

"We shall be gone soon," the little girl sighed.

"Yes," sighed her grandmother.

"Day after tomorrow we shall be gone," said David.

Out of the Knights' dining room windows the trees put out down like new-feathered chicks. The bright, benevolent sky floated across the panes and lifted the curtains in billowing sails.

"You people never stay anywhere," said the girl with the shanghaied hair, "but I don't blame you."

"We once believed," said Alabama, "that there were things one place which did not exist in another."

"Sister went to Paris last summer. She said there were—well, toilets all along the streets—I'd like to see it!"

The cacophony of the table volleyed together and frustrated itself like a scherzo of Prokofiev. Alabama whipped its broken staccato into the only form she knew: schstay, schstay, brisé, schstay, the phrase danced along the convolutions of her brain. She supposed she'd spend the rest of her life composing like that: fitting one thing into another and everything into the rules.

"What are you thinking about, Alabama?"

"Forms, shapes of things," she answered. The talk pelted her consciousness like the sound of hoofs on a pavement.

"——They say that he kicked her in the bust."

"The neighbors had to close their doors to keep out the bullets."

"And four in the same bed. Imagine it!"

"And Jay kept jumping through the transoms, so now they can't rent the house at all."

"But I don't blame his wife, even if he did promise to sleep on the balcony."

"She said the best abortionist was in Birmingham, but anyway they went to New York."

"So Mrs. James was in Texas when it happened, and somehow James got it taken off the records."

"And the chief of police took her off in a patrol wagon."

"They met at her husband's grave. There was some suggestion that he had his wife buried next door on purpose, and that's the way it began."

"So Greek!"

"But, my dear, there are limits to human conduct!"

"But not to human impulses."

"Pompeii!"

"And nobody wants any homemade wine? I strained it through an old pair of underwear, but it seems to still have a little sediment." In

St-Raphaël, she was thinking, the wine was sweet and warm. It clung like syrup to the roof of my mouth and glued the world together against the pressure of the heat and the dissolution of the sea.

"How is your exhibition?" they said. "We've seen the reproductions."

"We love those last pictures," they said. "Nobody has ever handled the ballet with any vitality since——"

"I thought," said David, "that rhythm, being a purely physical exercise of the eyeball, that the waltz picture would actually give you, by leading the eye in pictorial choreography, the same sensation as following the measure with your feet."

"Oh, Mr. Knight," said the women, "what a wonderful idea!"

The men had been saying "Attaboy," and "Twenty-three skidoo," since the depression.

Along the paths of their faces the light slept in their eyes like the sails of children's boats reflected in a pond. The rings where stones kicked from the walk sank, widened and disappeared, and the eyes were deep and quiet.

"Oh," wailed the guests; "the world is terrible and tragic, and we can't escape what we want."

"Neither can we—that's why there's a chip off the globe teetering on our shoulders."

"May I ask what it is?" they said.

"Oh, the secret life of man and woman—dreaming how much better we would be than we are if we were somebody else or even ourselves, and feeling that our estate has been unexploited to its fullest. I have reached the point where I can only express the inarticulate, taste food without taste, smell whiffs of the past, read statistical books, and sleep in uncomfortable positions."

"When I revert to the allegorical school," David went on, "my Christ will sneer at the silly people, who do not give a rap about his sad predicament, and you will see in his face that he would like a bite of their sandwiches if somebody would just loosen up his nails for a minute——"

"We shall all come to New York to see it," they said.

"And the Roman soldiers in the foreground will also be wanting a bite of sandwich, but they will be too jacked up by the dignity of their position to ask for it."

"When will it be shown?"

"Oh, years and years from now—when I have finished painting everything else in the world."

On the cocktail tray, mountains of things represented something else;

canapés like goldfish, and caviar in balls, butter bearing faces and frosted glasses sweating with the burden of reflecting such a lot of things to stimulate the appetite to satiety before eating.

"You two are lucky," they said.

"You mean that we've parted with segments of ourselves more easily than other people—granted that we were ever intact," said Alabama.

"You have an easy time," they said.

"We trained ourselves to deduce logic from experience," Alabama said. "By the time a person has achieved years adequate for choosing a direction, the die is cast and the moment has long since passed which determined the future. We grew up founding our dreams on the infinite promise of American advertising. I *still* believe that one can learn to play the piano by mail and that mud will give you a perfect complexion."

"Compared to the rest, you are happy."

"I sit quietly eyeing the world, saying to myself, 'Oh, the lucky people who can still use the word "irresistible." ' "

"We couldn't go on indefinitely being swept off our feet," supplemented David.

"Balance," they said, "we must all have balance. Did you find much balance in Europe?"

"You'd do better to have another drink—that's what you came for, isn't it?"

Mrs. McGinty had short white hair and the face of a satyr, and Jane had hair like a rock whirlpool, and Fannie's hair was like a thick coating of dust over mahogany furniture, Veronica's hair was dyed with a dark aisle down the centre part, Mary's hair was country hair, like Maude's, and Mildred's hair was like the draperies of the "Winged Victory," flying.

"And they said he had a platinum stomach, my dear, so that his food just dropped into a little sack when he ate. But he lived for years like that."

"That hole in the top of his head was to blow him up by, though he pretended that he got it in the war."

"So she cut her hair after first one painter then another, till finally she came to the cubists and camouflaged her scalp."

"And I told Mary she wouldn't like the hashish, but she said that she must get something out of her hard-earned disillusion, so there she is, in a permanent trance."

"But it wasn't the Rajah, I tell you! It was the wife of the man who owns the Galeries Lafayette," Alabama insisted to the girl who wanted to talk about living abroad.

They rose to leave the pleasant place.

"We've talked you to death."

"You must be dead with packing."

"It's death to a party to stay till digestion sets in."

"I'm dead, my dear. It's been wonderful!"

"So good-bye, and please come back to see us on your wanderings."

"We'll always be back to see the family."

Always, Alabama thought, we will have to seek some perspective on ourselves, some link between ourselves and all the values more permanent than us of which we have felt the existence by placing ourselves in our father's setting.

"We will come back."

The cars drove away from the cement drive.

"Good-bye!"

"Good-bye!"

"I'm going to air the room a little," said Alabama. "I wish people wouldn't set wet glasses down on rented furniture."

"Alabama," said David, "if you would stop dumping ashtrays before the company has got well out of the house we would be happier."

"It's very expressive of myself. I just lump everything in a great heap which I have labeled 'the past,' and, having thus emptied this deep reservoir that was once myself, I am ready to continue."

They sat in the pleasant gloom of late afternoon, staring at each other through the remains of the party; the silver glasses, the silver tray, the traces of many perfumes; they sat together watching the twilight flow through the calm living room that they were leaving like the clear cold current of a trout stream.

SCANDALABRA

*A Farce Fantasy in a Prologue
and Three Acts*

◇

Scandalabra was written by Zelda Fitzgerald in the summer and fall of 1932 when the Fitzgeralds were living at "La Paix," outside Baltimore. The play was produced in 1933 by the Junior Vagabonds and ran for a scheduled six nights in Baltimore, from June 26 to July 1.

There are two versions of *Scandalabra:* the ninety-one-page typescript deposited for copyright on October 31, 1932, and the undated sixty-one-page version in the Zelda Fitzgerald Papers at Princeton University Library. Both typescripts have a three-act structure; it may be that neither of these is the play as it was performed.

The shorter version printed here is almost certainly a later revision —if not the final one—of the longer text. Not only are speeches shortened and sometimes eliminated, but scenes are rearranged and new ones are added. The drastic cutting and revising produces a script that, while still probably a weak stage vehicle, at least reads more like a play in finished form.

Confusion within the play—as well as about the play—seems to reflect the turbulence in the Fitzgeralds' lives during the time *Scandalabra* was written. Zelda Fitzgerald had suffered two breakdowns, and their marriage was in jeopardy. After her novel, *Save Me the Waltz* (1932), Fitzgerald had forbidden her to write fiction that would preempt material he wanted for *Tender Is the Night.* If she wrote a play, it must not be about psychiatry, nor should its locale be the Riviera or Switzerland; moreover, Fitzgerald must be given the right to approve her idea. These restrictions were more than Zelda Fitzgerald could tolerate.

Because of Zelda Fitzgerald's determination to keep her work from Fitzgerald, he did not see a script for *Scandalabra* before its production. He first saw the play at dress rehearsal, which ran from approximately 8:15 p.m. to 1 a.m. The length of this performance made it clear that *Scandalabra* could not open as it was; Fitzgerald assembled the cast and

revised the acting script in an all-night session. Despite his efforts *Scandalabra* played to poor reviews and small audiences.

Scandalabra was first published in 1980 as a limited edition (Columbia, S.C., and Bloomfield Hills, Mich.: Bruccoli Clark). This corrected text is republished here.

PROLOGUE

◊

It's a rather curious room but somebody thought it was beautiful, I suppose. It's so complicated that a lot of human thought must have gone into it for some reason. It's really hardly anything save pearly walls and devices, all of them metallic, gleaming and ultra-modern. Just arbitrarily, it's in New York. It could just as well have been in New Orleans or Detroit or the capital of Arizona—but New York makes it more cosmopolitan. We do love the centre of things—you feel the motion so much less. There's a man, one of the oldest men in the world, sitting with his feet in a steaming pail—at least it's a champagne bucket. He looks very feeble and unpleasant. He's our Uncle Andrew Messogony, Esquire, and he's so rich that he thinks a depression is something caused by heart trouble. The man at the phone is the butler. He's terribly chic even for a butler. He's one of the most elegant people you ever met in your life. Uncle is speaking to him in a creaking, croaking voice. Uncle's voice croaks and Uncle is about to follow suit. But it's not a bit depressing. It's very gay and fashionable, the scene of Uncle's death. That's because he's so cranky that the significance of life has never been able to penetrate his crabby exterior.

BAFFLES *(Arranging Uncle in his chair)* There, Mr. Messogony, are you quite uncomfortable?

UNCLE As much so as could be expected. As a matter of fact, it feels rather wonderful to be nearing the end of life.

BAFFLES I should think so, sir. Is there any last thing I could do for you?

UNCLE For fifteen years, your job has been to keep me bored.

BAFFLES Yes, sir. There's nothing like a surfeit of life to keep a man from restlessness.

UNCLE I'm getting a little bit nervous about going to heaven. I never
went in for excursions.

BAFFLES Shall I do the tricks to keep you quiet, sir? They're very sed-
ative.

UNCLE We had the cards Friday. You're no good at it any more—
one of them came out right as I remember.

BAFFLES Then I'll just try the silk hat, sir. Which do you dislike the
most, rabbits or baby chickens?

UNCLE I can't abide rabbits.

*Baffles extracts from a cupboard in the cocktail bar a silk hat, a silk
bandanna, and begins the hocus-pocus.*

BAFFLES Rabbits it is, sir, within my powers.

*Waving his hands, Baffles taps emphatically on the top of the hat, lifts
the handkerchief, and lo and behold! There is nothing!*

UNCLE What is it, Baffles?

They stare dumbfounded.

BAFFLES I'm sure I believed it would be a rabbit.

UNCLE Well, what is it?

BAFFLES It seems to be a leprechaun, sir.

UNCLE What do they do, Baffles. Leprechauns?

BAFFLES I don't know, sir—but they must be considered undesirable.

UNCLE Ask him.

BAFFLES He says, sir, he's used for causing troubles.

UNCLE What kind?

BAFFLES Troubles, sir, resultant on changing people from one thing
into another. I suppose he means in this instance from a silk
hat into—well, voices.

UNCLE I didn't hear anything. *(Suspiciously)* Can you speak leprechaun, Baffles?

BAFFLES Kitchen leprechaun. I never learned it when I was young and had to pick it up from the maids.

UNCLE What shall we do with him?

BAFFLES Shall I just phone the lawyer?

UNCLE That's an idea. Have him put it in my will.

BAFFLES Along with the forty million dollars, sir?

UNCLE Of course. I can't leave all that money to a man without some guarantee that he'll have troubles enough to make him turn out all right.

BAFFLES *(Picking up the phone)* Hello. Abyssinial three hundred nine times six. Hello. Is that you, sir? Well, Mr. Messogony's got round to his dying at last and—*(Respectfully to Uncle)* The lawyer would like to speak to you about your death, sir.

UNCLE Tell him I can't answer the phone. *(Looking at his watch)* My time came a long time ago.

BAFFLES *(In phone)* He says he's dying, sir. You don't believe it? Very good, sir. I'll tell him.

UNCLE How does he know whether I'm dying or not? I hoped that by now the world had dispensed with the sentimentality of keeping alive.

BAFFLES He's located your nephew, sir.

UNCLE Well, what sort of a person is he?

BAFFLES *(In phone)* About young Mr. Andrew, sir—have you investigated his character? *(Pause)* Oh, dear! Well, there must be *something* with which to redeem it.

Baffles hangs up the instrument distastefully and approaches Uncle.

The lawyer was very upset. It seems that young Mr. Andrew has turned up in the country. In short, a farmer.

UNCLE Then he's sure to be a nincompoop!

BAFFLES The lawyer says he's a very good man at heart—weak, but good.

UNCLE That's enough to incapacitate him for living! If I could think of some way to develop him—but there's so little time left.

BAFFLES The constructive possibilities of evil have been greatly neglected, sir.

UNCLE Experience is what he needs.

BAFFLES The young people don't seem to know how to misbehave any more—*except* by accident.

UNCLE We must all have some possibilities for evil, if we can just look on the wrong side of things.

BAFFLES Don't you think, sir, that life will correct the good in Mr. Andrew?

UNCLE I'd like to have had him a strong character, able to stand on his own feet.

BAFFLES Well, sir, according to the will, he doesn't assume control of the money until he knows how not to use it. *That* ought to be an incentive.

UNCLE You'll have to see, Baffles, that my nephew gets all the disadvantages.

BAFFLES Yes, sir. There's more room for improvement in vice than anywhere else.

UNCLE Categorical sin at collectors' prices would be the idea.

BAFFLES To the best of my impossibilities, sir.

UNCLE See that he keeps irregular hours.

BAFFLES I understand, sir—and no spinach.

UNCLE *(Sighs)* A farmer! I never thought such a thing would touch the family!

BAFFLES We'll smooth it over, sir. You've done so much to upset humanity already it may place you quite with the great uplifters.

UNCLE I hope there'll be a smooth crossing on the Styx.

BAFFLES Can't I put some more gin in your bucket before you leave?

UNCLE Please. Just a touch.

Baffles measures gin carefully into the pail.

Are you sure that's the good gin? I seem to be shriveling up.

BAFFLES The same as we always use. I made it purposely weak in view of your condition.

UNCLE It wouldn't look right to be dying with pickled feet.

BAFFLES No, sir. Shall I put the Cinzano in your hair?

UNCLE I'm too far gone to discuss serious matters. Be flippant, Baffles.

BAFFLES This business of your death, sir——

UNCLE Ah! That's better.

BAFFLES Do you think I should have the mattress re-covered?

UNCLE What mattress?

BAFFLES The one on which they will accuse you of having lain.

UNCLE You are better able to misjudge that than I.

BAFFLES Everything shall be as you wish. Are you sure you're all ready?

UNCLE As well as could be expected. But I don't seem to be able to die with the leprechaun thing in the room.

BAFFLES Just don't think about it, sir. Mind over matter, you know— makes a neurosis.

UNCLE All right. I'll try. Do you like me in this position?

Uncle assumes a Gibson Girl attitude.

BAFFLES The other way was better. With your hands on your ears, sir.

UNCLE Like this?

Uncle strikes an idiotic pose reminiscent of the Goldberg cartoons.

BAFFLES That's perfect. Just right, sir. Now all you have to do is go
 ahead.

UNCLE Well, Baffles, my man, it's been very nice to have made your
 acquaintance.

BAFFLES The same to you, sir.

UNCLE And if you are ever dropping around heaven, be sure to look
 me up.

BAFFLES I've got some good addresses from the cook. But I'm always
 glad to see an old employer.

UNCLE Well, don't forget. And be sure to spend all the wooden nick-
 els you take.

BAFFLES *(Laughing affectedly)* I will, sir.

 *The two men shake hands in a business-like manner, Uncle standing
 elaborately in his tub and Baffles wringing his hand emphatically.*

UNCLE I won't see you any more.

BAFFLES No, sir.

UNCLE Well, that's all right.

BAFFLES S-u-r-e!

 *Uncle falls back in the tub abruptly and sits there staring blankly
 about like a wax dummy. Baffles bends over him, covers his head with
 the silk hat and the handkerchief, and taps. Nothing happens. He taps
 again.*

UNCLE Quit it! I told you I was dead. Can't you take a fellow's word
 for it?

BAFFLES Excuse me, sir, fashions change so in things like that, I just
 wanted to be sure.

 Leaving Uncle thus covered, he goes to the phone.

 I want Preposterous two hundred and eighty thousand point
 six. *(Pause)* Hello, is this Mr. Messogony's lawyer? Well sir,
 he seems to have died, after all. I suppose it is one of the first

consistent things he ever did, but you know, sir, he always was eccentric. May I come right over with a rather special package for his nephew? Thank you, sir. I will . . . No, it's not Scotch.

CURTAIN

ACT ONE

◇

Uncle's living room. Flower and Andrew Messogony, Jr., are sitting quietly before an elaborate fire. She is knitting; he reading. The scene is as domestic as possible in such an environment. Flower's tall and boyish and tousled. She's both careless and deliberate at once and she does everything she does after the manner of a lady giving a plate of bones to a hungry police dog. She's fundamentally gay, but as fed up with life as a girl brought up in a convent. The chorus is wonderfully educative—that's where Flower grew and grew—to perfect babyhood. Andrew's apologetic approach to life has almost effaced his attractions—but they're there. He's a nice man, all brushed and washed and very, very likable, though you can see he will have to be taken care of.

ANDREW You know, Flower, I'm crazy about you.

FLOWER Isn't it funny? So am I. We've been married a year, too.

ANDREW I always thought I'd be scared of a Follies girl.

FLOWER And innocent men gave me the horrors till I met you.

ANDREW Uncle's executors wouldn't like our being in love after marriage.

FLOWER No.

ANDREW I'm afraid they suspect. I haven't been to the club in two nights.

FLOWER They couldn't, Andrew. I'm nearly always in Harlem. I've done exactly what they wanted about the—the dissolution.

ANDREW They do, though. Baffles let on that we'd stayed home on Wednesday.

FLOWER Oh well, they won't be round before midnight even if they do come. I'd be so happy, Andrew, if we could have more hours like this.

ANDREW I suppose we'd never have met if they'd known how domestic you were——

FLOWER I wasn't as bad as they made out—just enough to please the press agent.

ANDREW You were supposed to be gay and frivolous.

FLOWER I know—the most unsuitable companion available.

ANDREW Imagine their falling on a girl like you. *(He laughs contentedly)*

FLOWER A *good* girl.

ANDREW *(Alarmed)* You mustn't say that. The lawyers wouldn't like it.

FLOWER From the moment I saw you I knew I'd like to settle down like this.

ANDREW *(Nervously)* We oughtn't to be here this way, reading. It's sure to get us into trouble.

FLOWER It's awful to have to sneak what innocent quiet we get out of life. I'd rather give up the money.

ANDREW Flower! We couldn't. I'd have to go back to the farm.

FLOWER Hadn't you rather be there?

ANDREW But I want to hold on to you.

FLOWER I once milked a cow——

ANDREW It must have been pretty to see you.

FLOWER Of course, it was a painted cow. We all had big pink sunbon-nets and——

ANDREW Sh—sh! You must never let the lawyers know.

FLOWER Oh, all right. As far as that goes, *you* ought to be at your club.

ANDREW I know. The executors will probably surprise us tonight, our first anniversary! Suppose they found out you'd spent it knit-ting?

FLOWER Andrew!

ANDREW You ought to be starting for Harlem, Flower.

FLOWER I *wish* you'd give it up. I'm sure we could have a lovely time on a farm. Farms are so quaint.

ANDREW We *have* to do what they want. They know so much more about going to pieces than we do.

FLOWER If you'd only put your foot down so we wouldn't have to sit around the nightclubs till I'm too old to care.

ANDREW Don't *you* begin arguing, too. I've got my hands full with my disintegration.

FLOWER Oh well, as long as we've got each other I guess it's all right.

ANDREW Please hurry, Flower, or you'll be caught at home. I'll ask Baffles to get your coat.

FLOWER Yes. *(Flower rings)* I s'pose we couldn't go out together?

ANDREW Of course not.

Baffles appears with coat.

FLOWER Baffles, you needn't wait up for me. If I lose my latchkey again, I'll just wait till morning so as not to disturb you.

BAFFLES Thank you, Miss Flower. I'll see that your exemplary misconduct reaches the lawyers.

ANDREW Do you think they will be here tonight?

BAFFLES I couldn't say, sir. *(Reproachfully)* You know you've refused your caviar for over a week.

FLOWER There! Don't worry, Andrew, I'll try to think up enough trouble to pacify them.

BAFFLES That's right, Miss Flower. Sows' ears can't be made of silk purses for nothing.

FLOWER What would you suggest for tonight, Baffles?

BAFFLES 32 West Eighty-second, ask for Charles; 425 East Seventy-third, Mr. Bailey; 298 West Forty-seventh, mention Mr. Gray;

207 East Forty-fifth, by divine revelation; *and* the East River bottom, Miss Flower.

FLOWER Thanks, Baffles. That's quite a long list; I'll have to begin if I'm to fit them all in before morning.

BAFFLES Good night, Miss Flower. I'll see that Mr. Andrew gets going as soon as I've administered the champagne.

FLOWER Life's hardly worth living. Nothing but orchids and a Rolls-Royce.

ANDREW Good night, Flower. *(Pleads)* You won't have a good time, will you?

FLOWER No, Andrew. I promise. Good night.

Baffles busies himself with preparing Andrew's wine, bustling solicitously about.

BAFFLES I don't want to criticize, Mr. Andrew, but don't you think Miss Flower's looking rather—well—*well* lately?

ANDREW I think she's just right.

BAFFLES We can only hope, sir, that the improvement will pass unnoticed.

ANDREW I like women with a little color in their cheeks.

BAFFLES Revolutionary tendencies have no place in the Uncle's program for you, Mr. Andrew.

ANDREW Baffles, I think I won't have any champagne tonight. I think I'll stay home and think of my wife's pink cheeks.

BAFFLES Why, Mr. Andrew! Come now, after the first quart you won't mind it at all.

Baffles measures the champagne for Andrew in a spoon and forces it down his mouth.

ANDREW Do you think anybody would guess if we had beer instead? They look as if they belonged in the same family, don't you think?

BAFFLES No, sir—in this world we have to consider the labels, Mr. Andrew.

ANDREW You shouldn't let spelling make such a difference, Baffles.

BAFFLES Expensive tastes are best appreciated when the bill comes in. Try to swallow it, sir, there's only about four-fifths of the bottle left.

ANDREW What else do we have to do?

BAFFLES There's the canapés. I've let you off for two nights already.

ANDREW I told you it's making me bilious, anchovies.

BAFFLES Symptoms *always* go with a lot of money.

ANDREW If I could only have just eggs.

BAFFLES There, there—suppose the lawyers heard you. It wouldn't sound nice, you know.

ANDREW I really deserve a night at home.

BAFFLES Here's your silk hat, sir, and the cane.

ANDREW Isn't there anything at all to prevent my going? I'd like to brood about my wife a little.

BAFFLES Who ever heard of a libertine in such a state over his wife, Mr. Andrew?

ANDREW I'm a nephew. A very quiet and respectable nephew. I'm not a libertine.

BAFFLES But you will be, sir.

ANDREW Why?

BAFFLES Because this is the provision life has made for you.

The bell rings. Enter Doctor and Lawyer. Lawyer examines watch.

LAWYER Midnight! And you're just now going out. Why the delay?

BAFFLES If the executors will excuse me, there was another difficulty about the wine. Look what Mr. Andrew has left undrunk!

The two men help themselves.

LAWYER Something gone wrong again! Maybe *you'd* better just look him over, Doctor.

DOCTOR *(To Baffles)* Any other complaints, my man?

BAFFLES Refused caviar. Requests eggs instead.

DOCTOR Very irregular.

Jams funnel down Andrew's throat and peers inside.

I don't believe he has a future. Unless, of course, the lawyer could discover something illegal about him.

LAWYER Futures never turn up till the autopsy. *(To Baffles)* Any inclination to gambling?

Andrew shakes his head in negation.

Women?

BAFFLES I can hardly get him to the club nights, sir. *(Lugubriously)* He just seems to want to sit home.

DOCTOR Then it's probably physical after all. Will you kindly say "Boo" for me, Andrew?

ANDREW I don't want to play games.

DOCTOR Oh but you'll love it once you get started. Boo!

LAWYER Boo!

They laugh uproariously.

DOCTOR *(Replacing the funnel in Andrew's mouth)* I do wish I could persuade you to try our little trick.

LAWYER Try him on "Twinkle, Twinkle, Little Star," Doctor. I love that poem.

ANDREW There's nothing the matter with me.

DOCTOR My dear fellow, then why don't you drink your champagne?

BAFFLES It's his wife, sir, if you'll excuse me.

LAWYER But she's a nitwit, frivolous—every qualification for disrupting a life. What's the matter with his wife?

ANDREW Nothing.

DOCTOR Then what's she done to upset you so?

ANDREW Nothing.

LAWYER Well, maybe we can manage without any facts.

BAFFLES I suspect Miss Flower of entertaining domestic proclivities, sir.

LAWYER Good Lord! When did this begin?

BAFFLES The very day of the wedding.

ANDREW I won't have anybody casting aspersions on my wife's——

Doctor shuts him up with a thermometer.

DOCTOR There. Go on.

BAFFLES Sometimes they sit here in the evenings and talk to each other.

LAWYER What about?

BAFFLES *(Despondently)* Politics.

LAWYER What do they say about politics?

ANDREW We say how wonderful they are. What's it to you?

LAWYER Rather less than forty million dollars is to you, my boy.

Andrew groans.

DOCTOR Haven't you tried to prevent these conversations? They might induce a state of coma.

BAFFLES Yes, sir. But my private belief is that Miss Flower has reformed herself.

LAWYER Do you think it likely with a closet full of Poiret underwear and a past like hers?

BAFFLES No, sir.

DOCTOR No, sir.

LAWYER No, sir.

ANDREW Don't say things like that!

DOCTOR Then will you drink your champagne?

LAWYER Come, be reasonable, or we may have to continue the investigation.

ANDREW Only a little bit then, Baffles.

BAFFLES Take the last drop, sir, just for me.

ANDREW I can't swallow the stuff, honestly. Maybe I ought to give up.

LAWYER Baffles, is Miss Flower out as much as she should be?

BAFFLES The house is conducted in strict accordance to the will, sir.

DOCTOR And how does she dress when she goes out?

ANDREW In pink mostly—you see, I like nice healthy col——

BAFFLES Appropriately, sir. Like a boat that was sailing for foreign parts at midnight.

LAWYER Is she alone when she comes in?

BAFFLES I couldn't say, sir, she returns so late.

ANDREW Flower would've got home sooner but the taxis had stopped for the night when she started.

LAWYER There, just as I hoped! And you still think, Andrew, that she's behaving herself?

ANDREW Stop it! You make me shake all over—sitting down, too.

DOCTOR That's f-i-n-e! My, how I love a collapse.

LAWYER It's not very promising, really. Rich, married, with full social irresponsibilities for over a year and he is just now beginning to feel upset.

DOCTOR Champagne, ideas! That's all he needs.

ANDREW If I could only have peace and my wife.

LAWYER Tut, tut. Isn't there some little disagreement between Mr. Andrew and his wife that you can remember, Baffles?

BAFFLES The incident of the hairbrush, sir. Miss Flower *says* it fell out of her hair on account of a shampoo the day before but it *could* be misconstrued to have been *thrown* into the rosebushes past Mr. Andrew's head.

LAWYER Cruelty!

ANDREW She's not cruel. Oh, I'm so tired of this nagging!

LAWYER Nagging with a hairbrush. That'll do very nicely for a divorce brief.

ANDREW You wouldn't dare do such a thing! Flower and I get along perfectly except for this nagging——

DOCTOR Of course, nagging *is* less stimulating than flagrante delicto.

ANDREW I couldn't live without my wife.

DOCTOR Then maybe you'll change your mind about the wine, Andrew——

LAWYER Just for us. And read your uncle's books. Have you learned them by heart?

ANDREW *(Picks up volume and reads) How to Bring Life to an Unprofitable End. Treatise on Preserving the Disgraces of Life.* What good is that to me?

DOCTOR There're plenty of places to go with delirium tremens *once* you've got them.

LAWYER The books don't help you to forget your morals?

BAFFLES Morals, sir, are the result of experience.

DOCTOR Maybe it's character that's causing the trouble. Character is what people tell us about ourselves.

LAWYER Has anybody been telling Mr. Andrew that he's a good man?

BAFFLES I've taken every precaution to avoid it, sir.

DOCTOR Think of your poor uncle. How he did believe in devolution!

ANDREW Didn't he have any word about my being natural part of the time, anyway?

DOCTOR Nature's place is in nature, Andrew.

LAWYER In the ash can, sir, in this case. I can't have the Messogony disrepute going for nothing this way.

BAFFLES In spite of my persistent cautioning Mr. Andrew fell asleep in his chair last night. I simply can't get him to observe the improprieties.

LAWYER Dreadful! We'll have to correct that! Baffles, you must know something more derogatory about Mrs. Messogony that we could use to advantage.

ANDREW I tell you, she's turned over a new leaf!

BAFFLES It's new leaves or none with the ladies, Mr. Andrew—in life as in everything else.

ANDREW Pretense! It's all pretending!

DOCTOR Late hours! French underwear! Nagging! Well, Andrew, I suppose if you put two and two together you'd know whether you got a four or a five?

LAWYER Especially if five was expected of you.

BAFFLES *(Apologetically)* Mr. Andrew's a very poor mathematician, sir, and four is less of a burden to accumulate than five.

LAWYER *(Sighing)* You make it so hard for us, Andrew. It takes considerable ingenuity to stay outside the law, you know.

ANDREW I don't seem to catch on. If you don't know what to do, why don't you call the police instead of dragging in Flower?

LAWYER Police! This is no time for spiritual advice!

BAFFLES The Borgias, sir, they would be the people to help us out!

DOCTOR Psychopathic—but decidedly above the average.

ANDREW What have they got to do with it?

DOCTOR Just say to yourself, "All life is a play." I had a patient who believed that so nicely before they took him off to Bloomingdale.

BAFFLES Mr. Andrew *will* confuse life with reality, sir.

LAWYER If you want to keep your money *and* your wife we'll have to get down to the truth.

ANDREW I hate the truth when it's a lie! Flower's just out masking her virtue the best she could.

Commotion among the three men.

DOCTOR It's love, all right. No use looking at the larynx.

LAWYER Don't you remember what it says in the books? "The function of love is to occupy our years of maturity with the extricating of ourselves from it!"

ANDREW I call it demoralizing.

LAWYER I'm afraid we'll have to be more scientific to convince our client.

DOCTOR Science! Our most ingenious defense of the unlikely! *(Pours some wine and drinks the toast)* Baffles, have you any idea where Mrs. Messogony might be—er—dislocated?

LAWYER We'll have the truth if it has to come out of our own heads.

BAFFLES Here's the list for tonight, sir. She *might* just be caught at something. At least she's out.

ANDREW It's awful! To have my wife trailed like a common— common———

LAWYER Now Andrew, don't work our hopes up too high. It's all very theoretical.

DOCTOR Of course, we hope that things may be blacker than they look. There's so much time to lose, why don't we get under way?

BAFFLES Yes, sir. It'll soon be morning. Even dark colors have a way of fading in the professional sanity of the morning sun.

LAWYER Are you coming, Andrew, to the exposé?

ANDREW I don't want to go. I'm sure Flower's *never* done anything wrong in her life no matter what she did before we were married.

DOCTOR Which had you rather have—your wife, or your love for your wife—without her?

LAWYER Think of your position! There's no man in America in more enviable disrepute than yourself. Clubs! Notoriety! Trouble!

BAFFLES There's no accounting for human distastes!

ANDREW Damn my uncle!

LAWYER You mustn't be Victorian about the situation—better even to be inhibited.

ANDREW I just sound that way because I never went to college. Nobody on the farm thought I was Victorian.

LAWYER Thinking we are incapable of our pasts is a necessity that gets a good many people into difficulties, my boy.

BAFFLES Good night, sirs. I hope Miss Flower will not have undermined your faith in bad women.

DOCTOR Don't worry. Everything will be all wrong. You see, there must be some bad in the bad of this world.

ANDREW Good night, Baffles. If Miss Flower gets home before I do will you tell her that I don't mind if she takes the side of the bed with the light—just for tonight——

Andrew, as the three men depart, stuffs a picture of Flower under his coat. They might well have been the handsome trio you met that night in New York. They've gone out into the exhausting fastnesses of human relaxation—and left Baffles alone in Uncle Andrew's stronghold of misdemeanor. Baffles looks lugubriously on a photograph of Uncle, dims the lights, confides to the audience:

BAFFLES It's far more comfortable to be an unwholesome sort of fellow like myself with at least a working knowledge of human foibles and furbelows.

He hasn't had time to settle himself when the doorbell rings—ting, ting—apologetically as a tram conductor ringing up one fare when he knows quite well he's collected two. It's nearly morning outside the windows. What a nocturnal family, the Messogonys—or maybe it's we who have no business snooping about after midnight. It's Flower at the door.

FLOWER What are you doing up at this hour, Baffles?

BAFFLES Entertaining the company, Miss Flower.

FLOWER The lawyer?

BAFFLES And the doctor.

FLOWER *(Uneasily)* Well, what were they doing?

BAFFLES Testing, Miss. Performing chemical experiences on Mr. Andrew.

FLOWER Oh! I hope they didn't make Mr. Andrew feel bad.

BAFFLES Mr. Andrew trembled, Miss Flower, until to look at him was as good as a trip to Luna Park.

Baffles smiles contentedly.

It was quite a success. It couldn't have been worse.

FLOWER Poor Andrew. Has he gone to bed?

BAFFLES I hope not. They've taken him away.

FLOWER Please tell me what's the matter! You can't be referring to the morgue!

BAFFLES *(Sleepily)* Ahem!

FLOWER Morgue, Baffles!

BAFFLES Were you *there?*

FLOWER Of course not. Where is my husband?

BAFFLES I gave them the same list I'd given you, Miss Flower, so as to facilitate their finding you.

FLOWER What did they want with me?

BAFFLES They said as how the *expedient* thing would be to unearth you in an adequately compromising intrigue.

FLOWER Gracious! So they've taken to shadowing me! I can't believe that Andrew would allow it.

BAFFLES Well, Miss Flower, he did take your picture with him to the exposé.

FLOWER To the what?

BAFFLES You see, the gentlemen were hoping for flagrante delicto.

FLOWER Baffles, would you believe that I haven't so much as looked at a man since my marriage?

BAFFLES I'm afraid I'd believe it, Miss.

FLOWER *(Flies to mirror)* You needn't hurt my feelings. Why would you believe it?

BAFFLES Now, Miss Flower, I never was given to religious arguments.

FLOWER I don't think I've gone off as much as all that in a year. Do you?

BAFFLES No, Miss Flower.

FLOWER I just wanted to finish up that side of myself forever.

BAFFLES Oh dear, Miss Flower!

FLOWER Did Andrew just believe whatever they said?

BAFFLES The executors thought it best that the master be a little more jealous and suspicious.

FLOWER So they've determined to invent my misdemeanors for me— Andrew too!

BAFFLES I believe Miss Flower is familiar with the constrictions of the will.

FLOWER But Andrew ought to know better than to let them hang my past in my closet like an old suit of clothes too useful to get rid of!

BAFFLES I've inherited more than one situation along with your uncle's old ties, Miss Flower, and my advice is to try to give satisfaction *any* way the case may be.

FLOWER You mean—to pretend that I'm whatever way they suspect me of being?

BAFFLES Life without pretensions leaves us facing the basic principles, which are usually a good deal worse and harder to unravel.

FLOWER But what of the consequences?

BAFFLES Pronunciation has made many an innocent word sound like a doctor's orders for a stomach pump, Miss Flower.

FLOWER We've got to call things what they are, Baffles. Suppose I was caught?

BAFFLES By their technical names, if Miss will excuse me.

FLOWER *(Dubiously)* And if a spade becomes a steam shovel, what do we do when it's time to spade the garden?

BAFFLES We spade with the steam shovel, Miss, in a case of necessity. But necessity is one of the rarest things in the world.

FLOWER Maybe you're right, Baffles. I don't know how to begin. I'm so settled down I don't know any men.

BAFFLES As to the matter of settling, down or up, according to what's demanded of you, Miss, is always the most modern method.

FLOWER If I only knew some man to call on. I can't teach a lesson alone, Baffles.

Baffles respectfully hands Flower the telephone book.

BAFFLES In my day there used to be a good many names in there, Miss Flower.

FLOWER Are you suggesting that I—that I——

BAFFLES Of course not, Miss. Good night, Miss Flower.

FLOWER *(Hesitantly)* Good night, Baffles.

Baffles goes out and leaves Flower to the mercy of the dawn. You know what dawns are: an eerie, supernatural time exaggerating things and making the people awake feel very superior to the people asleep, and, from that lonely vantage point, turn the world into a very personal affair as if they had exclusive rights to everything under the unrisen sun. Flower sits down for just a minute in a quandary. It's all right. She can swim. Dive, too, but there isn't any tank. She thinks you should have gone to the Hippodrome if you wanted to see somebody diving. Then a look of surprise comes over her pretty face, as if she had just got an idea. Clutching the volume under her arm and whistling like a little boy who's just discovered a loose tooth she goes to the telephone. Flower makes a big circle in the air with her finger and lets it fall anyplace in the directory.

Canapé! I never could stand canapés.

She turns a page rapidly and tries again.

Cohen! I used to know a man named Cohen but he's the one who died, I think.

So she has to try again.

Consequential! That's a good name. Peter H., 1066 Park Avenue.

She picks up the phone and begins——

I want Anathema zero zero. Hello, is this the *Morning Incubator?* Well, I want to report something. No—I *don't* think it would be the classified ads. Yes, sports would be better—you see, it's scandal. All right then, give me the political editor.

Flower goes on whistling as she waits. Not many of us can whistle like that; it's much better than a bird and nearly as good as a ventriloquist.

Hello! Well, I should say it *is* a scandal. Mrs. Andrew Messogony, Jr., and——

She reads the name under her finger carefully out of the phone book, address and all.

Mr. Peter H. Consequential of 1066 Park Avenue were routed together from a roadhouse by vice crusaders. The name of the roadhouse? The—the Martha Washington Tavern. Mr. Consequential was seen jumping through the window in a state of disarray as the arm of the law entered. The policemen were in formal dress attire. Mrs. Messogony, the last word in Paris chic in a black lace nightgown with a sweet little collar of pale blue charmeuse, received with retiring grace and dignity.

Flower smiles contendedly. She's almost purring as she goes on deliriously.

A bunch of moss roses on the left shoulder greatly enhanced the ensemble. Mrs. Messogony, a striking blonde, who was Miss Flower Nectar of the Frantics' Beauty-line before her marriage, convinced the participants that grace and delicacy are not exclusive with women brought down in social circles by her decorous reception of the detectives as they entered. Her hair was arranged in little ringlets—what? Of course I'm not joking! Of course it's real. This *is* Mrs. Messogony speaking. All right then, *send* the reporters. And could you just send one of those photograph lights out by your men? I look *so* awful in a flashlight picture. It's nearly as unbecoming as an X-ray. Thanks, that's awfully *sweet* of you. I hope the pictures will be nice. I've always liked your paper. Of course I mean it.

Flower is cut off. She clinks the receiver up and down and eventually gets somebody on the wire. In a voice like a covey of beaten-up partridges, she expostulates:

No. I don't know how many United Cigar coupons it takes to buy a coffin. Do *you* know the answer to this one?

She is laughing as the curtain goes down.

CURTAIN

So was I, for the matter of that. I hope you were—a little.

ACT TWO

◊

◦ Scene 1 ◦

This is morning coming to Peter Consequential's bedroom. It's a love of a morning, all soft and pink and exactly like its father. Peter ought to have been up a long time ago, but he's not eccentric enough to let his misgivings about life drive him into nature worship. Peter's crinkly hair waves about his forehead like treetops in an etching. We picked Peter bodily out of a directors' conference and his hour of squash to put him there in the bed. He's really very handsome, and he'd rather you didn't know about his ineffectuality—three financiers in his family have stayed out of jail; it wouldn't be fair to tradition. Peter's got a lot of talent for ushering at weddings and bachelor dinners but he has had to neglect it to get on in the world. The telephone is ringing violently—and more violently. The maid will answer sooner or later.

MAID Hello. Mr. Peter Consequential's residence. No, Ma'am, he's *not* up. Very well, Madam, I'll wake him—Mr. Consequential!

Peter stirs at the maid's lively tapping.

Mr. Consequential! Telephone.

PETER You know how I hate to answer the phone in my sleep. Who is it?

MAID A lady, sir. A Miss Urgent, I think she said.

PETER *(In phone)* Good morning, Miss Urgent. Oh—well, good morning, Mrs. Messogony. But what could there

227

be to explain—*(Pause)* Listen, lady—I can't play jokes like that before breakfast. Call me up this afternoon, why don't you?

Peter peremptorily bangs up the phone.

What are all those clothes on the floor?

MAID *(Inspecting something so very inconsequential that it hardly seems to belong in the same room with Peter)* I'm sure I don't know, sir. It must be something left over from the scene last night.

PETER There's a scene *every* night lately. I've got so I can hardly tell one from another.

MAID Yes, sir. Isn't it fascinating? *(Boastfully)* Mrs. Consequential loses her head more often than any lady I have ever served.

PETER Otherwise you'd have left long ago, I suppose.

MAID What I say is, the lower orders, sir, can hardly be expected to put up with ennui—what with all the other things they have to bear.

PETER Really! Well, I'd like a wife like Queen Victoria—perhaps not the same shape, but a similar idea. Don't you think that'd be nice?

MAID I like excitement myself.

PETER When you've been on this house party as long as I have you'll change your mind. How long do you think it can last?

MAID It's been going on, sir, since I came as kitchen maid in 1914.

PETER Where *is* everybody?

MAID They haven't come in yet. It's *only* eight in the morning, sir.

PETER I must have dozed off. And all those relations with my wife I had to think over!

MAID Yes, sir. You ought to take bromides. With that stuff inside you you *couldn't* fall asleep and you'd be able to keep up with the others.

PETER *(Hesitantly)* I was going to ask you something—very personal——

MAID *(Quickly protesting)* Oh, I *couldn't,* sir. The mistress wouldn't stand for it.

PETER I was just wondering what you thought of my wife.

MAID *(Sizing up the underwear)* Undernourished, sir.

PETER I mean, she's been treating me very badly—when she treats me any way at all.

MAID Marriage is such a sedentary life. Maybe she needs to get about more.

PETER That's her idea. It's been a great disappointment to her to find me a recluse after all she expected from my career at Yale.

MAID When there's nothing to worry about, sir, we women usually do take to worry.

PETER But I *have* to get up in the morning. You know, there's lots to do in an office, making mistakes for people.

MAID Oh, sir.

PETER Connie says that——

Peter begins shaving himself while the maid holds the mirror for him. He's in pajamas, but it's quite all right because they're such fine pajamas that they're quite impersonal.

I ought to go out more—ought to get my letter in society, so to speak. Now, I haven't thought much of things like that since college.

MAID Well, a man like you shouldn't allow himself to get suburban.

PETER She picks on me. Began just suddenly——

Offhand with a flourish of the razor.

immediately following the marriage ceremony.

MAID Perhaps you'd get along better if you could invent something for your wife to make the worst of. Just to simulate her interest in you. How would it be if you led her to expect that you'd been—well—er—being——

PETER I know. Biological terms are always embarrassing.

MAID *(Offended)* I was going to suggest "connubian," sir, with somebody else.

PETER *(Distastefully)* It sounds so African. Anyway, I wouldn't have the slightest idea of how to go about it.

MAID They usually begin with a poem—that gives the impression of uneasiness.

All this time the maid has been moving the mirror up and down till Peter can't possibly see himself and the two of them are alternately kneeling and on tiptoe, bobbing about.

PETER Would anything on the stock market do for the quotation?

MAID No, sir. But it ought to be something gloomy.

PETER *(Counting the strokes of his razor)* She loves me, she loves me not—but she's very negligent of me even if it comes out *both.*

MAID There's nothing better than negligee women to make a man take an interest in personal appearances.

PETER There *is* something better—only you must have bought the wrong postcards—they're better in France. I'd bring you some only my wife won't go away with me.

MAID How can you expect her to be contented with just a husband after all she's been used to, Mr. Consequential?

PETER I can't see what there is in strange men to make wives so frivolous.

MAID *(Contemptuously)* Cemeteries, sir, are the only things that have the same heart-interest the world over.

PETER I've never gone in for variety.

MAID Why don't you, sir? It might help with your wife.

PETER Oh, I'm always too busy thinking how busy I am.

MAID A man of the world should never know what's going on; the upsets only turn his head.

PETER Besides, I don't know anybody.

To the accompaniment of a final stroke with the razor.

Ah! Anyway, she loves me!

MAID *(Critically)* You've left a little patch up there.

PETER Where? There! You see she loves me not! I knew it from the minute she said she did—she's just the same as all devoted wives. *(Slams down mirror)*

MAID The great thing that love affairs *all* have in common, sir, is that they come out wrong.

PETER She hasn't said a loving word to me since—since— *(Mumbling)* '33, '32, '31—You know, Miss What's-your-name, I don't believe she has since she slapped my face for flirting with somebody else when we led the last prom together.

The door opens and in comes Connie Consequential. Connie is a very frivolous woman. When she makes sense it comes as much of a surprise to her as to everybody else. She's restless, pretty, and can't find any directions in the Social Register about what to do with these two important factors in her life. You know the type: meat for the traveling polo player. She's in a very exotic creation as inappropriate as possible to what she's doing—which is carrying Peter's breakfast tray. Luckily, there's an apron between the dress and the orange juice, so it won't be ruined and Connie can wear it again tomorrow night.

What on earth are you doing?

CONNIE I've brought you your breakfast, *(sweetly)* darling.

She takes up the maid's job and hums contentedly as she begins that process so disturbing to men, known by women as "arranging things."

PETER *(Suspiciously)* What's the matter with you?

CONNIE There's some shaving cream on your ear. Not everybody could look so nice in shaving cream.

PETER What have you been doing all night?

CONNIE Now, Peter, if I'd only known what a bad man you were, I'd have been here right by your side.

PETER Anaconda Consequential, has anybody been killed? Have you gone crazy?

CONNIE To think of my missing all the dreadful things you've been doing!

PETER You *have* treated me pretty casually.

CONNIE I'm sorry. I thought you were only working when you stayed at the office.

PETER You said yesterday I ought to play an extra at the wax museum. What's changed you so? *(Resentfully)* Have I been elected to something?

CONNIE Don't pretend you don't know. What a debt I owe the morning paper! If it hadn't been for the *Crimes Plutocrat* I'd have worn myself out, trying to make up for your good behavior.

PETER What's in the papers?

CONNIE The last accounts do make me feel my bran muffins— to be married to such a "disreputable" and "unprincipled" man!

PETER Now, Connie, you know that——

CONNIE That's what the papers say. All my friends will envy me so.

Connie solicitously places Peter's shoes before him and settles herself to sew while he reaches excitedly for the news.

PETER Will you give me that sheet?

CONNIE *(Unfolding the news)* I do hope the pictures do her justice.

Connie snuggles up close to Peter—not as close as she'd like to, but close enough to make it awkward for him to read.

Look, Peter—I'm knitting myself a hair shirt from the rope you gave me.

PETER Connie, are you actually in love with me again?

CONNIE We were awfully happy when I thought you were blind to women—now that I know you weren't.

PETER *(He hasn't got a chance to read yet)* The papers are all fiction, mostly——

CONNIE This one blamed your escapade on the spirit of the world. It was very clever of you to merit that, Peter.

PETER Bolshevism!

CONNIE When you come to that part about Mrs. Messogony's nightgown, tell me.

PETER When I come to *what?*

CONNIE Oh, it's nothing. I just thought it was in awful taste, that's all.

She reaches over Peter, begins to rummage and settles back in her place with a new piece of the paper at which she peers judiciously.

Is that a good likeness, Peter? If it is, her nose is too alkaline. I never did care for noses that do this.

Connie draws a preposterous figure in the air with her finger.

Of course nobody's nose ever did—except blood-hounds.

PETER *(Reading)* Good Lord!

CONNIE Well, I don't blame *you*, Peter. *You* couldn't help what she had on.

PETER She's *in bed.* *(Enthusiastically)* Say, she's good-looking, isn't she? She's one of the best-looking girls I've ever seen, as a matter of fact.

CONNIE She's not so wonderful as all that!

PETER But we'll never be able to live that down. It's scandalous!

CONNIE *(Disappointed)* Peter, don't you *like* their calling you witty and debonair? Don't you *want* to be a Lothario, Peter?

PETER Think of our position.

CONNIE What better position do you want than in the rotogravures?

PETER No. Yes. That is, I hadn't thought of it, Connie. Do you suppose I'm really like that?

CONNIE Of course, dear—it says so in the papers.

PETER It doesn't seem possible, it's such a nice day.

CONNIE *(Querulously)* But Peter, you needn't pretend to me. I want you to be your own wicked self.

PETER And if you found out I wasn't?

CONNIE Don't be silly.

PETER You'd rather I'd be myself in the paper or just myself, Connie?

CONNIE I'd rather know the truth than to think you were truthful, any day.

PETER I s'pose a person had better not begin counting their eggs till they've laid them.

CONNIE How did you think of it, Peter?

PETER *(Emphatically)* It was entirely impromptu. On the spur of the moment!

CONNIE That's funny! It's such a lovely scandal!

PETER Did you think it was funny when the bottom dropped out of the steel market?

CONNIE No, frankly, I didn't. Was it? It seemed sort of flat to me but maybe I just didn't get much out of it.

Connie flops on the bed disconsolately.

PETER What is it, Connie?

CONNIE Oh nothing—only her nose—*(Pointing)* Don't you think so, Peter?

Together with their arms folded about each other they inspect the intricacies of Flower Messogony's nose in her likeness in the paper.

That it's sort of aquatic?

PETER I believe you're jealous! You know I never notice noses, dear—unless they're rising or falling or doing something brokerish.

CONNIE But maybe you think it's a nice one, Peter.

PETER There's not much in noses financially.

CONNIE And her hair!

PETER Well, hair always shows up better on a blonde.

CONNIE Peter, please try not to notice hair, either.

PETER I'm glad something's brought us together again. It's been ages since you've been like this. You wouldn't kiss me, would you, Connie?

CONNIE Oh Peter! Would you *let* me? I mean, with all the other women that would be glad to—in view of the publicity?

Peter takes Connie in his arms right before the footlights and us all. Somebody ought to tell them this is a theatre but nobody does.

I want you to promise me just one thing. I know it's going to be hard for you.

PETER I'd do anything to keep you so interested in me that I didn't have to think of you, Connie.

CONNIE *(Purring)* Oh, Peter, it'll be *dreadfully* difficult.

PETER I promise.

CONNIE *(Falteringly)* I don't want you to ever speak to that Messogony woman again as long as you live. Could you promise even that, Peter?

PETER Even that, I promise.

CONNIE Well then, I suppose it's all right.

PETER *(Enigmatically over his paper)* The work people do before others are up never seems to count for anything. Now that you know my true character, maybe you'll be more considerate.

CONNIE I told you, Peter, I honestly will. How could I guess you were so pornographic?

PETER A man's got to have something from his wife besides her parents and her hangover.

CONNIE Wasn't it silly the way I behaved? Nothing but parties, and one thing leading to another cocktail.

PETER It was.

CONNIE Such a waste of time when there was all the wickedness I could have wanted right at home!

PETER Remember how I used to hold you in my arms like a sleepy kitten, Connie? You purred about me and stayed off back fences when I was busy.

CONNIE Rr-rr-rrr——

PETER I'd subscribe to *anything* to break you of fence-walking.

CONNIE Peter, if you'll give her up, I'll take that trip you've
 wanted for so long.

PETER We'll escape, Connie! We'll hide ourselves in a nice
 quiet place till the scandal blows over.

CONNIE I hope there'll be photographers and members of the
 press.

PETER We'll leave immediately so we can be ostracized in
 peace—We'll sail for Biarritz! *(Peter struts pompously)*
 Three times round a beach before lunch makes you
 wish you had never been born! We'll find a proper set-
 ting where we can let our bygones be the future.

CONNIE *(Petulantly)* Isn't a proper setting a place where every-
 thing passes unnoticed? I *would* like to make the Sunday
 edition!

PETER *(Threateningly)* Connie, do you want to have me forced
 into the woman by accident? I wouldn't take a chance
 of walking on the streets with things the way they
 are.

CONNIE But you will make a parting statement, won't you?
 About how you will always prefer my profile?

PETER Leave what I will do to me. One has to conceal one's
 temperament for climaxes.

 *Before we have time to give Peter's remark the attention we
 hope it deserves, the scene is invaded, in fact, it is nearly de-
 molished by a flock of very energetic gentlemen of the press.*

1ST REPORTER Climaxes! I knew we had the right party.

 Writing.

 "Consequential insults reporters!"

CONNIE *(Dashing to the mirror to primp)* Why, he hasn't said a
 word!

2ND REPORTER *(Writing)* "Refuses to talk, claims vice is hereditary."

PETER You'll have to go away. We've got to pack. We're leaving.

1ST REPORTER "Consequential in hiding. Wife suspects suicide."

PETER That's terrible. You don't, do you, Connie?

CONNIE Peter, please don't get between me and the camera.

2ND REPORTER Mrs. Consequential, would you move over a little? You're spoiling the profile——

CONNIE Won't you make it a family group?

1ST REPORTER If the lady insists.

The reporters busy themselves posing and adjusting Connie and Peter in a very domestic attitude. The phone begins to ring. There's general pandemonium as the maid tries to answer.

CONNIE Do you think this looks much like a going-away gown?

1ST REPORTER The very thing, Madam, if you'll slip it off the shoulder a bit.

MAID *(Yelling)* He can't answer the phone, he's leaving. I can't help it if it is Mrs. Messogony. If you want to speak to Mr. Consequential you'll have to go to Biarritz. Yes, Ma'am, Biarritz, France, he said.

The maid slams up the phone and edges herself into the family group as best she can, coyly posing.

1ST REPORTER He's hardly my idea of a rake.

CONNIE Well, can't you touch it up a bit?

PETER Wouldn't it be better if you used one of the President? Or *somebody* better known than I am?

CONNIE Peter! I've been longing for this for years. Don't cheat me of my happiness.

2ND REPORTER We'll entitle it "In a Love Nest."

1ST REPORTER Of course—but then we can use the wrong name.

The cameras click. Blop! goes the flashlight, the reporters dash valiantly about. On the whole it's a good thing the CURTAIN came down when it did or we might have had to witness a general smashup on the stage.

ACT TWO

◇

◦ Scene 2 ◦

One of those plages *that go on making people feel that life
is kinder and safer than it is. You can see what a nice hot
afternoon it is by the way the artist has put so much white in
the scenery—nothing but lethal blue and white. A promontory
juts out like a theory of nebular physics trimming the blue
stage with a bias fold such as blue sailor collars chew and left
the rest an azure wash. The big umbrella is so inviting it
seems a shame to have to leave it to the actors. Pretty soon
you see something. It's two people on the obliterated horizon.
That bright patch you thought was a vagrant planet is a
head—a yellow tousled head. The two people are laden with
bundles of newspapers, beach cushions, another folding um-
brella and two very late-rising expressions. The girl is dressed
in what appears to be something and what, on closer inspec-
tion, proves to be nearly nothing at all—a mere accessory to
her superb nakedness. There's no front and no back to her
costume and there are as many straps and trappings flying
about as an arrangement for keeping the flies off a racehorse.
The man looks as if he had meant to put on more if some-
thing hadn't distracted him at the last minute. Yes, it's An-
drew. He and Flower parade down the beach trailing Arab
bathrobes, Persian beach jackets and Japanese kimonos behind
them in the sand. Flower's equipped like a person who seems
to be traveling from one place to another for the sake of trans-
planting her belongings. They are followed by Baffles in the
grotesquerie of a striped bathing suit, a picnic basket and, at
a distance, two gendarmes. They are about to settle down to
the picnic when the gendarmes bristle up.*

241

IST GENDARME C'est défendu de pique-niquer dans cet endroit.

ANDREW *(Patiently)* Are you another reporter?

IST GENDARME Défendu! Vous comprenez?

FLOWER What did he say, Baffles?

BAFFLES I couldn't say, Miss Flower.

2ND GENDARME My friend, he say, no—pic-nic—here.

ANDREW Why not? Isn't there someplace where people can do what they want?

BAFFLES To have your own way, Mr. Andrew, you must first be able to take life by the horns and guide it through the gin bottles.

IST GENDARME C'est défendu. C'est la vie. C'est tout.

2ND GENDARME My friend, he say it is life. No pic-nic. That is all.

FLOWER But tell your friend we *must* stay here—we're all moved in.

ANDREW Maybe Baffles can get the authorities for us.

BAFFLES *(Indicating the Frenchmen)* They seem to be down in the boiler rooms, sir, working their ways through life.

GENDARMES Défense de pique-niquer.

FLOWER *(Brightly exhibiting the paper)* Here, look! That's me in the headlines. We're an asset to your beach. See?

The gendarmes pore interestedly over the photographs.

ANDREW Flower, I wish you wouldn't advertise how awful you've been to me.

FLOWER I wish you'd try to give up the irresponsibility of being the victim.

IST GENDARME Je le constaterai. Aprés!—Ah, je verrai si c'est possible de l'arranger.

He begins a detailed examination of Flower's physical assets.

FLOWER What's he looking for?

2ND GENDARME My friend, he say he will see the government about getting you permission to stay.

FLOWER Oh.

2ND GENDARME *(Lasciviously)* He say he think it will be very well—when he considers the—er—notoriety.

1ST GENDARME Je n'ai rien dit. Je verrai les authorités. C'est tout ce que j'ai dit.

2ND GENDARME He say we see you later. Not to go 'way.

FLOWER Thanks. There, you see, Andrew. Even a scandal can turn out to be very useful.

BAFFLES We must hope that Mr. Andrew will soon begin to see the light of unreason, Miss Flower.

1ST GENDARME *(As they leave)* Qu'elle est jolie, le petit chou-chou!

2ND GENDARME A bientôt.

GENDARMES Au revoir. A tout à l'heure.

BAFFLES *(Politely)* Good day. I'll tell the mistress you called.

FLOWER What a wonderful place to get off your feet!

ANDREW It's all right.

FLOWER I'm sorry you don't like it, Andrew!

ANDREW I said I think it's all right.

BAFFLES *(Sighing)* Perhaps Mr. Andrew's lonely. People *do* seem to be so far away that they're scarcely more than humanity from here.

FLOWER Wasn't it nice of me to have earned us a vacation?

Flower and Andrew begin rubbing each other vigorously with cocoa butter.

Uncle would have liked it.

BAFFLES I'm sure everything's as demoralizing as could be ex-

pected, sir. The last paper mentioned "notorious—philandering."

FLOWER And the *Morning Expectorator* called me "vicious."

ANDREW I can't bear to think of it.

FLOWER (*I hope that's not us she's pointing at*) All right, Andrew. You can think of the nice fish. Look! You can see them from here!

ANDREW It makes me nervous. Tearing off like this so suddenly.

BAFFLES Don't mind, sir. The European crabs never bite anybody but poets since Shelley, Mr. Andrew.

FLOWER Why don't you open the picnic, Baffles?

Baffles busies himself with elaborately laying the cloth.

ANDREW Let's not spread the cloth, Flower. It's so like a winding sheet.

BAFFLES Maybe Mr. Andrew *likes* a little sand in his sandwiches, Miss Flower.

ANDREW Gives 'em body.

FLOWER I should think you wouldn't be so grouchy, Andrew, now that everything's just as you suspected all along.

She polishes his back with a vindictive gouge.

ANDREW That Consequential's a nice-looking fellow.

FLOWER I hoped you'd approve of him.

ANDREW I thought you said you couldn't stand a man with curly hair.

BAFFLES Nobody's accountable for what happens in a flashlight, sir.

ANDREW (*As they begin picnic*) You know, Flower, these revelations don't seem to have changed you much.

BAFFLES (*Hastily*) Won't you try one of these, sir? I made them myself out of papier-mâché.

ANDREW Would you have liked me better if I'd got you into trouble as good as he did, Flower?

FLOWER Andrew, it's quite all right about the dilemma.

ANDREW But *I* couldn't jump out of windows. I'm too out of condition.

BAFFLES If you would only read the papers, sir. Mr. Consequential is described as "licentious." Now I'm sure you could manage that with a few weeks' training.

ANDREW He doesn't look very licentious.

BAFFLES Mr. Andrew, horse feathers have been known to make a bird of paradise out of many a Strasbourg goose.

ANDREW Maybe so.

FLOWER There! This is a good likeness, Andrew. Just the way I like to think of him.

ANDREW Don't, Flower—you shouldn't have done it.

BAFFLES Don't you think it's much better that what's in a person should be known, sir—by everyone except the person themselves, that is?

ANDREW I don't know. Say, Flower, what do you think of my stomach?

Andrew approaches Flower in what we may describe as his best collegiate manner. That is, he rotates his body to a closer proximity, with some suggestion of an unexpected intimacy for which he is taking no responsibility. What he does is an inverted attempt at exposition of the anatomy. To do it properly, you shrink in first one part and then another till you have reduced yourself to a twisting, writhing suction. I believe it's very good for a gall bladder when done in the morning with six encyclopedias over the muscles of the abdomen.

BAFFLES Now Mr. Andrew, you are very well preserved for such a young man.

ANDREW Has Peter Consequential got a stomach, Flower?

FLOWER It doesn't mention it in the accounts.

ANDREW I thought if you'd help me we could fix mine up a bit. Did you say he *did* have a stomach, Flower?

FLOWER I didn't say.

BAFFLES Here's a full-length account, Mr. Andrew.

ANDREW *(Shudders)* I don't want to see it.

FLOWER Andrew, a person's got to read *something* besides the Zonite wrappers.

ANDREW You don't know how awful it is to feel jealous—You know how you feel when you've just got off a merry-go-round? Well, that's the way I feel.

FLOWER Oh, I think jealousy sometimes keeps a marriage from going bad.

BAFFLES Acts as a sort of spiritual cellophane.

FLOWER Yes?

ANDREW I want you to promise me never to see Consequential again.

FLOWER Well, maybe just once more—just to say good-bye.

BAFFLES Promises, Mr. Andrew, are ordinarily to conceal one's temptation for doing something else.

ANDREW Please, Flower.

FLOWER Now, Andrew.

BAFFLES There, sir, it must be nearly time for your wine.

ANDREW Promise.

FLOWER *(Nervously)* Oh, all right. Isn't it peaceful here!

Flower sighs, expulsing some of the tranquility of the glorious beach from her lungs. It's just as well she got her breath out when she did because the beach umbrella has just collapsed on the stage. It's shockingly bad management, especially since a pair of legs are still inside it.

PETER Connie, do you know anything about how to get out of a beach umbrella?

CONNIE You might punch a hole in the top.

PETER There must be some other way. Think back, Connie. If one man got shut up inside an umbrella in half an hour, how many beach umbrellas would it take what was left of him to get out in two hours and forty minutes?

CONNIE Don't be highbrow, Peter, just because you're a celebrity. Why don't you come out of the bottom?

PETER Well, show me where it is then. Give me your hand, Connie.

Connie rises, starts and advances a few steps, drawn by her curiosity toward Flower as if toward a magnet. She glowers impolitely. Flower is absorbed by the legs and the air of general catastrophe. The two women are far too pretty to appear in a scene together. We shouldn't have done it; something is sure to happen.

FLOWER How do you do?

PETER Oh, I'm all right now. I just couldn't remember what Houdini said.

ANDREW I know I've seen that fellow before.

CONNIE Peter, it ought to be somebody else!

PETER As a matter of fact, maybe it is.

BAFFLES Was Madam expecting us?

ANDREW Of course not. Look at him, Baffles! I'd know that face anywhere.

FLOWER *(Elaborately)* How curious to run into you this way! Don't *you* think it's curious, Mr. Consequential?

PETER Just like the scandalous things you read in the papers.

ANDREW I don't see much to it. I believe you followed my wife here.

CONNIE Why, we left on a moment's notice. She must have followed my husband.

ANDREW Anyway, my wife's not to speak to him.

CONNIE Well, neither is he. He promised.

BAFFLES Will there be guests for the picnic, Miss Flower?

FLOWER Two extra, Baffles. And maybe you'd better lay the cloth, after all. It's rather special company.

BAFFLES Very good, Miss Flower.

ANDREW You don't mean they're going to *stay?*

FLOWER You've got to have supper *some*place, haven't you, Mr. Consequential?

PETER That is—yes. I've often wondered how much dinner my birthright would bring in.

ANDREW Hardly enough to carry you through the hot weather.

PETER I'd like you to meet my wife.

CONNIE How do you do?

FLOWER How d'you do?

CONNIE France is nearly as close as New Jersey, isn't it?

FLOWER If you take out the tunnel, that is.

CONNIE We might as well stay, I suppose.

FLOWER Won't you just sit over here? I don't believe you've got a very comfortable dune.

CONNIE The sea nettle is very nice where I am, thank you.

PETER Well, old man, I see you read a great deal.

ANDREW They try to get me to read which is the vermouth and which is the rye, but I don't seem to care for it.

PETER I see your point.

ANDREW *(Superiorly)* There's nothing in the papers except stuff nobody cares anything about.

PETER Politics, international debt——

ANDREW Things like that.

PETER A wife like yours does brighten things up.

CONNIE *(Haughtily)* You must give me the recipe for these sandwiches! Boric acid, aren't they?

PETER Connie, please don't be disagreeable. Remember how *nice* our little trouble has made you. *(To Flower)* You see, Connie has been much more pleasant since the scandal. It brought us together again.

FLOWER That makes me feel quite creative.

ANDREW Creative! I s'pose you mean, Flower, you'd like us to *believe* what *looks* so like lies.

BAFFLES Whether you believe it or not, Mr. Andrew, makes the only difference between fiction and reality.

FLOWER *(To Peter)* Tell me, did appearances come between you?

PETER That's all there was. You see, Connie thinks monogamy is what the parlor chairs were made of in the Nineties.

BAFFLES About the sandwiches, Miss Flower, you take some old securities and a lot of champagne——

FLOWER And mix them all up——

ANDREW Till they make an awful mess.

FLOWER Andrew, *please* don't be rude.

ANDREW Why not? In this predicament.

FLOWER The predicament has helped Mr. Consequential. Aren't you glad to bring a man and his wife together again, Andrew?

Andrew, who has been sizing up Peter, walks over and whispers something in Flower's ear while Connie and Peter are talking sub rosa.

CONNIE Go on and ask her.

PETER I don't *want* to ask her.

As the other two are speaking:

CONNIE You've spoken anyway, you might as well find out who does her hair.

PETER Maybe she bites it off with a set of false teeth.

FLOWER Andrew, it's too personal to ask him, really.

ANDREW Oh, go on and ask, Flower.

FLOWER But it must be exercise. There's no other way about stomachs.

CONNIE I don't see *why* it's so intimate after all you've been through together.

ANDREW I should think it'd be all right coming from a—a——

FLOWER *(To Peter)* I have a plan. They must go on believing. Make love to me quick.

PETER I love your nose, Mrs.—Mrs. Messogony.

FLOWER Call me Flower—just publicly.

PETER Flower——

ANDREW Why, he doesn't even know your name!

FLOWER Andrew, you know how a person is apt to forget things like names.

PETER Yes, indeed.

CONNIE *I* don't see how.

FLOWER You see, it's been a good while since we met, hasn't it—Peter?

PETER Oh my, yes. My latest papers are at least a week old.

FLOWER What a difference ten days can make in a lifetime!

BAFFLES If Miss Flower will excuse me, rather less than a lifetime can make in ten days.

ANDREW What does this mean?

CONNIE From the way they behave they might be perfect strangers.

ANDREW Just what *is* your position on this beach, Mr. Consequential?

BAFFLES Miss Flower, has Mr. Consequential seen the archipelago?

CONNIE I could wear my new Patou to court—if I *decided to sue.*

PETER Connie! You wouldn't want to lose faith in your husband forever, would you?

BAFFLES There's always the view, Miss Flower.

FLOWER The view, Mr. Consequential—I *must* explain the view.

PETER What made you pick on me? What if they find out? Or what if they never do?

FLOWER For the address. Ten sixty-six is the only date in history I could ever remember.

Flower envelops Peter in the brightness of the scene and maneuvers him off, chattering.

You've a *very* appealing press personality, Peter.

BAFFLES *(Sighing)* On a wet-enough pavement a person's sure to find himself footloose, sooner or later.

Andrew and Connie stare seriously at each other for a minute or two.

ANDREW What a powerful nerve your husband had.

CONNIE Oh, but it's meant so much to your wife.

ANDREW Say, when did it occur to you that Mr. Consequential wasn't a real person?

CONNIE Just now. I don't believe they ever knew each other— out of print.

ANDREW Then I was right. You know, Miss—er—Connie, there's something very nice about women who'll always admit I'm right.

CONNIE *I* don't care how they deceive us. There're just as good fish in the aquarium as ever came out of the sea.

ANDREW Baffles, do you think I could have a little wine, after all?

BAFFLES I think it would be very encouraging, Mr. Andrew.

ANDREW You know, Baffles—just a little bit too much.

CONNIE *Then* what'll we do? When we've had it?

ANDREW Look in the papers, Baffles, and see what it says people do next, under the circumstances.

 Baffles peruses several paragraphs.

BAFFLES "Morally lax," it says, sir—in the papers.

ANDREW How do you s'pose that would go?

CONNIE It has an element of interest.

ANDREW Something like itching, I suppose.

CONNIE I haven't been so lost in the prim confines of sex since my days at Bryn Mawr.

BAFFLES Sex, Madam, and climate. Our only real basis of communication!

ANDREW Doesn't it say something else?

BAFFLES At the end of the page it mentions "orgies."

CONNIE Even the word makes me feel like a butterfly. Flap! Flap!

ANDREW Butterflies don't make a noise.

CONNIE You've probably never seen a tight butterfly in all your life before.

 Connie hops tentatively on one foot in a general indication of what a butterfly is like when tight.

 Try it, Mr. Messogony, it's wonderful.

ANDREW My legs are too giggly but champagne certainly works up an interest in botany.

BAFFLES There's nothing quite like it for broadening the horizons, Mr. Andrew.

ANDREW There ought to be some way to drink faster, if we could only discover it.

CONNIE Faster and faster till we're back at the beginning.

ANDREW We'll learn our lesson.

CONNIE If we aren't a little more careful we'll be teaching one instead.

ANDREW I wonder why they did what they did?

BAFFLES If you're the kind of person the world expects a story from, Mr. Andrew, you'll be eventually cornered into giving it one.

CONNIE For years Peter has been so settled down that nobody but a mining engineer could have dug this up.

ANDREW That's what I thought about Flower.

BAFFLES *(Pouring himself a glass)* To our misunderstandings!

 Just as they are about to drink the toast, those two French policemen reappear amidst a positive explosion of very rapid French.

1ST GENDARME *(Preventing Baffles from swallowing his drink)* Je ne sais pas! Au moins on peut attendre la permission de la loi!

CONNIE What brought them back to life?

2ND GENDARME My friend, he say—but where is the other lady?

ANDREW You see, that's just what we aren't sure about ourselves.

1ST GENDARME Il faudrait voir la femme, *(lasciviously)* la femme qui était un peu plus jolie——

BAFFLES Perhaps they've stepped out for a little air—I'll just see.

CONNIE You can't interrupt us like this. Go on away.

She goes on pouring the wine.

ANDREW What right have they got to order us about? What right has *anybody* got? We'll put our feet down——

1ST GENDARME Non non non non non! Non non non! C'est défendu de pique-niquer.

ANDREW And defy the défendu!

CONNIE Don't pay any attention, Andrew. It's probably all a bluff.

Connie and Andrew settle themselves before the basket with their backs to the gendarmes.

ANDREW We'll pretend they aren't there.

CONNIE If we just keep on drinking maybe they'll go away.

2ND GENDARME *(Coming out of a huddle)* My friend say he *m-u-s-t* see the other lady—the lady in the papers.

CONNIE But he saw her, an hour ago. Tell him *we* have no further interest in the lady.

2ND GENDARME He say he have permission for the be-au-ti-ful lady, not for you. Pardon!

CONNIE You horrible person. Just because she had her picture in the papers. *(Sniveling)* Andrew, I wish *we* could have got into trouble——

1ST GENDARME Eh, bien! C'est comme ça. Rien à faire! Faut pas discuter! Je lui apprendrai à se moquer de la loi—Polissons!

2ND GENDARME He say you are arrest.

CONNIE What?

ANDREW What for?

2ND GENDARME For mocking the law!

1ST GENDARME Pique-niquer sur la plage!

2ND GENDARME The plage belong to the French Marine. You are out-
law. Under arrest.

CONNIE You're not going to take us to *jail?*

ANDREW I can't go to jail. The lawyers wouldn't like it.

CONNIE What'll my husband say? He never allows me to get
arrested.

2ND GENDARME You *must* go.

They seize Connie and Andrew and begin marching off.

1ST GENDARME Ou peut voir les authorités!

2ND GENDARME You may see the commissariat. Quelle chance!

ANDREW Oh well, it won't take long. We'll be out by the time
Flower gets back.

2ND GENDARME Certainly, Monsieur. The commissariat is away at this
hour. But he will be back before morning maybe.

CONNIE What!

2ND GENDARME Surely, Madame, *some*time before morning.

ANDREW *(Helplessly)* Baffles, *oh* Baffles——

The gendarmes drag them off the stage. Baffles appears.

BAFFLES They seem to have disappeared.

*He laughs in a Machiavellian way as he looks about, peeking
under the corner of the cloth and peering down a bottle neck.*

Brilliant futures that don't go off *usually* do get dug up
by the reconstruction committee.

*Baffles settles himself quietly to the picnic and the papers as
the CURTAIN falls, obscuring the beautiful beach just as the
last of the sunset is drowning itself in the glasses and bottles.*

ACT THREE

◇

It's absolutely black, and in the darkness there's some sten-torian whispering going on and a lot of bumping into things. You know how some people raise their voices when they're talking to a foreigner? How some ladies shout when they're deafened by a hair-drying machine? Well, that's what the darkness has done to our two voices. For all we know it may be the censors come to take over the show, or a game of sardines-in-a-box.

WOMAN'S VOICE Are you frightened?

MAN It's too dark. I can't tell.

WOMAN I feel like a burglar.

MAN *I* don't feel so clever.

WOMAN Where do you suppose they are?

MAN Your husband might have left the lights.

WOMAN Oh, I'm so worried.

MAN Well, I'm worried, too. Do you think I like my wife being out all night with strangers?

WOMAN To think of my darling together with somebody else! Oh, I'm so miserable.

MAN Isn't this the hour when most people die—between now and morning?

WOMAN Sh! What's that?

MAN A bird.

WOMAN Do you suppose he suspects anything?

MAN Sure. Other birds.

WOMAN What can my husband possibly have to say for himself?

No answer.

I said—Are you asleep?

MAN Yes.

WOMAN Don't boast.

MAN I didn't boast. I said "Yes."

WOMAN "Yes" sounds so egotistic. Maybe they've had an accident!

MAN What made you bring up an accident?

WOMAN If I could only *see* what's going on.

MAN It's silly to have black scenes on a stage.

WOMAN Who do you suppose we are? There! I found the lights.

The lights flash on and there are Connie and Andrew butting about in the salon of the Consequentials' villa. Gee! What a lovely room it would be if it wasn't littered with papers, champagne bottles, cigarette butts and Baffles asleep on the sofa.

BAFFLES The gentlemen were shorter or the sofas were longer when I was a young man.

ANDREW Very graceful, Baffles. I see *you* don't need any advice about how to go to pieces.

BAFFLES There would have been singing in Mr. Messogony's day.

CONNIE What is *he* doing here?

BAFFLES I was just waiting to see if the master needed me, Madam—just in case Miss Flower should demand an explanation.

CONNIE I never thought of *that*.

BAFFLES You see, when Miss Flower came back to the beach, you had quite disappeared.

CONNIE It doesn't seem right to have to furnish an explanation when you get into trouble.

BAFFLES Scratch a trouble, Madam, and you'll find a public monument.

ANDREW Maybe we'd have to explain an attack of measles.

CONNIE We were taken to the police——

BAFFLES Is it probable, Mr. Andrew, that the police story will be believed?

ANDREW But *you* believe it, don't you, Baffles?

BAFFLES *(Beginning to straighten the room)* However, you can say it was the influence of Miss Flower and Mr. Consequential which is responsible for *whatever* may have happened.

CONNIE I thought influence was only good for getting you into clubs.

BAFFLES Influence, Madam, is when there's somebody fond enough of us to justify our blaming them for our mistakes.

ANDREW Where is Miss Flower, Baffles?

BAFFLES I couldn't say, sir.

CONNIE People oughtn't to stay out all night when their wives are in prison. *(Weeping)* It's broken my heart!

BAFFLES *(As he dusts)* There's a new heart substitute made from broken confidences, Madam. I believe it's almost as good as the real butter.

CONNIE It's all your fault, Andrew. If you'd kept your wife where she belonged this would never have happened.

ANDREW D-o-o-n't——

CONNIE I hate you! I hate you so, I could pinch you.

ANDREW What'll I do?

BAFFLES Just try to be a little more upset, sir. Then you won't mind so much.

ANDREW And to have that bird singing as if everything were all right.

CONNIE There's no sense of decency left!

BAFFLES The trouble with birds is they imitate the vaudeville acts, and the vaudeville acts imitate the birds till we can't tell a real deception from a misconception any longer.

ANDREW I think it's nonsense, birds.

CONNIE Why did you have to come into my life? I'm going to tell my husband that you *forced* me to go away with those policemen.

ANDREW If your husband ever shows up, you can say whatever you like.

CONNIE You don't think my Peter's run off, do you?

BAFFLES He *may* have stopped by the library for a look at the Sibylline books. One can't say for sure, but he *may* have.

CONNIE This has taught me something.

BAFFLES Experience, Madam, gets you so in a rut.

CONNIE I want to get in a rut and stay there. *(Sobs)* I would be there already if it wasn't for *him*.

ANDREW Experience teaches you how to do things you never want to do again. Oh—oh—oh—I was so *happy* before I began to be educated.

BAFFLES Generally speaking, sir, if you want life to begin in a quandary and end in a federal prison, you start by comparing the advantages of yesterday with the advantages of tomorrow. When you find you have more of them in retrospect, that's a good start.

CONNIE What could we be doing when they come?

BAFFLES Madam *should* have had some orchids.

CONNIE I certainly don't want to look as if I had *anything* to do with this situation at all.

ANDREW Don't worry. Flower can't possibly have a word to say for herself.

BAFFLES People *have* said, sir, that they've been looking for Easter eggs—in case you yourself should need an excuse.

CONNIE That's very appropriate. I always had a kind of Easter intellect.

ANDREW But it isn't Easter, is it?

BAFFLES Surely it is someplace in the world, sir.

CONNIE He makes me shiver. There's something so positive in all he says.

ANDREW One *has* to be positive to be mistaken.

BAFFLES The lawyers, sir——

ANDREW All right. Go on and cable. Telephone, why don't you? I'm through.

BAFFLES Pardon, sir?

ANDREW The lawyers don't know any more about life than I do. From now on I'm going my own way.

BAFFLES You can't mean, sir, that you would renounce—when things are getting along as badly as possible?

ANDREW I do. All I want is to know where I actually stand with Flower. Then I'm leaving.

BAFFLES I see, sir. Red-handed, innocent or guilty, is the policy.

CONNIE I don't know what to call this horrible experience.

BAFFLES Why don't you call it Andrew Messogony, Madam, after Mr. Andrew's uncle?

ANDREW Where can I hide to trap them?

CONNIE You wouldn't have me to face matters alone, would you?

BAFFLES Why don't you both hide, sir, together on the balcony? Then you can hear what goes on when Miss Flower returns.

CONNIE I'm so afraid they will think it was we who were awful——

BAFFLES Air, sir, is the very best thing when the world rocks— You'd better step outside and watch the rise of another cocktail hour.

CONNIE I feel so guilty now that we're going to discover something——

ANDREW That's because the world's asleep.

BAFFLES No, sir. You're taking it out for its morning airing.

ANDREW I'm going to be free again as soon as I've got at the truth——

BAFFLES Mr. Andrew, you really should take less interest in life.

ANDREW I've taken less and less till now at last I'm down to fundamentals.

BAFFLES Very good, sir.

ANDREW Free from lawyers and money! Tomorrow I'll be myself again.

BAFFLES Tomorrows, Mr. Andrew, *will* be todays.

Connie and Andrew tiptoe out of the beautiful gilt door into the great pink lighting effect. Baffles continues reconstructing the scene as Flower and Peter enter.

FLOWER Why are you here, Baffles?

BAFFLES There was the milkweed to milk while I waited, Miss Flower—and there's dust on the parlor sky.

FLOWER Do you think you should be arranging the heavens in a strange house?

BAFFLES *(Sadly)* Mr. Andrew, Miss——

FLOWER Yes, Mr. Andrew. They're not here.

PETER Did you look under the table?

FLOWER There's no use. I'm beginning to think our scheme was too much of a success.

PETER Maybe they've been somewhere crying all night.

FLOWER But there's no place besides the casino where they could go to suffer.

PETER We'll never set this thing to rights.

FLOWER Not till it's sold to the moving pictures.

PETER If I'd known we were hurting them so much, I wouldn't have done it.

FLOWER Peter! And Andrew gets so little pleasure out of life.

PETER He chased after Connie till she gave in——

FLOWER He did not. She must have lured him away.

PETER She did not. Connie's always run after men—that's just the way Connie is.

FLOWER Well—Andrew never could keep from giving in.

PETER While you and I were dancing, Connie was somewhere—dancing—or being miserable.

FLOWER It certainly brings my carrier pigeons home to roost.

PETER I only hope she isn't living up to my reputation.

BAFFLES *(From behind the sofa)* I don't suppose any of us could get into the Foreign Legion on our reputations, sir.

PETER Maybe I *was* too quiet. Maybe other people's ideas of us are truer than our own.

BAFFLES Other people's ideas of us are dependent largely on what they've hoped for.

FLOWER How could we explain our position, Baffles?

BAFFLES Miss Flower, I've taught you all I know. I believe it's customary to bring in the word "inevitable," but it's only a technical trick.

PETER You know——

FLOWER Uh huh!

PETER You may have lost me my wife forever. How do I know what she's doing?

BAFFLES The only real faith, sir, is in what you don't know.

FLOWER Was it my fault that they ran off like that?

PETER It must have been your husband's idea.

FLOWER I never thought Andrew would behave that way. It's given me a new respect for him.

PETER You've got no right to upset my home this way.

FLOWER Oh, shut up. If I'd only known my poor Andrew had such a strong character!

PETER You've got to confess our innocence.

FLOWER All right. But where are our angry loving spouses?

Andrew and Connie appear from the balcony.

ANDREW Here I am, Flower. And I'm going to take you away from all this. *(Glares at Consequential)* We're going back to the farm.

PETER Where have you been with my wife?

ANDREW We've been in jail, if you want to know. And being there has taught me how to respect my wife's innocence.

FLOWER You mean, *suspect?*

ANDREW No, Flower. You and I are going to move back out of doors. Everything seems more innocent in the open air.

FLOWER Andrew, darling.

CONNIE Peter, can't we go to the country, too?

PETER *What?* I've been urging you for ages.

CONNIE I was so frightened when I thought I'd lost you. I'm going to give up *everything* for you, Peter.

PETER What are you going to give up?

CONNIE Oh—I'm not going to send Aunt Mary a Christmas present, and running around in general.

PETER Connie, darling.

BAFFLES Mr. Andrew, are you quite determined on this step?

ANDREW Yes, I am. A man's got to choose sometimes between other people's ideas of himself and his own.

BAFFLES Allow me to remind you, Miss Flower, that home brew from wild oats makes a volatile mixture.

FLOWER We can make a go of it, I'm sure.

BAFFLES Then if Miss Flower and Mr. Andrew are absolutely certain that they're finished with the debauch, I may as well disclose that that was the result your uncle had in mind at the beginning.

ANDREW What are you talking about?

FLOWER Don't mind, Andrew. We can do without the money.

BAFFLES The will was drawn up as it was, sir, to ensure you the experiences of life before allowing you the full responsibilities. Now that you've profited so wisely——

FLOWER We keep the money after all?

BAFFLES It passes unprovisionally to Mr. Andrew from the moment of his putting his foot down against its evil influences.

ANDREW What if I'd fallen for all this—hooey and high life?

BAFFLES Then, sir, the lawyers would have transferred it to the Associated Free Cabarets for Beggars-of-the-World.

FLOWER Baffles, you make me feel like the boy at the dikes.

PETER Who pulled out his finger because he liked the sound of running water.

CONNIE Leave her alone, Peter. I never could be near a falls myself without wishing I had a barrel.

PETER *I'm* not criticizing. Why, I hardly know her.

ANDREW Then how did this scandal blow up?

PETER Well, you might as well give up when you get your name in the phone book these days.

CONNIE I've always wanted to meet the man who wrote it.

PETER Wait! I'll ask for an autographed copy.

Peter hands the book and a pen to Flower. Now, Flower, who hasn't a very stern grip on such ponderous actualities, drops the book with a resounding crash.

FLOWER I really couldn't live without my inhibitions.

BAFFLES *(Excitedly rushing to the footlights at the noise)* There it goes! It's escaped!

Together agitatedly.

ANDREW What?

FLOWER What's the matter?

CONNIE Is my dress unfastened?

PETER He must have seen something!

BAFFLES It looks to me as if it's there—See, under the fat man?

Excitedly.

ANDREW What is it, Baffles?

FLOWER What could it be?

CONNIE He must have lost something.

PETER I don't see anything at all.

BAFFLES *(To Flower as he pushes her back)* It's Mr. Andrew's leprechaun, Miss. The noise must have startled it up.

Baffles leans far out into the audience.

Of course, sir, ungrounded suspicions have brought about the formation of many a strong character.

To the audience as he points:

But are you sure that uncomfortable feeling is just an attack of the hives? Because if you went home with our leprechaun we couldn't give the show tomorrow night.

FLOWER Oh, *there* it is!

CONNIE *(Jumps on sofa)* Oh! Oh! Oh!

PETER Don't be afraid! It's in the audience.

ANDREW I hope it doesn't go up my pants leg.

BAFFLES *(To audience)* There's practically no danger of that, Madam. But then, you never know *what* will turn out all right in the end.

CURTAIN

So let's not say they were silly because what you would have done depends also on what the people watching you expected of you, doesn't it? And if nobody was looking *at the time, well,* life *is a little like a rose without whiskers at times. So don't go home and tell your uncle what a preposterous play it was. If he didn't agree, he'd think it was you. We all do think there's something exclusive about our own tastes and morals—and, even more misleading, about ourselves.*

STORIES

◇

In addition to the ten stories or sketches published by Zelda Fitzgerald, she wrote at least eight lost stories that are known from synopses in the files of Harold Ober, the Fitzgeralds' literary agent.[1]

As with *Save Me the Waltz*, the six "girl" pieces—five of which were jointly bylined—occasioned literary territorial problems. F. Scott Fitzgerald reported to Ober that "most of them have been pretty strong draughts on Zelda's and my common store of material. This [The Girl with Talent] is Mary Hay for instance + the 'Girl the Prince Liked' was Josephine Ordway both of whom I had in my notebook to use."[2]

Most of her fiction was written between 1930 and 1932 in the clinics where she was a patient. Since the working drafts do not survive, it is impossible to assess her writing habits or the pains she took with her work. The extant stories have an improvised, spontaneous quality that may have been intentional. On the basis of the published stories it is fair to comment that she had structural difficulties: the plots are anecdotal, and the technique is essayistic. The defining qualities of her fiction are the style and wit. When Zelda Fitzgerald was able to bring her material under control, the results were remarkable—as in "Miss Ella" and "A Couple of Nuts," the latter of which is her best story.

1. Bruccoli, "Zelda Fitzgerald's Lost Stories," *Fitzgerald/Hemingway Annual 1979*, pp. 123–26.
2. Received 8 October 1929. *As Ever, Scott Fitz——*, ed. Bruccoli and Jennifer M. Atkinson (Philadelphia & New York: Lippincott, 1972), p. 146.

OUR OWN MOVIE QUEEN

◇

The Mississippi River came carelessly down through the pine forests and phlegmatic villages of Minnesota to the city of New Heidelberg, for the express purpose of dividing the ladies and gentlemen of the town from their laundresses and their butchers and their charioteers of the ash can—who dwelt in sodden bad taste upon thither bank. On the high and fashionable side an avenue lined with well-bred trees pushed itself out to where the river, by a series of dexterous swoops, brought the city to a tidy end.

On the low side there were huge chalk cliffs where the people grew mushrooms and made incompetent whiskey, and there were cobblestone streets where casual water lay incessantly in dull little pools. Here, too, was the morgue, with its pale barred windows, and here were rows of sinister, dull red houses that no one was ever seen entering or leaving. Back further from the water were railroad yards and stockyards and the spot (mark it now with an X) where Gracie Axelrod lived—Gracie who backed into local publicity a short year since as "our movie queen." This is the story of her screen career, and of a picture the memory of which still causes bursts of crazy laughter, but which, alas, will never be shown again in this world.

Gracie's neighbors were fat Italians and cheerless Poles and Swedes who conducted themselves as though they were conversant with the Nordic theory. Her father may or may not have been a Swede. He did not speak the language certainly, and his deplorable personal appearance cannot with justice be ascribed to any nationality. He was the sole owner of a tumbledown shanty where fried chicken of dubious antecedents might be washed down by cold beer, any time between ten o'clock at night and eight o'clock in the morning. Gracie fried the chicken with such brown art that complaints were unknown.

First appeared in the *Chicago Sunday Tribune,* June 7, 1925. Published as by F. Scott Fitzgerald, but Fitzgerald's *Ledger* notes: "Two thirds by Zelda. Only my climax and revision." Written November 1923. Previously collected in *Bits of Paradise* (1973).

For seven months a year New Heidelberg was covered with sooty snow, and mere zero weather was considered a relief from the true cold: citizens were glad to get home at night and there was little inducement to linger late around the streets. But dances were given in the best hotel and even Gracie had heard tales about the gaiety of the dwellers on the upper riverbank. She had seen them, too, arrive in closed automobiles and come shouting into the shanty at small hours, behaving as if it were a daring thing to do.

Gracie was pretty, but too full blown for a girl of twenty. Her flaxen hair was a glorious smooth color, and would have been beautiful if she had not snarled it and brushed it out over her ears until the shape of her head was entirely distorted. Her skin was radiantly pale, her large blue eyes were faintly inclined to bulge. Her teeth were small and very white. There was a warm moist look about her, as if she had materialized out of hot milk vapor—and perhaps she had, for no one had ever seen or heard of her mother. Her whole appearance was as voluptuous as that of a burlesque show prima donna—that was the way Gracie felt about it anyhow, and if Mr. Ziegfeld (of whom she had never heard) had wired her to join his show, she would have been only faintly surprised. She quietly expected great things to happen to her, and no doubt that's one of the reasons why they did.

Now on Gracie's side of the river Christmas eve was celebrated with no more display than the Dante centennial. But on the high bank where the snow lay along the fashionable avenue as if it had just been unwound from a monster bolt of cotton batting, every model home set out a tree adorned with electric bulbs. It was a gorgeous sight, and Gracie and her father always came every year and walked a few blocks in the icy cold. They compared each tree to the last one, and were scornful and superior toward the trees that had no stars on top.

Tonight was the fifth time that Gracie could remember having taken this walk, and as she bustled about after the excursion and filled the shack with greasy, pleasant-smelling smoke, she discussed it thoroughly with her vague parent.

"Honest," she complained, "if people ain't going to have better trees than them, I don't see why they want to get you out on a cold night like this for. There was only one place that didn't look like somebody was dead in it."

The place to which she referred was a great white house adorned with stone animal heads and Greek friezes which tonight had had sus-

pended proudly from its arched porte cochere, a huge electric sign which wished the passers-by a Merry Christmas.

"Who lives there, Daddy?" she asked abruptly.

"B'longs to the feller that owns the Blue Ribbon," elucidated Mr. Axelrod. "I guess he must be worth a good lot of money."

"Who says so?" demanded Gracie.

"Oh, some people told me," her father answered vaguely. He was propped up back of the stove, his hat shading his eyes as he read the evening pink sheet. Just at the moment the paper was open over his knees at a full-page advertisement: the Blue Ribbon Department Store wished everyone a happy New Year, and hoped they would attend the sale of white goods immediately after the holidays.

Mr. Axelrod read the composition to his daughter. He always read her everything in the big type. They liked to hear each other's voices, and as Gracie was too busy with the chicken and her father with the reading to pay much attention to the content, it was a successful arrangement. To Mr. Axelrod, reading in itself was enough and he would have enjoyed a Chinese newspaper just as much had the hieroglyphics aroused as familiar and soothing a sensation.

"He's a swell-looking fella, too," Gracie remarked after a moment. "Every time I go in there I see him walking up and down the store. B'lieve me, I'd just as soon marry a man like that. Then you could just walk in the store and say gimme this or gimme that and you wouldn't have to pay nothing for 'em."

This was worth thinking about apparently, for Mr. Axelrod discontinued his reading and looked Gracie over appraisingly.

In the long interval between the completion of the evening's preparation and the appearance of the first customer, they speculated upon the advantages of being married to a man who owned a store like the Blue Ribbon. No wonder Gracie was as surprised and as disconcerted as if she had been caught breaking his huge plate glass window when Mr. Blue Ribbon himself walked into the shack, demanding, in a loud and supercilious voice, chicken that was all white meat.

I say that this respectable gentleman walked in, but perhaps this is an understatement, for what he literally did was to reel in. And Gracie recognized the man she had seen walking up and down the Blue Ribbon's gorgeous aisles.

He was an officious little man, fat in spots and not unlike one of those bottom-heavy dolls which refuse to lie down. Tonight the illusion

was increased, for he swayed faintly with no partiality as to direction, as though if someone removed the weights from his great round abdomen he would keel permanently over and never again stand on his own initiative. There was a small cranium, a large jaw, and two superhuman ears—a comic valentine of a man with a pig's head. But he was affable, and tonight he was obsessed with the idea of himself, not as a comic valentine, but as a person of importance.

He announced that he was celebrating, and asked at large if it were possible that Gracie and her father did not know him.

"I should say," answered Gracie reassuringly, "why, you own the Blue Ribbon. I always notice you around every time I go in there."

If Gracie had made this speech in full possession of the facts in the case, it would have indicated an extraordinary subtlety and tact. For Mr. Albert Pomeroy did not own the city's biggest and best department store. But from eight in the morning until six at night he owned the departments of which he was in charge—notions, perfumes, hosiery, gloves, umbrellas, dress goods, and men's wear. Gracie had flattered not only him but his position in life. He beamed. For a moment he stopped bobbing around and focused unblinking eyes on Gracie.

"Not exactly," he managed, resuming his teetering. "I don't exactly own it. I run it. Blue Ribbon's got the money and I got the brains." Mr. Pomeroy's voice rose to a sort of confidential shout and Gracie was impressed in spite of her disappointment.

"You any relation to him?" she asked curiously.

"Not exactly relation," explained Mr. Pomeroy, "but close—very, very close." He implied that they were in all but complete physical juxtaposition.

"Can you just go and say, 'This looks pretty good to me. I guess I'll take it,' and walk right out of the store with anything you want?"

She was now engrossed by the man himself. Her father was also listening intently.

"Not exactly," admitted Mr. Pomeroy. "I can't exactly take things, but I can get 'em for about twenty or twenty-five dollars less than the people who don't have the influence and don't work there."

"Oh, I see." Gracie enthusiastically handed a platter of chicken to her important customer. "I suppose that's why them girls work in there. I'd like to try it for a while myself. I'd get what I wanted cheap and then quit."

Mr. Pomeroy's head waggled and his cheeks blew out, and he busied himself with his feed.

"Oh, no, you wouldn't," he managed to say. "You wouldn't quit.

You just say you'd quit." He waved a greasy drumstick in Gracie's face.

"How do you know I wouldn't quit, I'd like to know?" cried Gracie indignantly. "If I say I'm gonna quit, I'm gonna quit. I guess I can quit if I want to quit."

She became animated by the thought of quitting. She wanted passionately to quit, and doubtless would have done so immediately had there been anything to quit. Mr. Pomeroy, on his part, was incredulous toward the idea. It was inconceivable and beyond all reason to him that Gracie should quit.

"You just come down and see," he insisted. "Come down tomorrow and I'll give you a job. Just between you and me—our candidate's gonna win the Grand Popularity contest. Mr. Blue Ribbon says to me, 'Albert, old man, you pick out the girl and I'll make her the Grand Popularity queen.' "

Now one of the new items which Gracie's father had habitually read aloud of late bore always the headline OUR CITY'S QUEEN. The reading matter which followed explained how the Blue Ribbon, our largest department store, together with the *New Heidelberg Tribune,* our city's foremost newspaper, and the Tick-tock Jewelry emporium, and a dozen other business establishments were going to give some lucky young woman the opportunity for which every girl has always longed. She would be selected from the whole city of New Heidelberg, would "lead" all the affairs which centered around the winter carnival, and, last and best of all, would win a chance to distinguish herself in the movies.

"Who's your girl and how do you know she's gonna win?" Gracie demanded.

"Well, the folks from all the stores that's in on the thing each choose their own girl. Mr. Blue Ribbon, he says to me, 'Albert, the jane that represents this store wins the whole contest.' Everybody can't win, can they?"

Mr. Pomeroy was growing eloquent. He would probably have talked about himself through the waning night, but Gracie's interest was aroused in another direction.

"Aw, can it!" she interrupted. "I bet I'd quit anyhow, whether you or Mr. Blue Ribbon wanted me to or not. I'd just quit and show you I'd quit."

Mr. Pomeroy had finished his chicken, and an automobile horn was blowing furiously outside the shanty, demanding Gracie's attention, so he spoke one parting line.

"You come in tomorrow and see, Miss—Miss Quit," he remarked oracularly, and reeled out into the cold just as he had reeled in—with all the motion above the knees.

And that was how it happened that on Christmas night Gracie retired early and left Mr. Axelrod to shift for himself. She slept as determinedly as she usually fried chicken, and for about the same length of time. She was drinking coffee when she heard the first trolley pass a block below her house, and putting on a coat of some indeterminate fur that in damp weather smelled like a live animal, she minced over the ice and crusted snow to the trolley stop. The street she came along was steeply down-hill, and if she had been an exuberant person she might have taken a little skip and slid all the way. But she didn't—she walked sideways to keep from falling.

The car was filled with steamy heat and melted snow, and working-men puffing their ways to far parts of the city. Gracie reached the Blue Ribbon at the opening hour, and after some wandering among aisles and elevators located Mr. Albert Pomeroy.

He was more pompous and less verbose than when she had seen him before—but he remembered her perfectly and for the best part of an hour he initiated her, with severe finger shakings, into the art of being a saleslady.

Before Gracie had time to consider the question of quitting, a momentous occasion arose that drove the thought out of her head. She had been a participant in the activities of the store for less than a week when a general mass meeting of all the employees was held in the restroom after hours. Mr. Pomeroy, standing on a bench, acted as general chairman.

"We are gathered here," he announced from his rostrum, "for the purpose of discussing the subject of selecting the Blue Ribbon's representative in the popularity contest now being held under the auspices of Mr. Blue Ribbon, one of the town's leading businessmen, and several other of the town's leading businessmen." He paused here and took a long breath as one slightly dizzy.

"We must choose our queen—with honesty," he went on, and then added surprisingly, "which is always the best policy. Everybody knows that we have here in this store the most beautiful ladies that can be found in this town, and we must choose the best one among them all to represent us. You have until this time tomorrow to decide who you will vote for. I want to thank you on behalf of myself and Mr. Blue

Ribbon for your attention and——" he had prepared a strong finish for his speech, but it was considerably marred by the fact that just at this moment a stray thought of the haberdashery department flashed into his mind.

"In clothing, I wish to say——" He paused. "In clothing, I wish——" Then he gave up and ended somewhat tamely with, "And that's the way it is."

As Gracie went out through the employees' entrance behind the tittering file of females she saw Mr. Pomeroy on the corner under the white arc light. She walked quickly over and spoke to him.

"Honest," she said, "that was a great speech you made. I don't see how some people can all of a sudden just make up a speech."

She smiled and disappeared into the winter lights and the furry crowds and hurried toward her streetcar. Unwittingly, she had made up a good speech herself. Mr. Pomeroy, though impervious both to ridicule and insult, was a sensitive man to compliments.

The next afternoon in the Blue Ribbon restroom, Gracie was somehow being heralded as a leading candidate for the honor of representing the store. She was surprised—and in the same breath she was not surprised. She never doubted that she would win, although she was a newcomer and there were five girls competing against her. Two of the five were prettier than Gracie and the other three were not pretty at all. But the ballot found a spirit of irritable perversity in possession. The pretty women were jealous of each other and voted for the ugly ones. The ugly ones were jealous of the pretty ones and voted for the newcomer, Gracie—and ugly ones were in the majority. No one was envious of Gracie, for no one knew her. And no one believed she could possibly win the contest—but she did.

And Mr. Blue Ribbon was as good as Mr. Pomeroy's indiscreet and intoxicated word. He "fixed it," and at the end of the month came the day of the coronation. It was to proceed up the main business street and then along the fashionable avenue to the river. In effect, Queen Gracie Axelrod, in her royal coach, was to be borne through shouting mobs of faithful citizenry.

On a cold noon the cohorts gathered in front of the New Heidelberg Hotel, where there was much scraping of fenders and blowing of horns. Gracie sat in her car beside Mr. Pomeroy, whose title was "Blue Ribbon Courtier Dedicated to the Queen of Popularity." Behind Gracie a blue pole arose, balancing over her head a bright, insecure star. She carried

a scepter and wore a crown made by the local costumer, but due to the cold air, the crown had undergone a peculiar chemical change and faded to an inconspicuous roan. Of this Gracie was unaware.

From time to time she glanced tenderly at Mr. Pomeroy, and it occurred to her how nice it would be if his gloved hand should hold hers under the heavy robe. The thought was delicious, and she reached out experimentally until her finger barely touched his, just faintly suggesting an amour of digits to take place later in the ride.

The less important cars—loaded with representatives of fraternal orders and assistant queens from other stores—had begun to move slowly off, following the brass band, and now the chauffeurs of the principal floats were coaxing roars of white steam from their engines. The mayor's car set up a cloud of noise and vapor.

"What's the matter?" demanded Mr. Pomeroy anxiously of Gracie's chauffeur. "We don't want to be left behind."

"I'm afraid it's a little bit froze up." The chauffeur was unscrewing the radiator cap. "I guess maybe I'd better get some hot water from the hotel."

"Well, hurry up, then," complained Gracie. The car ahead of them was pulling out. "Let's start anyhow," she went on excitedly. "You can fix it when we get back."

"Start!" exclaimed the chauffeur indignantly. "Start! How can I start when it's froze up?"

The tail of the procession was a hundred yards up the street, and several automobiles that had no connection with the celebration had turned in and followed behind it.

Another car, containing a stout young man in the back seat, drove up alongside Gracie.

"Are you stuck?" asked the young man politely.

"Of course we are, you crazy fool!" shouted Gracie, whereupon the crowd laughed.

"You better get in this here car," suggested the young man, unabashed.

"Maybe we better jump in," said Mr. Pomeroy uncertainly. "When these things freeze up——"

"But how about all them decorations?" interrupted Gracie.

Willing onlookers began to tug at the ornamental star with the idea of transferring it to the other automobile, whereupon the support creaked, groaned, and collapsed neatly into four pieces.

The tail of the parade had by this time rounded a bend and was

passing out of sight far up the street; the music of the band was already faint and faraway.

"Here!" commanded Mr. Pomeroy, breathing hard, "get in!"

Gracie got in, and someone threw the star in after her for good luck. The young man drew the robe over them and they set off at full speed —but in less than a block the long-delayed cross traffic brought them to another halt. When they overcame this obstacle, a quarter of a mile of tight-packed cars still interposed between Gracie and the procession ahead.

"Tell your chauffeur to honk!" said Gracie indignantly to the fat young man.

"He isn't mine. They gave me this car. I just got into town, you see. I'm Joe Murphy, the assistant director."

"We got to get up to our place, ain't we?" shouted the queen. "What do you suppose everybody's going to say when they don't see me?"

The chauffeur obediently honked, but as everybody else was honking, too, it produced little effect. The other cars, having attained a place in line, were not disposed to relinquish it to an undecorated machine containing an obviously intoxicated young woman who kept threatening them with a long blue stick.

When the procession turned into the fashionable avenue Gracie began to bow right and left to the crowds that should have lined the way. She bowed to groups or individuals impartially, to babies, to responsive dogs, and even to several of the more pretentious houses, which answered her with cold plate glass stares. Here and there someone nodded back at her politely, and one group gave her a short cheer—but they obviously failed to connect her with the colorful display ahead.

Gracie bowed for over a mile. Then two young men on a corner yelled something that was perfectly audible to her. They yelled it over and over again, and several small boys on the sidewalk took up the cry:

"Where'd you get the gin, sister? Where'd you get the gin?"

Then Gracie gave up and burst into tears and told Mr. Murphy to take her home.

The movie *New Heidelberg, the Flowery City of the Middle West* was being filmed in the outskirts of the city. On a morning of February thaw Gracie stepped gingerly from the streetcar at the end of the line and, with the other city queens, navigated the melted snow and mud puddles that almost obliterated the ground. The lot was already crowded and Gracie, as leading lady, tried to locate those in charge. Someone pointed out a platform in the center and told her that the active little man who

was pacing nervously back and forth upon it was the director, Mr. De-courcey O'Ney. Gracie elbowed her way in that direction.

Mr. Decourcey O'Ney had come early into the pictures and back in 1916 had been known as a "big" director. Then, due to one of those spasms of hysteria which periodically seize upon the industry, he had found himself suddenly out of work. His acquisition by the Our Own Movie committee was especially played up by the *New Heidelberg Tribune*.

He was commenting to his assistant director on the undeniably swampy condition of the ground when a plump young lady with a big suit box under her arm appeared beside him on the platform.

"What can I do for you?" he asked absently.

"I'm the movie queen," announced Gracie.

Mr. Joe Murphy, "assistant director" and man of all work, confirmed this fact.

"Why, sure," he said warmly, "this girl was elected the most popular girl in the city. Don't you remember me, Miss Axelrod?"

"Yeah," said Gracie grudgingly. She had no wish to be reminded of the late fiasco.

"Have you had any experience in pictures?" inquired Mr. O'Ney.

"Oh, I seen a lot of 'em and I know just about how the leading lady ought to act."

"Well," murmured Mr. O'Ney alarmingly, "I think I'll have you gilded to start with."

"Mr. O'Ney means that he'll show you how to do," said Joe Murphy hastily.

"By the bye," said Mr. O'Ney politely. "Can you scream?"

"What?"

"Have you ever done any screaming?" And then he added in explanatory fashion, "The only reason I ask you is because I want to know."

"Why—sure," answered Gracie hesitantly, "I guess I can scream good enough, if you want somebody to scream."

"All right." Mr. O'Ney seemed greatly pleased. "Then scream!"

Before Gracie could believe her ears, much less open her mouth, Joe Murphy again interjected: "Mr. O'Ney means later. You go over to that house and put on your costume."

Somewhat bewildered, Gracie set out for the ladies' dressing rooms, and Joe Murphy looked after her admiringly. He liked blondes as full blown as himself—and especially those who seemed to have materialized out of the vapor from warm milk.

The picture, written by a local poetess, commemorated the settling of

New Heidelberg by the brave pioneers. Three days were spent in the rehearsal of the mob scenes. Gracie, relieved from work at the store, came every morning and sat shivering in the back of a prairie schooner. It was all very confusing, and she had little idea of what her part was to be. When the day came for the actual shooting she acted as she had never acted before. Entering the covered wagon, she violently elevated her eyebrows and crooked her little fingers into grotesque hooks. During the Indian attack she rushed about in the center of a blank cartridge bedlam, waving her arms and pointing here and there at the circling redskins as if to indicate startling tactical dispositions. At the end of the second day Mr. O'Ney announced that the shooting was done. He thanked them all for their willingness and told them their services were no longer required. Not once during the whole course of the picture had Gracie been required to scream.

Since Gracie had been "working days," Mr. Axelrod's business had fallen off. He went to bed at midnight just when he should have been most alert. It was lonely when Gracie wasn't there to fill the shack with warm chicken smoke, and he had no one to read the newspaper at. But he was vaguely proud of his daughter, and his drowsy mind grasped the fact that something apart from him was going on in her life.

He was flattered when Gracie asked him to accompany her one Thursday night to the private showing of the picture. Only the people closely concerned were to be there. The real showing would take place in grand style at the city auditorium.

The preliminary showing was at the Bijou, and when the small, select audience was seated and the red velvet curtains parted to show the screen, Gracie and her father became rigid with excitement. The first title flashed suddenly on.

<div style="text-align:center">

NEW HEIDELBERG

THE FLOWERY CITY OF THE MIDDLE WEST

AN EPIC OF PAST AND PRESENT

GROWTH AND PROSPERITY

BY

HARRIET DINWIDDIE HILLS CRAIG

DIRECTED BY

DECOURCEY O'NEY

</div>

There followed a cast of characters. Gracie thrilled when she found her name:

MISS GRACE AXELROD
WINNER OF THE POPULARITY CONTEST

And, after a line of dots:

AS AN EARLY QUEEN OF NEW HEIDELBERG

The word "Prologue" danced before her eyes, and Gracie felt in her stomach the sinking sensation that preceded dental work. She looked steadfastly at the clumsy covered wagons creeping across the plain and she gasped as there was a sudden close-up of herself, acting, in the canvas oval at a wagon's back.

LET US NEVER FORGET THE NOBLE MEN AND
WOMEN WHOSE SUPREME SACRIFICE MADE
POSSIBLE OUR GLORIOUS CITY

There were the Indians in the distance now—it was much more exciting than it had been on the suburban lot. The battle, looking desperately real, was in full swing. She sought herself anxiously amid the heat of conflict, but she might have been any one of a score of girls who it seemed had been acting just as violently as herself.

And here was the climax already. A savage rode up threateningly. Bang! And Gracie, or someone who looked like Gracie, sank wounded to the ground.

"See that? See that?" she whispered excitedly to her father. "That was hard to do, let me tell you!"

Someone said "Sh!" and Gracie's eyes again sought the screen. The Indians were driven off, a hearty prayer was said by all, and the fields were expeditiously plowed for corn. Then, to Gracie's astonishment, the whole scene began to change. The suburban plain disappeared, and one of the covered wagons faded before her eyes into a handsome limousine. From the limousine stepped out a modern young girl in a fur coat with hat to match. It was none other than Miss Virginia Blue Ribbon, the pretty daughter of the owner of the Blue Ribbon store.

Gracie stared. Was the pioneer part over, she wondered—in less than fifteen minutes? And what did this limousine have to do with the picture?

"They must of left out some," she whispered to her father. "I guess

they'll have me doing some more in a minute. But they shouldn't have showed so soon how I got wounded."

Even now she did not realize the truth—that she was in the prologue and the prologue was over. She saw Miss Blue Ribbon standing in front of her father's store and then she saw her shopping in the Blue Ribbon aisles. Now she was in a limousine again bound for the fashionable avenue, and later in a beautiful evening dress she was dancing with many young men in the ballroom of the big hotel.

In the dim light Gracie looked at her program. "Miss Virginia Blue Ribbon," it stated, "representing the Queen of Today."

"They must be saving some of that western stuff for the end," Gracie said in an uncertain voice.

Two reels flickered by. Miss Blue Ribbon manifested an unnatural interest in factories, jewelry stores, and even statistics. Gracie's bewilderment was fading now and a heavy burning lump had arisen in her throat. When the parade itself was thrown on the screen she watched through a blurry glaze that had gathered over her eyes. There went the automobiles through cheering crowds—the minor queens, the mayor, Mr. Blue Ribbon, and his daughter in their limousine—then the scent ended—and she thought of her car, lost somewhere back two miles in the crowd.

Gracie wanted to leave, but she still felt that all the audience were watching her. She waited, stunned and unseeing, until in a few minutes more the screen flashed white and the movie was over.

Then she slipped into the aisle and ran quickly toward the exit, trying to bury her head in her coat collar. She had hoped to evade the crowd, but the closed door detained her and she came out into the lobby simultaneously with a score of people.

"Let me by," she said gruffly to a portly person who had wedged her against a brass rail. The portly person turned, and she recognized Mr. Blue Ribbon himself.

"Isn't this the carnival queen?" he asked jovially.

Gracie straightened up and seemed to draw the half-ejected tears back into her eyes. She saw Mr. Pomeroy just behind his employer, and she realized that the floorwalker's leer was but a copy, on a small scale, of Mr. Blue Ribbon's business grin.

Then rage gave her dignity, gave her abandon, and Mr. Blue Ribbon and his employee started back as they saw the expression that transformed her face.

"Say!" she cried incredulously, "just let me tell you one thing right

to your face. I think the picture was rotten and I wouldn't pay a cent to see anything so rotten as that."

A lobby full of people were listening now; even the fountain in the center seemed puffing with excitement. Mr. Pomeroy made a move forward as if he would have seized her, but Gracie raised her hand threateningly.

"Don't you touch me!" she shouted. "I told you if I didn't like your old store I'd quit, and now I quit! When they go out and elect somebody queen they ought to make her queen of something except an old broken-down wagon." Her voice was soaring now to the highest pitch it had ever reached.

"I resign from the moving pictures!" she cried passionately, and with the gesture of one tearing up a million-dollar contract, she pulled a program ferociously from her pocket, tore it once, twice—and hurled the white segments into Mr. Blue Ribbon's astonished face.

Two o'clock that night. There were no customers in the chicken shanty and Mr. Axelrod, worn out with the excitement of the evening, was long gone to bed when the door opened suddenly and a stout young man with a baby's face stepped inside. It was Joe Murphy.

"Get out of here!" cried Gracie quickly. "You go on out of this chicken joint!"

"I want to speak to you about the movie."

"I wouldn't be in another movie if you gave me a million dollars! I hate movies, see? I wouldn't dirty my hands being in one. And, besides, you get out!"

She looked wildly about her, and as Joe Murphy saw her eyes fall on a dish of sizzling chicken gravy he took an instinctive step toward the door.

"I didn't have nothing to do with it. They fixed up the whole thing. Say, I wouldn't keep you out of a picture," and then he blurted out suddenly, "Why—why, I'm in love with you."

Gracie's plate rattled to the floor, where it vibrated for a moment like a top.

"Well," she snapped, "this is a fine time of night to come telling me about it!"

But she indicated that he should come in.

"Look here, Gracie," he began, "that was a dirty trick they did you and I was wondering, wouldn't you like a chance to get back at 'em?"

"I'd like to smash 'em in the face."

"That's the way Decourcey O'Ney feels about it," confided Joe. "He ain't a good businessman, you see, and they beat him out of some of the cash they said they'd pay him."

"Why didn't he let me be the leading lady when I should of been?" demanded Gracie.

"He says they told him not to," said Joe eagerly. "They said you was just an accident and wasn't important at all and not to waste any footage on you."

"Oh, they did, did they?" cried Gracie, red with rage. "Wait till the people who elected me queen see what they done to that picture!"

"That's what I think," agreed Joe, "and my idea is that we ought to fix that picture up. Because, like you say, I been thinking how sore those people are going to be."

"Gosh, they're going to be sore," said Gracie, drawing a pleasant warmth from the idea. "I bet they'll get after old Blue Ribbon. They'll all get together and never buy nothing more in his store," she added hopefully.

"That's right," agreed Joe with tact, "and that's why I think the thing for us to do is to try and fix that picture up. Mr. O'Ney, he's so mad he don't care what happens. He says for me to go ahead and do anything I want to. He don't care."

Gracie hesitated.

"I'd rather have it so nobody would ever go to the Blue Ribbon no more."

She visualized Mr. Pomeroy, out of a job, bobbing into the shack after a scrap of charity chicken. But Joe shook his head.

"I got a better scheme," he insisted. "I'll come around tomorrow morning at nine o'clock. Have your costume in a box—the one you wore in the movie."

When he went out, she stood in the doorway and followed his re-treating figure with her eyes. The roofs were dripping, and the stars were out, and there was a soft, moist breeze. An earlier remark he had made was reverberating persistently in her head.

"Say," Gracie called after him, "what did you mean when you said all that stuff about being in love with me?"

Joe stopped and turned.

"Me? Why—I just meant it, that's all!"

"That's funny," and then she added, "Say, come back here a minute, will you—Joe?"

Joe came back.

* * *

As the public performance drew near, the pavements grew sloppier and the snow in the gutters melted into dirty sherbet. On the great Saturday night the auditorium was jammed to capacity. There was a big orchestra this time, which played a stupendous overture, after which Mr. Blue Ribbon himself appeared on the lighted stage and advanced to the footlights.

"Fellow New Heidelbergians!" he began in an inspiring voice, "to make a long story as short as possible, this movie is a real—a real epoch in the life of our city. It shows first in a great sweeping epic a picture of what I may call an epic of our pioneer days when our grandfathers and grandmothers yoked up their oxen and came over here from—from Europe—looking for gold!"

He seemed to realize that there was some slight inaccuracy in his last observation, but as there was a burst of applause from a line of old, deaf, white-haired people in the middle of the house, he let it pass, and now turned to those without whose efforts this picture could never have been made. He wanted to thank first of all the splendid spirit of everyone who participated. This spirit had convinced Mr. Blue Ribbon that New Heidelberg could act as a unit. Next he turned to that distinguished director, Mr. Decourcey O'Ney. After constant triumphs in Hollywood Mr. O'Ney had come here because he had heard of the splendid spirit of the inhabitants.

Applause! Everyone turned to look at Mr. O'Ney. Mr. O'Ney, on being located, stood up and bowed. It was afterwards remarked by those nearest him that he glanced somewhat nervously around and that his eyes fell with most approval upon the red exit lamps over the doors.

"Then," continued Mr. Blue Ribbon, and this was true magnanimity, "let us not forget the young lady who was chosen by public acclaim as the fairest in our city and who adorns this work of art with her graces —Miss Grace Axelrod—Our Own Movie Queen!"

There was a storm of applause. Gracie stood up, bowed, and then sat down quickly, uttering a subdued ironic sound.

Mr. Blue Ribbon rambled on for some moments. Finally he ceased with a benign smile and, bobbing off the stage, took his seat down in front. The house grew dark, the orchestra struck up the national anthem, and the silver rectangle appeared upon the blue screen:

NEW HEIDELBERG, THE FLOWERY CITY
OF THE MIDDLE WEST

The preliminary titles were all as before. The wagons set off on the journey to outbursts of applause as the passengers were recognized by proud relatives and friends.

Then, to the surprise of those who had witnessed the private showing, a brand-new title flashed on:

MISS GRACE AXELROD

CHOSEN BY EVERYBODY IN THE CITY

TO BE QUEEN AND STAR OF THE PICTURE.

A PIONEER GIRL . . . MISS AXELROD

Mr. Blue Ribbon gasped faintly. The audience, unconscious of a change, applauded.

Here were the Indians now, shading their eyes with their hands and beginning their immemorial tactics of riding around their prey in concentric circles. The battle began, the wagon train was brought to a stop, the bedlam of blank cartridges was so real as to be almost audible. Clapping broke out. A title:

WHEN THE WHITE PEOPLE WERE GETTING

BEATEN, MISS GRACE AXELROD, THE CITY'S

QUEEN, SHOOTS THE INDIAN CHIEF WITH A

GUN SHE GOT.

The applause which greeted this was punctuated with an occasional gasp and somebody snickered. But the action which followed was even more curious. It showed Miss Axelrod snatching a rifle from someone who leapt quickly out of the picture, but who gave the undeniable impression of having been a young man in a derby hat. Miss Axelrod knelt and fired the gun in the direction of a telegraph pole, which had sprung up suddenly on the prairie. There followed a scene, so short as to be scarcely distinguishable, of a man falling down. This was obviously the Indian chief shot by Miss Axelrod, but again the realists in the audience perceived that the aborigine, though he wore feathers in his hair, was dressed in modern trousers rolled up above modern garters.

This time a long restrained titter broke out, but the audience were still far from the suspicion that this was not the film as originally planned.

AS THE INDIANS WERE NOT YET BEATEN OFF
BY MISS GRACE AXELROD'S ATTACK, SHE
SHOOTS THE SECOND IN COMMAND AND THUS
COMPLETES THEIR DISMAY.

The shooting of the second in command was remarkably like the shooting of the chief. There was the lean telegraph pole in the distance, and there was the begartered Sioux who in the next flash fell to the ground. The resemblance indicated that the second in command might be the chief's twin brother.

The whispering had now thickened to a buzz, and a suspicion was abroad that somewhere, somehow, something had gone awry.

On the screen, however, the action had returned to normality. The Indians, dismayed by the fall of the second in command—apparently he was the real power behind the throne—began to retreat in earnest, and the settlers, after embracing each other with shouts of joy, sang a hymn of thanksgiving and went about building New Heidelberg.

Mr. Blue Ribbon had for some time been stirring wildly in his seat, casting distraught glances rearward and then glaring back at the screen with unbelieving eyes. The prologue was over, and Miss Virginia Blue Ribbon's triumphant progress among the marts and emporiums should now have been recorded.

MISS GRACE AXELROD, WINNER OF THE CITY'S
POPULARITY CONTEST, GOES ON A TOUR TO
THE CITY'S BIG STORES.

And as the flickering letters flashed out, Mr. Blue Ribbon found himself gazing on an episode that was so cut as to expose only a back view of his daughter. She entered shops as before, she fingered materials, she admired jewelry—but whenever she seemed about to turn her face to the audience the scene ended.

Then the astounding information blazed across the silver sheet that:

MISS GRACE AXELROD LOOKS THINNER HERE
BECAUSE SHE'S GOT ON A BETTER CORSET
THAN YOU COULD EVER BUY AT THE BLUE
RIBBON STORE.

For a moment there was no sound except a long sigh from Miss Virginia Blue Ribbon as she fainted away. Then, with a low flabber-

gasted roar that increased to a din, pandemonium burst forth in the auditorium. Mr. Blue Ribbon rose choking from his seat and dashed for the back of the house, leaving a little path of awe that marked his passage through.

To the rest of the audience, history was being made before their eyes. A full close-up of Miss Blue Ribbon appeared, following the comment:

ONE WHO STUCK HER NOSE IN

After that the picture went on, but no one cared. It was a crazed howl from the gallery for "More Gracie!" which really terminated the entertainment. No one saw the end of the picture, in which the schoolchildren's black and white handkerchiefs spelled out the name of the city. The crowd was on its feet looking up at the balcony, where Mr. Blue Ribbon and other inarticulate, half-crazy citizens were trying to climb over the operator's back and stop the projector. A mob had gathered around Mr. Decourcey O'Ney, who stood calmly trembling. The only remark he was heard to make was that it would have been a bigger picture if he could have had everyone gilded.

Joe Murphy turned and whispered to Gracie, "We better beat it before they turn up the lights."

"Do you think it went off good?" she asked anxiously, as they came out by a side exit into the almost warm night. "I thought it was a swell picture, and I guess anybody would of but a lot of soreheads."

"Poor O'Ney," said Joe thoughtfully as they walked toward the streetcar.

"Do you suppose them people will put Mr. O'Ney in prison?"

"Well, not in prison." He pronounced the last word so that Gracie demanded:

"Where will they put him?"

Joe took Gracie's hand and squeezed it comfortably.

"They'll put him in a nice, quiet asylum," he said. "He's a good director, you know, when he's right. The only trouble with him is that he's raving crazy."

Gracie Axelrod and Joe Murphy were married late in March, and all the department stores, except the Blue Ribbon, sent her elaborate wedding presents. For their honeymoon they went to Sioux City, where every night they went to the picture show. Since they've been back in New Heidelberg and started the restaurant, which has made them rather more than prosperous, Gracie has become the neighborhood authority on the

subject of pictures. She buys all the movie magazines, *Screen Sobs, Photo Passion,* and *Motion Picture Scandal,* and she winks a cynical eye when a new opportunity contest is announced in Wichita, Kansas.

Mr. Decourcey O'Ney has been released from the asylum and engaged by Films Par Excellence, at two thousand a week. His first picture is to be called *Hearts A-Craze.* Gracie can hardly wait to see it.

THE ORIGINAL
FOLLIES GIRL

◇

The thing that made you first notice Gay was that manner she had, as though she was masquerading as herself. All her clothes and jewelry were so good that she wore them "on the surface," as superficially as a Christmas tree supports its ornaments. She could do that because she, too, was awfully good quality and had nothing to conceal except her past. That is to say, she had unquestionably the best figure in New York, otherwise she'd never have made all that money for just standing on the stage lending an air of importance to two yards of green tulle. And her hair was that blonde color that's no color at all but a reflector of light, so that she seldom bothered to have it waved or "done."

The first time I saw her she was eating raspberries and cream in the Japanese Garden at the Ritz. There was a cool sound on the air from the tiny fountain and the clink of jeweled bracelets, and the vaporous hush of midsummer had settled over the voices. I thought how appropriate she was—so airy, as if she had a long time ago dismissed herself as something decorative and amusing, and not to be confused with the vital elements of American life.

Her eyes were far apart and small. All of her was small, though she wasn't in the least restricted or economized upon, rather, polished away. She was quite tall, and all of her fitted together with delightful precision, like the seeds of a pomegranate. I suppose that *objet d'art* quality was what drew about her a long string of men-about-town.

But she had another quality which you couldn't help feeling would betray her sooner or later. It was the quality that made her like intellectual men, though I'm sure that she never read a book through and preferred beer to all other drinks; a quality that made her love "dives"

First appeared in *College Humor*, July 1929. Published as by F. Scott and Zelda Fitzgerald, but written by Zelda. Previously collected in *Bits of Paradise* (1973).

and learn French and waver back and forth between Theosophy and Catholicism.

She wasn't at all the tabloid sort of person. From the first, the men who liked her were very distinguished. She had learned discretion at the start, almost as if it were a thing she wanted for herself, to use so as to be freer therewith—the aristocratic viewpoint.

And then, though undeniably an adventuress of a quiet order, she was financially safe, which relieved her from the taint of hysteria that goes so often with her kind of life. Of course she hadn't always had enough to live on, but in the early years, before producers found out that she made the rest of the chorus look like bologna sausages, there had been a husband with a gift of fantasy that cost him five thousand dollars a year for the rest of her life. That left Gay free to pay her respects to the primrose path, undoubting.

Those first years she came quite near destroying her value. She went to all the parties recorded in the Sunday supplement, and the press photographs of her were so startling that the mysterious notoriety about her was almost turned into vulgarity. But she learned to like absinthe cocktails and to want a serious stage career, which turned her toward successful people and saved her from the usual marriage-to-pugilist end.

She was very kaleidoscopic. There were times when she'd just sit and drink and drink, ending the evening with a heavy British accent, and there were other times when she'd drink nothing but would eat great trays of asparagus hollandaise and swear she was going to enter a convent. Once, when she seemed particularly serious about taking the veil, I asked her why and she said: "Because I've never done *that*."

This was in the stage of her career when she lived in a silver apartment with mulberry carpets and lots of billowing old-blue taffeta, so you see how bored she must have been with her Louis XVI tea service and her grand piano, the huge silver vase that must have calla lilies in it and the white bearskin rug.

Gay was swamped in a flood of interior decorators' pastel restraints. She knew she didn't like the apartment, but the vanity of taking her friends there made her stick for quite a while. It had so obviously cost a lot.

In the vestibule the only French telephone in New York modestly hid itself. You worked the elevator yourself, which in Gay's circle was very *recherché* and showed a fine disdain for American commercialism. She must have passed eternities just waiting in all this carefully faded finery, though she kept an engagement book and always had to look all through the Wednesdays and Sundays when you asked her to tea. There

was a purple address book on the marble mantel shelf, chock-full of phone numbers from Naples to Nantucket; couturieres and expatriates, millionaires and hairdressers, the restaurants in Rome and the summer homes of producers. It was her attempt at system and gave her a sense of the solidity of organized life. Once you were inscribed in that book you were Gay's friend and theoretically available for bridge or ocean crossings, or any unforeseen contingency such as making the extra man for the Fourth of July in Timbuktu.

But in spite of all the names and numbers, she lived mostly alone, and to soften the harsh loneliness she soon began to live in a great many places at once. She spent a year on the London stage, with a suite in Paris and innumerable trips to New York, carrying about with her an air of urgency and mystery that made her very elusive.

Gay en route meant the arrival of countless bandboxes, mountains of tissue paper, telephone calls in a rapid foreign tongue, people dropping in who didn't know she was going and whom she hadn't seen for years, and always newspaper reporters because they liked Gay and made up important-sounding little stories about her. The pictures that went above these anecdotes nowadays were heads, well-groomed, unpretentious heads, and the "Miss" was always printed in front of her name.

In Paris she lived in a blue velvet trunk. Lost in the intricate fragility of France's imitation of its lost grandeur, there was a cold-looking bath hiding in the corner of a banquet-sized room, that all Gay's bottles and atomizers and bright dressing gowns couldn't make informal. Next to that there was a gray and gilt sitting room which she always kept full of South Americans. The marbletop tables were covered with champagne cocktails and big paperlike magenta roses with stems like pipes.

In her bedroom there was a picture of her sister's child, a little girl with Gay's wide eyes, lost in the square of a huge red leather frame.

She found the hotel apartment much less oppressive than the silver walls in New York, because it did not belong to her and she could wipe cold cream on the towels and rub her shoes with the bath mat.

At this time she was making an awful struggle to hang onto something that had never crystallized for her—it was the past. She wanted to get her hands on something tangible, to be able to say, "That is real, that is part of my experience, that goes into this or that category, this that happened to me is part of my memories." She could not correlate the events that had made up her life, so now when she was beginning to feel time passing she felt as though she had just been born; born without a family, without a friendly house about her, without any scheme to settle into or to rebel against. The isolation of each day made

her incapable of feeling surprise and caused her to be wonderfully tolerant, which is another way of saying that she was sick with spiritual boredom.

The blue velvet trunk became so plastered with hotel labels that it had to be revarnished. Then Gay filled it again with three thousand dollars' worth of sunburn georgette crepe cobwebs and a statue that she went to Florence for, and set out for Biarritz. She was jaunty and courageous, and whenever the corners of life got stuffed up with laundry lists and stale cigarettes, she would be off for a new place with an ever-changing, starchy maid who she pretended had been with her for years.

She felt that people should be used to their surroundings, and should like old things. The intense obligation she felt of being appreciative was a thing she had learned by finding out, afterwards, how many of the things she hadn't instinctively liked were of recognized merit.

Gay came back from Biarritz that year looking very pale. She was one of the few people who could have managed so many long hours on a beach and emerge positively bleached. It was part of a sadistic interpretation of Anglo-Saxon self-discipline that she should always be Hawaiian brown in winter and as white as the fox on the collars of her transparent coats in summer.

If she had lived longer, she would have owned innumerable lace parasols, long beige gloves, floppy hats, and a perroquet. Gay liked style, fluttering, feminine style, better than anything she knew, and she never even once suspected that she had it because she dealt so completely in fundamentals—how many children you'd had or how many millions you'd made, how many roles you'd acted or the number of lions you'd tamed.

All these wanderings about took time, and Gay was being forgotten in New York like all people are who are not constantly being casually run into. There were other girls from fresher choruses, with wide clear eyes and free boyish laughs, and you heard less and less about Gay. If you asked for news of her, a blank look or a look of hesitancy would cross the face opposite you as if its owner didn't know whether he should have news of Gay or not, since her present status was undetermined. People said she was older that she was, when they talked about her—men, mostly, who were anxious that she should belong to a finished past.

She couldn't possibly be the ages they said, because I saw her not long ago under the trees in the Champs-Elysées. She looked like a daffodil. She was taking a yellow linen sports thing for an airing and she reeked of a lemony perfume and Bacardi cocktails. She wouldn't

come to tea with me because her favorite barber had been ill for a long time and Gay was taking him the money for a month in the country.

Before I had half finished looking at all the little tailored bows that made the yellow thing just right for Gay, she was pressed up the broad avenue by the mist from the fountains and the glitter of bright flowers in the shadow, the curling blue haze and the smell of excitement that make a Paris summer dusk. I thought she seemed pale and fragile, but Gay was always on some sort of an ascetic diet to keep her beautiful figure. These long régimes would bore her so that afterwards she'd go on a terrific spree and have to spend two weeks at a rest cure. She wore herself out with the struggle between her desire for physical perfection and her desire to use it.

The next news of Gay was a small bit on the bottom of the front page. It was an obituary notice from Paris. The papers were sketchy and said pneumonia. Later, I saw an old friend of hers who had been with her just before she died, and she told me that Gay had wanted the baby. Well, the child lived. And Gay still lives, too—in all the restless souls who follow the season in its fashionable pilgrimage, who look for the lost spell of brown backs and summer beaches in musty cathedrals, who seek the necessity for solidity and accomplishment but never quite believe in it, in all of those who make the Ritz what it is, and ocean travel an informal affair of dinner clothes and diamond bracelets.

She was very courageous—braver than the things that happened to her, always—and since courage has a way of pushing itself out, I suppose that's why she wanted a child. But it must have been awful, dying alone under the gilt curlicues of a Paris hotel, no matter how expensive the gilt, nor how used to them she was.

Gay was too good a companion and too pretty to go dying like that for a romanticism that she was always half afraid would slip away from her.

SOUTHERN GIRL

◇

The solid South stretches away for miles from Jeffersonville, long clay roads climbing slow hills covered with straggling pines, broad, blank cotton fields, isolated cabins in patches of sand, and far off in the distance the blue promise of hills. The town is lost beside a wide brown swirling river which cuts swiftly under its high red banks on either side. Deep trees overhang the brown foam at the edges, and shadows lie long and sleepily under the Spanish moss where darting hard-shelled insects fall down from the branches. Brown mud oozes between the cobblestones of the ponderous width of Jackson Street where it curls down to the riverside, lined with decaying wharves from the time when there was much shipping on the river.

Every springtime the brown water, with foam and twirling twigs and bits of feather, seeps slowly up the street until finally it reaches the gutters in front of the biggest hotel in Jeffersonville; then the inhabitants know that all the red clay bottoms for miles around are under water.

Wistaria meets over the warm asphalt in summer, and the young people swim in the lukewarm creeks. The drugstores are bright at night with the organdy balloons of girls' dresses under the big electric fans. Automobiles stand along the curbs in front of open frame houses at dusk, and sounds of supper being prepared drift through the soft splotches of darkness to the young world that moves every evening out of doors. Telephones ring, and the lacy blackness under the trees disgorges young girls in white and pink, leaping over the squares of warm light toward the tinkling sound with an expectancy that people have only in places where any event is a pleasant one.

Nothing seems ever to happen in Jeffersonville; the days pass, lazily gossiping in the warm sun. A lynching, an election, a wedding, catastrophes, and business booms all take on the same value, rounded, com-

First appeared in *College Humor*, July 1929. Published as by F. Scott and Zelda Fitzgerald, but written by Zelda. Previously collected in *Bits of Paradise* (1973).

plete, dusted by the lush softness of the air in a climate too hot for any but sporadic effort, too beneficent for any but the most desultory competition.

In my youth, number Twenty State Street had a pincushion of grass pushing up on either side of the straight brick path, and two cracked concrete steps leading to the blue and white octagonal paving blocks that formed the sidewalk. The roots of big water elms cracked the blocks, and we children skating home from school fell over the crevices. The house was an apologetic one for sheltering big families that had grown faster than the family income in that way obligations have of increasing their proportions more rapidly than the hopes and abilities that begot them.

Number Twenty was where Harriet and a fragile mother and Harriet's younger sister lived in one room and a latticed back porch. The rest of the house, all the three-cornered bedrooms and back hallways and waste space under the stairs, was rented. It was, in fact, a boarding-house of a very friendly Sunday dinner sort, and as we grew up and Harriet's mother softly became an invalid, it grew to be Harriet's responsibility. If the boarders weren't friendly when they came, they soon fell into the note of shy bravado about the long table, and they never seemed able to dispense with it even after they realized how uncomfortable they were, what with Harriet's squeezing them in between her beaux and her halfday job teaching school. The young men waiting to be married and old couples living on one railroad bond, and all the cheerful lot who came in the evening to sit about the stove in the parlor, seemed to find an ease and relaxation in Harriet's jovial irony and in the big horselaugh she gave any pretentiousness.

Her manner with the old was free and impeccable. To the rest, she gave the right to all the self-deceptions they found necessary for their peace of mind, so long as they granted her that sudden, blatant laugh that began with a sort of ticklish chuckling and ended with a series of in-drawn screeches bordering on hysteria. The roots of it lay deep in fatigue and strain, and if it didn't spare anyone's nerves, well, ever since Harriet walked for the last time with the rest of us between the blind-eyed Venus and plaster Minerva that were just inside the high school door, she had never spared her own.

People early wondered why she didn't go in for something more satisfactory and spectacular than teaching school and supervising a boardinghouse. It seemed to us such a waste of her energy and ability. The reason was probably that she was incapable of giving up anything; of relinquishing the smallest part of a conception or a phase of her life

until she felt that it had been completed. She left school with all sorts of convictions about sticking to things until the ultimate desired effect was produced, and it kept her hoeing a hard row, sticking by the hopeless patchwork of the various responsibilities that were hers instead of trying to turn them into one bigger unit of a job.

Every place has its hours: there's Rome in the glassy sun of a winter noon and Paris under the blue gauze of spring twilight, and there's the red sun flowing through the chasms of a New York dawn. So in Jeffersonville there existed then, and I suppose now, a time and quality that appertains to nowhere else. It began about half past six on an early summer night, with the flicker and splutter of the corner streetlights going on, and it lasted until the great incandescent globes were black inside with moths and beetles and the children were called in to bed from the dusty streets.

The leaves of the elms stenciled black friezes over the sidewalks, and men in shirt sleeves threw arcs of warm rubber-smelling water onto the moonvines and Bermuda grass until the air was fresher with a baked, grassy scent, and the ladies behind the thick-flowering vines had a moment's respite from their fanning. The town waited for the nine o'clock breeze in a floating stillness so complete that you could hear the grinding wheels of a trolley car climbing a hill six blocks away. Inside, girls in preparation for the evening dance struggled between the difficulties of the spasmodic sweep of an electric fan and the dripping heat.

That was how it happened that one night during the war, when Harriet was still only nineteen and at the beginning of her effort, the doorbell rang and she answered it in a pair of blue bloomers and a huge bath towel. The doorbell before nine could only mean a telegram or something that could be reached around for. She swung the door back in front of her as a screen, and there stood Dan Stone, all the high spots of him lighted up and shining with the light from the hall. He was a big, square soldier, fine legs like a Greek athlete, and a handsome Ohio face with a chin and a big arena of teeth.

He had behind him a girl who, even in the dark, Harriet knew was not Southern. Her black hair was too sleek to have known the muddy water of summer creeks, and her dark clothes were cut with a precision and directness which could not have been interrupted by frequent half-hour respites from the heat. Harriet was swept with an exultant embarrassment that she always felt in a situation promising adventure. She laughed and he laughed, and the gray eyes back of his shoulder started a little to hear so much instantaneous comradeship bouncing down the worn veranda.

He explained about himself to Harriet, about how he was engaged to the cloudless eyes in the faultless *tailleur,* and how the hotel lobbies filled with fan-draped flags and khaki hats and Red Cross posters were not the place to leave his fiancée. His mother had intended coming South, but she was ill. The regiment was leaving any time now, so couldn't Harriet's mother find a place for Louise among the hot biscuits and iced tea and fresh vegetables.

So Louise and Harriet, living in the same house, became friends for three weeks—which is a long time in wartime—and Harriet initiated Louise into our dawdling late yellow afternoons of Jeffersonville; into the automobile rides past dusty mock-orange hedges, the beveled fruit rotting beneath; into the sweet tartness of Coca-Cola cooling in wooden tubs beside a country store; into the savory vapors of Mexican hot dog stands, and into all the mysteries of a town that, to escape the heat, sleeps nine months a year under its banks of four-petal roses.

We knew all about each other in Jeffersonville: how each other swam and danced and what time our parents wanted us to be home at night, and what each one of us liked to eat and drink and talk about, so that we all were one against the taller, broader, older youth in uniform which had begun from boredom to invade the ice cream parlors and the country club dances, and to change into something serious the casualness of an intimate social world founded on the fact that people like filling the same hours with the same things. We swam at five o'clock because the glare of the sun on the water was too hot to permit swimming before that, but with the advent of a colder-climate organization that five o'clock swim and the six o'clock soda became self-conscious rituals that moved along more robustly than the long-legged, affable young men of Jeffersonville could follow with ease.

There weren't enough girls to go around. Girls too tall or too prim for the taste of Jeffersonville were dragged from their spinsterly pursuits to dance with the soldiers and make them feel less lonely through the summer nights. You can imagine how the popular ones fared! Harriet's sagging veranda was almost completely in uniform. It looked like a recruiting station.

During the weeks that Louise spent in the vine-clad smouldering depths of the South, Dan was always there at Harriet's, lounging over the front banisters with the loose longness of a rubber man, or standing under the stairs, his face in a beam, while he waited for the girls to materialize out of the dust of powder and squeaks and slamming of doors that always began when they heard him in the hall below. He came every day in the firefly hush before supper, and he stayed until

the last trolley rolled its cargo of summer light down the dim streets and out to camp.

At first, he and Louise fought shy of the lazy groups of us banging the screen door and laughing and shouting plans back and forth. They would have dinner in town under big fans like airplane propellers, waiting for the steaming corn on the cob to cool and the ice cream to melt, unable to eat in the lush, fertile heat. Gradually, they became part of the restless inertia of Harriet's porch. Dan liked it, and little by little Louise of the indigo hair and aquamarine eyes was left lost and baffled in the horsey smell of men in khaki and the heavy fragrance of white flowers in the semi-tropics. From soft shaded corners, the great rolling, enveloping laugh of Dan swept out, coming closer all the time, the way thunder seems to come nearer as you hear it passing over; and then out of the same lacy, geometric dusk, the audacious friendliness of Harriet's kidding horselaugh.

They were always together, and for the last few days before Louise left, a sort of desperation hung about the trio. It seemed as if Dan was driven by some inner necessity for honesty to wound and hurt Louise in Harriet's presence. Not that he was cross or ungracious or even impolite, but he simply unchained a robustness that he knew would terrify her, a quality that she thought of as masculine and frightening and that he thought of as particular to himself. They couldn't seem to agree even about why they were not happy together any more.

At last one hot five o'clock, he hurried Louise over the pulpy boards of the station platform and into a long sleek train with a special name like a racehorse. While he waited for the train to pull out, they sat opposite each other on the green, prickly, cindery seats, and broke their engagement. There must have been some protecting quality about the Northern solidity of the steel and screens and humming fans that gave Louise the confidence and courage to face the fact that Dan was breaking their engagement. And he found something in the cart of dripping ice beside the steaming train, in the lounging, muddy river beside the tracks, in the low brick station with its long shed over the freight cars and drowsy porters, to keep him from minding that he was changing her life at a word into something quite different from how she had thought of it for two years. When the in-drawn siren call of ' 'Board' swept along from the back of the long train, Dan swung down the steps with no remorse.

He was only ten minutes behind his usual time of arriving at Harriet's, which meant to him simply that he had lost his seat in the creaking swing and that she was ten minutes deeper in the freshness of rose

Southern organdy when they swung off together into the light and dark of the ambling street. They were in love.

Months afterwards when the war got itself over in one way or another, and after Dan had been to the port of embarkation and tasted New York on the eve of a departure that never came off, and after Harriet had had a dozen other beaux and a hundred other heartaches, he wrote for her to come to Ohio to visit his mother.

They had been engaged so long now, had written so many letters to each other from so far away, that their relationship had become a background for their lives rather than a reality, but Harriet decided to make the trip, searching vaguely to re-create those moments of mutual discovery that she and Dan had shared. From Jeffersonville, deserted in August, rows of newspapers yellowing in the heat before closed doorways, neglected lawns parching under the burning sun, shut windowpanes ricocheting the sun's rays onto the already burning pavements, Harriet set out for the North to recapture the balm and beauty of war nights under an Alabama moon. In Ohio she sought the hoarse croaking of frogs in the cypress swamps, the glint of moonlight on black scummy water, the smell of pine rolling up from lone cabin chimneys, and, above all, the svelteness of youth in leather and uniform—young, strange foreign soldiers, conquerors of her most enthusiastic years.

Dan, she wrote home, met her in the huge glass and tile station. The nearest thing like it that Harriet had ever seen was an operating room, and immediately a sense of alarm arose out of the back of her neck and undermined the easy delight with which she had been looking forward to seeing him. The blue-white rays from the station skylight pelted mercilessly on rouge more convincing in the soft, fuzzy light of the South, and all his politeness could scarcely keep out of his eyes the dubious quality that men feel when they find themselves with women from a different financial plane than themselves. In the quiet beige heaviness, avenues lined with small clipped trees and gleaming white façades slid past until at last he helped her out in front of a gleaming glass and grilled door. Inside his mother waited.

Dan's mother was as concise and formal and as black and white as a printed page, and Harriet, who was used to the old being tired and worn, fell into a panic. She lost her attention amongst the myriad silver picture frames and the bright backs of books that lined the walls, and her eyes kept hiding in corners behind the baskets of flowers or under the bearskin rug. It was an inauspicious beginning. She wanted to run, and in all the days she spent in the big redbrick house, she never quite

conquered the feeling that she, on confronting its mistress, might jump suddenly out of the window.

The summer nights passed in cabarets or circling about between rows of geraniums down the broad gravel drives of country clubs. People were away and there weren't many parties, so they even sought Louise, for old times' sake, to complete a foursome.

They drove sometimes over the trim tar roads to an amusement park. Harriet liked that best of all because there, floating over the smell of the hot butter from the popcorn, the acrid smoke from the shooting gallery, and the tart brassness of the merry-go-round, their two laughs sounded together on the night air like an echo from the war. But those moments were rare.

Louise and Dan rediscovered a common taste for the wicker chairs and long frosted glasses of club verandas. Gradually they lapsed together into a silent, fashionable sentimentality amidst the clatter of golf clubs and automobile horns and the dim chink of poker chips drifting from the bar.

To Harriet it all seemed like an illustration, an advertisement that reads under the bottom, "In Palm Beach they all smoke Melliflors." This one would read, "In Ohio we have more and better of the best young people." She was surprised at the robustness of her own laugh and distressed by the freeness of her Southern manner. She felt foreign to herself in finding herself so foreign to the others. She, never having been rich and "marriageable," had never learned the protective formalities and reserves of expensive society. She was a lonely appendage to these white flannel afternoons.

With a sense of relief, she entered into the last week of her visit. Louise was constantly about the house now, her quiet voice muffled on the thick carpeted stairs or languidly discussing with Dan's mother leagues and organizations and societies for the prevention of things. She belonged in that quiet house. The candlelight singing in the globular sides of silver bowls, the gleam of a gold plate under the strawberries, the feel of water heavier than the glass that contained it, called out no overpowering confusion, no overwhelmed inadequacy in her calm twilight eyes.

Harriet sensed all that, and so it was that she was less hurt and surprised than Dan had supposed she would be when he told her that he wanted to marry Louise. All she wanted at that moment were the bare floors of Jeffersonville, the succulence of a Sunday baked ham, the familiar clatter of green-rimmed dishes on the boardinghouse table.

When she got home, she told us all about the clubs and motorcars and how people dressed in the North, and she said simply that she and Dan had decided not to marry. She didn't feel that she could leave her mother.

I left Jeffersonville about then, but I can imagine how the winter came and the groups about the parlor at Harriet's grew bigger and perhaps younger. At holiday time there were dozens of college boys, joking and shooting dice and teasing the girls, so that if Harriet wanted to be alone she had to leave the house. At the Saturday night dances she often passed from one pair of arms to another without dancing a step. Everybody was fond of her, of her tireless good humor and impersonal intimacies.

Old people said they didn't see how she found the courage to work all day and dance all night and look after the boardinghouse in odd moments, and always to be laughing and happy. She saved the money she earned, a little at a time, and twice every year she went to some big city. One summer she visited me in New York. She learned a vague species of French and bought all the fashionable magazines. She was determined to find for herself a bigger sophistication than Jeffersonville had to offer.

Five more summers and winters steamed off the slow river and passed like a gentle mist over the salvia beds and Cherokee hedges and ribbon grass of the town, and now the children she had drawn paper dolls for crowded the country club dances, and most of her contemporaries had kids of their own.

From time to time I went home and found the girls she grew up with vaguely pitying her about their bridge tables and over their bassinets, speculating about why she had not married this man or that, and wondering why she preferred long chalky hours in a primary school and the gentility of aged boarders' complaints to the gilded radiators and flowered chintz of a suburban bungalow.

People went away and came back; friends of hers who had married or boys she had known in the army said she hadn't changed a bit. The people she saw now formed an expensive white bungalow ring about the city, and they all owned silver cocktail glasses and dined by candlelight and liked the taste of preserved caviar. They gave teas and dinners and parties late at night for strangers in Jeffersonville who had arrived with cards to the club or letters of introduction, or who had come to give a concert or a lecture.

Charles was one of the ones who came with a letter. He was an

architect. Jeffersonville is as famous for its old stairways and fanlights over its doorways as it is for its hospitality. Harriet met him in an odd sort of way. He just came bounding in one night, the light from the hall lighting up his square shoulders and an arena of big white teeth. He was tall and he laughed outrageously at her because she was all wrapped up in a bath towel with a few fluttery things underneath. She hadn't known, naturally, that he would bounce in so unexpectedly, demanding a room. They laughed together, and evidently she felt the fear of losing interest in life scurry away down the worn veranda, worsted by the heartiness of two ringing battle laughs.

They were seen about together so constantly that nobody was much surprised when they ran away and got married. You see, he lived in Ohio, and he didn't want to wait while a lot of elaborate preparations were made. That happened about two years ago, and the news is that they are perfectly happy—as she always showed herself and so deserved to be. They live behind an expensive grilled door with his mother, a black taffeta widow who is very rich and formidable, and Harriet seems to spend a great deal of time working for leagues and societies of all sorts.

Their life is full of candlelight and gleaming bright things. And, of course, she has the baby who, from his pictures, is big and square even for his age. She called him Dan "because," she wrote me, "it's the only name that really suits him."

THE GIRL
THE PRINCE LIKED

◇

Helena always said that all she had from her father was the big clock that stood in .the hall, engraved with a touching testimonial from his employees, but she forgot the eight million dollars and the driving, restless ambition that had led him to accumulate his money so relentlessly. She had also from him a pair of mystic, deep-set eyes and an unbroken, round hairline and a deep, straight crease above her lips when she laughed. These showed very plainly in her wedding photographs, when she was still completely under his living influence.

When I first knew her she was already twenty-seven, and the corners and ridges of a successful personality had been modulated and polished by a Parisian finishing school, seven years in *Town Topics*, two children, and an enormous collection of second prizes from golf tournaments. Heaven knows what the force of her must have been in its aboriginal state! She once showed me lots of grayish-brown photographs of a huge frame house whose ground plan must have looked like a roller coaster, so much was it of the billowing Nineties. Here she had spent a dynamic, motherless childhood. It was easy to imagine her skipping rope on the circling verandas, while the summer rain trickled down the tin gutters onto the deep hydrangea beds. She must have been a small, slight little girl full of sudden flashing indications of a firm and constant energy, because she was still like that years after when I got to know her.

At first it was disconcerting because her vitality did not come and go like most people's, but simply changed from one sort to another. From a vibrant excitement that she could convey when she wanted to be disturbing, it would quiet down into a smouldering yellow light back of

First appeared in *College Humor*, February 1930. Published as by F. Scott and Zelda Fitzgerald, but written by Zelda. Previously collected in *Bits of Paradise* (1973).

her light eyelashes, back of her yellow-brown eyes crouching there independent of Helena, watching you, always taking note of everything.

That was one of the ways she established social dominance over people: she would sit and watch until she frightened them, and then suddenly be friendly and free and just as charming as she had been formidable.

The summer that I knew her best, she was already in the direct line of succession to the social throne of the big windswept Middle Western city where she had lived since her husband had taken her there after their wedding. It was not such an easy place to subjugate; the people there were terribly rich and awfully proud of their fine possessions. Everybody who counted had everything; their houses were full of sea green bowls of fragile things that grew in their own conservatories, and their walls were lit with those expensive globules of light that only millionaires' architects seem able to invent. There were marble bathrooms and painted ones whose pictures were in *Town and Country,* and there were dozens of houses with rooms as long and still and thick as a very fashionable hotel lobby. The cream brick façades and the concrete drives, punctuated with heavy powerful roadsters, forged a chain about the rendezvous of the people of importance, whom Helena wore like a string of glass beads. The others loved that nonchalance of hers.

The winter I was there, they liked going to dinner at her house. It was always a sort of boyish affair where Helena sat half holding her breath in the hope that perhaps the menu would be different from what she had ordered, suppressing in herself a feeling of guilt that she had not given her afternoon to improving it, impatient with the Nordic progress of the Swedish maids about the table, pleased and jocular after the first mishap which released her of feeling that somehow, in spite of her carelessness, the meal might achieve perfection, as a race that's run releases the rambler's tension.

Helena's personality was so strong that the most insensitive of her guests could never relax if she was nervous; they must all await the figurative plate-breaking. That excitement in her did not come from shyness. I've seen her walk into a Christmas cotillion and butlers and footmen fall about her at the door like a flurry of early snow, and I've asked myself what it was that gave her so much instantaneous authority, because even on the most formal occasions of the winter she never looked any way except like a very young person with very clean ears.

She went through her wintertime *beaux* with the same air of impassibility and detachment. On the list of her admirers there were sober, efficient young men who organized balls, and middle-aged men with

fine figures and a devoted reticence, and tall, trim men from New Or-
leans, and two or three admirable pianists, and an almost magnificent
tenor. She had around her, too, lots of young boys still in college—
very attractive, straight young athletes, mostly, who were afraid of the
difficulties that lay in sentimental relations with girls their own age. In
winter she kidded these young ones mercilessly and asked them one at
a time to the parties she gave and sometimes went to their sleigh rides,
all bundled up in tawny, fluffy wool, with her feet in doeskin moccasins.
In summer she kissed them—on flag walks beside freshwater lakes; in
the webbed moonlight spun into fragile patterns by pine needles, beside
a cool wide river; on long asphalt roads beaten by the sun till the tar
and rubber melted and the automobile wheels whirred like telephone
wires as they rode along.

Helena was far too personal to like dancing, and often from the
screened balcony of the Yacht Club during the Saturday night celebra-
tion, I've watched her strolling along the jetty, with a pair of flannel
trousers; with a few truncated gestures, changing a likely candidate for
the diplomatic corps into a hopeless gigolo who would speak his lines
for life like a person talking a jazz ballad. Inconstant, consequent Hel-
ena! The others fared just as badly.

It was hard to find and keep chauffeurs in our state at that time (I
think they were all in Congress), so Helena used to borrow the great,
rolling, padded cells of the portentous men of affairs, who kept the vases
inside these limousines full of orchids for her. Her own garage had a
place for three cars and there was one that was always broken, but she
liked using other people's things, not for what she got out of them but
for the sense of power it gave her to have somebody doing things for
her. She was like a beautiful general on a tour of inspection when she
picked the finest car she could for paying her Sunday calls—sipping the
eggnog in one place, nibbling the cinnamon toast in another, her gray
fur coat trailing behind her like a Greek toga, everything gray but her
black suede slippers and herself. She was rose-gold.

All through the winter she went about talking of how dull life was
and how she wanted to go away. People listened to her with the same
rapt hope of illumination with which unaccustomed sinners listen to the
Lord's Prayer.

When summer came, all the people who liked the summertime moved
out to the huge, clear lake not far from town, and lived there in long,
flat cottages surrounded with dank shrubbery and pine trees, and so
covered by screened verandas that they made you think of small pieces
of cheese under large meat safes. All the people came who liked to play

golf or sail on the lake, or who had children to shelter from the heat. All the young people came whose parents had given them for wedding presents white bungalows hid in the green—and all the old people who liked the flapping sound of the water at the end of their hollyhock walks. All the bachelors who liked living over the cheerful clatter of plates and clinking locker doors in the Yacht Club basement came, and a great many handsome, sun-dried women of forty or fifty with big families and smart, crisp linen costumes that stuck to the seats of their roadsters when they went to meet their husbands escaping from town in the five o'clock heat.

With all those people, you see how it was that there were always so many parties during the summertime. Helena never tried much to be a good hostess; she was content always to be the perfect guest and liked saving her energies for being attractive. An important part of her line was kidding things about her, and that was easier when she wasn't at home; in her own house a great chorus of "Oh, no's" arose when she put on that very surprised look and made some horrid remark about the dinner. Sympathetic protestations slowed her up; she liked better to be somewhere else and, saying things in that explosive way of hers, to start giggles and whispers scurrying about the long lace tablecloths.

I remember one summer when Helena had a green dress with patches sewed all over it, in which she used to play golf. When she stood on the first tee to drive off over the embankment, she gave the effect of clean laundry in a March wind, there was so little of her and so much of crispness silhouetted against the Queen's Checker Board of the golf course. Her hard gold hair did not escape into the sunshine but lay close to her head like a protective helmet. That and her tanned skin and a "stripped for action" quality she had made me think of a pine wood, when I saw her blowing in and out of bunkers, up and down the long grass aisles.

It was the same summer of the big regatta on the lake. Canadians in blue blazers and Americans from all around the Great Lakes and from all over the West came with their fast, graceful boats and sun-beaten faces, and Helena captivated them all. She seemed awfully happy, running about in her big station wagon, supervising the seating of people for dinners, choosing between orchestras for dances and pretending she would have nothing to do with the arrangements.

I think that was the last summer that she got any real pleasure out of doing what she liked with us all, because toward autumn when the deep woods began to smell of Indian campfires from the past, and goldenrod lined the dusty roads, she was less and less with us. She started

riding again and became awfully serious about golf. Her parties weren't the same either; at some of them there were even people quite obviously tight. Helena usually kidded those propensities out of her guests, forcing them to behave to their best advantage, but now she didn't seem to care.

By the time the tiny purple asters baked in the yellow autumn sun, she was so definitely bored that night after night she didn't go out at all, leaving the dregs of the summer moon to a disbanding crowd—a crowd becoming every day less harmonious, a crowd without a leader, breaking up into small groups, drifting with their individual inclinations now that Helena had lost her former interest in being our center.

When everybody moved back to town, Helena bought a new house, a huge stone place with a fountain in the conservatory and a series of gloomy velvet rooms, all with official titles: the Music Room, the Library, the Study—and there was a stairway that should have been in an embassy. She said she meant to do it over, but I think it got to seem a sort of protection from the intimacies of a town where in every familiar face you saw, you could trace the family likeness. What she did over was her list of friends. The charades that rose against the heavy paneling of the dining room took on a suggestion of obscenity in the expensive candle shadows, and Helena's parties gave off that aroma of danger that only people already in the age of security can afford.

Handsome men who spent their mornings telephoning fortunes to New York and San Francisco, spent their evenings in defiant supplication of chance, nature, and God to place in the pearls of their friends' wives just one disastrous gleam. They were all too used to each other to furnish much mutual excitement, so it was easy for Helena, with her affrontal gallantry of a boy of thirteen and her uncomplaining husband, to become indispensable to that roster of owners of railroads and banks and nationwide trademarks that made up the older set in search of pleasure.

After Christmas, when the snow wears gray and glassy and the cold is so severe that even the biggest houses get full of week-old steam heat, she and her family and her dogs and her maid and chauffeur, and the children's maid and nurse, and the valet that she thought her husband should have, all set out for Florida. All that retinue must have given the press photographers the same impression that it gave us, of a young prince and playmates traveling, because every Sunday, for the two months she was away, there were brown pictures of them in all the papers big enough to boast a rotogravure section.

Of course all of us were jealous, and we said how silly and affected it was of Helena suddenly to become so doggy. The real affectation had

been when she ran about the lake pretending she was not as rich and powerful as infinite charm and inexhaustible funds could make her.

So Florida was a series of successes. There were two Knickerbocker names, and a cruise on a world-famous yacht that became public property, and I don't know what private triumphs. It was natural that she should find us dull when she came back to the dripping, crunching slush of our late spring, and that she should turn her eyes toward theaters more worthy of her talents.

Chicago took her just about two weeks, I should say. I was living in the East then and I saw her only occasionally for lunch on the flying shopping trips she made. She would sit chuckling and smoking over a green sea of salad, the rise of the social barometer plainly visible in the immaculateness of her hairline, in the quiet insistence of her very correct accessories. She was trimmer and prettier than ever, and formidable! She could devastate a person with an apparently harmless little story about his personal eccentricities, and annihilate another with a broad, good-natured joke about his physique.

Judging from the way she looked when I last saw her, with her smooth gold hair drawn tight from the middle over her ears and her yellow eyes full of the promise of sun in the winter and cool summer shadows, she should have had a good ten years of organization ahead of her. But then she met the most famous young man in England.

We heard several versions of the story about how he singled her out of a party in Chicago and sat talking with her through a heavy, silhouetting moon, on a balcony, both of them dangling their legs over the Renaissance balustrade and making wisecracks. He stayed only a few days and after he left, the rumors whirred about like hummingbirds' wings. People exaggerated and pretended they were sorry for a husband in so obviously helpless a plight. Even the few people who had not been interested in Helena became consumed with curiosity to gauge the charm that had thrilled the young-man-who-had-everything.

Their overtures weren't very long in boring Helena to a terrific impatience. One morning, with very little warning, she packed the white lace film in which she'd first laid eyes on that famous boyish face, and with that and all her household goods, stepped briskly over the bent back of Chicago into a big white house that sat in the center of a mystic maze of pebble walks in the most fashionable corner of Long Island.

Motoring home on summer evenings through the blue dusk that turns New York to a city under the sea, she would roll over the scalloped bridge hanging like draped lace between the stenographers and the families of American capitalists. From it she could see a sign flashing forth

its mechanical pride in the product of her father's ingenuity. I remember her telling me once that that sign made her feel safe and secure. She had always thought of herself as an Easterner. It must have been pleasant and familiar to her to step out of the big car and guess who was waiting on the dusky porch, by the timbres of their voices. There would be the crunch of shaved ice in the sweating silver glasses and the smell of mint, and they would all stay for a summer supper under the spell of Helena. She must have had a vague sensation of comfortable recognition such as you would feel on finding yourself in a place where you'd been in a dream, but it was not a life she'd ever really led—that drifting and whirling through the piles of raw material and great plans drawn in the sky that make New York so glamorous.

However, it was the environment in which she was born, and the atmosphere of the place in which we pass our earliest youth seeps into us through the slats of our cradles. But I don't believe she was happy even here, back in the place she came from. There is something infinitely disturbing in the phosphorescent rosiness that surrounds the successful and the great, a mystic magnetism that promises the same freedom from doubt and trouble that is part of themselves to all who surround them. Hundreds of people must have felt it at one time or another about Helena in her triumphant progress across half a continent and back, and now, contact with a personal power more compelling than her own left her wanting to seek its mystery in the rhythm of railroad wheels and the creaking beams of ships at sea.

One night in Paris she found him again. A sudden summer rain fell, drenching the *gala fleuri* at the Château de Madrid, passing through the colored lights like a blurring hand over a wet picture, forcing the trick shadows to disgorge their secrets. From behind the gauze of fountains and from out of the dark, under elms, streamed the incognitos, the maharajas, the figurants of current scandals, and many millionaires who knew what to buy with their money. Then, just as the nicest presents on a Christmas tree are hidden far under the branches, Helena saw his boyish face, covered with raindrops, charging into the light where she stood. That meeting marked the beginning of a time when they were seen about Paris together a lot.

When the time came that this most famous person had to leave, he probably said to Helena, "Well, if you ever are in my part of the world, look me up, won't you?" And she promised she would, and she *did,* because not very long after the good times they'd had in Paris had come to an end, she found herself quite by accident in the great gray city where the magic person lived and had his palace. He was awfully

pleased and excited at the prospect of seeing her again, and insisted that she come to tea. Helena was charming: she told him that she was desperately afraid of so many butlers and lackeys and footmen and guards, and he could only persuade her to come when he promised to send them all away.

Picture to yourself Helena, trim, golden, dynamic, getting out of a yellow taxi in front of a palace so big and full of spires that to stand in front of it gives you the feeling that you are one of those dots of people in the engravings of biblical market squares. And picture the most romantic young man of our era, sitting whistling on the top of the second flight of long steps, without a butler or a soldier or a lackey in sight.

And that is the last news I had of Helena, though she is often on the passenger list of the fashionable transatlantic liners and is usually registered at the Ritz in Paris and New York in between seasons, or in some small, unpretentious hotel on the Left Bank that costs more. You will know her immediately, if you should run into her, by the raillery in her confident voice and by the awkward, stuffy way you feel before her.

If you are famous or rich or very, very handsome, she will annex you and give you a good time and hurt your feelings. If you just meet her because chance has thrown you into her path without exciting her curiosity about you, she will simply hurt your feelings, and you will never be part of that fine group of Helena's intimates all over the world whose insides fit their outsides as they should.

When she's finished with dashing about, disturbing the susceptible, making susceptible the disturbing, perhaps you will find her one day enveloped in Venetian shawls, hugging the most elaborate heating system that money can buy and ending her tales with, "Of course it's true; it happened to me." But she will have to be a very old grandmother, indeed, because she doesn't like talking about herself and has so little of the romantic about her that, so the story goes, she took the bracelet (which she will always keep as proof that romance has not passed out of the world) into a jeweler's to have it valued.

I wonder if the reflections of the palace lying in the depths of the stones added to the weight in the jeweler's scale, or if that added importance is only for Helena, to help her remember her best fairy story when life leaves her time for telling it.

THE GIRL WITH TALENT

◊

The febrile winter sun felt its way along the basement stairways, digging out the corners of the cold stone steps into live cubistic patterns. Tentatively it flicked the red and green electric bulbs that framed a Chinese restaurant into glassy momentary life. It slipped on the gilt of a second-story costumer's sign and fell with a splash under the canopy of a Forty-third Street theater. Then it wound itself in and out around the noise and smells of trucks and taxis, a hurdy-gurdy, a porcelain lunchroom, a gigantic tooth over a dentist's window—slithering its way through the warm oily fumes of a coiffeur's, glinting the glass rectangle of a cheap photographer's showcase. With cold calculation it avoided the alley up which I turned and left it sunless, trafficless, bounded with a network of fire escapes and filled with a stolid gray silence like a street in Dickens' England.

It was a theatrical alley, lined with green baize doors; in its gutters bits of program from yesterday's matinee floated morosely. Where the words, *Stage Entrance,* were hollowed out in green glass I went in.

The theater was dark and on the stage in the half gloom a girl with short black hair raced about, tapping out the rhythm of a mountain cataract to the tune of the hit of the winter. As she moved, her hair flowed back from her pert, serious face like the hair of a person coming up from a dive. She stopped suddenly and a deep chuckle rose from somewhere and enveloped her. All her gestures were involuntary like that, as if superimposed on a colossal dignity and restraint and as much a surprise to her as to the rest of the world. That quality was known to theatrical managers as hot stuff, to a large and discerning public as physical magnetism, and to a widish circle of enemies from lower theatrical planes as lack of talent. "Why," they loved saying, "she can't *do*

First appeared in *College Humor*, April 1930. Published as by F. Scott and Zelda Fitzgerald, but written by Zelda. Previously collected in *Bits of Paradise* (1973).

anything. She doesn't know how to sing or dance, and she's built like a beef-eating beer bottle——" Which libelous slander had hindered her progress to the stars' dressing room not at all.

Lou found her way through the maze of steel cables and slack ropes and bits of painted garden to the place where I waited against the bare concrete wall. I followed her courageous little lilt along the long stone corridor full of electric switches and signs about smoking, past a water cooler and a pile of Lily cups and an old man in a tilted chair, past two men with their hands in their pockets and a fire-extinguishing apparatus to a gray door with a star stenciled high up in the center and *Miss Laurie* in a box underneath. Two soft blue ballet skirts formed amorphous clouds against the door and a light swung in a cage, like a golden bird, above a long mirror framed with cards and papers. Among them I saw a poem written on the back of an old program, a lacy Victorian valentine, two long telegrams for austerity, a few calling cards, a beautiful picture of a baby playing in long curly grass, and by its side a newspaper picture of a handsome young husband, rich and famous enough to have claimed a good quarter of the front page.

All these things were hers. There was, as well, a grinning Bahama maid emanating an aura of irregularity, and the soft seduction of a gray squirrel coat hovering over the radiator in the corner. A big decisive automobile waited beyond the alley. I couldn't restrain an involuntary, "Such a lucky girl—you've got everything," as I ran my mind slowly over the delectable list of Lou's possessions. She had a band of gauze about her hair and she was digging away at a big tin of cold cream. She answered me from the mirror. "Yes," she said, "except a cocktail. Let's go and have a drink."

Out of the quiet resonance of the passage and down a short flight of stairs, we followed the loopings of the tinsel January sun and left it at the entrance to a dark dining room that smelt of orange juice and gin. Lou's dancing partner was there, hard at work on creating a smokescreen about himself. They laughed and pushed each other about with friendly little pats, talking shop in a professional lingo that I only half understood. She was fond of him, I knew, and we were all having a good time, but even so she gave the impression of constraint and of awaiting the passage of time as one waits for the five-fifteen. Her partner was reading her a half-kidding lecture about drinking too much gin, and finally it made her angry and we left. Outside she stood on the curb like a fine, highbred hunter picking up a cosmic scent on the early winter night, the bright silver buckles on her slippers twinkling and

twinkling with a restlessness to be off. "Oh, hell," she said obscenely, "I wish there were——"

High up over Central Park the beautiful baby was eating carrot soup with nice crispy things in it that caused the tiny mouth to weave a rhythmic circle to and fro, almost obliterating its startling likeness to Lou. A cardboard nanny stood over the small wicker chair, waving a spoon about with the delicate emphasis of an orchestra leader and speculating mildly on the whereabouts of Madam. In the Tudor splendor and oaken shadows of the tall living room, a handsome young husband sat straining his cheekbones white against the gloom and feeling strongly the poignancy of his tilted, famous chin. Three expensive dresses lay pressing their Alice-blue pleats and twinkling buttons against discreet box tops.

Still no Lou—that is, no Lou in the high and fine apartment. No Lou running a noisy shower, changing the sterile tiles of the bath to a broadcasting apparatus for slushes and gurgles and burst of a piercing, unmusical whistle. No Lou wandering in and out of the massive shadows, overawed and defiant, shoulders pressed back and rounded out by the weight of the sky itself into a noble dignity of line that accepted no mastery from paneling or marble hearths. No Lou to feel sorry for such a little baby eating such a lot of soup.

At that moment she sat incredibly immobile in a beige corner of her snug limousine and turned wide eyes like holes in a frozen lake on the cross-stitching of the elevated, on the red and yellow lights that went round and round and the green lights that made squares and the lights that outlined stars and words and shapes of things. I supposed she was brooding, or maybe enjoying that delicious feeling of motion that makes children hum in motorcars, so I didn't disturb her. We went all the way home in silence, crawling the pharmaceutical smells and the smell of hot bread, of gasoline and city dust, the overpowering smell of friction and all the used-up smells that escape into the New York streets with the letting down of business hour discipline.

We were late, and her husband was terribly annoyed when we finally got there. I suppose meeting her at the door all ready to be cross and finding himself frustrated by the presence of a stranger gave him a sensation like finding oneself at a ball in pajamas, or waking up in a dinner coat on a bright sunny morning.

"You'll be late for the theater," he said automatically.

"I know. I'll hurry. Did my dresses come? I thought we'd all have dinner together."

"Dinner! My God, it's eight o'clock! Luckily gin's very nourishing, I believe."

"Absolutely no calibers at all—I mean calorics. Oh, don't nag. I never nag, nag, nag at you."

The buckled shoes beat out a lively rhythm. There were tears in the big, translucent eyes; back and forth flew the quiet angry words like a game of kitty o'cat. The sternness of a North American Indian settled over the famous profile.

"I wouldn't care," he said, "if it wasn't always these cheap theatrical folks. I don't see how Lou stands them—sitting on their laps, slobbering over them."

Somehow feeling included in the sweeping condemnation, I felt emboldened to protest.

"There was once," I began, "a house of such wonderful shining glass that it was almost a diamond——"

He froze to precision before my eyes and bade us good night with the austere benevolence of an early colonial minister saying good-bye to his flock as he softly closed the door. Lou's "Well, I suppose that's that" made me think morosely that she might be able to sing mammy songs with moving conviction.

The winter went on and packets of pansy seeds and tulip bulbs cluttered the bird stores along Sixth Avenue. Swift sudden winds lifted the sunshine high in the air and crumpled together the violet and yellow petals in the flower sellers' baskets. Lou's show had shut, that amateurish, fresh flavor that she had on the stage proving not strong enough to carry a star part through a winter of the caprices of a New York public. I thought when I read that the show was leaving that she would probably sink back into a more peaceful domesticity, away from the detested theatrical world. But nothing of the kind. Later in the spring, when the time came that any two people meeting on the street greeted each other with "What boat are you going on?" I bumped into Lou on a corner of Fifth Avenue.

"Oh, hello!" she gurgled. "When are you sailing?"

A gray cape floated out behind her, like a fairy story illustration, and the cool sun dusted the bits of metal about her costume. I knew by her exuberance that she was on her way from the steamship booking office.

"I'll see you there before long," I promised.

"Sure you will, because I'll be dancing at Les Arcades, and you'll be needing to go there to keep up with the *monde*——"

The lights changed and she, like a visiting officer in the frontline trenches, dashed appraisingly across the line of cars.

"Are you *all* going?" I called after her.

"Oh, no," she grinned, and then, not smiling any more, she added, "Oh, no!"

Now a Paris nightclub during the season is a very serious affair. The seriousness begins with the waiters. If you are not known, they have an awful time finding you just the right table for your station in life, and if you are known they have an awful time giving your table to somebody else. The strain shows in their earnest white faces. There are clients who must be hidden without their knowledge behind palms and screens and may be even behind the cold buffet, and there are other clients who must be exploited and forced to like being put in the position of a sort of social sponsor to the party in spite of their inclination toward inaccessible corners.

Then there is the question of the orchestra: suave and supple it must be and conduct itself with grave decorum in moments of calculated abandon. It must transfer through the convolutions of its golden hours the certain hopes of the past into the uncertain expectancies of the future. It must make people want to eat and dance and drink and do what other people want them to, particularly what proprietors of nightclubs want them to. Naturally, all this responsibility makes fashionable orchestras pale and solicitous and scoops great bays deep into the hair of their foreheads.

Lastly there is the décor adding to the solemnity, being sometimes so restrained as to be almost inside out. Every night quite late, in any one of these sophisticated rendezvous, a powerful white spotlight falls blindly toward the dance floor, bodily picking out big men with cigars who turn themselves sideways and try not to smile, and thin hanging women who cover their eyes with long white hands, and fat women who fluff up their features, and sleek girls' eyes giving back the glare from the dark like the eyes of an animal. The light lumps them all at the far, impersonal end of a telescope. Swooping about amid gilded chair legs and many strata of smoke, the fluffy ends of summer gowns and the sharp crease of black broadcloth, it finally fixes itself a transparent geometric cone, rising like a prestidigitator's hat from the shining floor.

At Les Arcades it performed its magic for Lou. Straight into the suspended gravity of adults amusing themselves, she walked each midnight with the air of a child saying, "Now you can watch me play." No heavenward smiling, no sidewise grimaces, no attempt to let the audience in on her secret. She moved about under the light with preoccupied exaltation, twirling and finding it pleasant; twirling again, then beating swiftly on the floor like a hammer tapping the turns into place. A plea-

surable effort shone in the infinitesimal strain on her face, and her out-
stretched arms seemed to be resting on something soft and supporting,
so clearly did you sense their weight and their pulling on the shoulder
sockets.

"I like to dance," she seemed to say. "There's nothing so much fun
as this is."

Of course, she was an enormous success. People beat on the table
with little hammers and, enchanted with the noise, beat louder. Lou
asked for more money and got it, and asked for rake-offs in formidable
couturieres' and got them. She bought dark blue dresses with Peter Pan
collars, and bright red dresses with skirts like carnations, and big hats
that flopped over one eye and small ones that half covered the other.
She bought masseurs to rub her in the morning, and too many sidecars
before lunch, and underwear in which to find herself dead. There her
expenses stopped. Her beaux bought champagne and taxis and curried
chicken at Voisin's and half the perfume in Babani's. There wasn't really
much they could buy for her because she was such a boyish little person,
with black hair turning up like a bell back of her jaws, so that only a
fishing rod or a pocketknife would have been really appropriate. She
liked best the men who bought her eating and drinking and excitement.

One day she got soaking wet in a leaden Paris rain and stopped into
my place to dry her stockings. I tried making one of those appropriate
drinks like mulled claret, and while we were waiting for the foul thing
to cool, I said to her, "Lou, does your husband know you're raising
Cain over here?"

"Cain?" she echoed incredulously. "Why, I am so good as to make a
mother superior seem like a glandular phenomenon."

It was a week after that that she disappeared.

It seemed as if all Paris had been on a big bust all during the week,
and the survivors of dozens of small groups were meeting every night
under the pale late lights, driven by common fear of the stillness of a
bedroom between midnight and dawn to hunt the morning over the
cobblestones and pointed alleys of Montmartre. Now Lou was always a
survivor, and one night, when it had got so late that we all sat huddled
over the drum in a Negro joint, like people engaged in a tribal rite, we
annexed another.

He was tall and dark, as neat as the washed flower beds around Les
Ambassadeurs, as romantically presented as a soft waltz at Armenon-
ville, and he shone like a prize apple even at six in the morning. I half
expected to see him take a strip of dingy flannel from his immaculate
dinner coat, spit in his palm, and begin polishing his head, rolling it

round on the inside of his arms like a kitten washing itself, then swiftly sawing the cloth back and forth over his forehead. Instead, he sat down next to Lou so softly that I had a momentary illusion that he had come down on wires from heaven. He spoke low to her, bending himself almost to his knees with each word as if forcing the words out like notes from an accordion. There was a pained and questioning group of shadows just above his eyes and about the corners of his nose, and Lou talked to him with her face straight ahead and only moving her eyes in his direction. "Love at first sight, undoubtedly," I thought philosophically.

We had all drunk enough champagne to keep us in bed for a day, and had begun saying quarrelsome things to each other, pretending that we were being friendly and frank, so when somebody suggested that we leave, everybody was ready to go. Standing in the corridor with the door swinging open and shut on a street full of yellowish blue, and the glitter of a red sunrise coursing along the flowing gutters, we shook off the gloom that had settled over the party and said robust good nights and felt rather fine and cozy and suddenly sleepy as we rolled off down the hill in rickety old red taxis.

The morning held a cool, fragile mist that did not permeate it but lay along its promise of heat like drops of water on a sprinkled rose. The July sun peeled the tops of trees to orange-gold, and warmed and shrunk the slim shadows tracing the buildings. All over, beyond and above the cracking red in the East, the sky was the dense and colorless blue of a dawn inalienably identified in my mind with the dawn of battles. I was so absorbed with all these things, and with the sweet smell of the woods and ferns given off by a cart piled high with raspberries on its way to the market, that I didn't notice that Lou and the man with the high patina were not with us any more.

She had been staying with some very discreet mutual friends of ours, and if the telephone hadn't got mixed up in the affair probably nobody would have known about it. The manager of the nightclub started it, naturally, by phoning all the people he'd ever seen Lou with to know what he should do about his grand gala. All the silk dolls and little hammers and balloons and, oh, my God, the champagne! Lou's name out in front a mile high and Lou's chiffon dresses floating out at the opening of the dressing room like colored papers on an electric fan— and Lou vanished off the face of the earth.

We couldn't find her either, though there was no place that we could look except up and down the labyrinthine corridors of our friend's apartment, in and out of speckled French bedrooms, searching through a

maze of splitting yellow satin and deep sepulchral beds. She simply wasn't there—until after five days of looking, just as we were about to notify the police, she suddenly *was* there again, stretched across the bed in such a state of fatigue that to look at the small body sleeping you would have thought it molded from lead, so heavy did it seem. She slept for hours and hours and hours, and I never saw her again until after her divorce.

It's hard to tell what brave people think. Courage is almost like a sixth directing sense, and I think sometimes that their judgments and decisions wait on its dictates. I hadn't been back to America the winter that Lou was getting her divorce, but stories of a desperate sort of dissipation slid down back of the leather cushions in the bar chairs of pompous ocean liners and reached Paris like a new edition of the *Arabian Nights*. It must have been hard, selling all that mess of pottage for a birthright, and Lou probably went through some pretty nightmarish times. Of course she was dancing all the time in a big hit and she didn't have to be eternally fabricating complex philosophical reasons for why she cared about the things she liked.

When she came back to France she seemed taciturn, but Lou was always that way, as if she was afraid of what ecstatic sounds might escape that primitive throat of hers. To my mind, people never change until they actually look different, so I didn't find her greatly modified. She missed the baby terribly. I suppose we always feel a deep regret for the things we leave behind incompleted, but it is a regret inextricably mixed with human disappointment at human imperfections and fastens itself to one thing in the past as readily as to another. She had never seen much of the child.

I saw her when she was passing through Paris, filling up her trunks like an engine drawing water. One day I found her helpless in the hands of two dressmakers. They were sticking mouthfuls of pins into her, and all about her feet were the white lights and deep apricot folds of gold satin. She stood there as rigid as a lighthouse, and I wondered vaguely where those fine muscles came from. Suddenly I remembered stories of a past trailing away over the water under ripe Hawaiian moons, doubling over itself like a game of hare and hounds about half the army posts of the Western world. She must have been brought up on baking horseback trails and bamboo verandas and swims miles long in fruitful Southern waters—a good school of unrest for adventurous, restless spirits.

"Well, Lou, or Brünnhilde, or whatever your name is, what do you intend to do now?"

"I am going to work so hard that my spirit will be completely broken, and I am going to be a very fine dancer," she answered, trying to look as if she saw visions. "I have a magnificent contract in a magnificent casino on the Côte d'Azur, and I am now on my way to work and make money magnificently."

Thinking that those were excellent defense plans that would never be carried out because of lack of attack, I made no comment. Neither could I think of anything appropriate to say later when somebody told me critically that just in the middle of a big success, when Lou was making an unprecedented hit, she ran off to China with a tall blond Englishman. Now, I believe, they have a beautiful baby almost big enough to eat carrot soup from a spoon.

A MILLIONAIRE'S GIRL

◇

Twilights were wonderful just after the war. They hung above New York like indigo wash, forming themselves from asphalt dust and sooty shadows under the cornices and limp gusts of air exhaled from closing windows, to hang above the streets with all the mystery of white fog rising off a swamp. The faraway lights from buildings high in the sky burned hazily through the blue, like golden objects lost in deep grass, and the noise of hurrying streets took on that hushed quality of many footfalls in a huge stone square. Through the gloom people went to tea. On all the corners around the Plaza Hotel, girls in short squirrel coats and long flowing skirts and hats like babies' velvet bathtubs waited for the changing traffic to be suctioned up by the revolving doors of the fashionable grill. Under the scalloped portico of the Ritz, girls in short ermine coats and fluffy, swirling dresses and hats the size of manhole covers passed from the nickel glitter of traffic to the crystal glitter of the lobby.

In front of the Lorraine and the St. Regis, and swarming about the mad-hatter doorman under the warm orange lights of the Biltmore façade, were hundreds of girls with marcel waves, with colored shoes and orchids, girls with pretty faces, dangling powder boxes and bracelets and lank young men from their wrists—all on their way to tea. At that time, tea was a public levee. There were tea personalities—young leaders who, though having no claim to any particular social or artistic distinction, swung after them long strings of contemporary silhouettes like a game of crack-the-whip. Under the somber, ironic parrots of the Biltmore the halo of golden bobs absorbed the light from heavy chandeliers, dark heads lost themselves in corner shadows, leaving only the rim of young faces against the winter windows—all of them scurrying along the trail of one or two dynamic youngsters.

First appeared in *The Saturday Evening Post,* May 7, 1930. Published as by F. Scott Fitzgerald, but written by Zelda. Previously collected in *Bits of Paradise* (1973).

Caroline was one of those. She was then about sixteen, and dressed herself always in black dresses—dozens of them—falling away from her slim, perfect body like strips of clay from a sculptor's thumb. She had invented a new way to dance, shaking her head from side to side in dreamy, tentative emphasis and picking her feet up quickly off the floor. It would have made you notice her, even if she hadn't had that lovely bacchanalian face to turn and nod and turn away into the smoky walls. I watched her for ages before I asked who she was. There was a sense of adventure in the way her high heels sat so precisely in the center of the backs of her long silk legs, and a sense of drama in her conical eyebrows, and she was much too young to have learned such complete self-possession in any legitimate way.

Her story, to date, was short and hysterical—a runaway marriage— annulled immediately—a year in small parts on the New York stage, and the scandalous journalism that followed that affair of Brooklyn Bridge. It must have demanded a good bit of vitality to bring all that to the attention of so many people in such a short time, especially since she started out empty-handed, equipped with only the love and despair in her father's vague eyes. He was one of those people who distinguish themselves in an obscure profession, and Caroline was far from considering *Who's Who* an adequate substitute for the Social Register. She was ambitious, she was extravagant, and she was just about the prettiest thing you ever saw. I never could decide whether she was calculating or not. I suppose any young person in a red-flower hat who suddenly, in the midst of an undergraduate hullabaloo, meets the heir to fantastic millions, and who thereupon smiles poetically into his brown eyes, could be called calculating, but Caroline had made the same gestures so many times before without material considerations.

They looked fine together; they were both dusted with soft golden brown like bees' wings, and they were tall, and the color under their skins was apricot, and there was harmony in the way he leaned forward and she leaned back against the red-leather bench. You could see that he was rich and that he liked her, and you could see that she was poor and that she knew he did. That, at their first meeting, was all there was to be seen; though psychics might have found an aura of tragedy whirling above their two young heads even then. They seemed too perfect.

The winter got old and frayed the edges of the palms in the quiet clinking of the Plaza lobby. The steam heat twisted their tips into little brown mustache ends, and people waiting for other people ripped short slits about their lower leaves. Caroline had worn out two big branches since the day she discovered that Barry was not even regular about being

late. It was a nuisance, that; it meant that she had to sit there rigid, being stared at by men without knees, in spats, and bellboys without necks, in billiard-table covers, and clerks without shoulders, in cages, while Barry did something somewhere to one of his automobiles. He had three, so underslung that riding in them was like climbing a mountain in a cable car. They used to go together for mad rides up and down Long Island, or splitting the green of Connecticut hills in the spring; Caroline so lost in the snakeskin cushions that she seemed deflated; Barry steering the monstrous thing as if he were sketching in charcoal, and both of them singing chorus after chorus of monotonous Negro blues.

One late winter Sunday when the glare of the afternoon snow forced the shadows into great banks in the corners of the living room, Caroline and Barry drove out to see us. They came in breathing off a refrigerated crispness of lettuce just off the ice chest; the moisture on the tips of their long-haired furs refracting the hall lights to a purplish halo.

"Hello," she said. "Is this Fitzgerald's roadhouse?"

Her voice was as full of varied emotions as sinking into a soft cold bed after a strenuous day. Over its voluptuous nuances brooded the purring monotone of well-bred New York.

"It is," I affirmed, "and there's cold turkey and asparagus for supper; so come in and get warm while you wait."

Barry sat under the one light in the far end of the long living room, turning over a great pile of phonograph records, and Caroline sat rigid in the pink shadows, both of them so conscious of each other that they gave the impression of two hidden enemies waiting to attack. We listened to the big logs popping in the quiet like wet firecrackers, and to the clinking of the furnace being fixed for the night, and to the sound of a bath running on the second floor. Supper was being laid in the dining room opposite, and an intimate unwarranted friendliness stole into our low monosyllabic conversation. I felt like reciting " 'Twas the night before Christmas" and going to sleep on the rug, when suddenly Barry, from way over there under the light, asked Caroline to marry him. The slow dignity of her acceptance made us realize the seriousness of the affair; there was nothing to do but try to garnish our Sunday scraps into an engagement supper.

They were both absorbed and quiet during the meal, and, not knowing quite what to say, I began thinking of all sorts of things—of Caroline the winter before, in creamy white georgette and a fog of gray squirrel, coming down the steps of a narrow Fifth Avenue mansion, freezing her tears on the clear winter air. It was a debut party, and she had tried crashing too formidable a gate. New York butlers are not hired

for their response to beauty and this one had turned her away decisively. I thought of Barry calling for his mother at an embassy tea in Rome— of Barry, nineteen, elegant, impeccable, preferred of all the mothers of girls whose families chose for them their paths of light. He was spoiled and wild, but since he had probably met Caroline on some sort of jag, that was no reason why there should be any miscomprehension between them on that score. I wondered how he would explain his intimacy with so lovely and scandalous a person to his austere family, and if they would accept Caroline with no matter what explanation he could invent.

That winter to me is a memory of endless telephone calls and of slipping and sliding over the snow between the low white fences of Long Island, which means that we were running around a lot. We met Caroline and Barry in town occasionally, in the aquarium lights of an expensive nightclub or under the glare of a theater portico. People said they were always together and never went out without each other. She was one of the few women I've known who was both fluffy enough and concise enough to look pretty in ermine, and when you saw them stepping together into his huge automobile it made you think of musical comedy principalities or glamorous suppers from Renaissance paintings.

Of course, all the scandal sheets had a dig at them. There were venomous little paragraphs in most of the Broadway oracles, particularly after people found out how strongly his family disapproved. I believe they tried buying her off, and it was something to do with that that precipitated that awful row in Ciro's. As is mostly the case when something dreary happens to you, all their friends seemed to be there that night. It was an absurd place, done with the most pretentious simplicity, so that you saw quite clearly what was happening around you, and, to make matters worse, Caroline and Barry were directly facing the whole room over by the orchestra. First she threw her glass on the floor, then, unwinding her beautiful figure from an enormous napkin, a slim chair-back and a dozen scattering cigarettes, she fixed on Barry a look of such malevolent hatred that the saxophone player blasted a wild siren cry into his silver horn and the maître d'hôtel came hopping up to represent the management. She was utterly furious and kept demanding her car, as if it could be driven straight on to the waxed floor. Barry told them to take her away, as if she'd been something inedible served from the kitchen.

Everybody was delighted with so public and melodramatic a *crise* in a romance that had inspired so much envy. Before they left, even the waiters in the place had gleaned the story of Caroline's foolish accep-

tance of a nice big check and an automobile from Barry's father. She claimed, to Barry, that she had not understood it was to have been the reward for letting him go, and he claimed in no uncertain terms that she was fundamentally, hopelessly, and irreclaimably dishonest. It seems too bad they couldn't have done their claiming at home, because then they might have patched up the mess. But too many people had witnessed the scene for either of them to give in an inch.

Several days later Barry shut the bumpings and thumpings of the embryo delirium tremens that usually follows a complete disillusionment into a golden-oak suite of one of the biggest transatlantic liners, en route for Paris. Two weeks later, as I was bumping along the walnut panelings of a transcontinental express on my way to California, I slipped along the rounded corner and bang into Caroline. I don't know how I had expected to find her, but I was terribly surprised with her air of elegant martyrdom. She was royalty in exile. From the slope of her shoulders to the eloquent inactivity of her hands her whole person cried out, "This is the way I am, and I'm going to stick by it." Now I knew that Caroline had not a bit of that fading-violets, closing-episode note of the minor lyric poet that makes people run from things in her erstwhile personality, and I wondered what determination had sent her scurrying from a world that she knew, but that didn't know her, across a continent to a world that knew her from her escapades, but that she didn't know. It seemed to me an unreasonable exchange. If it was not escape that motivated her, then it must be vengeance, I told myself, and it was all I could do to keep from asking her on the spot.

Thinking of that long ride to California, it does not appear remarkable that people should lose their sense of proportion on the way. The pattern of the tracks at the beginning lies like featherstitching along the borders of a land suggesting the tin scenic effects that are sold with mechanical trains; a green and brown hill, a precipitate tunnel, a brick station too small for the train, an odd gate, a lamppost, and a little lead dog. The first night there is a feeling of accomplishment that you are installed in your apple-green compartment, moving in a phosphorescent line through the red and purple streaks of a Western dark. The dining car glistens with bright new food; the train is still a part of its advertising pamphlets and has not yet settled down to its own dynamic ends. You can still smoke without tasting brass cartridges in the back of your mouth. I didn't see Caroline at first, to victimize her by my curiosity. We were both fascinated by the limitations of life on the train, probably; but later, when even Mr. Harvey's ingenuity could invent no name for

hash-brown potatoes exotic enough to tempt our cindery palates, we sat in mutual lamentation amongst the catsup bottles and vinegar cruets of the diner.

The countryside was changing. The faraway hills did not meet the horizon, and the trees and houses on the green mountainsides seemed on probation. Caroline was suddenly fed up with the quiet reserve that her getting-away-from-it-all manner had imposed upon her and was bursting to talk. She told me she had a part in a movie and was going west to work. In the course of a long conversation I gathered that she was completely determined to distinguish herself and force Barry to realize the enormity of his error in leaving her so precipitately. She talked and talked, fascinating herself with the idea of success, until by the end of the trip I think she never wanted to see me again, so full had she filled me with her hopes and plans. I could see her changing personalities behind the first onrush of people in the Los Angeles station, marking herself with the silent wary confidence so necessary in a world of competitive struggle.

We found ourselves at the same hotel. About the central mass there lay shimmering in the rarefied sun low lines of bungalows like the tentacles of a sea monster crystallizing itself in the humid heat. Grass like wet paint covered the gushing squares of earth between the cement paths in the court, and from one doorway to another white rose vines stretched and aspired along a trellising of flaky zinc pipes. Caroline's rooms were opposite mine, and I could tell by the number of waiters who were always scurrying in and out that she was auspiciously launched in her new milieu. I had to pass her door on my way in, and there was always a paper envelope hanging on her knob, bulging with telephone messages. More and more often there were yellow roses under the yellow curtains at her window. I knew which director preferred yellow roses and referred to them, amusingly, as "radishes."

Sometimes I burrowed my way through the candy stores and barbershops and glass cases filled with the curlicues of Oriental art to the great supper room of the hotel. There, in the brightly lit darkness of an artificial Hawaii, was always Caroline, sitting, listening, elegant and fragile, *connaisseuse* of perfumes and parades. People knew her by name; her career was getting under way. She drank little and spent the mornings having herself pummeled and pounded into a nervously receptive state that was, for film purposes, the equivalent of dramatic ability. She learned to accentuate a slight defect in her lovely face with heavy makeup, so that her wide cheekbones gave her a Tatar look under the creamy powder. She learned to be distrait and aloof and passed those

two qualities off as sophistication and disillusionment. Hollywood was captivated. I'd been out there about two months when I heard that Caroline was not able to work and was holding up a costly production with uncontrolled flares of nerves. I concluded she was about to get fired, so I ran to stick my finger in the pie. I persuaded her to drive to the sea with me.

I don't know what there is about California that makes it seem so inland. I suppose it's that sparse attempt to enclose so much space with two orange trees and an oil well. Anyway, I felt that it would do her good to escape that feeling of being in a vacuum that the wide-spaced city gives me, and she had never seen the Pacific, so we hired an open car and became part of an unbroken line of automobiles weaving along under the vast sky, like an invasion of beetles, toward Long Beach. She was hardly interested in the flatness of a country that was bright like a dirty mirror from its lack of color in the sun, and I could see that the chauffeur's fast driving made her nervous. Having wrecked my own nerves years ago, I like advising other people about their own.

"You're going too hard," I told her, "and if you keep on living at such tension that you can't sit in an automobile without grabbing the sides you won't last long at your work." The sun curved along her high cheekbones and dug a white triangle under her lifted chin. A big bunch of pink sweet peas tattered themselves against the brim of her white felt hat in the wind and blew against her shining face as she turned and cheerfully agreed with me that she would probably collapse before long.

"But it isn't the work," she said enigmatically.

"Oh, gosh," I thought, "she's going to start proving she's right again."

We had luncheon in a dingy dining room facing a brick wall, with pictures of the ocean painted about the ceiling. There was nowhere else in Long Beach on the sea to have luncheon, since nonalcoholic races are too suspicious of reality to face even the ocean. We both tried temporizing with a soggy shrimp cocktail. Caroline leaned over the table and asked me suddenly for news of New York in such an apologetic, eager way that I sensed what she really wanted to talk about. It was Barry. People had, naturally, avoided the subject with her, I suppose, and I was feeling complacent enough to say what she wanted.

"Aren't you over that yet?" I asked.

She smiled with detached desperation.

"Oh, yes, of course, but I hate to lose touch with him," she answered. "Ever since I met him everything I do or that happens to me has seemed because of him. Now I am going to make a hit so that I can choose him

again, because I'm going to have him somehow. I wanted to say that to somebody, so I'd have to do it. I'm sorry to spoil your ride, but it's made me able to go back to work again. You see, I haven't any friends," she finished simply.

When she left me at the door of her bungalow that night so much sadness sank into the shadows about her eyes and so much unsurety sounded in her footfalls along the cement steps that a surge of hatred swept over me against trim seaside hotels, and even old Balboa, and the East and the West and love affairs. As she climbed the stairs the heels of her slippers echoed as if the shoes were empty. I spectrally crossed over the fog to my own door.

Next day it began to rain in California, much against the better judgment of the most influential citizens—not just ordinary rain the way it rains in other places, but great brown bulks of water flowing down the gutters like hot molasses candy. At the bottom of hills where two streets met, the water came up to the running boards of automobiles. It seethed through umbrellas in a fine spray and covered the sidewalks with slippery mud deltas. If the sun came out for a minute the air steamed with hot vapor and the sodden cushions of grass smoked under its discouraged rays. Naturally, going about was unpleasant, so I spent most of my time in my room, washing down quantities of spring onions and alligator pears with California Bordeaux. When I traveled the flood again Caroline's picture was finished and March was powdering the air with spring dust. I had heard talk about the film; apparently she came off with flying colors. The director had been so pleased with her work that, with the final assembling of the picture, her part had grown to star proportions, and there was nothing between her and a successful career. I was pleased that she was glad to see me again and that she gave me seats to the opening. It was surprising that such a prospect hadn't erased that distant distress in her eyes but had only superimposed an air of excitement on the placidity of her lovely white features.

A Hollywood opening night is a fairy-tale affair. A street is flooded with blue-white diamond light that glints over the trees and lies like mica over their foliage and along their trunks. There are festoons of ordinary lights like strings of golden oranges swung from pole to pole in the ether whiteness, and all is broken into a million cones and triangles by the headlights of hundreds of automobiles. The shadows fall short about their objects—thick gluey puddles under the cars and people. A red carpet bridges the pavement between automobiles and the theater door, and grinding cameras envelop the arriving celebrities. A gigantic megaphone cries out famous names to the crowd waiting on

the edge of the light, and they, in turn, respond with loud applause or rustling silence—a sort of trial by fire. Fine, uncharitable ladies in silver shoes and ermine may be greeted with protesting murmurs from under the trees, and gay young girls in coral velvet that people know have helped their kind may start the clatter of many hands swelling from far around the corner, in the approval of a public that considers itself humanitarian.

There is no expectancy in the air; it is the dumb hero worship of fans gathered in the gloom like medieval serfs awaiting a conquering baron that dominates the atmosphere—that and the shining assurance that insecure people must assume in places of authority. I had never been to an opening before, so I stood for an hour watching from across the way. It was like an elegant feminine circus breaking ground. I wanted terribly to see Caroline come in. It was her night, and I knew she would have something amusing to contribute—some little unpretentious trick of pinning her flowers in an unexpected corner, of forcing her hair to interrogative angles, of wearing some funny thing like a dagger, or a tiny bell at the side of her slippers—but the line of cars moved faster and faster before the door and the cheaper cars were making their appearance, so I knew I'd be late if I didn't go inside.

The picture was fine. Caroline's beautiful biblical eyes dimmed and shone over teacups and decanters and through the spray of shower baths and dominated the mists of a good art director. I felt a secret jealousy of such assured success. I came outside in the entr'acte to see if I could find her in the crowded lobby. She was nowhere around, and feeling rather gloomy at being alone among so many people using so many adjectives, I went along bareheaded through the moist spring air to the corner drugstore. It was like all drugstores—gift cases of perfume and powder, writing paper and books, round tables of incense burners and picture frames and all the things you couldn't imagine buying in a drugstore—and I don't know why that sudden sense of disaster came over me. I felt as if I were in an exiled and floating world, isolated from all necessities of life except the one of buying things. To bring myself back to reality I went to the cigar counter and chose the late edition of an evening paper. On the front page was a big picture of Barry and his fiancée, telegraphed from Paris. HEIRS OF TWO GREAT FORTUNES TO HAVE QUIET CEREMONY. I was glad Caroline had made such a killing in the film and I wondered if she'd mind much when she saw those blaring headlines.

The picture was thoroughly amusing. There was always that horizon quality in her eyes, and nobody ever had a more symmetrical body to

help her to stardom, or one that she could work so well. It was like a splendid mechanical installation in its trim, impersonal fitness. Toward the end she surprised me with an intensely moving scene—some sort of stuff about two young lovers being separated by a misunderstanding. The audience was moved and would have been even more affected, I think, except for the violent clanging of an ambulance bell, jarring throughout the quiet of a pathetic episode. It was a pity; it took half the value away from the scene.

Next morning I hurried out for all the papers, from a malicious curiosity to see whether Caroline or Barry would have the choicest space. She won, hands down. The dramatic columns were full of laudatory accounts of the film, obviously written the night before; and the front pages were full of last-minute headlines and two-column stories of her attempted suicide on the night of her successful debut. The sob sisters made a very dramatic episode out of her clanging past the theater in an ambulance on the opening night.

Two weeks later, when she was well enough to receive visitors, I called at the hospital to see her. I almost had to engage a room for myself when I ran into Barry. For he was there, very solicitous and proprietary, and you'd never have guessed from his manner that he was responsible for her half death or half responsible for her death, so I didn't stay long. I left, pondering all the way back to town over the wonders that long-distance telephones and a dramatic sense can accomplish when brought in close proximity. One of those friends that Caroline disclaimed must have called up Paris for her.

She married him, of course, and since she left the films on that occasion, they have both had much to reproach each other for. That was three years ago, and so far they have kept their quarrels out of the divorce courts, but I somehow think you can't go on forever protecting quarrels, and that romances born in violence and suspicion will end themselves on the same note; though, of course, I am a cynical person and, perhaps, no competent judge of idyllic young love affairs.

POOR WORKING GIRL

◇

Eloise Everette Elkins stood on a dilapidated pair of wooden steps that belonged to a faded frame house with rain-colored trimmings. Eloise and the house were standing in the middle of a community that had of recent years grown very prosperous and so outgrown the capabilities of its older inhabitants. This was why all the good jobs in town were held by imported young men, who in turn imported their sweethearts from large neighboring cities and felt no necessity to know Eloise socially. And that was why all the boys whom she could have married were inadequate for marrying purposes and spent their lives limping along on a salary that she thought she could have earned herself. Industries, when they get started, grow faster than men or towns and do not allow the time for lying fallow which people seem to need when they have always lived in close proximity to cultivated fields.

Eloise was twenty and carefully protected but unprovided for. Her two aunts and her grandmother nagged her quite a bit about her laziness, but there wasn't really much that she could do. Mamma and Father had seen to it that she had an education in a college for girls downstate, and nature had done well by the storehouse for all this knowledge. It must have been quite a strain for so Anglo-Saxon and flawless a skin to contain the verse and choruses of all the popular songs for five years back, together with a real talent for the ukulele, a technical knowledge of football, ten poetic declamations and a lyric taste in dress. Eloise knew shorthand, too, but she fumbled about in it and was pleased with herself when it worked, like a famous person making a speech in a foreign language. She knew how to get breakfast if the stove was electric and not overpoweringly large and if things could be cooked one at a time.

First appeared in *College Humor,* January 1931. Published as by F. Scott and Zelda Fitzgerald, but written by Zelda. Previously published in *Bits of Paradise* (1973).

Her eyes were so clear that you could see right through to the mechanics of them, and she was altogether remarkably pretty and new looking even for an American girl of her age. She had twelve-year-old legs, like Mary Pickford's, that were intriguing when they grew out of those square rubber bottom shoes which give strangers the idea that we are a sturdy race, but these same little girl legs had too much curve on the outside when she put on the tall heeled silver slippers which go with tulle and taffeta.

Anyway, she poked them out in front of her this morning and sat down on the third step because it had less splinters along the worn edge and wouldn't send runs climbing along the back seams of her stockings, which shows that she had it in her to be more painstaking than she was. She opened *Every Evening* from yesterday. She had decided to go to work and she was looking for the want ads. She read with mingled suspicion, fear, and personal interest about all the people who wanted chocolate dippers and part-time maids and people to make fortunes selling unnamed things that sounded secret and complicated. Eloise knew she could *never* sell *anything,* and her light eyes moved lazily on down the column. Then she found a neat little square with all the dignity of a calling card, which announced tersely and dramatically that Mr. and Mrs. Goatbeck were looking for Eloise.

It seemed that they had a very refined child in a refined but isolated home with nobody refined to play with, so that Eloise could earn seventy-five dollars a month for just being natural and keeping a little girl from running over automobiles. She thought of all the refinement to be bought with seventy-five dollars: the twenty-five-dollar dresses and the ten-dollar perfume. Then she multiplied by four and five and thought of New York and Broadway. That brought her around after a while to thinking of the night after the commencement play when the college president himself had told her what a real dramatic gift she had.

All that ambitious thinking made it much easier for Eloise to contribute the outstanding excitement of months to the family dinner table. Over the sweet potatoes and meat pie and muffins wavered the announcement that she was going to leave home. Even when she was "in college" she had always slept at home and so it was not hard to understand why Mamma pictured Eloise in a strange land with a strange disease, somewhat like pneumonia only much more painful, and with nobody to look after her. There was indignation in Mamma's mental picture. It somehow included the law and all the hygienic societies and the pound. Father didn't see why girls didn't stay at home, but he had

his own worries and he made it a rule never to complain until afterwards.

The aunts thought that serious employment would be fine for Eloise. She had always helped them with their children and she could save her money and it wasn't as if there weren't telephones, so finally all was agreed upon. When everybody had got all he could of his own righteousness out of the situation, she set out with her semi-fiancé in his secondhand car to interview the Goatbecks.

Eloise had been half engaged for four years now to numerous editions of the same young man. He always had a secondhand car, a fur coat, that irregular cast of feature known as an open countenance, and a gold football on his watch chain. Having him waiting outside in his long gray car while she went in to her interview reinforced her in a feeling of reduced circumstances. So many young Americans have that feeling as their sole equipment for meeting reality: the sense of being in circumstances reduced from the dreams and pamperings of parents still guided by the wisdom of an epoch when the mere fact of children to run the farm was an asset; reduced circumstances with its half whine and its fierce swallowed pride which robs the children of the old Americans of the clarity so necessary to success, and which inevitably nourishes the sulkiness that follows the first failure.

But it is a feeling that goes very well with taking care of refined offspring. Eloise told the lady humbly how she had to work and how she loved children, and the lady told Eloise that she was much too pretty to bury herself in a nursery. Eloise liked that idea and felt pleased and bravely sorry for herself. She made up her mind to be perfect and to live up to her reduced circumstances in all things.

When she started out for home again with the young man, she felt positively married to him. He had seen her ask for a job. They had gone through an overwhelming adventure together. As she put her arm under his on the steering wheel everything seemed changed to her, as if she'd already worked at her job, at all jobs, and now wanted to settle down with the fur coat and the football and cook breakfast on a ukulele for the rest of her life.

If you asked Eloise what happened for the next six months, she would say she worked and worked and got so nervous that life didn't seem worth living. If you asked Mrs. Goatbeck she would say that Eloise didn't keep her shoes in a row and that providence alone protected her refined child from a series of accidents.

But Eloise stuck to her job and did her best when she hadn't been up

too late the night before, and it really looked as though all her reading of dramatic school prospectuses might help her formulate a future after all. She was gravely saving money to study in New York.

But then spring came right in the middle of things, as it always does, and the manufacturers flooded the showcases with shoes for tramping golf courses, and the smell of chocolate began to seep through the more open doors of drugstores, and music from the phonographs in the ten-cent stores became audible above the noise of the trolleys, and Eloise succumbed.

The first thing she bought was a tan coat much too thin to wear until it would be too hot to wear it. To make up for that, she wrote for more dramatic school prospectuses and wore the coat anyway, so she got the grippe. After that she had an awful attack of loneliness on account of having been in bed, and spent a lot of her money on some blue things with feathers and something green with pink hanging off. And there was a little rounded hat that was too old for her and another one that she wore on one side so it looked like the rings around Saturn on her head. Self-expression, that was, and it runs expensive. But she told the lady that she was going to save every cent of her money for the next three months and go to New York in the summer.

The self-expression served one purpose: it renewed her confidence in college presidents as dramatic critics and, just for good measure, attached some new young men to Eloise—one with a face as open as a cracked safe, and one who recited *The Ladies* to Eloise.

Finally, she felt so sure that she was going to save enough money to keep her safely in New York while she studied that she went home to consult her family about it. Father's idea of the stage was founded on the stereopticon slides of 1890, and Mamma's was positively biblical. You would have thought Morris Gest wanted to produce *The Miracle* in the front parlor! Eloise drew courage from all the gold footballs and signed photographs in her bureau drawer and went back to work in such a dynamic frame of mind that the refined child learned two multiplication tables in a day. Nothing remained but to save her salary.

Long days went by. In the mornings there were lessons, a correspondence course for children which gave Eloise a sort of missionary pleasure. The half hour of mythology she especially liked. To hear the labyrinthine Greek names twisting the tongue of the child always left her with a feeling that life was perhaps a bizarre affair after all.

Eloise had grown quite fond of her charge, so fond of her that she could forget her entirely on the long afternoon walks in the country and project herself into a dream that consisted of all the hazy, unsolved

things of the past and an unresolved future state—not rosy nor misty nor anything definite, but just a flooding of a gentle light, as a blind person must feel when he finds himself in a pale spring sun.

At night there was the bath hour and several choruses of "What's the Use?" and then, often, when the family wasn't going out, there were the movies or dancing at the local hotel with her current beau. Eloise loved ice cream. It was extraordinary how her skin stayed like that with her eating it on top of pie and under cake and around bananas, and disguised as stews and soups and puddings. But it was certainly not a taste for simplicity that made her enjoy so many simple things.

Now spring came in earnest and America began to look like the inside of a small boy's pocket to Mr. and Mrs. Goatbeck. The migratory instinct settled over the house until the suburban stillness teemed like flies in a bottle. Eloise went out more and more at night, so by the time the air began to melt and settle and touch the earth as capriciously as falling toy balloons, her ambition fell away to the same tempo. In spite of her determination to finish her job well, now that the Goatbecks had decided to go abroad, her lapses began to catch up with each other so that soon she was floundering about in a void of things-not-done, with the child following after like an inquisitive puppy sniffing at the unusual.

The row came when there were only four days more to go. There were recriminations on the stairway and nonchalance in the day nursery and tears in the hallways, and finally cryptic telephone calls in a deeply injured tone of voice. It seems the cupboards weren't in order and the child had no clean socks and there was eight dollars' worth of telephoning to numbers unknown to the Goatbecks—a formidable list of misdemeanors. Eloise tried awfully hard to care (she admitted to Mrs. Goatbeck that she hadn't been doing her duty lately), but it was too near the end for that, so she left one afternoon in a battleship gray secondhand car, with all her photographs and dance cards and some letters that Mr. Goatbeck had given her to theatrical managers in New York—enough letters to get her into forty choruses and a house of correction.

But to Eloise, all motivating power was of divine origin and people waited for its coming like a prisoner for a trial, with the expectation of release or a sense of black misgiving. Both these sensations were merged in her when she found herself at home again. She couldn't decide whether or not she was as wonderful as she thought she was, and New York seemed awfully far from the yellow frame house full of the sweetness of big Sunday meals and the noise of the cleaning in the mornings and black shadows from an open fire.

New York seemed so far away that it was a full three months before Eloise stretched out her rubber soled shoes and let herself gently down into a patch of sunshine on the third step. Then she opened *Every Evening* and once again began on the want ads.

When the Goatbeck family came back months later, she was working in the capacity of pretty girl in the local power plant. All the secondhand automobiles that waited out front at five-thirty added quite a lot to the traffic congestion around that quarter.

The refined child saw her one day in a theater lobby; she didn't remember her fair flaxen skin and eyes like transparent pearls, though she remembered several governesses she had before Miss Elkins. The blood in Eloise's veins had worn itself out pumping against the apathy of weary generations of farmers and little lawyers and doctors and a mayor, and she couldn't really imagine achieving anything. She came from our worn-out stock. But perhaps there are lovely faces whose real place is in the power company; perhaps Eloise wasn't destined for Broadway after all.

MISS ELLA

◇

Bitter things dried behind the eyes of Miss Ella like garlic on a string before an open fire. The acrid fumes of sweet memories had gradually reddened their rims until at times they shone like the used places in copper saucepans. Withal she was not a kitchen sort of person, nor even a person whom life had found much use in preserving. She was elegant, looking exactly like one of the ladies in a two-tone print on the top of a fancy glove box. Her red hair stuck out of a choir cap on Sundays in a tentative attempt to color the etching of her personality.

When I was young I loved Miss Ella. Her fine high instep curved into her white canvas shoes in summer with the voluptuous smoothness of a winter snowbank. She had a lace parasol and was so full of birdlike animation that she teetered on her feet when she spoke to you—sometimes she had meals with us and I remember her twittering about on our hearth after supper, dodging the popping bits of blue flame from our bituminous coal, believing ardently that "one" could keep fit by standing up twenty minutes after eating.

All the people in the world who were not her blood relations were impersonally "one" to Miss Ella. She was severe with the world and had she ordered the universe she would have kept it at runners' tension toeing the chalk starting mark forever. I don't know which would have upset her equanimity more: the materialization of a race or the realization that there wasn't going to be any. In any case, "one" must keep fit for all problematical developments.

Even her moments of relaxation were arduous, so much so as to provoke her few outbursts of very feminine temper and considerable nervous agitation. She was essentially Victorian. Passing along the sidewalk in the heat of the afternoon and seeing Miss Ella far away in her hammock in the shade of the big elms by the house, her white skirt

First appeared in *Scribner's Magazine*, December 1931. Previously collected in *Bits of Paradise* (1973).

343

dusting a white flutter off the snowball bushes as she rocked herself
back and forth, you would never have guessed how uncomfortable she
was or how intensely she disliked hammocks. It always took at least
three tries before she was tolerably ensconced: the first invariably loos-
ened the big silver buckle that held her white-duck skirt in place; the
second was wasted because it might result in immodest exposure of her
fragile legs, by furling too tightly around her the white canvas lengths.
After that she simply climbed into the hammock and did her arranging
afterwards, which is about as easy as dressing in a Pullman berth. The
hammock fanned its red and yellow fringe in a triumphant crescent
motion that discomfited Miss Ella. By holding tightly to the strings at
one end and desperately straining her foot against the worn patch of
clay in the grass underneath, she managed to preserve a more or less
static position. With her free hand she opened letters and held her book
and brushed away things that fell from the trees and scratched the itch-
ings that always commence when stillness is imperative.

These were Miss Ella's hours of daytime rest. She never allowed
herself to be disturbed until the sun had got well to the west and down
behind the big house, its last light pulsing through the square hallways
in the back windows and out the front, vivisected by the cold iron tra-
cery of the upstairs balcony, to fall in shimmering splinters on the ba-
nana shrubs below. At five a decisive old lady rolled up the drive in a
delicate carriage, high and springy, with a beige parasol top. Her hair
was snow-white and her face was white and pink with antebellum cos-
metics. Even from far away they emanated the pleasant smell of orris
root and iris. She held the reins absentmindedly in one hand, the big
diamonds in their old-fashioned settings poking up through her beige
silk gloves. Her other arm made a formal, impersonal nest for a pow-
dered spitz. When she called to Miss Ella the words slid along the sun
rays with the sound of a softly drawn curtain on brass rings. "Ella! It's
time to cool off, my child. The dust is settled by now. And oh, Ella, be
a good girl and find Aunt Ella's fan, will you?"

So Miss Ella and Aunt Ella and the white dog went for their afternoon
drive, leaving the sweet cool of the old garden to the aromatic shrubs,
the fireflies, and the spiders who made their webs in the boxwood, to
the locusts tuning the air for night vibrations and to three romantic
children who waited every day for the carriage to roll out of sight before
scaling the highest bit of wall that surrounded the grounds.

We loved that garden. Under two mulberry trees where the earth was
slippery beneath our bare feet there stood a wooden playhouse, relic of

Miss Ella's youth. To me it never seemed an actual playhouse but to represent the houses associated with childhood in homely stories; it was in my imagination the little red schoolhouse, the farmhouse, the kindly orphan asylum, literary locales that never materialized in my own life. I never went inside but once, because of a horror of the fat summer worms that fell squashing from the mulberry trees. It was dry and dusty, scattered traces of a frieze of apple blossoms still sticking to the walls where Miss Ella had pasted them long ago.

No one but us ever went near the playhouse, not even the grand-nieces of Aunt Ella when they came occasionally to visit. Almost buried in a tangle of jonquils and hyacinths dried brown from the summer heat, its roof strewn with the bruised purple bells of a hibiscus overhanging its tiny gables, the house stood like a forgotten sarcophagus, guarding with the reticent dignity that lies in all abandoned things a paintless, rusty shotgun. Here was a rough oasis apart from the rest of the orderly garden. From out of the delicate concision there foamed and billowed feathery shell-colored bushes that effervesced in the spring like a strawberry soda; there were round beds of elephant's ears with leaves that held the water after a rain and changed it to silver balls of mercury running over the flat surface. There were pink storm lilies on their rubbery stems, and snowdrops, and shrubs with bottle-green leaves that ripped like stitching when you tore them. Japonicas dropped brown flowers into the damp about the steps of the square, somber house, and wistaria vines leaned in heavy plaits against the square columns. In the early morning Miss Ella came with a flat Mexican basket and picked the freshest flowers for the church. She said she tended the garden, but it was really Time and a Negro contemporary of his who did that. In front of the kitchen door, the old black man had a star-shaped bed of giant yellow cannas covered with brown spots and in a crescent were purple pansies. He scolded appallingly when he caught us on the grounds: he was most proprietary about the place and guarded the playhouse like some cherished shrine.

That was the atmosphere that enveloped the life of Miss Ella. Nobody knew why she found it sufficient; why she did not follow the path of the doctor's coupé that divided its time between the downtown club and the curb in front of her shadowy lawn. The reason was Miss Ella's story, which like all women's stories was a love story and like most love stories took place in the past. Love is for most people as elusive as the jam in *Alice in Wonderland*—jam yesterday, jam tomorrow, but no jam today. Anyhow, that was how it was with Miss Ella, living titularly on

the jam of some time ago, skimming over life's emotions like a bird flying low over the water detaching bright sprays into the air with its wings.

In her youth she was as slim and smooth as a figure in blown glass. Compact in long organdies that buoyed themselves out on the bars of a waltz, she stood firm in the angular aloof arm of her fiancé.

He pyramided above her, two deep lines from the corners of his eyes, his mouth closed tight over many unuttered words, a deep triangle about the bridge of his nose. In the autumn he stood for hours up to his knees in the greasy backwash from the river, the long barrel of his gun trained skyward on wide files of green-backed ducks flying south over the marshes. He brought his loot to Miss Ella in bunches and she had them cooked in her white-pine kitchen, steeped in port and bitters and orange peel, till the brown delicious odor warmed the whole house. They sat together over an enormous table, eating shyly in the dim rings of light that splattered the silver and crept softly over the heavy frames of the dark still lifes that lined the wall. They were formally in love. There was a passive dignity in the currents that passed between them that quieted the air like a summer Sunday morning. The enveloping consideration of him, the luminous fragility of her, they made a harmonious pair.

In those days the town was small, and elegant ladies agitated their rockers with pleasure back of boxwood gardens as Miss Ella and her beau whipped past in his springy carriage, the light pouring over the polished spokes of the wheels like the flowing glint of water over a mill.

He called her "dear"; she never called him anything but Mr. Hendrix. In the soft chasm of the old hall after a late party, he reverently held her hands, hands filled with a dance card, a butterfly pin, a doll in feathers, trinkets of the dance, souvenirs of dreamy rhythms that wavered in her head with the fluctuations of watered silk propelled by the warmth of quiet happiness. They poured the plans for their life together into the molds of the thick tree shadows and turned them out on the midnight air marked with the delicate tracings of the leaves—modest stable plans of two in love. He told her how things were to be, and she acquiesced, pleased with his quiet voice piling up in midair like smoke in an airless room.

They were both religious to a fashionable restrained extent, and it was the church which drew Andy Bronson across the strings of their devotion, to saw them and haggle them and finally leave the broken ends twisting upward, frayed and ruined, dangling loose in tragedy with

the resonance of twisted catgut. Miss Ella and Mr. Hendrix planned to be married in the square white church in the spring. Entering from the back where the iron banisters led to the balcony, they planned to walk in solemnity through the misty gusts of face powder, the green smell of lilies, the holiness of candles, to barter with God at the altar; toil and amiability for emotional sanctity. He said that there would be beauty and peace forever after and she said "Yes."

Sorting their dreams absentmindedly, like putting clean linen in a cupboard, they stood side by side dreaming of that at Christmastime. A church festival was going on and there were eggnog and lemonade and silver cake baskets filled with sliced fruitcake and bonbonnières of nuts and candy in the Sunday school room. The church was hot, and young men drifted out and in again, bringing with them the odor of overcoats and cigarettes smoked in the cold, and fumes of bourbon. There in the smoky feminine confusion stood Andy Bronson, the excitement of Christmas hanging bright wreaths about his cheekbones, a mysterious quiet certitude proclaiming nefarious motives.

Miss Ella was conscious of him in a still world beyond reality, even as she talked with animation of all the years that would churn behind the honeymoon boat that plied between Savannah and New York. From that tremulous duality she shivered into the confusion that followed the bang of the giant firecracker that Andy had lit beneath the steps that led to the balcony. A spark caught in her flimsy Dolly Varden and Ella's dress was in flames. Through the slow split groups laughing, disapproving, explaining, not knowing what had happened, Andy was the first to reach her burning skirts, clapping the blaze between his palms until only a black, charred fringe was left.

The day after Christmas, hid in an enormous box of roses so deep in red and remorse that their petals shone like the purple wings of an insect, he sent her yards and yards of silk from Persia, and then he sent her ivory beads, a fan with Dresden ladies swinging between mother-of-pearl sticks, a Phi Beta Kappa key, an exquisite miniature of himself when his face was smaller than his great soft eyes—treasures. Finally he brought her a star sapphire (which she tied about her neck in a chamois bag lest Mr. Hendrix should know) and she loved him with desperate suppression. One night he kissed her far into the pink behind her ears and she folded herself in his arms, a flag without a breeze about its staff.

For weeks she could not tell Mr. Hendrix, saving and perfecting dramatically the scene she hopefully dreaded. When she did tell him, his

eyes swung back in his head with the distant pendulousness of a sea captain's. Looking over her small head through far horizons with the infinite sadness of a general surrendering his sword, finding no words or thoughts with which to fill her expectant pathos, he turned and slowly rolled the delicate air of early spring down the gravel path before him and out into the open road. Afterwards he came to call one Sunday and sat stiffly in a bulbous mahogany chair, gulping a frosted mint julep. The depression about him made holes in the air, and Miss Ella was glad when he left her free to laugh again.

The southern spring passed, the violets and the yellow-white pear trees and the jonquils and cape jasmine gave up their tenderness to the deep green lullaby of early May. Ella and Andy were being married that afternoon in her long living room framed by the velvet portieres and Empire mirrors encasing the aroma of lives long past. The house had been cleaned and polished, and shadows and memories each put in their proper place. The bride cake nested on southern smilax in the dining room and decanters of port studded the long sideboard mirrors with garnets. Between the parlor and the dining room calla lilies and baby's-breath climbed about a white tulle trellis and came to a flowery end on either side of the improvised altar.

Upstairs, Miss Ella was deep in the cedar and lavender of a new trunk; fine linen nightgowns and drawnwork chemises were lifted preciously into the corners and little silk puffs of sachet perched tentatively over the newness. A Negress enamored of the confusion stood in the window drinking in the disorder from behind dotted swiss curtains, looking this way and that, stirring the trees with the excitement of her big black eyes and quieting the room with the peace they stole from the garden.

Miss Ella heard the curtains rip as the strong black hands tore them from the fragile pole. "O Lawd—O Lawd—O Lawd." She lay in a heap of fright. By the time Ella reached the heavy mass, the woman could only gesticulate toward the window and hide her face. Ella rushed to the window in terror.

The bushes swished softly in the warmth. On the left there was nothing remarkable: a carriage crawling away far down the road, and plants growing in quiet now that their flowers were shed. Reassurance of the coming summer pushed her leaping heart back into place. Ella looked across the drive. There on the playhouse steps lay Mr. Hendrix, his brains falling over the earth in a bloody mess. His hands were clinched firmly about his old shotgun, and he as dead as a doornail.

Years passed but Miss Ella had no more hope for love. She fixed her

hair more lightly about her head and every year her white skirts and peekaboo waists were more stiffly starched. She drove with Auntie Ella in the afternoons, took an interest in the tiny church, and all the time the rims about her eyes grew redder and redder, like those of a person leaning over a hot fire, but she was not a kitchen sort of person, withal.

THE CONTINENTAL ANGLE

◇

Gastronomic delight and sartorial pleasure radiated from the two people. They sat at a table on a polished dais under a canopy of horse chestnuts eating of the fresh noon sunlight which turned the long, yellow bars of their asparagus to a chromatic xylophone. The hot, acrid sauce and the spring air disputed and wept together, Tweedledum and Tweedledee, over the June down that floated here and there before their vision like frayed places in a tapestry.

"Do you remember," she said, "the Ducoed chairs of Southern tearooms and the leftover look of the Sunday gingerbread that goes with a dollar dinner, the mustardy linen and the waiters' spotted dinner coats of a Broadway chophouse, the smell of a mayonnaise you get with a meal in the shopping district, the pools of blue milk like artificial opals on a drugstore counter, the safe, plebeian intimacy of chocolate on the air, and the greasy smell of whipped cream in a sandwich emporium? There's the sterility of upper Broadway with the pancakes at Childs drowned in the pale hospital light, and Swiss restaurants with walls like a merry-go-round backdrop, and Italian restaurants latticed like the lacing of a small and pompous Balkan officer, and green peppers curling like garter snakes in marshy hors d'oeuvre compartments, and piles of spaghetti like the sweepings from a dance hall under the red lights and paper flowers."

"Yes," he said, but with nostalgia, "and there are strips of bacon curling over the country sausage in the luminous filterings from the princely windows of the Plaza, and honeydew melon with just a whiff of lemon from narrow red benches that balustrade Park Avenue restaurants, and there's the impersonal masculinity of lunch at the Chatham, the diplomacy of dinner at the St. Regis; there are strawberries in winter

First appeared in *The New Yorker*, June 4, 1932. Previously collected in *Bits of Paradise* (1973).

on buffets that rise like fountains in places named Versailles and Trianon and Fontainebleau, and caviar in blocks of ice."

"If you eat late on Sunday at the Lafayette," she continued blandly, "the tables are covered with coffee cups and the deep windows let in the wheezing asphalt and you look over boxes of faded artificial flowers onto the tables where people have eaten conversation and dumped their ashes in their saucers while they talked, and at the Brevoort men with much to think about have eaten steak, thick, chewing like a person's footfalls in a heavily padded corridor. In all the basements where old English signs hang over the stairs, years ago they buried puddings, whereas if you have the energy to climb a flight of stairs, there are motherly nests of salad and perhaps something Hawaiian."

"Ah, and at Delmonico's there were meals with the flavor of a trans-atlantic liner," he said; "at Hicks there are illustration salads, gleaming, tumbling over the plate like a raja's jewels, cream cheese and alligator pear and cherries floating about like balls on a Christmas tree. And *filet de sole* paves the Fifties, and shrimp cobbles Broadway, and grapefruits roll about the roof and turn roof gardens to celestial bowling alleys. There is cold salmon with the elegance of a lady's boudoir in the infinity of big hotel dining rooms, and Mephistophelean crab cocktails that give you the sweat of a long horseback ride and pastry that spurts like sum-mer showers in restaurants famed for their chef."

"And there are waffles spongy under syrups as aromatic as the heat that rises in a hedged lane after a July rain, and chicken in the red brick of Madison Avenue," she pursued. "And I have eaten in old places under stained glass windows where the palm fronds reflected in my cream of tomato soup reminded me of embalming parlors, and I've gulped sweet potatoes in the Pennsylvania Station, ice tea and pineapple salad under the spinning fans blowing travelers to a standstill, tomato skins in a club sandwich and the smell of pickles in the Forties."

"Yes," he said, "and raspberries trickling down the fountain at the Ritz, bubbling up and falling like the ball in a shooting-gallery spray, and eggs in a baked potato for ladies and———"

"*Pardon, est-ce que Madame a bien déjeuné?*"

"*C'était exquis, merci bien.*"

"*Et Monsieur, il se plaît chez vous?*"

"What the hell did he say, my dear? I learned my French in America and it doesn't seem to be completely adequate."

"Ah, sir, I understand perfectly. I be so bold as to ask if Monsieur like our restaurant, perhaps?" answered the waiter.

A COUPLE OF NUTS

◇

The summer of 1924 shriveled the trees in the Champs-Elysées to a misty blue till they swayed before your eyes as if they were about to go down under the gasoline fumes. Before July was out, dead leaves floated over the square of St-Sulpice like paper ashes from a bonfire. The nights lifted themselves exhausted from the pavements; restless midnights settled over the city like the fall of a cooling soufflé in the bowl of early morning. Sleep was impossible and I wasted lots of time in Montmartre. The grass in the Bois was as baked from the heat as pressed flowers under a bell, and bed was only possible comparatively, so I lethalized myself in *boîtes de nuit* night after night that I might find my apartment bearable afterward. That was how I got to know Larry and Lola.

They already had a certain clientele. I mean there were groups who drifted into their "club" specially to hear them play and offered them drinks and asked for their favorite tunes. The two kids sat in a state of watchful collapse, holding on to the dying spring excitement as if they were having a tug of war with itinerant Americans who would have dragged it south. They were nothing but kids, either of them. She was a protruding Irish beauty, full and carnivorous, with black hair slicking up her conical brows, and hunter's eyes that trapped and slew her mouth. She moved the masses of her body with the slow admiration of a baby discovering its toes, deliberately, like a person at chess, so that it gave no impression of movement, just constant arrangement and rearrangement. You would have thought she had learned to breathe on the piano bench.

They played me the old war tunes and I jounced my youth upon my knee as if it had been a lusty grandchild instead of a string of intangible memories. We got to be sentimental friends. Sometimes very late when

First appeared in *Scribner's Magazine*, August 1932. Previously collected in *Bits of Paradise* (1973).

the place was deserted and shirtfronts sailed the thick smoke like racing yachts in a fog, they asked me for definitions of love and success and beauty. Larry would say tentatively, "Now, Lola, I think *she's* beautiful." Lola, piling herself very high, dismissed us tolerantly. "Of course we don't know much about life. We've always had each other." As if that were a sop to fate!

In those days of going to pieces and general disintegration it was charming to see them together. Their friends were divided into two camps as to whose stamina it was that kept them going and comparatively equilibrated in that crazy world of ours playing at prisoner's base across the Atlantic Ocean. Some people thought they weren't married, they were so young and decorative. They had walked across Panama on their honeymoon. A sort of practical imagination they shared pulled them in and nearly out of all their adventures, through the muddlings of high society's private checking accounts and through the sordid backwash that people rich enough to take their amusements seriously scatter behind them like wrappings from candy eaten along the way. If she had told, for instance, how she got the ruby bracelet she wore as a memento of a party they once played for on Long Island, a famous millionaire would have buried his face in the Sound, and I happen to know that it was a duchess who paid for his sunstroke. But they themselves were at that time innocent children as faithful to each other as two aristocratic borzois on the same leash. Larry was wonderful looking. He humped his shoulders over his banjo like a football player huddling a ball. When he sang he opened his mouth sideways and howled and broke the notes and fitted them back together with the easy precision of cogs slipping into place, shaking the tones loose on the air as if he were freeing his fingers from some ticklish substance. If he had been born twenty years before, or in a country town, he might have worn a blond pompadour and clerked in the village drugstore. Instead, he shared our generation's intellectual yearnings and was a little ashamed of his métier. "Oh!— oh—oh," he sang, luring the boldness of great ladies from mulatto staccato to Spanish persuasion and "tum—diddle—um—dum," he urged them back again till they didn't know what they felt. He was a banjo player, and they were the people who rose with the moon and swamped his soul in uncategorical dismay. He had the nicest face opening out beneath his eyes like wide and friendly prairies in a copper glow. His smile tucked up his skin back of one ear like satin skirts held high from a rainy pavement.

Well, they managed to stick together through everything when they

couldn't pay for their sheet music and had to refuse the champagne that was offered them because of their empty stomachs. Afterwards, when unhappiness used up the unexplored regions in their laughter and hardened their gestures into remembered mimicry, they got to love telling people about the hard time they had had getting started. It must have brought them closer for a moment, retracing the days when they knew they couldn't have borrowed five dollars.

When they first floated up on the heat wave they made music in a dump that prides itself on discovering new people. Their patrons later turned out to be the heroes and heroines of half our modern novels, and their fortunes rose on the insatiability of the Paris lion hunters. So long as there is money to buy leisure there is the necessity to forget we have it, and Lola and Larry might still be successfully blasting Time from the stones of the rue Pigalle if they hadn't gradually become obsessed by their "rights."

That was what engaged them in an eternal round of petty quarrels. It was either the drummer who wanted to get them fired or the bartender whom they suspected of making dirty cracks about them, or the manager who was an impossible person. The domestic element in Lola's life was replaced by these pitiful bickerings, and I suppose that for him they satisfied some instinct of taking things in hand, the same as paying the weekly bills does for most of us. They seemed to forget the ultimate dispensability of jazz singers. One night they lost their job—drinking, I think. When I came in, Lola's cheeks were floating over the room like two red clouds, her eyes playing about the edges of the manager like an Indian sword-thrower, picking out his bulky form against the desolate room. The *boîte* somehow seemed inside out in the confusion, bolstered together like the wrong side of stage scenery. You could see the joints in everything, even the people. Larry was all for a placative attitude. He stuffed his hands in his pockets as if he gathered back his words in fistfuls to carry away with him. I heard him say to Lola: "There's nothing to say. You can't argue with a kike like him. Get your coat, that's all." I walked along with them under the dripping shadows of a Paris night, mauve and rose quartz under the streetlamps, pattery, clattery before the yellow cafés, droning, groaning, sucking its breath up the dark side streets, and I lent them twenty dollars to pay their board bill when I left them at their dingy pension.

"That old crab," Lola exploded, "he just wanted to get rid of us, said we sat around with all of you too much and didn't play enough to suit him. Sometimes I sang so much that my voice sounded like convicts

breaking rocks by morning—and out we go at the end." She turned to Larry like a well-behaved child who had upset his glass at the table. "Well, what'll we do now—what will Larry and Lola do now?"

Jeff Daugherty was the answer to that—a genial expatriate who counted his spotted ties in hundreds and expatiated his existence with discoveries of the last word in entertainment. All of us who had ever been shortchanged out of a five-franc note or tried to cash a check at lunchtime or had any dealings with a French post office brought our violence to Jeff, confident that he could tell us where to find echoes from America to soothe our nostalgic lamentations. Larry and Lola took him by storm.

You would have thought they were buying a seat on the stock exchange if you'd heard them discussing how much they were going to ask him, to play at his dinner. They fixed on the absurdity of twenty-five dollars. It was the first time Jeff had been presented with a bill as small as that since college; it moved him to a patronly feeling. "I've got rather a nice little place on the Riviera, where I'll be in a week," he said, tracing their future on one of his calling cards. "Come down and play for me there." Jeff drew a magic circle round his phone number. "That," he said, "is the combination of my private safe." They told me that they ran all the way home that night, their feet just tickling the pavement like the feet of marionettes, strung with happiness at the possibility of getting out of Paris.

It was late in the summer when I got away to Cannes. All the gay and glamorous people had floated off on the fumes of alcohol to Biarritz and Switzerland, Vichy and Aix-les-Bains to steam and sweat and look with satiated moralism over other gambling tables than those that wilted in Mediterranean vapors. I hadn't been long at my hotel when Jeff phoned me for dinner. He had never been a great friend of mine but the season was disintegrating, already split into quarreling groups and cliques intent on their private affairs, and I was glad to fit in somewhere. "I've got hold of two lambs," he said, "and I'm giving a slaughter. If your sanguinary tastes are nicely developed you might drop in." Since I have for years considered all of Jeff's friends more or less of a menagerie, I never thought twice to ask for details. After a day on the parched beach I squirmed my dinner clothes over my puffy, sunburned back and with my shoulders feeling like a package of live fish and my arms running up and down themselves like vibrating rubber and I damned Jeff as an animal-fancying exile, who meant no good to us who intended to escape from life. By the time I arrived, a group about the piano were whipping the party round and round like one of those gyroscope affairs

to keep an airplane from falling. There was a lush hardness in the voice that sustained it, a voice removed from personal appeal, a prince and princess quality, gracious and cavalier. Most of those ingratiating voices that hang on the air like juicy ripening fruit hold a promise of initiation—this one didn't. It was a secret you could never share, as detached from its owner as from you. I knew it was Lola. Nobody else could sing like that. So Jeff was going in for troubadours! The confident notes whipped the summer night to a Negroid frenzy and she sang about "loving you—you—you." She put on a show about being glad to see me and made the party roar with an account of how she'd cheated their landlady out of my twenty dollars and blown into Cannes on the profit. I thought she was overexuberant and after a while I decided that they were both respectably but quite definitely drunk. When Jeff drinks it's because he has been drinking for so long that liquor is as much a part of his daily ritual as his morning massage, and when I drink it is to fill up the gaps in human relations, but Lola and Larry were drinking to create the illusion that they had some reason for it. I suppose it didn't make any eventual difference, since somebody else paid for their drinks, but they hadn't yet staked out a claim for themselves on the face of this difficult earth, and it depressed me to see barriers go crashing before they were constructed. Jeff hung over the piano, svelte and proprietary. Even when he joined the scattered tables you could feel Lola's attention following him, participating in his security. Larry seemed flattered, or thought he should be, by Jeff's attention to his wife. Anyhow, he talked to me in alcoholic modesty for a long time, and when the party shattered itself on the back of the August night, I drove him home. We left Lola in the midst of innumerable "My dears" and promiscuous "Darlings" tidying up the immaculate Jeff as if he'd been a cabinet of bibelots, and he extremely passive even for a cabinet. Next morning Larry was very determined in his attempt to be worldly about the fact that Lola got home after breakfast, had skated in on his fried eggs, so to speak.

Well, the rest of that summer Larry's role was not to care. He was awfully good at it and grew as stolid as a substitute halfback; toward the end he didn't even seem to expect to be called into the play. Financially, they had done very well by themselves, playing at private parties and finally organizing a short-lived club which rocked itself to a lonely, delirious death to the tune of her garrulous blues. It was pounded out of existence by the roar of the autumn sea. Jeff left with his fatuous coterie. We three shivered alone in the prickly sunshine of the beach. The ocean turned muddy and our bathing clothes didn't dry from one brisk swim to another; we grew irritable with the unspent tang of the

sea. They made certain pretensions at a sophisticated coldness between them, but I could see how necessary they were to each other even in their disagreements. Larry behaved as if he'd been brought up on the Murad advertisements, and Lola was proud of his pseudo-worldliness in spite of her inflation at Jeff's attention. Being always a little bit chilly was ruining my disposition and I decided to move on. They didn't know where they were going that winter so when I left I offered to drive them to Monte Carlo. The first day of school hung in the air, crisp and anticipatory, and resuscitated our dog-eared hopes as we drove along. We stopped for beer and cheese along the way and looked sentimentally on the fall concision of the Mediterranean. Those white and blistered palaces that line the Nice seafront had opened their shutters once more and the gray rocks about the coast were no longer vaporous bathings of sunshine but scenery preening itself in an invitation to be appreciated as obvious as the coquetries of a marriageable daughter. The country was selling itself. We absorbed its bright confidence, a sort of transfusion of light after the summer gulling.

When I rode off into the carnation-padded hills of Italy and left them there in the subdued hubbub of Monte Carlo, I had somehow a feeling that they were all right, safe with the rich and privileged. My emotion may have been evoked by the outlandish number of policemen there were about. Have you ever noticed what a lot of watching the rich seem to need?

° II °

In Rome I had a letter. "Jeff got us a wonderful job at a *café de Paris,* but we haven't been able to save any money. We hate to bother you like this but Lola's in trouble and if you could spare us forty dollars, you know how grateful we'd be. We can't afford a child at present, though we both feel terrible about it." Of course I sent it and they continued to write me from time to time. In the course of our correspondence, it developed that the last of some pharaohic dynasty had lent them one of those apartments consisting entirely of boudoirs, whose blinding fronts corset the pompous hills of Monaco with musical comedy stairs. They were apparently living in royal disarray, drinking and playing, and howling like banshee from the yachts in the harbor. They referred to the Egyptian as their "nigger friend," and taught him the Charleston and in spite of their hangovers remained dependent on each other. Their stuff was spectacularly American and they made a

killing at it, being simple kids. It wasn't until another spring that I saw them again in Paris. Frankly, Larry looked as if he'd just slept out the year in a cloakroom. The stagnant smoke of nightclubs had worn an embalmed, unearthly swirl over his head and he was as glazed as the surface of a delicatessen mince pie. They were prosperous and very much in vogue. Both of them had acquired a calculating quality and I missed the old "nothing to lose" bravery that used to be in their music when they tipped over their chairbacks and sang. I asked them out with me but they were always busy. Life had become a sort of Virginia reel of dissolute counts and American millionaires and disillusioned English —and Jeff. Larry was funny about Jeff. He treated him now as if he'd been a rare find from some obscure curio shop that he'd managed to buy for Lola with cautious saving. Of course, Jeff wasn't serious about Lola, but he followed her everywhere, batting her cigarette ashes with his signet ring and picking up the little bits of her that seemed to detach themselves whenever she moved.

"What do you think of this fellow Daugherty?" Larry asked me one night, assuming a confidential air as if Jeff had come up for a club election. "Well, I don't know," I answered. Jeff was an older, if more casual, friend of mine than Larry and I wasn't going into the days when he had had an artificial shower arrangement outside his windows to keep girls from leaving his apartment, and was only saved by his youth and suavity from the accusation of lechery. "He's a charming person, really. He used to write musical comedies years ago."

"Oh! did he? Were they any good?" Larry's face fell in blank incredulity. He couldn't bear it that Jeff should have had ambitions, and perhaps talents, the same human attributes as his own.

"Well, yes, I believe they were good—something very special and sophisticated for that time."

"Why did he give it up? You know, I think *Europe* is a bad influence. I mean, life's so easy over here. I've been trying to get Lola to go home." You could tell by the way he balanced the words and tentatively meted them out that the idea had just come into his head. I supposed he wanted to get Lola away from their environment and Jeff. I cannot tolerate buoyant comedy characters when they lapse into that attitude of baffled seriousness just "to show you the stuff they're really made of," so I paid my check and walked off, feeling rather pleased with myself that I hadn't betrayed Jeff: I so often do make nasty cracks about my friends. I didn't see Larry again until June.

That spring the lilacs dumped their skirts over the walls in the Boulevard St-Germain and wanderlust sprinkled the air. I wanted to stop at

every "Rendezvous des Cochers" and "Paradis des Chauffeurs" I passed as I strolled along. It was like walking with a child beside you, the morning was so tender. I had got as far as the Café des Deux Magots, enjoying the people airing themselves on the sidewalk, when Larry caught up to me. I expected some coldness when I remembered the abrupt end of our last meeting, but he was beaming away in the daylight like a beacon left burning from the night before. "We're going," he said triumphantly, as if we'd never parted. "Sailing at noon tomorrow. At first Lola didn't want to for a damn, but I finally got her to see that if we're ever going to make a name for ourselves we've got to go home now while we're known and settle down."

"I think you're very sensible," I said cautiously, in surprise. It seemed rather silly to me that they should tear off just now when people were beginning to recognize them over here but of course I guessed his motives. There had been some malicious talk about Jeff and Lola. He slipped his hand under my arm and we slid down one of those brown streets padded with humanity that mark dark vistas to the Seine. The shadows cooled the inside of my nose like a breath of melting snow; the sun was fragile as a blown glass casing around the world. Larry stopped and lit a cigarette. Something in his movements suggested a boy scout about to perform a good deed. I waited. "Say," he said, "if you see Jeff any time soon you might tell him I'm sorry I was rude the other night. I'm afraid I was awful. I thought he was pawing Lola but as soon as I sobered up I saw how absurd I was. You will tell him, won't you, and that Lola sends her love? And say, I'm gonna send him a check for what I owe as soon as we get to America." He seemed relieved after that as if he had somehow discharged all obligations and could now withdraw from the scene with a clear conscience. I left him by the river where it flows like a typewriter ribbon printing the alphabet of Paris on the city itself, wishing them good luck and bon voyage. As it happened I hadn't seen and didn't see Jeff for six more months.

I woke up one Sunday morning having lost my superiority on Saturday night and I thought it would make me feel more respectable to look at the cold equilibrium of the Luxembourg statues. So I did every surface thing a person can to myself and delivered my interior chimney-sweepishness onto the sidewalks. Symphonic taxi horns blew the muffled suppression of Sunday calmly through the narrow streets as I trod the quiet tones through the soles of my shoes. I ran into Jeff by accident outside the museum and we decided to lunch together. I suppose people with like habits discover the same escapes from them. We went to Foyot's where we devoted two hours to eating ourselves into a lethargy.

We soon exhausted our categoric conversation, and searching the past
for titbits, I remembered Larry's message. Jeff smiled with dubious skep-
ticism and when he saw that I disapproved of that particular conquest
he began to expand in self-justification. Jeff is a bore when he expands;
he usually goes into details about how much it cost in telegrams to
extricate himself and leaves you guessing as to the situation, but I was
interested in the kids and it was a long time since I'd had any news of
them. "Lola and Larry," he commenced, "are a couple of museum
pieces, early Neathandral* I make them. I don't see why they can't take
life like adults. I was very fond of her, you know, and he seemed a nice
sort of chap, so when they left Europe, I sent out mail-order blanks to
some friends who used to put on my fiascoes in the days when failure
was still a novelty to me, trying to get them a decent job. Maybe you
know Les Arcades? Well, it's so chic that people sit about in a gunman
hush and sense the satisfaction that they're paying ten dollars more for
their champagne than all the other people similarly seated in similar
circumstances. They were supposed to sing and pass themselves off as
society toughs. They got away with it beautifully for a while. I mean,
they fitted all the current adjectives, 'hectic and delirious and killing' and
all that, and people went there in droves to keep from having to think
up new epithets for their conversation. Everything went along like fire-
works in an oven until my ex-wife appeared on the scene, or until the
scene swallowed her up, I can't make out which. Mabel, you know,
rejoices in her quaint Victorian ways and I suppose it hurt her pride
that there should be a man in America she hadn't slept with besides
myself. So she began making passes at that handsome exterior of Lar-
ry's, which, I believe, were eventually fatal. She'd turn up every night
with Lord Ashes of Alley or the Hon. Hick-ups, and graciously surren-
der them to Lola. The four of them spent evening after evening gloom-
ily soaking cigarette butts in the dregs of their highballs, happily
quarreling. Mabel is a glamorous person, and she eventually located
Larry's Achilles' heel in *Brett's Peerage*. At any rate, Lola became pugil-
istic when she found she was losing Larry. When the situation got to
the stale mustard point, the clientele, bored with the unpleasant aura,
wandered off. I mean, everybody knew the four of them wanted to bash
each other's faces in, and no reasonable person is going to squander a
hundred dollars a night for the privilege of being sorry for two clowns.
So they got fired. Well, one must live, and bread and whiskey are ex-
pensive since the war. Lola got a Broadway jackal to bring suit for

*Thus in the *Scribner's Magazine* text.

alienation, and it looks as if the whole thing were going to cost some hundred thousand dollars. Mabel hasn't got a penny outside her alimony and the price is extravagant even for an eccentricity. Of course, I can't afford to have the mudslinging in the papers. Really, these days I never know when my breakfast rolls will be loaded with dynamite. I suppose, however, it is my just deserts for fooling around with such a couple of nuts."

Jeff is a genial individual who learned his philosophy from checkbooks and I confess that I envied him the equanimity with which he accepted his schooling. He drove placidly off in a taxi and I stood there in the skeleton sun terribly conscious of the frailty of human relations. I was wondering about the kids. They had possessed something precious that most of us never have: a jaunty confidence in life and in each other like the plaiting together of a lovely cravat from an assortment of shoestring. What did Lola want? It seemed to me her broken heart came a bit high—a hundred thousand, Jeff had said, but I somehow couldn't believe she was the kind that cared much about money. Nevertheless, the blue surface of her eyes was jagged with a predetermination not to care, a vengeful quality like sharp rocks where the water is too shallow to dive. Larry was a nice fellow. I wondered if he had given in to Mabel to be vindictive. The whole thing oppressed me. I disliked thinking that where there had been something pleasant and clean and crisp as an autumn morning now there was nothing. To see them again would be like revisiting the scenes of my youth and finding my mother's house no longer there, so I put them out of my mind, as I would have dismissed a false conception when I found that it was wrong.

Three weeks later I picked up the paper and saw that ghastly tragedy staring out from the front page. The fact that it was Mabel's yacht made it headline news. They had all put off in a hurricane, Mabel and Larry and some of those imported brummagem of hers and the high sea swallowed them up like gulls pouncing on the refuse from an ocean liner. It was horrible. A boy who almost drowned once told me that while he was trying to keep himself afloat, birds settled on his head and pecked at his eyes. The papers said the sea that drowned them was the worst in forty years, so I hope they sank at once and weren't left there a long time struggling. Larry's body was never found, nor any of the others—only Lola. She lay for weeks in a recuperating hospital. Lola wrote me a pathetic letter when she got well again. "Can you spare me some money? I think I've got a job in a new show that's opening in the spring, but you know we never saved anything and I've got to get along until

then. You've always been so kind to us and now that I haven't got Larry any more all of our friends seem to have disappeared. I could ask Jeff but sometimes I feel that if we'd never known him none of this would ever have happened. He and his wife were such a couple of nuts. What were we doing on a yacht? Before we met Mabel we could always quarrel well enough at home and forget about it afterwards."

Lola and Larry! No, they never saved anything. Well, I sent her the money and I suppose she'll be all right for another five years. She'll be pretty that long anyway. It takes time a good thirty years to batter down a woman's looks and crumple the charm she acquires from moving in a world she finds rich in that fantastic quality. Poor kids! Their Paris address turned up just the other day when I was looking for my trunk keys, along with some dirty postcards and a torn fifty-franc note and an expired passport. I remembered the night Larry gave it to me: I had promised to send them some songs from home—songs about love and success and beauty.

OTHER NAMES FOR ROSES

◇

This all happened a long time ago, before Vengeance of God and the Japanese War, and it concerns itself with having a good time: and how to. Most of the formulas for pleasure at that time were, presumably, outworn and the rites become inadequate to postwar spiritual exigencies of the early Twenties—since so many people were so nearly bored to death. Everybody had to be wonderful after that war: wonderfully enduring the eccentricities of the tragic destinies then in fashion. Beatitudes of prosperity steeped the world in abeyant promise; cars streamed through the dusk and lost themselves in the costly rites of happiness beyond Queensboro Bridge. Woolworth installed a special counter of silver spoons and the lilies at Schling's turned gilt overnight. All things which were expected had been expected for so long that plans had begun to wear the mark of doom. Even the muddles of the day were, largely, unprecedentedly ominous.

Glittering dusks muffled the side streets of New York in truncate splendors; the whitest of mornings removed all personal implication from the scene. Many souls, unaccustomed to thinking of themselves in terms of such magnitude, turned to drink; it made the brooding more companionable. Others began to drift about over Europe. So, eventually, it touched them too and the Joneses decided to leave. There had to be a reason for this, for neither the social status nor the natural predilections of Fedora and Jayce Jones permitted of reflexive responsibility.

Of course, he was glad of the bondage—as it might be termed. No-

This previously unpublished story has been edited from the undated typescript at the Princeton University Library. Since the story is not included in the list of stories Zelda Fitzgerald attempted to sell during 1930–1932 (Bruccoli, "Zelda Fitzgerald's Lost Stories," *Fitzgerald/Hemingway Annual 1979*, pp. 123–26), it is probably a later work.

Spelling and punctuation have been emended, but the author's neologisms have been preserved.

body ever said that he had sold himself, though he might have brought considerable in the open market: his courageous features and the costly glow of professional health and the gently controlled right of criticism in his manner: these are collectors' items in metropoles. To him, her money only clinked when one opened the family closets; exteriorly she was ingeniously imperious, keenly appreciative, impersonally responsive, and decidedly not to be bothered about what make of voiture molded the contours of the Champs-Elysées from year to year. Another thing: she was still a pretty woman. Though the elegance of her appurtenance was never insistent, one knew intuitively that she kept regular appointments at the hairdresser and the masseuse; though the freshness was no longer spontaneous, it breathed an air of costly secrecy which was, perhaps, the more engaging.

By mutual consent they declared New York given up.

"I simply cannot do this thing again——" that from him in front of her mother's damask curtains, shaming her grandmother's portrait, shaming the Rubens, shaming the Sevres, and doing heaven knows what to the autographed memoirs.

"——but Mother is so well-meaning."

"But she does feel that life could be better." Jayce pulled himself up looking for the last straw. Not finding any, he continued astutely, "It's not that they mean to be superior; it's just that whatever I do does not affect the stock market or the listing of the family pew so that most of my actions pass unremarked."

"I'm sure they're proud of you," Fedora suggested politely.

"They don't care what I think about anything save how well done the roast is."

Jayce, feeling that his repertoire was being frittered away, finished grandly,—"They're a damned lot of stuffed asses," he yelled triumphantly.

There was enough of her family in Fedora for that last to sound improbable—another of those things to be assuaged, a sort of unaccountable temperamentality; not as bad as a drug addict but impolitely aberratory.

"Dear——"

Jayce half wept—"O my dearest one," he protested. "Don't think that I have forgotten all our little things together: the Sundays at home, and you in the bathtub and the duets and—everything."

Fedora smiled indulgently. "Your mother used to melt into the portraits when you sang," pursued Jayce wistfully. "Why doesn't your

mother melt any more?" he pursued, his face lighting up. "Why doesn't she just melt now?" he demanded. "It was such a good idea."

What Fedora couldn't stand was the uncatalogued strain.

Acting on the urgency of a black-silk Sunday, "Mother," she said,— "You should make more effort to get along with Jayce; he's sort of hurt sometimes."

"My Dear——" Mrs. Highgate never did anything so committal as to glower,—"that borders on false witness, you really must see the clergyman."

"You know"—Fedora went on implacably—"he is not just a family retainer—he'll have bigger obligations when"—not being able to think when, Fedora decided on the academic version—"when the lawyer dies."

"He's so charming," murmured Mrs. Highgate, "so charming. I love having you here—the sense of inevitability is so assuring." Mrs. Highgate lapsed into self-hypnosis. "We've just got the nicest husband," she continued to herself. "Why, if it weren't for Jayce there wouldn't be half the confusion."

"Stop talking baby talk."

Mrs. Highgate deliberated, "The trouble is, Fedora, that you don't make enough of your husband. You will find someday that you can more easily get your way by making a grand hullabaloo over his. Now, I, for instance, adore him; thus I am free to mind my own business as far as Jayce is concerned."

So finally, when Jayce gave up the family job and refused to put foot in the Rolls, they looked up some places in the almanac and sailed. Choosing the proper setting for fostering the proper appreciation, stimulating his inspiration and altogether keeping them from dying, or being vanquished or however you want to put it, they fled to southern France.

Around Hyères on the coast of Provence the land is time-strewn and memory-worn. Poppies shatter in midsummer ecstasy over the fields; the pines are old and resin-dripped and lanes swoon under the aura of honeysuckle. Dust of the grain steeps the long roads in memory. After a while the way climbs, hangs precariously over much sea and space, is patched to the earth with bright plaster villas swung through blue eternities of sun-tempered air. The land is lone and virginal; here is a rendezvous of weathers. As the way careens up the pink coast at Golf Juan, the world again bears witness to the maps. Browned people splash themselves with the goodness of life along a shore quietly humming to itself of the imperishability of its dusks and the unpregnability of its

noons—weather designed to conserve the aspirations of many people who had thought all along that the first objective of life was to die efficiently. Cosmic intent takes a new breath: good wine and good ways and the acceptance of days. Juan-les-Pins and Antibes come down to earth with bright prescriptions for pleasure and formulas of beauty which save the mind much wear and tear of inventing further raison d'être. Here people from many countries rest their souls amidst the colorful immaculacies of the meticulous paradise from St-Raphaël to Nice.

Nice Christian people.

There was no telling what made the garden the way it was. There were olive trees with roots in Palestine and ferns from Paul Rousseau and paths keeping tryst under the pines and eucalyptus. This was a blessed world and they were fine healthy solvent people; for its great beneficence, they gave voluble thanks to the social structure.

"Isn't it wonderful that people invented this?"

"Isn't it swell that we have been thus enabled——?"

"I am so glad that Jayce learned about France in his geography——"

"——and from friends at college."

Agreeing that the perspicacity of their acumen and the poesies of their aspirations had indeed richly endowed life, they blessed themselves and thanked each other and gave great credit to Harvard and Yale. Not one remembered to thank the Lord.

That's a lovely villa beyond the bend of the road storing in its glass-paned chambers all the sky and fragrance left over when its pine-bursed balconies were finished. It swings across the gravel plateau and, swooning unpremeditatedly out beyond the foundations, ricochets the late sun back into the garden paths beneath. It is a garden where rendezvous and serenade have been incubating since they went out of fashion elsewhere. The Joneses live there: their names are incontrovertibly painted in gold on an azure board where steps plunge desperately from the high road into the garden's first overtures to adventure; Jayce Jones, Fedora Jones, as plain as if it were in American.

◦ II ◦

It did not take long for them to become indigenous: arrangements were made for shipments of American silk and English whiskey and reading matter from the States. Fedora had soon inculcated a felicitous New York technique into the maid-servants and fitting British mannerisms

into the valet. Jayce was finding more time to assert himself and plenty of time to magnify the various significancies—which hadn't changed as much as he had, privately, expected.

There was a low-slung beach winding itself under the imperviously promissory heavens until it fell dead in love with the pines. Its protectiveness, gleaning the morning of tentative ecstasies, echoed the remoteness with cosmic happinesses. The Joneses went there every noon, scattering themselves through the sunshine looking for things; bright-colored bits of memory, sea monsters and cataclysmic items from the morning paper. There were other people; Fedora and Jayce went along on the assumption that they would get to know them. It began with that intricate-looking brown man, for instance, who kept explaining things into and out of the lives of the other two with him.

They definitely didn't like the brown-boned person, and the people with him echoed his sinister suavities: a ballet dancer, porcelain-limbed and theoretically articulated with the beseeching eyes of a faun, and a man. After a little while Fedora noticed the man; definitely. He was reminiscent of the ideals of some earlier day and she soon found herself wondering about the authenticities of her bathing suit whenever he appeared. His hair was pale gold, his features promised the excitement of various interpretations, and he moved poetically. Mr. Brown-Bones unpremeditatedly introduced the whole lot with emphasis—indeed, as he let it be known, Tillyium was a poet: all Mr. Brown-Bones' visitors were distinguished. "And I want you to get to know each other," unctuously insisted the impresario. He did not say why.

Fedora soon noticed that the poet's flair for dramatization did not confine itself to the theatre; Fedora was forgetting her regular prescripts of male desirability before she's had time to get them ready for reference.

Jayce, hopefully abandoning himself to the rites of possible adventure, was addressing himself fervently to Mademoiselle.

"So you are Belanova. I've gone home on my toes many times after your performance." He laughed encouragingly. Her English was not perfect, it required attention to follow her. Jayce hadn't had such a good time in years: it was something like this which he had planned for the more inspired sequences for life: items, which could be termed, in terms of any retrospect, discreetly evocative.

"Listen," he said urgently when they got home, "I want to see something of those people, they'd be helpful to me."

Fedora considered: she didn't care, Jayce probably needed help: men were supposed to, according to Fedora. Maybe Brown-Bones and the

other younger one—needed help also; Fedora remembered how she's often thought of writing poetry herself sometimes at night when Jayce had been mean to her. The thing was working out very questionably enough.

Anyway, Mr. Brown-Bones basked proprietorily as he got more and more rides in the Joneses' car. He seemed inordinately happy about something; something sweet smelling and deferential, as the car settled over the roads like a powerful wind alighting, whirring up a story as much to Brown-Bones' liking as it was to his convenience—as were most things to Brown-Bones if they deserved his attention at all. "If Monsieur Jones was going to Nice anyway, Mr. Brown-Bones would be glad of the lift" or, "if Madame Jones was *sure* that it wouldn't be out of her way—that is, if she had an engagement at the château anyway —would she be so kind——"

Fedora has never understood how people with everything could be restless because her own happiness was an official estate, bearing an undercurrent of defensiveness as if the less fortunate estates of others were a constant challenge to her precepts of grace. Yet the weeks were piling up restraints, cumulative discontent augmenting itself with every good night.

"What a wonderful party," they told each other, letting it be implied to each that the pleasure was his own peculiar contribution, growing vaguely regretful about having to include the others. Nightingales haunted the garden and the threat of ghosts hung abeyant over the stillness of outgoing tides; good nights were wrung from the promise of dawn. Things were even as could be expected; life knew its business and kept its obligations—given half a chance.

It was the best party they'd had in ages. Belanova glowed spectrally in the dusk and Jayce, remarking to himself how much easier it is to find a felicitous phrase in French, was almost spitefully attentive. Tillyium said, "My dear people, now let me tell you about the night."

"There aren't any tea leaves," protested Fedora hastily, wondering which night he would choose.

"It's a very remarkable night," he insisted. His voice was as full of innuendo as if he were about to confide a revelation peculiar to himself yet relevant to all. His voice extolled the beauties of love, now that love was more promising amidst all these felicities.

For a couple of weeks Fedora had been anxious; he might tell Jayce about kissing her that day in Nice. Tillyium, she reminded herself daringly, was a poet, and as such likely to be more interested in possibilities of drama than in her convenience. "Couldn't you tell us tomorrow?"

"No." Peering behind the oleanders distractedly for a comprehensive phrase, he made Fedora more than nervous.

That was the third bottle of champagne over which the row precipitated; it wasn't so much a row as the bitter restraint of a row. For they wanted to know if each other was trying to tell the other what to do.

"Let him talk," insisted Jayce.

"No," said Fedora. "This is not the time to talk about the night."

"There, the same old protagonist!"

"——never mind, they said, probably a touch of liver."

"Let us be embittered," breathed Fedora wistfully.

"Well," said Jayce peremptorily, "I'd just as soon let you. Just go on," contributed Jayce, "pretending things are perfect; any dunce could see we're all upset—I think the garden is haunted, personally."

Fedora muffled her protest in polite incredulity.

"You should see the clergyman," she expostulated. "Listen to me, Jayce—you buy things and give them away and there are many things which need your attention—why aren't things all right?"

Jayce breathed fervently. "Truly inexcusable," he muttered.

"Jayce always feels that the world should end at twilight," Fedora went on to herself.

"I have often wondered what made it last that long," contributed Tillyium imperviously.

"Gin," she said bitterly, "gin and champagne."

The summer was no longer a closed proposition of muffled echoes and grieving bird-song and unfathomable domestic statistics. The Joneses had so many virtues: Mademoiselle Belanova smiled enigmatically across the summer night to Tillyium. Fedora decided peremptorily that she didn't like Belanova; everything the girl did seemed completely for her own delectation.

"It seems too bad——"

"——The natural dénouement," apostrophized Jayce rapturously.

Fedora turned to the ballerina—"Dancers," she pronounced in impeccable and meticulous banality, "never drink, do they? So they probably don't have qualms or have to worry about evil spirits."

Belanova, attributing the whole episode to racial peculiarity, continued corroborative. "Just a little sometimes," she smiled, raising her glass, "when they feel blue or in love?"

Suddenly Jayce peremptorily ordered Fedora into the house.

Tillyium heard their voices scratching themselves on the cacti and palms. "But I think it's a lovely party," wept Fedora, "just nice the way it ought to be, considering where we are."

"Well, I think it's likely to be Hell," threatened Jayce, "and I know more about the way these kind of parties ought to be than you do: this is not the right way. For instance."

They didn't come back for a half hour; then Jayce ran about figuratively in circles, protectively offering politesse to Belanova and preventing Fedora from further—further—he didn't really know in what she had sinned, but the time was indicated for him to say "NO." The hour was late; the wine began to spill; shadowy foliage grew tired about the edges of a world being frittered away by cross-purposes. Belanova said she had to go.

"You will be there tomorrow?" she wheedled Jayce; a right to expect him seemed already established—

He would be there; he'd also take her there, irrespectively.

Fedora laughed a cheap laugh, tinny like the last resistance of a cheap mechanical toy unwinding itself.

"I'll see that he doesn't forget," she proffered. "He came yesterday, didn't he, and Tuesday; and tomorrow will probably be another bright day——"

Jayce's politeness was ominous. "You're so thoughtful," he threatened. "If it weren't for my wife," he told Belanova reassuringly, "I'd never remember my rubbers."

"So I hear," Belanova murmured corroboratively. "You know," she was telling him as they climbed the path to the car—"I have *often* heard what a wonderful person Madame Jones is——" deferentially asking his permission to the right of opinion, her voice became fuller on purpose as she and Jayce reached the road and—and went off—concluded Fedora noncommittally—went off.

In the ghostly gloom before dawn, it seemed to Fedora that Belanova already knew Jayce better than Jayce knew his wife; well, dancers were supposed to be highly intuitive people. She was scared.

"Well," said Tillyium, "this is not an hour for starting new things: rather than spoil the continuity——"

"O!" protested Fedora, "but you are not going to stay here to tell me things. The party is definitely over——"

"Don't be so American," cajoled Tillyium. "We are surely going to Nice—in pursuit of the dawn—we are going to watch the dawn coagulate"—Tillyium spread his shoulders hospitably. "Coagulate," he repeated grandly, "above the breakfast hour at Nice."

They must not have looked as rich as they were; the waiters were unenthusiastic. "It is too near morning," the *garçon* protested, suggesting policies of more rationality.

"The calendar," pronounced Tillyium forcing his way, "is in no wise dependable enough to influence destiny—five hours sooner in New York, breakfast time in Berlin and some other time altogether in China. Be reasonable, my old friend."

So the management set them in a corner just in case they might be more important than they looked. Then, just in case they might not, the busboys went on sweeping the floor.

"I am in love with you," Tillyium said officially to Fedora.

"You are not supposed to tell me," Fedora suggested tentatively.

"Do you realize what this means coming from one of my métier?"

"Probably a new sonnet." She pretended that her thoughts were elsewhere.

"A saga," Tillyium agreed, "of ominously epic proportions. It begins tonight—as soon as they get through sweeping."

"I can't have a saga," gloomed Fedora, "my husband doesn't allow it."

"As I was telling you," went on Tillyium, "the opening scene is a Nice café. A very superior café. Come to attention," he said peremptorily. "I am still making love to you."

"One shouldn't do that."

"One has to; it is absolutely obligatory in sagas."

The road home gleamed coldly in the wash of dawn; the context of the night was as over as the purposes of a dead man on view at the undertakers.

"I don't want you to come in," urged Fedora. "Jayce will surely protest." She didn't like what she was saying; it implied that her intimacy with him was more intimate than her relations with Jayce. She wouldn't do that.

"I wouldn't miss it," protested Tillyium. "Not only that, I am going to insist on my right to iambic pentameter until after lunch."

Though the maid was in ambush in the kitchen and the breakfast hour was over, the house was undisturbed. Fedora felt cheated: where was Jayce to make the scene? Fedora grew panicky; she had always had to have Jayce handle moments like this; maybe they should have come in by the back way.

"You'll just have to go," she said. "There's nobody home."

About three weeks later, Tillyium came in without announcing himself. The afternoon hid itself in the corners of the glass living room and swayed back and forth between the mirrored mantel and reflection of the pines in the windows.

"Has Jayce written?" he said.

Fedora anxiously sought the exact phrase. "I had a note from Paris——"

"I said," suggested Tillyium, "what is Jayce going to do?"

Fedora didn't know; not wanting to get in any arguments about it, she suggested placatingly, "We'll have tea."

"Yes," the poet assented bitterly, "Jayce always had tea at this hour, didn't he?"

There must be some rite which would ease the situation. "Do you sing?" said Fedora. It seemed to Tillyium that she was being relentlessly social.

"It never came out right," defended Tillyium.

"You should have tried tea in bags——"

"I meant my singing; it varies."

"I thought that we could try those duets——" She smiled coercively. "Jayce and I were going to try the duets if an afternoon like this ever came up."

Tillyium laughed operatically as he followed her to the piano. "By all means," he agreed, "the duets."

The music didn't fall appropriately; the sound didn't blend with the reverberant hush of the garden and no other sounds of life modulated the blatancy.

"However," Fedora reassured herself, "it is the very thing. How pleased Jayce would be to have Tillyium so appropriately in love with me." She sang well: Mississippi mud and Georgia cotton field, seldom receiving such tenacious treatment, hung about the low-slung room in determined but unconvincing fanfare of homely glamours of far-off places.

"I don't like to sing *any* songs; I definitely don't like understudying."

Fedora knew that something was going to happen: Jayce always showed the guests the sunset from the balcony after the singing; feeling vaguely apologetic about the remissness, she reminded herself that this afternoon there weren't any guests. Then she reminded Tillyium that they were alone. No doubt Tillyium would know what to do—even without guests.

"I am not going to kiss you," Tillyium announced prophetically, "in your husband's house."

Tillyium came like that for about a week. Jayce's absence kept them apart and reduced the afternoons to uncomfortable measure. The late skies did not blaze obviously as they had in July: they blazed academically. Tillyium got tired of the sour-sweet sticky Bacardi; one could taste the label on the vermouth. He didn't want to say that Fedora was te-

dious; it would be too trying to have to say that; after all the rhapsod-
izing he'd done, it didn't fall into Tillyium's poetic categories.

"Is that a chip I see on your shoulder?" Besides, that authoritatively
possessive manner of Fedora's annoyed him—annoyed him, too. Yes,
that was it—too.

"But not off the old block," replied Tillyium. "It's a new kind of
plastic chip. I am going to tell you something." Tillyium withdrew into
his official capacity. She didn't care much what he was going to say
because he wasn't half as impressive when the breezes of Montmartre
began rumpling his spirits. The week's tentative playing with unex-
ploited solitude had no doubt begun to wear on them both. Fedora felt
a little sickly, as she had sometimes when people went out thanking her
unduly for a lousy party.

"About the three bears?" She simulated excitement.

"First, I was serious when I asked you to marry me."

It was a relief to be back on the plot, anyway.

"I have come here to flatly state something."

Fedora, in searching for precedent, recalled the stentorian rumblings
of the house in Madison Avenue and decided to be as ominous as the
summer season permitted.

"Maybe it would simplify matters just to send an itemized treatment
by mail."

Inexorably Tillyium pursued his objective. "I did not," he said, "want
to marry your husband."

"Oh—Jayce," Fedora fluttered expectantly; tentative recommendation
of Jayce already formulated persuasively in her eyes.

Tillyium stared at her incredulously. He made a harrowed stab at the
idea. "That's just it," he cried triumphantly. "It's perfectly clear to me:
Jayce's duets, Jayce's twilights, Jayce's sympathetic discontents! Why
you're nothing but a litany of Jayce's improbably preposterous felici-
ties."

Fedora listened obediently aghast, as Tillyium went on with this aw-
ful harangue. Of course she knew that she usually deferred to Jayce, but
it suddenly occurred to her that she also had a possible right to live.
There wasn't any breeze and the smell of resin was heady and sweetly
suffocating on the asphixiating tranquility of the day. She was going to
say something to Tillyium which would have changed her whole life,
would commit her to other ways of thought. But he had fled. He had
freakishly shot himself through the windows into the blinding hiatus of
the sun, propelled by the magnitude of his idea like the man in the
circus who gets himself shot out of a cannon.

"You're nothing," his voice drifted back in a triumphant howl from the peony walk, "but a little tin reflection of Jayce. I wish I had never given you a thought; I wish that I had just taken the sleeping pills in the first place."

Fedora's voice claimed right-of-way over his disappearing back; after all, they were her good times he had been having.

"I will thank you," she yelled, "to get out of my peony bed. Get out!" she yelled, "and stay out!"

◦ III ◦

Paris is only a day's drive, really. By leaving early in the morning one ought to get there for breakfast next day; yet the worlds are so changing along the way that it seems like miles and miles.

"Miles," sighed Jayce as the road tugged them inexorably on. Belanova, surreptitiously beaming, carried on a pantomime of appreciation half behind his back. By noon, the broken-hearted tangles and the spectral splendors of lost Riviera gardens were behind them and the car went purring through the poplar lanes, through the smell of peat and courgette and the breath of Provençal husbandries, vinicles and thresheries.

"I am so happy," beamed Belanova discreetly, "to get this chance of a drive back."

One of the nice things about her was that the railroad fare still meant something to her, Jayce thought; most situations still required consideration to Belanova. Jayce thought approvingly also of a world where everything one had bore the simple significance of earned worth and the enjoyment of days could bloom uncurtailed by theories of sheerly categorical value; not that he hadn't been happy at home.

"Look at these roads," he ejaculated to stop himself thinking. "Aren't the plane trees beautiful swathing the country in dreams?" He finished daringly, "Rocking the idylls to sleep."

"Oh but yes," Belanova agreed. Artfully she tried to say something indicative of her spiritual adequacy to Jayce's necessity to commune. "What a good set for my new photographs—the dress could go—so." Belanova rhapsodically indicated some problematical contours with a gesture of grandiose invitation. Jayce quelled his disappointment.

"I saw it in the movies," he commented, reserving his right of appreciation.

"What else do they do in the American cinema?" she pursued interestedly.

"We're always too busy to go. Maybe we can go in Paris." Pleased with the idea of learning something with her, of sharing revelations, Jayce smiled promissorily.

"Well, perhaps," she agreed. Deciding that Jayce, on more exigent acquaintance, might not prove worthy any proprietary prerogatives, her face set admonitorily. "If some evening a conference is not called or something should not turn up; I mean, I do not have to see anybody or there are no arrangements. But I do not go often to merely entertain myself."

"Of course."

The French sense of rite is a decorous thing to live with, endowing the mechanics of everyday significancies which, in other countries, sometimes seem easy as to be undeserving such finesse. This observance of ameliorating felicities is even apparent in the weather. On a fine Sunday, for instance, the Parisian populace ecstatically dramatizes its absence of something to do. People air their appreciation of the fall sunshine along the broad sandy avenues of the Bois: rhapsodically apostrophize the wonders of animal life in the zoo. Conscientiously appreciative crowds assiduously woo the passage of much bright time through the echoing Sunday oblivious of the Place de la Concorde and the Arc de Triomphe.

Jayce had it carefully planned: they were going to St.-Cloud to eat the view and watch the high banks swim in the last long dreams of summer. He waited at Belanova's door for this celebration which so devotedly he had earned—having waited devoutly before enough doors and anterooms in the last few weeks to have commanded rewards of unprecedented enjoyment. As soon as she opened the door, he knew that it wasn't going to be as much fun as he had hoped; then he knew that it wasn't going to be any fun. That same air of inexorable professional right claimed her attentions—which, to defeat, Jayce avowed to himself, was worse than Fedora's worldly considerations.

"My poor Jayce, say you will forgive me one more time."

"Then we can't go."

"I would love to with all my heart," she fervently breathed. "But Madame Stéphanie is working this morning and I simply must be at the studio."

Jayce had to keep his manners.

"Of course, couldn't I see you later?"

"I've got to pick up a new routine; there will be explanations. My poor boy." Her face fell condolently.

The "poor boy" was obviously routine phraseology. Belanova never

let anything interfere with her work—even, it must be said to her credit,—the work itself. Belanova was sorry; however, Jayce was too impeccable to demand much worrying about. "I would ask you to see the work," she offered, "but they do not permit outsiders——"

"Naturally." Jayce didn't like outsiders either; maybe that was it: in fact, he was getting so fed up with outsiders that he often found himself wondering how Fedora's peonies had got along in the fall heat; the dahlias must be in flower by now.

"Well, I'll pick you up tomorrow." There really, at that time, didn't seem much else that he could say. He could cancel the table at St.-Cloud by phone; but he would have to go out anyway to pay for the champagne; that was all the difference it made—another possibility of happiness.

It was turning winter in Paris, facets of life which were not expensive were harder to bear. One could sense the frugality already. The glue in artificial flowers melted in the autumn fogs and autumnal pungencies blew back to town from the Midi. He was definitely tired of taking Belanova to her lessons and leaving her there.

Pulling up between the trick shop and the conciergerie by the Théâtre Caumatin, he hesitated. It would be more expedient to know exactly what he was angry about before he began.

"So I can't come in," he said, feeling the way.

Belanova's eyes welled in owlish innocence. "But people would talk"; she sounded like a mother inventing excuses for the present which had been forgotten from a shopping trip.

"I haven't seen you half an hour since we got to Paris."

"Have we got here so long ago as that?" she expostulated. "You bring me here, and so you come at six o'clock to get me again," she wheedled.

Jayce, being unconversant with life on these terms of no matter how glamorized scuffle for existence, couldn't think of anything to say, so he said, "I don't see why, but I will."

By twenty minutes after six, his eyes were sore with querulous watching: he had had to tell himself so many times that these rendezvous were worthwhile that it was almost like inventing Belanova over and over again to be glad to see her.

Lots of faces just as pretty passed in the dusk; what promises of peculiar excitement had swung him up to Paris? It was a beautiful twilight scintillant of a city's excitement at exodus: the mysterious purposes of dusk to be fulfilled, new mornings brewing in the vistas; the arbi-

trariness of souls at home and the promise of far places over the seas, over the Channel, over the Simplon Orient. Belanova turned up at last a masterpiece of the hour, mysterious and able, under the subdued radiance of hard hours' work.

When he saw her, Jayce knew that what he wanted in her was to be identified with purposes more compelling than his own volitions. She radiated the mobilized expectancy of all these inexorable purposes; her life had been passed in rigorous apprenticeships. It seemed to Jayce that this way of hardships and effort offered salvation from the sensory exhaustions of—just life. He knew that no matter how elegant her clothes, they were less soignée than the body beneath. Knowing that no matter how intricate the tempo, it was less than the complications of her daily life, she seemed each time he met her to have stepped into a spiritual arena and Jayce's thumbs popped up automatically.

"Do you think," Belanova moved wistfully into the protective luxuries of his car, "my dear Jayce, that we could stop at Bucher's? I do so want to get those films——"

There wasn't any use poisoning the evening with violence. Though this was to have been an hour of sweetness, and something to lull the frittered hours to solacory measure, he smiled grimly and politely and only said, "Anywhere else?"

Belanova wound the twilight about her other shoulder. "I wouldn't ask you," she wheedled, "but I ask you."

"Then where would you like to go?"

Belanova beamed. "How did you know——?" She gleamed rhapsodically. "My dear Jayce, I sometimes feel that you have second sight. There is another place——"

Jayce finally put her out behind the respectabilities of Parc Monceau. All his plans were upset, all his lists were interrupted with her incessant obligations and engagements.

"Errands, rendezvous," he was half crying over vexations of life as he began to wonder if his frustrations were a universal estate. "What I'd like to do is to buy you some underwear."

Thinking laboriously to himself, "Why she's got more designs than the wolf in 'Little Red Riding Hood'—more Sunday obligations than Fedora ever had Victorian virtues," he went to her apartment to wait.

◦ IV ◦

Anyway, he'd keep on waiting. Glad of the stillness of the apartment, he corrected himself "that he didn't feel a bit as if he were snooping," and even decided to answer the bell when it rang.

"I do not know where Mademoiselle Belanova is." Jayce undulated an exasperated shriek in his voice—"Furthermore," he went on—"I don't know."

Brown-Bones unctuously dismissed the consideration of Jayce's immediate honesty. "But I just thought you might be able to direct me— that is, to give some indication of where Mademoiselle might be located at this hour."

Jayce did not relent. "If she's where she usually is," he propounded in unqualified disgust, "she's just got to see the *maître de ballet*, the photographer, the press agent, and the passport bureau; then she may stop in a few places to say 'Oh, hello!' Why not look for her there?" he pursued bitterly.

Brown-Bones spat a little over the more difficult English words, and complicated situations caused him to dribble consternately about the corners. "This relates to a most curious coincidence," he pursued persuasively.

"Too curious to be of any possible interest to one of my materialistic temperament," pronounced Jayce defensively.

Brown-Bones shifted his weight in choreographic overture to reason —"It's about Mr. Belanova," he began.

"What!"

"You see——"

"I don't see, I have never laid eyes on the man." Jayce was suddenly awfully glad that there was one; glad to find it over, as a person who has fallen downstairs is glad of the bottom. He continued with emphasized precision—"and not much of his wife either; if that's any consolation."

"I know that Mademoiselle is a very busy figure," agreed Brown-Bones apologetically.

Jayce decided that he might as well find out about things. "What does he want?" he demanded peremptorily—"Mr. Belanova?"

"Oh, I haven't seen him yet; however, he is habitually a man of very simple tastes."

"You unconscionable lunatic, you human doormat," yelled Jayce, "are you suggesting blackmail?"

Brown-Bones smiled in sweet acidity. "It might be a little complicated." Taking a swooping inventory of the apartment, he commented imperviously, "Tillyium had good taste, n'est-ce pas, Monsieur?"

Jayce wasn't hurt; he didn't have any right to be hurt and one thing which he'd never gone in for was extraneous emotions: Jayce wasn't crazy enough about the Latin races for that.

"Tillyium probably still has them."

"Time changes things," went on Brown-Bones.

"It certainly does," substantiated Jayce vehemently. "Where you're going and how to get there, for one thing; and for one other thing, time definitely makes a difference in whose business it is—will you tell Mademoiselle that I have left Paris tonight for the Midi."

Brown-Bones smiled. "Naturally, Monsieur, I would," he agreed immobilely, "but I too was about to say that I have to go back south by tomorrow and I wondered, since you were going that way anyway——"

"Yes," yelled Jayce, "but you'll have to sit in the back—every step of the way in the back."

"Of course, Monsieur."

"And you can't talk any more pigeon French to me."

Motoring from Paris to the Côte d'Azur isn't a tiring trip. Burgundy, as academically pleasing as the illustrations in a first reader, gives the impetus, and the car coasts through the tunneled arcs of feudal towers and sleepily enchanted villages. Soon the massive trees begin again to drip with time, and southern fields part with their panorama of sun-strewn reluctance. By twilight, the lugubriousness of ages swathes the deep alleys in story; roads wander vaguely in the dusk. Soon immaculate insouciances in detachments of Olympian happinesses and one is almost home.

Fedora will no doubt be willing to include him in her lists again— after all, what else is there but love and keeping alive; according to the designations of traditions of course. And Jayce will no doubt write in shaving cream on his bathroom mirror, "Don't forget not to begrudge about dinner at so-and-so——" It would be just as much fun to go along from time to time, and in the meantime, he and Fedora would find much to recommend the exciting adventurousness of life within the restraints of the social order.

ARTICLES

◇

It is difficult to evaluate the articles Zelda Fitzgerald wrote during the Twenties because they were mostly commissioned by slick magazines as celebrity pieces (wife of famous writer reveals unconventional thoughts)—indeed, two were companion pieces to articles by F. Scott Fitzgerald. Yet these personal essays do not seem as personal as her stories. The exceptions to this observation are the 1934 retrospective essays, "Show Mr. & Mrs. F. to Number———" and "Auction—Model 1934," which develop intensely private material. Unlike other jointly bylined pieces, these two appear to have been actual collaborations; but it is impossible to differentiate the contributions of Zelda and F. Scott Fitzgerald.

FRIEND HUSBAND'S LATEST

◇

I note on the table beside my bed this morning a new book with an orange jacket entitled *The Beautiful and Damned.* It is a strange book, which has for me an uncanny fascination. It has been lying on that table for two years. I have been asked to analyze it carefully in the light of my brilliant critical insight, my tremendous erudition, and my vast impressive partiality. Here I go!

To begin with, everyone must buy this book for the following aesthetic reasons: first, because I know where there is the cutest cloth-of-gold dress for only three hundred dollars in a store on Forty-second Street, and also, if enough people buy it, where there is a platinum ring with a complete circlet, and also, if loads of people buy it, my husband needs a new winter overcoat, although the one he has has done well enough for the last three years.

Now, as to the other advantages of the book—its value as a manual of etiquette is incalculable. Where could you get a better example of how not to behave than from the adventures of Gloria? And as a handy cocktail mixer nothing better has been said or written since John Roach Straton's last sermon.

It is a wonderful book to have around in case of emergency. No one should ever set out in pursuit of unholy excitement without a special vest pocket edition dangling from a string around the neck.

For this book tells exactly, and with compelling lucidity, just what to do when cast off by a grandfather or when sitting around a station platform at 4 a.m., or when spilling champagne in a fashionable restaurant, or when told that one is too old for the movies. Any of these things might come into anyone's life at any minute.

Just turn the pages of the book slowly at any of the above-mentioned trying times until your own case strikes your eye and proceed according

First appeared in the *New York Tribune,* April 2, 1922, under the heading "Mrs. F. Scott Fitzgerald Reviews 'The Beautiful and Damned,' Friend Husband's Latest."

to directions. Then for the ladies of the family there are such helpful lines as: "I like gray because then you have to wear a lot of paint." Also what to do with your husband's old shoes—Gloria takes Anthony's shoes to bed with her and finds it a very satisfactory way of disposing of them. The dietary suggestion, "tomato sandwiches and lemonade for breakfast" will be found an excellent cure for obesity.

Now, let us turn to the interior decorating department of the book. Therein can be observed complete directions for remodeling your bathroom along modern and more interesting lines, with plans for a bookrack by the tub, and a detailed description of what pictures have been found suitable for bathroom walls after years of careful research by Mr. Fitzgerald.

The book itself, with its plain green back, is admirably constructed for being read in a tub—wetting will not spoil the pages; in fact, if one finds it growing dry, simply dip the book briskly in warm water. The bright yellow jacket is particularly adapted to being carried on Fifth Avenue while wearing a blue- or henna-colored suit, and the size is adaptable to being read in hotel lobbies while waiting to keep dates for luncheon.

It seems to me that on one page I recognized a portion of an old diary of mine which mysteriously disappeared shortly after my marriage, and also scraps of letters which, though considerably edited, sound to me vaguely familiar. In fact, Mr. Fitzgerald—I believe that is how he spells his name—seems to believe that plagiarism begins at home.

I find myself completely fascinated by the character of the heroine. She is a girl approximately ten years older than I am, for she seems to have been born about 1890—though I regret to remark that on finishing the book I feel no confidence as to her age, since her birthday is in one place given as occurring in February and in another place May and in the third place in September. But there is a certain inconsistency in this quite in accord with the lady's character.

What I was about to remark is that I would like to meet the lady. There seems to have been a certain rouge she used which had a quite remarkable effect. And the strange variations in the color of her hair from cover to cover range entirely through the spectrum—I find myself doubting that all the changes were of human origin; also the name of the unguent used in the last chapter is not given. I find these aesthetic deficiencies very trying. But don't let that deter you from buying the book. In every other way, the book is absolutely perfect.

The other things that I didn't like in the book—I mean the unimpor-

tant things—were the literary references and the attempt to convey a profound air of erudition. It reminds me in its more soggy moments of the essays I used to get up in school at the last minute by looking up strange names in the *Encyclopaedia Britannica*.

I think the heroine is most amusing. I have an intense distaste for the melancholy aroused in the masculine mind by such characters as Jenny Gerhardt, Antonia and Tess (of the D'Urbervilles). Their tragedies, redolent of the soil, leave me unmoved. If they were capable of dramatizing themselves they would no longer be symbolic, and if they weren't —and they aren't—they would be dull, stupid and boring, as they inevitably are in life.

The book ends on a tragic note; in fact a note which will fill any woman with horror, or, for that matter, will fill any furrier with horror, for Gloria, with thirty million to spend, buys a sable coat instead of a kolinsky coat.* This is a tragedy unequaled in the entire work of Hardy. Thus the book closes on a note of tremendous depression and Mr. Fitzgerald's subtle manner of having Gloria's deterioration turn on her taste in coats has scarcely been equaled by Henry James.

*Kolinsky is the fur of the Asian mink, also known as red sable or Tatar sable.

EULOGY ON THE FLAPPER

◇

The Flapper is deceased. Her outer accoutrements have been be-
queathed to several hundred girls' schools throughout the country, to
several thousand big-town shopgirls, always imitative of the several
hundred girls' schools, and to several million small-town belles always
imitative of the big-town shopgirls via the "novelty stores" of their
respective small towns. It is a great bereavement to me, thinking as I
do that there will never be another product of circumstance to take the
place of the dear departed.

I am assuming that the Flapper will live by her accomplishments and
not by her Flapping. How can a girl say again, "I do not want to be
respectable because respectable girls are not attractive," and how can
she again so wisely arrive at the knowledge that "boys *do* dance most
with the girls they kiss most," and that "men *will* marry the girls they
could kiss before they had asked papa"? Perceiving these things, the
Flapper awoke from her lethargy of sub-deb-ism, bobbed her hair, put
on her choicest pair of earrings and a great deal of audacity and rouge,
and went into the battle. She flirted because it was fun to flirt and wore
a one-piece bathing suit because she had a good figure; she covered her
face with powder and paint because she didn't need it and she refused
to be bored chiefly because she wasn't boring. She was conscious that
the things she did were the things she had always wanted to do. Moth-
ers disapproved of their sons taking the Flapper to dances, to teas, to
swim, and most of all to heart. She had mostly masculine friends, but
youth does not need friends—it needs only crowds, and the more mas-
culine the crowds the more crowded for the Flapper. Of these things
the Flapper was well aware!

Now audacity and earrings and one-piece bathing suits have become
fashionable and the first Flappers are so secure in their positions that
their attitude toward themselves is scarcely distinguishable from that of

First appeared in *Metropolitan Magazine*, June 1922.

their debutante sisters of ten years ago toward *themselves*. They have won their case. They are blasé. And the new Flappers galumping along in unfastened galoshes are striving not to do what is pleasant and what they please, but simply to outdo the founders of the Honorable Order of Flappers: to outdo *everything*. Flapperdom has become a game; it is no longer a philosophy.

I came across an amazing editorial a short time ago. It fixed the blame for all divorces, crime waves, high prices, unjust taxes, violations of the Volstead Act and crimes in Hollywood upon the head of the Flapper. The paper wanted back the dear old fireside of long ago, wanted to resuscitate "Hearts and Flowers" and have it instituted as the sole tune played at dances from now on and forever, wanted prayers before breakfast on Sunday morning—and to bring things back to this superb state it advocated restraining the Flapper. All neurotic "women of thirty" and all divorce cases, according to the paper, could be traced to the Flapper. As a matter of fact, she hasn't yet been given a chance. I know of no divorcées or neurotic women of thirty who were ever Flappers. Do you? And I should think that fully airing the desire for unadulterated gaiety, for romances that she knows will not last, and for dramatizing herself would make her more inclined to favor the "back to the fireside" movement than if she were repressed until age gives her those rights that only youth has the right to give.

I refer to the right to experiment with herself as a transient, poignant figure who will be dead tomorrow. Women, despite the fact that nine out of ten of them go through life with a deathbed air either of snatching-the-last-moment or with martyr-resignation, do not die tomorrow—or the next day. They have to live on to any one of many bitter ends, and I should think the sooner they learned that things weren't going to be over until they were too tired to care, the quicker the divorce court's popularity would decline.

"Out with inhibitions," gleefully shouts the Flapper, and elopes with the Arrow-collar boy that she had been thinking, for a week or two, might make a charming breakfast companion. The marriage is annulled by the proverbial irate parent and the Flapper comes home, none the worse for wear, to marry, years later, and live happily ever afterwards.

I see no logical reasons for keeping the young illusioned. Certainly disillusionment comes easier at twenty than at forty—the fundamental and inevitable disillusionments, I mean. Its effects on the Flappers I have known have simply been to crystallize their ambitious desires and give form to their code of living so that they *can* come home and live happily ever afterwards—or go into the movies or become social service "work-

ers" or something. Older people, except a few geniuses, artistic and financial, simply throw up their hands, heave a great many heart-rending sighs and moan to themselves something about what a hard thing life is—and then, of course, turn to their children and wonder why they don't believe in Santa Claus and the kindness of their fellow men and in the tale that they will be happy if they are good and obedient. And yet the strongest cry against Flapperdom is that it is making the youth of the country cynical. It is making them intelligent and teaching them to capitalize their natural resources and get their money's worth. They are merely applying business methods to being young.

DOES A MOMENT OF REVOLT COME SOMETIME TO EVERY MARRIED MAN?

◊

After every dress I buy for which I pay twenty-five dollars more than I am allowed, after every washday when his woolen socks come up from the laundry two inches smaller because I forgot to buy stretchers for them, and after every meal during which I ask him to please eat more vegetables because so much meat is not good for him, I suspect my husband of instantaneous and insuppressible revolt. Then I crawl to him on apologetic knees begging him please not to act like the man in *Cytherea** and making rash and frantic promises to sew all the buttons on all his pajamas and to rub his back for an hour if he will please not revolt just this once. But, theoretically, I believe that every happy bridegroom revolts at the altar and from then on goes revolting through life with varying degrees of violence until his final revolt against life helps him briskly to extinguish himself. Men seldom seem to realize that taking a wife and assuming the responsibility of living to an overripe old age are generally merely simultaneous and not absolutely connected. The thought in their minds of what they might have been had they never married is, in most cases, incentive enough for a revolt a week— to give a minimum estimate.

My bookshelves have recently become inhabited by numbers of charming male characters who are bent upon insidious and incomprehensible revolt. From modern fiction I have learned that even a perfect husband may leave home without a moment's notice in search of gin or the Holy Grail, so I have turned propagandist. If I were a husband I

First appeared in *McCall's*, March 1924. One of seventeen responses to the question, including F. Scott Fitzgerald's.
Cytherea, 1922 novel by Joseph Hergesheimer.

would certainly revolt whenever my wife hurried me with my dressing so that I got wrong studs and forgot my handkerchief and then kept me waiting. I would also revolt if she refused to allow me to cook eggs in the kitchen after midnight because the servants didn't like it. But I would never indulge in a strong silent revolt, and I would most emphatically do all my revolting at home.

WHAT BECAME
OF THE FLAPPERS?

◇

Flapper wasn't a particularly fortunate cognomen. It is far too reminiscent of open galoshes and covered-up ears and all other proverbial flapper paraphernalia, which might have passed unnoticed save for the name. All these things are—or were—amusing externals of a large class of females who in no way deserve the distinction of being called flappers. The flappers that I am writing this article about are a very different and intriguing lot of young people who are perhaps unstable, but who are giving us the first evidence of youth asserting itself out of the cradle. They are not originating new ideas or new customs or new moral standards. They are simply endowing the old ones that we are used to with a vitality that we are not used to. We are not accustomed to having *our* daughters think our ideas for themselves, and it is distasteful to some of us that we are no longer able to fit the younger generation into our conceptions of what the younger generation was going to be like when we watched it in the nursery. I do not think that anything my daughter could possibly do eighteen years from now would surprise me. And yet I will probably be forbidding her in frigid tones to fly more than three thousand feet high or more than five hundred miles an hour with little Willie Jones, and bidding her never to go near that horrible Mars. I can imagine these things now, but if they should happen twenty years from now, I would certainly wonder what particular dog my child was going to. . . .

The flapper springs full-grown, like Minerva, from the head of her once-déclassé father, Jazz, upon whom she lavishes affection and reverence, and deepest filial regard. She is not a "condition arisen from war

First appeared in *McCall's*, October 1925. Published with F. Scott Fitzgerald's "Our Young Rich Boys" under the joint title "What Becomes of Our Flappers and Our Sheiks?" by F. Scott Fitzgerald and Zelda Sayre Fitzgerald.

unrest," as I have so often read in the shower of recent praise and protest which she has evoked, and to which I am contributing. She is a direct result of the greater appreciation of beauty, youth, gaiety, and grace which is sweeping along in a carmagnole (I saw one in a movie once, and I use this word advisedly) with our young anti-puritans at the head. They have placed such a premium on the flapper creed—to give and get amusement—that even the dumbbells become Dulcies and convert stupidity into charm. Dulcy* is infinitely preferable to the kind of girl who, ten years ago, quoted the *Rubáiyát* at you and told you how misunderstood she was; or the kind who straightened your tie as evidence that in her lay the spirit of the eternal mother; or the kind who spent long summer evenings telling you that it wasn't the *number* of cigarettes you smoked that she minded but just the *principle,* to show off her nobility of character. These are some of the bores of yesterday. Now even bores must be original, so the more unfortunate members of the flapper sect have each culled an individual line from their daily rounds, which amuses or not according to whether you have seen the same plays, heard the same tunes, or read reviews of the same books.

The best flapper is reticent emotionally and courageous morally. You always know what she thinks, but she does all her feeling alone. These are two characteristics which will bring social intercourse to a more charming and more sophisticated level. I believe in the flapper as an involuntary and invaluable cupbearer to the arts. I believe in the flapper as an artist in her particular field, the art of being—being young, being lovely, being an object.

For almost the first time we are developing a class of pretty yet respectable young women, whose sole functions are to amuse and to make growing old a more enjoyable process for some men and staying young an easier one for others.

Even parents have ceased to look upon their children as permanent institutions. The fashionable mother no longer keeps her children young so that she will preserve the appearance of a debutante. She helps them to mature so that she will be mistaken for a stepmother. Once her girls are old enough to be out of finishing school a period of freedom and social activity sets in for her. The daughters are rushed home to make a chaotic debut and embark upon a feverish chase for a husband. It is no longer permissible to be single at twenty-five. The flapper makes

*Dulcy, the title character in the 1921 play by Marc Connelly and George S. Kaufman, is a featherbrained young wife.

haste to marry lest she be a leftover and be forced to annex herself to the crowd just younger. She hasn't time to ascertain the degree of compatibility between herself and her fiancé before the wedding, so she ascertains that they will be separated if the compatibility should be mutually rated zero after it.

The flapper! She is growing old. She forgets her flapper creed and is conscious only of her flapper self. She is married 'mid loud acclamation on the part of relatives and friends. She has come to none of the predicted "bad ends," but has gone at last, where all good flappers go— into the young married set, into boredom and gathering conventions and the pleasure of having children, having lent a while a splendor and courageousness and brightness to life, as all good flappers should.

BREAKFAST

◇

See if there is any bacon, and if there is, ask the cook which pan to fry it in. Then ask if there are any eggs, and if so try and persuade the cook to poach two of them. It is better not to attempt toast, as it burns very easily. Also in the case of bacon, do not turn the fire too high, or you will have to get out of the house for a week.

Serve preferably on china plates, though gold or wood will do if handy.

First appeared in *Favorite Recipes of Famous Women* (New York & London: Harper & Brothers, 1925) under the by-line "Mrs. F. Scott Fitzgerald, Wife of the author of 'The Beautiful and Damned,' 'The Jazz Age,' etc."

THE CHANGING BEAUTY
OF PARK AVENUE

◊

Beginning in the pool of glass that covers the Grand Central tracks, Park Avenue flows quietly and smoothly up Manhattan. Windows and prim greenery and tall, graceful, white façades rise up from either side of the asphalt stream, while in the center floats, impermanently, a thin series of watercolor squares of grass—suggesting the Queen's Croquet Ground in *Alice in Wonderland*.

It is a street for satisfied eyes. A street of unity where one may walk and brood without being distracted by one's own curiosity. Through the arches and open gates one sees paved courtyards big enough to convey a cloistered, feudal feeling. It is the guarantee made by realty barons that people under their protection will always have enough air—and always morning air. For Park Avenue has the essence of a pen-and-ink drawing of Paris. In the morning, when it is hot noon and lunch hour on Fifth Avenue it is still nine o'clock on Park. Even the crisp, translucent New York twilight, hovering high above the city, seems here to drift along in order to conceal the missing afternoon.

There has never been a faded orchid on Park Avenue. And yet this is a masculine avenue. An avenue that has learned its attraction from men—subdued and subtle and solid and sophisticated in its understanding that avenues and squares should be a fitting and sympathetic background for the promenades of men.

In the bright gusty mornings, Park Avenue is animated with sets of children, slim and fashionable, each set identically dressed and chaperoned by white and starched English nurses or blue-flowing French nurses or black and white maids. They clutch in gloved hands the things

First appeared in *Harper's Bazaar*, January 1928. Published as by Zelda and F. Scott Fitzgerald, but credited to Zelda in his *Ledger*.

that children carry only in illustrations and in the Bois de Boulogne and in Park Avenue: hoops and Russian dolls and tiny Pomeranians.

There is a lightness about these mornings. Nobody has ever asked a geographical question on Park Avenue. It is not "the way" to anywhere. It exists, apparently, solely because millionaires have decided that life on the grand scale in a small space is only possible with as tranquil and orderly a background as this long, blond, immaculate route presents. It is a fitting resting place for the fine and glittering automobiles that browse the curbstones under the patronage of gilded concierges. Even the traffic here is aloof and debonair with an inch more freedom than it enjoys in other streets, and seems to progress by a series of hundred-yard dashes. Taxi-chauffeurs wave gaily as they rush by with empty cabs—the result of too much morning air and too much reading of the Social Register; and newsboys roller-skate under the smartest motors.

High in the air float green-blue copper roofs, like the tips of castles rising from the clouds in fairy tales and cigarette advertisements, fragile points and crags and sturdy shelves suspended on a fortress. There is even the drawbridge in the Grand Central runway, so that sweeping off into the Avenue one experiences the emotion of entering a stronghold —the stronghold of easy wealth.

Little shops, like sections of a glass-fronted dolls' house, nestle in the corners along the lower avenue—shops of the boudoir sort, where one may buy an apple with as much ritual as if it were the Ottoman Empire, or a limousine as carelessly as if it were a postage stamp. These crystalline shops, lying shallow against buildings, exist on sufferance so long as they are decorative.

Park Avenue is first the New Yorker's street. It is full of nuances and suggestions of all New York, but they are shaped and molded into an etched pattern. There are disciplined, cool smells—the smell of hot motors and gusty dust—of violets and brass buttons—globular lights through an apologetic mist—gay awnings in the rarefied sunlight— Sunday bells and rows and rows of icy windows. It is the place to walk, which means that it is an international street—where the tradespeople are accustomed to a clientele who need nothing, want nothing, and buy freely because they have large leisure and filled purses. Here shopping is pleasant and expensive and holy. There are foreign chemists with remedies for French-speaking germs, and Dutch florists with bulbs grown only on dikes; and there are corners stuffed with hunting-print hatboxes. Yet there is none of the atmosphere of the bazaar that colors Madison Avenue a block away. These shops are yourself in Paris—in Rome—wherever you'd like to be, without being incontestably re-

minded that you are somewhere else. It is a street for strutting. It is a street for luncheon in impeccable French restaurants. It is a street to use when in a hurry, and it is a street for dawdling down. It is a street to have friends on at teatime. I suppose a street could be other things . . . but in the immortal words of Ring Lardner, "What of it?"

Late at night, dignity departs not from the reproachless lane. It even lends a majesty to the great revolving broom that polishes away imaginary dirt between the hours of three and five—invests the functioning of the Street Cleaning Department with the isolated and pink-lit smallness of a Whistler London night. Occasionally a flying police car or sometimes a fire engine tears past, lost in the black and misty light before the sound is out of your ears—mysterious night riders hastening to a destiny other than their own, disturbing the peace of a street too alert ever to give a sense of repose.

At one time we have known in a single apartment house, a moving-picture star, an heiress, a famous amateur athlete, a publisher, an author, and a friend. It was very convenient and we were sorry when cornice trouble or a delinquent summer or bankruptcy caused them to scatter along the street. Such is this flaming street—widened now until it has become the most colossal thoroughfare in flaming Manhattan. It is known the world over. And yet we heard a well-groomed and cosmopolitan-looking young lady say one day, "Oh yes, that's the street next to Madison, isn't it?" And she lived in New York!

LOOKING BACK
EIGHT YEARS

◇

In those years of panic during and immediately after the war, age became a sort of caste system, so that all people of the same number of years were automatically antagonistic to all others. Perhaps it was the civil effect of draft laws and perhaps it was because the days were so full around that time that each additional year of age seemed like an added century of emotional experience. Even the knitting of gray wool socks and the packing of Red Cross boxes was regulated by ages. The lowest of all these strata, the boys and girls who were just too young to go to France, blossomed out shortly afterwards as the Younger Generation. Even so late as a year ago people's attitudes and animosities toward a generation prematurely forced to maturity furnished an astounding amount of newspaper copy.

The jazz and the petting parties with which that generation "tapered off" have become the custom of the country and the world has become interested in more mature crimes. Now that we have recovered our equilibrium we see again the superior attraction of the ax murder as opposed to the mythical checked corset, and the newest generation of young people is being born full-grown, parroting forth the ideas of President Coolidge or of H. L. Mencken in the rhythmic meters of Lloyd Mayer.[1]

What has become of the youth which for so many years bore the blame for everything except the Prohibition Amendment, now that they are turning thirty and receiving the portions of responsibility doled out as we pass that landmark? For by that time one has either earned the right to take chances or established himself as indispensable in some routine.

First appeared in *College Humor*, June 1928. Published as by F. Scott Fitzgerald, but credited to Zelda in his *Ledger*.

1. Lloyd Mayer, author of *Just Between Us Girls* (1927).

As a matter of fact, the increasing importance of the youngest war generation is a constant surprise. If this, in some measure, is due to the inevitable vacancies left as others move on, it is also the result of a sort of debonair desperation—a necessity for forcing the moments of life into an adequacy to the emotions of ten years ago. The men who at twenty-one led companies of two hundred must, it seems to us, feel an eternal letdown from a time when necessity and idealism were one single thing and no compromise was ever necessary. That willingness to face issues, a relic of ten years ago, is perhaps the explanation of some of the unrest and dissatisfaction of today. With millions of young people ready to "face things" with so much personal feeling, I can think of nothing short of another national crisis which would furnish strong enough material to unify and direct such valiant insistence upon essentials.

Success was the goal for this generation and to a startling extent they have attained it, and now we venture to say that, if intimately approached, nine in ten would confess that success is only a decoration they wished to wear: what they really wanted is something deeper and richer than that. An habituation to enormous effort during the years of the war left a necessity for trials and tests on them.

It was not only the war. The war was merely a heightening and hurrying forward of the inevitable reaction against the false premises doled out to their children by the florid and for the most fatuous mothers of the Nineties and the early 1900s, parents who didn't experience the struggles and upheavals of the Sixties and Seventies and had no inkling of the cataclysmic changes the next decade would bring. Children were safe in the world, and producing them apparently ended the mother's responsibility. With the streets free from automobiles and morals free from movies and, in a large portion of America, corners already free from saloons, what did it matter what these children thought as they lay awake on warm summer nights straining to catch the cries of newsboys about the attempted assassination of Roosevelt and the victory of Johnson at Reno?[2] It was a romantic time to be a child, to be old enough to feel the excitement being stored up around them and to be young enough to feel safe. Formed in such a period of pregnant placidity, left free to wonder and dream in a changing age with little or no pressure exerted upon them by life, it is not amazing that when time, having brought everything else out of the hat, produced his *pièce de*

2. Jack Johnson defeated James J. Jeffries at Reno, Nevada, on July 4, 1910, thereby becoming the first black heavyweight champion.

résistance, the war, these children realized too soon that they had seen the magician's whole repertoire. This was the last piece of wizardry they believed in, and now, nearing middle age and the period when they are to be the important people of the world, they still hope wistfully that things will again have the magic of the theater. The Teapot Dome[3] and Mrs. Snyder[4] and the unspeakable Forbes[5] do not quite fill the gap.

It is not altogether the prosperity of the country and the consequent softness of life which have made them unstable, for almost invariably they are tremendously energetic; there has never been a time when so many positions of importance have been occupied by such young men or when the pages of newspapers and anthologies have borne the names of so many people under thirty. It is a great emotional disappointment resulting from the fact that life moved in poetic gestures when they were younger and has now settled back into buffoonery. And with the current insistence upon youth as the finest and richest time in the life of man it is small wonder that sensitive young people are haunted and harassed by a sense of unfilled destiny and grope about between the ages of twenty-five and forty with a baffled feeling of frustration. The philosophy with which most of the adolescents were equipped implied that life was a truncated affair ceasing abruptly with the twenty-first birthday, and it is hardly of enough stamina to serve an age in which so many have tasted the essence of life—which is death—just as a balloon is biggest when it bursts. From those inflated years to being concerned over whether the most oil or gold was stolen from the government is a difficult adjustment, but perhaps the cynicism with which the war generation approaches general affairs will eventually lead to a more intelligent attitude—even in the dim future to actual social interest.

Perhaps it is that we are still feeling the relaxation of the postwar years, but surely some of this irony and dissatisfaction with things supposedly solid and secure proceeds from the fact that more young people in this era were intense enough or clever enough or sensitive or shrewd enough to get what they wanted before they were mature enough to want the thing they acquired as an end and not merely as a proof of themselves. Perhaps we worked too much over man as the individual,

3. In 1922, Secretary of the Interior Albert B. Fall secretly leased naval oil reserves at Teapot Dome, Wyoming, to Harry F. Sinclair.

4. Ruth Snyder, together with her lover, Judd Gray, was executed in New York for the 1927 murder of her husband.

5. Possibly the pioneering business magazine publisher and capitalist advocate Bertie Charles Forbes (1880–1954).

so that his capabilities are far superior to the problems of life, and now we have endless youth of a responsible age floundering about in a morass of unused powers and feeling very bitter and mock-heroic like all people who think the element of chance in their lives should have been on a bigger scale. Outside of war men of the hour haven't had a romantic opportunity near home since the last gold rush and a great proportion of young men feel that their mental agility or physical prowess can never be really measured in situations of their own making. This has perhaps been true of all times but it is more pronounced now that emergencies have, faced with the tremendous superiority of modern youth, lost their dignity as acts of God and been definitely relegated to the category of human inefficiency, if they are recognized at all.

We wonder if that is because a whole generation accustomed itself to a basic feeling that there are two ways to be: dead and alive, preferably alive and probably dead. So that now the nuances and gradations of society in general seem of the same importance as the overtones of society in particular; sauce and trimmings make better eating than the meat. And we predict a frightful pandemonium to eat it in unless indeed every generation has gone through the same difficulties of adjustment. It may be that this one is simply more expressive. Oddly enough we have but one set of contemporaries. It has always surprised us that whether there is a war or not we will always be of the war generation and we will always have unclarified ways of reacting, privy only to ourselves.

WHO CAN FALL IN LOVE
AFTER THIRTY?

◇

As maturity forces order and segregation upon human lives love falls naturally into place as a habit, or it doesn't exist at all.

A person who ever since the age of twenty has been wooing sleep through a succession of half-remembered but significant faces, might conceivably do some of his most powerful loving after thirty, but for those less romantic—no. If there is an hour or two in the course of the day which has been habitually passed since the impressionable years in nebulous and undeliberate speculation upon the romantic, the chances are that the victim of this attitude, upon being presented with a member of the opposite sex possessed of necessary vibration, will succumb whether he be twenty-four or going on eighty-seven.

On the other hand, a man who has never fitted himself into any moving picture save the films of Tom Mix, or whose waking dreams have always been of empire, is likely to approach the mating impulse with self-control and suspicion, because it is not identified in his mind with those roseate eventualities which we promise ourselves as rewards. He soon finds that the face of his lady, no matter how enamored he is, and his plans and schedules are not intermingled. The lady is something extra which is not the reality of his life. The lady loses.

But where the habit of being in love is of long enough standing to leave a vacancy when love itself has gone the way of all flesh, the patient notoriously becomes susceptible to a grand passion, as has been the case of so many real and fictitious men on the rebound, neglected husbands or wives, ex-consorts of Nat Goodwin[1] and any maharaja seeing Paris for the first time.

First appeared in *College Humor,* October 1928. Published as by F. Scott and Zelda Fitzgerald, but credited to Zelda in his *Ledger.*
 1. Nat Goodwin (1857–1919), comedian and actor.

All the "it" in all the works of Elinor Glyn[2] has not been responsible for one-fifth of the undying passions inspired by the fact that boys of twenty and girls of eighteen have little to brood about except each other and can, with admirable dexterity, fit any name into a popular song, any photograph into their favorite frame.

People who realize young that emotions are measured by their depth and not by how long they last are not likely to abandon the excitement and promise that lies in emotional flights when they reach an age which can afford indiscretion, because sentimental affairs are progressive and the habitual lover approaches each succeeding one believing himself endowed by past experience with the clarity, wisdom, and poetry requisite to make this last the love of his life. At ninety he is probably still feeling a vague sense of frustration that his own willingness has met with no adequate entanglement, and contemplating a companionate marriage with his trained nurse. Passion is no less real for the fact that it is repetition. In fact, as years and events press in and fill life with an accumulation of tastes, and a knowledge of how to indulge them, an amorous attachment seems to prove its virility by its mere recognition.

That life is ordinarily so highly organized by the time one is thirty that the intrusion of any unexpected force is more easily controlled and disciplined does not mean that the force is less profound. Younger people in love usually have not got away from the sense of being taken care of, and feel more necessity for human and binding contact. By the time a man has blundered confusedly into the age of responsibilities, he has realized that the qualities he sought in people he found most satisfactorily understandable in himself, that his most vital contacts lay in a community of working interests, that the mystery he thought lay in people was in reality his own wonder and bewilderment—and so if he has passed the thirty mark without a walk down a beribboned aisle, he is not likely to tread it impetuously later. Men are by then familiar with the sacred smell of greenish lilies and wary of the fashionable suckings of organ pipes.

But they remain capable if not voluntary candidates for falling, first, aesthetically in love and, second, curiously in love (which is different from the mystery quality of young emotion), or third, possessively in love, when they feel they have met a paragon with whom it is flattering to be seen, and fourth, advisedly in love for quite worldly reasons.

The one passion that does not exist for the men of forty is the bom-

2. Elinor Glyn (1864–1943), English novelist, author of *Three Weeks* (1907), who was responsible for defining "it" as sex appeal.

bastic, reckless, uncalculated, uncompromising one mostly responsible
for adolescent marriages. Their horizon has broadened, their energies
are spread over a wider field, they have learned to discipline and weigh
their impulses toward adventure. The whole varied glamour of existence
can no longer be concentrated at will into another person, but that does
not mean the urge toward the one of their choosing is less sincere. The
measure of a man's tenderness cannot be taken by how violently he
yields to it because he will yield according to his necessity to annex the
object of his passion—and a full life naturally feels that necessity less.

Nevertheless it is the loves over thirty that have, as proof of their
vitality, led to operas and Anna Karenina and the recent recipes in the
Daily News for cooking Ruth Snyder.[3]

Perhaps the often public character of adult philanderings leads to a
belief that they are abnormalities, but it is they are too recurrent to be
the exceptions to the rule. The fact that mature emotional response soon
reduces itself to essentials does not mean that it is of a different quality
from youthful enthusiasm in a like direction—it simply means that the
means of expression are different. One's vocabulary changes much more
than what one has to say. Perhaps the loyalty to the lyricism of some
young forgotten love affair may help keep some men free, or the natural
skepticism which accumulates with the years, or lack of money.

But while one of these may suffice to make the church door look the
black hole of Calcutta to a man of the "about town" age, not all of them
together could stop his redecorating his apartment, or changing his hair-
cut, or making any of those personal adjustments that he bravely thinks
he makes to please himself when he comes in contact with a girl who
suggests to him the things he likes: the top of the Alps or the Ritz Bar
or Mother's pancakes or achievement.

It seems to us that at thirty, the haze of youth having lifted a little,
emotions are stronger for their clarity, more definite for the fact that by
then they have a category, a place where they belong—for the same
reasons that wine in a bottle with a year is better than wine on tap; and
if it is more costly and intoxicating, well, maybe that's why people drink
less of it!

3. Ruth Snyder and her lover, Judd Gray, were executed in New York for the 1927
murder of her husband.

PAINT AND POWDER

◇

Did you ever interrupt an invective against the rouge pot and the marcel iron to ask by what means the venerable speaker attracted beaux back in the Nineties? She might not confess to a dampened red ribbon scrubbed on her cheeks "innocent of paint" or to nights of agony spent tossing about on little lumps of curlpapers with sugared water dripping down her forehead. Today there isn't time for gathering rose leaves to make cold cream and no necessity for dying of lead poisoning like Lady Hamilton.* The cleverest chemists are employed in purifying and harmonizing powders and rouges, soaps and creams, for the express purpose of making safe the correction of nature's shortcomings.

The moralists who still shout, though somewhat feebly, that facial embellishment is the mark of a questionable woman, that it is a shameful waste of money that might be used to convert the Chinese to Christianity, radio, and world wars, that it is unnatural and sinful, have perhaps forgotten that, with prosperity and power, comes art, the desire for beauty, the taste for the decorative. More pretty girls and prettier, until all America becomes like Hollywood where Venus shows you your seat in the theater and Salome checks your hat and coat.

All women can't be classic beauties, but almost any young woman can be pleasant to the eye. The competition is heavy and in the open. Man is vain of his accomplishments, he has never apologized for the fact that he is strong or clever, that he has made a fortune or invented a good mousetrap. If a girl is a better facial draftsman than her neighbor, why shouldn't the world make a beaten path to her door?

Rouge means that women want to choose their man—not take what lives in the next house. Paint and powder do not prove the sensuality of an era—rather on the contrary, they are a refinement, a choice ele-

First appeared in *The Smart Set,* May 1929. Published as by F. Scott Fitzgerald, but credited to Zelda in his *Ledger.* The article was written by her for *Photoplay* in 1927, but not published there.
 *Emma, Lady Hamilton, Lord Nelson's mistress.

ment of the stark sex factor. If we like veils, better a rosy one than a black! Why not bright cheeks and varicolored clothes as a sign that the women are as vital and vivid as the billboards, the beach parasols, the one hundred–story buildings, the gasoline stations, and the prosperous skies. Paleness today is just as iconoclastic as rouge was twenty years ago—let us be grateful for the mascara and red paste which keeps young girls and old ladies in tune with their atmosphere.

Almost all the superfluous wealth of America goes into display. If this is decadence, make the most of it—but I should think the sign of decadence would be surfeit, and not a lust for more and more—more of those delicate luxuries that account for twenty billion dollars a year of the wealth of the United States, more doodads, jimcracks, fads, fashions, fooleries, and fripperies, the making of which keeps thousands of workers in Fords and radios—more of those things that must make up to Americans by tinsel brightness for the Louvre, the family homestead and the outdoor restaurant—for the poppies of France, for the poplars of Lombardy, and the pink lights of Paris.

If our young women were to give up decorating themselves, we would have real cause to worry over the future of this country! We might then have some reason to speculate on decadence, for when women cease wanting to please there usually comes a withering of the spirit. Look back over the pages of history and see how the loveliness of women has always spurred men—and nations—on to great achievement! Perhaps at times the achievement has been misguided, perhaps eyes have been blinded by too much beauty. But the desire to do tremendous things, whether that desire be misguided or not, stands, after all, for progress.

Helen of Troy started a war because of her feminine charm and, though nations were torn, she made history.... Marie Antoinette went to extremes in the matter of extravagance and self-decoration, and lost her head because of it. But across the years she stands for an example of daintiness and luxury and pretty things, whereas many a plain woman, who died in her bed at the age of eighty, is quite forgotten.

Try to think of some woman who was without charm—some woman who made a place for herself in world history! There have been women who were not pretty, who have swayed hearts and empires, but these women undoubtedly tried to embellish their plainness with whatever means came to hand. They did not disdain that thing for which paint and powder stands. They wanted to choose their destinies—to be successful competitors in the great game of life.

This country needs its quota of beauty, and if we cannot get it from our young women, where will we find it?

And so if our women gave up decorating themselves we would have time to turn sad eyes on the bleak telegraph wires, the office buildings, like homes of trained fleas, the barren desolateness of city streets at dusk, and realize too late that almost the only beauty in this busy, care-less land, whose every acre is littered with the waste of day before yesterday, is the gorgeous, radiant beauty of its girls.

SHOW MR. AND MRS. F.
TO NUMBER——

◇

° 1920 °

We are married. The sibylline parrots are protesting the sway of the first bobbed heads in the Biltmore paneled luxe. The hotel is trying to look older.

The faded rose corridors of the Commodore end in subways and subterranean metropolises—a man sold us a broken Marmon and a wild burst of friends spent half an hour revolving in the revolving door.

There were lilacs open to the dawn near the boardinghouse in Westport where we sat up all night to finish a story. We quarreled in the gray morning dew about morals; and made up over a red bathing suit.

The Manhattan took us in one late night though we looked very young and gay. Ungratefully we packed the empty suitcase with spoons and the phone book and a big square pincushion.

The Traymore room was gray and the chaise longue big enough for a courtesan. The sound of the sea kept us awake.

Electric fans blew the smell of peaches and hot biscuit and the cindery aroma of traveling salesmen through the New Willard halls in Washington.

But the Richmond hotel had a marble stair and long unopened rooms and marble statues of the gods lost somewhere in its echoing cells.

At the O. Henry in Greensboro[1] they thought a man and wife ought not to be dressed alike in white knickerbockers in 1920 and we thought the water in the tubs ought not to run red mud.

Next day the summer whine of phonographs billowed out the skirts

First appeared in Esquire, May–June 1934. Published as by F. Scott and Zelda Fitzgerald, but credited to Zelda in his Ledger. Previously collected in The Crack-Up (1945).

First appeared in *Esquire*, May–June 1934. Published as by F. Scott and Zelda Fitzgerald, but credited to Zelda in his *Ledger*. Previously collected in *The Crack-Up* (1945).

1. The *Esquire* text read "Greensville," but the O. Henry Hotel was in Greensboro, North Carolina.

of the Southern girls in Athens. There were so many smells in the drugstores and so much organdy and so many people just going somewhere. . . . We left at dawn.

<p style="text-align:center">° 1921 °</p>

They were respectful in the Cecil in London; disciplined by the long majestuous twilights on the river and we were young but we were impressed anyway by the Hindus and the royal processions.

At the St-James and Albany in Paris we smelled up the room with an uncured Armenian goatskin and put the unmelting "ice cream" outside the window, and there were dirty postcards, but we were pregnant.

The Royal Danieli in Venice had a gambling machine and the wax of centuries over the windowsill and there were fine officers on the American destroyer. We had fun in a gondola feeling like a soft Italian song.

Bamboo curtains and an asthma patient complaining of the green plush and an ebony piano were all equally embalmed in the formal parlors of the Hôtel d'Italie in Florence.

But there were fleas on the gilded filigree of the Grand Hôtel in Rome; men from the British embassy scratched behind the palms; the clerks said it was the flea season.

Claridge's in London served strawberries in a gold dish, but the room was an inside room and gray all day, and the waiter didn't care whether we left or not, and he was our only contact.

In the fall we got to the Commodore in St. Paul, and while leaves blew up the streets we waited for our child to be born.

<p style="text-align:center">° 1922–1923 °</p>

The Plaza was an etched hotel, dainty and subdued, with such a handsome headwaiter that he never minded lending five dollars or borrowing a Rolls-Royce. We didn't travel much in those years.

<p style="text-align:center">° 1924 °</p>

The Deux Mondes in Paris ended about a blue abysmal court outside our window. We bathed the daughter in the bidet by mistake and she

drank the gin fizz thinking it was lemonade and ruined the luncheon table next day.

Goat was to eat in Grimm's Park Hotel in Hyères, and the bougainvillea was brittle as its own color in the hot white dust. Many soldiers loitered outside the gardens and brothels listening to the nickelodeons. The nights, smelling of honeysuckle and army leather, staggered up the mountainside and settled upon Mrs. Edith Wharton's garden.

At the Ruhl in Nice we decided on a room not facing the sea, on all the dark men being princes, on not being able to afford it even out of season. During dinner on the terrace, stars fell in our plates, and we tried to identify ourselves with the place by recognizing faces from the boat. But nobody passed and we were alone with the deep blue grandeur and the *filet de sole Ruhl* and the second bottle of champagne.

The Hôtel de Paris at Monte Carlo was like a palace in a detective story. Officials got us things: tickets and permissions, maps and newly portentous identities. We waited a good while in the formalized sun while they fitted us out with all we needed to be fitting guests of the Casino. Finally, taking control of the situation, we authoritatively sent the bellboy for a toothbrush.

Wistaria dripped in the court of the Hôtel d'Europe at Avignon and the dawn rumbled up in market carts. A lone lady in tweeds drank martinis in the dingy bar. We met French friends at the Taverne Riche and listened to the bells of late afternoon reverberate along the city walls. The Palace of the Popes rose chimerically through the gold end of day over the broad still Rhône, while we did nothing, assiduously, under the plane trees on the opposite bank.

Like Henri IV, a French patriot fed his babies red wine in the Continental at St-Raphaël and there were no carpets because of summer, so echoes of the children's protestations fell pleasantly amidst the clatter of dishes and china. By this time we could identify a few words of French and felt ourselves part of the country.

The Hôtel du Cap at Antibes was almost deserted. The heat of day lingered in the blue and white blocks of the balcony, and from the great canvas mats our friends had spread along the terrace we warmed our sunburned backs and invented new cocktails.

The Miramare in Genoa festooned the dark curve of the shore with garlands of lights, and the shape of the hills was picked out of the darkness by the blaze from the windows of high hotels. We thought of the men parading the gay arcades as undiscovered Carusos, but they all assured us that Genoa was a business city and very like America and Milan.

We got to Pisa in the dark and couldn't find the leaning tower until we passed it by accident leaving the Royal Victoria on our way out. It stood stark in a field by itself. The Arno was muddy and not half as insistent as it is in the crossword puzzles.

Marion Crawford's[2] mother died in the Quirinal Hotel at Rome. All the chambermaids remember it and tell the visitors about how they spread the room with newspapers afterwards. The sitting rooms are hermetically sealed and palms conceal the way to open the windows. Middle-aged English doze in the stale air and nibble stale-salted peanuts with the hotel's famous coffee, which comes out of a calliope-like device for filling it full of grounds, like the glass balls that make snowstorms when shaken.

In the Hôtel des Princes at Rome we lived on Bel Paese cheese and Corvo wine and made friends with a delicate spinster who intended to stop there until she finished a three-volume history of the Borgias. The sheets were damp and the nights were perforated by the snores of the people next door, but we didn't mind because we could always come home down the stairs to the Via Sistina, and there were jonquils and beggars along the way. We were too superior at that time to use the guidebooks and wanted to discover the ruins for ourselves, which we did when we had exhausted the nightlife and the marketplaces and the campagna. We liked the Castello Sant'Angelo because of its round mysterious unity and the river and the debris about its base. It was exciting being lost between centuries in the Roman dusk and taking your sense of direction from the Colosseum.

° 1925 °

At the hotel in Sorrento we saw the tarantella, but it was a *real* one and we had seen so many more imaginative adaptations....

A southern sun drugged the court of the Quisisana to somnolence. Strange birds protested their sleepiness beneath the overwhelming cypress while Compton Mackenzie told us why he lived in Capri: Englishmen must have an island.

The Tiberio was a high white hotel scalloped about the base by the rounded roofs of Capri, cupped to catch rain which never falls. We climbed to it through devious dark alleys that house the island's Rembrandt butcher shops and bakeries; then we climbed down again to the

2. American novelist F. Marion Crawford.

dark pagan hysteria of Capri's Easter, the resurrection of the spirit of the people.

When we got back to Marseilles, going north again, the streets about the waterfront were bleached by the brightness of the harbor and pedestrians gaily discussed errors of time at little cafés on the corner. We were so damn glad of the animation.

The hotel in Lyons wore an obsolete air and nobody ever heard of Lyonnaise potatoes and we became so discouraged with touring that we left the little Renault there and took the train for Paris.

The Hôtel Florida had catacornered rooms; the gilt had peeled from the curtain fixtures.

When we started out again after a few months, touring south, we slept six in a room in Dijon (Hôtel du Dump, Pens. from 2 frs. Pouring water) because there wasn't any other place. Our friends considered themselves somewhat compromised but snored toward morning.

In Salies-de-Béarn in the Pyrenees we took a cure for colitis, disease of that year, and rested in a white pine room in the Hôtel Bellevue, flush with thin sun rolled down from the Pyrenees. There was a bronze statue of Henri IV on the mantel in our room, for his mother was born there. The boarded windows of the Casino were splotched with bird droppings—along the misty streets we bought canes with spears on the end and were a little discouraged about everything. We had a play on Broadway and the movies offered sixty thousand dollars, but we were china people by then and it didn't seem to matter particularly.

When that was over, a hired limousine drove us to Toulouse, careening around the gray block of Carcassonne and through the long unpopulated planes of the Côte d'Argent. The Hôtel Tivollier, though ornate, had fallen into disuse. We kept ringing for the waiter to assure ourselves that life went on somewhere in the dingy crypt. He appeared resentfully and finally we induced him to give us so much beer that it heightened the gloom.

In the Hôtel O'Connor old ladies in white lace rocked their pasts to circumspection with the lullabyic motion of the hotel chairs. But they were serving blue twilights at the cafés along the Promenade des Anglais for the price of a Porto, and we danced their tangos and watched girls shiver in the appropriate clothes for the Côte d'Azur. We went to the Perroquet with friends, one of us wearing a blue hyacinth and the other an ill temper which made him buy a wagon full of roasted chestnuts and immediately scatter their warm burnt odor like largesse over the cold spring night.

In the sad August of that year we made a trip to Menton, ordering

bouillabaisse in an aquarium-like pavilion by the sea across from the Hôtel Victoria. The hills were silver-olive, and of the true shape of frontiers.

Leaving the Riviera after a third summer, we called on a writer friend at the Hôtel Continental at Cannes. He was proud of his independence in adopting a black mongrel dog. He had a nice house and a nice wife and we envied his comfortable installations that gave the effect of his having retired from the world when he had really taken such of it as he wanted and confined it.

When we got back to America we went to the Roosevelt Hotel in Washington and to see one of our mothers. The cardboard hotels, bought in sets, made us feel as if we committed a desecration by living in them—we left the brick pavements and the elms and the heterogeneous qualities of Washington and went further south.

° 1927 °

It takes so long to get to California, and there were so many nickel handles, gadgets to avoid, buttons to invoke, and such a lot of newness and Fred Harvey,[3] that when one of us thought he had appendicitis we got out at El Paso. A cluttered bridge dumps one in Mexico where the restaurants are trimmed with tissue paper and there are contraband perfumes—we admired the Texas Rangers, not having seen men with guns on their hips since the war.

We reached California in time for an earthquake. It was sunny, and misty at night. White roses swung luminous in the mist from a trellis outside the Ambassador windows; a bright exaggerated parrot droned incomprehensible shouts in an aquamarine pool—of course everybody interpreted them to be obscenities; geraniums underscored the discipline of the California flora. We paid homage to the pale aloof concision of Diana Manners'[4] primitive beauty and dined at Pickfair to marvel at Mary Pickford's dynamic subjugation of life. A thoughtful limousine carried us for California hours to be properly moved by the fragility of Lillian Gish, too aspiring for life, clinging vinelike to occultisms.

From there we went to the DuPont in Wilmington. A friend took us to tea in the mahogany recesses of an almost feudal estate, where the sun gleamed apologetically in the silver tea service and there were four

3. Reference to Harvey chain of railroad restaurants.
4. Lady Diana Manners, English actress.

kinds of buns and four indistinguishable daughters in riding clothes and a mistress of the house too busily preserving the charm of another era to separate out the children. We leased a very big old mansion on the Delaware River. The squareness of the rooms and the sweep of the columns were to bring us a judicious tranquility. There were sombre horse chestnuts in the yard and a white pine bending as graciously as a Japanese brush drawing.

We went up to Princeton. There was a new colonial inn, but the campus offered the same worn grassy parade ground for the romantic spectres of Light-Horse Harry Lee and Aaron Burr. We loved the temperate shapes of Nassau Hall's old brick, and the way it seems still a tribunal of early American ideals, the elm walks and meadows, the college windows open to the spring—open, open to everything in life—for a minute.

The Negroes are in knee breeches at the Cavalier in Virginia Beach. It is theatrically Southern and its newness is a bit barren, but there is the best beach in America; at that time, before the cottages were built, there were dunes and the moon tripped, fell, in the sandy ripples along the seafront.

Next time we went, lost and driven now like the rest, it was a free trip north to Quebec. They thought maybe we'd write about it. The Château Frontenac was built of toy stone arches, a tin soldier's castle. Our voices were truncated by the heavy snow, the stalactite icicles on the low roofs turned the town to a wintry cave; we spent most of our time in an echoing room lined with skis, because the professional there gave us a good feeling about the sports at which we were so inept. He was later taken up by the DuPonts on the same basis and made a powder magnate or something.

When we decided to go back to France we spent the night at the Pennsylvania, manipulating the new radio earphones and the Servidors,[5] where a suit can be frozen to a cube by nightfall. We were still impressed by running ice water, self-sustaining rooms that could function even if besieged with current events. We were so little in touch with the world that they gave us an impression of a crowded subway station.

The hotel in Paris was triangular-shaped and faced St-Germain-des-Près. On Sundays we sat at the Deux Magots and watched the people, devout as an opera chorus, enter the old doors, or else watched the

5. Double-door device in hotels, permitting valet service to deliver cleaning and pressing without entering the room.

French read newspapers. There were long conversations about the ballet over sauerkraut in Lipps, and blank recuperative hours over books and prints in the dank Allée Bonaparte.

Now the trips away had begun to be less fun. The next one to Brittany broke at Le Mans. The lethargic town was crumbling away, pulverized by the heat of the white hot summer and only traveling salesmen slid their chairs peremptorily about the uncarpeted dining room. Plane trees bordered the route to La Baule.

At the Palace in La Baule we felt raucous amidst so much chic restraint. Children bronzed on the bare blue-white beach while the tide went out so far as to leave them crabs and starfish to dig for in the sands.

<p style="text-align:center">° 1929 °</p>

We went to America but didn't stay at hotels. When we got back to Europe we spent the first night at a sun-flushed hostelry, Bertolini's in Genoa. There was a green tile bath and a very attentive *valet de chambre* and there was ballet to practice, using the brass bedstead as a bar. It was good to see the brilliant flowers colliding in prismatic explosions over the terraced hillside and to feel ourselves foreigners again.

Reaching Nice, we went economically to the Beau Rivage, which offered many stained glass windows to the Mediterranean glare. It was spring and was brittly cold along the Promenade des Anglais, though the crowds moved persistently in a summer tempo. We admired the painted windows of the converted palaces on the Place Gambetta. Walking at dusk, the voices fell seductively through the nebulous twilight inviting us to share the first stars, but we were busy. We went to the cheap ballets of the Casino on the jetée and rode almost to Villefranche for Salade Niçoise and a very special bouillabaisse.

In Paris we economized again in a not-yet-dried cement hotel, the name of which we've forgotten. It cost us a good deal, for we ate out every night to avoid starchy table d'hôtes. Sylvia Beach[6] invited us to dinner and the talk was all of the people who had discovered Joyce; we called on friends in better hotels: Zoë Akins,[7] who had sought the picturesque of the open fires at Foyot's,[8] and Esther[9] at the Port-Royal,

6. Proprietor of the Paris bookshop Shakespeare & Co. and publisher of *Ulysses*.
7. American dramatist.
8. Paris restaurant.
9. Probably Esther Murphy.

who took us to see Romaine Brooks'[10] studio, a glass-enclosed square of heaven swung high above Paris.

Then southward again, and wasting the dinner hour in an argument about which hotel: there was one in Beaune where Ernest Hemingway had liked the trout. Finally we decided to drive all night, and we ate well in a stable courtyard facing a canal—the green-white glare of Provence had already begun to dazzle us so that we didn't care whether the food was good or not. That night we stopped under the white-trunked trees to open the windshield to the moon and to the sweep of the south against our faces, and to better smell the fragrance rustling restlessly amidst the poplars.

At Fréjus Plage they had built a new hotel, a barren structure facing the beach where the sailors bathe. We felt very superior remembering how we had been the first travelers to like the place in summer.

After the swimming at Cannes was over and the year's octopi had grown up in the crevices of the rocks, we started back to Paris. The night of the stock market crash we stayed at the Beau Rivage in St-Raphaël in the room Ring Lardner had occupied another year. We got out as soon as we could because we had been there so many times before—it is sadder to find the past again and find it inadequate to the present than it is to have it elude you and remain forever a harmonious conception of memory.

At the Jules César in Arles we had a room that had once been a chapel. Following the festering waters of a stagnant canal we came to the ruins of a Roman dwelling house. There was a blacksmith shop installed behind the proud columns and a few scattered cows ate the gold flowers off the meadow.

Then up and up; the twilit heavens expanded in the Cévennes valley, cracking the mountains apart, and there was a fearsome loneliness brooding on the flat tops. We crunched chestnut burrs on the road and aromatic smoke wound out of the mountain cottages. The Inn looked bad, the floors were covered with sawdust, but they gave us the best pheasant we ever ate and the best sausage, and the feather beds were wonderful.

In Vichy, the leaves had covered the square about the wooden bandstand. Health advice was printed on the doors at the Hôtel du Parc and on the menu, but the salon was filled with people drinking champagne. We loved the massive trees in Vichy and the way the friendly town nestles in a hollow.

10. English painter.

By the time we got to Tours, we had begun to feel like Cardinal Balue in his cage in the little Renault. The Hôtel de l'Univers was equally stuffy but after dinner we found a café crowded with people playing checkers and singing choruses and we felt we could go on to Paris after all.

Our cheap hotel in Paris had been turned into a girls' school—we went to a nameless one in the Rue du Bac, where potted palms withered in the exhausted air. Through the thin partitions we witnessed the private lives and natural functions of our neighbors. We walked at night past the molded columns of the Odéon and identified the gangrenous statue behind the Luxembourg fence as Catherine de Medici.

It was a trying winter and to forget bad times we went to Algiers. The Hôtel de l'Oasis was laced together by Moorish grills; and the bar was an outpost of civilization with people accentuating their eccentricities. Beggars in white sheets were propped against the walls, and the dash of colonial uniforms gave the cafés a desperate swashbuckling air. Berbers have plaintive trusting eyes but it is really Fate they trust.

In Bou Saada, the scent of amber was swept along the streets by wide desert cloaks. We watched the moon stumble over the sand hillocks in a dead white glow and believed the guide as he told us of a priest he knew who could wreck railroad trains by wishing. The Ouled Naïls were very brown and clean-cut girls, impersonal as they turned themselves into fitting instruments for sex by the ritual of their dance, jangling their gold to the tune of savage fidelities hid in the distant hills.

The world crumbled to pieces in Biskra; the streets crept through the town like streams of hot white lava. Arabs sold nougat and cakes of poisonous pink under the flare of open gas jets. Since *The Garden of Allah* and *The Sheik* the town has been filled with frustrate women. In the steep cobbled alleys we flinched at the brightness of mutton carcasses swung from the butchers' booths.

We stopped in El Kantara at a rambling inn whiskered with wistaria. Purple dusk steamed up from the depths of a gorge and we walked to a painter's house, where, in the remoteness of those mountains, he worked at imitations of Meissonier.

Then Switzerland and another life. Spring bloomed in the gardens of the Grand Hôtel in Glion, and a panorama world scintillated in the mountain air. The sun steamed delicate blossoms loose from the rocks while far below glinted the lake of Geneva.

Beyond the balustrade of the Lausanne Palace, sailboats plume themselves in the breeze like birds. Willow trees weave lacy patterns on the gravel terrace. The people are chic fugitives from life and death, rattling

their teacups in querulous emotion on the deep protective balcony. They
spell the names of hotels and cities with flower beds and laburnum in
Switzerland and even the streetlights wore crowns of verbena.

° 1931 °

Leisurely men played checkers in the restaurant of the Hôtel de la Paix
in Lausanne. The depression had become frank in the American papers
so we wanted to get back home.

But we went to Annecy for two weeks in summer, and said at the
end that we'd never go there again because those weeks had been per-
fect and no other time could match them. First we lived at the Beau
Rivage, a rambler rose-covered hotel, with a diving platform wedged
beneath our window between the sky and the lake, but there were enor-
mous flies on the raft so we moved across the lake to Menthon. The
water was greener there and the shadows long and cool and the scraggly
gardens staggered up the shelved precipice to the Hôtel Palace. We
played tennis on the baked clay courts and fished tentatively from a low
brick wall. The heat of summer seethed in the resin of the white pine
bathhouses. We walked at night toward a café blooming with Japanese
lanterns, white shoes gleaming like radium in the damp darkness. It was
like the good gone times when we still believed in summer hotels and
the philosophies of popular songs. Another night we danced a Wiener
waltz, and just simply swep' around.

At the Caux Palace, a thousand yards in the air, we tea-danced on
the uneven boards of a pavilion and sopped our toast in mountain
honey.

When we passed through Munich the Regina-Palast was empty; they
gave us a suite where the princes stayed in the days when royalty trav-
eled. The young Germans stalking the ill-lit streets wore a sinister air
—the talk that underscored the beer-garden waltzes was of war and
hard times. Thornton Wilder took us to a famous restaurant where the
beer deserved the silver mugs it was served in. We went to see the
cherished witnesses to a lost cause; our voices echoed through the pla-
netarium and we lost our orientation in the deep blue cosmic presenta-
tion of how things are.

In Vienna the Bristol was the best hotel and they were glad to have
us because it, too, was empty. Our windows looked out on the moldy
baroque of the Opera over the tops of sorrowing elms. We dined at the
widow Sacher's—over the oak paneling hung a print of Franz Joseph

going some happier place many years ago in a coach; one of the Roths-childs dined behind a leather screen. The city was poor already, or still, and the faces about us were harassed and defensive.

We stayed a few days at the Vevey Palace on Lake Geneva. The trees in the hotel gardens were the tallest we had ever seen and gigantic lonely birds fluttered over the surface of the lake. Farther along there was a gay little beach with a modern bar where we sat on the sands and discussed stomachs.

We motored back to Paris: that is, we sat nervously in our six-horse-power Renault. At the famous Hôtel de la Cloche in Dijon we had a nice room with a very complicated mechanical inferno of a bath, which the valet proudly referred to as American plumbing.

In Paris for the last time, we installed ourselves amidst the faded grandeurs of the Hôtel Majestic. We went to the Exposition and yielded up our imaginations to gold-lit facsimiles of Bali. Lonely flooded rice fields of lonely far-off islands told us an immutable story of work and death. The juxtaposition of so many replicas of so many civilizations was confusing, and depressing.

Back in America we stayed at the New Yorker because the advertise-ments said it was cheap. Everywhere quietude was sacrificed to haste and, momentarily, it seemed an impossible world, even though lustrous from the roof in the blue dusk.

In Alabama the streets were sleepy and remote and a calliope on parade gasped out the tunes of our youth. There was sickness in the family and the house was full of nurses so we stayed at the big new elaborate Jefferson Davis. The old houses near the business section were falling to pieces at last. New bungalows lined the cedar drives on the outskirts; four-o'clocks bloomed beneath the old iron deer and arborvi-tae boxed the prim brick walls while vigorous weeds uprooted the pave-ments. Nothing had happened there since the Civil War. Everybody had forgotten why the hotel had been erected, and the clerk gave us three rooms and four baths for nine dollars a day. We used one as a sitting room so the bellboys would have someplace to sleep when we rang for them.

<center>° 1932 °</center>

At the biggest hotel in Biloxi we read Genesis and watched the sea pave the deserted shore with a mosaic of black twigs.

We went to Florida. The bleak marshes were punctuated by biblical

admonitions to a better life; abandoned fishing boats disintegrated in the sun. The Don Ce-sar Hotel in Pass-A-Grille stretched lazily over the stubbed wilderness, surrendering its shape to the blinding brightness of the gulf. Opalescent shells cupped the twilight on the beach and a stray dog's footprints in the wet sand staked out his claim to a free path round the ocean. We walked at night and discussed the Pythagorean theory of numbers, and we fished by day. We were sorry for the deep-sea bass and the amber jacks—they seemed such easy game and no sport at all. Reading the *Seven Against Thebes,* we browned on a lonely beach. The hotel was almost empty and there were so many waiters waiting to be off that we could hardly eat our meals.

° 1933 °

The room in the Algonquin was high up amidst the gilded domes of New York. Bells chimed hours that had yet to penetrate the shadowy streets of the canyon. It was too hot in the room, but the carpets were soft and the room was isolated by dark corridors outside the door and bright façades outside the window. We spent much time getting ready for theaters. We saw Georgia O'Keeffe's pictures and it was a deep emotional experience to abandon oneself to that majestic aspiration so adequately fitted into eloquent abstract forms.

For years we had wanted to go to Bermuda. We went. The Elbow Beach Hotel was full of honeymooners, who scintillated so persistently in each other's eyes that we cynically moved. The Hotel St. George was nice. Bougainvillea cascaded down the tree trunks and long stairs passed by deep mysteries taking place behind native windows. Cats slept along the balustrade and lovely children grew. We rode bicycles along the windswept causeways and stared in a dreamy daze at such phenomena as roosters scratching amidst the sweet alyssum. We drank sherry on a veranda above the bony backs of horses tethered in the public square. We had traveled a lot, we thought. Maybe this would be the last trip for a long while. We thought Bermuda was a nice place to be the last one of so many years of traveling.

AUCTION—MODEL 1934

◇

◦ July 1934 ◦

Of course we asked our friends what they thought and they said it was a perfect house—though not even the California claret could induce them to admit that it was the sort of place they would have lived in. The idea was to stay there until the sheets were shredded away and the bedsprings looked like the insides of broken watches: then we wouldn't have to pack any more—the usages of time would have set us free. We could travel again in a suitcase, and not be harassed by bills from a storage warehouse. So we gathered our things from here and there; all that remained from fifteen years of buying, except some faded beach umbrellas we had left at the American Express five years ago in Cannes. It was to have been very edifying to have only the things we were fond of around us again and maybe we'd like the new place so well that we'd never move any more but just sit behind the wistaria and watch the rhododendron disintegrate beneath the heat of June, July, and August, and the fanfare of the dogwood over the hills.

Then we opened the packing cases.

Lot 1. The first case is oblong and enormous and about the right shape to have contained enormous family portraits—it holds a mirror bought a long time ago for practicing ballet dancing at home. It once decorated the wall of a bordello. Any bids? No! Take it to that little room in the attic.

Lot 2. A smaller crate of the same shape containing fifty photographs of ourselves and drawings of the same by various artists and pictures of the houses we lived in and of our aunts and uncles and of where they were born and died. In some of the pictures we are golfing and swimming and posing with other people's animals, or tilting borrowed surf-

First appeared in *Esquire*, July 1934. Published as by F. Scott and Zelda Fitzgerald, but credited to Zelda in his *Ledger*. Previously collected in *The Crack-Up* (1945).

boards against the spray of younger summers. There are also many impressive photographs of old and very dear friends whose names we have forgotten. These faces were very precious to us at the time, and now those times are very precious, though it is hard to imagine how we came to ask from life such an exaggerated head of Mae Murray.[1] It must have been that summer day in Paris when we watched the children bowl the summer sun along the paths of the Jardin des Plantes—we might, late that afternoon, have begged for the photograph. And one of Pascin, whom we met over a pebble-rocked table watching the elegant ladies circle the Rondpoint attending upon the natural functions of Pekinese—Pascin[2] already enveloped in tragedy and pursued by a doom so powerful that he could well afford the nonchalance in which lay his somber charm. And one of Pearl White[3] that she gave us in a spring when she was buying the Paris nights in clusters. Any bidders? No? The little room in the attic, Essie.

Lot 3. A pornographic figurine bought with great difficulty in Florence twelve years ago. *"Une statue sale*—no, we don't mean *salle* that way—we mean *sale."* Slightly damaged—any bidders? All right, take this, too, Essie, while you're going up. It seems a shame after all the lascivious gesticulation it took to obtain it.

Lot 4. Two bronze busts of Shakespeare and Galileo with which the family had hoped to anchor us to permanent abodes. Slightly used in the fireplace but ineffectual as andirons. Any bids?—all right, Essie.

Lot 5. A barrel. Contents cost us something like a thousand dollars during the boom. Chipped pottery tea set that was worth the trip to Venice—it had seemed such a pity not to buy something from that cluttered bazaar fanned by the plumy shade of the white plane trees. We didn't know what we wanted to drink; the white haunted countryside was hot; the hillsides smelled of jasmine and the hot backs of men digging the roads.

Two glass automobiles for salt and pepper stolen from the café in St-Paul (Alpes-Maritimes). Nobody was looking because Isadora Duncan was giving one of her last parties at the next table. She had got too old and fat to care whether people accepted her theories of life and art, and she gallantly toasted the world's obliviousness in lukewarm champagne. There were village dogs baying at a premature white exhausted August

1. American actress.
2. Jules Pascin, Bulgarian born French painter who committed suicide in 1930.
3. Star of the movie serial *The Perils of Pauline.*

moon and there were long dark shadows folded accordion-like along
the steps of the steep streets of St-Paul. We autographed the guest book.

Fifty-two ashtrays—all very simple because Hergesheimer[4] warned
us against pretentiousness in furnishing a house without money. A set
of cocktail glasses with the roosters now washed off the sides. Carl Van
Vechten[5] brought us a shaker to go with them but nobody had opened
the letter announcing his arrival—nobody knew where the mail was
kept, there were so many rooms, twenty or twenty-one. Two curious
vases we won in the amusement park. The fortune teller came back
with us and drank too much and repeated a stanza of Vachel Lindsay[6]
to exorcise the mansion ghost. China, China, China, set of four, set of
five, set of nine, set of thirteen. Any bids? Thank God! The kitchen,
Essie.

Lot 5.[7] Plaid Shawl donated by Carmel Myers.[8] Slightly fatigued after
long use as a table cover and packing wrapper for china pigs and dogs
which held pennies turned out of the pockets of last year's coats. Once
a beautiful Viennese affair, with memories of Carmel in Rome filming
Ben Hur in bigger and grander papier-mâché arenas than the real ones.
One gong. No memory of what it was for or why we had bought it.
Stick missing. Looks, however, like a Chinese pagoda and gives an
impression of wide travel. Bits of brass: wobbly colonial candlesticks
with stems encircling little bells which ring when walked with à la Bea-
trix Esmond[9] or Lady Macbeth. Two phallic symbols bought from an
archaeologist. One German helmet found in the trenches of Verdun.
One chess set. We played it every evening before we began to quarrel
about our respective mental capacities. Two china priests from Vevey.
The figures are strung on springs and wag their heads lasciviously over
bottles of wine and hampers of food. A whole lot of broken glass and
china good for the tops of walls. All right, Essie. Go on—there's plenty
of space up there, if you know how to use it.

Lot 6. Contents of an old army trunk. Nobody has ever explained
where mothballs go; moths thrive best on irreplaceable things such as
old army uniforms. Then there was a pair of white flannels bought with
the first money ever earned by writing—thirty dollars from Mencken's

4. American novelist Joseph Hergesheimer.
5. American novelist.
6. American poet.
7. The designation for "Lot 5" was repeated in Esquire.
8. American movie actress.
9. Heroine of Thackeray's Henry Esmond.

and Nathan's old *Smart Set*. The moths had also dined upon a blue feather fan paid for out of a first *Saturday Evening Post* story; it was an engagement present—that together with a Southern girl's first corsage of orchids. The remains of the fan are not for sale. All right, Essie.

Lot 7. The daughter's first rubber doll, the back and front stuck together and too gummy to save for the grandchildren. Teething beads in good condition—never used. Any bids? *Pu*lease!

Lot 8. Ski pants. Guaranteed to remind the bankrupt traveler of blue snow-padded slopes, high in the Juras in Switzerland, with gargantuan discs of cheeses served by cow-herders in flowered velvet vests; of bells and the smell of coffee drifting out over the snow mountain clubs, of yodeling and blowing melancholic flats through long horn trumpets; of melting snow to drink from the pockets of these pants, together with inconsequential trains in angry red winter dawns, cluttered with skis in stacks and the discarded wrappings of Peter's chocolate. Any bids? Hey, Essie!

Lot 9. Cotton bathing trunks, full of the bright heat of the Mediterranean, bought in the sailors' quarter of Cannes. They make swell dust cloths but don't belong on an American beach. Used at present to wrap up the arsenal: a twenty-two that goes off if you stare at it hard enough, a cavalry carbine carved with the name "Seven Pines" and an uncle's name and some suspicious-looking notches, an old thirty-two, and a police thirty-eight. On the whole we keep the arsenal and would like to pick up an old submachine gun cheap. Whisk 'em away.

Lot 10. Another barrel full of tops of things: sugar bowls, vanished mustard pots, lovely colored lids for jars that must have been quite nice. Look, for instance, at this rose-encrusted top to the bowl for rose leaves: a bowl for rose leaves. There is the top of the delicate Tiffany urn from a chocolate set that was our first wedding present. The set remained on a dressing table at the Biltmore all during our honeymoon beside a fading Easter lily. On rainy afternoons we leaned into the brick area and listened to the music from *The Night Boat* swinging its plaints from one walled surface of the hotel to another. Any bids? Surely this gentleman—all right then. Essie, the trash heap.

Lot 11. A real Patou suit. It was the first garment bought after the marriage ceremony and again the moths have unsymmetrically eaten the nap off the seat of the skirt. This makes fifteen years it has been stored in trunks because of our principle of not throwing away things that have never been used. We are glad—oh, so relieved, to find it devastated at last. There was a rippling sun along Fifth Avenue the day it was bought and it seemed very odd to be charging things to Scott

Fitzgerald. The thing was to look like Justine Johnson[10] at the time and it still seems a fine way to have looked. The shopper was two days out of Alabama. From the shop we went to tea in the Plaza Grill. Constance Bennett[11] was still a flapper and had invented a new way of dancing with a pendulous head. We went to *Enter Madame* and the actors were cross because our tickets were in the front row and we laughed appreciatively at the wrong places and uproariously at the jokes we made up as the show went along. We went to the midnight roof and stood up to see Ziegfeld's taffeta pyramids. We thought the man was real who straggled into the show dressed like a student and very convincingly got himself thrown out. Anyhow—thank you, moths—Can you use this, Essie?

A white sweater next that really can't be disposed of, though the front is clotted with darns and the back all pulled apart to make the worn places elsewhere meet; it was used while writing three books when the house grew cold at night after the heat went off. Sixty-five stories were forced through its sagging meshes. It was a job of years to wash it—that and the socks from England of gargantuan wool. We have often thought seriously of having other feet knit into these; we can't see them go. We remember that late afternoon in Bond Street where we bought them from stores looking like Dickens' forehead, and how we had had to hurry because we had taken so much time seeking the Half Moon Crescent that appeared in Mackenzie's *Sinister Street*. These socks made us late for a dinner with Galsworthy while the twilight turned purple and Turneresque over the Thames. These socks have wrinkled above the parquets of Lady Randolph Churchill's London house and waltzed in a sad Savoy Hotel to the envy of women in black at twenty-one, because a lot of men had forgot to come home. Of course, such wool is fine for polishing mirrors—but there are other considerations. No sale. Wake up, Essie!

Lot 12. Twelve scrapbooks, telling us what wonderful or horrible or mediocre people we were. Try and get them. What's that? No, not for twice that. Four dollars you say? Sold!

Lot 13. Here is a jug, a beautiful black milk jug—the dairyman left it years ago when it was cheaper to make your own ice cream. Anyway, it once looked lovely filled with rambler roses, and now it looks nice with calla lilies. You can hardly tell it wasn't made for such a purpose in the first place. We have mixed punch inside it for so many parties

10. Justine Johnstone, musical-comedy star.
11. American movie actress.

before we inherited the cut-glass bowls. We fermented our first California grape juice in something exactly like it. These ten-cent-store plates we bought for the kitchen did very well for the table the summer we tried eating outdoors. That sort of thing never works in America, but remembering how happy we were over how it ought to have been, we like these dishes. No sale.

Lot 14. Remains of a service set shot to pieces by Charlie MacArthur in target practice on the lawn at Ellerslie, the day we invented croquet-polo on plowhorses borrowed of a farmer. Also this Lalique turtle which once nested in a shop across from Vantine's, when there was such a place. Nobody bought him but he remained as expensive as ever until finally he lost one foot in the crush of modern window display, and *we* bought him and a joiner put him together again. It is the turtle who held the white violets the first night Ernest Hemingway came to our house, it is the turtle who hid the burned-out bulbs from so many Christmas trees over the holidays. He is out of style and no longer holds water but is good for old keys that don't fit anything. Any bids? The attic, Essie. Lalique in the attic!

Lot 15. A silver cake basket and a table that belonged to Francis Scott Key and a bed we had copied from a design in *House and Garden*—but on the whole we have decided to keep all these things forever, and put them up in the attic. The house is full and comfortable. We have five phonographs, including the pocket one, and no radio, eleven beds and no bureau. We shall keep it all—the tangible remnant of the four hundred thousand we made from hard words and spent with easy ones these fifteen years. And the collection, after all, is just about as valuable now as the Polish and Peruvian bonds of our thriftier friends.

ON F. SCOTT FITZGERALD

◊

During the last world war, many cosmic destinies were strung together on the tone of tragic gallantry and courage to the purpose of binding within tradition the dramatic and pictorial tempos to which the age had fallen heir. Habits of men at this time included shivering to death in boxcars over the lost frontiers of lonely foreign provinces, drowning in mud, and smothering in submarines. Many had learned too much of painful and even exotic ways to die so that life presented itself by contrast in less agonizing, if more immutable, terms than before the trouble in Europe.

This era assisted at the nursing of a badly shell-shocked logos back to some semblance of tenability on the dreary and dusty sun parlors of châteaux converted to convalescent hospitals and entered a failing social structure from personal necessities of survival.

A few facetious gestures: dancing with the dead at Cambrai, the painting of the Portughese leavened the four-year spectacle and diverted some of the spiritual casualties from despair to bitterness—perhaps the easier to bear.

When nobody could think up any more mathematical formulas for destruction and no further ways for forwarding the plot, the war was declared to be a political inconvenience, and ended. Through the disorientations resultant from many distrusted and uncondoned experiences the soldiers looked toward home as the right of a long and hard-earned holiday. People that had been spared active participation in the gala debacle converted themselves into a grand pleasure chorus as effectively as possible and dedicated the decade to reconstituting the shattered illusions of those who had served in France with, perhaps, more verve and courage than judgment.

This tribute was probably intended for the group of posthumous recollections and assessments of Fitzgerald published in *The New Republic* in 1941. It was not used, and first appeared in the *Fitzgerald/Hemingway Annual 1974.* Spelling and punctuation have been corrected.

The United States greeted the returning young men with appropriate tragic and ecstatic pathos, and compensatory dramatics, but still the erstwhile doughboys languished, and weren't quite able to take up the thread on the same attenuate pitch as before.

It was past time for whatever had been scheduled to have happened and people were worn out with long abeyant attendance.

The prophet destined to elucidate and catalogue these pregnant and precarious circumstances was F. Scott Fitzgerald. The times exacted a dramatization compelling enough to save its protagonists from sleepwalking over the proscenium in the general doesn't-matter suasion of the letdown; and splendidly tragic enough to turn the barbarism of recent war experiences into drama. Fitzgerald was the first and always the most indicative of authors to persuade the desperate latent flare of these souls so tolerantly and self-abnegatively pursuing policies of *qui en-faire* to attitudes of a better-mastered Olympian regret. He endowed those years that might have been so garishly reckless with the dignity of his bright indicative scene, and buoyed the desperation of a bitter day with the spontaneity of his appreciation.

Fitzgerald's heroines were audacious and ingenuous and his heroes were fabulous strangers from lands of uncharted promise. His tragedies were hearts at bay to the inexorable exigence of a day whose formulas no longer worked and whose ritual had dwindled to less of drama than its guignol. His pathos was the pressure of inescapable necessities over the keeping of a faith. His poignancy was the perishing of lovely things and people on the jagged edges of truncate spiritual purpose. These were the themes that transcended the crassness and bitterness which so easily betrays the ironic pen and leads the conviction of tragedy too frequently astray in the briars of scathing invective.

Fitzgerald seized, from the nebulous necessities of an incubating civilization, the essence of a girl able to survive the new, and less forbearing, dramas and presented in poetic harmonies the tragically gallant stoicism so indispensable to traversing that troubled and turbulent epoch between world wars.

As the era is absorbed by its category and lost in its platonic sources, one remembers romantically the figure who so ingratiatingly reconciled his readers to the diminution of individuality and rendered more tangible those movements which he affectionately and indulgently humanized: "youth movements, suffrage drives, temperance objectives," and many no-matter-how-dearly-bought subscriptions to any dominant idea which carried the promise of salvation by rote.

As promissorily as the least tractable wellings of the soul are curbed

to the poet's pentameter, as surely as the most unique of cadets is lost on the line of march, so does each generation yield to the thematic persuasions of the day. The meter being waltz time which moves nostalgic twilights to their rendezvous, the world believes again in sentiment and turns to fairy tale; whereas those years haunted by the more aggressive sadnesses of march time produce a more dynamic, tragic spiritual compensation. Thus the manners and aspirations that were not too long ago recut and polished in the staccato relevance of *This Side of Paradise* and *The Beautiful and Damned* have been able to defend themselves with a better-perfected hardihood and by means of a faith in *technique* from the heartbreak and subsequent ruthless purpose of the 1920s.

Fitzgerald's books were the first of their kind and the most indicative. If his people didn't have a good time, or things come out well at the end, the scene of their activity was always the arena of some new philosophic offensive, and what they did was allied with many salient projects of the era. The plush hush of the hotel lobby and the gala grandeur of the theater porte-chochère; fumes of orchidaceous elevators whirring to plaintive deaths the gilded aspirations of a valiant and protesting age, taxis slumberously afloat on deep summer nights——

Such Fitzgerald made into many tragic tales; sagas of people compelling life into some more commensurate and compassionate measure. His meter was bitter, and ironic and spectacular and inviting: so was life. There wasn't much other life during those times than to what his pen paid the tribute of poetic tragic glamour and offered the reconciliation of the familiarities of tragedy.

Rest in peace.

LETTERS TO
F. SCOTT FITZGERALD

◇

The Fitzgeralds were rarely apart between their marriage in 1920 and the time of her hospitalization in 1930. Except for a few courtship pieces, her letters to him perforce provide a record of her illness. Although the clinic communications are sometimes recriminative, they document the intensity of emotion that the Fitzgeralds generated about each other.

These letters were previously collected in *Correspondence of F. Scott Fitzgerald,* ed. Bruccoli and Margaret M. Duggan (New York: Random House, 1980). The texts have not been emended; they are printed as written.

Spring 1919 AL, 4 pp. Princeton University
 Montgomery, Alabama

Sunday—

Darling, darling I love you so—To-day seems like Easter, and I wish we were together walking slow thru the sunshine and the crowds from Church—Everything smells so good and warm, and your ring shines so white in the sun—like one of the church lillies with a little yellow dust on it—We ought to be together this Spring—It seems made for us to love in—

You can't imagine what havoc the ring wrought—A whole dance was completely upset last night—Everybody thinks its lovely—and I am so proud to be your girl—to have everybody know we are in love—It's so good to know you're always loving me—and that before long we'll be together for all our lives—

The Ohio troops have started a wild and heated correspondence with Montgomery damsels—From all I can gather, the whole 37th Div will be down in May—Then I guess the butterflies will flitter a trifle more —It seems dreadfully peculiar not to be worried over the prospects of

the return of at least three or four fiancees—My brain is stagnating owing to the lack of scraps—I havent had to exercise it in so long—

Sweetheart, I love you most of all the earth—and I want to be married soon—soon—Lover—Don't say I'm not enthusiastic—You ought to know—

Spring 1919 AL, 8 pp. Princeton University
 Montgomery, Alabama

Scott, my darling lover—everything seems so smooth and restful, like this yellow dusk. Knowing that I'll always be yours—that you really own me—that nothing can keep us apart—is such a relief after the strain and nervous excitement of the last month. I'm so glad you came —like Summer, just when I needed you most—and took me back with you. Waiting doesn't seem so hard now. The vague despondency has gone—I love you Sweetheart.

Why did you buy the "best at the Exchange"?[1]—I'd rather have had 10¢ a quart variety—I wanted it just to know you loved the sweetness —To breathe and know you loved the smell—I think I like breathing twilit gardens and moths more than beautiful pictures or good books— It seems the most sensual of all the sences—Something in me vibrates to a dusky, dreamy smell—a smell of dying moons and shadows—

I've spent to-day in the grave-yard—It really isn't a cemetery, you know—trying to unlock a rusty iron vault built in the side of the hill. It's all washed and covered with weepy, watery blue flowers that might have grown from dead eyes—sticky to touch with a sickening odor— The boys wanted to get in to test my nerve—to-night—I wanted to *feel* "William Wreford, 1864." Why should graves make people feel in vain? I've heard that so much, and Grey is so convincing, but somehow I can't find anything hopeless in having lived—All the broken columns and clasped hands and doves and angels mean romances and in an hundred years I think I shall like having young people speculate on whether my eyes were brown or blue—of cource, they are neither—I hope my grave has an air of many, many years ago about it—Isn't it funny how, out of a row of Confederate soldiers, two or three will make you think of dead lovers and dead loves—when they're exactly like the others, even to the yellowish moss?[2] Old death is so beautiful—so very beautiful—We will die together—I know—

Sweetheart—

1. Fitzgerald had bought a bottle of liquor at the Exchange Hotel when he visited her.
2. Fitzgerald used this graveyard description in *This Side of Paradise*.

February 1920 ALS, 4 pp. Princeton University
 Montgomery, Alabama

Dearest—

I wanted to for your sake, because I know what a mess I'm making
and how inconvenient it's all going to be—but I simply *can't* and *won't*
take those awful pills—so I've thrown them away I'd rather take
carbolic acid. You see, as long as I feel that I had the right, I don't much
mind what happens—and besides, I'd rather have a *whole family* than
sacrifice my self-respect. They just seem to place everything on the
wrong basis—and I'd feel like a damned whore if I took even one, so
you'll try to understand, please Scott—and do what you think best—
but don't do ANYTHING till we *know* because God—or something—has
always made things right, and maybe this will be.[1]

I love you, Darling Scott, and you love me, and we can be thankful
for that anyway—

Thanks for the book—I don't like it—

 Zelda Sayre

1. She was not pregnant.

February 1920 AL, 6 pp. Princeton University
 Montgomery, Alabama

Darling Heart, our fairy tale is almost ended, and we're going to marry
and live happily ever afterward just like the princess in her tower who
worried you so much—and made me so very cross by her constant
recurrence—[1] I'm so sorry for all the times I've been mean and hateful
—for all the miserable minutes I've caused you when we could have
been so happy. You deserve so much—so very much—

I think our life together will be like these last four days—[2] and I *do*
want to marry you—even if you do think I "dread" it—I wish you
hadn't said that—I'm not afraid of anything—To be afraid a person has
either to be a coward or very great and big. I am neither. Besides, I
know you can take much better care of me than I can, and I'll always

be very, very happy with you—except sometimes when we engage in our weekly debates—and even then I rather enjoy myself. I like being very calm and masterful, while you become emotional and sulky. I don't care whether you think so or not—I do.

There are 3 more pictures I unearthed from a heap of débris under my bed—Our honored mother had disposed of 'em for reasons of her own, but personally I like the attitude of my emaciated limbs, so I solicit your approval. Only I waxed artistic, and ruined one—

Sweetheart—I miss you so—I love you so—and next time I'm going back with you—I'm absolutely nothing without you—Just the doll that I should have been born—You're a necessity and a luxury and a darling, precious lover—and you're going to be a husband to your wife—

1. During the early days of their engagement in 1919 she continued to go out with other men, which elicited Fitzgerald's repeated comment that now he knew why princesses were locked in towers.

2. They had renewed their engagement during Fitzgerald's recent visits to Montgomery.

June 1930 ALS, 2 pp. Princeton University[1]
 Prangins Clinic, Nyon, Switzerland

Dear Scott:

Just at the point in my life when there is no time left me for losing, I am here to incapacitate myself for using what I have learned in such a desperate school—through my own fault and from a complete lack of medical knowledge on a rather esoteric subject. If you could write to Egorowa[2] a friendly impersonal note to find out exactly where I stand as a dancer it would be of the greatest help to me—Remember, this is in no way at all her fault. I would have liked to dance in New York this fall, but where am I going to find again these months that dribble into the beets of the clinic garden? Is it worth it? And once a proper horror for the accidents of life has been instilled into me, I have no intention of joing the group about a corpse. My legs are already flabby and I will soon be like Ada ——, huntress of coralled game, I suppose, instead of a human being recompensed for everything by the surety of a comprehension of one manifestation of beauty—Why can't you write me what you think and want instead of vague attempts at reassurance? If I had work or something it would be so much decenter to try to help each other and make at least a stirrup cup out of this bloody mess.

You have always had so much sympathy for people forced to start over late in life that I should think you could find the generosity to help me amongst your many others—not as you would a child but as an equal.

I want you to let me leave here—You're wasting time and effort and money to take away the little we both have left. If you think you are preparing me for a return to Alabama you are mistaken, and also if you think that I am going to spend the rest of my life roaming about without happiness or rest or work from one sanatorium to another like Kit you are wrong. Two sick horses might conceivably pull a heavier load than a well one alone. Of cource, if you prefer that I should spend six months of my life under prevailing conditions—my eyes are open and I will get something from that, too, I suppose, but they are tired and unhappy and my head aches always. Won't you write me a comprehensible letter such as you might write to one of your friends? Every day it gets harder to think or live and I do not understand the object of wasting the dregs of me here, alone in a devastating bitterness.

<div style="text-align: right">Zelda</div>

Please write immediately to Paris about the dancing. I would do it but I think the report will be more accurate if it goes to you—just an opinion as to what value my work is and to what point I could, develop it before it is too late. Of cource, I would go to another school as I know Egorowa would not want to be bothered with me. Thanks.

1. Zelda Fitzgerald suffered a collapse in April 1930, partly caused by her intense efforts to become a professional ballet dancer. In June she became a patient of Dr. Oscar Forel at Prangins Clinic, where she remained until September 1931.
2. Madame Lubov Egorova, her ballet teacher in Paris.

After June 1930 AL, 8 pp. Princeton University
 Prangins Clinic, Nyon, Switzerland

Dear Scott:
 You said in your letter that I might write when I needed you. For the first time since I went to Malmaison I seem to be about half human-being, capable of focusing my attention and not walking in black horror like I have been for so long. Though I am physically sick and covered with eczema I would like to see you. I'm lonely and do not seem to be able to exist in the world on any terms at all. If you do not want to come maybe Newman[1] would come.

Please don't write to me about blame. I am tired of rummaging my head to understand a situation that would be difficult enough if I were completely lucid. I cannot arbitrarily accept blame now when I know that in the past I felt none. Anyway, blame doesn't matter. The thing that counts is to apply the few resources available to turning life into a tenable orderly affair that resembles neither the black hole of Calcutta or Cardinal Ballou's cage.[2] Of cource, you are quite free to proceed as you think best. If I can ever find the dignity and peace to apply myself, I am sure there must be something to fill the next twenty years of a person who is willing to work for it, so do not feel that you have any obligations toward me, sentimental or otherwise, unless you accept them as freely as you did when I was young and happy and quite different from how I am now—

I am infinitely sorry that I have been ungrateful for your attempts to help me. Try to understand that people are not always reasonable when the world is as unstable and vacillating as a sick head can render it— That for months I have been living in vaporous places peopled with one-dimensional figures and tremulous buildings until I can no longer tell an optical illusion from a reality—that head and ears incessantly throb and roads disappear, until finally I lost all control and powers of judgement and was semi-imbecilic when I arrived here. At least now I can read, and as soon as possible I am going on with some stories I have half done. Won't you send me "Technique of the Drama" please? I have an enormous desire to try to write a play that I have begun a little.

Scottie has not written but I know she is happy with Madamoiselle. I'm glad you are better. It seems odd that we were once a warm little family—secure in a home—

Thank you for the books—

Was it fun in Paris? Who did you see there and was the Madeleine pink at five o'clock and did the fountains fall with hollow delicacy into the framing of space in the Place de la Concorde, and did the blue creep out from behind the Colonades of the rue de Rivoli through the grill of the Tuileries and was the Louvre gray and metallic in the sun and did the trees hang brooding over the cafés and were there lights at night and the click of saucers and the auto horns that play de Bussey—

I love Paris. How was it?

1. Newman Smith, husband of her sister Rosalind.
2. Cardinal Balue was imprisoned in a cage for six years by Louis XI.

Late summer/early fall 1930 AL, 42 pp. Princeton University
 Prangins Clinic, Nyon, Switzerland

Dear Scott:

 I have just written to Newman[1] to come here to me. You say that
you have been thinking of the past. The weeks since I haven't slept
more than three or four hours, swathed in bandages sick and unable to
read so have I.

 There was:

 The strangeness and excitement of New York, of reporters and furry
smothered hotel lobbies, the brightness of the sun on the window panes
and the prickly dust of late spring: the impressiveness of the Fowlers[2]
and much tea-dancing and my eccentric behavior at Princeton. There
were Townsend's[3] blue eyes and Ludlow's rubbers and a trunk that
exhuded sachet and the marshmallow odor of the Biltmore. There were
always Ludow and Townsend and Alex and Bill Mackey[4] and you and
me. We did not like women and we were happy. There was Georges[5]
appartment and his absinth cock-tails and Ruth Findleys gold hair in his
comb, and visits to the "Smart Set" and "Vanity Fair"—a collegiate
literary world puffed into wide proportions by the New York papers.
There were flowers and night clubs and Ludlow's advice that moved us
to the country. At West Port, we quarrelled over morals once, walking
beside a colonial wall under the freshness of lilacs. We sat up all night
over "Brass Knuckles and Guitar."[6] There was the road house where
we bought gin, and Kate Hicks and the Maurices and the bright harness
of the Rye Beach Club. We swam in the depth of the night with George
before we quarrelled with him and went to John Williams parties where
there were actresses who spoke French when they were drunk. George
played "Cuddle up a Little Closer" on the piano. There were my white
knickers that startled the Connecticut hills, and the swim in the sandaled
lady's bird-pool. The beach, and dozens of men, mad rides along the
Post Road and trips to New York. We never could have a room at a
hotel at night we looked so young, so once we filled an empty suit case
with the telephone directory and spoons and a pin-cushion at The
Manhattan—I was romanticly attached to Townsend and he went away
to Tahatii—and there were your episodes of Gene Bankhead and Mir-
iam. We bought the Marmon with Harvey Firestone and went south
through the haunted swamps of Virginia, the red clay hills of Georgia,
the sweet rutted creek-bottoms of Alabama.[7] We drank corn on the
wings of an aeroplane in the moon-light and danced at the country-club

and came back. I had a pink dress that floated and a very theatrical silver one that I bought with Don Stewart.[8]

We moved to 59th Street. We quarrelled and you broke the bathroom door and hurt my eye. We went so much to the theatre that you took it off the income tax. We trailed through Central Park in the snow after a ball at the Plaza, I quarrelled with Zoë about Bottecelli[9] at the Brevoort and went with her to buy a coat for David Belasco.[10] We had Bourbon and Deviled Ham and Christmas at the Overmans[11] and ate lots at the Lafayette. There was Tom Smith[12] and his wall-paper and Mencken[13] and our Valentine party and the time I danced all night with Alex and meals at Mollats with John[14] and I skated, and was pregnant and you wrote the "Beautiful and Damned." We came to Europe and I was sick and complained always. There was London, and Wopping with Shane Leslie[15] and strawberries as big as tomatoes at Lady Randolph Churchills. There was St. Johns Ervines[16] wooden leg and Bob Handley in the gloom of the Cecil—There was Paris and the heat and the ice-cream that did not melt and buying clothes—and Rome and your friends from the British Embassy and your drinking, drinking. We came home. There was "Dog"[17] and lunch at the St. Regis with Townsend and Alex and John: Alabama and the unbearable heat and our almost buying a house. Then we went to St. Paul and hundreds of people came to call. There were the Indian forests and the moon on the sleeping porch and I was heavy and afraid of the storms. Then Scottie was born and we went to all the Christmas parties and a man asked Sandy[18] "who is your fat friend?" Snow covered everything. We had the Flu and went lots to the Kalmans and Scottie grew strong. Joseph Hergesheimer[19] came and Saturdays we went to the University Club. We went to the Yacht Club and we both had minor flirtations. Joe began to dislike me, and I played so much golf that I had Tetena.[20] Kollie[21] almost died. We both adored him. We came to New York and rented a house when we were tight. There was Val Engelicheff and Ted Paramour[22] and dinner with Bunny[23] in Washington Square and pills and Doctor Lackin And we had a violent quarrell on the train going back, I don't remember why. Then I brought Scottie to New York. She was round and funny in a pink coat and bonnet and you met us at the station. In Great Neck there was always disorder and quarrels: about the Golf Club, about the Foxes, about Peggy Weber, about Helen Buck, about everything. We went to the Rumseys,[24] and that awful night at the Mackeys[25] when Ring[26] sat in the cloak-room. We saw Esther and Glen Hunter[27] and Gilbert Seldes.[28] We gave lots of parties: the biggest one for Rebecca West.[29] We drank Bass Pale Ale and went always to the Bucks or the Lardners

or the Swopes[30] when they weren't at our house. We saw lots of Sydney Howard[31] and fought the week-end that Bill Motter was with us. We drank always and finally came to France because there were always too many people in the house. On the boat there was almost a scandal about Bunny Burgess. We found Nanny[32] and went to Hyeres—Scottie and I were both sick there in the dusty garden full of Spanish Bayonet and Bourgainvilla. We went to St. Raphael. You wrote, and we went sometimes to Nice or Monte Carlo. We were alone, and gave big parties for the French aviators. Then there was Josen[33] and you were justifiably angry. We went to Rome. We ate at the Castelli dei Cesari. The sheets were always damp. There was Christmas in the echoes, and eternal walks. We cried when we saw the Pope. There were the luminous shadows of the Pinco and the officer's shining boots. We went to Frascati and Tivoli. There was the jail,[34] and Hal Rhodes at the Hotel de Russie and my not wanting to go to the moving-picture ball[35] at the Excelsior and asking Hungary Cox[36] to take me home. Then I was horribly sick, from trying to have a baby and you didn't care much and when I was well we came back to Paris. We sat to-gether in Marseilles and thought how good France was. We lived in the rue Tilsitt, in red plush and Teddy[37] came for tea and we went to the markets with the Murphies.[38] There were the Wimans[39] and Mary Hay[40] and Eva La Galliene[41] and rides in the Bois at dawn and the night we all played puss-in-the-corner at the Ritz. There was Tunti and nights in Mont Matre. We went to Antibes, and I was sick always and took too much Dial.[42] The Murphy's were at the Hotel du Cap and we saw them constantly. Back in Paris I began dancing lessons because I had nothing to do. I was sick again at Christmas when the Mac Leishes[43] came and Doctor Gros said there was no use trying to save my ovaries. I was always sick and having picqures[44] and things and you were naturally more and more away. You found Ernest and the Cafe des Lilas and you were unhappy when Dr. Gros sent me to Salies-de Bearn.[45] At the Villa Paquita I was always sick. Sara brought me things and we gave a lunch for Geralds father. We went to Cannes and listned to Raquel Miller[46] and dined under the rain of fire-works. You couldn't work because your room was damp and you quarrelled with the Murphys. We moved to a bigger villa and I went to Paris and had my appendix out. You drank all the time and some man called up the hospital about a row you had had. We went home, and I wanted you to swim with me at Juan-les-Pins but you liked it better where it was gayer: at the Garoupe[47] with Marice Hamilton and the Murphys and the Mac Leishes. Then you found Grace Moore[48] and Ruth and Charlie[49] and the summer passed,

one party after another. We quarrelled about Dwight Wiman and you left me lots alone. There were too many people and too many things to do: every-day there was something and our house was always full. There was Gerald and Ernest and you often did not come home. There were the English sleepers that I found downstairs one morning and Bob and Muriel and Walker[50] and Anita Loos,[51] always somebody—Alice Delamar and Ted Rousseau and our trips to St. Paul[52] and the note from Isadora Duncan and the countryside slipping by through the haze of Chamberry-fraises and Graves—That was your summer. I swam with Scottie except when I followed you, mostly unwillingly. Then I had asthma and almost died in Genoa. And we were back in America— further apart than ever before. In California, though you would not allow me to go anywhere without you, you yourself engaged in fla- grantly sentimental relations with a child.[53] You said you wanted noth- ing more from me in all your life, though you made a scene when Carl[54] suggested that I go to dinner with him and Betty Compson.[55] We came east: I worked over Ellerslie incessantly and made it function. There was our first house-party and you and Lois—and when there was noth- ing more to do on the house I began dancing lessons. You did not like it when you saw it made me happy. You were angry about rehearsals and insistent about trains. You went to New York to see Lois and I met Dick Knight[56] the night of that party for Paul Morand.[57] Again, though you were by then thoroughly entangled sentimentally, you forbade my seeing Dick and were furious about a letter he wrote me. On the boat coming over you paid absolutely no attention of any kind to me except to refuse me the permission to stay to a concert with whatever-his- name-was. I think the most humiliating and bestial thing that ever hap- pened to me in my life is a scene that you probably don't remember even in Genoa. We lived in the rue Vaugirard. You were constantly drunk. You didn't work and were dragged home at night by taxi-drivers when you came home at all. You said it was my fault for dancing all day. What was I to do? You got up for lunch. You made no advances toward me and complained that I was un-responsive. You were literally eternally drunk the whole summer. I got so I couldn't sleep and I had asthma again. You were angry when I wouldn't go with you to Mont Matre. You brought drunken under-graduates in to meals when you came home for them, and it made you angry that I didn't care any more. I began to like Egorowa—On the boat going back I told you I was afraid that there was something abnormal in the relationship and you laughed. There was more or less of a scandal about Philipson, but you did not even try to help me. You brought Philippe[58] back and I couldnt

manage the house any more; he was insubordinate and disrespectful to
me and you wouldn't let him go. I began to work harder at dancing—
I thought of nothing else but that. You were far away by then and I
was alone. We came back to rue Palantine and you, in a drunken stupor
told me a lot of things that I only half understood:[59] but I understood
the dinner we had at Ernests'. Only I didn't understand that it mattered.
You left me more and more alone, and though you complained that it
was the appartment or the servants or me, you know the real reason
you couldn't work was because you were always out half the night and
you were sick and you drank constantly. We went to Cannes. I kept up
my lessons and we quarrelled You wouldn't let me fire the nurse
that both Scottie and I hated. You disgraced yourself at the Barry's[60]
party, on the yacht at Monte Carlo, at the casino with Gerald and
Dotty.[61] Many nights you didn't come home. You came into my room
once the whole summer, but I didn't care because I went to the beach
in the morning, I had my lesson in the afternoon and I walked at night.
I was nervous and half-sick but I didn't know what was the matter. I
only knew that I had difficulty standing lots of people, like the party at
Wm J. Locke's and that I wanted to get back to Paris. We had lunch at
the Murphy's and Gerald said to me very pointedly several times that
Nemchinova[62] was at Antibes. Still I didn't understand. We came back
to Paris. You were miserable about your lung,[63] and because you had
wasted the summer, but you didn't stop drinking I worked all the
time and I became dependent on Egorowa. I couldn't walk in the street
unless I had been to my lesson. I couldn't manage the appartment because
I couldn't speak to the servants. I couldn't go into stores to buy clothes and
my emotions became blindly involved. In February, when I was so sick
with bronchitis that I had ventouses[64] every day and fever for two
weeks, I had to work because I couldn't exist in the world without it,
and still I didn't understand what I was doing. I didn't even know what
I wanted. Then we went to Africa and when we came back I began to
realize because I could feel what was happening in others. You did not
want me. Twice you left my bed saying "I can't. Don't you
understand"—I didn't. Then there was the Harvard man who lost his
direction, and when I wanted you to come home with me you told me
to sleep with the coal man. At Nancy Hoyt's[65] dinner she offerred her
services but there was nothing the matter with my head then, though I
was half dead, so I turned back to the studio. Lucienne[66] was sent away
but since I knew nothing about the situation, I didn't know why there
was something wrong. I just kept on going. Lucienne came back and
later went away again and then the end happenned I went to Mal-

maison.[67] You wouldn't help me—I don't blame you by now, but if you
had explained I would have understood because all I wanted was to go
on working. You had other things: drink and tennis, and we did not
care about each other. You hated me for asking you not to drink. A girl
came to work with me but I didn't want her to. I still believed in love
and I thought suddenly of Scottie and that you supported me. So at
Valmont[68] I was in tortue, and my head closed to-gether. You gave me
a flower and said it was "plus petite et moins etendue"[69]— We were
friends—Then you took it away and I grew sicker, and there was no-
body to teach me, so here I am, after five months of misery and agony
and desperation. I'm glad you have found that the material for a Jose-
pine story[70] and I'm glad that you take such an interest in sports. Now
that I can't sleep any more I have lots to think about, and since I have
gone so far alone I suppose I can go the rest of the way—but if it were
Scottie I would not ask that she go through the same hell and if I were
God I could not justify or find a reason for imposing it—except that it
was wrong, of cource, to love my teacher when I should have loved
you. But I didn't have you to love—not since long before I loved her.

I have just begun to realize that sex and sentiment have little to do
with each other. When I came to you twice last winter and asked you
to start over it was because I thought I was becoming seriously involved
sentimentally and preparing situations for which I was morally and
practicly unfitted. You had a song about Gigolos: if that had ever en-
tered my head there was, besides the whole studio, 3 other solutions in
Paris.

I came to you half-sick after a difficult lunch at Armonville and you
kept me waiting until it was too late in front of the Guaranty Trust.

Sandy's[71] tiny candle was not much of a strain, but it required some-
thing better than your week of drunkenness to put it out. You didn't
care: so I went on and on—dancing alone, and, no matter what happens,
I still know in my heart that it is a Godless, dirty game; that love is
bitter and all there is, and that the rest is for the emotional beggars of
the earth and is about the equivalent of people who stimulate them-
selves with dirty post-cards—

1. Newman Smith, husband of her sister Rosalind.
2. Ludlow Fowler, Fitzgerald's school friend, was the model for Anson Hunter in "The Rich Boy."
3. Townsend Martin, Princeton classmate of Fitzgerald's.
4. Alexander McKaig and possibly William Mackie.
5. Drama critic George Jean Nathan.
6. "Dice, Brass Knuckles & Guitar" was written in January 1923—not in Westport in 1920.
7. Summer 1920; this trip provided material for "The Cruise of the Rolling Junk," *Motor* (Febru-
ary, March, April 1924).

8. Humorist Donald Ogden Stewart.
9. Playwright Zoë Akins; Botticelli is a parlor game.
10. Theater producer.
11. Lynne Overman, stage and screen actor.
12. Editor Thomas Smith of Boni and Liveright.
13. Critic H. L. Mencken.
14. Poet John Peale Bishop, Fitzgerald's college friend.
15. Sir Shane Leslie, British literary figure.
16. St. John Ervine, British playwright.
17. A comic song Fitzgerald had written.
18. Xandra Kalman, a St. Paul friend.
19. Novelist.
20. Possibly tetany, a condition resembling tetanus.
21. Oscar Kalman, husband of Xandra.
22. Prince Vladimir N. Engalitcheff, son of the former Russian Vice Consul in Chicago and of a wealthy American mother; the Fitzgeralds met Engalitcheff aboard the *Aquitania* in 1921 while he was an undergraduate at Brown University. E. E. Paramore, a writer best known for "The Ballad of Yukon Jake"; later a Hollywood collaborator with Fitzgerald.
23. Critic Edmund Wilson.
24. Charles Cary Rumsey, sculptor and polo player who had an estate at Westbury, Long Island.
25. Probably financier Clarence MacKay.
26. Writer Ring Lardner.
27. Actor Glenn Hunter appeared in *Grit* (1924), a silent movie for which Fitzgerald wrote the scenario.
28. Critic.
29. English novelist.
30. Herbert Bayard Swope, executive editor of the *New York World.*
31. Playwright.
32. Scottie's nurse.
33. Edouard Jozan, French naval aviator with whom she was romantically involved in the summer of 1924.
34. In the fall of 1924, Fitzgerald was jailed in Rome after a brawl.
35. A Christmas party for the cast of *Ben Hur.*
36. Howard Coxe, journalist and novelist.
37. Possibly composer Theodore Chanler.
38. Gerald and Sara Murphy, American expatriates and close friends of the Fitzgeralds.
39. Theater producer Dwight Wiman.
40. Actress.
41. Actress.
42. Preparation containing alcohol; used as a sedative.
43. Poet Archibald MacLeish.
44. Probably *piqûres* ("injections").
45. Spa in the Pyrenees where she took a "cure" in January 1926.
46. Raquel Meller, internationally known Spanish singer.
47. A beach at Cap d'Antibes.
48. Opera singer and actress whom the Fitzgeralds knew on the Riviera.
49. Ruth Ober-Goldbeck-de Vallombrosa, an American married to the Count de Vallombrosa; playwright Charles MacArthur.
50. Walker Ellis, Princetonian with whom Fitzgerald had collaborated in the Triangle Club.
51. Author of *Gentlemen Prefer Blondes.*
52. St-Paul-de-Vence, a town in the mountains above the Riviera where Zelda was angered by Fitzgerald's attentions to Isadora Duncan.
53. Zelda resented Fitzgerald's interest in actress Lois Moran.
54. Novelist Carl Van Vechten.
55. Movie actress.
56. New York lawyer Richard Knight.
57. French diplomat and author; best known for *Open All Night* (1923) and *Closed All Night* (1924).
58. Paris taxi driver whom Fitzgerald brought to "Ellerslie" in 1928 to serve as chauffeur.
59. Fitzgerald had come home after a drinking session with Hemingway and passed out. In his

sleep he said, "No more baby," which Zelda interpreted as evidence that Fitzgerald and Hemingway were engaged in a homosexual affair.
60. Playwright Philip Barry.
61. Writer Dorothy Parker.
62. Prima ballerina Nemtchinova.
63. Fitzgerald believed he had tuberculosis.
64. French medical term for cupping.
65. Novelist; sister of Elinor Wylie.
66. Ballerina in Madame Egorova's studio.
67. Clinic outside Paris, where she was treated in April–May 1930.
68. Val-Mont Clinic at Glion, Switzerland, where she was treated in May 1930.
69. Smaller and less stretched; Fitzgerald used this phrase in one of Nicole's letters from the sanitarium in *Tender Is the Night*.
70. In 1930 Fitzgerald began a series of five stories for *The Saturday Evening Post* about Josephine Perry, a teenaged girl who undergoes a process of "emotional bankruptcy."
71. The Kalmans were in Paris at the time of Zelda's breakdown in the spring of 1930.

Fall 1930 AL, 3 pp. Princeton University
 Prangins Clinic, Nyon, Switzerland

Goofy, my darling, hasn't it been a lovely day? I woke up this morning and the sun was lying like a birth-day parcel on my table so I opened it up and so many happy things went fluttering into the air: love to Doo-do and the remembered feel of our skins cool against each other in other mornings like a school-mistress. And you 'phoned and said I had written something that pleased you and so I don't believe I've ever been so heavy with happiness. The moon slips into the mountains like a lost penny and the fields are black and punguent and I want you near so that I could touch you in the autumn stillness even a little bit like the last echo of summer. The horizon lies over the road to Lausanne and the succulent fields like a guillotine and the moon bleeds over the water and you are not so far away that I can't smell your hair in the drying breeze. Darling—I love these velvet nights. I've never been able to decide whether the night was a bitter [] or a grand patron—or whether I love you most in the eternal classic half-lights where it blends with day or in the full religious fan-fare of mid-night or perhaps in the lux of noon—Anyway, I love you most and you 'phoned me just because you 'phoned me to-night—I walked on those telephone wires for two hours after holding your love like a parasol to balance me. My dear—

I'm so glad you finished your story—Please let me read it Friday. And I will be very sad if we have to have two rooms. Please.

Dear. Are you sort of feeling aimless, surprised, and looking rather reproachful that no melo-drama comes to pass when your work is

over—as if you ridden very hard with a message to save your army
and found the enemy had decided not to attack—the way you some-
times feel—or are you just a darling little boy with a holiday on his
hands in the middle of the week—the way you sometimes are—or are
you organizing and dynamic and mending things—the way you always
are.

I love you—the way you always are.

Dear—
 Good-night—
Dear-dear dear dear dear dear dear
Dear dear dear dear dear dear dear
Dear dear dear dear dear dear
Dear dear dear dear dear dear
Dear dear dear dear dear dear
Dear dear dear dear dear dear
dear dear dear dear dear dear
dear dear dear dear dear dear
dear dear dear dear dear dear
dear dear dear dear dear dear

1930/1931 AL, 3 pp. Princeton University
 Prangins Clinic, Nyon, Switzerland

My dearest and most precious Monsieur,
 We have here a kind of a maniac who seems to have been inspired
with erotic aberrations on your behalf. Apart from that she is a person
of excellent character, willing to work, would accept a nominal salary
while learning, fair complexion, green eyes would like correspondance
with refined young man of your description with intent to marry. Pre-
vious experience unnecessary. Very fond of family life and a wonderful
pet to have in the home. Marked behind the left ear with a slight ten-
dency to schitzoprenie.
 We thought it best to warn you that said patient is one of the best
we have at present in the irresponsible class, and we would not like any
harm to come to her. She seems to be suffering largely from a grand
passion, and is easily identifiable as she will be wearing the pink of
condition and babbling about the 6.54 being cupid's arrow. We hope
this specimen will give entire satisfaction, that you will entrust us with

all future orders and we love you with all all all our hearts and souls and body.

Wasn't it fun to laugh together over the 'phone? You are so infinitely sweet and dear—O my dear—my love, my infinitely inexpressible sweet darling dear, I love you so much.

Our picnic was a success and I am cooked raw from the sun. A lady came with us who behaved about the row-boat like I used to about the Paris taxis so it was a lively expedition. What fun, God help us—

Goofy! I'm going to see you to-morrow to-morrow! You said you wouldn't 'phone, so what time will I expect your call?

If all the kisses and love I'm sending you arrive at their destination you will be as worn away as St. Peter's toe and by the time I arrive have practically no features left at all—but I shall know you always by the lilt in your darling person

Dearest!

Spring/Summer 1931 AL, 3 pp. Princeton University
 Prangins Clinic, Nyon, Switzerland

Darling, Berne is such a funny town: we bumped into Hansel and Gretel and the Babes in the Wood were just under the big clock. It must be a haven for all lost things, painted on itself that way. Germanic legends slide over those red, peeling roofs like a fantastic shower and the ends of all stories probably lie in the crevasses. We climbed the cathedral tower in whispers, and there it was hidden in the valley, paved with sugar blocks, the home of good witches, and I asked of all they painted statues three wishes.

That you should love me

That you love me

You love me!

O can you? I love you so.

The train rode home through a beautiful word: "alpin-glun."[1] The mountains had covered their necks in pink tulle like coquettish old ladies covering scars and wrinkles and gold ran down the hill-sides into the lake.

When we got home they said you had 'phoned, so I phoned back as indiscreetly as possible since I couldn't bear not having heard your voice, that lovely warm feeling like an emotional massage.

O my love—how can you love a silly girl who buys cheese and plaited bread from enchanted princes in the public market and eats them

on the streets of a city that pops into life like a cucoo-clock when you press the right note of appreciation

I *love* you, dear.

1. *Alpenglühen*, the glow of the Alps at sunset.

After August 1931 AL, 6 pp. Princeton University
 Prangins Clinic, Nyon, Switzerland

Dearest, my Love—

Your dear face shining in the station, your dear radiant face and all along the way shimmering above the lake—

It's so peaceful to be with you—when we are to-gether we are apart in a high indominatable place, sweet like your room at Caux swinging over the blue. I love you more always and always—

Please don't be depressed: nothing is sad about you except your sadness and the frayed places on your pink kimona and that you care so much about everything—You are the only person who's ever done all they had to do, damn well, and had enough left over to be dissatisfied. You are the best—the best—the best and genius is so much a part of you that when you find a person you like you think they have it too because it's your only conception—O my love, I love you so—and I want you to be happy. Can't you possibly be just a little bit glad that we are alive and that all the year that's coming we can be to-gether and work and love and get some peace for all the things we've paid so much for learning? Stop looking for solace: there isn't any and if there were life would be a baby affair. Johnny takes his medicine and Johnny get well and a quarter besides. Think! Johnny might get some mysterious malady if left to develop and have it named for him and live forever, and if Johnny died from not having his syrup the parable would have been a moralistic one about his mother.

Dear, I'm tired and in an awful muddle myself and I don't know what to tell you—but love is important and we can make life do and you are greater than any of them when you're well and rested enough not to know they exist.

Stop thinking about our marriage and your work and human relations—you are not a showman arranging an exhibit—You are a Sun-god with a wife who loves him and an artist—to take in, assimilate and all alterations to be strictly on paper—

Darling, forgive me, I love you so. I can't find anything to say beyond that and I'd like a wonderful philosophy to comfort you.

Dear, my love.
Think of me some—
 It's so happy to touch you.

December 1931 ALS, 2 pp. Princeton University
 Montgomery, Alabama[1]

Dearest My D.O—
 Sunday in a trance and sleeping all afternoon like a deserted cat on your bed and now its night and the house seems to be nothing but overtones with you away—Tho you hat is in the hall and your stick still on the bed and you could not tell that it's all just a bluff and a make-shift without you. I feel like going to Florida for the week-end. It's only six hours in the car, and I imagine at this time of year it would be very reedy with lone fowls strung on the horizon and the seaflinging loose gray cowls on the sand and long yellow beaches that look like womens' poetry and belong to the Swinburne apostles.
 The cat is the most beautiful fellow. He broods over ancient Egypt on the hearth and looks at us all contemptuously. Julia and Freeman[2] are very good and considerate and Mlle and I get along very well and have not yet come to blows. She is a nice girl. Scottie is engrossed in protecting herself against being disillusioned about Santa Claus and is as pretty as a moon-beam. She dresses herself by my fire and it's a joy to watch her long sweet delicate body and the cool of her pale hair quenching the light from the flames. However, my disposition is very bad and asthmatic and it is just as well that you are out of this homely lyric. I am going to dig myself a bear-pit and sit inside thumbing my nose at the people who bring me carrots and then I will be perfectly happy. My mother and father are civilized people: it is strange the rest of us should be so inadequate. There are some lovely bears in Berne who live in a mythical world of Sunday afternoon and little boys and itenerant soldiers and the one in Petrouschka is very pleasant and sometimes they live on honey and wildflowers when they are off duty from the fairy-tales. But I will be a very dirty bear with burrs in my coat and my nice silky hair all matted with mud and I will growl and move my head about disconsolately.
 There are no grands évènements to report. I am sending my story to Ober[3] as it now seems satisfactory to me, but nobody will buy it since it is mostly about champagne. They wouldn't buy it anyway even if it was about hydrochloric-acid or mystic anti-kink so what ho!

Darling I miss you so terribly—You can never go off again. It's absolutely impossible to be very interested in anything without you or even to get along very well—at all.

Love and Love and Love

<div align="right">Zelda</div>

1. Fitzgerald was in Hollywood alone during November–December writing an unproduced screenplay.
2. The Fitzgeralds' servants.
3. Harold Ober, Fitzgerald's literary agent.

December 1931 ALS, 4 pp. Princeton University
 Montgomery, Alabama

Dearest my love:
 I am positively tormented by all sorts of self-reproaches at leaving. Scottie is so sweet and darling and the house is so pleasant and I have everything in the world except you. And yet I am nervous and too introspective and stale—probably because since you left I haven't felt like amusement and recently I have not been able to exercise at all. So I am leaving for the week-end only, in the hopes that just long riding rolling along will give me back the calm and contentment that has temporarily disappeared with my physical well-being. Please understand and do not think that I leave in search of any fictitious pleasure. After the utter solitude of Prangin there have been many people lately and people that I love with whom my relations are more than superficial and I really think I need a day or two by myself. I will leave Sun. and be back Wed. night—While we are away, Julia is thorough cleaning. She is a peach.
 D.O. I realize more completely than ever how much I live in you and how sweet and good and kind you are to such a dependent appendage.
 Chopin has his nest in our bath-room. He is so lovely with a face like a judicial melancholic bear, the Polly scornfully eats peanuts, and Uncle[1] rakes the leaves like father Time sorting over the years of the past.
 Scottie and I have had a long bed-time talk about the Soviets and the Russian idea. I lent her "The Russian Primer"[2] to read and will be curious to hear her reactions when I get back. She is so responsive and alert. You will be absolutely ravished by her riding trousers and yellow shirt and Scottie rearing back in her saddle like a messenger of victory. Each time she goes she conquers herself and the pony, the sky, the

fields and the little black boy who follows on a fast shaven mule. I wish I were a fine sweet person like you two and not somebody who has to go 200 miles because they have a touch of asthma.

The house is full of surprises—but as usual I did everything at once and there's nothing left for the end, except finish my story which is too good to do uninspirationally and out of sorts.

God! I hope you haven't worked yourself to death. We *must* reduce our scale of living since we will always be equally extravagant as now. It would be easier to start from a lower base. This is sound economics and what Ernest and most of our friends do—

Darling—How much I love you.

<div align="right">Zelda</div>

1. The yardman.
2. M. Ilin, *New Russia's Primer* (1931).

After February 1932　　　　　　　AL, 4 pp. Princeton University
　　　　　　　　　　　　　　　　　Phipps Clinic, Baltimore, Maryland[1]

Dearest:

Life has become practicly intolerable. Everyday I devellop a new neurosis until I can think of nothing to do but place myself in the Confederate Museum at Richmond. Now it's money: We must have more money. To-morrow it will something else again: that I ran when Mamma needed me to help her move, that my hips are fat and shaking with the vulgarities of middle-age, that you had to leave your novel, that there are unemployed, or millionaires, people better than I am and people worse, a horrible sickening fear that I shall never be able to free myself from the mediocrity of my conceptions. For many years I have lived under the disastrous pressure of a conviction of power and necessity to accomplish without the slightest ray of illumination. The only message I ever thought I had was four pirouettes and finité. It turned out to be about as cryptic a one as Chinese laundry ticket, but the will to speak remains.

O Darling! My poor dear—watching everything in your life destroyed one by one except your name. Your entire life will soon be accounted for by the toils we have so assiduously woven—your leisure is eaten up by habits of leisure, your money by habitual extravagance, your hope by cynicism and mine by frustration, your ambition by too much compromise. D.O. it is very sad and utterly meaningless and the only real emotion I have which will bear inspection is an over-

whelming desire to expose the charlatanism and ignominious harlotrys of what we so eruditely refer to as our civilizations. Freud is the only living human outside the Baptist church who continues to take man seriously.

Bunny's mind is too speculative—Nothing but futures, of the race, of an idea, of politics, of birth-control. Just constant planning and querulous projecting and no execution. And he drinks so much that he cares more than he would.

Darling:

I want to go to fabulous places where there is absolutely no conception of the ultimate convergence of everything—

I *Love You*

1. After Zelda Fitzgerald suffered a relapse during a trip to Florida in January, Fitzgerald placed her in the Phipps Clinic and returned to Montgomery.

March 1932 ALS, 4 pp. Princeton University
 Phipps Clinic, Baltimore, Maryland

Darling, Sweet D.O.—

Your dear letter made me feel very self-condamnatory. I have often told you that I am that little fish who swims about under a shark and, I believe, lives indelicately on its offal. Anyway, that is the way I am. Life moves over me in a vast black shadow and I swallow whatever it drops with relish, having learned in a very hard school that one cannot be both a parasite and enjoy self-nourishment without moving in worlds too fantastic for even my disordered imagination to people with meaning. So: it is easy to make yourself loved when one lives off love. Goofo—I adore you and worship you and I am very miserable that you be made even temporarily unhappy by those divergencies of direction in myself which I cannot satisfactorily explain and which leave me eternally alone except for you and baffled. You are absolutely all in the world that I have ever been able to think of as having any vital bearing on my relations with the evolution of the species.

"Freaks" gave me the horrors.[1] God! the point of view of sanity, normality, beauty, even the necessity to survive is so utterly arbitrary. Nobody has ever been able to experience what they have thoroughly understood—or understand what they have experienced until they have achieved a detachment that renders them incapable of repeating the experience. And we are all seeking the absolution of chastity in sex and

the stimulation of sex in the church until sometimes I think I would loose my mind if I were not insane.

Darling, darling. The Zola is wonderful. Had he ever fallen into the hands of the authorities, we should have missed his contribution to neurasthentic symptology sadly. It is a long time since I have had any new symptoms and I am bored with all the old tricks of my shattered organism

I love you and I would like us to be covered with the flake of dried sea water and sleeping to-gether on a hot afternoon. That would be very free and fine. Dear Heart!

I have got so fetid and constantly smell of the rubbery things about here—It's ghastly, really. I do not know to what depths the human soul can sink in bondage, but after a certain point everything luckily dissolves in humor. I want to fly a kite and eat green apples and have a stomach-ache that I know the cause of and feel the mud between my toes in a reedy creek and tickle the lobe of your ear with the tip of my tongue.

If Trouble[2] still bites give him a good kick in the ass for me.

Darling, I love you so.

<div align="right">Zelda.</div>

P.S. I do not see how Dr. Squires[3] can remain a sprig of old English lilac in this seething witches cauldron. Did you know the Furies turned out to be respectable old women who went about the countryside doing good and laying eggs in their night shirts? So much for Eschyllus. The old moralist!

1. A 1932 movie.
2. Scottie's dog.
3. Dr. Mildred Squires of the Phipps Clinic, to whom Zelda Fitzgerald dedicated *Save Me the Waltz*.

March 1932 ALS, 2 pp. (with Fitzgerald's annotations)
<div align="right">Princeton University
Phipps Clinic, Baltimore, Maryland</div>

Dearest, my own Darling D.O—

I hadn't realized how much I wanted to see you till night came and you had telegraphed your delay—Here, living so that every action is a ritual and every smallest bit of energy expended is of interest to *somebody,* there's not much time left for projecting yourself into distant

places and speres of an ordinary existence. One day goes and then another and the cradle rocks on in the continuous lullaby of recapitulations. My heart fell with a thump that you didn't come—So I have been very cross and rude and blaming the Sicilian Vespers[A] and St. Bartholemew's on Dr. Myers.

Dearest:

Dr. Squires tells me you are hurt that I did not send my book to you before I mailed it to Max.[B] Purposely I didn't—knowing that you were working on your own and honestly feeling that I had no right to interrupt you to ask for a perious opinion. Also, I know Max will not want it and I prefer to do the corrections after having his opinion. Naturally, I was in my usual rush to get it off my hands—You know how I hate brooding over things once they are finished: so I mailed it poste haste, hoping to have yours + Scribner's criticisms to use for revising. (all this reasoning is specious or else there is no evidence of a tornado in the state of Alabama[C]

Scott, I love you more than anything on earth and if you were offended I am miserable. We have always shared everything but it seems to me I no longer have the right to inflict every desire and necessity of mine on you. *I was also afraid we might have touched the same material.*[D] Also, feeling it to be a dubious production due to my own instability I did not want a scathing criticism such as you have mercilessly—if for my own good given my last stories, poor things. I have had enough discouragement, generally, and could scream with that sense of inertia that hovers over my life and everything I do. So, Dear, my own, please realize that it was not from any sense of not turning first to you—but just time and other ill-regulated elements that made me so bombastic about Max.

I have two stories that I save to show you, and a fantastic sketch.

I am going to begin a play as soon as I can find out about length etc—for which I ordered Baker's[E] book—

Goofo, please love me—life is very confusing—but

1 √

?
(perilous)
FSF

2 √
This
is
an
evasion

3 √

4 √
5 √

6

(7.) √

I love you. Try, dear—and then I'll remember when
you need me to sometime, and help.

I love you—
Zelda

The numbers and check marks in the margin are Fitzgerald's. Editorial footnotes are identified by
the letters A–E.
A. September 1931 Mafia murders.
B. Zelda Fitzgerald had written the first version of *Save Me the Waltz* at Phipps and sent it directly
to Maxwell Perkins, Fitzgerald's editor at Scribners. When Fitzgerald learned about it, he was
bitterly angry because he felt she had used material that belonged to him. The first draft of *Save
Me the Waltz* does not survive.
C. Fitzgerald's note; there had recently been a tornado in Alabama. The words "of Alabama" are
smeared.
D. Probably underlined by Fitzgerald.
E. George Pierce Baker, professor of playwriting.

April 1932 ALS, 2 pp. Princeton University
 Phipps Clinic, Baltimore, Maryland

Dearest:

Of cource, I glad submit to anything you want about the book or
anything else. I felt myself the thing was too crammed with material
upon which I had not the time to dwell and consequently lost any story
continuity. Shall I wire Max to send it back? The real story was the old
prodigal son, of cource. I regret that it offended you. The Pershing
incident[1] which you accuse me of stealing occupies just one line and
will not be missed. I willingly relinquish it. *However, I would like you to
thoroughly understand that my revision will be made on an aesthetic basis: that
the other material which I will elect is nevertheless legitimate stuff which has cost
me a pretty emotional penny[2]* to amass and which I intend to use when I
can get the tranquility of spirit necessary to write the story of myself
versus myself. That is the book I really want to write. As you know
my contacts with my family have always been in the nature of the raids
of a friendly brigand. I quite realize that the quality of this book does
not warrant so many excursions into the bizarre—As for my friends:
first, I have none; by that I mean that all our associates have always
taken me for granted, sought your stimulus and fame, eaten my dinners
and invited "the Fitzgeralds" place. You have always been and always
will be the only person with whom I have felt the necessity to com-
municate and our intimacies have, to me, been so satisfactory mentally
that no other companion has ever seemed necessary. Despised by my
supiors, which are few, held in suspicion by my equal, even fewer, I

have got all external feeding for my insignifgant flames from people either so vastly different from myself that our relations were like living a play or I have cherished my inferiors with color; to wit; Still [] etc. and the friends of my youth. However, I did not intend to write you a treatise on friendship in which I do not believe. There is enough difficulty reconciling the different facets in one single person to bear the context of all human communication, it seems to me. When that is accomplished, the resultant sense of harmony is what is meant by benevolent friendship.

D.O. I am so miserable at not being able to help you. *I know how upset you get about stories. Don't worry.*[3] If we have less money—well, we can always live. I promise to be very conciliatory and want nothing on earth so much as for you to feel that you can write what you want.

About my fish-nets: they were beautiful gossamer pearl things to catch the glints of the sea and the slow breeze of the weaving sea-weed and bubbles at dawn. If a crab filtered in and gnawed the threads and an octpus stagnated and slimed up their fine knots and many squids shot ink across their sheen and shad laid comfortable row on their lovely film, they are almost repaired once more and the things I meant to fish still bloom in the sea. Here's hope for the irridiscent haul that some day I shall have. What do you fish with, by the way? that so puts to shame my equipment which I seriously doubt that you have ever seen, Superior Being—

> With dearest love, I am your irritated
> Zelda

1. In Book I, Chapter 18 of *Tender Is the Night*, Abe North pretends to be General Pershing at the Paris Ritz.
2. Possibly underlined by Fitzgerald.
3. Possibly underlined by Fitzgerald.

March 1934 ALS, 6 pp. Princeton University
 Craig House, Beacon, New York

Dear Scott:

I quite realize the terrible financial pressure of the last year for you, and I am miserable that this added burden should have fallen on your shoulders. All the beauty of this place must cost an awful lot of money and maybe it would be advisable to go somewhere more compatible with our present means.[1] Please do not think that I don't appreciate the strain you are under. I would make the best possible effort to rehabili-

tate myself under any less luxurious conditions that might be more expedient.

Please don't give up Scottie's music. Though she is at an age when she resents the practice, I feel sure that later she will get an immense satisfaction out of the piano. About the French, do as you think best. She will never forget it at her age and could pick it up again quickly as soon as she heard it around her.

It's too bad about Willie She was the best cook we've ever had in years and I've always held Essie in suspect: there've been such a long succession of rows over missing things since she became part of the household.

The trunk arrived. I am very much oblidged. However, I would also like my blue bathing-suit which may be in the box with moth balls in the back room on the third floor, and also the rest of my clothes: a blue suit, a green checked skirt and the evening clothes. ALSO PLEASE ask Mrs Owens to send me a $2 pointed camel's hair brush from Webers and the two unfinished canvases from Phipps, and a pound can of Weber's permalba.

Dear: I am not trying to make myself into a great artist or a great anything. Though you persist in thinking that an exaggerated ambition is the fundamental cause of my collapse, knowing the motivating elements that now make me wa[nt] to work I cannot agree with you and Dr Forel—though of cource, the will-to-power may have played a part in the very beginning. However, five years have passed since then, and one matures. I do the things I can do and that interest me and if you'd like me to give up everything I like to do I will do so willingly if it will advance matters any. I am not headstrong and do not like existing entirely at other peoples expense and being a constant care to others any better than you like my being in such a situation.

If you feel that it is an imposition on Cary to have the exhibition, the pictures can wait.[2] I believe in them and in Emerson's theory about good-workman-ship. If they are good, they will come to light some day.

About my book: you and the doctors agreed that I might work on it.[3] If you now prefer that I put it aside for the present I wish you would be clear about saying so. The short story is a form demanding too concentrated an effort for me at present and I might try a play, if you are willing and don't approve of the novel or something where the emotional purpose can be accomplished by accurate execution of an original cerebral conception. *Please say what you want done,* as I really do not know. As you know, my work is mostly a pleasure for me, but if it

is better for me to take up something quite foreign to my temperament, I will—Though I can't see what good it does to knit bags when you want to paint pansies, maybe it is necessary at times to do what you don't like.

Tilde[4] 'phoned that she and John would drive over to see me. I will be very glad to see them.

<div align="right">Love
Zelda</div>

1. Zelda Fitzgerald failed to show improvement at Phipps, and Fitzgerald moved her to Craig House in Beacon, N.Y., where the minimum rate was $175 a week.
2. Her paintings and drawings were shown at Cary Ross's gallery in Manhattan March 29–April 30, with a smaller exhibit at the Algonquin Hotel.
3. A second novel that was never finished.
4. Clothilde Palmer, Zelda's sister.

April 1934 ALS, 1 p. Princeton University
<div align="right">Craig House, Beacon, New York</div>

Dear—The book is grand.[1] The emotional lift sustained by the force of a fine poetic prose and the characters *subserviated* to forces stronger than their interpretations of life is very moving. It is tear-evoking to witness individual belief in individual volition succumbing to the purpose of a changing world. That is the purpose of a good book and you have written it—Those people are helpless before themselves and the prose is beautiful and there is manifest an integrity in the belief of both those expressions. It is a reverential and very fine book and the first literary contribution to what writers will be concerning themselves with some years from now.

<div align="right">Love
Zelda</div>

1. *Tender Is the Night* was published on April 12.

After 12 April 1934 ALS, 3 pp. Princeton University
<div align="right">Craig House, Beacon, New York</div>

Dearest D.O.:

I was afraid you might worry about some of the silly reviews[1] which I have not seen until to-day *Please don't* All the opinion which you

respect has said everything you would like to have said about the book. It is not a novel about the simple and the inarticulate, nor are such a fitting subject for literature one of whose primary functions is to enrich the human mind. Anybody granted a certain talent can express direct action, or even emotion segregated from the activities of the world of their day but to present the growth of a human tragedy resultant from social conditions is a big feat. To me, you have done it well and at the same time preserved the more simple beauties of penetrating poignancy to be found in the use of exquisite prose.

Don't worry about critics—what sorrows have they to measure by or what lilting happiness with which to compare those ecstatic passages?

The atomists who followed Democritus said that quantity was what differentiated one thing from another—not quality—so critics will have to rise one day to the high points of good books. They cannot always live on reproductions of their own emotions in simple enough settings not to distract them: the poor boy having a hard time which is all very beautiful because of the poverty, etc.

It's a swell heart-breaking book, because the prose compels you to respond to the active situations—which is as it should be.

I am very worried about the finances. PLEASE don't hesitate to do *anything* that would relieve the strain on you.

<div style="text-align: right;">

Love
Zelda

</div>

1. The reviews of *Tender Is the Night* were mixed, with several critics expressing confusion at the structure of the novel.

After 12 April 1934 ALS, 4 pp. Princeton University
 Craig House, Beacon, New York

Dearest Do-Do:

I was so worried that you would be upset about some of those reviews—What critics know about the psychology of a psychiatrist, I don't know, but the ones I saw seemed absurd, taking little account of the fact that a novel not in 18 volumes *can't* cover everything but must rely on the indicative You know yourself that as people yours are moving and heart-rending creations; as instruments of your artistic purpose they arrive at an importance which they would otherwise not have had, and that is the function of characters in a novel, which is, after all, a way of looking at life Do you suppose you could get Menken to write an intelligent review? The rest do not seem to know what they

think beyond the fact that they have never thought of such problems before. And *don't* let them discourage you. It is a swell evokation of an epoch and a very masterly presentation of tragedies sprung from the beliefs (or lack of them) of those times which bloomed from the seeds of despair planted by the war and of the circumstance dependent on the adjustment of philosophies—Woolcot might be good to review it, since he had some appreciation of the spectacle which it presents, but I have seen some very silly and absurd commentaries of his lately, and he may have succumbed to the pseudo-radical formulas of Kaufman and Gershwin by now.[1]

Let Bromfield[2] feed their chaotic minds on the poppy-seed of farm-youth tragedies and let them write isolated epics lacking any epic quality save reverence Yours is a story taking place behind the scenes, and I only hope that you will not forget that most of the audience has never been there—

Anyway, they all seem to realize that much thought and a fine equipment has gone into its making and maybe—if they only could understand—

D.O.—darling—having reached the people you wanted to reach, what more can you ask? Show man ship is an incidental consideration, after all—they have its glittering sequins in the circus and the Hippodrome and critics yelling for more in literature seems a little like babies crying for things they can't have between meals—put card-board cuffs on their elbows—Those antiquated methods are the only ones I know.

<center>x x x x</center>

Since writing your letter has come. Of cource, I missed all but a few reviews. Bill Warren has a swell sense of the dramatic and I hope he'll separate out the points that will appeal to Mr. Mayer.[3] My advice is to revert to the money-triangle as you can't possibly use the incest. Or make the man a weak and charming figure from the first, always gravitating towards the center of things: which would lead him, when he was in the clinic, to Nicole and later to Rosemary. Regret could be the motif of the last section—Naturally, it's only advice, and I don't know if a male star would like to play something so far removed from Tarzan and those things about the desert where people are so brave, and only minor figures make mistakes

<div align="right">Love
Zelda</div>

1. Alexander Woollcott did not review *Tender Is the Night*. George S. Kaufman collaborated with George and Ira Gershwin on *Of Thee I Sing* (1931) and *Let 'em Eat Cake* (1933).

2. Novelist Louis Bromfield.
3. Charles Marquis Warren was working on a screenplay of *Tender Is the Night* that Fitzgerald hoped to sell to MGM.
4. Louis B. Mayer, head of MGM.

April 1934 ALS, 4 pp. Princeton University
 Craig House, Beacon, New York

Dearest Scott:

I am glad you did not let those undiscerning reviews upset you— You have the satisfaction of having written a tragic and poetic personal drama against the background of an excellent presentation of the times we matured in. You know that I have always felt that the chief function of the artist was to inspire *feeling* and certainly "Tender" did that. What people will live on for the next ten years I do not know: because, with the synchronization of light and sound and color (still embryonicly on display at the world's Fair) there may be a tremendous revision of aesthetic judgments and responses. Some of the later movies have cinematic effects unachievable with a brush—all of which tends to a communistic conception of art, I suppose. In this case, I writing might become the most individualistic of all expressions, or a sociological organ.

Anyway, your book is a sustained and exalted piece of prose—

Bill Warren, in my opinion, is a silly man to get to transcribe its subtleties to a metier that is now commanding the highest talents: because people will be *looking* thus expecting to be carried along by visual emotional developments as well as story and you will be robbed of the inestimable value of your prose to raise and cut and break the tension. But you know better than I. In the movies, one symbolic device is worth a thousand feet of explanation (granted you haven't at your disposal those expert technicians who have turned out some of the late stuff) Go to see Ruth Chatterton and Adolph Menjou in the last thing about murder.[1] It's a swell straight psychological story—I simply thought that with all the stuff in your book so much could have been done: the funicular, the beach umbrellas, the garden high above the world, and in the end the two people swimming in darkness.

When Mrs O. sends
1) Dramatic Technique
2) Golden Treasury
3) Pavlowa's Life
4) The Book on Modern Art, I will return Scottie's Treasury. Until

then, I have nothing to read as I can't stand the Inferno or the pseudo-noble-simplicity of that book Dorothy P. gave me.

Won't you ask her to? Also the paint from Webers. She said she would—They would mail it.

<div style="text-align: right">Love
Zelda—</div>

1. *Journal of a Crime.*

<div style="text-align: right">ALS, 3 pp. Princeton University
Sheppard and Enoch Pratt Hospital
Towson, Maryland</div>

After 13 June 1934

Dearest Do-Do:

Do-Do you are so sweet to do those stories for me. Knowing the energy and interest you have put into other people's work, I know how much trouble you make appear so easy. Darling—

I will correct the stories as soon as I can—though you know this is a very regimented system we live under with every hour accounted for and not much time for outside interests. There was a better, later version of the dance story[1]—but maybe I can shift this one since I remember it.

You talk of the function of art. I wonder if anybody has ever got nearer the truth than Aristotle: he said that all emotions and all experience were common property—that the transposition of these into form was individual and art. But, God, it's so involved by whether you aim at direct or indirect appeals and whether the emotional or the cerebral is the most compelling approach, and whether the shape of the edifice or the purpose for which it is designated is paramount that my conceptions are in a sad state of flux. At any rate, it seems to me the artists business is to take a willing mind and guide it to hope or despair contributing *not* his interpretations but a glimpse of his honestly earned scars of battle and his rewards. I am still adamant against the interpretive school. Nobody but educators can show people how to think—but to open some new facet of the stark emotions or to preserve some old one in the grace of a phrase seem nearer the artistic end. You know how a heart will rise or fall to the lilt of an a-laden troche or the sonorous dell of an o—and where you will use these business secrets certainly depends on the author's special evaluations. That was what I was trying to accomplish with the book I began: I wanted to say "This is a

love story—maybe not your love story—maybe not even mine, but this is what happened to one isolated person in love. There is no judgment."—I don't know—abstract emotion is difficult of transcription, and one has to find so many devices to carry a point that the point is too often lost in transit—

I wrote you a note which I lost containing the following facts

1) The Myers have gone to Antibes with the Murphys—

2) Malcolm Cowley arrested for rioting in N.Y.

3) I drink milk, one glass of which I consider equal to six bananas under water or two sword-swallowings—

There didn't seem to be anything else to write you except that I love you. We have a great many activities of the kind one remembers pleasantly afterwards but which seem rather vague at the time like pea-shelling and singing. For some reason, I am very attached to this country-side. I love the clover fields and the click of base-ball bats in the deep green cup of the field and the sky as blue and idyllic as parts of your prose. I keep hoping that you will be in some of the cars that ruffle the shade of the sycamores. Dr. Ellgin said you would come soon.

It will be grand to see Mrs. Owens[2]—I wish it were you and Scottie. Darling.

Don't you think "Eight Women" is too big a steal from Dreiser[3]—I like, ironicly, "My Friends" or "Girl Friends" better. Do you suppose I could design the jacket. It's very exciting.

My reading seems to have collapsed at "The Alchemist."[4] I really don't care much for characters named for the cardinal sins or cosmic situations. However I will get on with it—

Thanks again about the book—and *everything*—In my file there are two other fantasies and the story about the judge to which I am partial—and I would be most grateful if you would read "Theatre Ticket"[5] to see if it could be sold to a magazine maybe—

<div style="text-align:center">

Love Why didn't you go to

Zelda. reunion?

</div>

Do you think the material is too dissimilar for a [co]llection? It worries me.

1. Unpublished
2. Isabelle Owens, Fitzgerald's secretary.
3. Theodore Dreiser's *Twelve Men* (1919).
4. By Ben Jonson.
5. Unpublished.

ALS, 4 pp. Princeton University
Sheppard and Enoch Pratt Hospital
Towson, Maryland

June 1935

Dearest and always
Dearest Scott:

I am sorry too that there should be nothing to greet you but an empty
shell. The thought of the effort you have made over me, the suffering
this *nothing* has cost would be unendurable to any save a completely
vacuous mechanism. Had I any feelings they would all be bent in grat-
itude to you and in sorrow that of all my life there should not even be
the smallest relic of the love and beauty that we started with to offer
you at the end.

You have been so good to me—and all I can say is that there was
always that deeper current running through my heart: my life—you.

You remember the roses in Kinneys yard—you were so gracious and
I thought "he is the sweetest person in the world" and you said "dar-
ling." You still are. The wall was damp and mossy when we crossed
the street and said we loved the south. I thought of the south and a
happy past I'd never had and I thought I was part of the south. You
said you loved this lovely land. The wistaria along the fence was green
and the shade was cool and life was old.

—I wish I had thought something else—but it was a confederate,
a romantic and nostalgic thought. My hair was damp when I took
off my hat and I was safe and home and you were glad that I felt that
way and you were reverent. We were gold and happy all the way
home.

Now that there isn't any more happiness and home is gone and there
isn't even any past and no emotions but those that were yours where
there could be any comfort—it is a shame that we should have met in
harshness and coldness where there was once so much tenderness and
so many dreams. Your song.

I wish you had a little house with hollyhocks and a sycamore tree
and the afternoon sun imbedding itself in a silver tea-pot. Scottie would
be running about somewhere in white, in Renoir, and you will be writ-
ing books in dozens of volumes. And there will be honey still for tea,
though the house should not be in Granchester—[1]

I want you to be happy—if there were justice you would be happy
—maybe you will be anyway—

Oh, Do-Do
Do-Do—

 Zelda.

I love you anyway—even if there isn't any me or any love or even any life—

I love you.

1. Rupert Brooke, "The Old Vicarage Grantchester" (1912).

1936/1937 ALS, 4 pp. Princeton University
 Highland Hospital, Asheville, North Carolina[1]

Dearest, dearest Do-Do:

What a funny picture of you in the paper. I wish we had just been swimming together, the way it seems—I'll be so glad when you come home again. When will we be three of us again—Do you remember our first meal in the Biltmore when you said "And now there'll never be just two of us again—from now on we'll be three—" And it was sort of sad somehow and then it was the saddest thing in the world, but we were safer and closer than ever—Oh, I'll be so glad to see you on the tenth.

Scottie was as sweet as I had imagined. She's one inch shorter than I am and weighs four pounds more—and I am her most devoted secret admirer—

Maybe I can come home—

O my love }
O my darling } Yes, I mean it

That's what we said on the softness of that expansive Alabama night a long long time ago when you envited me to dine and I had never dined before but had always just "had supper." The General was away. The night was soft and gray and the trees were feathery in the lamp light and the dim recesses of the pine forest were fragrant with the past, and you said you would come back from no matter where you are. So I said and I will be here waiting. I didn't quite believe it, but now I do.

And so, years later I painted you a picture of some faithful poppies and the picture said "No matter what happens I have always loved you so. This is the way we feel about *us*; other emotions may be super-imposed, even accident may contribute another quality to our emotions, but this is our love and nothing can change it. For that is true." And I love you still.

It was me who said:

I feel as if something had happened and I don't know know what it is

You said:

—Well and you smiled (And it was a compliment to me FOR you had never heard "well" used so before) if you don't know I can't possibly know

Then I said "I guess nobody knows—

And

you hoped and I guessed

Everything's going to be all right—

So we got married—

And maybe everything is going to be all right, after all.

There are so many houses I'd like to live in with you. Oh Wont you be mine—again and again—and yet again—

Dearest love, I love you

Zelda

Happily, happily foreverafterwards—the best we could.

1. Zelda Fitzgerald became a patient at Highland in April 1935; she remained there until 1940, after which she returned intermittently.

1939 ALS, 2 pp. Princeton University
Highland Hospital, Asheville, North Carolina

Dear D.O.:

It rains, and sleets; and is indeed as malevolent a time as ever attacked. The hills are steeped in Cosmic regrets and the valleys are flooded with morose and aimless puddles.

However, the stores bloom and blossom and ingratiates themselves with the brighter of spring-times and the newest of aspirations. The drugstores are still fragrant of chocolate and aromatic of all sorts of soaps and bottled miracles. This town is so redolent of hushed rendez-vous: I always think of you when I wait in Faters for the bus or hang around Eckerts before a movie—or even after a movies, thus making orgy.

"The Hunchback of Notre Dame" is the most magnificent fusion of music and action and the signifigance of lines that I have seen. The acting is far more than usually compelling: and the orchestration does not confine itself to the music but includes the whole performance.

There does not seem to be any news: which some people think of in terms of an advantage, but which, to me, presents itself vaguely in terms of disaster. Well anyway we're better off than the Finns + the Russians.[1]

I cant understand about your stories. The school that you started and the vogue which you began are still dictating the spiritual emulation of too many people for your work to be irrelevant: and certainly the tempo of the times ought to bring you some success.

Would it be a good idea if you tried Harold Ober again?[2] That seems to me a most sensible way of handling the situation: Ober knows so much better than anybody else how to handle your work.

<div style="text-align:right">

Devotedly
Zelda
</div>

Peter Liddle might be a lucky nom-de-plume.[3]

1. Finland and Russia were at war.
2. Fitzgerald's literary agent.
3. Fitzgerald was considering submitting his short stories under a pen name.